East window
of chapel

"I couldn't live in a flint house; flint houses look like dolls' houses," said an otherwise reasonable woman not long ago. "Flint buildings," she added, "look not only toy-like but amateurish;" which is partly true, and is half their charm. When dug from the local soil flint looks agreeable in the landscape in colour, and it always has a "rustic" texture—hence its attraction for the Gothick folly and lodge builders (top right: lodge at Cranborne, Dorset) and for the Victorian church builder (bottom right: Booton Church, Norfolk, designed by an amateur-architect incumbent.) A flint wall provides what might be called a formalised antique surface: exaggeratedly grey and rough, as if with weathering. The black knapped flints of Norwich, and Norfolk and north Suffolk generally, have been used since the fifteenth century for the purely decorative "flushwork," by church builders and others (top left: St. Michael Coslany, Norwich; south chapel. Bottom left: St. Stephen, Rampant Horse Street, Norwich). A common Victorian practice was to build a flint wall with horizontal bands and indented quoins and dressings of red, yellow, grey or purple bricks, which contrast in colour with the main grey wall surface, accentuating, of course, the "doll's house" effect of the whole. Examples are shown of Hampshire flints combined with yellow brick (opposite page, top: Micheldever Station) and of knapped flints combined with red brick—the wall being further strengthened and patterned in this case by an interlocking pattern of bricks (opposite page, bottom left: wall in Tombland, Norwich).

D0907143

John Piper, Myfanwy Piper

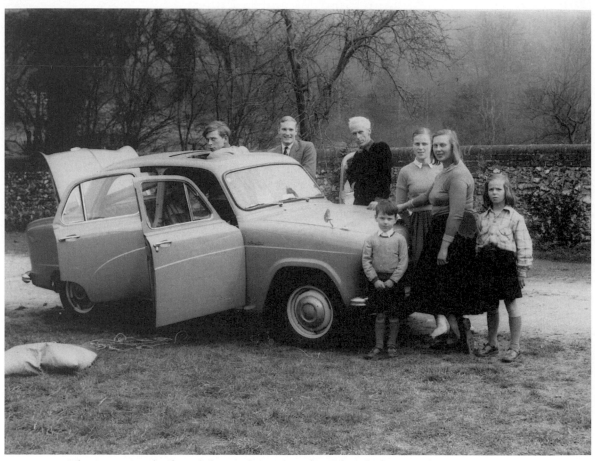

The Piper Family (from left to right): Edward, unidentified man, John, Sebastian, Clarissa, Myfanwy, Suzannah.

John Piper

Myfanwy Piper

LIVES IN ART

Frances Spalding

OXFORD
UNIVERSITY PRESS

OXFORD

UNIVERSITY PRESS

Great Clarendon Street, Oxford OX2 6DP

Oxford University Press is a department of the University of Oxford.
It furthers the University's objective of excellence in research, scholarship,
and education by publishing worldwide in

Oxford New York

Auckland Cape Town Dar es Salaam Hong Kong Karachi
Kuala Lumpur Madrid Melbourne Mexico City Nairobi
New Delhi Shanghai Taipei Toronto

With offices in

Argentina Austria Brazil Chile Czech Republic France Greece
Guatemala Hungary Italy Japan Poland Portugal Singapore
South Korea Switzerland Thailand Turkey Ukraine Vietnam

Oxford is a registered trade mark of Oxford University Press
in the UK and in certain other countries

Published in the United States
by Oxford University Press Inc., New York

© Frances Spalding 2009

The moral rights of the author have been asserted
Database right Oxford University Press (maker)

First published 2009

All rights reserved. No part of this publication may be reproduced,
stored in a retrieval system, or transmitted, in any form or by any means,
without the prior permission in writing of Oxford University Press,
or as expressly permitted by law, or under terms agreed with the appropriate
reprographics rights organization. Enquiries concerning reproduction
outside the scope of the above should be sent to the Rights Department,
Oxford University Press, at the address above

You must not circulate this book in any other binding or cover
and you must impose the same condition on any acquirer

British Library Cataloguing in Publication Data

Data available

Library of Congress Cataloging in Publication Data

Data available

Typeset by Sparks Publishing Services, Oxford – www.sparkspublishing.com
Printed in Great Britain
on acid-free paper by
CPI Antony Rowe, Chippenham, Wiltshire

ISBN 978-0-19-956761-4

5 7 9 10 8 6 4

Dedicated
to the memory of
Arthur Humphrey (1909–2000)
whose love of music and art
encouraged many

Acknowledgements

The writing of biography involves journeying to many places and into other lives. A great many people have assisted with the making of this book but first and foremost my thanks go to the Piper family and to John and Virginia Murray. It was John Murray's idea that a joint biography was needed, of John *and* Myfanwy Piper. The book was initially commissioned by him and I began work in the John Murray offices at 50 Albemarle Street, London, reading my way through the Piper correspondence which had been temporarily lodged in the Murray Archives. It was an enormous pleasure to work in a building so rich in literary history. I am especially indebted to Ginny Murray who carried huge box-loads of papers up to the room I was allocated, as well as numerous cups of coffee and tea, with unstinting encouragement. Marvellous, too, was the generosity with which the Piper family responded to my questions. I am grateful to Suzannah Brooks, Sebastian Piper, Prue Piper, Luke Piper, Henry Piper and Emily Cruz, and especially to Clarissa and David Lewis for their most generous hospitality in the course of my visits to their home outside Aberystwyth.

My thanks go also to Julian Barnes, Margaret Belcher, Mary Bland, Ian Bostridge, Victor Bugg, Robert Camac, Louise Campbell, Margie Campbell, Lord Camoys, Frieda Charlesworth, Jonathan Clark, Brian Clarke, Canon Methuen Clarke, Robin Cohen, Basil Coleman, the late Howard Colvin, Caroline Compston, the Hon. Mrs Harriet Cotteril, Arthur Cotton, John and Pam Deeker, Giles de la Mare, Gordon Dent, Sheila Dickinson, Margaret Dornan, John Doyle, Roderic Dunnett, Geoffrey and Pat Eastop, Geoffrey Elborn, the late Lord and Lady Esher, Paul Fincham, Victoria Gibson, Phillida Gili, Mike Goldmark, Rigby Graham, Derek Granger, Lavinia Grimshaw, the late Bodfan Grufydd, Richard Hamilton, Martin Harrison, the late Lady Harrod, Kitty Hauser, Robin Healey, Bevis Hillier, John Hitchens, the late Alun Hoddinott, Rhiannon Hoddinott, Patrick Horsbrugh, Patricia Howard, Caroline Humphrey, Richard Ingrams, The Rev. Gerard Irvine and Rosemary Irvine, Phil James, Stanley Jones, Patricia Jordan Evans, Peter Khoroche, James Kirkman, Cara Lancaster, Claire Lewis, Lord Lewis, Joyce R. Lindley, Candida Lycett Green, Jean Marsh, Donald Mitchell, the late Nigel Nicolson, Jerrold Northrop

Moore, the late John Mortimer, Diana Murray, Malcolm Nix, June Osborne, Julian Potter, John Playll, Charles Piper, Jeremy Purseglove, Patrick Reyntiens, Joan Rouse, the late John Russell, Norman Scarfe, George Sidebottom, Mark and Deidre Simpson, the late Sir Reresby Sitwell, Lady Sitwell, Humphrey Stone, the Hon. Georgina Stonor, the Hon. Julia Stonor, Rosamund Strode, the late Frank Tait, John Russell Taylor, Dinny Thorold, the late Henry Thorold, John Thorold, Roger Vlitos, the late Justin Waddington, the Rt.Rev. Peter Walker, Davis Wasley, the late Kitty West, Michael White, Roger White, Catriona Williams, Nancy Woods, Davina Wynne-Jones. On several occasions unexpected conversations with scholars encountered in the Tate Archives, the Britten-Pears Library in Aldeburgh or elsewhere have proved enormously beneficial. Especially stimulating have been my exchanges with David Fraser Jenkins, the long-standing expert on John Piper, who has been unremittingly generous with his knowledge and insights. So too has Hugh Fowler Wright, a formidably well informed and passionate John Piper collector, who has been unstinting with his time, interest and willingness to share his grasp of minutiae.

Librarians, archivists, and curators sit at the interface between their collections and the public and I gratefully acknowledge the help given me by the following: Nigel Harris, Senior Verger at St Margaret's, Westminster; Julia Aries, at Glyndebourne Archives; Christopher Lux, Headmaster of Malsis School; Simon Martin, at Pallant House, Chichester; Ron Clarke of the Herbert Gallery, Coventry; Peter Young at the Hereford Museum; Joan Williams of Hereford Cathedral Libray; Chris Peller and the McPherson Library, University of Victoria; Neil Butters, Secretary, Railway Heritage Committee, Strategic Rail Authority; Penny Hatfield, Archivist, and Michael Meredith, Librian, Eton College Library; Jean Walsh, Archivist at Ewell Library, Bourne Hall; Alan Scudding, Archivist, and Graham Poupart, Head of Art, Epsom College; Kate Austin, Marlborough Fine Art Archives; the late Commander George Coupe, Archivist, Robinson College, Cambridge; Sandy Rower of the Calder Foundation; Ian Beard of Barclay Capital; Peter Whicker of Marsh Associates; the Rev. Elizabeth Knyton, Chaplain to the Royal Surrey County Hospital; Joan Bullock-Anderson, Archivist. Churchill College, Cambridge; Ashmolean Museum, Prints and Drawings Department; Victoria & Albert Museum Glass and Ceramics Department; the Rev. Ian Brown, Chaplain at Oundle School; Pamela Clark, Archivist, Royal Collection, Windsor Castle; Susan Owen, former curator, the Royal Collection, Windsor Castle; Pat Taylor of the Tapestry Studio at West Dean College; Bernard Nurse, Librarian to the Society of Antiquaries; the Rev. John Smith of St Andrew's, Wolverhampton; Christopher Whittick of the East Sussex Records; and especial thanks for the unstinting helpfulness

I received from Chris Grogan, Nick Clark, Jude Brimmer and others at the Britten-Pears Library and from all those who work at the Hyman Kreitman Research Centre in Tate Britain.

For copyright permissions, I am grateful to the following: Clarissa Lewis, on behalf of the Piper estate, for quotations from documents by John and Myfanwy Piper and for the right to reproduce John Piper's work; to Candida Lycett Green and the John Betjeman estate for permission to quote from John Betjeman's writings and from Penelope Betjeman's letters; to Lavinia Greenshaw, for permission to quote from John Russell's letters; to the late Sir Reresby Sitwell for permission to quote from Sir Osbert Sitwell's writings; to the Britten-Pears Foundation for permissions in connection with letters from Benjamin Britten and Peter Pears; and to Roderic Dunnett for permission to quote from his interview with Myfanwy Piper.

After this book was begun, I gained a position at Newcastle University where I have benefitted from discussions with colleagues in my own department and in Music over aspects of John and Myfanwy Piper's work. I acknowledge a debt to the Arts & Humanities Research Council for a grant towards a short period of research leave, and to the Paul Mellon Foundation for a Senior Fellowship which gave me a year off in order to complete the writing of this book. During that time, spent in close proximity to archives and libraries in Cambridge, I was elected a Visiting Research Fellow by Newnham College, an association that proved enormously stimulating.

As my research progressed, this book changed its emphasis. In order to bring out the full stature of John and Myfanwy Piper as creative individuals, I began to place more emphasis on the context of their varied achievements. Meanwhile, the publishing house of John Murray was sold and became part of a larger firm. The combination of these two developments brought me to Oxford University Press. I am especially grateful to Andrew McNeillie, for the immediate interest he took in this book, also to my editor Jacqueline Baker, my copy-editor Charles Lauder, and to the excellent production team under Fiona Vlemmiks, including the designer Simon Witter. I could not have found myself in better hands. It has also been most gratifying to know that financial support from the John Murray Trust, as well as from the Marc Fitch Fund, has contributed to then cost of acquiring and reproducing illustrations.

Friends have also been a great support in the course of this project. I travelled round North Wales in John Piper's footsteps with two natives, Sara Mahmood and Glyn Roberts. I did the same in Pembrokeshire, searching out the many sites Piper either painted or photographed, this time in the company of an artist from this region, David Tress. My thanks go also to Stephen Alexander for his

persistent interest, to Richard Luckett for the capacious knowledge he brought to his reading of my manuscript, and to Lucy Gent, for her astute editorial advice. Throughout, my agent Gill Coleridge and her assistant Cara Jones have provided unfailing encouragement and support. Like most biographies, this is an edifice that breathes collective memory as well as individual effort. One of the many pleasures in writing such a book has been this shared interest and collaborative endeavour.

Frances Spalding

Contents

CONTENTS

List of Illustrations

Unless otherwise stated all illustrations are by John Piper

Colour plates

1. *Houses in Surrey*, *c.*1928. Oil on canvas, 61 × 50 cm (private collection).
2. *The Stoning of Stephen.* Stained glass, Grately Parish Church.
3. *Beach with Starfish*, 1933–4. Ink and gouache with collage, 38 × 48.5 cm (Tate, London).
4. *Houses on the Front*, 1933. Watercolour with collage and stencil, 37.5 × 46.3 cm (private collection).
5. *String Solo.* Oil on board, 48 × 58 cm (River and Rowing Museum, Henley on Thames).
6. *The Harbour at Night*, 1933. Oil on paper, collage and sgraffito, 50 × 60.5 cm (private collection).
7. *Foreshore with Boats, South Coast*, 1933. Oil on canvas with collage, 63.5 × 77 cm (private collection).
8. *Abstract Construction*, 1934. Oil with sand on wood, 53.3 × 62.8 cm (Whitworth Art Gallery, Manchester).
9. Imperial Airways brochure, designed by John Piper (private collection).
10. *Painting*, 1935. Oil and ripolin on canvas on board, 29 × 48 cm (private collection, courtesy of Jonathan Clark and Co., London).
11. *Newhaven*, 1936. Collage, gouache, oil, black ink and scrim, 37 × 50 cm (private collection).
12. *Forms on Dark Blue*, 1937. 75 × 27.5 cm (Courtesy of the Pym's Gallery).
13. *Autumn at Stourhead*, 1939. Oil on canvas, 63.3 × 76.2 cm (Manchester City Art Gallery).
14. *Nursery Frieze I and II: Seascape and Landscape*, 1937. Lithograph, 46 × 121.5 cm (private collection).
15. *Regency Square from the West Pier*, from *Brighton Aquatints*, 1939. 21.2 × 29.2 cm (private collection).
16. *The Metropole Hotel from the West Pier*, from *Brighton Aquatints*, 1939. 21.2 × 27.6 cm (private collection).

In-text illustrations

Frontispiece: The Piper Family (from left to right): Edward, unidentified man, John, Sebastian, Clarissa, Myfanwy, Suzannah.

Endpaper: Two double page spreads, showing articles written and illustrated by John Piper, from the *Architectural Review*.

26. Harvest Festival at Charlbury, *Oxon* (photograph: John Piper).

27. 'The Nautical Style', double-page layout from *Architectural Review.*

28. *Brighton Aquatints*, 1939. Title page.

29. Hafod in 1939 (photograph: John Piper).

30. *Horizon*, cover design by John Piper.

31. Jeanne Stonor and John Piper, 1948 (photograph: Janet Stone).

32. The ruined Coventry cathedral, looking eastwards towards the apse.

33. Graham Sutherland, John Piper, Henry Moore, and Kenneth Clark the morning after, at Temple Newsam, Leeds. 1941.

34. Train journey to Leeds on a summer's evening. Graham Sutherland, Philip Hendy, Myfanwy Piper, Colin Anderson, Kenneth Clark, and Jane Clark.

35. British Restaurant, Merton, with John Piper decorations.

36. *Seaton Delaval*, 1941, pencil, ink, and wash, 64.7 × 55.8 cm (private collection).

37. Myfanwy in the kitchen at Fawley Bottom.

38. Paul Sandby, *The Lower Ward seen from the base of the Round Tower, ca.1760*, watercolour with pen and ink over graphite 28.1 × 60.9 cm (The Royal Collection © 2008 Her Majesty Queen Elizabeth II).

39. Bath, after the Blitz.

40. *Renishaw Hall: North and South Fronts*, both in ink and wash, 50.2 × 19.8 cm (private collection).

41. *The Lake at Renishaw, at sunrise*, ink and wash, 53.3 × 40.7 cm (private collection, courtesy of the late Sir Reresby Sitwell).

42. *The Gothic Temple*, ink and wash, 50.8 × 40.9 cm (private collection, courtesy of the late Sir Reresby Sitwell).

43. *Gordale Scar*, illustration for the *Geographical Magazine*, December 1942.

44. *Cave Entrance in Easegill*, 1942, pen and ink, 53 × 41 cm (private collection).

45. *Devizes*, illustration for the *Cornhill Magazine* (1944).

46. *Fonthill.* Design by John Piper for cover of *Architectural Review*, Vol.95, June 1944.

47. Old railway wagons in Middlesbrough (photograph: John Piper).

48. Tea in the garden at Fawley Bottom, Clarissa, Myfanwy, Edward and John Piper. c.1945.

49. John in his barn studio, 1962 (photograph: Jorge Lewinski) © The Lewinski Archive at Chatsworth.

50. Reynolds Stone and John Piper on the Glyders, 1949.

51. *Albert Herring*, John Piper's model for Act II, Scene 1, vicarage garden.

52. *Albert Herring*, Act II, Scene 1, vicarage garden with tables.

List of Abbreviations

BPL	Britten–Pears Library, Aldeburgh.
JPT	John Piper Papers, Tate Archives, Hyman Kreitman Research Centre, Tate Britain. NB: This collection of papers also contains documents relating to Myfanwy Piper.
SR	Sitwell Papers, Renishaw Hall.
TA and TGA	Tate Archives, Hyman Kreitman Research Centre, Tate Britain. NB: Older items in the Tate Archives begin their references with the initials TGA, referring to the former name, Tate Gallery.
Victoria	Archives and Special Collections, McPherson Library, University of Victoria.

Preface

This is a book about a journey which John and Myfanwy Piper made together, about a couple who early on settled down at a remove from the metropolis, in a small hamlet on the edge of the Chilterns, whence they proceeded to produce work which placed them both centre stage in the cultural landscape of the twentieth century: for their journey encompassed not only a long marriage and numerous private and professional vicissitudes, but also left a genuine legacy of lasting achievements in the visual arts, literature, and music.

It is also a trajectory shaped by a hiatus within the history of modernism and thus sheds new light on the story of British art in the 1930s. In the middle of this decade John Piper and Myfanwy Evans (they did not marry until 1937) were at the forefront of avant-garde activities in England, Myfanwy editing the most advanced art magazine of the day and John working alongside Ben Nicholson, Barbara Hepworth, Henry Moore, and others and enjoying good contacts with artists in Paris. But as the decade progressed and the political situation in Europe worsened, they began to reassess the legacy of early modernism and the direction in which it was moving. By the end of the 1930s John Piper had started opening his art to a sense of place, belonging, identity, history, and memory, all issues very much to the fore in today's world. At the time this counter-modernism seemed to some regressive, parochial, or provincial, but, from the vantage of the twenty-first century, it can be viewed as a radical alternative to the Modern Movement's aesthetic totalitarianism, one that has licensed expression of much in the human psyche.

John Piper was an extraordinarily prolific artist in many media, his fertile career stretching over six decades and involving him in many changes of style. The knowledge acquired during his abstract period continued to inform much that he did, but he became best known for his landscapes and architectural scenes in a romantic style. This core interest, in the English and Welsh landscape and the built environment, developed in him a sensibility that took in almost everything, from gin palaces to painted quoins, from ruined cottages to country houses, from Victorian shop fronts to what is nowadays called industrial archeology. His capacious and divided sensibility made him a defender

of eighteenth-century classicism and its elemental vocabulary of forms, of box pews and country churches of the most humble sort, of pub lettering and maritime architecture, while in his art he became a neo-romantic, an heir of that great tradition encompassing Wordsworth and Blake, Turner, Ruskin, and Samuel Palmer. He was, in short, torn between the pleasures of an abstract language liberated from time and place and those embedded in the locale, in buildings, geography, and history.

The whole of his vast, sprawling, ungainly career can be described as an effort to negotiate between these competing claims, heeding now one, now the other, while gradually taking up an ever vaster array of media: book il-lustration, stage design, photography, stained glass, murals, pottery, textiles, mosaics, and even fireworks. It is this expansive contradictoriness that today seems quintessentially modern, his divided response finding an echo in our own ambivalence towards modernity: our desire to preserve heritage on the one hand and to tear down and build new developments on the other; our love affair with digital technology and simultaneous repulsion at the disembedding mechanisms within it; and our continuing suspicion that modernist utopias have contributed to the dysfunctional aspects of modern society.

Myfanwy Piper shared John's interest in an emancipatory aesthetic, one that could react and adapt to the changing cultural and political climate. While he was still firmly committed to abstract art, she stated the belief that for 'art to have any importance it must be intimately related to life in its own time'.[1] In the years that followed, she turned her hand to a variety of literary tasks, writing, among other things, three libretti for Benjamin Britten, while also managing family and domestic life, cooking with magnificent insouciance, and receiving a steady stream of friends and visitors.

Both Pipers had strong personalities. They engaged readily with ideas and lived in the present, but a present thickened and challenged by awareness of the past. In the course of their long partnership, they created what seemed to many observers an ideal way of life, involving children, friendships, good food, humour, the pleasures of a garden, work, and creativity. Running through their lives is a fertile tension between the new and the old, between a commitment to the modern *and* a desire to reinvigorate certain native traditions. This tension produced work, neither timid nor conformist, but the outcome of passionate interest and ready experiment. It involved using one's eyes and taking nothing

1 Myfanwy Evans, 'Abstract Art: Collecting the Fragments', *New Oxford Outlook* (22 No-vember 1935), 260.

for granted. 'Only those who live most vividly in the present', John Russell observed of John and Myfanwy Piper, 'deserve to inherit the past.'[2]

No previous author has encompassed in a single account the lives and work of John and Myfanwy Piper. Myfanwy's name appears in numerous memoirs and biographies, is known to opera fanatics and to art historians interested in the 1930s, but she has not previously been the subject of any study. John, on the other hand, is the subject of a clutch of monographs which, written over the years, have looked at various aspects of his work. I acknowledge my debt to the work of John Betjeman, S. J. Woods, Orde Levinson, Anthony West, Richard Ingrams, June Osborne, and especially David Fraser Jenkins, who in recent years has done more than anyone to promote John Piper. With him I co-curated the 2003 Dulwich Picture Gallery exhibition 'John Piper in the 1930s: Abstraction on the Beach' and I have benefitted greatly from our many conversations.

The chief difficulty in writing about John Piper is his diversity. But his achievements are interconnected and their significance grew as they accumulated. For he is an artist who has reached into the hearts of a very wide audience and touched our lives in many ways: through his celebration of landscape and architecture in his paintings and prints; through his photographic illustrations in the Shell Guides and elsewhere; through his writing and editing, his stained glass and tapestries; through his contribution to postwar debates about planning and conservation, his extensive committee work, and his support of numerous appeals. But the corollary of all this is that, for the sake of narrative pace and avoidance of undue length, I have limited the amount of visual analysis given to his work. I have attended in some detail to major commissions and their historical and cultural context but with a mass of others I have had to summarize and select. Thankfully, Myfanwy, though she left behind a significant body of work, had a welcome streak of laziness which acted as a foil to John's relentless hard work and fertile creativity. Nevertheless, they both brought a zest and rigour to everything they did, qualities I have tried to catch in the writing of this book.

Finally, nomenclature. In a biography, the surname is properly the correct means by which to refer to your subject. But here I am writing about a team, rather than an individual, and for the sake of clarity and parity I have, for

2 John Russell, *From Sickert to 1948: The Achievement of the Contemporary Art Society* (London: Lund Humphries, 1948), 75.

the most part, used their Christian names, unless the context is such that the surname is preferable.

Frances Spalding

PART

I

1

John

Giacommetti has often come to mind while writing this book, for his etio-lated figures, with their urgent modelling and inner vitality, have been for me an image of John Piper's unremitting energy. Tall, thin, and angular, with deep-set blue eyes and an aquiline profile, he seemed to his namesake, the art historian David Piper, to be a figure carved or etched by an artist from a distant age, from the transitional period between late Romanesque and gothic, and worthy of a niche somewhere between the *portail royal* and the north portal at Chartres.[1] This association with sacred architecture is apt, given John Piper's love of churches; yet this same man also had a passion for lighthouses, seaside architecture, railway buildings, and pub lettering, among other things. He surveyed both landscape and the built environment with the eyes of a hawk and journeyed far round Britain and Europe.

In his art, he worked at speed with astonishing control across a whole range of media. Whether designing for the stage or stained glass, writing articles for *The Listener* or the *Architectural Review,* or editing *Shell Guides*, he brought great proficiency to any task and had a reputation for being businesslike and always delivering on time. Beneath a polite, self-contained manner coursed a passionate nature. He was moved not just by architecture but by the effect on a building of nearby industry, fire, war, or weathering. More than any other artist of his era, he sought to translate native traditions into modern terms, rediscovering the sublime in his Welsh mountain scenes and the picturesque in his wartime paintings of ruins, thereby making late eighteenth- and early nineteenth-century aesthetic concerns serve contemporary looking.

In front of a piece of architecture, he knew how to convey both mass and detail, how to indicate the bones of a building as well as the sparkle of light on stone. Over the years, he became an outstanding recorder of England's topo-

graphical and architectural heritage, helping to create the widespread appreciation that exists today. Ironically, he suffered a bout of adverse criticism just as his popularity took off, and for a while, like others of his generation, fell out of favour with the critics. It was then that John Betjeman bolstered him with these words: 'You have saved much of England by your pictures of architecture and landscape. What is more you have increased our vision. Things look like pictures by Mr Piper and look better for having been seen by him.'[2]

His willingness to follow Alexander Pope's advice—'Consult the Genius of the Place'[3]—aligns John Piper with a topographical vein within the British Romantic tradition. But what is this 'genius loci'? It is not simply something out there, to be found in nature, but instead is the product of a sensibility responding to the experience of place, time, and circumstance. Though many of John Piper's titles simply name the place he has painted, the pictures themselves indicate, as he once claimed, 'that there was an involvement *there*, at a special time: an experience affected by the weather, the season and the country, but above all concerned with the exact location and its spirit for me'.[4] He once told John and Vera Russell that this feeling for place remained 'the basic and unexplainable thing about my painting'; it arose, he insisted, not from any formal notion of travel, 'but just going somewhere—anywhere, really—and trying to see what hasn't been seen before.'[5]

This interest may have begun with Hilaire Belloc's *The Stane Street*, which he read as a boy.[6] This famous Roman road started from the East Gate of Chichester and ended, Belloc conjectures, at the southern end of London Bridge. He analyses the road's relation to military camps, monastic institutions, modern divergences, and the general lie of the land, and points out that the last visible trace of this road can be found near Epsom, where the young John Piper lived. Belloc would have taught that, owing to the shaping power of time and history, there is more to landscape than meets the eye. After reading *Stane Street* John began drawing trees, possibly those pockets of woodland which the road entered as it neared Epsom. Evidently, the book's rather dim pictures by William Hyde left him dissatisfied.

Stane Street stirred his interest in journeying and, soon after, he began writing a novel 'about people going to places (in the upper Thames valley)', which involved detailed descriptions of sunsets and thunderstorms.[7] He had also begun to discover that landscape itself had for him especial importance. One year the Piper family took a holiday at Sutton Bank, in Yorkshire. While his two elder brothers tested their motorcycles against a fierce gradient, John's interest was caught by the view across harvest fields in the Vale of York, their wide acres

punctuated by corn stooks standing sentinel in the hazy sunlight. 'It was the first time I took in the country,' he recollected,[8] registering an act of attention that became habitual in the course of his long career. Stimulated by buildings and prospects, it was to operate across a great range of techniques and stylistic manoeuvres, with great freedom and verve; producing astonishingly fertile and at times achingly beautiful results.

Epsom, itself, is surrounded by fine countryside. The small town, praised by C. J. Swete in his *A Hand-Book of Epsom* (published 1860) as 'a place of quietness and peace', drew from Charles Dickens the remark that for 364 days of the year you could fire a cannonball from one end of the town to the other without endangering human life. It was only on Derby Day that crowds, making their way to the racecourse, suddenly surged and rolled through its streets. But even in the mid-nineteenth century, Epsom, situated on the main road from London to Dorking, was busier than Dickens suggests. Though it has remained a picturesque town, it doubled in size during the first decade of the twentieth century, for the arrival of not just one but two railway lines, the LBSC (London, Brighton, and South Coast) and the LSWR (London and South Western Railway), made Epsom popular with commuters, for in less than an hour they could reach stations at either Victoria or Waterloo.

John Edgerton Christmas Piper was born on 13 December 1903 in Ashley Road, in the second of three houses which his father, Charles Alfred Piper, named in succession 'Alresford' after the Georgian market town in Hampshire associated with his forbears. Situated on an ancient invasion path and on the main route between Winchester and London, Alresford had become a centre of industry for clothiers, dyers, and tanners. Here John's great-grandfather William Piper worked as a tanner and skin-dresser, taking as his second wife a woman named Lucy Christmas and leaving her, at his death in 1839, with six children in her care, all under the age of thirteen. One of these, Charles Christmas Piper (1831–84), left Alresford for Farnham, to train as a bootmaker. After a seven-year apprenticeship, he walked to London and took a small shop in Tothill Road, Westminster. A farmer's daughter bore him five children (one dying in infancy), but she died young, leaving him a widower. He coped by withdrawing into himself, communicating little with others or his children, and concentrating almost entirely on his business. 'When not so engaged,' his son recalled, 'he took long whole-day walks by himself into the country, and returned home moody and exhausted.'[9] He evidently placed his faith in the countryside as, even before he was widowed, he had begun sending his children to a farmer and his wife in Gloucestershire for long periods of time.

With hindsight his son, Charles Alfred Piper (1866–1927), who had been five at the time of his mother's death, saw that sustained grief had created a barrier between himself and his father. Then in 1881, Alice, the younger of his two sisters, died aged seventeen. This second death left the fifteen-year-old Charles numb and confused. Previously he had gone to evening classes on drawing and architecture, but now he lost all motivation. He worked for a period as a builder, then in his father's business, but without satisfaction. Next a clerkship was found him in a bank where he lasted six months. When a schoolmaster suggested he should become a solicitor, he agreed, simply because he felt that he would as soon do this as anything else. But it proved the right choice of profession, refocusing his energies and interests. He later boasted that astute decisions had enabled him to secure a successful and remunerative career. He was equally determined in his pursuit of Mary Ellen Matthews, the daughter of the housekeeper to the Duchess of Roxburghe and a working partner in a fashionable hat shop. Many years later, he presented her with a copy of his autobiography, proudly inscribed: 'To my wife of forty years | the gentlest and wisest woman I have met | The Author Sept 1926'.[10]

1. Charles and Mary Piper with their three sons, Charles, Gordon, and the youngest, John, in the centre.

Their married life had begun modestly, in rooms above his firm's offices in Vincent Square, Westminster. But as soon as Charles's earnings permitted, they began travelling abroad, trips that were in part restorative as he suffered recurrent illness, probably caused by stress. After one particularly bad patch, and a long period of recuperation, he moved his wife and small son (another Charles, born 1893) out of London, taking a house in St Martin's Avenue, Epsom, which he renamed 'Alresford'. There a second son died soon after birth, possibly as a result of the influenza caught by his mother during the last weeks of pregnancy. A third son, Gordon, was born in 1897, and finally, in 1903, John arrived.

By this time the family had moved round the corner to 'Longwood', which, like their former house, was renamed 'Alresford'. It sat on the east side of Ashley Road, just south of the junction with St Martin's Avenue, in an acre of land, with a stable at one side and a carriage sweep

between the two front gates. After some ten or twelve years the appearance of dry rot and other defects revealed that this elegant late Georgian or early Victorian house had been badly built. Charles Piper, after consulting friends, pulled down one third of the house and lived in the remaining part while a new 'Alresford', was built. His sons watched with interest as the building went up and money was spent on the wood panelling in the hall and parquet flooring. It was completed in 1909 and, soon after, the remains of the earlier house, with its yellowish brick and white stucco trim, were demolished. John, though only six or seven at the time, regretted its disappearance. The new red-brick, neo-Georgian villa, however, was comfortable and well provisioned with a cook and maids in service. There was a rocking horse in the attic and a billiards table elsewhere. Later on, John set up his first studio in here.

Today the house no longer exists; the plot of land it occupied contains a block of flats, Briavels Court, and the Pipers' garden, with its monkey puzzle tree, shrubberies, flowers, vegetables, fruit bushes, its arrangement of lawns, tennis court, and greenhouse (full of toads), ruled over by the gardener, a Mr Willard, has given way to a bald, low-maintenance landscape. All that survives of John's childhood home is the carriage sweep, now blackened with tarmac.

One of Epsom's attractions to John's father may have been its famous boys' school. Founded in 1853 as the Royal Medical Benevolent College, for sons of the medical profession, it had been renamed Epsom College in 1902 and charged less than most other public schools. A high proportion of the boys still came from medical backgrounds or the armed services. And many arrived from the nearby preparatory school, Kingswood House, which congratulated itself on having no pupils from families whose income came from 'trade'. Here John began his education, moving, at the age of fifteen, to Epsom College.

His familiarity with art began young, when his mother, not realizing how much it would mean to him, popped him into the Tate Gallery while she went shopping at the Army and Navy Stores in Victoria Street, presuming it a safe place, also convenient because her husband, working just round the corner in Vincent Square, could pick John up. This was soon after a Turner wing had opened, filled with paintings from this artist's bequest to the nation. It began the boy's love of Turner. His father, recognizing this, gave John a packet of Turner postcards as a reward for having been brave at the dentist.

Yet his juvenilia, made for his own amusement or in autograph books belonging to friends, stemmed less from art than from his interest in topography, for his earliest drawings imitate the small vignettes, especially those by F. L. Griggs, found in *Highways and Byways.* This series of county guides steadily

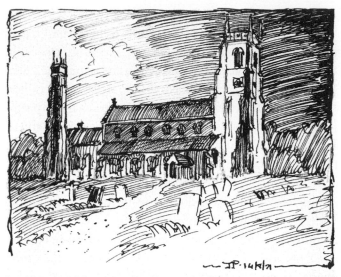

2. *St Nicholas Church, Blakeney*, 1921. Pen and ink, 7 × 9 cm (private collection).

accumulated in the Piper home. A copy of Kent arrived for John on his tenth birthday, as a gift from an aunt. His father obtained *Surrey* soon after it appeared, and another volume in this series was gifted John by an uncle. After this the young boy, borrowing money from his mother which he paid back in installments, bought each new volume as they appeared.[11]

These books were designed to appeal to walkers or bicyclists. In *Surrey*, Eric Parker tells his readers: 'It is only by walking that you will see the best of the Thursley heather, or the Bagshot pines and gorse, or the whortleberries in the wind on Leith Hill, or the primroses of the Fold country, or the birds that call through the quiet of Wey Canal.' This emphasis on sensuous appeal was combined with the *Highways and Byways* habit of mixing observation with historical fact, folk stories, and extracts from diaries and letters of earlier travellers. Many years later, in his own topographical writings John Piper rejected this discursiveness in favour of clear and accurate reporting in a terser style. Nevertheless, he owed much to these books, for they deepened his interest in place and taught him how to look.

Charles Piper was intrigued by his sons' interests. Charles, the eldest, loved working the lathe and making steel mechanisms. Gordon had a collecting instinct and went after birds' eggs and butterflies. But it was John who surprised his father the most with his interests in drawing, music, painting, poetry, architectural lore, and topography. He encouraged his family to tour parts of England and began making his own guides, with photographs, drawings, and

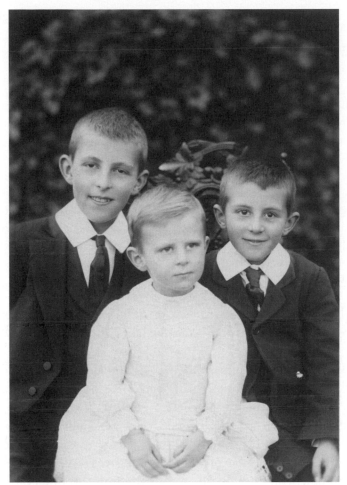

3. Charles, Gordon, and John Piper.

brief written descriptions. On one such trip they drove to the Midlands and then toured certain East Anglian towns. John had adopted the habit of making brass-rubbings and in Trumpington church, in Cambridgeshire, was pleased to find two of the oldest brass engravings in the country. At Grantchester he dutifully read Rupert Brooke's 'The Old Vicarage, Grantchester,' copying into his notebook:

> And laughs the immortal river still
> Under the mill, under the mill?
> Say, is there Beauty yet to find?
> And Certainty? and Quiet kind?

His father notes in his autobiography that though John was the 'baby' of the family, he had shown them things of interest in the countryside that otherwise they might never have visited.

His interest in architecture led to him being given a useful lesson:

> When I was about twelve an architect friend of my father took a sketchbook of mine and on the back page drew careful, pencil studies of Saxon, Norman, Early English, Decorated and Perpendicular church windows. I was delighted with these, not only because they were much more fun and full of personal character than the old engravings in Parker's *Glossary*, but because I saw at once that they had about them that mixture of knowledge and enthusiasm that is precious. I was busy looking at buildings and sketching them, but I suddenly saw vividly that a building was not just a picturesque or ugly, object, but a sum of its parts, and that of these parts the openings are about the most important; also, that you couldn't draw a building until you understood a bit about what its builders were aiming at.[12]

He carried this understanding with him when he looked at churches, claiming in adulthood that by the age of fourteen he had visited almost every church in Surrey.

At Epsom College he encountered a bracing climate. With its agglomerate of red-brick Victorian buildings, it sat within an estate of eighty acres on the slope of Epsom Downs. It was not, however, beautiful. Hugh Walpole, a former schoolmaster at Epsom College, lampooned it as 'Moffat's' in his novel *Mr Perrin and Mr Traill* (1911), where its 'fresh-lobster colour' horrifies the new teacher Traill: 'You never saw anything so hideous. The red brick all looks so fresh, the stone corridors all smell so new, the iron and brass of the place is all so strong and regular. It's like the labs at Cambridge on an extensive scale; you'd think they were inventing gases or something, not teaching boys the way they should go.'[13]

It was a tough place in more ways than one, for it was populated with rugger types and rife with bullying. John recollected being reduced to 'absolutely abject fear and trembling', though he added: 'I rather loved Epsom, in a ghastly way.'[14]

Charles Piper sent all three of his sons to this school, even though Charles, his eldest, a 'grave thoughtful boy',[15] consistently received bad reports and then, on taking the School Leaving Certificate, surprised the head and assistant masters by achieving first class in five out of his seven subjects. The school immediately altered its attitude towards him, but it was too late: instead of staying on in the Sixth Form taking the Higher Certificate and sitting for a university

scholarship, Charles entered his father's office as an articled clerk. His younger brother, Gordon, may have been happier at the school as he had a passion for natural history which was one of the school's strengths, but he attained no high academic achievement. John, too, was to underachieve, the emphasis on science perhaps proving unsympathetic.

He entered the school late, at the age of fifteen, in the autumn of 1919. Recent improvements had provided all the house classrooms with toyses (individual study areas for the boys). The former Big School had been converted into a library and reading room which could be used for concerts and lectures, and, as a memorial to Epsomians who had fallen in the war, a move was afoot to complete the chapel, begun by Sir Arthur Blomfield. But the optimism expressed by these developments was not shared by John who mostly hid in the Holman Art Room and at first attempt failed to gain entrance into the sixth form. Sixty years later he could still imitate the frightening lurch of the headmaster as he walked into Big School and retained mixed feelings about the College:

> I had a generally horrible time at Epsom (as a day boy), redeemed by the protection of a delightful English master—who greatly encouraged me: I sometimes think kept me alive—and the Art Room. The art master in my

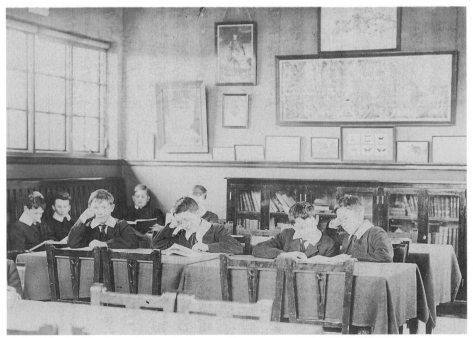

4. Boys in the Reading Room, Epsom College.

time was T. M. Smith followed by a man called Bown. Both were nice; and one year I won the art prize.[16]

Another artist who attended this school was Graham Sutherland, but he left the year John arrived. Piper inherited Sutherland's *Shorter Latin Primer* and found drawings of the Kaiser inside the covers. In general, it was not easy being, like his brothers, a day-boy in a school primarily composed of boarders, but his father was opposed to boarding on humane grounds. One advantage was that John could bicycle home each day for lunch, leaving behind what he later called 'a terrible reprobate lot'.[17]

Much of his journeying at this time was done on bicycle, a passion he shared with his father. Travelling down quiet lanes lined with hawthorn and black-thorn hedges and banked with cow parsley, he had easy access to the Surrey countryside. But his interests at this time also focused on Wiltshire, with its downland, prehistoric sites, sarsen stones, and Silbury Hill, and, while still a teenager, he joined the Wiltshire Archaeological Society. Soon afterwards, in 1919, he joined the Surrey Archaeological Society and published in the *Architect's Journal* what is probably his first article—'Old Wooden Cottages at Epsom Surrey'.[18] In 1920 his father also joined the Surrey branch, and the following year John, not yet eighteen, became local secretary for the Epsom area, a post he filled for the next nine years. He kept up his membership of this Society until 1937, by which time he was no longer living in Surrey.

At the same time he was very gregarious. Arthur Cotton, whom he had met at prep school, was one of a group of boys who used to congregate at 'Alresford' to listen to John improvise jazz on the piano. He was largely self-taught, learn-ing to play by ear while pedaling away at the pianola. His father subscribed to the London Aeolian Company in Bond Street, and allowed John to choose the pianola rolls from its lending library. In this way he familiarized himself with the classics and discovered Scriabin. Though he remained an amateur musi-cian, he did have a few lessons with James McKay Martin, the church organist at Fetcham, near Leatherhead, who is said to have introduced him to Vaughan Williams and his music.[19] Cotton remembers John at this time, looking more like his mother than his father, with a long face, long fingers, and a rather sober disposition. Nevertheless, he played with two others in a dance band, earning 2 guineas a night. He also designed sets and costumes for musicals performed by a local amateur group at the Epsom Congregational Hall.

Everything suggests a congenial upbringing. His mother, a spirited, decided personality, shared with John her love of books. She moderated her husband's assertiveness, for this self-made man had an authoritarian streak. He enjoyed

philosophizing aloud and, though Darwin had altered his views on man's origins, he remained interested in religious thought. He affiliated himself with the Methodists, but fell out with the Wesleyan Chapel on a management issue and, with others, went off to found an independent society, 'The Nomads', which met in private houses. Eventually, however, he joined St Martin's, Epsom's parish church and aligned himself with the Church of England, if only half-heartedly, for he was still a Nonconformist at heart and none of his children were baptized or confirmed. St Martin's may have been acceptable to him because it refused to engage in ritualistic practices. Still today it claims to be 'middle of the road'.

5. Charles Alfred Piper.

Epsom, no less than any other place, had been swept up in the surge of patriotic feeling that followed the outbreak of the 1914–18 war. The University and Public Schools brigade were billeted in the town and quartered for a period in a hutted camp at Woodcote Park. Later, when huge numbers of wounded soldiers began returning home, Woodcote Park became a convalescent home, as did the nearby Horton Manor. Soon after the war began, the eldest Piper boy, Charles, was called up, owing to his earlier affiliation with the London Rifle Brigade. Before leaving for the Front, he wrote his parents a letter explaining why he felt it his duty to fight. It remained a cherished possession, for, killed at the second battle of Ypres on the 13 May 1915, Charles Piper joined the names, neatly inscribed in black ink, in the book in St Martin's Church, listing those who lost their lives in the Great War.

Although there was scarcely a family in England untouched by a loss of this kind, Charles's death was nevertheless a severe blow to the Piper family. John's mother was reduced to 'an indifferent state',[20] while his father suffered a return of his iritis, an eye illness that sent him into a London nursing home and brought on an intense depression. Then Gordon enlisted, spending the next three years in khaki, leaving John, still a young teenager, to cope as well as he could. The one pillar of strength, at this time, was the nurse from Edgbaston whom Charles Piper had earlier employed to help look after the children while

he and his wife made visits to the Continent. She was, he records, 'a most efficient, capable and reliable lady, unsurpassed in fidelity and industriousness ... absolutely trustworthy, honest and good-tempered'.[21] She stayed with the family some fifteen or sixteen years and, as Charles Piper admits, his children owed 'a great deal to her quiet, religious, and good-tempered handling'.[22]

Whenever possible, John escaped into the countryside, sketching with Frank Milward, a fellow Epsomian. They bought art materials from Mr Birch, the stationer, who sang in the choir at St Martin's and whose son David taught art at Epsom County School for Boys.[23] David Birch thought the boys needed broader horizons and advised them to pool resources and buy copies of the art magazines *Studio* and *Colour*. This they did, but before long John let Birch know that he found the *Studio's* idea of good painting inadequate. When Birch asked why, John instanced the use of colour. Initially he had been at a loss to know how to express what he meant; but then he remembered the impact made on him as a boy by medieval stained glass. It was an experience he was to recall again in his seventies. 'When I was about ten my father took me into a French cathedral—Notre Dame I think—and I still remember a thrilling shock at the first sight of the stained glass. Light coming through a maze of richly coloured glass, in general darkness: what a wonderful idea!'[24] Compared with this experience, the colour images in *Studio* seemed to him to offer a low return.

There were other indications of his growing independence. For a period, he reacted against his parents' half-hearted Anglicanism and took to chapel-going, as his father had earlier done, bicycling miles to attend an early morning service. He also began to differ with his father over art.

Charles Piper prided himself on his interest in pictures which he had cultivated on his trips abroad. But in commissioning an artist to copy MacWhirter's *June in the Austrian Tyrol* in the Tate Gallery's collection, he revealed how conventional and old-fashioned his taste was. He himself made watercolour copies of paintings he liked, some by Turner. But he took against Cézanne. Modern art seemed to him a grotesque mockery, an anarchic attack on accepted standards of beauty, a moral offence. He also failed to respond to the contemporary French painter Jean Marchand, even though his friend John Hilton, who had risen from mill mechanic in Bolton to Director of Statistics in the Ministry of Labour, owned examples of his work and knew the artist. Once, when Marchand was in England, Hilton brought him to 'Alresford' to meet the Pipers, for Sunday lunch and an afternoon of croquet.

This may explain why in 1920 John bought a newly published monograph on this artist. Perhaps, too, he had read Roger Fry's essay on Marchand in *Vi-*

sion and Design, also published that year. But as he later admitted, Marchand's art did not entirely convince, and, privately, he continued to prefer the work of Frank Brangwyn, also that of James Pryde and William Nicholson and the woodcuts they produced under the title the Beggarstaff Brothers. These prints, with their bold outlines and simplification of the subject, invite comparison with stained glass, as did the work of Georges Rouault, who had initially been apprenticed to a stained-glass designer. John became so interested in Rouault that he asked Hilton if, on his next visit to Paris, he would buy for him a monograph on this artist in the Gallimard series, *Les Peintres francais nouveaux*.[25]

Hilton did much for John at this time. He took him to Percy Moore Turner's Independent Gallery in London to see work by Cézanne, Bonnard, Vuillard, Derain, Matisse, and Segonzac. He also introduced John to socialism, took him on walking holidays during school holidays, and invited him to spend weekends at his 'dacha' at Beaconsfield, where his guests might include G. K. Chesterton or the literary critic Richard Church. And it was Hilton, who became Professor of Industrial Relations at Cambridge in 1931, who brought out the young man's intellectual side, encouraging him to become more talkative. In later years, an easy flow of interesting conversation contributed to his modest and polite manner, behind which lay a keen mind.

When he left school he wanted to study art. But art, his father reckoned, was a 'wildly chancy trade',[26] and a poor source of livelihood. He urged John instead to do as his brothers had done and enter the family firm as an articled clerk. What made refusal difficult was the young man's awareness that the death of his brother Charles had been a terrible blow to his father. He therefore complied with his wishes.

In previous books, the date often given for John's entrance into the firm of Piper, Smith and Piper at 13 Vincent Square is 1921. But he is still listed as a pupil in the records at Epsom College for the year 1921–2. Similarly, a tour of Northern Italy (Venice, Sienna, Volterra, and San Gimignano) which he made with his father is also dated 1921, though it is more likely to have taken place in May 1923, the date given to a poem John wrote about the famous Venetian church Santa Maria della Salute.[27] This tour opened up for John the world of Italian art and architecture, and on his return he tried again to convince his father that art was for him not just a pastime but a vocation. This time a compromise was agreed: his father would pay for John to study at art school, if need be in Paris, but only after he had qualified as a solicitor.

To his credit, Charles Piper did acknowledge John's gifts. His autobiography mentions his son's ability to draw and paint, as well as the fact that he had 'written poems which have been spoken well of by persons of discrimination'.[28]

Nevertheless, he also proudly remarks that, at the time of writing, John was an articled clerk in his office, working 'in a way that compares favourably with my five years under articles'.[29] This sadly reveals how blind parental love can be, for Charles' ambitions for his son ran wholly contrary to John's talents, hopes, and desires.

2

'That's Painting!'

Two years before John Piper entered the family firm, in the wake of his elder brother Gordon, Jock Archer had joined as an office boy, aged fourteen, earning 12 shillings a week. It was his task to reproduce, in fine copperplate handwriting, the letters that Charles Piper (or C.A.P., as he was referred to in the office) dictated. Archer was favourably impressed by John, but quickly saw that he had no ambition to follow in the footsteps of his 'wonderful father'.[1] Nevertheless, tutored very patiently by Gordon, John remained in this office for the next five years. He was, to a degree, interested in law, especially criminal law; and on the whole he had an easy time of it, he later admitted.[2] But he nevertheless looked back on this period as wasted time: and for long afterwards felt five years behind his peers.[3]

For an artist, however, even fallow periods can be productive. While working in Westminster as an articled clerk, John seized whatever opportunities were available. He sketched, wrote poetry, and took advantage of his proximity to the National Gallery and the Tate, building on his early love of Turner and gradually getting to know their collections.

The Tate was then still relatively new. Founded in 1897 as the national collection of modern British art, its role had expanded after the First World War to include modern foreign painting; and, in 1919, the transfer from the National Gallery of some two hundred British pictures enabled it to become the focus for an historic British collection which at that time went back to Hogarth. Officially it was still called the National Gallery, Millbank. But, owing to the generosity of its original donor Henry Tate, it was familiarly known as the Tate Gallery and in time this title was to be officially ratified.

John's interest in topography drew him to certain landscape painters. At a time when James Ward's *Gordale Scar* was regarded as an eccentric oddity, he

17

recognized in it a magnificent response to the scene's grandeur and sublimity. Here, too, he would have gained an introduction to the Impressionists and Post-Impressionists, for in March 1924 the Tate showed a loan exhibition of William Burrell's outstanding collection of mostly French art. The year before Samuel Courtauld, the rayon manufacturer, had donated £50,000 for the purchase of modern foreign art and over the next few years work by Van Gogh, Seurat, and others entered the Tate collection, though these French paintings did not go on show until 1926 when the modern foreign galleries, paid for by the dealer Joseph Duveen, opened. Until then, the Tate was largely dominated by Victorian and Edwardian subject pictures, in which tired methods of representation were infused with a high degree of sentimental anecdotalism.

In this context the work of William Blake stood out. John never forgot the impact made on him by an exhibition at the Tate of all Blake's illustrations to Dante's *Divine Comedy*. These had been sold by the Linnell family at a Christie's auction as one lot in 1918. The Tate's director, Charles Aitken, knowing that the Gallery could not afford to buy the entire collection, had formed a consortium with other interested public art galleries and private individuals and thus succeeded in securing for the Tate twenty of the finest drawings in the series. Before the series was divided up, the entire collection went on show at Millbank. John studied them closely, admiring Blake's exuberant creativity, his calligraphic treatment of foliage, his dramatic compositions and bold use of space.[4] He began reading Blake and was startled by these words: 'Shall painting be confined to the sordid drudgery of facsimile representations of merely mortal and perishing substances and not be, as poetry and music are, elevated to its own proper sphere of invention and visionary conception?'[5] It was a question he never forgot.

The Russian Ballet, likewise, gave him a more ambitious grasp of what art could be and do. His enthusiasm for Diaghilev's productions began in the summer of 1919 when he saw *The Three-Cornered Hat*, with costumes and scenery by Picasso, and *Boutique Fantasque*, with designs by Derain. The principal scene painter for both ballets had been Vladimir Polunin, a Russian who had settled in England shortly before the First World War. He and his assistants proved endlessly inventive in their translation of the artist's designs into exotic, colourful, and expressive sets. John had earlier admired Edward Gordon Craig's work for the theatre, and Diaghilev's productions must have confirmed the rightness of Craig's move away from realism in favour of broader and more abstract effects, achieved through the use of gauzes transfigured by changing effects of light. Strong colour was a recurrent aspect of the *Ballets Russes*, and this combined with modern dancing and modern music gave John a thrill he never forgot.

During the early 1920s, whenever Diaghilev's ballets were in season, he went regularly to the Coliseum where, for 1/6 or 1s, he sat in the gallery, which was usually filled with art students. Later, when he himself began designing for the stage, he drew on his memory and appreciation of Diaghilev's success.

Also important to him at this time were the novels of D. H. Lawrence. He was seventeen when *Women in Love* was published and thereafter he read every new book by Lawrence, as well as his 1928 essay on Galsworthy in *Scrutinies.* Here Lawrence argues that, to be effective, a critic must find in himself a force and complexity comparable with that in a work of art. 'A man with a paltry, impudent nature will never write anything but paltry impudent criticism. And a man who is *emotionally* educated is as rare as a phoenix.' Throughout this essay it was the linking of life and art that impressed the twenty-four-year-old Piper: 'I remember the thrill of reading his attack on Galsworthy and thinking "This is it! He's killed that sort of writing for ever." He gave you a new way of life—you didn't talk about art any more: you behaved it.'[6]

This was not easy to do in the offices of Piper, Smith and Piper. He snatched time to draw the view from the window, but also dutifully prepared for his ex-

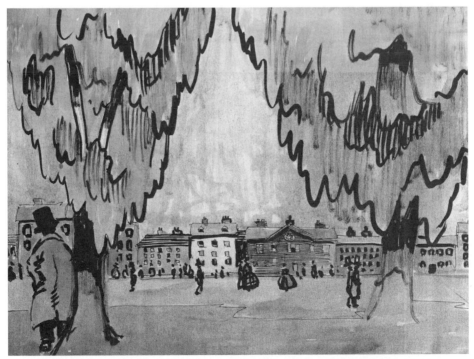

6. *Vincent Square*, 1923. Watercolour and ink, 43 × 58.5 cm (private collection).

19

aminations and took himself off to the law tutors, Gibson and Weldon, where he sat at the same desk as his former schoolfriend Arthur Cotton. Bored stiff, he resorted to doodling on Cotton's notebook a caricature of an advertisement on the London Underground—'Every girl sees her home through a Bravington engagement ring'—the diamonds throwing out enormous sparkles. But in holiday periods, he went sketching and camping with his Epsomian friends Frank Milward and David Birch. In this way he first experienced Romney Marsh, explored Sussex, and painted in Cornwall where Birch kept a horse-drawn Romany caravan at Mullion Cove. Sometimes he accompanied his father on his now twice-yearly visits to Switzerland, which permitted stops at Chartres, Paris, and elsewhere. On one of these trips John found himself shaking with excitement in front of one of Monet's paintings of Rouen Cathedral, for he was thrilled to discover that such a free, almost abstract style could be combined with a recognizable scene.

Though he was merely a Sunday painter, he achieved a degree of success at an exhibition shared in February 1927 with David Birch at the Arlington Gallery, 22 Old Bond Street. *The Times* pronounced it 'promising' and praised John's woodcuts and pencil drawings.[7] In fact his woodcuts were wood-engravings, a medium undergoing a revival at this time. Before long his wood-engravings began to appear in magazines: *Coldkitchen Farm* was printed in *Drawing and Design* in July 1927, with images by others, under the heading 'Unknown Artists'.[8] The same print appeared again in the *London Mercury* in 1930, along with his *The Pond*, one of his more sophisticated wood-engravings.[9]

A few years earlier, he had found an outlet for his creativity in the writing of poetry. He published two short collections, the first of which, *Wind in the Trees*, was privately printed in 1923,[10] and decorated by him with small vignettes. He later dismissed these poems, perhaps because they are tinged with a slightly naive romanticism reminiscent of the prose in *Highways and Byways*.[11] But the use of metaphor is apt and they communicate an intense response to the world around him. In 'Cotswold Gables', based on Upper Slaughter Manor in Gloucestershire, he senses the personality of the house and describes how its attic windows peer out from the stone wall 'like old grey-silvered eyes'.

Another poem, 'The Saint', focuses on the great Venetian church Santa Maria della Salute to which he returned time and again in his work.[12] Inside this great masterpiece of baroque architecture, built in honour of the Virgin Mary to commemorate the city's release from the plague, John passed over the Luca Giordanos, the Titians, the Tintoretto, and other grand works of art in order to draw attention to a clumsy image of St Anthony of Padua, in the middle chapel on the left-hand side of the church.

7. *Coldkitchen Farm*, 1930. Woodcut, 17.7 × 12.1 cm (private collection).

Ugly the saint is—rudely done
And yet he shines as a setting sun
On a barren landscape: shedding grace
On the cold, grey church's cold, grey face.
The candles flicker and light the saint
With the face of gilt and the robes of paint;
And all the light seems to come from there,
And radiates in the thick, dark air
Across the church …

.

 Why is it he shines?
With such crude colours, and such crude lines …

.

The godlike thoughts of those that wrought—
These things we know are what we ought
To make our standard, and we see
That they did make things thoughtfully.
They wrote their own salvation down
By seeking God's will, not their own

Something in this poem—possibly its statement of aesthetic intent—pleased the twenty-year-old John Piper. He retitled it 'The Gaudy Saint' and made it the eponymous poem within his next collection.

The Gaudy Saint and Other Poems, printed in 1924 by the Horseshoe Publishing Company, Bristol, though it incorporates several poems from his earlier collection, is more up-to-date, for by now John had discovered Harold Monro's Poetry Bookshop and the Georgian poets. But the most outstanding ingredient is still his intense responsiveness to visual things and to colour. This confirms the overall impression that poetry merely provided a temporary outlet for a creativity that would, in time, flow in other directions.

On 14 March 1927, John happened to be watching the curtain rise on a Diaghilev ballet at the moment when his father died.[13] Forty years later he recollected this coincidence in an interview with Tom Driberg in the *Evening Standard*.[14] Sadness may have been tinged with relief, for he had just learnt that he had failed to pass his law examinations. Two years earlier, he had pleased his father by devising for Charles Piper's autobiography (privately printed at the Curwen Press) chapter headings and endpieces in the style of Lovat Fraser, whose designs for *The Beggar's Opera* had aroused John's enthusiasm. But relations between father and son must nevertheless have been strained, for Charles had

stymied his son's choice of career. In his will, Charles Piper left his share in the family firm Piper, Smith and Piper in equal amounts to his two remaining sons, but his younger son's bequest was conditional: if he failed to become a solicitor he forfeited his share. Instead £2,000 would be put aside for him, the income from which would go to his mother during her lifetime. John's decision to turn to art, therefore, lost him financial security. But the death of his father lifted the obligation to do law, and he must have felt, as with the Diaghilev ballet, that the curtain was rising on a less hide-bound and more imaginative world. The immediate effect on his painting could be seen the following August, at Gunwalloe, in Cornwall, where he began painting in a freer style.

Though fond of his father, John had looked elsewhere for paternal interest and encouragement. As an unhappily placed articled clerk, he had turned not only to John Hilton but also to a man seven years his senior, Joseph (John) Henry Woodger, a Reader (later Professor) in biology at London University whose love of philosophizing earned him the nickname 'Socrates'. He and his wife, Dorothy Eden Buckle, lived near Epsom, at 'Tanhurst', Langley Bottom, and opened their house to young people in need of undemanding kindness. A term's leave in Vienna, in 1926, had awoken Woodger's interest in the decorative arts. He and his wife adopted the Arts and Crafts aesthetic, pursued the 'Simple Life' and William Morris's belief that you should have nothing in your house that was not either beautiful or useful. Staying with the Woodgers made John aware of the need to decide how, with what, and with whom one wanted to live.

They may also have stirred his desire to marry. Now tall and spare, neatly dressed, and with his hair at this date divided by a central parting and already beginning to turn grey, he had become an eligible bachelor and a welcome addition to weekend outings or house parties. Photographs exist showing him in the company of the daughters of the novelist Gilbert Frankau, Ursula and Pamela, and their friends. Both sisters, like their father, wrote novels, but it was Pamela, the younger of the two, who had the greater drive and more lasting career. (It was also she who took charge after their parents divorced and looked after their mother, both financially and emotionally.) John's attention, however, was caught by Ursula and he must have proposed to her as they became engaged, an event commemorated by a silver cigarette box inscribed with their names.[15] For reasons unknown, the engagement was soon broken off.

It was not a young woman but his mother, Mary Ellen Piper, who changed his life, by making it financially possible for him to abandon law and approach

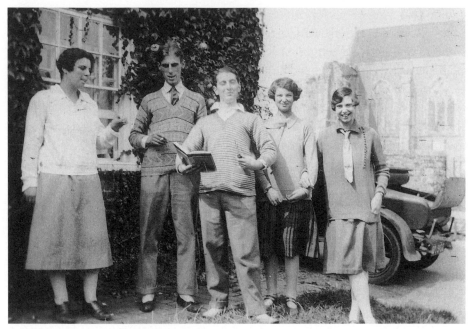

8. Weekend outing. John Piper second from left and Ursula Frankau far right.

the Royal College of Art. There the Registrar, Hubert Wellington, after viewing his portfolio, advised him to go away and improve his life-drawing, and recommended Richmond School of Art. John followed his advice, signed up at Richmond, and received tuition from Raymond Coxon (a Yorkshireman, recently married to the artist Edna Ginesi) in whom John recognized 'the easygoing life and humour of a born painter' as well as a very good teacher.[16] He claimed that Coxon had taught him how to look, but Coxon, on hearing this remark, countered it with the observation that John had done a lot of hard thinking before he arrived at Richmond School of Art.[17] The two men quickly became friends and went on painting expeditions together in John's first car, a bull-nosed Morris. Piper also met Henry Moore, with whom Coxon had been a fellow student at the Royal College of Art, an institution which, owing to Coxon's teaching, John himself entered on 26 September 1928.[18]

One thing Coxon had stressed was the importance of Cézanne. This may explain why John, as a student, copied Cézanne's *Aix, a Rocky Landscape* (now in the National Gallery but donated to the Tate by Samuel Courtauld in 1926), though Anthony West claims that John copied this painting at the suggestion of William Rothenstein, Principal of the Royal College of Art, as an alternative to attending some lectures which he found unacceptably boring.[19] What is certain is that the person who stimulated in him a still more up-to-

date knowledge of French art was H. S. (Jim) Ede, the Tate curator who drew John's attention, in the late 1920s, to musical references in Georges Braque's work. These inspired him to decorate a chest with similar motifs, in homage to this artist.

Contact with Ede may also have sent him to Paris in May 1928, in search of work by Picasso. It was then that he also saw Miró's first major exhibition—a retrospective mounted by the Galerie Georges Bernheim, in association with the Galerie Pierre, which kept Picasso's work in stock. In John's mind, the Miró exhibition became connected with Lawrence's attack on Galsworthy. He told John and Vera Russell: 'The Galsworthys of art were in full control at that time, and when I saw Miró's first big show in Paris I said to myself "That's painting! And you can throw the rest away." '[20]

It was hard to reconcile an interest in Braque, Picasso, and Miró with the teaching at the Royal College, for the Painting School was going through an uninteresting phase. Piper later acknowledged a debt to Morris Kestelman, Charles Mahoney, and Tom Monnington, but he nevertheless found the teaching of life-drawing at the College unbearably dull. An additional problem was his relative maturity: after five years in a solicitor's office, he had a degree of worldly sophistication which made him, as he later admitted, arrogant and lacking in humility. But his experience at the College was perhaps more positive than this suggests. In the Design School he discovered the stained-glass designer Francis Spear, who taught him lithography and various attendant processes, including the use of wax crayon to create a resistant ground, a technique which in later years was to become the starting point for many of his own mixed media pictures.

More formative was the friendship he enjoyed at this time with a young curate who, in January 1927, had joined St Martin's, Epsom, to serve under the Revd Pattison Muir. V. E. G. Kenna was a Cornishman with wide-ranging interests. He had graduated in 1924 from the University of Leeds, trained for the Anglican ministry at the College of the Resurrection, Mirfield, and been ordained deacon in the diocese of Winchester. He had also taken lessons with the pianist Arthur Schnabel. His intelligence was more developed than John's for he had a disciplined scholar's mind and in his spare moments devoted himself to the study of Cretan seals, becoming in time a leading authority on this subject.[21] He was also passionately interested in the formalizations and abstractions characteristic of Celtic and Middle Eastern prehistoric art, and simultaneously cultivated an interest in contemporary art, architecture, music, and literature. Through him, John not only learnt about earthworks, hilltop forts, barrows, and other aspects of prehistoric England, but he began to attend to

the scholarship surrounding certain composers, and started to listen to music with greater discrimination. Kenna also drew his attention to avant-garde literary magazines, to the Sitwells' *Wheels*, to *Arts and Letters*, *Coterie*, and Eliot's *Criterion*. Almost certainly it was Kenna who drew his attention to Lawrence's essay on Galsworthy in Edgell Rickword's 1928 *Scrutinies*.

An influential figure in Kenna's life had been Sir Michael Sadler, who up until 1923 had been Vice-Chancellor of Leeds University. Kenna took John to Oxford, where Sadler was now Master of University College, to see his art collection. Having initially focused his attention on English watercolourists, Sadler had moved on, progressing through Corot and the Barbizon School to some of the leading names among the French Post-Impressionists. He had been one of the first in England to appreciate Kandinsky, whom he visited in Murnau before the First World War, and he was also a strong supporter of modern British artists. In the Master's Lodge, John found paintings by Gauguin, Matisse, Rouault, Léger, and Kandinsky, as well as Segonzac's *Bucolic Landscape*, which he gained permission to copy. But part of the excitement of this visit was meeting Sadler, himself, for John had often heard his name mentioned at contemporary art exhibitions in London. The best work had often been sold, the gallery owner whispering, 'Sir Michael Sadler bought that one.' Such advanced taste was rare at this time. As Piper later recalled: 'It was only a dozen years after the first post-impressionist exhibition; Roger Fry's lectures had yet to fill the Queen's Hall; the seats on the Underground trains had yet to grow their jazz patterns, and Picasso had hardly become a music-hall joke, let alone an accepted master.'[22]

As his horizons broadened, those at the Royal College seemed to narrow. At the same time his attention was caught by a fellow student—Eileen Holding. She had come to the College via Richmond School of Art and the Slade School of Art.[23] She had entered the Slade in September 1927, to study painting and drawing, but had stayed only one term. If she returned to Richmond, she would have met John before arriving at the Royal College in the autumn of 1928, on 8 October. Born Eileen Darlington Holding on 1 March 1909, in Fulham, she was the daughter of Clement Holding, a printer's manager, and his wife, Margaret Eliza (née Counter). She gave 9 Park Avenue, East Sheen, as her home, on her registration form at the Slade, but under 'Parents' listed only her mother's name which suggests an absent father. Before their first year at the Royal College had ended, she and John had decided to wed. Though the College deemed marriage incompatible with studentship, this did not deter them and, on 1 August 1929, the twenty-five-year-old John married the twenty-

9. Chalkpit Cottage, Betchworth.

year-old Eileen at Richmond Register Office. Both identified themselves as art students on the certificate.

Their married life began at Chalkpit Cottage, The Coombe, at Betchworth in Surrey. This small studio-cottage, with a thatched roof, together with a summer studio in its garden, had been built for John in 1927, and paid for by his mother, after the Woodgers had insisted that he needed his own base if he was to develop as an artist. This had upset Gordon Piper, who resented the fact that his brother was getting more of his father's money, on top of the allowance his mother gave him. (Gordon had married in 1924; and though his wife, Gwen, and their two children, Charles and Joy, always got on well with John, the relationship between the brothers was for some years slightly strained.) A patch of land had been found at the end of a cul-de-sac on the side of the North Downs, on a plateau in front of an overgrown disused quarry, and a cottage built which overlooks a breath-taking view of the south of England, stretching as far as the eye can see. Something of the happiness that the house initially gave John is conveyed by the painting he did of nearby houses, in a fresh and exuberant, faux-naif style reminiscent of Christopher Wood (Plate 1).

Yet, very soon the cottage at Betchworth seemed to him 'subtly wrong'.[24] Perhaps the Surrey landscape was associated in his mind with the New English Art Club and a style of painting unsympathetic to a young artist increasingly attracted to the Modern Movement. Perhaps the flaw lay in his marriage and in Eileen's dislike of the countryside. Whatever the cause, after only one summer there together, he and Eileen abandoned Betchworth, letting the cottage to a friend and retaining the small glass and metal studio in the garden for summer or weekend use. By the autumn they were living in a rented flat in St Peter's Square, Hammersmith, a move that brought Eileen and John within reach of the Royal College of Art where they continued for one more term. Both left the College on 21 December 1929 without any form of qualification.

Anthony West quotes an unnamed friend on John and Eileen's marriage:

> Eileen was so Bohemian, a Renoir person—impulsive, instinctive, natural and easy-going; and John was so very much the opposite of all that, gothic, cerebral, measured and controlled—but when I'd become used to seeing them together I could see that each found something in the other that seemed to be lacking in their own personality—as they grew up, and they were both growing very fast, they became aware that these things had been buried in themselves all along, and that looking outside for them had been a mistake, or, rather, unnecessary. The marriage was a typical marriage of inexperience and immaturity, and it simply ceased to exist when the parties to it had discarded their youthful inhibitions and anxieties and found out who they were.[25]

John once hinted that some physical difficulty on Eileen's part made sexual relations difficult, but this may have been less a cause than a symptom of their incompatibility. From the little that is known about Eileen, the impression is gained of an independently minded, feisty woman. After marriage, she kept her maiden name, presumably for professional purposes. Angered by a journalist's attack on modern art, she sent a letter to the *Saturday Review*. It was printed on 2 August 1930, and was evidently written at the Woodgers, as it gives their address. 'Mr Bury may have failed to see any character in Cezanne's heads,' she writes, 'but it is there in plenty. By character I mean the underlying personality of every individual, not the fleeting facial expression so easily caught by any designer of a monthly magazine cover.'

If Eileen had felt exiled at Betchworth, John was no happier in Hammersmith. The houses in St Peter's Square had dignity, the stucco chiselled to look like handsome blocks of Ashlar stone, and the river was only two streets away. Though a rough area, it was attractive to artists because of the river walk

10. Page from a John Piper sketchbook, with a woman reading, thought to be Eileen Holding (private collection).

and the various moods offered by the mists, sunsets, and changing light, and because prices were cheap. The Pipers soon found themselves part of a bohemian colony which, in St Peter's Square, included Robert Graves and Laura Riding, and the artist Ceri Richards. Nearby in Hammersmith Terrace was the Irish artist Norah McGuinness, who introduced John to David Garnett, and through Garnett John is said to have 'entered the outer fringe of literary Bloomsbury'.[26] It is was probably Garnett, therefore, who brought him to the attention of Leonard Woolf, then literary and assistant editor of the *Nation and Athenaeum*, which published John's name under a review of an exhibition of Daumier's lithographs (23 November 1929), probably in the wake of a number of short unsigned notices.[27] But as Roger Fry was the *Nation's* chief contributor

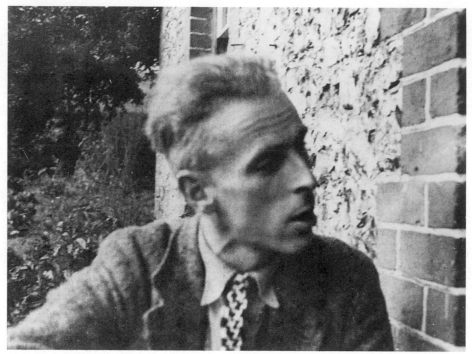

11. John Piper.

on art, there was no likelihood of regular work here. If he wanted an income from journalism he would have to look elsewhere.

He began to do pieces for the *Saturday Review*,[28] a respectable but slightly downmarket version of the *Nation and Athenaeum*. His first signed piece (22 March 1930) was on D. H. Lawrence's posthumous book of poems, *Nettles*. He thought it 'a rather bad-tempered little book and one which will in no way add to the author's reputation', but it offered him a platform on which to explain why Lawrence mattered. His tone is confident, his prose lively. His next article, on gramophone music, showed his up-to-date knowledge of available recordings of classical music (*Saturday Review*, 26 April 1930). A third article found him taking the measure of Herman Melville's greatness and explains why his novel *Pierre* remains less well known than *Moby Dick* (28 June 1930). By then, having demonstrated his versatility, he found himself again in favour with the *Nation and Athenaeum*, where Edmund Blunden had taken over from Leonard Woolf. Blunden invited John down to his home in Kent and is said to have tutored him in the art of writing short descriptive pieces.[29]

Because it was very hard at this time for a young artist to make a living from painting, journalism proved a lifeline, and over the next six months John produced seven pieces for Blunden. He reviewed the exhibition 'English Landscape Painting: 1750–1930', mounted by the London Artists' Association, enjoying the dialogue between old and new, the juxtaposition of contemporary and past art (7 June 1930). Here he uses for the first time the image of a tree as a metaphor for the English landscape tradition: 'It grew early into a sturdy tree, and with the help of constant succour from indigenous roots, and timely lopping, it has grown to noble proportions and still vigorously puts forth leaves and branches.' He also notices 'how healthily and productively the influence of Cézanne has bitten into' this English tradition.[30]

Journalism not only earned him money, it also offered him a sounding board for his ideas. He wrote not just on art, but also on novels, memoirs, and books on music, England, and English churches, and would also act as the paper's second-string drama critic under Raymond Mortimer. His criticism is fresh, lively, occasionally sharp; Cecil Beaton never forgave him for dismissing his *The Book of Beauty* as 'a monument of vulgar advertising'.[31] Then, at the end of February 1931, the *Nation* merged with the *New Statesman*, becoming the *New Statesman and Nation* and Blunden stepped down from his editorial position, moving to Merton College where he was to spend the next thirteen years as an Oxford don. His departure may explain why John's work does not appear again in this paper until 1933.

Piper was later dismissive of his early journalism. 'I'd hate anyone to treat these casual pieces of mine as committed work—it was quite simply a matter of keeping going.'[32] But a bit of regular journalism, however rapidly or laboriously done, keeps one mentally alert, sharpens looking, and quickens thought. John's reviews, always well composed and often witty, fostered his skill at writing and extended his knowledge and experience. Journalism helped develop in him that complexity and force, without which, in D. H. Lawrence's view, a critic is unable to feel the impact of a work of art.

3

Stained Glass and Coastal Gaiety

John Piper never forgot the excitement experienced in childhood on first seeing a major example of stained glass. From then on, he combed guidebooks for further information and examples. But only when be became an articled clerk and read a fat book on this subject by a curator in the Department of Ceramics in the Victoria & Albert Museum, soon after it appeared in 1926, did his understanding of this medium deepen. Herbert Read's monograph is both scholarly and polemical, for it demanded that stained glass should be *judged* by the same aesthetic standards applied to other arts of its day. It also taught John that stained glass is an integral and essential part of the building that houses it. The book gave him a crucial insight: that the study of native traditions could inspire and feed into modern art.

After reading this book he began making copies of stained glass. In 1929 he made his way to the hamlet of Grateley, in Hampshire. There, in the simple church, St Leonard's, he made a watercolour copy of thirteenth-century glass showing the martydom of St Stephen, with the inscription 'Stephanus orans expirat'—'Stephen prays as he dies' (Plate 2). This medallion did not originally belong to this church but had been brought there by the incumbent of St Leonard's after the medieval glass in Salisbury Cathedral, much of it damaged and fragmentary, had been thrown into the town ditch when Wyatt restored and 'Georgianized' the Cathedral. The salvaged medallion had been inserted into a window on the south side of St Leonard's nave. (When Piper copied it, some bits of thirteenth-century border work could be found in the east window, but these have since been moved and now frame the medallion.)

Many examples of stained glass, in the 1920s, remained unrecorded. In his role as antiquarian, John made at least three other copies of thirteenth-century glass around this time, at Westwell and Woodchurch, both in Kent, and at

Wilton, in Wiltshire. In 1932 he offered these, together with his Grateley medallion, to the Victoria & Albert Museum, in the hope that the Glass and Ceramics Department would purchase them, for he was aware that this aspect of English stained glass was not well represented in the Museum's collection. A polite letter informed him that though under normal conditions they would gladly have acquired these 'somewhat unknown examples', they had exhausted their Purchase Grant for this and the following year.[1]

Some forty years later, in his book *Stained Glass: Art or Anti-Art?*, John wrote of his 'The Stoning of St Stephen': 'On the whole I learnt more about using colours doing this copy than I have ever learned before or since.'[2] His analysis of this window draws attention to several things: the way in which St Stephen's head is represented by a piece of red 'flashed' glass, 'shaded in deepening red in an abstract impression of him bleeding to death as he kneels';[3] how the necessary compartmentalization of colour enhances the decorative strength of the image and, at the same time, reinforces the symbolism and drama of the scene; how, with its dual role, colour is both representational and abstract at the same time; and made sonorous by use of echoes and repetitions. As a result, the Grateley medallion has a compact, jewel-like brilliance, and a completeness owing to the confident, easy flow that sweeps through the entire design.

He acknowledges that the subject of the window was a common one, that the medallion would have been part of a programme and to some extent done by rote; 'in other words it is not a wholly original masterpiece, or anything of the kind. But owing to time, place and circumstances, which in this case have been more chancey even than usual, it has a life and personality that is rare and fragile, and beyond price for those that feel its presence.'[4] What exactly he means by 'life' in this context is explained by a reference to *Modern Painters*. In this book Ruskin writes of the old tower of Calais Church—'it completely expresses that agedness in the midst of active life which binds the old and the new into harmony,' a claim that alerted John to the way in which an ancient building or piece of stained glass can become a connecting agent between past and present. In time, it was precisely this dialogue that he later sought in his architectural and topographical scenes, and led to his concept of 'pleasing decay'.[5]

Writing with hindsight, Piper argued that what made Romanesque stained glass sympathetic to twentieth-century eyes was its use of primary colour contrasts, geometrical arrangements, and the absence of any desire to suggest formal recession.[6] As a young man, he had no difficulty aligning his interest in stained glass with his growing commitment to modern art. Hence he claimed,

over thirty years later, that the medallion at Grateley, though not a particularly distinguished piece of thirteenth-century glass, had become 'very much part of my life'.[7]

While copying stained glass, John's hunger for modern art led him to Zwemmer's in Charing Cross Road. This was no ordinary bookshop, but 'a challenge in the midst of our provincial ignorance and philistinism, a beacon of enlightenment', as Herbert Read has written.[8] John began haunting its premises in 1928. He approached it always with a growing tension, 'because I knew that all I wanted to know about what Matisse, Picasso and Braque were doing was to be found in books there.'[9] Although Picasso, even in 1928, seemed an undeniable giant, there were as yet no monographs available on him, so John began compiling his own, filling a scrapbook with copies he had made of Picasso's work or reproductions culled from magazines. Several issues of the lavishly illustrated *Cahiers d'Art* were bought for this purpose. In this way he learnt not only about Picasso but, in 1931, encountered a lengthy article on *papiers-collés* by Tristan Tzara which began 'a profound and lasting collection of influences on me'.[10] Again, it was profusely illustrated, with Picasso the artist best represented.

Until 1931, when Reid and Lefevre mounted a retrospective, it was difficult in England to see Picasso's work. The Tate Gallery neither owned examples of his art nor showed any desire to buy one. The first Picasso to hang at the Tate had been smuggled into the collection in the spring of 1929, by the curator Jim Ede guilefully persuading the collector Frank Stoop to donate one, as a short-term loan, while he was away on holiday. Even so, the Picasso retrospective of 1931 was treated warily, the art critic William Gaunt publishing in *The Studio* an article entitled 'Picasso and the Cul-de-Sac of Modern Painting'.[11] Then in May 1933 *The Listener* carried a reproduction of a Picasso at the Mayor Gallery, with the announcement that a number of artists (unnamed) were keen to have it bought for the Contemporary Art Society so that it could be presented to a public gallery. The periodical's letters page was soon filled with protest.

The Listener was then the forum in which social and cultural issues were given the widest airing. G. Faulkner Armitage, a specialist in decorative arts, began the debate: Picasso and his admirers were accused of seeking to destroy beauty, truth, and good craftsmanship. John came to his defence:

> Some of your correspondents demand an *explanation* of the painting by Picasso reproduced in your columns a few weeks ago. May I ask why? ... what would Mr Faulkner Armitage say if I wrote to The Listener demanding an

explanation of the fact that a grove of beech trees had been purchased by the National Trust and preserved for the nation? A beech tree and a Picasso may be beautiful or they may not: everybody has to make the decision for himself in the end; but surely neither needs any more *explanation* than a nice cut of roast beef.[12]

This caused such a stir that the debate continued week after week, until 9 August 1933, when the editor, presumably for reasons of space, declared the controversy closed. He terminated it with a list of books on Picasso, for readers who 'may wish to get at the root of the matter for themselves'. John was given the final word:

> There is no explanation of a work of art of any period. The merit of a picture is unalterable from the moment it is painted: it is unaffected by praise or abuse or even explanation. The most a critic can do is to describe the technical method of an artist, which may be uninteresting, or write about his own reactions to a work of art, which may be unrepresentative. It is to be hoped that your correspondents when they look at a Raphael feel the beauty of what they see, and do not admire it because they have been told to by generations of critics. … And do not let them be put off by Mr English who diagnoses a 'subconscious inferiority complex' in the modern artist, and, having seen some modern advertisement, decides that 'modern art is propagandist'. All good art is propagandist, whether it wants to be or not. But Byzantine art is not made futile by the existence of the Albert Memorial.[13]

His sprightly confidence in print was at odds with his personal life which was far from secure or happy. His frequent changes of studio may be an expression of this, for he shuttled to and fro between St Peter's Square and Chalkpit Cottage, tried working in a basement room at Hammersmith, then in the small garden studio in the country; next he needed additional space and so rented a loft over the stables at the Dolphin Inn, Betchworth. By the early 1930s he was sharing a studio in the King's Road, Chelsea, with Pat Millard, a former pupil at Richmond School of Art, whose seriousness and application he respected.[14] It was probably Millard who persuaded the Heal's Mansard Gallery, in 1931, to mount an exhibition of watercolours and offsets from stage designs by himself, Eileen Holding, Clarice Moffat, and Piper. Millard was a natural leader and two years later he took over the principalship, with Ernest Perry, of the St John's Wood School of Art. John stayed on for a short while in the King's Road studio, kept in touch with Millard, and was persuaded to preside over one

of the School's monthly Sketch Clubs. All his life, he remained impressed by Millard's unstinting dedication as teacher and administrator.

The outcome of all this was that John, too, now wanted to become more professional. He tried to achieve recognition by sending to the London Group's annual exhibition in 1931, but these shows were large and uneven, not the best forum for a young artist anxious to make his mark. John already had his eye on the more select Seven and Five Society (originally founded by seven painters and five sculptors), for his paintings were now similar in manner to the *faux naif* style and painterly lyricism associated with Christopher Wood, who, before his tragic death at the age of twenty-nine in August 1930, had been a highly visible figure within this society. Wood's directness of touch inspired John's watercolour *Rose Cottage, Rye Harbour, Sussex*.[15] This house, overlooking the beach, he rented briefly in 1931. The seaside had become a major source of inspiration, for it was through coastal subjects that he found his way into the avant-garde.

The sea, John insisted in 1933, is a 'powerful emotive force' in English art.[16] During the late 1920s and early 1930s, while based at Betchworth, he had relative ease of access to the south coast and he made visits to Bognor Regis, Dungeness, Newhaven, and Rye, later going further afield, to Aberaeron in Wales, to Portland and Chesil Beach in Dorset, and to Cornwall. But, as he pointed out in an article in *The Listener*, there is no place in England more than seventy miles from the sea: 'The sea is the mystery that lies beyond the flat fields and the woods, the downs, the rough moors and the Black Country recesses: never far away.'[17]

What began as a childhood pleasure became in adulthood a passion. And there were many aspects of the sea that he loved: remote and empty beaches; rocky coastlines; the gaiety of coastal buildings; the romance of lighthouses; fishermen's huts and signal masts; and the elegant sweep of the grander seaside resorts such as Brighton and Scarborough. He was more broadly responsive to coastal subjects than any other artist at this time. 'Bless all ports,' Wyndham Lewis had urged in 1914, in the first issue of *BLAST*, helping to weave maritime subjects into the history of modernism.

By 1938, when Piper wrote his seminal article 'The Nautical Style',[18] in which he revealed his responsiveness to the seaside manner in all its cultural manifestations, he was very aware of the extent to which maritime or nautical issues had influenced theoretical debates about the Modern Movement, in art, architecture, and design. Le Corbusier had made this connection in his manifesto, *Vers une architecture*, which appeared in English, translated by Freder-

ick Etchells as *Towards a New Architecture*, in 1927. In his promotion of the house as a machine for living in, Corbusier turned to steamships ('a machine for transport') as a further 'important manifestation of temerity, of discipline, of harmony, of a beauty that is calm, vital and strong',[19] recommending also that a modern house, in its use of space, should be conceived as economically as a ship's cabin. By the 1930s this association of good design with a ship's architecture had become so accepted that when King George V's yacht, RYS *Britannia* was dismantled, the art dealer Rex Nan Kivell bought a number of parts from its equipment and incorporated them into the new premises of his Redfern Gallery in Cork Street. So it is not difficult to see why John's interest in the trimness, purposefulness, and swagger of seaside architecture and maritime design chimed nicely with the Modern Movement. He argued that ' "Modern" architecture should have a pull by the seaside, because its straightforwardness, its clarity and functionalism are in the nautical tradition.'[20]

Whereas most people go to the coast in search of refreshment and escape, John went because 'the whole gamut of heightened contrasts that the seaside provides' made life seem 'fuller and gayer',[21] and because the experience returned him to the present. 'Our epoch is fixing its own style day by day,' wrote Corbusier. 'It is there under our eyes.'[22] John not only discerned it, but contributed to its making. And then began to question and rethink its direction.

During the early 1930s John experimented with some of the ploys driving the modernist endeavour. In a series of paintings of boats on the foreshore he copies Braque and allows a line to drift off, abandoning its descriptive role in order to create a linear arabesque which binds the composition together.[23] This tension between abstraction and representation is further pursued in his sketchbooks where he drew tiered rows of figures, one following another almost like knitting or handwriting, the cursory drawing uncovering variation within repetition. Then, in 1932, a series of reclining figures by Braque in *Cahiers d'Art* gave him the idea of using string, looped across the picture surface, to suggest a figure reclining on the beach, as if seen from above (Plate 5). Around the same time he also began making ingenious use of paper doilies: as stencils for crisp, delicate patterning on still-life objects, and in their own right, as witty substitutes for lace curtains which sometimes frame the view through a window (Plates 4 and 6). Further use of collage is found in his cliff and beach scenes, incorporating newspaper, marbled paper, and scrim, as well as vividly detailed engravings of shells and fish, cut out of aquarium catalogues, which charge the picture with a surreal quality reminiscent of Max Ernst (Plate 3).

His use of collage aligned him with what Tristan Tzara called 'le moment le plus poetique, le plus revolutionnaire' in the evolution of painting.[24] In 1933, the Lefevre Gallery agreed to show a group of his collages. No catalogue of this event exists, but John later told David Fraser Jenkins that it amounted to his first solo exhibition.[25] A young painter called Kitty Church, soon to become a good friend, was impressed by this show, and it evidently pleased the directors of the Lefevre Gallery as they sent three of his works, *The Back Room*, *Harbour*, and *Shells* in February 1935 to the Brooklyn Museum, New York, for its eighth biennial exhibition of watercolours, pastels, and drawings by American and foreign artists.[26]

Increasingly, he thought about abstraction. In December 1933 he drew attention in his journalism to four abstracts by Kandinsky at the Mayor Gallery. 'We do not hear enough of Kandinsky in London,' he wrote, 'in spite of *The Art of Spiritual Harmony*, now twenty years old, which has proved prophetic and still makes lively reading.'[27] This same month he praised some of Edward Wadsworth's abstracts in words possibly inspired by his fondness for Haydn's 'Pieces for Working Clocks'. The Wadsworths had, he wrote 'this likeness to clocks and revolvers … they are composed of carefully selected and unerringly arranged parts that make a working whole.'[28]

His article on Wadsworth caught the attention of the artist Ben Nicholson, who a few months earlier, in August 1933, while staying at Seahouses, Northumberland, had spent time examining photographs of John's recent work. As Nicholson had become an influential figure within the Seven and Five Society, it would seem John was being vetted as a potential new member, and, by the following spring, he had not only been elected to membership, but had also been given the role of Secretary and Chairman of the Hanging Committee. Nicholson's intervention may have proved timely. For though there is no doubt that Piper wanted to be an artist first and writer second, he only achieved prominence as an artist by joining the Seven and Five.

Soon after Piper entered this Society, it demonstrated its progressiveness by replacing the nouns in its title with numerical digits. (It then shortened its title further to '7 & 5', Ben Nicholson finding 'Society' redundant and old-fashioned.) The constitution of this Society contained a rule which annually enabled it to refresh its membership: after every exhibition an election was held at which only those members whose 'ayes' exceeded its 'noes' were re-elected. This forestalled stagnation and, instead of trailing reactionary chains of members, the group's character changed each year, renewing its vitality. Five John Piper collages, of seaside subjects, were shown in its annual exhibition in

March 1934.[29] But in the course of the election held immediately after this exhibition, it was agreed that the next show should be 'non-representational', for Nicholson, who proposed this motion, was determined to make the 1935 exhibition entirely abstract.[30] At this same meeting, the selection process purged the 7 & 5 of Aldridge, Bawden, Jowett, and Lye, confining the membership to eleven artists: Ivon Hitchens, Frances Hodgkins, Ben Nicholson, Winifred Nicholson, David Jones, W. Staite Murray, Barbara Hepworth, Henry Moore, Francis Butterfield, Arthur Jackson, and John Piper. The 'non-representational' motion led to the resignation of Frances Hodgkins. John read out her letter at a General Meeting on 3 May 1934 and afterwards reported the regret expressed by all those present.[31]

It was no small feat to find himself occupying a significant role within England's most avant-garde exhibiting society, and at a period which Andrew Causey has described as 'a moment of ambition, energy and uncertainty in British art'.[32] Though he had not yet produced any abstract work, he had, as a journalist, shown himself in sympathy with the Modern Movement. In effect, he had written his own testimonial in 1933, when Janet Adam Smith at *The Listener* commissioned from him three articles on contemporary art.[33] These brought him considerable attention. In them he suggested that the French emphasis on structure in art could also be found in the best contemporary English art. He gives, as an example, Ben Nicholson's still-life on a cafe table, *January 27, 1933*:

> This is a painting which is both decorative and expressive, and expressive of the artist and the age. 'Tragedy', wrote Jean Cocteau ten years ago, 'no longer consists in painting a tiger eating a horse, but in creating, between a glass and the carving of an armchair, plastic relations capable of inspiring an emotion without the interposition of an anecdote.[34]

John's arguments align him at this date with Roger Fry and Clive Bell's promotion of 'significant form', and with R. H. Wilenski's small book *The Meaning of Art* (1931), which promoted the idea that the Modern Movement in art owed much to the formal principles of architecture. But a careful reading of these *Listener* articles shows that, already, John's interests extend beyond the narrowly formalist approach to art and embrace certain native traditions. 'Landscape has always played a large part in English art,' he writes. 'The English climate, unlike that of most countries, makes landscape painting at least a possible pursuit. And the Englishman's partiality for his native land, even for his native county, seems to act as a powerful emotive agent.'[35]

One artist he praised was Ivon Hitchens who soon afterwards became a friend. In October 1933 Hitchens held an exhibition at the Lefevre Gallery and John was asked to write a foreword for the catalogue. In preparation for this, Hitchens joined John and Eileen for a weekend at Chalkpit Cottage. They had a lively discussion about Herbert Read's new book *Art Now,* but as a whole the visit was not a success. John wrote:

> Eileen refutes the impeachment that there was thankfulness in her eyes at your departure, and says you mistake her callous indifference to good-byes, which she regards as superfluous adjuncts to a departure … I'm sorry the visit here was not more profitable. Was it the place? Was it us? Or don't you know? Anyway I hope it won't put you off for ever. We can't alter the place, but we might see what we can do about ourselves if you decide to try Betchworth again this year—next year—sometime.[36]

The foreword, however, got written and was suitably admiring. Hitchens, mollified, remained on terms of friendship which, though sometimes prickly, continued for many years.

Behind the awkwardness that marred Hitchens' visit to Chalkpit Cottage lay marital tension. Eileen had begun spending long periods at the Woodgers and was possibly already emotionally involved with the artist Ceri Richards, their near neighbour in Hammersmith. A year later, Ivon Hitchens, remembering John's troubled look, invited him to spend a long weekend with himself and others at Sizewell, on the Suffolk coast, in a tin-roofed cottage among the dunes owned by Richard Bedford, sculptor and Keeper of Sculpture at the Victoria & Albert Museum. As Eileen was away, John left a note telling her where he was going. What exactly he said is not known, but her postcard in reply, which reached him at Sizewell, suggested that his defection was perfectly acceptable as she 'had been about to take off on her own too'.[37]

Piper left no immediate record of his feelings at this time. He journeyed to Sizewell, to join Hitchens and his friends, and learnt, on arriving, that another guest, coming by train, would have to be picked up at Leiston. John volunteered, and set out for the station in his car, unaware that he was about to meet the person with whom he would spend the rest of his life.

4

Orchard's Angel

The woman who stepped out of the train that evening was twenty-three years old and not long down from Oxford. She had bobbed hair, which she tucked behind her ears, a style that made pronounced the planes of her face. She had pale-blue eyes and a small, straight nose. Though at this age she still retained an adolescent charm, she was neither conventionally pretty nor were any of her features especially fine. But she conveyed the impression of a definite, lively, intelligent personality: once seen, she was not easy to forget.

Mary Myfanwy (pronounced My*v*anwy) Evans had been born on 28 March 1911 at 93 Walworth Road in Southwark. Once, while driving down that road with Benjamin Britten and Peter Pears, she mentioned this fact. A stunned silence followed; then Pears burst out: 'Nobody could be born *here*.'[1] But born there she was because her father David George Evans, a pharmaceutical chemist from Milford Haven, after doing an apprenticeship with a chemist in a small Welsh border town and obtaining a job with the Pharmaceutical Society, had inherited a failing chemist's shop in the Walworth Road. It continued to decline and before long he returned to his former employer. Myfanwy spent only six months living in Southwark before moving with her family to Sutherland Avenue, Maida Vale.

There were clergymen on both sides of her family. Her paternal grandfather, Lodwig Evans, was a Baptist minister in Tenby, married to the daughter of a prosperous farmer from outside Fishguard. Her maternal grandfather, Charles Playll, was a disaffected Anglican who became a Congregational lay minister in Louth and whose wife, Ada, was of French Huguenot extraction. They had four children—Dorothy, Lena, Grace, and Edward.

Dorothy came to London to do a secretarial course. She met David Evans in a Bloomsbury boarding house and they married on 28 August 1909. It

was discovered that Dorothy's blood group was rhesus negative, which then made childbirth dangerous. She is said to have had at least one miscarriage. In time, Myfanwy learnt to be philosophic about being an only child, recognizing that her family had very little money and more children would have diminished what advantages she received. Among her immediate family was her maternal grandmother, Ada Playll, who moved to London after her husband's death, a frugal, sensible, undemonstrative woman whose only extravagance was a love of buying cookery pots, During the 1914–18 war, while her father served with the Royal Army Medical Corps and her mother worked as a medical secretary, Myfanwy spent much time with her grandmother and her aunts, one of whom, noticing the child was left-handed, insisted she should learn to eat with the knife or spoon in her right hand. For a short while she and her mother lived next to her grandmother and one aunt in a flat in Clifton Gardens, Maida

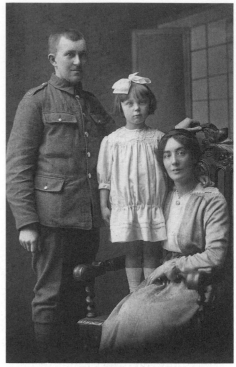

12. David and Dorothy Evans and their daughter Myfanwy.

Vale. As the houses backed on to a communal garden, Myfanwy found one or two playfellows, but mostly her childhood was solitary.

Though praised in dispatches for gallant and distinguished service, David Evans returned from the war sadly altered, a stranger to his daughter. But the bond between them was soon renewed thanks to his love of books and the theatre. She found on his shelves Gissing's *New Grub Street* and *The Private Papers of Henry Ryecroft*, Ruskin's *Unto This Last* and *Sesame and Lilies*, in India paper editions, *Sartor Resartus*, *The Poems of Robert Browning*, and *The Autobiography of Mark Rutherford*.[2] She developed the habit of reading her school essays to her father and found his comments 'always very encouraging, helpful and correct';[3] and together they went on long walks, sometimes in the company of Dorothy's brother, Edward ('Teddy') Playll, who worked in a papermaking business. But as time went on Myfanwy's father began to display the characteristics of a damaged and disappointed man. It did not help that his profession gave him access to the kind of drugs that offered a temporary panacea.

At the age of six Myfanwy began travelling with her mother every day by tube to Harley Street. While Mrs Evans performed the role of secretary to several doctors, her daughter went to school further down the road, joining the kindergarten at Queen's College where one of her fellow pupils was Penelope Chetwode, the future wife of John Betjeman. One day a senior member of staff interrupted a singing lesson with the announcement that the Armistice had been signed. In the awkward silence that followed, Penelope's unabashed upper class cockney voice could be heard—'Ooaah! Naah we can all go to France!' After two years at Queen's College Myfanwy moved on to Camden School; and the following year, 1920, she gained entrance at the age of nine to North London Collegiate School. This prestigious day school, then in Sandall Road, Camden, was within walking distance of her home, her family now liv-

13. Myfanwy Evans.

ing over 'Allchins', a Pharmaceutical Society chemist shop on the corner of England's Lane and Primrose Gardens in Belsize Park, still in existence today.

Always her own person, Myfanwy would picnic alone on Hampstead Heath. She also read a great deal. On one occasion she and her father visited his friend the librarian and curator at Keats's House, in nearby Keats's Grove, where Myfanwy was given mulberry wine made from the tree under which Keats had written poems. This seemed to her very romantic. But she also found poetry in the course of her daily walk to school, 'past the lilac and laburnum of Haverstock Hill, along the mean two-toned half slum of Prince of Wales Road ... [through] the real squalor of Kentish Town to the fading stucco of Camden Road'.[4] This area, damaged by the disruption caused by the building of the three great railway termini, Euston, St Pancras, and King's Cross, gave her an especial sympathy with George Gissing, whose *New Grub Street* she first read, along with George Moore's *Esther Waters*, when she was sixteen. The mundane lyricism in both novels chimed with her love of wandering 'with purposeless melancholy adolescent curiosity' through her particular area.[5] Years later, when Myfanwy re-read *New Grub Street,* it brought back vividly 'my own adolescent exploring of London streets and expressed so forcibly the human apprehension that I had had about the lot of mankind in greater London.'[6]

Each summer she spent the whole of August and part of September with relations in Pembrokeshire. She especially enjoyed staying with her Welsh grandparents, who lived at Deer Park, Tenby, for her grandfather's love of word games taught her to play with language. But here, too, having no friends, she spent much time on her own, though she did find a pal in the milkman who gave her drives on his float. Especially memorable were family trips into Anglesey. Years later in a radio programme she evoked the sense this area gave her: 'impossible to define but for that all the more powerful, of it having been a place of great importance in ancient times, a place full of life, a place of religious fervour'. She loved the breathtaking beauty of Telford's suspension bridge and never forgot how on one of her first visits they drove straight to Red Wharf Bay on the east side. It was a summer evening, pellucid after rain, and they arrived at a small hotel that looked out over the bay where

> the sand ran shining right back into the land towards Maltraeth as if it were trying to make another straits across the island. ... I remember how the little tongues of rock ran right out into the sea so that one could plunge into it without wading horribly to one's middle and I remember the shore covered with shells unrivalled for quantity and variety, all cast up unspoilt, unbattered, many with both halfs still perfect.[7]

Returning home from Wales, after eight weeks of picture-book freedom, in the care of the train guard, her feelings were ambivalent. For every time the train advanced towards Paddington through 'the long evening tunnel of brick and mist', her throat contracted with excitement and despair as she experienced 'the anguish and rapture of being enclosed in once more by streets—streets where the air, still heavy with dust and smell of summer, is barely stirred by a September breeze'.[8]

Owing to the family association, on her mother's side, with the Congregational church, she was sent on Sundays to King's Weigh House, a Congregationalist church in Mayfair. Originally founded in Eastcheap, over the place where goods were weighed for custom's duties, it had, since 1891, resided in a magnificent church built by Alfred Waterhouse on a site donated by the Duke of Westminster. Here William Ellis Orchard preached outspoken pacifist sermons and attracted congregations larger than the building could hold. He longed to reconcile Catholic and evangelical worship and introduced more and more ritual until the services were almost indistinguishable from those of the Roman Catholic Church. There were beautiful processions, Myfanwy among them, for she sang in the choir, becoming one of 'Orchard's angels'. It is not known when she left, but she knew that Orchard's resignation, in 1932, in order to become ordained a Roman Catholic priest, had plunged the church into disarray. It never fully recovered. Disbanded in 1966, King's Weigh House is now the Ukrainian Catholic Church Cathedral of the Holy Family in Exile.

Myfanwy was not particularly bright at school but North London Collegiate, then as now, was renowned for its academic excellence. Founded by Frances Mary Buss in 1850, its standards had been maintained and improved by its second headmistress, Mrs Sophie Bryant, herself a formidable scholar and the first woman Doctor of Science. She held to the belief, quoted in her obituary in the school magazine, that 'women's lives would be happier and sounder if they had, as a matter of course, the fair share of the sterner intellectual discipline that had been such a joy to me.' One of her appointments was Bernard Shaw's mother who headed the Music Department; another was a Miss MacDonnell, a dedicated Irish patriot, bursting with salutary literature. Mrs Bryant, herself, was a strong supporter of women's suffrage which helped associate the school with a radical, left-wing ethos. But so successfully had she stamped her high standards on the school that her successor, Miss Isabella Drummond, who took over the headship in 1918, had to proceed cautiously with the changes she wanted to introduce. By the time Myfanwy arrived at the school in the autumn of 1920 there had been a slight relaxation of the rules and the atmosphere, though still very high minded, was less rigid.

An only child and fairly solitary, Myfanwy tended not to run screaming round the playground. ('I didn't know about screaming,' she later recollected.[9]) Instead she would often walk with the prefect in charge and chatter. In this way she got to know Helen Gardner, seven years older than her and later to become an eminent literary scholar. School life on the whole kept Myfanwy busy. She played hockey and rose steadily to the First XI, also swimming in the school team. She joined the school's Dramatic Society and its Musical Society; wrote poems which were published in the school magazine; and during her last two years acted as the Magazine's assistant subeditor. She was also a prefect.

Rather exceptionally, North London Collegiate boasted a spacious studio—the Drawing School—which was well lit and furnished with easel and tables, and its walls were lined with linoleum for pinning up drawings and reproductions. When asked for her memories of the school,[10] Myfanwy recollected that the art teacher, Isobel Monkhouse, 'was very proud of her art room and ran it with tolerance and imagination'. As a result North London Collegiate was the only school from which the Royal College of Art would accept students with a Higher Certificate Art pass, without first making them sit the Royal College's own intermediate exam. Though Miss Monkhouse talked little about Surrealism, Picasso, or Braque, she accepted work vaguely imitative of Cubism and Vorticism and encouraged her pupils to read Roger Fry, Clive Bell, and R. H. Wilenski. Myfanwy learnt from Miss Monkhouse how to do Turner skies by wetting coarse watercolour paper and dropping in colour from the top, and generally found her 'stimulating, practical and blessedly uninterfering'. Myfanwy drew well enough at this age to make people think that she might be heading for art school.

Still more important was her English teacher, Florence Gibbons, a pale, thin woman with rather untidy features, who, after ten years service at North London Collegiate, resigned owing to ill health and died, aged thirty-six, of tuberculosis in 1932. She was a devout Anglo-Catholic with a nervous giggle. Her rather holy and elevated manner, Myfanwy recalled, was mixed with an approach to her subject which encouraged any positive reaction, whether academically acceptable or not. She had a great feeling for words and gave the sixth form advice on writing and language which Myfanwy thought 'brilliant'.

> She had a wonderful ear and would make us find out what style was about by writing in the style of say Sir Thomas Browne or Dr Johnson or Walter Savage Landor, at the same time encouraging us to write simply and truthfully what we had to say in our own way. It was entirely her encouragement and capacity to see beyond the rather careless and slipshod attitude I had to most work that made me, in spite of opposition from other staff, try for Oxford

(I had to get a scholarship or exhibition because I needed an LCC grant to enable me to go). ... Although her appreciation of Eng. Lit. was pretty broad her real love was the 17th century, George Herbert, Vaughan, etc. I'm not sure that her taste in modern poetry was sound. She would extol poems by, for instance, Humbert Wolfe that I, in my own priggishness thought not up to scratch—on the other hand she admitted and appreciated Eliot.

It says much for Miss Gibbons that she nurtured Stella Gibbons (of *Cold Comfort Farm*) and the poet Stevie Smith, as well as Helen Gardner, who proved helpful to Myfanwy. 'It was Helen Gardner who, when she came back to N.L.C.S. one day met me in the corridor and said "I hear you're trying for Oxford. Take my advice, don't do Wordsworth and the Romantics, everyone does, do Milton and the seventeenth century for your entrance paper." It worked.' She enjoyed a further piece of luck when she sat the 1929 general paper for Oxford entrance, because

> slipped in among such expected bores as 'what are the advantages of proportional representation?' was a gift, 'The painter should not imitate the photographer: discuss.' And a happy hour was spent slaughtering *The Monarch of the Glen* with the distorted rocks of *Mont St. Victoire*.[11]

In consequence, in the autumn of 1930 Myfanwy went up to St Hugh's, Oxford, on an exhibition. This gave her scholar's status: she wore a scholar's gown and retained her college room for all three years she was there. Loneliness wore off when she made friends with some 'Pauliners', as pupils from St Paul's were called, who were on the whole more sophisticated than girls from North London Collegiate. Strict rules were in place to protect female students from the opposite sex. If invited to take lunch or tea at a man's college, permission had to be obtained from the Principal, Miss Gwyer. One of Myfanwy's friends, having obtained such permission, was walking towards the door when the Principal spoke again: 'And remember Miss Hesketh-Wright, all well conducted lunch parties end at 3 o'clock.'[12] But there were other reasons why Myfanwy was at first disappointed in Oxford. There was scant interest in Virginia Woolf, whom she had been encouraged to read by some Hampstead friends; the general run of fellow undergraduates were no more enterprising than her schoolmates; and the food in the women's colleges, she couldn't help noticing, was foul.

Nevertheless, at Oxford she gained a swimming blue, captained the team at St Hugh's, and led it to victory in the University Swimming Competition in 1932. She also went regularly to concerts, going one Sunday to hear Berg's *Wozzeck* premiered at the Albert Hall in London. Her companion was often

Howard Hartog, who was to make his reputation as a music publisher. And in Oxford she had the opportunity to hear many fine performers, including the Lener and Busch Quartets, the sisters Adele Fachiri and Jelly D'Aranyi, and Arthur Schnabel. She also went for the first time to Glyndebourne, to a Sunday afternoon concert. At lunch beforehand, in a Lewes hotel, her companion (probably Howard Hartog) pointed out the severe musicologist, Donald Tovey, at a nearby table, whose voice caught Myfanwy's attention. 'During one of those fruitful hushes that sometimes overtake a crowded room I was delighted to hear him boom "Grieg's Piano Concerto—macaroons, sheer macaroons." I'm ashamed to say that Grieg's Piano Concerto was on my 'unthinkable list' for many a long day afterwards.'[13]

While at Oxford she became an avid gallery-goer. She joined the Oxford Arts Club, which mounted exhibitions of contemporary art, showing work by Paul Nash, Duncan Grant, and Vanessa Bell. Enthused by what she saw, she ventured into print for the first time. Two pieces, signed 'M.E.' in the undergraduate magazine, *The Cherwell*, can be attributed to her.

> The Arts Club has not always had the patronage it deserves among undergraduates. It would now be the best thing in the world for us to pawn our Clive Bell and text-book on Burlington House, and buy a subscription to this Club with the proceeds. For not only are the exhibitions in the Club rooms of exceptional interest; a series of lectures on art has now been instituted.[14]

The talks excited her, giving her the opportunity to hear Eric Gill, and on another occasion, Paul Nash. After the latter she wrote:

> Mr Nash proceeded to give us a brilliant talk on the aims of modern artists in England; and the evening's discussion inevitably produced the old problem as to what constitutes a good picture. To this Mr Nash gave a sound, practical answer, the only answer, indeed, that an artist can give. But of course it was hardly calculated to please either the philosophers of [or] the Pre-Raphaelites, who commenced to assail him from all directions.[15]

The debate gave her a foretaste of the arguments over which she herself would later preside as editor of *Axis*. The Arts Club also brought her the friendship of Nicolete Binyon, daughter of Laurence Binyon, the 'scholar-poet' of the British Museum, who had freed his daughter from conventional visual taste by encouraging her to look at art from many periods and different cultures. Myfanwy's new avidity for visiting galleries and museums may have been fanned by Nicolete's enthusiasms.

Meanwhile she read English, changing to PPE for one term before finding economics so 'fearfully dull'[16] that she returned to her original subject. She specialized in the seventeenth century. In her third year she had regular meetings (rather than strict tutorials) with the poet and literary editor Edmund Blunden in his rooms at Merton. These proved to be an affable mix of literary chat and Oxford gossip. Later, she wished she had made better use of these sessions.

Also at Merton and likewise studying English was the Rhodes Scholar Franklin Folsom, an American whom Myfanwy had first met while doing vacation work in the British Museum. Folsom had ambitions to be a poet, sent poems to *The Listener*, and got Myfanwy into bed. Though already committed to a woman called Mary Elting (whom he eventually married), he argued that if he and Myfanwy confined themselves to a 'reasonable' relationship and no more, it would be 'a little like existing on the bran flakes you so detest'.[17] This lightly engaged but honest relationship perhaps suited them both, and for decades afterwards they continued to correspond. On his return to the States, Folsom busied himself as a poet and organized a Communist Party unit; edited newspapers for the Unemployed Council; and twice got himself arrested, once during an unemployment demonstration, and again while handing out leaflets in support of a strike. In 1937 he became national executive secretary of the League of American Writers, which had strong links with the Left and intervened on the political scene.[18] It was probably owing to Folsom that Myfanwy, who had joined the Socialist Labour Party at Oxford, also briefly aligned herself 'in a dim kind of way', as she later admitted, with the Communist Party. All her life she voted for the Labour Party except on those occasions when she chose to abstain.

She was known at Oxford as 'the Chemist's daughter of Jermyn Street', for by now the family was living over a shop in Mayfair—a useful rendezvous for her friends. She had also begun reading the *New Statesman and Nation* where among the reviews in the literary section her attention had been caught by a critic called John Piper. 'I was charmed by his stylish, undidactic writing, relaxed jokes and perceptive eye. I used to think, idly, "There is someone I could talk to and what's more, he would make me laugh." I thought no more and didn't pursue it.'[19]

She came down from Oxford in the summer of 1933 with unpaid bills as the abandonment of the Gold Standard had diminished the value of her LCC grant. On her own admission she had not worked very hard, and graduated with a Second in English. H. F. B. Brett-Smith, Reader in English Literature, who tutored her for one term in her final year, told her that she had done 'some very good work in schools, and much of it would have been even better but

for a certain lack of finish about the style'. Brett-Smith also supplied her with a reference:

> Miss Evans was placed in the Second Class in the Honours List, but several of her papers were of First Class quality, and of all this year's candidates she was one of two who, in my judgement, showed most promise of developing and improving with greater maturity. She would, I think, be successful either as a teacher or as a writer in her subject.[20]

In 1933, when few jobs were available, Myfanwy gained employment with the Times Book Club. Here she found herself packing (rather clumsily) parcels—'a thing I was not born to do'.[21] It was a relief to be transferred to its library. At the same time she began lecturing one evening a week on literature at Morley College in Lambeth, at the request of its principal, Eva Hubback.

Her introduction to Eva Hubback had come through her Hampstead friends, the Blanco-Whites. As a teenager she had fallen in with their younger daughter, Justin (so-called before birth, in the expectation that she would be a boy). Though Justin attended a different day school, St Paul's, she lived nearby in Downshire Hill. Her quick-wittedness, eager, unusually honest personality and her interest in art attracted Myfanwy and drew her into a way of life very different from her own. The father, Reeves Blanco-White, was a barrister and the mother, Amber, a socialist, intellectual, and former mistress of H. G. Wells, her elder daughter being his illegitimate child. Friendship with the Blanco-Whites extended Myfanwy's intellectual horizons—'I learnt a more civilised and well-heeled life with them,' she recollected.[22] She frequently accompanied Justin on weekend visits to her mother's country cottage in Sussex, and on one occasion impressed another guest, Olivier Popham (later to marry Virginia Woolf's nephew, Quentin Bell), with her fast crawl when they went swimming in the River Arun.

In an empty room in this Sussex cottage was a gramophone and a large collection of records, once played avidly by the Blanco-Whites. It was here that Myfanwy's discovery of music had mingled with her surprise at finding herself, a Londoner, in the country; listening to records with Justin in this empty room merged with the pleasure she took in the scent and light of Sussex in spring and early summer. 'It was usually Bach or Handel—we were limited if not severe in our tastes at fifteen or so, but I was bowled over by it all—in a very romantic way.'[23] Many years later, when invited to select pieces of music for the radio programme *Woman of Action*, she chose a keyboard piece by Couperin to evoke these early musical experiences: 'The feeling one had that the particular

moment would go on forever, sun and scent and sound, but at the same time beyond that place and time there were more marvels and riches; a whole life-time of them.'[24] The piece in question—'Les Barricades Mysterieuses'—came from his *Suite in Bb*, its title underlining her nostalgia.

At this cottage in Sussex, Myfanwy first met Ivon Hitchens, a near-neighbour of the Blanco-Whites in Hampstead, for he lived in Adelaide Road. He took a liking to Myfanwy, and she began posing for him in London, as did Katherine (Kitty) Church, a young woman who loved cooking but was determined to make painting the focus of her life. This impressed Myfanwy and the two women became lasting friends. In June 1934, Hitchens invited both of them to Suffolk, to the cottage he had been lent at Sizewell. That same week Myfanwy, having given notice, walked out of the Times Book Club for the last time and caught a train to Saxmundham, changing there for Leiston, as Hitchens had instructed. There, to her surprise, she was met by a man who turned out to be the John Piper she had formerly encountered only in print, and who, she quickly discovered, was not only a critic but also an artist. Her interest was matched by his: as the train pulled in and a young woman got out, he thought immediately 'she was the cat's whiskers'.[25]

Conditions were propitious, Myfanwy recalled. 'The summer night was warm and the sea phosporescent. We bathed before going to the cottage and dried ourselves by running along the strip of sand between the shingle and the shining water.'[26] They arrived later than expected, incurring the disapproval of Ivon Hitchens, who had a parsonical side to his nature. This did not diminish the pleasure of that hot weekend during which John and Myfanwy never stopped talking. But the fact that they enjoyed each other so much may explain why, in John's memory, they 'spoilt the weekend and came home early'.[27] But in years to come two local residents, Benjamin Britten and Peter Pears, would celebrate the meeting of John and Myfanwy by metaphorically raising their hats every time they drove over Sizewell level crossing.

PART

II

5

Going Modern

Soon after her visit to Sizewell in 1934, Myfanwy encountered J. M. Richards, an Anglo-Irish architect who had practiced in Dublin and America before turning to journalism and becoming assistant editor on the *Architect's Journal*. It was owned by the Architectural Press, which also published the more distinguished *Architectural Review*, as well as books on architecture. Richards had soon realized that his new job left him well placed to meet others in his field, among them, the young John Summerson, then working as assistant editor of the *Architect and Building News* (but shortly to establish his reputation as an architectural historian with his 1935 biography of John Nash), and John Betjeman, assistant editor of the *Architectural Review*.

Jim Richards first met Myfanwy through Justin Blanco-White. He had become very attached to Justin, now studying at the Architectural Association, and, along with her brother, they had spent the summer of 1932 in Germany, walking in the Black Forest and looking at modern architecture. Justin was, for Richards, his first serious emotional involvement and he was hurt when she decided that she preferred someone else. Needing to talk about her, he invited her friend to lunch.

> Myfanwy was a sympathetic but sensible confidante. She had just come down from Oxford and had a lively mind with wide-ranging interests, mostly literary. Over lunch, when the time came for me to listen to her instead of making her listen to me, she told me that she had spent the previous week-end in Suffolk, visiting the painter Ivon Hitchens, where she had met another painter whom she had liked enormously. He was called John Piper and she was meeting him again that very afternoon on the steps of the National Gallery.[1]

Jim asked where John Piper lived. 'St Peter's Square, Hammersmith,' Myfanwy replied. 'Oh, can't be any good,' he opined, as most of the architects and artists he knew resided in Hampstead.[2] Nevertheless, Richards intuited that Myfanwy's meeting with John had been significant. 'It was clear that something important was going to come of this and it did. A short while afterwards Myfanwy invited me to dinner at the flat in Holland Park where she lived with her aunt and grandmother, to meet John Piper, who was to be introduced to her family.'[3]

It is hard to know on what terms she introduced this married man to her aunt and grandmother. In old age Myfanwy said that when she met John he had already separated from Eileen.[4] This may be true in spirit but not in letter for he and Eileen were still living together. Myfanwy caused no sudden crisis in John's married life, though his attraction to her is evident in the friendly, excited letters and notes which he sent soon after they met. Eileen knew about Myfanwy and may have met her: a letter sent by John to Myfanwy on 13 July mentions that Eileen sends her love. Soon afterwards Myfanwy left 100 Holland Road for a holiday in Devon and Cornwall. 'Send me some S.Devon lighthouses from Dartmoor and other intimations of your existence,' he begged.[5] A similar request followed her to St Ives. 'Don't miss it,' he wrote, referring to the lighthouse, 'and postcards of all angles please.'[6] He himself was back at Chalkpit Cottage, at Betchworth, living and working alongside his wife.

One bond between John and Myfanwy was their interest in art. He had shared with her his enthusiasm for Braque, and while she was in Cornwall, in July, he reported to her his excitement over meeting this artist, for Braque had come to London in connection with his exhibition at the Lefevre Gallery:

> We met last Friday—who do you think?—BRAQUE (and his wife and Ben [Nicholson] and Barbara [Hepworth]). Can you leave handy Braque *Cahier d'Art* for me to fetch if I want it from Holland Road? I may find I can't paint without my copy books. I have done 1 1/2 paintings so far and am hard at it.[7]

John's passion for Braque was such that he inadvertently held up the traffic for ten minutes at Dorking while he read Gwen Raverat's review of the Braque exhibition in *Time and Tide*. Her patronizing stance ('we recognize apples, women, jugs, without hesitation, though without enthusiasm') infuriated him. Even her praise was ambivalent: 'Picasso and Braque are both intellectually interested in carrying the possibilities of pattern as far as they can possibly go; and in this narrow field, this no-thoroughfare, Braque seems to me the greatest

of living painters.' John thought of writing to *Time and Tide* in protest. But, ironically, Raverat's reservations, which he dismissed as 'kindergarten stuff',[8] end by outlining the direction which he himself would eventually take.

> For Braque seems to me to have already gone as far as, or further than is profitable in a direction which leads to a sort of Nirvana, when nothingness is best of all; when a circle painted white is the greatest picture in the world; and from that place there is nothing left for a living man to do but to turn round and come back again to the beginning, and to paint once again still-lifes of apples with passionate love for the appleiness of them. I think we shall live to see all the greatest of the abstract painters walking backwards down their paths.[9]

Abstract art in England, by 1934, had slowly regained the interest it had aroused in the years leading up to the First World War. As early as 1912, Roger Fry, in his catalogue introduction to the Second Post-Impressionist exhibition, had argued that a purely abstract language—'a visual music'—was the logical outcome of the general move away from art as imitation to an art that aspired to a more immediate expression of reality. Soon after this the three main Bloomsbury artists, Vanessa Bell, Duncan Grant, and Roger Fry, had begun to explore an abstract language. This, however, did not progress far beyond the level of tentative experiments and it was the Vorticists, led by Wyndham Lewis, who, in their search for a machine-age aesthetic, arrived at a more convincing abstract style, although allusions to figures and buildings still clung to their images. Further progress was undermined by the First World War and many years passed before talk of non-figurative art revived. But in 1931 Paul Nash, reviewing the 'Recent Developments in British Painting' at Tooth's Galleries, London, noticed a move towards abstraction and sought to explain it:

> Does it occur to anyone, I wonder, that English artists to-day, may feel a need to create something for themselves which is neither imitative nor interpretative of what is generally seen; that the inevitable reaction from the insecurity and muddle in which they live is a determination to construct, in however apparently small a space, an ordered, independent life; that in contrast to the crowd of undisciplined 'buildings' which surround them they would make an architectural thing in paint or stone?[10]

Nash identifies here a key motivation behind 1930s abstraction, not only in England but also on the Continent: a desire for order, for a stability that would withstand the chaos and conflict elsewhere.

The following year Nash devoted an entire article in *The Listener* (17 August 1932) to abstract art. In his view, it had been a viable form of artistic expression for some twenty-five years and, far from being 'played out', was very much alive in England. His attempt to persuade the public that abstraction is a coherent, logical practice had been echoed by John, who in December 1933 had praised Wadsworth's abstract compositions.[11] On the whole, however, interest in abstract art in England remained thin on the ground. Meanwhile, following the closure by police in 1933 of the Bauhaus in Germany and the imposition of socialist realism on art in Russia, many artists fleeing totalitarian regimes moved to Paris which became a centre for abstract or non-figurative art. The historic context framed this art as a 'free' international style.

A key figure in this development was Jean Hélion. In April 1930 he had brought flair and determination to the formation of an international coalition called *Art Concret*. It published a review of the same title and, in its manifesto, claimed that this group's abstract art owed nothing to nature and excluded all lyrical, dramatic, and symbolic values. Instead its significance derived solely from its material properties, its clear, simple, visually explicit construction, and from its impersonal, exact, and anti-Impressionist techniques. When financial difficulties troubled the second edition of *Art Concret*, Hélion and Theo van Doesburg decided to broaden the group and in February 1931 *Abstraction-Création* came into existence, Hélion taking on the roles of Secretary and Treasurer. Its principal activity, from 1932 onwards, was the publication of an annual journal in which its members, listed alphabetically, were represented by one or two reproductions of their work alongside statements of their ideas. Various styles of abstraction came under its auspices, including the work of the constructivists who encouraged the use of non-traditional materials in the making of sculptures or reliefs.

When John joined the 7 & 5 Society in 1934, his work was still figurative. Nicholson's drive to make the 1935 exhibition 'non-figurative' made it imperative that he should catch up with avant-garde ideas, particularly those emanating from Paris. After Nicholson headed off in that direction in April 1934, John had sent him a postcard of Beachy Head lighthouse: 'Paris must be interesting now. We are going in June.'[12] And that month, armed with an introduction from Nicholson to Jean Hélion and other artists (possibly César Domela who gave lessons on abstract art to Ben's estranged wife, Winifred Nicholson), he and Eileen had visited Paris.

His first meeting with Myfanwy occurred soon after his return, when his head was still full of what he had seen. He had admired in particular Alexander Calder's wire sculptures, weightless and untethered, and Cesar Domela's con-

structivist polychrome reliefs, crisp arrangements of modern materials which banished quotidian muddle and mess. This art gave him the desire to break up and diversify the picture surface. The following month at Betchworth he experimented with the making of painted reliefs incorporating synthetic materials (Plate 8), while his wife created painted wooden constructions in a style indebted to the De Stijl artist Georges Vantongerloo.

On hearing that Myfanwy, too, was going to Paris, John insisted that she come and look at his work before leaving. Ceri Richards had been staying with them for the better part of a week and John had found him inspiring. 'An excellent draughtsman', he told Myfanwy, 'and he may do great things, and anyway he must be in 7 & 5.' While staying with the Pipers, Richards had made humorously lewd collages, using images and words from the *Farmer's Weekly*, which they found in a pub, and the *New Statesman*. 'Very highbrow–lowbrow,' John commented.[13] More serious was Richards's attraction to Eileen. Many years later John told a friend, the dealer Howard Roberts, that returning home one day he had found Ceri and Eileen in a compromising situation. Story has it that he packed a bag and went straight off to Myfanwy. This may or may not be accurate. It is, however, known that Richards ran off with Eileen for a few days, until a stinging letter from his father brought him back to his wife.[14]

It may have been in the aftermath of this that, as Anthony West records, John remained at Betchworth for the rest of this summer, while Eileen spent more and more of her time with the Woodgers in Epsom. By mid-autumn their neighbours in Hammersmith concluded they must have given up the St Peter's Square flat. Rent bills remained unpaid and, so John told West, in October, when he made a return visit to the flat, he found that the landlord had stripped it and impounded all their furniture and possessions.[15] Though Eileen returned to Betchworth that autumn, she and John now recognized that their marriage was over.

There had been a moment, back in July 1934, when John had hoped he and Eileen might join Myfanwy in Paris. She had been lent the use of a flat in the Rue Madame for the whole of August and was living off the £20 given her by an aunt. At this time, though outwardly still committed to Eileen, John evidently found it hard to let Myfanwy go. He wrote:

> Thank you for lovely postcard and lovelier letter and loveliest drawings. What a place is St Ives. Keeps Winsor & Newton in business though so that one can still buy paints in this country.

Sadly, sadly, sadly, it looks as though we aren't going to see you before you go to Paris. … But what would you say if we did come to Paris for 2 days and 1 there and 1 back? End of August or right at the beginning of Sept. Would you be very annoyed? Anyway a nice cold postcard from there will put us off and a warm one probably bring us. No money, but then a 4-day excursion costs next to no money. …

Anyway in the meantime go and see Jean Hélion and give him our love and tell him you're ever so nice and so's he and so's everybody and have tea with him and eat lots of American wife's waffles and see his pictures and Alexander Calder's wire cow that drops a cow pat, and if you do you'll come away having found out all the pictures in obscure places in Paris that are worth seeing.[16]

He enclosed Hélion's address and advice on the nearest Metro, and directed her to the Cahiers d'Art Gallery in the Rue du Dragon and to Bernheim Jeune 'where there are always Picasso and Braque'. He himself was hard at work, getting up at seven each morning and working all day. He was also expecting a visit from Ivon Hitchens. 'I shall hear all about Kitty no doubt. Sizewell only ended last week.'[17]

Paris, which Myfanwy had never visited before, galvanized her. Thirty years later she recollected a dream in which two bicyclists gyrated around in a field of unbroken snow, creating black lines while simultaneously casting around them small scarlet and blue triangles. 'There was no story,' she recollected, 'only the intense visual excitement. Whatever hidden meaning the dream may have had it could not have been expressed in those terms before 1934, for only then did I have the waking visual experiences to supply them.'[18]

She took with her to Paris her familiarity with the ideas of Roger Fry and Clive Bell and the concept of 'significant form'. This she had learnt to perceive in the French paintings at the Tate Gallery. But this easy pleasure, she now realized, had been gained without any perception of the urgency that lay behind these pictures; or, as she recollected, 'without relating it to the tougher developments of the movement—the austere, the eccentric, the violent, or the strange, that made so many English painters [seem by comparison] stale and etiolated versions of the Fauves'.[19] It was only after her visit to Paris in August 1934 that she understood why the more go-ahead dealers in London regarded English art as provincial and snobbishly preferred the Ecole de Paris.

On arriving in Paris, in August 1934, Myfanwy found the city 'suspended in heat and emptiness'.[20] Everyone seemed to have gone away, except artists who could not afford to do so. Among theses were Mondrian, Brancusi, Kandinsky,

Domela, and Giacometti, all of whom she met through Jean Hélion. He, him-self, had been most welcoming, as Myfanwy later recalled:

> the moment I walked into the high studio in Montparnasse I was knocked silly by the amazing vitality of everything around me and especially by yours, Jean—your eloquence and sparkle both in French and English (luckily for me) left me spell-bound. So we got on. I remember staying, that first day, an unconscionable time sharing your and your American wife Jean's sup-per and walking back through the unfamiliar dark streets in a state of high exaltation.[21]

Hélion showed her his paintings, stacked and hung around the room. Segments of cylinders and other abstract shapes, shaded in a schematized manner which he had adopted from Léger, floated across a flat background. The arrange-ments played on oppositions of height and width, form and space, using similar relationships to those which he admired in the art of Poussin or Seurat. 'I can hear your voice,' Myfanwy recollected, 'feel again the passion with which you embraced the art of the past within the possibilities of the present.'[22]

Hélion's network stretched far and wide. Owing to him, Myfanwy met Giacometti ('silent, secretive, ambivalent'[23]); visited Hans (Jean) Arp and his wife Sophie Taeuber-Arp at their home in a tree-shaded suburb, where his sensuous white sculptures seemed 'quite at home and at the same time wittily incongruous amongst the geraniums and gravel and the frilled window curtains of the neighbours';[24] discovered Kandinsky in a tiny flat, neatly dressed, with the remains of his life's work stacked wall to wall; and walked into Brancusi's studio which seemed to her like 'some strange cathedral':

> One wandered in through a forest of columns thrusting upward from the floor of fine stone dust: far away, beyond the white and gold and brassy yellow, the floating shapes of fish or bird or bodiless head, egg-shaped upon its plinth, the mysterious baroque twists of wood, the lumps of marble or alabaster, as yet lifeless, unconjured, the small figure of the sculptor lurked, a little doubtful, suspicious even, half-priest, half-peasant, in his linen smock.[25]

Equally unforgettable, for her as for others, was a visit to Mondrian's double-cube studio where he lived alone, pale and thin, in conditions of spartan sim-plicity. Dressed in a shabby but conventional suit, he would suddenly throw off his melancholy and, putting jazz on the gramophone, dance frenziedly with whoever was present. Myfanwy evidently danced with Mondrian, both in his

studio and possibly elsewhere. (Hence John's apocryphal story, later told to John Russell Taylor, that when Henry Moore called on Mondrian and learnt that Myfanwy was in Paris, he wondered if he might take her out. 'Do,' Mondrian replied, 'she's too representational for me.'[26])

These encounters changed her perception of art. Previously, she had looked at it from the outside; now, listening to these artists talk, she began to perceive its inner motivation, and with that experience came 'an upsurge of belief' in contemporary painting: 'Its comparative beauty, its lasting power, its worth, were questions that did not arise. This was the way it was being done. What mattered was the capacity to be in it at the moment of existence.'[27]

Though many of these artists were quite far on in their careers, they were still having to fight for recognition. This made her interest welcome. 'All the artists that I visited that summer had the same quality of private, active intensity in the midst of an indifferent world—a world that, all the same, like a selfish parent, had produced the very life that it rejected or was bored by.'[28] In her memoirs she remained tacit about the bickering that broke out that summer among Abstraction-Création artists, between the wholly non-figurative artists and those who worked with biomorphic abstraction which, they argued, retained a relation to life.[29] The schisms caused Hélion, Arp, and others to resign from Abstraction-Création. In the wake of this hiatus, Hélion urged Myfanwy to take up the abstract cause. Already aware that abstract artists urgently needed a voice and a shop window, she now found herself pushed by Hélion's 'vision and insistence'. Fifty years later she re-evoked the conversation that triggered her decision to edit *Axis*:

H. You will go back to England and start a magazine of abstract art.

M. I don't know enough.

H. You will learn,

M. I haven't any money.

H. It will come.

M. Surely Herbert Read should do it.

H. You are young enough to afford a failure, he isn't.

M. So be it.[30]

6

Axis

After receiving Myfanwy's report of her conversation with Hélion, John immediately rallied behind the idea of a magazine devoted to abstract art. 'I have masses of titles for the new magazine,' he replied, 'and have filled the first 12 numbers with super ideas. ... *The Studio* will be crying for help in a fortnight. What a sensible man Jean Hélion is, hitting on the right idea straight away.' He also dismissed doubts she had about her credentials. 'Holes in knowledge be damned. Knowledge is not a bit of Gruyere cheese, what is needed is grit. (You might begin your first editorial like that.) Hurry home and be at it.'[1]

One person he knew would be interested was Ben Nicholson whose personal life, like his own, was undergoing momentous change: while gently extracting himself from marriage to Winifred Nicholson, Ben had begun his association with Barbara Hepworth, who was expecting his child (which turned out to be triplets). 'Shall I tell him [Ben] and get him all excited and on the hop about the new and only art magazine, or keep it a secret from him from [Herbert] Read from everyone from no-one?' John asked Myfanwy. While waiting for her return, he worked on his constructions ('The one you didn't like different and better, 2 more and one on the stocks'). These he brought one by one to London, their fragile nature making separate journeys necessary. 'Paul Nash coming to look when we get back,' he threw in, adding: 'Drop us a card with date of return and intention. ... Store up anecdotes of Mondrian, Arp, etc. Seen Pic. yet?'[2]

The magazine was named *Axis*, and, as plans unfolded, Myfanwy discovered that she had in John a co-producer and designer. He and Eileen now agreed to separate and the proceedings to terminate their marriage began, with Eileen divorcing John.[3] Myfanwy later admitted that it was not an easy period. But there appears to have been the minimum of acrimony, and it says much for all

concerned that Eileen and John continued to exhibit together and she contributed roundups on London shows to four issues of Myfanwy's *Axis*. These ended in the summer of 1936, when she may have gone abroad. By the mid-1950s, she was living in New York where she took lessons at the Art Students' League under the tuition of Richard Bové. She continued to exhibit in group shows, not as a constructionist but as a painter.[4] (She reappeared once in John's life in the 1960s, by which time he and Myfanwy were married and had a family. 'Who was that?' asked their younger daughter after Eileen left. 'Oh don't you know?' Myfanwy replied. 'That was Papa's first wife.' Until then, no previous marriage had ever been mentioned.)

Axis began at a time when Myfanwy did not keep letters. But she no doubt received from Hélion similar advice to that which he sent Ben Nicholson. The new magazine, he said, should have an English focus and an emphasis on abstract art; it should not be too dependent on a small group, yet needed to keep its direction in the hands of the few; it should neither give too much space to the well known, nor seek to imitate *Cahiers d'Art*. He was keen, too, that it should not praise or support Surrealism. Myfanwy must have agreed, as Hélion reported to Nicholson: 'got a note from Myfanwy saying NO surr. was going to be praised in the review. OK.'[5]

Myfanwy's initial task was to lobby supporters. She and John went to see the painter Edward Wadsworth, who lived with his wife, Fanny, at Maresfield in Sussex. Wadsworth had trained as an engineer in Germany before going to the Slade where he had become the ally of Wyndham Lewis. He was a rigorous modernist, and owned paintings by Léger and a large wooden sculpture by Zadkine which sat on the lawn outside his house. The sight of it, as their car turned into the drive, filled Myfanwy with encouragement.

> It made our interest in post-impressionist and abstract art seem more normal instead of a rather absurd and impractical whim, and so did the generous and courteous attention that Fanny and Edward [Wadsworth] paid to our plans. We knew that he had not been his old self for some years, but that did not stop him from encouraging us and giving us a cheque to help get us going. I can't remember how much it was now—we kept no records—but probably £50, which was a lot of money in those days.[6]

She and John regarded Edward Wadsworth and Paul Nash as 'fathers and heralds of our hopes.'[7] A painting by Wadsworth—*Composition 1932*—was illustrated in the first issue of *Axis*.

Others whom they canvassed included John Hilton, who gave money, the poet and Blake scholar Ruthven Todd, and the critic Herbert Read to whom

Myfanwy had been introduced by Howard Hartog. John kept Ben Nicholson up to date with their progress: 'Myfanwy Evans's magazine is going forward—she has seen [Michael] Sadler (as well as Read and Grigson) with fairly encouraging results.'[8] Geoffrey Grigson, editor of *New Verse*, struck a deal, as a result of which the first issue of *Axis* carried an advert for *New Verse*, while the February 1935 issue of *New Verse* promoted *Axis*. Further help in kind came from the bookseller and gallery-owner Anton Zwemmer, who agreed to sell the magazine and at one point lent them a real Picasso, so that John could reproduce it in *Axis* by means of Paramat blocks. These were metal sheets covered with a thin layer of hard rubber which could be cut away, leaving raised areas for printing, thereby making simple colour reproduction affordable.

The magazine's address was initially 100 Holland Road, where Myfanwy lived. But as autumn turned into winter, she and John became an inseparable couple, despite the disapproval of Myfanwy's parents. And though unable to marry until his divorce came through, they needed somewhere to live.

In Myfanwy's recollection, everything at first seemed negative. John did not want to live in London, but the cost of fares and petrol, as well as Myfanwy's weekly lecture at Morley College, meant they could not live too far out. He vetoed Essex, Surrey, Sussex, and Hertfordshire, and both abhorred the thought of low ceilings and beamed rooms. Then Myfanwy remembered staying with a school-friend one half-term near Turville, so they stuck a pin in a map at that point and drew a ring which included Wycombe, Marlow, Henley, and Beaconsfield, and on 31 December 1934 they set out to look for a home.

In a small hamlet occupying a corner of Oxfordshire (later Buckinghamshire, though the Post Office continued to insist that letters should be addressed 'near Henley-on-Thames, Oxon'), at the bottom of a steep, narrow, unmade-up road leading down from the village of Fawley, they found on the edge of a beech wood an abandoned farmhouse. Four-square, unpretentious, and built out of flint and brick, Fawley Bottom Farmhouse sat within their pin's circle. It had no water or electricity, and the ground floor was littered with torn wallpaper, broken glass, and chicken manure. But there was a well with drinking water only a field away and outside the back door was a brick rainwater tank from which water could be pumped into the kitchen. The house and its outbuildings had once been a dairy farm and belonged to the Stonor Park estate. John and Myfanwy arranged to rent it and two months later moved in, acting with speed and decisiveness. Myfanwy recalled: 'The pin was for long a sore point with friends—it really hurt—who wanted to find homes like Fawley Bottom. "Where do you want to be?" we said. "Anywhere," they said. "Impossible you must have a pin," we would smugly reply.'[9]

14. Fawley Bottom Farmhouse.

On that raw winter day it must have seemed something of a miracle to find a house within relatively easy reach of London in such a sequestered place, enclosed and embraced by the narrow valley which winds its way along the foot of the Chilterns. Myfanwy wrote towards the end of her life,

> It has a numinous quality … perhaps because it has remained untouched by development, perhaps because the road leads past to Kimble Corner, Cymbeline's grave (or tumulus) into the Celtic hideouts of the Chilterns, but this is fanciful. Perhaps it is because it has, and always has had a genius loci, that mysterious magic presence that collects the dreams of the past which, like wasp stings accumulating in the blood, accumulate in the mind and imagination. Perhaps again because it is here that I lived for nearly sixty years with John and that, in spite of a prestigious London school, a serious addiction to art galleries and three years at Oxford, I first began to live and learn.[10]

* * * * * * *

When *Axis: A Quarterly Review of Contemporary 'Abstract' Painting and Sculpture* appeared in January 1935, a small audience for it was ready and waiting. Two years previously the Mayor Gallery had opened in London's Cork Street

with its interior designed by Bryan O'Rourke. It attracted a great deal of comment, for, unlike other private galleries where damask wall coverings were the order of the day, it had white walls, unadorned by any cornice, and steel-framed furniture. In keeping with its modern setting, its owner Freddy Mayor, who ran it in partnership with James Duthie and Douglas Cooper, set out to promote the latest in contemporary art. It was here that Edward Wadsworth had exhibited his abstract paintings towards the end of 1933, and here that Unit One, an avant-garde association of artists, had its unofficial headquarters.

In his promotion of Unit One, Paul Nash had helped prepare the way for *Axis*. He had announced in a letter to *The Times* (12 June 1933) the formation of a group committed to 'the expression of a truly contemporary spirit' and determined to make good the lack of structural purpose in English art. He had first conceived the idea of Unit One while talking with the architect Wells Coates, who was then forming an architectural research group at the invitation of the secretariat of the International Congress of Modern Architecture. Like others at this time, notably Le Corbusier, Nash saw in the Modern Movement a recovery of the architectural values of classicism. But, for him, 'going modern' did not necessarily deny the possibility of 'being British'.[11] He also disliked coercion in the promotion of ideas, displaying a typically English distrust of didacticism. Of Unit One he wrote: 'We would … avoid the strict kind of purism represented by the writings of pedagogues of the negative school. We should use—purposefully—all the complexity of human emotions.'[12] Because both this short-lived group and Abstraction-Création had been fractured by internal disagreements, Myfanwy, when she began editing *Axis*, sought consistency but resisted any too dogmatic party line. She later recalled: 'No sooner had I got an absolute policy for *Axis* than I wanted to open the door and let something else in.'[13]

Behind *Axis* lay one clear intent: 'We thought there was a voice behind abstract work,' Myfanwy recollected, 'and it was a good thing to have it heard—that's all.'[14] Widespread prejudice against non-figurative art had caused Oliver Brown at the Leicester Galleries to terminate his association with the 7 & 5 Society after seeing its annual show in March 1934, with its strong abstract contingent. Aware, too, that a decision had been taken to make the 1935 exhibition entirely abstract, Brown wrote to John explaining that he thought the show had insufficient chance of success to justify his usual allocation of two large rooms to the 7 & 5. As a result, the 1935 exhibition took place in the gallery which Anton Zwemmer had opened in 1929, at 26 Litchfield Street, in a side street almost adjacent to his bookshop. He had appointed the son of one of his artist-customers, the nineteen-year-old Robert Wellington, as manager.[15]

Earlier, in the spring of 1934, this young man had shown 'Objective Abstractions', by Graham Bell, Thomas Carr, Rodrigo Moynihan, Victor Pasmore, Ceri Richards, and Geoffrey Tibble. These were near-monochrome abstract paintings, the product of experimentation with gestural brushwork and a light palette. Even those which had begun with a figurative subject had ended as an accumulation of abstract marks, for the intention was to promote the primacy of paint in opposition to the tired naturalism of academic art and the formulaic imitation of French art. Myfanwy had seen this show at Zwemmer's and thought it amounted to 'a kind of homage to the physical richness of paint'.[16] But 'Objective Abstractions' somehow lacked a decisively modern note and proved to be a short-lived phenomenon.

In Paris the situation was different, for there the search for innovation was aligned with a demand for artistic and intellectual freedom. On her visit to the French capital Myfanwy had come to recognize that abstract art was not just a decorative venture, but an historical necessity. She was also aware that Nicholson and Hepworth, both of whom were members of the Abstraction-Création group, had preceded her to Paris and were more advanced in their understanding of the goal of purity within abstraction. She was to promote their work in *Axis*, even though there was a part of herself that acknowledged the limitations of abstract art.

A careful reader of *Axis* would have detected this ambivalence in its first issue. The cover was strikingly modern. Designed by John, it marks the beginning of his passion for typography, with its bold, uncluttered layout, sans-serif lettering, and crisp delivery, close in style to the work of Jan Tschichold. All the names of the contributors are listed down one side of a vertical division. But the impact of the cover was not matched by Myfanwy's first editorial, 'Dead or Alive', which betrays her struggle to extract a cogent argument from the conflicting opinions surrounding abstract art. She had deliberately clothed the term 'abstract' in the magazine's subtitle with inverted commas, for she was all too aware that it was applied haphazardly to work that was non-naturalistic or Surrealist or merely decorative, and as a label was inadequate and sometimes misleading. 'It suggests certain limits rather than defines them and is not in itself a criterion,' she observed.[17] Nevertheless *Axis* no. 1 achieved its purpose. Its illustrations alone, showing the work of Arp, Calder, Domela, Giacometti, Gonzalez, Hélion, Hepworth, Arthur Jackson, Paul Nash, Nicholson, Miro, Moore, Picasso, Piper, Ceri Richards, and Wadsworth, heralded a new stage in the recognition of modern art in England.

Among the defenders of abstract art was H. S. Ede. 'It is a kind of discipline which opposes itself to the degenerations of the Royal Academy,' he wrote in

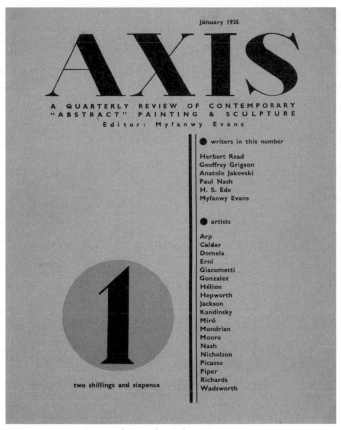

15. *Axis*, *1* January 1935. Cover design by John Piper.

this first issue, 'and out of it will spring a clearer conception of the nature of art.'[18] But elsewhere Paul Nash and Geoffrey Grigson expressed reservations. Nash had initially felt ineligible for inclusion in a magazine devoted to non-figurative art, but Myfanwy had assured him that it was perfectly acceptable for him to explore his reluctance to submit to a non-representational idiom. Though she removed a great many commas in his article (which he reintroduced at proof correction stage), she did not attempt to modify his views. In a memorable passage, he explains:

> I discern among natural phenomena a thousand forms which might, with advantage, be dissolved in the crucible of abstract transfiguration; but the hard cold stone, the rasping grass, the intricate architecture of trees and waves, or the brittle sculpture of a dead leaf—I cannot translate altogether beyond their own image, without suffering in spirit.[19]

Thus her magazine contained from the start seeds of rebellion and dissent. Geoffrey Grigson was allowed to grumble that the English paintings and sculptures reproduced in *Axis* no. 1 represented 'a small history of English ideas, English hesitancy, English error and English performance'.[20] He went on to detail his reaction to every artist in turn, with corrosive honesty. On Ben Nicholson's white reliefs, he wrote: 'An image of infinity, ordered by saying "no" rather than "yes". … Admirable in technical qualities, in taste, in severe self-expurgation, but too much "art itself", floating and disinfected.'[21] John, despite his friendship with Grigson, fared not much better. 'Domela somewhat vivified,' Grigson observed. 'An attempt to advance in biomorphic abstraction, though irresolute here and there in form.'[22] The best that can be said for such dispiriting appraisals is that they demonstrated the magazine's willingness to acknowledge differing points of view. *Axis*, despite its overriding purpose, would always remain broad church.

John's constructed reliefs first went on show in January 1935, at 59 Finchley Road, the headquarters of the Experimental Theatre. This 'scratch' collection of items, as a young writer on art and literature, Hugh Gordon Porteus, in *Axis* no. 1 described the show, nevertheless mustered work by Kandinsky, Klee, Nicholson, Miro, Paul Nash, and Wadsworth, and justified this same writer's claim that it was the most impressive exhibition in London. The reliefs were John's first totally abstract pictures, and they were constructed out of straight and bent rods, discs, and planes at different levels, some covered with smooth enamel, neighboured by coarse sandpaper areas (Plate 8). Porteus found these reliefs, one of which was reproduced in *Axis* no. 1, 'precise and complex'. He noted 'hunks of cable, rods, drums, ribbed lavatory panes, strips of perforated bluebottle-metal, etc. and painted in sober earth colours'. These industrial materials transgressed conventional aesthetic expectations and reminded him of 'UndergrounD [*sic*] wiring diagrams, or nightmare relief maps such as a neat and gifted electrician might improvise in sleep.'[23]

Whether driving a car or tying a parcel, John brought to everything he did an innate sense of craftsmanship.[24] His friend John Hilton, admiring this use of everyday materials in his constructions, got him to talk about them in one of his radio programmes for the unemployed.[25] But this winter John moved on, making his first abstract paintings. Motivated, like other abstract artists, by modernist ideals of rigour and purity, he began working with a preconceived set of shapes which he followed through from one painting to the next. His studio at this time was a front parlour room in Fawley Bottom Farmhouse, where a small abstract by Hélion hung on the fireplace wall, like a talisman of modernity.[26] Here John distilled abstracts from the shapes and colours he had admired in nautical

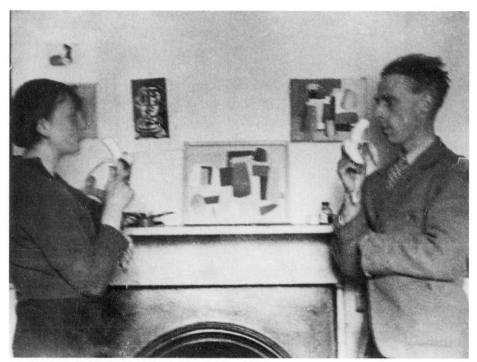

16. Myfanwy and John, either side of a Jean Hélion.

objects, in buoys, staysails, masts, and hulls of boats.[27] But the organization of these abstracts, with their intense awareness of interval, rhythm, harmony, and proportion, is also indebted to his love of music. When Myfanwy first knew John he and an organist friend had a passion for Handel's Second Concerto for Organ and Strings, which they would play over and over again, by turns, on the piano.[28] John, himself, once likened a Henry Moore drawing to one of Bach's 'engine-rhythms', by which he meant the following: 'Balance, separation, silence, precision, sternness, nakedness, delicacy, rigour: all the words one might find helpful in attempting to describe the nature of a Bach fugue.' He admitted it would be absurd to push the analogy too far, yet he also found in Bach and in the Moore drawing 'the same absorption with human experience, and the same detachment from the particular manifestation of it.'[29]

Paradoxically, abstract art, with its severe restrictions, permitted John the sensuous excitement of placing one hue next to another, in such a way that a colour chord was created sonorous enough to bind the composition into a taut whole. 'It taught me something of the value of clear colours,' he later recalled, 'one against another, when they have no goods to deliver except themselves.'[30] As his abstracts progressed, he showed a preference for flat, sharp-edged areas

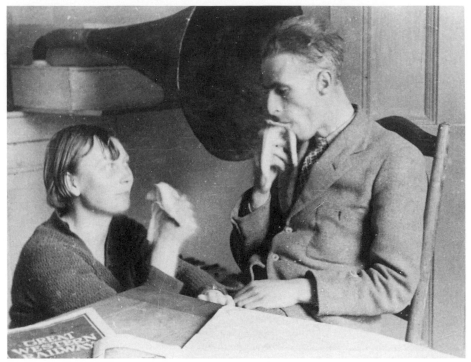

17. Myfanwy and John and the wind-up gramophone.

of colour, arranged, for the most part, in vertical formations like strips of paper (Plate 10). He opted for a limited palette—red, black, and white forming the sharp notes within a more muted context of quiet dark greys, grey-blues, and brown-mauves, colours, Philip Hendy noted, which had 'a deliciously cool equilibrium between them, which makes them exist calmly in their own right'.[31] Much had already been learnt from stained glass. And at one point in the 1930s John deliberately arranged a corner of his studio with abstracts interspersed with his copies of stained glass and photographed the ensemble. There could be no clearer demonstration of his belief that a modernist style could be sourced by ancient native traditions.

It was not just stained glass that spoke directly to present practice. In John's mind, so too did Anglo-Saxon and Romanesque carvings. While he and Myfanwy remained unencumbered by children, and Fawley Bottom Farmhouse was still very derelict, they were free to take off, in search of Kilpeck (Herefordshire) and Malmesbury (Wiltshire), also searching out isolated fonts in Yorkshire, Cornwall, Cumbria, Dorset, the Midlands, and Kent. John had bought a very old Lancia for £15, and putting a tent in the back, also a Tilley

lamp and some paraffin, they would set off with the intention of making a photographic record of what they found. They took with them a sponge with which to wet the sculpture, thereby bringing out the crevices and incisions in the stone. Myfanwy held up the lamp, moving it about so as to illuminate dark corners and to prevent too hard a shadow forming round the back of fonts, while John took photographs. His equipment was a box camera with a rising front, which, at the age of eighteen, he had bought in Brighton, a number 2 Brownie with a Zeiss lens. The name 'Ideal' was indented into its black leather. He found it worked easily for horizontal and vertical shots and after ten years he had it adapted to take film packs.

His interest in early English carvings was serious enough for him to begin discussion with Oxford University Press about the possibility of a book on this subject. Many of the photographs he took are superb and he rightly assumed that the Victoria & Albert Museum would be interested in acquiring some, for in 1936 they paid £3.18.0 for 26 photographs of English Romanesque sculpture.[32] An internal memo recording this purchase states: 'Incidentally, Mr Piper is writing a book on the subject and is the first person who has made a thorough examination of our collection. He says that it is the best in the country, not excluding the Courtauld.'

This suggests that John was unaware that at the British Museum Thomas D. Kendrick was compiling a photographic survey of Saxon and Celtic crosses in England. An introduction was soon effected and the two men became great friends. Kendrick was shortly to become Keeper of the Department of British and Medieval Antiquities, and later Director and principal librarian of the British Museum. He made many visits to Fawley Bottom and entertained the Pipers with his passion for churches and fondness for outrageous limericks about vicars. He sent John a spoof correspondence between Sir Hercules Read, who had delayed Kendrick's election to the fellowship of the Society of Antiquaries, and the late Victorian painter of sentimental scenes, Sir Lawrence Alma-Tadema. Before meeting John, Kendrick had made a public appeal to amateur photographers for photographs of ancient crosses in far flung parts of the country. John and Myfanwy were now recruited to this cause.

Meanwhile, negotiations with OUP broke down, the publisher wanting a 'corpus' study whereas John favoured a selective and more aesthetic approach. An alternative outlet was found in the *Architectural Review*, which published his article 'England's Early Sculptors', generously illustrated, in the October 1936 issue. His and Myfanwy's groundwork caught the attention of the eminent archaeologist A. W. Clapham (later Sir Alfred),[33] who asked Kendrick, 'Who are these two young people who I hear are going round England photographing

those awful *golliwogs*?'[34] Clapham, like other experts at that time, dismissed these early carvings as crude, ugly, and incompetent. 'Nobody ever looked at them,' John recollected. 'It was incredible. They were hardly ever mentioned in any guide book.'[35] If today the genius of Kilpeck and the main south door of Malmesbury are widely acclaimed, this change in perception is in part due to these early pioneers. And when Kendrick's survey was exhibited in public for the first time, in April 1937, in the British Museum's Iron Age Gallery, a screenful of John's photographs was incorporated into the display.

Looking back on the 1930s, John agued that behind abstract art lay 'a revolt against a surfeit of half truths', also 'a restatement of older truths'.[36] Some of these older truths he found in early English carvings, as did Henry Moore, who took intense interest in John's photographs. In his *Architectural Review* article John writes:

> The purely non-figurative artists of some early Northumbrian and Cornish crosses were the forbears of the pure abstractionists of to-day. There were also early reactions against recognized forms, and obvious expressions of the subconscious, that find a contemporary parallel in surrealism. Many a Picasso-like profile is to be found on twelfth-century fonts and capitals.

He also likens the 'bigness and strangeness' of the font at Toller Fratrum, Dorset, to that found in much of Picasso's work. In contrast with the negative views of contemporary archaeologists, he claimed that the Toller Fratrum font has 'immense personal conviction', a conviction that can be found in most sculpture in England of the eighth to twelfth centuries. Pointing to one example after another with passionate enthusiasm and conviction, he calls for a reassessment of the art of this period. 'Early English Sculpture' remains one of his most persuasive pieces of writing. It is also a landmark in the growing appreciation of early English art.

Throughout 1935 and into 1936 *Axis* appeared at quarterly intervals, maintaining an English emphasis but an international outlook, with Picasso its presiding genius. A black-and-white reproduction of his stark *Intérieure* (1928) had appeared as the frontispiece of the first issue. From then on the challenge offered by Picasso continued to haunt *Axis*. If he is not, at first sight, an obvious mentor for a magazine devoted to abstract art, his dazzling originality and rapid changes of style proved both stimulating and provocative. The second issue, published in April 1935, opened with John's first Paramat-block colour reproduction of Picasso's 1926 *Head* (courtesy of Anton Zwemmer). It offset Myfanwy's edito-

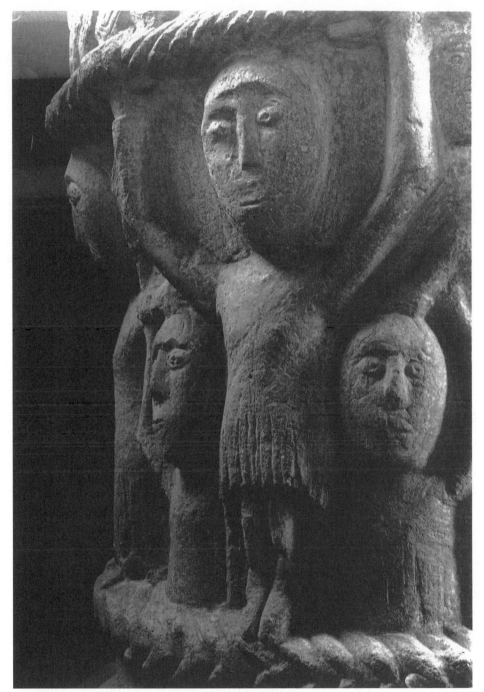

18. The font at Toller Fratrum (photograph: John Piper).

rial, 'Beginning with Picasso'. Unlike her first editorial, it is confident, direct, and almost gnomic in its brevity. It begins: 'Picasso looks at a wineglass for the sun, a guitar for the moon, a table for the whole universe. He never gets away from the object, but through it. The object is not a symbol for anything, it is everything … the object radiates out to the world and becomes the world.'[37]

In addition to Picasso, *Axis* no. 2 focused on Kandinsky and Klee, and devoted two articles to Ben Nicholson's recent white reliefs, one by Herbert Read, the other by the typographer Jan Tschichold. But, again, in among serious exposition of the virtues of abstract art was a conflicting note of hesitation and doubt. Hélion, though still a practitioner of abstract art, had begun to question its continuing viability and in a lengthy essay, 'From Reduction to Growth', he suggested that abstract art 'offers certitude, order, clarity, but also extreme limitation.' Not even Mondrian, he insists, can escape this drawback. 'The field of possibilities', he insists, 'must be kept wide open.'[38]

The third issue of *Axis* was devoted to sculpture and the only one to be thematic in content. The fourth issue, published in November 1935 immediately after the 7 & 5 annual show in which John had played a significant role, contained two articles on his work: one, 'Piper and Abstract Possibilities', by Hugh Gordon Porteous and the other by Herta Wescher. Earlier that year, in May, this German critic had visited Fawley Bottom Farmhouse (a 'learned and sensitive' woman, in Myfanwy's opinion),[39] and took away ten photographs. But it was Porteous who best understood John's abstracts, recognizing the tension he deliberately created by the introduction of an arbitrary, non-geometrical element. For him, the result had 'a beauty, a purity, and an honesty' which compelled admiration.

Axis brought John critical acclaim, but did not benefit him financially, for it was extremely difficult at this time to sell abstract art. Nevertheless, his abstracts had acquired a definiteness and distinction which could not be denied. Six of them had hung in the 7 & 5's October 1935 exhibition—the first entirely abstract show in England. The centrepiece had been a large abstract, *Painting 1935*, which, with three watercolours, John afterwards hired out, for the sum of £3, to C. H. Waddington, a biologist (shortly to marry Myfanwy's friend Justin Blanco-White); the large oil hung in Waddington's rooms at Christ's College, Cambridge. Composed of contrasting rectangular and rotund shapes, this abstract incorporates, like other Pipers of this period, a broken line which stitches its way down the left-hand side of the canvas, from top to bottom. It not only aerates the brown and purple background but also serves to alleviate the heaviness of the shapes elsewhere.

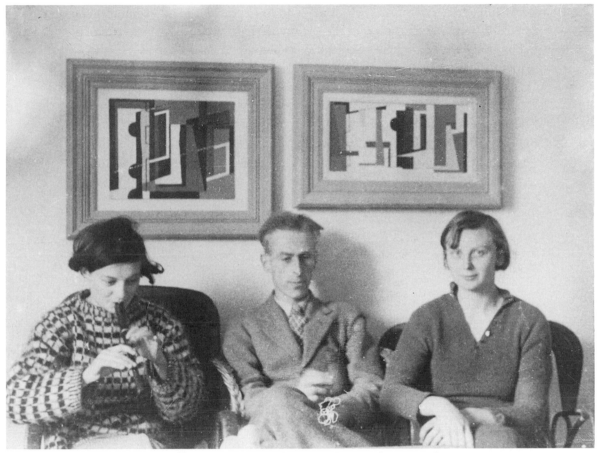

19. Justin Blanco-White, John, and Myfanwy, with two John Piper abstracts, c.1935, on the wall behind.

John's abstracts fall into families or clusters, with certain colours, lines, and forms recurring. An obvious debt to Cubism can be observed in the use of overlap and the suggestion in places of transparency. The use of Paramat blocks for printing purposes may have been an influence here, for the layer of canvas stuck down on board is in places cut away, like rubber from the block, thereby creating contrasts of texture and low-level relief. Earlier, in March 1935, during a visit to Paris, which John and Myfanwy had made in order to renew contacts with artists and writers, they had visited the Galerie Pierre in the Rue de Seine, and there seen an exhibition devoted to Picasso's 1912–14 *papier-collés.* It left John deeply impressed by the intense poetry Picasso generated in this medium, adding a few ink marks as and where they were needed. They also had a directness which he envied. And the following year he, too, turned again to collage.

While abstract art and *Axis* dominated his creative life, other interests remained dormant. However, in the spring of 1935 he wrote a short article for *Axis* no. 2 on Sir Michael Sadler's collection. Though unsigned, the article draws on his knowledge of Sadler's collection. At one point he praises Cotman's skill at drawing old Norfolk churches, and the way in which he infuses them 'with so much feeling that they develop almost human characters and differences under his pencil'. It is a surprising passage to find in a magazine devoted to abstract art. Yet four years later, in 1939, John would write to Sadler, asking if he could revisit his collection, specifically to see again his Cotmans. But by then his passionate interest in landscape, architecture, and topography had become the determining ingredient in his career.

7

Abstract and Concrete

While busy promoting abstract art, John and Myfanwy were simultaneously resurrecting a derelict farmhouse. Soon after they arrived at Fawley Bottom in 1935 a great frost set in, which they survived, confining themselves to only four rooms. For long afterwards living conditions remained spartan: a large backroom was whitewashed in May 1935 so that it could become a temporary gallery for John's paintings. They had so little furniture that when the artist Alexander (Sandy) Calder first visited, some two years after they had moved in, he scavenged around for materials and made an impromptu chair. Open fires heated a house which was lit by Aladdin lamps and candles. This practice continued until electricity arrived in the 1950s. In Myfanwy's mind the house and *Axis* were somehow linked. 'This house', she wrote in her journal, 'is rather like "Axis", we shall stay in it till its absolutely super, with the garden flourishing, all the rooms whitened and lovely and all the fleas flies bugs and beetles killed, and then we shall go off and leave it. It's a nice idea.'[1]

Gradually the garden was dug and planted with vegetables and flowers. Myfanwy's brief and spasmodic diary entries record their first pears, the first cabbage, the last of the spinach, the culling of the blackcurrants for jelly, and how their home-made cowslip wine exploded. Visitors helped cut down ivy and scythe nettles, and at intervals John levelled a new patch of lawn. In the evenings he and Myfanwy, still child-free, often went for a drink or a meal in a nearby pub, played darts with the locals, or engaged in country barter. 'Went to the Golden Ball after supper', reads one slightly inebriated entry in Myfanwy's diary, 'and took Harris a dozen bulbs. He gave us a rabbit. We shan't plant it.'[2] When one day they discovered that the house they were living in was up for sale, they acted fast. Again, it was John's mother who came to the rescue, Mrs

Piper paying £2,809 10s for the farmhouse and the farm buildings that formed a courtyard to one side of the house.

Initially there was no kitchen in the farmhouse, merely a kitchen range in one parlour with a little hot water tank on one side and an oven on the other. This was supplemented by a smoky oil stove that had to be handled with care or everything tasted of paraffin. Most of their utensils were cast-offs, though Myfanwy bought an old-fashioned mincer when she discovered that, far from being an expensive gadget, it cost only twelve shillings and sixpence. But in time things improved: mains water was brought to the house and a new stove arrived. A kitchen was created which became Myfanwy's domain. She bought a cookery book by Boulestin, which remained the basis of her culinary skills. She also made her way to Madam Cadec's, a small French kitchen shop in Soho's Greek Street. (The phrase—'I got it at Cadec's'—was then a sign of a proper interest in food and cooking.) Here she bought a small charcoal stove, just big enough to grill two cutlets, and some small deep copper saucepans. Later, in 1950, she acquired an Aga cooker and from then on swore she would never be without one.

Many days passed unrecorded, Myfanwy simply logging in her diary 'peaceful day'. At weekends the arrival of visitors broke their isolation. One regular was John's childhood friend, the printer Miles Marshall; another was Ruthven Todd, the somewhat unhealthy-looking, penniless, and unemployable Scottish poet and scholar who, when not working with John in the garden, helped Myfanwy make marrow jam. Jim Richards, who had moved to the *Architectural Review* as assistant editor after John Betjeman left to edit the *Shell Guides*, stayed in March 1936, bringing with him the left-wing artist Peggy Angus whom he was shortly to marry. Myfanwy's diary records that 'a fierce and rather rude argument about Communism' blew up.[3] The habit of work had taken root at Fawley Bottom, but talk and good food were also staple ingredients, as were the rows that erupted between John and Myfanwy. But beneath the brittle words lay a bedrock of surety.

Eileen Holding appears to have vanished from their lives in the summer of 1936, but she reappeared in February 1937, John making a trip to London specially to see her. Interestingly, this meeting is noted in Myfanwy's diary, where the entries are few and far between, and it appears to have had a finality. Nine days later John and Myfanwy cleared out Chalkpit Cottage. 'Home via Betchworth', Myfanwy wrote, 'where we made a beautiful and final bonfire in the chalkpit of canvases, books, old clothes, shoes, an easel and a beehive.'[4]

Myfanwy still taught at Morley College one evening a week, and on these London visits she sometimes secured useful contacts for *Axis*. In this way she

managed to edit a cutting-edge journal while living in rural surroundings. At regular intervals, she and John drove to Aylesbury to hand over the next issue to the printer. Donations rather than sales made the venture feasible. Not a single writer or artist was ever paid anything in connection with *Axis*, but, even so, the costs mounted. 'Bills. Bills. Bills. *Axis* to go on despite of,' reads an entry in Myfanwy's diary for January 1936. It may have been partly for economic reasons that this year she turned her hand to the writing of children's stories, publishing, with Collins, *No Rubbish Here* in 1936 and *Diggory Goes to the Never-Never* in 1937. Both were illustrated by Margaret Tempest, in a succinct but slightly sweet style which jars with Myfanwy's texts, for woven into her tales is the kind of blunt realism that reflects a child's point of view. Thus while writing children's stories, attending to local gossip about the killing of a badger, and noting on occasion that she and John 'talked our energy away' while eating bacon and eggs at the White Hart, she continued to edit the most radical art magazine in Britain, the first seven issues of *Axis* appearing without fail, at quarterly intervals, until the autumn of 1936. It strengthened the debate about modern art in England, at a time when London, or more precisely Hampstead, was becoming a focus for international modernism.

Influential in this respect was the *Architectural Review* which, under the editorship of Hubert de Cronin Hastings, had become not only one of the most handsomely illustrated journals in the visual arts field but also a leading forum for debate on architecture and related subjects. It promoted the Modern Movement while also making a distinction between the intrinsically modern and the fashionably *moderne*, or the 'jazz-modern' as Hastings called it. Still more emphasis was placed on the Modern Movement after Betjeman was replaced by Jim Richards, who, after 1935, more or less ran the magazine in the late 1930s while Hastings began spending much of his time on his farm in Sussex.

The Modern Movement in England benefited greatly from the displacement caused by the rise of the Nazis. A wave of émigré artists, architects, and designers came to London, among them three luminaries from the Bauhaus[5]— Gropius, Marcel Breuer, and Moholy-Nagy. Breuer masterminded the decoration of the restaurant for Isokon Flats in Lawn Road, Hampstead, designed by Wells Coates. It was conceived as a paradigm of modernist, communal housing and became a meeting place for artists, designers, and intellectuals. Other landmarks in this development were Berthold Lubetkin's Penguin Pool at London Zoo and his block of flats, Highpoint I in Highgate, and Mendelsohn and Chermayeff's De La Warr Pavilion at Bexhill in Sussex. At the same time the link between the Modern Movement and maritime or nautical style

was reasserted when the Orient line launched the 'Orion', its interior designed by the architect Brian O'Rourke. Instead of a 'floating palace', furbished like a baronial country house, the ship was praised in 1935 for having 'the merits of honesty, simplicity and (watchword of the modern world) fitness-for pur- pose'.[6] Meanwhile, Alfred Barr, the influential curator at New York's Museum of Modern Art, commented in 1936 on the 'surprising resurgence of abstract art' in England.[7]

One interested observer in London was a young man called Sydney John Woods, who got to know John, Eileen, and Myfanwy.[8] He first began living in Hampstead in 1933, as a teenager, lodged first with a White Russian family, then with Professor C. M. Joad, whose philosophy classes at Morley College he attended in the evenings. In the daytime he wrote and designed publicity mate- rial for Fox Film Company (later 20th Century Fox), then moved to the British Movietone News Theatre (owned by Fox), and gained the chance to interview people engaged with the arts for a four-page weekly publicity sheet which he designed and wrote. Woods then astonished Joad by chucking in his job and opting instead for the precarious existence of a full-time abstract painter and arts journalist. In January 1935, now aged nineteen, he reviewed (and may have organized) the scratch exhibition of modern art held in the entrance to the Experimental Theatre, where John's constructions were first shown.

By then Woods was not only familiar with artists and designers in the Hamp- stead area, but, on a visit to Paris, had also gained access to Arp, Brancusi, Pevsner, Mondrian, Kandinsky, Ozenfant, and Picasso. Back in London, he began writing for *Decoration*, a high-class glossy periodical with a strong commitment to modern interior design. In January 1936 it carried his article 'Why Abstract?', which showed work by Moore, Holding, Jackson, Piper, and Nicholson in a domestic setting, to point up the shared ideals in architecture, painting, and sculpture.[9] Woods argued that all three arts, having assimilated 'the Machine', now had a common foundation in their use of space, light, and precision. 'From this starting point', he enthused, 'our culture could be raised to great heights.'

The following month the magazine published a letter by Herman Schrijver denouncing Woods' article as 'clear nonsense'. John came to his defence in the March issue and objected to Schrijver's claim that 'art like religion is a subject which means something different to each person'. 'Art, like religion,' John argued, 'is at its best—indeed classical art only exists at all—under the strictest control. When the control slackens art—and religion—become (in strict rela- tion) vague and rudderless.' This is a significant letter for it aligns Piper with the modernists' belief that art should transcend personality and nationality in

20. Irina Moore, S. J. Woods, and Henry Moore.

its search for a universal language. Both art and religion, he argues, need a code.

> And the only painting and sculpture to-day which has any code, that is to say any humility or order, is of the type touched on by Mr. Woods. And it is so because it is practiced by the only artists who are humble enough to submit to an ideology dictated by, and characteristic of, the times: artists who thereby allow themselves a chance of finding themselves as individuals.[10]

Though soon to lose faith in just the kind of ideology he here espouses, Piper, in March 1936, fully supported Woods' missionary zeal. Wanting to broaden the constituency for modern art, Woods organized three exhibitions in non-art venues. The first, in November 1935, placed work by Nicholson, Hepworth, Moore, and Piper in the Everyman Cinema and Theatre at Hampstead, in tandem with showings of two abstract films by the Fishinger brothers

in their 'Lichtertanz' series, created by the play of light on abstract mobiles placed against a black background. Copies of *Axis* were on sale in the foyer, together with a brochure, by Woods, containing a defence and explanation of abstract art. The other two shows promoted abstract art as the ally of modern architecture and design.

Woods cleverly placed the first of these—'Modern Pictures for Modern Rooms'—in the Duncan Miller Showrooms, Lower Grosvenor Place, London, in April 1936. Here paintings and sculpture mingled with furniture by Marcel Breuer, a radiogram by Wells Coates, and rugs and textiles by Ashley Havinden, among other items. 'If you travel by car or tube or aeroplane, live in glass and concrete, move in a world where speed and space, light and precision are elements of importance', began Woods's introduction, 'you expect an art arising out of this.' The result was an impressive line up: Gabo, Brancusi, Giacometti, Hélion, Arthur Jackson, Miro, Moholy-Nagy, Hepworth, Mondrian, Moore, Nicholson, Paalen, Piper, Eileen Holding, and S. J. Woods. There were 21 works in all and the entire collection could have been bought for £653 1s but, owing to the lack of public interest in abstract art, not a single work sold. The idea was repeated on a less ambitious scale in November 1936 when abstract art was shown in room situations in Bowman's, a popular furniture shop in Camden Town, where good modern furniture could be acquired at economical prices. Woods kept no record of the artists he included in this show, but a photograph exists showing a large John Piper abstract hanging on one wall.

Forms on Dark Blue was just over 5 ft × 6 ft in size and caught the attention of the Russian-born architect Serge Chermayeff and it later hung at Bentley Wood, the house he created for himself in Sussex in 1937–8 (Plate 12). Whether this painting was bought or given, or the one that Piper exchanged with him in return for a table, is not known, but a friendship between John and Chermayeff began in 1936, possibly in the offices of the *Architectural Review*, both having a friend in Jim Richards. Chermayeff himself liked to paint in an abstract style imitative of Braque and he copied at least one of John's pictures, perhaps taking his lead from John's imitation of a Picasso.[11] In turn, John may have been influenced by Chermayeff's colour schemes: Alan Powers has observed that some of Piper's abstracts make use of a sombre background charged with small touches of red, as do some of Chermayeff's experiments with interior colour.[12] It certainly delighted John when Chermayeff designed an entire room around his *Forms on Dark Blue*, for a piano exhibition at Dorland Hall. 'It pleased me so much,' he told Winifred Nicholson, 'as it seemed the proper way to deal with that kind of painting, and so much <u>more</u> proper than hanging in galleries.'[13]

21. John Piper's *Forms on Dark Blue* hanging in Bowman's furniture shop, Camden Town, London, 1936.

In January 1937 John and Chermayeff worked together on a television broadcast on 'Art in Modern Architecture', in which Chermayeff remarked that the clean interiors of modern homes were an invitation to colour and not a denial of it. This was one of five fortnightly live discussions on some aspect of art, led by John, to which he brought a number of pictures with an abstract tendency. In these early days of television, programmes were treated rather like lectures, as Myfanwy recalled of the one she, too, did at this time:

> Mine was on what you could see in the country from a bicycle. There was a static camera and you were allowed to bring in a few objects with which to

illustrate your 'lecture'. I brought the landlord from the Golden Ball pub in Lower Assenden who was an ex-policeman and the inn sign from the Black Boy on the road at Hurley.[14]

A readiness to link art with design made John willing to engage with advertising. He applied his skills to the making of a pamphlet for Imperial Airways, at the request of Marcus Brumwell, patron and friend of Ben Nicholson and Barbara Hepworth. Underneath the words 'Modern Travel for Modern People', the cover sports an abstract by him (Plate 9). Inside the pamphlet he states:

> My intention in drawing and painting is not to imitate anything but to originate something. I have tried to make a bright design that will catch your eye and make you wonder what is inside this book. People usually want to 'understand the meaning' of pictures. Why? They do not ask to understand the meaning of the enjoyment of good food, country air, or the colour of beech leaves in autumn—they do not even ask to understand the irritation of wet weather at the seaside.[15]

This bright confidence, if it suited the world of advertising, did not in fact tally with his growing frustration over the limitations of abstract art. By 1937, the forms in some of his abstract paintings began to cluster together against an atmospheric ground which, in its suggestiveness of sky or sea, conveys the feeling that the outside world is trying to break in. Nevertheless, this same year he accepted a commission to paint an abstract mural for the architect Francis Skinner, in his flat in Lubetkin's Highpoint II, Highgate. The mural itself no longer exists,[16] but another major abstract which John painted this year, *Screen for the Sea, Black Background*, now hangs in the Scottish National Gallery of Modern Art. It was commissioned, or bought, by the advertising artist and designer Ashley Havinden,[17] which can be taken as further evidence of the creative synergies at this time between modern art, design, and architecture.

With hindsight, a high watermark had been reached in the spring of 1936, with the famous 'Abstract and Concrete' exhibition. This was the brainchild of Nicolete Gray (née Binyon), who, since leaving Oxford, had married a young curator at the British Museum. While starting a family, she had set up a contemporary art loan scheme which Ben Nicholson suggested should be advertised in *Axis*. On seeing the magazine, Nicolete, intrigued to find here abstract art that could not be seen in London, conceived the idea of bringing a representative selection to England. Myfanwy supplied her with artists' addresses and together they found venues for the exhibition and drew up a list of patrons. Ben Nicholson chipped in with advice, and two of his patrons, Helen

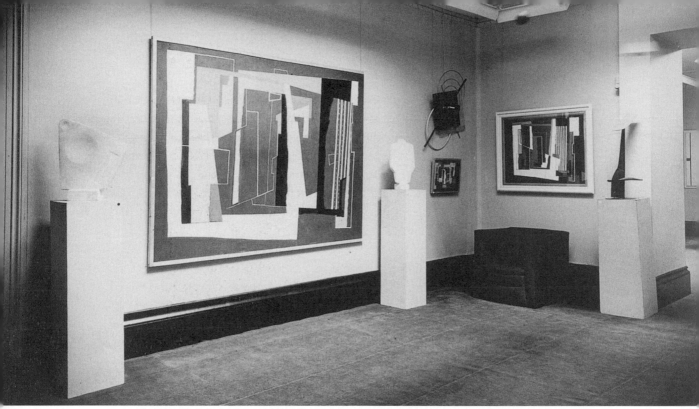

22. Abstract and Concrete exhibition, 1936, Lefevre Gallery, London, April 1936, showing three John Piper paintings.

Sutherland, who was also a friend of Nicolete Gray's, and Marcus Brumwell, agreed to help finance the venture.

As one of the venues was to be Oxford, Myfanwy and Nicolete agreed to write on abstract art for the November 1935 issue of the *New Oxford Outlook*. Their articles are very different. For Nicolete, abstract art is neo-platonic and a form of spiritual activity; it 'partakes of the harmony, completion and other attributes natural to the idea of perfect unity. In this sense each abstract work becomes a possible symbol for God or Tao or any conception of supreme power.'[18] For Myfanwy, abstract art was the product of the lived moment ('art to have any importance must be intimately related to life in its own time'); it was a response to an immensely complex, disorganized world in which all ideological values were suspect. It seemed natural to her that, in such a climate, artists should turn to 'the most severe and most stable elements, straight lines, curves, simple shapes and use them as a base', in a search, amid scattered and meaningless objects, for some new organization, thereby creating 'a new complexity which has an organic and spiritual force'.[19]

John's part in all this was the designing of a poster for 'Abstract and Concrete'. In order to get the necessary materials, he and Myfanwy went into Reading, and found stencils and printing sets in a pet shop, among the dog baskets,

bones, collars, and soap. John's initial design incorporated lettering above an enormous line-block of a black and white Mondrian. 'Ben would write more to us from Paris if he suspected we were using Mondrian's picture like an advertisement for a gas cooker,'[20] Myfanwy accurately surmised, for a vehement protest did indeed reach them through Barbara Hepworth and the poster had to be altered. Good relations had been restored by 15 February 1936, the day on which the show opened at 41 St Giles, Oxford, as two days later John and Myfanwy had tea with Ben and Barbara.

John did all he could to make the show a success. He got Duncan Macdonald of the Lefevre Gallery to come to Fawley Bottom to meet Nicolete. 'Macdonald came,' Myfanwy's diary records, '—snorted and scoffed and talked big and small was sincere charming deferential and obstreperous and rather humiliating. Shot off with the superior office boy in the Rolls without having come to any consensual conclusion.'[21] John pursued the matter, going the next day to London to see Macdonald, with the result that 'Abstract and Concrete', after touring Oxford and Liverpool (School of Architecture), was shown, in expanded form and better hung,[22] at the Lefevre in April 1936 before moving on to Gordon Fraser's Gallery in Portugal Place, Cambridge. Despite this lengthy tour, few works sold, but among them were two Pipers. These would appear to be the first abstracts that earned John money.[23]

English artists had seen their work hung alongside their Continental rivals previously. Nevertheless, this was a landmark exhibition—the first truly international display of abstract art in Britain, including Arp, Calder, Domela, Giacometti, Hélion, Kandinsky, Miró, and Mondrian. In her preface to the list of exhibits, Nicolete Gray claimed that 'for the first time since the eighteenth century England is making a real contribution to an international art'. But though the exhibition marked a further stage in the acceptance of modernism in Britain, abstract artists were still surrounded by philistinism on all sides. The *Daily Mail* dismissed the show as 'a jolly leg-pull'. Christie's, for the purposes of customs and insurance, were prepared to testify that the exhibits were almost worthless in terms of monetary value. The Mondrians on sale were priced at £50, but neither the Tate nor the Contemporary Art Society bought one. (That which Helen Sutherland acquired, and later bequeathed to Nicolete Gray, eventually entered the Tate collection, after Nicolete's death, for an undisclosed sum.)

John had good reason to be pleased with this show. Not only was his work at last beginning to sell, but among the five works he exhibited was his five-by-six foot *Forms on Dark Blue*, which chimed well with the overall mood of highbrow seriousness. He had directed much of his time, energy, and goodwill

towards the abstract cause over the previous months. But in May 1936, while 'Abstract and Concrete' was still running, he began to resent what seemed to him the hardening of an association into a party line.

To Ben Nicholson he explained:

> There is nobody I'd rather be associated with than you (and Barbara and Jackson) in any continent—but with you and Barbara and Jackson as individuals—as artists—and not as part of a movement. I persist in thinking this very important. I believe that movements are only <u>discovered</u> afterwards. That forcing them at the time of their progress is to kill the artists in them. ... The Abstract-Conc[rete] show I regard as a purely commercial necessity in its present form. As in no way <u>ideal</u>. As a delightful show, because by far the best there has been in England in this century ... But for it to be ideal it would have to be arranged <u>entirely</u> by you or me or Barbara or any one individual <u>with</u> an ideal about such work. ... In the meantime ... it merely lays each individual open to criticism on the general level of the show (see Porteus's justified remarks in Saturday's *New English* about 'almost academic' etc.)[24]

A tighter ideological focus worried John. Having witnessed the way in which the 7 & 5 had evolved, changing and refreshing its membership at regular intervals, he favoured organic growth. His letter to Nicholson is adamant that history can't be made, only recognized later, and that the single most important ingredient should remain the artists themselves:

> They must agree to show with one another kick one another out without sentiment when they want to and propose new exhibitors whose work they like, on the grounds of that alone (not because it fits in with a theory). That is bound to make a movement that will be recognised as of GREAT HISTORIC SIGNIFICANCE.

This letter made it evident that he was determined to stand apart if need be. Ben and Barbara, perhaps sensing this, made a visit to Fawley Bottom a few days later, on 13 May 1936. Myfanwy's diary records: 'Ben and Barbara. Hell.'

A parting of the ways had been reached. A month later Nicholson, Hepworth, and the Russian Constructivist Naum Gabo hit upon the idea of publishing an international survey of constructive art.[25] A series of editorial meetings took place over the summer of 1936, with Gabo, Nicholson, and the architect Leslie Martin acting as the book's three editors. *Circle*, with its illustrated essays on art, architecture, engineering, and design, was to promote a new cultural unity under the banner of the 'constructive idea', and would appear in January 1937.

Gabo, having played a significant role within the Parisian avant-garde, now settled in London, his presence strengthening the abstract cause. Meanwhile, in July 1936, Nicholson and Hepworth sent curt notes resigning from the 7 & 5,[26] perhaps having heard of John's rebellion against the 7 & 5's 'non-figurative' rule which he now felt was pointless.[27] In an undated letter to Winifred Nicholson he wrote of his belief that the 7 & 5 ought to be 'a group of good artists standing for nothing but the accumulated effect of their work seen together.'[28] All this made John in Ben Nicholson and Hepworth's eyes a betrayer of the modernist cause. Almost fifty years later John recollected, with some feeling, the 'belligerance and antagonism' that he had encountered at this time,[29] remarking to a curator that Herbert Read had been among those who regarded him as 'an apostate'.[30]

Behind his and Myfanwy's stance lay their awareness of the worsening political situation in Europe. Ironically, as the emphasis on pure abstraction hardened into an ideology, it began to betray an affinity with totalitarianism, which, Tzvetan Todorov argues, was the great innovation of the twentieth century precisely because it played so successfully to people's need for an absolute.[31] No fellow traveller, John showed in his letter to Nicholson that he was not prepared to sacrifice the present to an historical concept; nor was he willing to sacrifice art to a cause.

One reason why the abstract contingent had decided to close ranks was because of the Surrealists. On 11 June 1936, immediately after the 'Abstract and Concrete' exhibition closed, the International Surrealist Exhibition opened at the New Burlington Galleries in London. Its various publicity stunts drew attention to this art which, with its emphasis on the disordered and the irrational, challenged the abstract artists' search for clarity, harmony, and order. Myfanwy, keeping her finger on the pulse, had devoted the fifth issue of *Axis* entirely to artists associated with 'Abstract and Concrete', giving the editorial ('Abstract Art: A Note for the Unitiated') to Herbert Read. But, in recognition of the forthcoming Surrealist event, she had asked Roland Penrose to review David Gascoyne's *A Short Survey of Surrealism*. Readers, however, could infer ideological differences as a footnote appended to Penrose's review stated ominously: 'There will be a reply to this article by the editor in the next number.'

'Order, order!' rapped out *Axis* no. 6, in the summer of 1936, its cover asking 'Abstraction? Surrealism?' Myfanwy's editorial made it clear that a turning point had been reached and fresh decisions were needed.

Both she and John were aware of changes that recently had taken place both in the art world and on the wider political front. In November 1935,

after Mussolini's invasion of Abyssinia, John had contributed to the exhibition 'Against War and Fascism', organized by the Artists International Association in a house in Grosvenor Square. In March 1936 Hitler sent his troops into the demilitarized Rhineland. Then in July 1936, Spain's right-wing generals began a civil war against the democratically elected republican government, thereby bringing into sharper focus the Fascist threat to democracy. In such a climate Myfanwy found herself suddenly impatient with both the abstractionists and the Surrealists. Her irritation fed into her editorial where she expressed a disinclination to support either those who used art to promote a Utopian ideal of precision, light, and clarity or those who tried to jar the mind and set it dreaming. Instead her interest lay with art which bound her to the present; with those artists who felt it 'right to alter according to their inclination and nature, and not according to a group-programme'.

John was evidently one of these. His contribution to this issue was an article entitled 'Picasso belongs where?' Picasso, he pointed out, was a 'shocking manifesto-follower', for though his work betrayed affinities with both abstraction and Surrealism, he could be assigned to neither camp. Alan Powers observes that Picasso here offered a paradigm for '*Axis's* desire to escape from art politics into a greater imaginative reality'.[32] This issue of *Axis* offended Ben Nicholson, as a letter from John to Winifred Nicholson reveals:

> I don't agree about the 'personal attack' on Ben in *Axis*—nobody has expressed such an opinion except Ben and you to us. Myfanwy and I both have a great opinion of Ben, and think his contribution of vital importance—but its seems to me that Myfanwy's article (and John Woods') were perfectly justified personal statements of their attitudes—and very genuine attempts to clear the ground and find where they stood. I personally admire Ben so much that I feel entitled to criticize his attitude to myself occasionally as well as praising him continually.[33]

But there was no going back. In the same issue S. J. Woods bluntly insisted: 'It is time we forgot Art and Abstract, time the "movement" ceased and manifestos were burned. … Art has chased out life and now life must come back if art is to remain.'[34]

The solution for John was a return to the beach. In 1936 he revisited Seaford, Newhaven, Dungeness, and also went to Aberaeron, on the Cardiganshire coast, on his first working visit to Wales. He took with him a big sketchbook full of scraps of coloured paper, pen and ink, a pair of scissors, and a bottle of gum, as well as old blotting paper, home-made marbled paper, and discarded sheet

music which had been used to clean the presses in the old Curwen lithography studio at Plaistow where he had picked it up off the floor, for to his eyes the smudged and overprinted lines and blurred musical notation made the paper look very abstract and handsome. With these ingredients he began making collages. But instead of studio productions, as before, they were made on the spot (Plate 11). With cut or torn bits of paper he found he could establish an area of colour, a shape or pattern with an exciting economy of means, using blotting paper, for instance for clouds. *Papier-collé* made possible schematic evocation of place, while the edges of the paper had a quality both arbitrary and spontaneous. He was still painting abstracts in the studio, but he now wanted these, too, to have 'some of the natural energy and fecundity of nature'.[35]

Picasso's use of *papier-collé* had licensed the scratchiest, most offhand treatment. Piper's late 1930s collages splutter with delight as he registers, with crudely cut or torn paper and scribbles of ink, visual metaphors for the harbour and boats at Newhaven, the chirruping waves and distant lighthouse at Dungeness, and the trim Victorian boarding houses at Aberaeron. Over the next couple of years he also went inland, to various ancient sites, to the standing stones at Avebury, to Grongar Hill and the ruined church at Knowlton in Dorset, finding through his collages 'a life line to natural appearances—and so to early Palmer, to Turner, early and late ... and to our whole Romantic tradition in which it has always been possible for meaningful details to shine like beacons in the damp, misty evanescence of our beautiful island light and weather.'[36] By standing back from international modernism, which, in its search for the absolute and universal, sought to transcend place, time, and nationality, John had allowed earlier interests to flood back, among them his fascination with the *genius loci,* with the particularities of a scene, and with the concept of Englishness. The question he now faced was 'where do we go from here?' Looking into his heart, he recognized that he was both English and Romantic. This licensed his interest in Cotman, Turner, Blake, Palmer, and others, and brought him the realization that he was free 'to draw the things I seemed born to love'.[37]

This change of heart chimed with Geoffrey Grigson's thinking about English art. Though Grigson had been on the scene since *Axis* began, the two men only became close friends in the autumn of 1936, each writing alternate paragraphs for the article 'England's Climate', which appeared in the seventh issue of *Axis*. It is a strange, deliberately quizzical piece. But what does emerge clearly is the idea that the way forward for contemporary art must involve a return to the past. The illustrations—drawings by Fuseli and Samuel Palmer, sea-pieces by Constable and Christopher Wood, and John's own copy of the thirteenth-

century stained glass panel at Grateley—confirm that contemporary artists can learn much from their English forbears:

> Any Constable, any Blake, any Turner has something an abstract or a surrealist painting cannot have. Hence, partly, the artist's pique about them now, and his terror of the National Gallery. The point is fullness, completeness: the abstract qualities of all good painting together with the symbolism (at least) of life itself. To-day, both cannot go together. Abstraction and surrealism can choose, but they do not choose both. They can build, and be filled with an ambition for future life, but hardly can express a fullness of the present life. Constructivism is building for the future—and so far an escape into the future. The Royal Academy, a hesitation in the past.[38]

John wanted an art that expanded in meaning beyond the here and now. A Constable letter, he argued, or a Blake poem, or an early glass painting reaches beyond the life of the artist. 'A Samuel Palmer of a barn at Shoreham, or a hillside "means" Palmer's whole existence and surroundings, and it fixes the whole passion of his age. A Bewick woodcut, the same.'[39]

In January 1937 three of his abstracts went on show in a contemporary art exhibition at Thomas Agnew and Sons in Bond Street, a gallery more usually associated with the Old Masters. Only two paintings sold: one by Roy de Maistre, the other by Ivon Hitchens. The return of his three pictures would have confirmed John's awareness that there was scant audience for abstract art. By now he not only doubted its 'fullness, completeness' but also its relevance to the needs of the day. Nevertheless, on the piano at Fawley Bottom sat a white relief, only a few inches square, by Ben Nicholson. Almost certainly it had been given to him or Myfanwy in 1935, when *Axis* no. 2 ran an article by Herbert Read praising Nicholson's white reliefs as being 'integral with light and precision, with economy and cleanliness—with all the virtues of modern sensibility'. By the late 1930s John's interests had changed, but his commitment to the modern remained. This may explain why Nicholson's small relief remained at Fawley Bottom, like a talisman, for the rest of John's life.

8

'Look, stranger, at this island now'

After the appearance of its seventh issue in the autumn of 1936, *Axis* lay dormant for almost a year. No explanation for this hiatus was ever given. But for John and Myfanwy a break in the labour involved in each issue must have proved welcome. It made possible bursts of travel, to Derbyshire and Yorkshire in August 1936, and, in the course of the following year, to Avebury, Fonthill, and, for the first time, Stourhead. At the same time new friendships developed and fresh outlets unfurled.

One of these was Contemporary Lithographs Ltd, a scheme launched by John Piper and Robert Wellington in the autumn of 1936. Working at the Zwemmer Gallery, Wellington had noticed that one of his customers, Henry Morris, the director of education in Cambridgeshire, in order to brighten school walls and replace dull, old-fashioned matter, bought imported reproduction prints of modern art. A better solution, thought Wellington, would be to put contemporary art on school walls by getting artists to make lithographic prints, representational in style but with good formal qualities, which could be sold cheaply. This idea had evolved in conversation with John and benefited from the sale of his Betchworth cottage,[1] for soon afterwards a couple of second floor offices, found by Myfanwy, at 15 Fitzroy Square became its base. Here Wellington administered the scheme, assisted by Ormerod Greenwood, who took time off from his role as secretary of the Group Theatre to act as traveller and assistant. John became the equivalent to Works Manager, for the knowledge of lithography he had gained at the Royal College of Art enabled him to liaise with artists and printers. Wellington, on the other hand, claimed no practical knowledge whatsoever of the process.

Lithography was a popular medium for posters, and those made for Shell or London Transport had incorporated artists' designs with striking effect. (John

himself devised a lorry bill for Shell, at a time when the firm was linking its brand of petrol with various professions, all of whom were said to 'prefer' Shell. Captioned 'Clergymen prefer Shell', it had to be abandoned as the association of clergymen with commerce was thought 'disrespectful to the cloth'.[2]) Contemporary Lithographs differed from these schemes by inviting artists to go to the Curwen Press or the Baynard Press[3] and draw directly on the stones or plates, without the intervention of a camera or a craftsman. It thus remained faithful to the artist's conception yet enabled original work to reach a wide public. Autho-lithography, as it was then called, was popular in Paris but new in London. The first set of Contemporary Lithographs, offering a representative cross-section of modern British art, was printed in colour with the help of Harold Curwen. Another printer aficionado associated with the Curwen Press, Oliver Simon, advised on how to run a limited company.

The ten artists commissioned were Eric Ravilious, Edward Bawden, Clive Gardiner, Paul and John Nash, Norah McGuiness, Graham Sutherland, Barnett Freedman, Robert Medley, and H. S. Williamson. In January 1937 their prints hung in the gallery at the Curwen Press, 108 Great Russell Street, and the project was launched with a three-day party. It received three reviews,[4] the most substantial of which was 'Pictures in Schools', in the *Architectural Review* which helped make this first batch of lithographs a success. Encouraged by this, Piper and Wellington went ahead with a second series of fourteen prints,[5] again commissioning a range of representational artists, among them Edward Ardizzone, Duncan Grant, Vanessa Bell, John Aldridge, and Mary Potter. They also placed a two-page advertisement in *The Studio* offering 'households with small incomes a representative and wide choice of good modern work', thereby making, so this magazine claimed, a healthy link between art and the public.[6] In September 1938 both series went on show at the Leicester Galleries, a letter from Sir Michael Sadler acting as a foreword to the catalogue.[7]

While working at the Curwen Press with other artists, John learnt much about lithography from Barnett Freedman with whom he often overlapped. Through Contemporary Lithographs he also met Graham Sutherland, established a friendship with Eric Ravilious, and became devoted to the New Zealand artist Frances Hodgkins. 'She was a sweet character—I loved her,' he later told Pat Gilmour.[8] When he showed her Ravilious' lithograph of Newhaven harbour, which, with its blues, greys, and whites, was slightly prim and conventional, Hodgkins put her head on one side and remarked: 'So glad he didn't put in a seagull!'[9] The success of this venture meant that the small offices in Soho saw 'constant activity with people coming and going'.[10]

Contemporary Lithographs coincides in date with Walter Benjamin's 'The Work of Art in the Age of Mechanical Reproduction', the essay which voices his desire for an anti-Fascist aesthetic that would engage with new technologies to produce a communal art capable of satisfying and empowering the masses.[11] Piper and Wellington, though less overtly political in their intent, were similarly anti-elitist, and it is significant that all the artists involved with Contemporary Lithographs employed a representational style. The only abstract is by John, working with his now familiar abstract vocabulary. The other two prints which he made for this scheme make exuberant use of collage and, when joined together, offer a lively panorama of beaches, boats, lobster pots, cliffs, lighthouses, and seaweed (Plate 14). John evidently intended this breezy celebration of coastal pleasures to appeal to children, for he titled these prints *Nursery Frieze*, and in at least one London house they were pasted on to the wall at a height with which small people could engage.[12] Owing to the greater than usual width of these two beach scenes, the Curwen Press had to send John to another printer, Waterlow's, in the City, where he hid away in an upstairs cobwebby room, to avoid falling foul of the printers' union. *Nursery Frieze* belongs to the second series of Contemporary Lithographs and the two prints were almost certainly produced, not in 1936, as previously stated,[13] but in 1937, after John's visit to the *Exposition Internationale* in Paris, in July, where, as will be discussed, he saw Dufy's huge mural, *La Fée Électricité*.

His artistic personality was now split between the subject matter which had reappeared in his collages and in *Nursery Frieze*, and his abstracts which remained remorselessly non-figurative, except for a hint in one or two of sea or sky in the background. A tautly designed abstract by him appeared as a frontispiece in the July 1937 issue of Oliver Simon's trimestrial *Signature*, but at the same time he was finding visual interest in a wide array of sources. *Axis* no. 7 carried a photograph of graffiti, showing a butterfly scratched onto the cement wall of a Cornish mine, something that would have looked quite out of place in earlier issues. Paul Klee appears to have been the cause. 'I see a Paul Klee hanging in luxury,' Myfanwy later recollected in *Harper's Bazaar*: 'tender, questioning, absurd, personal, and yet with an overtone of that anonymous anxiety that his example taught us to notice in *graffiti*, the butterflies and symbols of abandoned walls.'[14] At the same time, John no longer looked to Paris for inspiration: instead he journeyed around England in search of the picturesque and the prehistoric.

In February 1937 he and Myfanwy had toured Wiltshire and Dorset, making their first port of call the Early Bronze Age monument of Avebury which Paul Nash had visited and photographed in 1933, its stones becoming also

the subject of his Contemporary Lithograph. Since 1934 the marmalade millionaire, Alexander Keiller, who had bought up the entire site in 1924, had been in charge of restoration. Work had recently been completed on the West Kennett Avenue leading up to the great stone circle. 'Not bad but a bit cleaned up and sanitary—railings and notices rather prominent,' Myfanwy noted in her diary,[15] which also mentions that at Devizes they stayed at the Crown, 'had an early supper and went to a lousy flick'. The following morning they spent time in the Museum. John drew pots while the curator Mrs Cunnington entertained them, and Myfanwy obtained, at half-price, a bargain copy of William Long's *Stonehenge*, with its many excellent engravings. (Many years later John's drawings of pots fed into a stained glass window he designed for this museum, while Myfanwy's interest in Stonehenge led her to write the entry on it in the *Shell Guide to Wiltshire*.) Their journey continued, over the downs, through Imber and Warminster, past Long Knoll and White Sheet Camp, to Stourton where they had lunch. Afterwards John made his first visit to Stourhead, and though the park was closed to the public in winter, he glimpsed the architectural monuments that ornament this landscaped garden, the whole devised to offer Claudian scenes and picturesque views. At Fonthill, they stopped again so that John could draw the famous arch, and that night they stayed with Kitty Church, now married to the author Anthony West and living outside Tisbury.

Behind this trip lay John's growing fascination with archaeology. Like other artists at this time, he had begun to find in prehistoric remnants a vocabulary of form that was abstract yet not divorced from human rituals and needs, and which, despite its great age, seemed remarkably modern.[16] This period interest seemed to him proof of a growing desire to reconnect with the visual world, proof, also, of the desire to reintroduce the subject into art. He voiced this idea later that year in an essay titled 'Lost, A Valuable Object':

> artists everywhere have done their best to find something to replace the object that cubism destroyed. They have visited museums, and skidded back through the centuries, across whole continents and civilisations in their search. ... In this country, for instance, we find Paul Nash identifying all nature with a Bronze Age standing stone, and Ben Nicholson even assisting at world-creation. Henry Moore has landed us back in the stomach of pre-history while Paul Nash, again, leaves us with the bare sea-washed bones of it.[17]

Of his own activities in this area, he later told Paul Joyce: 'I did relate to archaeology, rather like Paul Nash did, to painting, and I did [photograph] a lot of landscapes in Wiltshire—barrows—right up to the war. ... I did several

pictures of land use, too, when they were ploughing up land that had never been ploughed up since Doomsday.'[18]

These interests chimed with a series of 'Period Maps', recently printed, on Roman Britain, Neolithic Wessex, and Britain in the Dark Ages and which historicized landscape. Published by the Ordnance Survey, they were overseen by O. G. S. Crawford, Archaeology Officer of the Ordnance Survey, trained geographer and editor of the journal *Antiquity*, which he had founded in 1927 with financial assistance from Alexander Keiller. Crawford—familiarly referred to as 'OGS'—had become the lynchpin in a network of young enthusiasts working in the relatively new field of modern archaeology and he used *Antiquity* to bring their discoveries to the attention of an educated public. He succeeded in making this specialist magazine popular, by insisting that it should be well printed and look attractive. It carried an image of Stonehenge on its cover, made generous use of photography, and had a tone and style that appealed to a wide audience. At the same time its content was sufficiently well presented to hold its own among learned journals in other fields.

This magazine so fascinated John that he extracted select articles from it, bound them into two volumes and added his own typed index.[19] He was especially interested in the archaeologist's uses of aerial photography to discover more about landscape than could be discerned on the ground by the human eye, and he wrote on this subject in the eighth and final issue of *Axis*. Again, he owed much to Crawford who had published, with Keiller, the hugely influential *Wessex from the Air* (1928), and had built up, at the Ordnance Survey offices in Southampton, a huge collection of aerial photographs. Crawford's use of these showed how history could unfold through landscape, vestigial remains of the past appearing in the present. So it is not surprising that on the third and final day of their Wiltshire/Dorset tour, John and Myfanwy drove to Southampton, to call on Crawford at the Ordinance Survey Office.

At first he seemed stand-offish, Myfanwy noted in her diary, but he then decided to thaw and became completely charming. On learning that he was going to Newbury, they offered him a lift and had 'a grand drive through Wessex', as Myfanwy recorded: 'OGS got everything he possibly could out of every camp, barrow, track celt field church ditch and spring on the way. Most exciting to be with.'[20] Crawford, skilled at making half-obliterated signs and features in the landscape reveal the lineaments of the past, could detect in a weed-covered furrow what might be the register of the wheels of chariots on a Roman road, while a group of fruit trees were indicative of a long-vanished homestead. In his company, the Pipers would have gained a sharper sense of the layering of landscape, for the lens through which Crawford looked turned the countryside

into, in his words, 'a palimpsest, a document that has been written on and erased over and over again'.[21]

Immediately after their return to Fawley Bottom, Miles Marshall arrived for the weekend. On Sunday they all set out for a day-long walk. At Newington John made them wait forty-five minutes, till the sun came out and he could photograph Newington House, before they proceeded to Marsh Baldon, through countryside that offered a clear view of Wittenham Clumps. After lunch they followed a Roman track to Dorchester, continuing, after what Myfanwy called a 'rather Sunday afternoonish' tea at The Bull, to Overy Mill and Warborough, where the walk ended with a pleasant drink in a pub.

The following day they rose early, in order to go to London, where John and Myfanwy obtained a special licence (costing £2.14s 7d) that would permit them to marry the following Wednesday. Myfanwy then went to see Macmillan about her proposed book ('not much forwarder, but plenty of good will'). And that evening they dined with Robert Wellington and attended 'a Surrealist do' at the London Gallery, a frequent haunt at this time, owing to their liking for its owner, E. L. T. Mesens, who was jolly, witty, and well-informed. In the wake of the 1936 International Surrealist Exhibition, a debate had arisen about the 'social function' of the artist, though what the issues were on this occasion Myfanwy does not record. She found it 'pleasantish company', but when Moholy-Nagy entered it was for her 'like catching sight of a nice warm radiator in a rather shadowy room'.[22] She listened carefully when Magritte spoke, smiling benignly, but was more impressed by the clear-spoken, confident Mesens. 'What he said', she concluded afterwards, 'was a little elegant, a little complimentary, a little witty and a little stirring but not enough to make one throw away all and follow him or what he stands for.'[23]

Unable to commit themselves wholeheartedly to either the abstractionist or the Surrealist cause, John and Myfanwy had difficulty at this time answering the question 'Whose side are you on?' But it was just at this moment that John Betjeman entered their lives, his noisy laughter banishing uncertainty and heralding gusts of change. This friendship began when Jim Richards, aware of the consistent sharpness in John's design of *Axis*, recommended him to Betjeman as an 'excellent typographer'. Betjeman had left the *Architectural Review*, having persuaded Jack Beddington, the publicity manager of Shell, to sponsor a series of county guides, and he was now working three days a week in the offices of Shell-Mex and BP Ltd. To John himself, Richards suggested, while chatting with him at the opening of an Artists' International Association exhibition, that he should write one of these Shell Guides. 'Marx', as Betjeman

23. John Betjeman on Chesil Beach.

nicknamed Richards owing to his left-wing views, evidently told Betjeman the same, as John soon received a letter inviting him to visit Shell-Mex house where he found Betjeman and one of his colleagues writing limericks about the secretaries. Talk bubbled up about churches, following mention of a book by an obscure cleric, and generally John felt that the atmosphere in Betjeman's office was more amusing than anything he had hitherto experienced. 'I wasn't used', he later recalled of Betjeman, 'to that acute constructive sensibility.'[24] Betjeman was equally taken with Piper: 'We realized we liked the same things.'[25]

A certain relief may lie behind this remark. Like John, Betjeman had been expected to enter the family business but had opted instead for architectural journalism and had experienced periods of doubt and uncertainty. Like John, Betjeman had early on learnt the differences between Norman, Early English, and Decorated churches and had spent his school holidays discovering churches in forgotten places. In 1933 he had published a witty and irreverent account of the history of architectural taste. This small book, *Ghastly Good Taste*, when reprinted thirty-eight years later, drew from him the admission that he had composed it in a muddled state—'wanting to be up to date but really preferring all centuries to my own'.[26] A similar unease can be found in an

article Betjeman had published in *The Studio* early in 1937. In order to show what had happened to many small Georgian towns since the early nineteenth century, he invented Boggleton and described the impact on it of the railways and market forces, how it altered in response to changes in fashion and taste, fell under the dominance of London, and suffered the loss of local talent and craftsmanship. At one point Betjeman states his belief that architecture is 'the outward and visible form of inward and spiritual grace or disgrace'; and that any future improvement in design must rest on widespread spiritual change. He offers glimpses of what can be done if England manages to escape from under the speculator and the commercial gentleman, singling out for praise 'a few blocks of flats in highbrow suburbs', by which he meant, as a photograph made clear, Lubetkin's Highpoint I in Highgate.[27]

If while working for the *Architectural Review* under the editorship of de Cronin Hastings and Christian Barman, Betjeman had learnt to discern the difference between the truly modern and that which merely adopted a veneer of modernity, it was friendship with John that affirmed his personal enthusiasms and his love of the demotic; that encouraged him to look again at neglected styles and reassess what had formerly been regarded as ugly and meretricious.[28] Though funny, exuberant, and hugely interested in the world around him, Betjeman had pockets of insecurity. John made a difference: in his company, Betjeman later acknowledged, he felt more confident of his judgement.[29] In time, Piper's capacity to find visual interest in unexpected places opened up the 'gates of enjoyment' for Betjeman.[30] But the benefits that accrued from this friendship over the years were mutual. Piper's association with the Shell Guides, over four decades, secured architecture as a core interest in his life, while his exploration of the Picturesque, already begun, was to be encouraged by Betjeman, who, in the course of his frequent visits to secondhand bookshops, had built up a fine collection of books on eighteenth- and early nineteenth-century architecture and design, many of them illustrated with sepia or coloured aquatints. These encouraged John's move, in the space of just two years, from the making of abstract art to the use of aquatint for architectural illustration. This route, others have rightly noticed, is 'perhaps the most remarkable travelled by any artist of the 1930s'.[31]

'J. saw Betjeman—good sign for guide.' So Myfanwy's diary records for 15 March 1937.[32] With equal brevity she had recorded a rite of passage that took place on 24 February 1937. 'Married at 10.0. Justin [Blanco-White] ten minutes late as usual. J[ohn] rushed off to the Ally Pally with Robert Medley.' The venue was Marylebone Register Office and the only other people present were

the two witnesses Justin Blanco-White and Miles Marshall. John once intimated that they had married because Myfanwy was pregnant,[33] but this was not the case, and a more likely spur was simply the fact that his divorce had now come through. He accompanied his proposal with the offhand remark—'I'm afraid I never take a holiday. Do you mind?'[34] The better part of his wedding day was spent at Alexandra Palace with Medley, making a television programme on modern art and stage design.

Friendship with Medley involved the Pipers with the Group Theatre. This had been founded in 1932 by the choreographer Rupert Doone, formerly a 'premier danseur' in the Diaghilev Ballet who had learnt production under Tyrone Guthrie. Doone's ambition was to adapt the principles of classical ballet to the training of actors. He insisted on a choreographic use of space: no movement or gesture could be made, and no position held that was inexpressive. What began as an actors' collective had expanded into a theatrical community which recognized the artistic integrity of all those who contributed—writers, actors, artists, and musicians. The Group Theatre was determined to avoid the established repertoire of plays in order to concentrate instead on folk and medieval sources and on experimental re-workings of classical drama. Although it was never as political as the Unity Theatre (with which it is sometimes confused), its fame chiefly rests on its production of left-wing poetic dramas by Auden, Isherwood, MacNeice, and Spender. In 1935 Auden brought in a young composer who at first sight seemed the epitome of convention. In the semi-darkness of the Westminster Theatre, where the Group was rehearsing, Robert Medley noticed 'a slim, young man, unobtrusively dressed in sports jacket and grey flannel bags, with irregular features and crinkly hair, and wearing a pair of slightly owlish spectacles, which emphasized his watchful reticence'. Medley, like others, soon discovered that Benjamin Britten's 'diffident manner disguised a wiry personality',[35] and before the end of that year Britten had become *the* composer for the Group Theatre. John had first met him in 1932 at a concert at the Queen's Hall in London and now crossed paths at advisory meetings and other events, for, in addition to its productions, the Group Theatre mounted a programme of lectures, exhibitions, and debates for its members and associate members.

Doone, however, unlike Diaghilev, was neither entrepreneur nor a good organizer, and the company suffered friction and dispute. One (now legendary) meeting was held over the August Bank Holiday weekend in 1937 at Fawley Bottom Farmhouse. Somewhat against his wishes, Benjamin Britten was among the party. 'Pretty grim outlook,' he noted in his diary. '—house filled with people—I have to sleep on the floor—no accommodatory luxuries'.[36]

He and John had a conversation about music and musicians and discovered a shared enthusiasm for Poulenc.[37] The aim of the weekend was a discussion of future plans, but things went awry when two of their playwrights, Auden and Isherwood, arrived with the announcement that they were aiming their next play at a West End production. This was bitter news as the identity of the Group Theatre was by then bound up with these two authors. The absence of any legal contract had allowed a desire for commercial success to override loyalty. 'Rows—& more rows,' Britten recorded in his diary, disappearing into the garden to have his first cigarette. Nor was the gloom dispelled when Auden began vamping hymns, and then began picking out with one finger 'Stormy Weather', while Britten provided two-handed accompaniment. For one entire day Doone was locked away in a room with Isherwood and Auden. When finally they emerged it had been agreed that *On the Frontier* would, after all, be produced by the Group Theatre. Tension and anger subsided further with the arrival of Nancy Cunard and her black boyfriend.

It was with the Group Theatre that John made his début as a stage designer, producing sets for Stephen Spender's play *Trial of a Judge*, which ran at the Unity Theatre in Goldington Street, St Pancras, 18–28 March 1938, with music by Benjamin Britten and Brian Easdale. The play's theme is the crisis of liberal conscience in the face of Fascism. It drew upon an actual incident, which had taken place in Silesia in 1932, at a time when the Weimar Government was still ambivalent in its attitude to Hitler. A Polish Jew had been murdered by Nazis and Nazi confederates had interfered with the trial of the murderers. In the play, the Judge is reluctantly having to pass a death sentence on three Communists for the capital offence of carrying firearms and wounding a policeman. At the same time he is urged to reprieve the Blackshirts, convicted of the brutal murder, by his wife and by a Government Minister who thinks that the Nazis must be appeased if they are to be controlled. Despite this expediency, the revolution spreads and the Judge is charged with treason. At his trial and while in prison awaiting his execution, he explores the moral dilemma of an upright judge in a world given over to the rule of violence,

In Doone's production, the emphasis on stylized movement and classical formality freed John from any need to design period sets. Working with Medley in the cramped and gloomy basement of the Phoenix Theatre, they made bold use of abstract colours—Prussian blue, light blue and scarlet, with touches of black and white. John's most ingenious idea was an irregularly shaped rostrum, which could be turned to present different angles. It also had a post attached to it on which several flat screens pivoted, like the leaves of a book. In this way, changes of scene were easily achieved. Interestingly, an abstract language,

previously associated with freedom and idealism, is here used to suggest the opposite: 'The brightly coloured, severely geometrical scenes and the simple, stylized balcony helped to create a powerful—even terrifying—image of cruel and implacable forces bearing down upon vulnerable individuals.'[38] It would seem, with hindsight, that these stage designs, making successful use of a modernist style, were, at the same time, part of his valediction to abstraction.

'Look, stranger, at this island now | The leaping light for your delight discovers, | Stand stable here | And silent be'. So begins the eponymous poem in W. H. Auden's collection *Look Stranger!* (1936), from which John quotes in an article on modern drawing for the November 1937 issue of *Signature*. Auden's injunction could not have been more timely. It licensed the revival of John's interest in churches, topography, the lie of the land, the shape and nature of towns; it encouraged him to admit that he liked living in a flint-clad house because the flints, dug out of local soil, had a rustic texture and looked agreeable in the landscape. One day he set off for Dorset at two in the morning, to arrive three hours later at Stonehenge, afterwards moving on to Toller Fratrum, for the chief purpose of this trip was to show S. J. Woods the Romanesque font in the church. By standing back from the imperatives of modernism, he permitted the return of other values, other views.

This was the decade in which the vogue for celebrating England and Englishness, partly fostered by the growth in travel in the interwar years, by preservationist bodies, and by the publication of best-selling books, reached its peak. Access to the countryside had been enhanced by the establishment of the Youth Hostels Association (1929), the Ramblers' Assocation (1932), and the Footpaths Act of 1934. But at the same time the countryside, through which John had cycled as a boy, was rapidly changing. Almost four million new homes were built in England between 1919 and 1939, and concern was being loudly voiced over the jerry-builder, the destruction of town centres, and the curse of suburbia. If nowadays much of the 1930s protest against development sounds too easily apocalyptic, and part of what Timothy Mowl has called the 'Whither England?' school of writing, nevertheless by the end of the 1930s it seemed to many that development was out of control. 'We are all now apprehensively aware', wrote Clough Williams-Ellis in *Beauty and the Beast* in 1937, 'that a mere handful of active speculators of only average barbarity can quite easily destroy the virginity of a whole territory in no more than a year or two.'[39] Increased awareness of the need to conserve English heritage had resulted in 1926 in the formation of the Council for the Preservation of Rural England (now the Campaign to Protect Rural England) and the onset of the National

104

Trust Historic Country Houses Scheme in 1936. Meanwhile the increasing fear of war, and the possibility of attack and invasion that this would bring, enhanced appreciation of English, or British (the two were often conflated), culture and national identity.

On 30 April 1937 *The Times* carried a notice headed 'The Amateur to the Rescue. An Antiquarian Survey'. There followed an account of the photographic survey of Saxon and Celtic crosses which Kendrick had instigated at the British Museum, a selection of which had gone on view in the Iron Age Gallery, along with a screenful of John's photographs of Anglo-Saxon and late Romanesque sculptures. But the page from this newspaper which the Pipers tore out, and kept,[40] was that in which the top half was filled with a huge photograph of a spring landscape, filled with plum blossom, in the Avon valley. The view, from Cress Hill, overlooked the river and village of Welford. The caption beneath points out that the parish church can just be seen behind big elm trees towards the centre of the photograph. Below, on the lower half of the page, is a motley collection of images recording topical events, among them one of the first photographs shown in the British press of the desolation brought to the Basque capital, Guernica, after intensive bombing by insurgent aeroplanes. Elsewhere in this same issue, *The Times* recorded Viscount Cecil of Chelwood's response in the House of Lords to the events described by a Special Correspondent in the paper the day before. 'If the report was accurate, he said, the bombing of that small open town, which was of no military value, was one of the most horrible things ever done, and was without precedent in the history of civilized nations.'

It was just at this moment that John turned away from the anonymous surfaces of international modernism and began looking at the local and particular, for the purposes of his Shell Guide to Oxfordshire. A letter commissioning *Oxon*, as this guide was called, had arrived in April 1937, soon after his initial meeting with Betjeman. It began: 'Dear Artist, I have seen Mr J. L. Beddington, and he will be very pleased for you to do a *Guide to Oxfordshire*, starting at once, if you can manage it, and letting me have the MS by the middle of December this year.'[41] The fee for this task, which refocused John's interest in architecture and its relation to place, was fifty guineas, with an additional ten guineas for expenses. Money was also available to pay photographers, while in addition the Shell staff photographer, Maurice Beck (whom Betjeman nicknamed 'Old Filthy' for he was fat, full of laughter, and specialized not just in churches and Georgian houses but also in pictures of nude women covered in oil) would be put at his service, free of charge, throughout May; 'Coronation included,' Betjeman added. As no previous author to these guides had also

been a photographer, it was proposed that some financial arrangement could be reached later, when it became clear how many of John's own photographs would be used.

On this basis, John set to work. Between May and October 1937, he spent many days journeying around, filling half a dozen sketchbooks with annotated landscape and architectural drawings and taking hundreds of photographs. He familiarized himself with the look of England as it presented itself to him in this, so he claims in *Oxon*, 'one of the most ordinary of English counties'. It suited him perfectly, his preface to the gazetteer explains: 'Though I like churches to be special I like country to be ordinary, and have looked at that kind hardest.' He had always enjoyed the vernacular style of local guidebooks, and before embarking on this project he read or re-read the work of his predecessors.

Seven Shell Guides were already in existence when he began this work and three more appeared in the course of 1937. In addition to a gazetteer, most contained articles on some salient feature of the county. Initially some had even included information on field sports and golf courses, but these uneasy stabs at popularity had been abandoned. Already a characterful style had emerged, its 'pungent idiosyncrasy' owing much to the editor,[42] for Betjeman was in his element commissioning talented authors to write these Guides,[43] fulfilling an ambition he had formed as a student. Soon after he married Penelope Chetwode, he had embarked on a guide to Cornwall, and, with Jack Beddington's help, obtained a contract with Shell-Mex that enabled him to leave the *Architectural Review* and devote three days a week to editing Shell Guides.

His manifesto for these guides was published in the spring of 1937, in Robert Harling's periodical, *Typography*. Methuen's *Little Guides*, he argues, are only useful to the archaeologist and the antiquarian, whereas the popular end of the market, represented by Ward Lock's Guides, found on every railway station's bookstall, is directed at 'the uncritical tripper'. Shell Guides, on the other hand,

> had at once to be critical and selective ... to illustrate places other than the well-known beauty spots, and to mention the disregarded and fast disappearing Georgian landscape of England. Churches with box pews and West galleries; handsome provincial streets of the late Georgian era; impressive mills in industrial towns; horrifying villas in overrated 'resorts'. ... Add to them the realization that the purchaser of the guide is probably not an intellectual in search of regional architecture of the early nineteenth century, but a plus-four'd week-ender who cannot tell a sham Tudor roadhouse from a Cotswold Manor, and you will have some idea of the scope of the books.[44]

In June 1937, while touring the West Country with Jim Richards, in connection with work for the *Architectural Review*, John read Betjeman's *Devon*. By then he had embarked on *Oxon* and thanked Betjeman for 'writing what I regard as the model *Shell Guide* for all time'.[45] Like Betjeman, he sought to redress the prejudice against churches built in the classical style—denounced as 'pagan' by the Cambridge Camden Society (founded in 1839), deplored by Ruskin as part of the Classical School, and usually dismissed in guide books as 'utterly soulless'. John protested on behalf of Georgian churches in the pages of *The Listener*,[46] also in *Oxon* where Chiselhampton is said to be 'about the best building in the county for combined fitness and elegance'. (The 1896 edition of *Murray's Guide* to Oxfordshire had sniffed at this 'modern church with a bell-turret such as is usually placed on stables', as John reminds us.) Another fine church in this county was for John, as for Betjeman, Waterperry, where John made watercolour copies of the thirteenth-century stained glass.

The prose in John's gazeteer is brisk, his looking receptive to effects but wholly unsentimental. In this, too, he fitted in with the style of these *Shell Guides*. 'Their brevity and arresting style of presentation', writes Alan Powers, 'belong to the motor age as the Edwardian *Highways and Byways* series belongs to the bicycle age.'[47] We catch the tone, in the 1938 edition of *Oxon*, in the first entry: 'Adderbury: on the Oxford-Banbury road has greens and trees and stone gabled houses. Oxfordshire stone gives it fine colour, and its builders give it space and sense in planning. Church to match, with celebrated spire (*see* Bloxham). Largely spoilt inside, but restorers could not spoil its scale. Screen and brasses: manor: tithe barn.'

Fourteen years later, when a new edition was published, John revisited all the places mentioned and rewrote, corrected, and expanded almost all the entries.[48] By then Pevsner's *Buildings of England* series had begun, nine volumes appearing between 1951 and 1953, and their greater attention to detail and factual accuracy made the Shell Guides look impressionistic and dilettante. But while every new volume by Pevsner steadily contributed to the monumental scholarship which the *Buildings of England* series (or the *Pevsner Architectural Guides* as they were renamed in 1999) today represents, the Shell Guides had a different agenda. John confronts this difference in the preface to the 1953 edition of *Oxon*. The plan, he says, remains the same—'to present one man's reactions to the countryside and buildings, with *no kind of claim to authority or completeness*' (my italics). What is offered instead is lighter in touch but possibly more telling. 'I like a guide book', he admits, 'to be to some extent a diary, with a diary's prejudices and superficialities, and perhaps some of its vividness.' Nevertheless his revisions suggest that he was very aware of

the challenge Pevsner's new series presented. The 1953 entry on Adderbury, for example, has more than doubled in length, is more careful, and is better furnished with references to dates, styles, and names. It does not, however, compare with the description of Adderbury found in the 1999 *Buildings of England Oxfordshire*, which runs to six-and-a-half pages of dense print. Its concern, however, is entirely with buildings and we learn little or nothing about setting or place, whereas John devotes a full page, in both the 1938 and 1953 editions of *Oxon*, to a photograph of Adderbury, showing a semi-derelict backwater. The 1953 edition explains: 'A path beside a slow-flowing stream to the west of the church provides views of walls and dark-earthed back gardens that tell more about local character than any main-road view.' If today we turn to Pevsner for information on *what* it is that we are looking at, it is still the Shell Guide that teaches us *how* to look. Candida Lycett Green has rightly claimed

24. Adderbury, a photograph from *Oxon* (photograph: John Piper).

that the collaboration between Betjeman and Piper on the Shell Guides 'produced a magic which changed people's perceptions of England'.[49]

When the 1953 edition of *Oxon* appeared, John acknowledged the help of his neighbour, the Hon. Sherman Stonor, then living over the hill at Stonor Park. But when preparing the first edition his travelling companion had most often been Myfanwy. Both were fascinated by what could and could not be seen. 'Church overlooks the tumbled mounds of a vanished manor house,' John wrote of Ambrosden. Myfanwy contributed an essay, 'Deserted Places', which begins: 'Oxfordshire is the place for vanished magnificence.' Other idiosyncrasies in this early edition include John's interest (again slightly modified in the later edition) in the 1843 barrel organ at Brightwell Baldwin, for the reader is not only told that it still plays the voluntary every Sunday, but also some of the items in its repertoire. Then, too, in 1938, he dealt breezily with Checkendon: 'Week-endy. Secluded. Paintings in the church. Cherry country.' The 1953 entry is more respectful, its author older and more considerate. 'Checkendon. Quiet and remote-seeming, for anywhere so near to Reading. Threaded by narrow lanes. Paintings in the interesting Norman and later church, which is picturesque and has an apse. Cherry-growing country.'

Oxon, in Timothy Mowl's view, 'was the definitive article in the interaction of text and photographs and line drawings, white on black', which rapidly became 'a bibliophile's treasure'.[50] It satisfied Betjeman's passion for typography and layout, about which he had learnt much when working for the *Architectural Review*, under Hubert de Cronin Hastings. His stated aim, in connection with the Shell Guides, was to make every page 'a surprise',[51] through amusing arrangements of the title page, a fresh approach to design (Betjeman's model of compression was Bradshaw's Railway Guide), or the use of unexpected captions, such as the one he supplied for John's photograph of roadside advertisements hung from a central wooden pole—'A tree of knowledge'. Nothing, however, in *Oxon* matches the exuberant collage which Lord Berners executed, at Betjeman's request, for the cover of *Wiltshire*, though it was Betjeman's own *Cornwall* that began the tradition of using visually dramatic endpapers. In *Oxon* these are derived from a photographic negative of a collage which Piper created out of insignia, maps, and place names in a great variety of lettering.

Though some illustrations are by Maurice Beck, a photographer in sympathy with Betjeman's aims, most of the photographs are by John himself. They catch not only the elegance of church spires and the grace of country houses but also the texture of Englishness, as found in dry-stone walls, hawthorn bushes in flower, and forgotten backwaters. He favoured deep shadows and a rich use of

25. Endpapers for *Oxon*.

velvety blacks, which can heighten a scene's intimacy. He enjoyed incongruity, catching the clash of cultures represented at Witney by the billboard hung on a dignified old stone house—'Site for SUPER CINEMA'. (The photograph is dropped from the 1953 edition of *Oxon*, perhaps because by then both building and billboard had vanished.) More enduring was the poetry which John found in the ordinary, in the fitting of a wooden lintel and door into a stone wall, or the curve of a road at Epwell, cutting between a church and its burial ground and neatly built cottages. In October, as his work on this guide was approaching completion—('What a job,' he wrote to Betjeman. 'It is worth five hundred pounds')—he found 'prayer books and pumpkins' in the church at Charlbury,[52] making a memorable photograph of Harvest Festival litter. Elsewhere, both in text and image, he could be eloquent about ribbon development. One photograph, captioned ironically (in the 1938 edition) 'Progress along the Oxford road at KIDLINGTON', fully upholds his entry on Kidlington in the gazetteer: 'Worst Oxfordshire example of building atrocities. The Banbury road is hideous for miles on each side of it.'

Kidlington is redeemed, however, by a panel of thirteenth-century glass in its church's east window—'of a quality like that at Canterbury, Lincoln and Char-

26. Harvest Festival at Charlbury, *Oxon* (photograph: John Piper).

tres'. Wherever possible John drew attention to fine stained glass and to what were then often ignored—seventeenth- and eighteenth-century monuments. He persuaded Katharine Esdaile, author of *English Monumental Sculpture since the Renaissance* (1927) to contribute to the Guide, but her essay and list make dry reading after the gazetteer. It is left to John to point out that the 'wonderful cross-legged effigy of a knight' at Dorchester Abbey has 'a twist in the form that attracts modern sculptors', an allusion that has always been taken to refer to Henry Moore. It is also John who, in the entry on Swinbrook, observes: 'In the church effigies of intelligent, wicked-looking former lords of the village lie on slabs like proud sturgeon, in enormous wall tombs.' His twentieth-century looking keeps nostalgia at bay. At Rousham he found a church 'rich in Jacobean

pews', as well as 'monuments and glass, and coats-of-arms on panels that might have been painted by Fernand Léger, the cubist: gay and angular'. In keeping with Betjeman's wish that there should be a surprise on every page, the first edition of *Oxon* ends on an elegiac note with photographs of William Morris's funeral cart decorated with willow branches and of his grave. Throughout, *Oxon* set a new benchmark with its intense evocation of place.

Oxon lit the fuse. Soon after, John eagerly began making lists of eighteenth- and nineteenth-century churches in Shropshire, in preparation for another Shell Guide, on which he was to collaborate with Betjeman. Neither knew the county well and this made the project slightly exotic. 'It was like going to Brazil or somewhere,' Betjeman recollected. 'It was also frightfully funny. He [Piper] always related people to buildings. He liked speculating about vicars and architects.'[53] On one of these visits they stopped for tea at Much Wenlock and had to wait for a table to become free. When the waitress called them through, in a dainty North Country voice, Betjeman picked up the accent and began referring to his companion as 'Mr Pahper'. From then on John was always 'Mr Pahper' in Betjeman's mind, and the nickname stuck.

The text for *Shropshire*, though finished by June 1939, was shelved at the onset of war. The *Shell Guides* ceased, Betjeman's job as their editor came to an end, and it was not until some years after the return to peace that *Shropshire* was eventually published, its foreword explaining their shared stance:

> we have been more interested in the evident beauties of a clear crown-glass window than in the hidden stories of a double piscina, and in the virtue of a well-planted churchyard than in a fragment of fourteenth-century tracery. We have often mentioned whether or not a church has been scraped of its plaster by Victorians. ... We have mentioned, usually, when a village has been affected by new houses, pylons, gas works, reservoirs, main roads and conifers. And particularly we have remarked on previously unnoticed examples of good Georgian, Victorian and even Edwardian architecture and planting.[54]

Their work was greatly admired by Thomas Kendrick, who dedicated his book *British Antiquity* (1950) to Piper and John Betjeman, in words that glorify them as disciples of the famous sixteenth-century antiquarian John Leland: 'Ad Jo. Piperum necnon et Jo. Betjehominem, Lelandi discipulos.'

Stepping in and out of numerous churches, the two Johns had encountered more than stones and mortar. 'Along with the building', Betjeman later re-

called, 'went the Vicar, the Verger and the Parish Magazine, and so our affection for churches grew.'[55] Later, when the theologian Harry Williams referred to churches as 'banks of affection', Betjeman understood what he meant and knew that it was precisely this affection which keeps them standing. 'John [Betjeman] was very keen on the church,' John later told Sebastian Faulks. 'He always had doubts you see, and that was why he was so churchy.'[56] But Betjeman sometimes complained when Piper tried to see more than ten churches in one day. There were times when he succeeded. In 1943 en route to Cornwall to award a drawing prize at Clifton College, the school having been evacuated to three hotels in Bude, they visited a dozen churches in Exeter.[57] At Bude they were treated like royalty, 'and buzzed from housemaster to housemaster to meet their wives and drink their beer, attend a concert, go to school chapel and so on'.[58] The prize-giving event proved riotous, as Betjeman and Piper, vying with each other, entertained their audience with a lengthy digression on the respective merits, timetables, and routes of the South Eastern and Great Western Railways.

PART

9

Not Playboys but Agents: 1937–8

While writing *Oxon* in 1937, John Piper led a divided life, attending to medieval churches on the one hand and his abstracts and collages on the other. He was, however, beginning to jibe at the constraints of non-representational art. We find him writing an article on John Constable, the centenary of whose death fell this year, for the *Architectural Review*,[1] in the same sketchbook that he also jotted down observations on pure abstraction ('as narrow a doctrine as pure bathroom graining') and on Surrealism: 'Surrealism is as bad, too, with its literary programmes. It has produced a genius or two, and that gives it its excuse.' Anyway, he sighed, 'whoever wanted to do without the subconscious in art?'[2]

Both Pipers now distrusted ideological strait-jackets, Ben Nicholson's purist aesthetic as much as the Surrealists' preordained strategies, indeed anything that put theory before practice. When in 1939, the London Gallery mounted 'Living Art in England' and asked all the exhibitors to define themselves as either 'Constructivist', 'Surrealist', or 'Independent', John sent in *Coast of Wales* (1938; National Museum of Wales, Cardiff), a small painting which hovers ambiguously between representation and abstraction, and showed his irritation with labels by calling himself 'a cubist, abstract, constructivist, surrealist independent'.[3]

Myfanwy, looking back on this period, noted that many artists at this time were coming to terms with the aftermath of Cubism and finding a way of dealing with the fragments and remnants of objects left in its wake. What they confronted, she astutely observes, was 'not a new world but the old world in new and shattered circumstances'. It was here she felt art history in the making, not in the idealist embrace of a modernist utopia, but in the negotiations and reconciliations between rooted experience and innovative methods. Here, too,

she argued was a chance to apprehend 'the mutual nakedness and defenceless-ness of artist, subject and material at all times'.[4]

Politics, she recollected, 'pressed further and further into our consciences'.[5] Earlier in the 1930s, she had heard Ernst Toller, the most successful and widely translated German political dramatist of the interwar period, talk in Red Lion Square. This may have been 1934, when an English translation was published of his autobiography, *I was a German*. After the burning of the Reichstag in February 1933, Toller's apartment had been raided, manuscripts confiscated, his works removed from libraries and officially burnt. Hearing him speak left Myfanwy with 'the feeling of exultation at his personality and despair at his situation'.[6] Her pragmatism made her willing to engage with left-wing activity yet aware of the limitations of what it could achieve.

> I remember the people who abandoned their talents to organize the peace pledge, run *Essential News*. The Group Theatre production of Spender's *Trial of a Judge,* grim in its red, white and blue abstract setting, was at the Unity Theatre; when we were setting up and painting the scenery, members of the Unity Theatre Club came in calling out 'Anyone seen the banner for the Demo?' We tried to detach ourselves but it was not possible. There was a perpetual mixture of exhilaration and uneasiness. The fear and horror of war constantly took the attention of the only people who had any under-standing or interest in modern art and literature. The rest were indifferent to both—culture and the threat of extermination.[7]

Owing to their friendship with Peggy Angus ('Red Angus' as she was nick-named), the Pipers became involved with the Artists International Associa-tion, John exhibiting with them and producing a lithograph for their Everyman series of prints. But they remained left-wing supporters rather than political activists. The cry which they had overheard at the Unity Theatre—'Anyone seen the banner for the Demo?'—lodged in their minds and became something of a joke.[8]

Exhilaration and uneasiness were also to be found at the July 1937 Exposi-tion Internationale des Arts et Techniques in Paris, which the Pipers visited. The two works of art that caught the public's attention were Picasso's *Guernica* in the Spanish Pavilion and Raoul Dufy's enormous mural—60 metres (200 ft) long and 10 metres (33 ft) high and painted in 25 panels—*La Fée Électricité*, which decorated the interior of the Pavilion de l'Électricité at the end of the Champ de Mars.[9] Commissioned by the Compagnie Parisienne de Distribu-tion d'Électricité, it celebrated the union of nature and technology. Dufy, liberated by the Cubists' rejection of traditional perspective, here unfurls a

panorama teeming with gods and goddesses, factories, ships and railways, men, animals, and machinery. The lower half is filled with a small army of figures, each identified by means of a painted inscription as persons who had in some way contributed to the discovery of electricity. John was so engaged by it that he took, or obtained, four black and white photographs which reproduce the greater part of this enormous mural.[10] Dufy's huge decoration offered a hymn to modernity, but it did so in an infectiously light manner and with a great deal of descriptive detail; it was witty, agreeable, and interesting. Almost certainly it was after seeing this mural that John turned his back on abstraction and created the *Nursery Frieze* prints, Dufy having licenced both the scattering of form and more precise representation.

Picasso's *Guernica*, on the other hand, offered a howl of protest and rage. It has, however, never been an easy picture to understand and in 1937 it baffled many. Le Corbusier has put on record that, while visitors spent a long time in front of Dufy's mural, they turned their backs on *Guernica*.[11] But it had now begun its journey into public consciousness, and that summer the painting, along with related studies and Dora Maar's photographs of earlier states, dominated *Cahiers d'Art*. By the time *Guernica*, and studies for it, came to England in October 1938, it had become a universal protest against violence and oppression, as Herbert Read recognized when he announced in the *London Bulletin* this month: 'Not only Guernica, but Spain; not only Spain, but Europe, is symbolized in this allegory.'[12]

Myfanwy contributed to its fame, for she was the first in England to repro duce *Guernica* in book form, a Dora Maar photograph of it, taken while the painting was still in the artist's studio, appearing in her anthology of artists' essays, *The Painter's Object* (1937). Picasso's personality and aggression, she later recollected, 'acted upon us like rape just when we had settled for the Mondrian cloister'.[13] In the eponymous essay which is found in her anthology, she acknowledges that, with *Guernica*, Picasso had once again reset the artistic agenda: by 'purging into formality' a difficult subject, he had demonstrated that 'unbearably violent emotion' could become 'a formal symbol for *art* to-day'.[14]

The creation of *Axis* had been for Myfanwy 'a journey into life and lives'.[15] It brought her and John new friends, among them Oliver Simon, who, after studying typography in Germany, had been taken on by Harold Curwen at the Curwen Press where he shared an office with the famous typographer Stanley Morison. Simon devoted his life to fine printing. The clarity, restrained use of ornament and judicious choice of fonts which marked out his books made them a legend. Another string to his bow was the trimestrial *Signature*, a journal

of typography and the graphic arts, which he had launched in 1935. It never sold more than 1100 copies but was highly regarded and read by artists. Simon, who with his wife became a frequent visitor to Fawley Bottom, had been a supporter of *Axis* from its beginning and Myfanwy's *The Painter's Object* was his idea. Though it did not immediately attract a publisher, one had been found in Geoffrey Howe.

In her introduction to this anthology Myfanwy uses a gossipy, unstable voice to reflect the uneasiness of the period, the 'whose-side-are-you-on' mood. 'Introduced to all the boys last night, to Picasso, Miró, Ernst and so on. No, not Cocteau, not these days, because, of course, it's not the same (Diaghileff's dead), not the same post-war excitement. We are more serious now, not really playboys but agents.' This spirited satire soon gives way to a cacophony of voices:

> we have got into the middle of not one but a thousand battles. Left, right, black, red (and white too, for the fools who won't take part and so constitute a battle line all on their own), Hampstead, Bloomsbury, surrealist, abstract, social realist, Spain, Germany, Heaven, Hell, Paradise, Chaos, light, dark, round, square. Let me alone—you must be a member—have you got a ticket—have you given a picture—have you seen *The Worker*—do you realize—can you imagine—don't you see you're bound to be implicated—it's a matter of principle. Have you signed the petition—haven't you a picture more in keeping with our aims—*intellectual freedom*, FREEDOM, **FREEDOM**—we must be allowed, we can't be bound—you can't, you must fight—you *must*, That's not abstract, sir—that's not surrealist, sir—that's not—*not*. Anything will do—send it along—the committee will hang it—sit on it—no, not him, he'll want his friends in—it's a matter of *principle*.[16]

To an extent the book was a riposte to *Circle: international survey of constructive art*, edited by Nicholson, Gabo, and the architect Leslie Martin, which had appeared, in June 1937, under the Faber and Faber imprint.[17] Its four sections—painting, sculpture, architecture, art and life—were all intended to bear witness to Naum Gabo's essay 'The Constructive Idea in Art'. This articulated the rather loose belief that 'the constructive idea' was 'a general concept of the world, or better, a spiritual state of generation, an ideology caused by life, bound up with it and directed to influence its course'. The cover of the book, with its columns of names in sans serif lettering echoed the design of *Axis*, and, as a whole, the book is often seen to represent the high watermark of international modernism in Britain. Most artists, architects, and writers had been invited either by letter or personal connection to submit contributions.

John, however, was annoyed to find that two of his abstracts had been illustrated without his permission. He and Myfanwy admired the book, but also felt there was something 'priggish'[18] about its missionary belief that highbrow, often serenely beautiful abstract art should act as a catalyst for the improvement of society. In Gabo's view, and that of Nicholson and Hepworth, abstract art spoke a universal language, and they believed that what was now the taste of the few would, in time, become the desire of many.

Today the hope that such rigorous purity would attain universal appeal and become popular taste seems incredible. But even before *Circle* was published the tide of modernism had begun to recede and a younger generation of artists were already reacting against such extreme asceticism. The year 1937 also marked the founding of the Euston Road School, which rejected all ideas about the need to be progressive. Instead, its teaching encouraged a non-rhetorical, objective appraisal of reality. When in 1938 it put on 'Pictures of London', the show was deliberately aimed at the man-on-the-street: every tenth Smith or Brown in the telephone directory was invited to the private view and a passerby was invited to open the show.

Myfanwy objected to the abstract ideal by drawing attention in *The Painter's Object* to Picasso. She argues that 'his whole practice as an artist has been to make a formal virtue out of chaos, to exploit the incredible ruin and inconsequence and purposelessness of the world today.'[19] Picasso's significance is further underlined by the frontispiece, which offered colour reproduction of one of his still-lifes which John had copied by means of Paramat blocks.

The essays were by a galaxy of leading artists—Picasso, Calder, Hélion, Ernst, Kandinsky, Ozenfant, de Chirico, Léger, and Moholy Nagy—as well as a strong English contingent, Paul Nash, Henry Moore, Graham Sutherland, and Julian Trevelyan. But unlike *Axis,* for which essays had been commissioned, *The Painter's Object* mostly drew upon published material drawn from a variety of French, English, and Italian magazines. Myfanwy explained:

> Artists don't usually write unless they have something to say, and they have a directness of approach and a lack of literary prejudice that makes their writing extraordinarily exciting to read. I have enjoyed so much that has been written by artists during the last year or two, and been annoyed by so much that has been written about them, that it seemed worth while to try and collect some of the scattered writings of artists actually living and working to-day.[20]

Nevertheless, the overarching aim of her book is hard to discern. Topographical essays by Nash and Sutherland sit alongside Max Ernst's description

of 'frottage' and collage, and de Chirico's essay on Courbet in which the term 'Romantic' is explained as that which 'today implies simply an art firmly rooted in reality'.[21] A passage in Nash's essay 'The Nest of Wild Stones' best catches the mood of this anthology:

> So life runs on, not cut and dried like some horrible tobacco the Padre smokes, nor locked away in an abstract like a fly in amber. But flowing backwards and forwards and throughout; a complex maze of associations which keep the mind guessing, and imagination hovering.[22]

Historically, one of the most interesting essays is John Piper's 'Lost, A Valuable Object'. Owing to its extensive use of metaphor and paradox, it is possible that Myfanwy had a hand in its making. The title alludes to the recent vogue for displaced or found objects in art and photography. Both Paul Nash and Henry Moore, influenced by Surrealism, had developed a keen eye for stones, bones, or fallen trees which could be made to embody a sense of personality.[23] John, himself, was experimenting with constructions made out of driftwood and pieces of metal, two of which he sent, in November 1937, to the 'Found Objects' section of the 'Surrealistic Objects and Poems' show at the London Gallery. One—made out of beach debris—he called *Chesil Beach Engine*. While celebrating the reappearance of objects in art, his article observes that artists remained fearful of placing the object in its context. 'But the object must grow again; must reappear as the "country" that inspires painting,' he writes.[24] This yearning for a wider context than abstraction permits, leads to his conclusion: 'It will be a good thing to get back to the tree in the field that everybody is working for. For it is certainly to be hoped that we shall get back to it as fact, as a reality. As something more than an ideal.'[25]

But if there is a central theme or leitmotif running through *The Painter's Object* it is surely the need for change. 'As so many of these articles point out,' Myfanwy remarks, 'it is not possible *to-day* to do what was done yesterday.'[26]

An advertisement for *The Painter's Object* figured in the eighth and final issue of *Axis*, which, after a lengthy gap, appeared in the early winter of 1937. Though it announced that the next issue would appear early the following year, this proved an unrealistic boast. The avant-garde momentum in London was on the wane: Moholy-Nagy had left to set up a new Bauhaus in Chicago; Gropius had accepted a professorship at Harvard University; and, as *Axis* no. 8 revealed, the magazine had changed its original focus. The lead article in this final issue promoted, not the pieties of international modernism, but the

power of the past to return and inform the present. Written by John, it was entitled 'Prehistory from the Air' and dealt not with abstract art but with aerial photography and archaeological sites.

Crawford's *Antiquity* had convinced John that flying served the new consciousness, and that the horizonless views offered by aerial photography echoed the flattened use of space in modernist painting. Hence this article which links Miró and Picasso with prehistory. But it was not just the formal or aesthetic aspect of aerial photographs that intrigued; they challenged shallow modernity by showing how ancient sites, Iron Age forts or Neolithic barrows, could reappear in the present, clarified by the information obtained from an aerial perspective. It made possible a more layered understanding of landscape. John, aware that aerial photography had solved the dispute over the path of an avenue leading to Stonehenge, that it revealed variations in the colour and growth of crops related to centuries-old disturbances in the ground, became entranced by this new way of looking. He declared these images to be 'among the most beautiful photographs ever taken', completely 'un-art-conscious', sharp and very detailed.

The excitement they generated suggests a still deeper satisfaction: it was as if the implications of aerial photography liberated him from the cage of the present. He could now view Silbury Hill either through an aerial photograph or through an eighteenth-century engraving by the antiquary William Stukeley: both gave him compelling evidence of 'this large and curious mound', while the Stukely, he insisted, offered as sharp an experience as a journey round a wineglass with Picasso.[27] Myfanwy, too, understood this time-travelling. She wrote of Paul Nash in *Axis* no. 8: 'He has no interest in past as *past*, but the accumulated intenseness of the past as *present* is his special concern and joy.' This stance licensed a revival of interest in location, memory, history, literary associations, and native traditions, all gaining in intensity as war approached.

At the same time *Axis* had always striven to be international; and its final issue carried reviews of the Paris *Exposition Internationale* as well as two shows in Munich where the new House of German Art, commissioned by Hitler from his favourite architect Ludwig Troost, was displaying Führer-approved art, while elsewhere the infamous 'Decadent Art' exhibition was filled with the kind of modernist pictures and sculpture which he condemned. Robert Medley's review of the two Munich shows duly noted their differing contents and contrasting methods of presentation. But evidence of the aggressive nationalism that would soon threaten to destroy Europe was also apparent in Paris.

At the *Exposition Internationale*, the German and Russian pavilions, two of the largest, faced each other at the end of the main avenue, both conveying, by means of imperial architecture, irresistible power. On top of one stood a bronze eagle; on the other, a giant sculptured family bearing aloft a familiar implement. Herbert Tayler spotted this tense rivalry, and, in his *Axis* review, observed that 'the German eagle, Mickey-Mouse-like, taps its foot impatiently at the brandished sickle opposite.'

Among the four illustrations in *Axis* no. 8 relating to the Paris exhibition, two were of the 'Mercury Fountain' by Alexander Calder, which sat outside the Spanish pavilion. Hélion had introduced the Pipers to this artist and a lasting friendship took root. An American, living in Paris, Sandy Calder was a great bear of a man who had studied mechanical engineering before turning to art. He adopted wire as the medium with which he could draw in space, making caricatures of people and animals, as well as an entire circus, including articulated trick-cyclists, gymnasts, and tight-rope walkers which he would animate on the floor. Its imaginative whimsy had greatly appealed to Miró, who had become one of Calder's closest friends. A more abstract vein had appeared in his work after a visit to Mondrian's studio.[28] Calder had also become famous for his 'mobiles', as Marcel Duchamp named them, which were carefully calibrated so that they responded to movements in the air. First exhibited in 1932, these had developed further his interest in processes of construction and industrial materials. He had showed with the Abstraction-Création group, and, along with Miró and Arp, had inspired in Nicholson awareness of a 'new freedom' in art.[29]

In July 1937, the Pipers spent a weekend with Calder and his wife, Louisa, at Varengeville, where they had rented for the season a south-facing chalet in walking distance of the beach.[30] Calder had also invited Nicholson and Hepworth, but, aware that these two couples no longer saw eye to eye, he arranged things so that they did not overlap. It amused him to observe, as he waited at Dieppe for the ferry, that John and Myfanwy were the last off the boat. 'Such is British restraint,' he comments in his autobiography.[31] In Myfanwy's memory, it was the Charentais melons, peaches, figs, and cheeses as well as a goose, obtained in the market, which made this visit memorable. The goose had come to market undressed and was too large to cook in the oven. Calder deftly made a spit, while the goose was plucked and damp wood coaxed into a fire. But by one in the morning the bird was still not properly cooked and everyone's eyes were smarting from the fire. Fruit and cheese saved the day, together with a great deal of wine.

Later this summer, the Calders stayed with the Pipers and overlapped with another visitor, Ferdinand Léger, who was in London working on a film. The Calders had brought with them fishermen's vests bought in Barcelona. On Sunday morning they all walked to a nearby pub, the Calders wearing yellow and orange vests, the Pipers blue and red, their apparel triggering ideas in Léger for the design of a ballet. This summer Fawley Bottom received several leading modernists, some of whom looked a little out of place: Myfanwy recollected Gabo ill-at-ease amongst the grass and trees but talking excitedly once he was in the studio; Moholy-Nagy, awkward in his city clothes, marvelling at some flints found in a nearby field; and Léger, who worked with stereotypes, making a watercolour of his surroundings while complaining about the lack of cows.

At Fawley Bottom Farmhouse Calder gave a performance of his circus. He mounted another in 1938 at the Mayor Gallery, in London, in the course of an exhibition given him by Freddy Mayor. Many of the mobiles shown there had been made at Fawley, and others produced in a London foundry. While preparing for this exhibition, he and his wife, Louisa, had made use of a studio flat which Myfanwy had found for them in Belsize Park and which Calder painted white and furnished with a large red Moroccan rug. Both in his person and in his art, his vitality and joy proved irresistible. Myfanwy persuaded him to write an essay on his mobiles for *The Painter's Object*, and he and John exchanged work, John giving two collages to the Calders while, over the years, the Pipers acquired some seven works by Calder, including a large mobile which sat on the terrace at Fawley Bottom Farmhouse,[32] and a necklace which Myfanwy wore. Not only had the Pipers found in the Calders lifelong friends, but association with such an independent mind may have strengthened John's confidence in his own interests. Later, in the 1950s, the Calders acquired a house in the Loire, the Pipers visiting them on at least three occasions.

In the wake of the 1936 International Surrealist Exhibition, with its 'chance encounters' and techniques intended to shock or disturb, new attention was being given to the evocative power of the image. At the same time there was a revival of interest in a wide range of earlier English art. John's essay on Constable, for the April 1937 *Architectural Review*, was part of this development. It had led him to immerse himself in John Constable's life, letters, and work. In his essay he links this artist with another of his favourites, Gilbert White, whose book *The Natural History of Selborne* he had given to Myfanwy in 1934, soon after they met. Both, he said, had a genius for observing and translating nature and were alike in their 'purity and integrity'. But in Constable there was also a modern ingredient, an abstract element held in balance with his

concentrated observation: 'His power of *feeling* a particular time of year or time of day in his landscapes without ever resorting to straight copying in form or colour, is amazing.'[33] Though interest in Constable had sprung to life in the 1920s after a period of neglect, John's conclusion—that Constable was 'one of the greatest artists that England has produced'—conveys the excitement of a personal awakening. From now on he kept Constable's letters always close to hand. From Constable, he learnt much about skies and about the need to develop a dramatic instinct in the placing and visual presentation of his subject matter.

By 1938, several of the Pipers' friends had begun to look askance at abstract art. One was the elderly New Zealander, Frances Hodgkins, a sensitive, intelligent artist in need of friendship but fearful of any form of intimacy that would impede concentration on her work. On her visits to Fawley Bottom she would walk up the road to a small farmyard. Its owner, believing that once war began bartering would become the chief means of exchange, had collected anything he could lay his hands on—old doors, sheds, lavatory basins, and all kinds of objects. Here Frances Hodgkins would sit, stare, draw, and paint, fascinated by this characterful mess of objects, their faded air lending itself to her appreciation of the latent colour in things. John thought it much to her credit that she not only felt the absurdity in this accumulation of assembled junk, but also enjoyed it and made something of it.

Still more intense was the friendship which had evolved between him and Geoffrey Grigson. An early supporter of Auden and MacNeice, Grigson's modernist taste in verse ran alongside his love of plants, place names, geography, and sense of landscape, the outcome of his Cornish childhood, spent living, as he describes in his autobiography, within 'the valley, the shining leaves and the antiquities of Pelynt'.[34] The son of a clergyman, he had grown up aware that his parents were ill-matched. The youngest of seven brothers, Geoffrey had lost three of them in the First World War, including his favourite, Lionel, who had been a keen antiquarian and whose disappearance 'left an extraordinary blank' in his life, as he later acknowledged, until he met John, finding in him a companion with whom he could explore the countryside.[35]

Their friendship evolved slowly. Contact was first made when *Axis* was on the drawing board, but it was not until after the death of his first wife, after childbirth, in 1937, that Grigson opened himself to new relationships. It was the following year, after he returned from Austria with his second wife, Bertschky, that he began to discover that he and John liked similar things, Grigson listing 'barrows, standing stones, churches, ruins, outcrops of rock,

limestone especially, caves, waterfalls, etchings and water-colours by Cotman, full moonlights by Samuel Palmer'.[36] They sang together, with affectionate mockery, hymns ancient and modern, with John at the piano, and found mutual pleasure, Grigson recalls, in 'impossible jokes, catch-phrases, verbal nonsense of every kind, guidebooks, at least the Victorian ones by parsons and scholars and antiquaries, which had something to say, and guided us to much that seemed forgotten or disregarded, especially those detailed red guidebooks which had been published by John Murray'.[37] Grigson was, in his own words, 'churchy', but 'without a profound appetite for the Christian purposes of nave and chancel and altar'.[38] Once John began to revisit the Picturesque for modern purposes, Grigson became a natural ally for he was immensely learned, had an excellent eye, a gift for making convincing parallels between art and literature, and took a pioneering interest in Samuel Palmer. This first emerged in an article he wrote in 1938 for *Signature*, the same periodical in which John, perhaps in imitation of Grigson, sought to reawaken interest in Fuseli.[39] But Grigson was also a prickly individualist, a curmudgeon, with grievances curiously undefined, and, in Myfanwy's opinion, a tiresome character, inclined to be bossy and didactic. She never forgot how, when he and John went bicycling together, they often came back separately, having quarrelled.[40]

More straightforward was the Pipers' relationship with Paul Nash. Though now a senior figure within the art world he was, like many avant-garde artists at this time, dogged by poverty and therefore glad of whatever publicity he could get. Myfanwy had been persistent in her pursuit of him, commissioning articles for *Axis* and for her compendium, *The Painter's Object*, and herself writing on Nash in the final issue of *Axis*. 'Paul Nash', her essay begins, 'has absorbed the English climate.'

> Everything is translated into weather. However far from representation his work is, his violence is always the violence of an English storm, his clarity that of the Purbeck hills before rain, his brilliance the intermingled contrast of frost and sun and the whiteness of white stones on ploughland.

Many years later she re-evoked his presence in *Dictionary of National Biography*. Nash is here presented as the leading exponent of his day of the *genius loci* and the epitome of Englishness: his work 'retained the sweetness of the English landscape, the uncertainties of the English weather, and the whimsicalities of a cultivated English mind'. His sense of fitness, she notes, extended to his clothes which were excessively neat. 'All this with his black hair, brilliant blue eyes, and fine profile made him seem a very exquisite person. But his features never

stayed put, to be admired; they were mobile, sensitive to atmosphere and, this was his saving grace, ironical.' He was also both a witty man and one who inspired wit in others. 'No nuance was ever lost,' Myfanwy observed.[41]

John likewise esteemed Nash. In May 1937, when reviewing some Paul Nash watercolours on show at London's Redfern Gallery, he praised their 'fantasy, vividness and economy', qualities which he insisted could be found in much of the best English art—in Gilbert White, Sir Thomas Browne's *Urne Buriall*, Constable, Turner, medieval sculpture, and stained glass. Here, too, he mentions his first meeting with Nash, which took place at Swanage. It is typical of John that he remembered this meeting in terms of what lay outside him rather than with reference to any inner marker.

> We walked out to a garden promontory, and reviewed the sights; the Dorset downs with their nests of wild stones, stopping abruptly in the curiously weather-sculptured Ballard Head; Swanage itself down in the hollow, an urban collection with a rich scattered paraphernalia of oddments, tentacles, of new brick bungalows, and beyond, the sea.[42]

On one or more occasion John drove Nash to places he wanted to photograph, and witnessed the tension experienced by the asthmatic Nash as, struggling with ill health, he waited for just the right effects of light to illuminate the scene. Perhaps it was after one of these trips that Nash gave the Pipers a watercolour, *Circle of the Monoliths*.

Like Nash, Eric Ravilious, another recent friend of the Pipers, used abstraction to refine and distil his depiction of nature. This appealed to John, as did the way in which this artist demonstrated the strength of a certain English tradition, for his vision of England looked back to the work of Paul Sandby, Thomas Girtin, and Francis Towne while also having a surface tautness that was modern. The two men had worked together on Contemporary Lithographs, but they may have met earlier, through Helen Binyon, Ravilious's friend and lover and the sister of Nicolete Gray. Helen, while living above Jim Richards and Peggy Angus, had invited John and Myfanwy to her flat-warming party. In turn, she had spent a weekend at Fawley Bottom in May 1937, when Miles Marshall was also present. They all went to a pub at Stonor. 'We seemed to booze a great deal,' Helen afterwards wrote to John Nash, '—one night we had rum in our beer ... rather good I thought.'[43]

By the following year, when John wrote a commentary for *Signature* on Ravilious's lithographs of shop fronts (published in book form under the title *High Street* by Country Life), he and Ravilious had become good friends.

While Ravilious was painting at Capel-y-ffin in February 1938, John and My-fanwy visited and took him to the local pub for a meal. John had with him some collages he had been making of Aberaeron and of Nonconformist chapels in which he had recognized an unsung feature of the Welsh landscape.[44] 'They came back here and helped finish my gin and Italian [vermouth],' Ravilious chatted in a letter to Helen Binyon, 'and we looked at John's pictures, mostly of chapels lovely colour and gay and some very good ones of beach scenes. He did three I think a day for which I frankly envy him.'[45]

Collage had permitted the return of subject matter in John's art. Later in life he would quote a famous tag by Ruskin—'There is nothing I tell you with more earnest desire that you should believe than this—that you will never love art well till you love what she mirrors better.' He had, he admitted, ignored these words for years, and so had also ignored intense, early loves. However, he did not regret his abstract phase, but instead felt that the business of placing pure colours side by side, in fairly simple and schematized patterns, had been a useful training. Similarly, he knew that by copying stained glass he had learnt something about the emotional use of colour. Interestingly, when he held his first major solo exhibition at the London Gallery in May 1938 his collages equalled in number his abstract paintings in oil. Paul Nash, in his preface to the catalogue, noted that both abstract and representational pictures were given rather similar titles.[46]

More collages were made in June 1938 when John travelled round Ireland with James Johnson Sweeney and his wife, Louisa. Sweeney had begun his career as an art critic and Harvard lecturer, had moved on to the Museum of Modern Art, New York, as curator of painting, and was eventually to become Director of the Guggenheim Museum. He was a great supporter of Miró and a good friend to Calder, who may have introduced him to the Pipers.[47] John loved this Irish trip, the coast, the Georgian houses, the chapel at Thurles, Shannonbridge, peat bogs ('Not enough peat bogs did I draw'[48]) and ancient crosses at Cardonagh in Ineshowen and elsewhere. He was especially smitten with Marble Hill, in County Donegal, a house which its owner was on the point of selling and which had prehistoric dolmens in its grounds. He reported on his Celtic finds to Kendrick, who had recently been elevated to Keeper of the British and Medieval Antiquities at the British Museum. Kendrick suggested that John should publish some of his photographs in the periodical *Antiquity*.

John Betjeman, if not present for the whole of this trip, joined John in Dublin, where they ransacked second-hand and antiquarian bookshops for

eighteenth-century travel books, especially those illustrated with aquatints. These stimulated Piper's growing interest in the Picturesque and fired in him a desire to revive this medium from a vanished age. By the end of 1939, as we shall see, he had published his own book of aquatints. But at the start of this year he was still working in an abstract vein in connection with the eight-foot-square abstract mural commissioned by the architect Francis Skinner for his flat in Lubetkin's Highpoint II in Highgate. This 'decoration', as John called it, was finally completed in March 1939 and a party was held to celebrate it. John commissioned a photograph of it, because Percy Horton wanted to include an image of it in the Tate Gallery's photographic exhibition 'Mural Painting in Great Britain 1919–1939'.[49] But recognition of his abstract work had come too late: in July 1938, immediately after his return from Ireland, he had said goodbye to abstract art in an issue of *Vingtième Siècle*. 'Abstraction is a luxury,' he insisted, whereas at the seaside subjects 'worthy of contemporary painting' presented themselves to him at every turn. 'Pure abstraction is undernourished,' he concludes. 'It should at least be allowed to feed on a bare beach with tins and broken bottles.'[50]

Towards the end of his life, he more that once claimed that he never sold an abstract painting. This is not true. But it reflects his awareness that abstraction had brought him scant financial reward. At a time when Myfanwy was pregnant with their first child, his May 1938 exhibition had proved a financial failure; and though there are many reasons why John abandoned abstraction, one is undoubtedly economic. As the birth drew near, Myfanwy went into St Mary's, Paddington, London, for there was no family doctor at that time in Fawley. And on 12 November 1938, Edward Blake Christmas Piper was born.

The birth of his first child coincides, in John's career, with his decision to return, as a painter, to the English tradition. This meant that places he loved, such as Cheltenham, with its Gothic Revival and Italianate architecture, and Stourhead, began to appear in his work. Many of the sites he now painted have a numinous quality associated with the *genius loci*. He sought out, for instance, Knowlton Rings, the Bronze Age stone and earth circles in Dorset, inside which sits a ruined medieval church said to be haunted. Here, as with Stourhead, he worked initially with collage, as if needing to find his way into these subjects in a simplified, near abstract fashion. But a sense of place and of history was now a determinative ingredient, as he set about remaking the English landscape tradition in modern terms. Justifying this ambition, he would later recall: 'the looming war made the clear but closed world of abstract art untenable to me.

It made the whole pattern and structure of thousands of English sites more precious as they became more likely to disappear.'[51]

His change of direction aroused a great deal of anger. He was aware that Ben Nicholson, Herbert Read, and others regarded him as a turncoat, a traitor to the modern cause and faithless to its creed.[52] Some form of defence was needed and John first began mounting it in November 1937, in an essay on modern drawing:[53]

> The tradition, once more, has to stretch. It always has to stretch—must be forced if necessary even to bursting point—to include anything and everything that has a pointed reference to life, however little it appears to agree, or be able to shake down comfortably with what has gone before it, or what we feel has got to come after, in point of time. People think it dishonest to be chameleon-like in one's artistic allegiances. On the other hand, I think it dishonest to be anything else. Not only must one change one's spots or stripes or other outward markings according to the influences one truly experiences, within oneself, but surely one's whole nature, *aesthetic-sensually*, as it were, should be susceptible of change.

His article ends with the injunction which André Breton had uttered in his speech at the International Surrealist Exhibition: 'Changez la vue … Changez la vie!'

More recently John Piper has been accused of insularity, of helping to bring about a Romantic Revival incompatible with the values of a wider and more cosmopolitan art.[54] This assumes that modernity was solely the prerogative of abstract art and could not be explored in other ways. It also suggests that all English abstract art in the 1930s was cutting edge and international in outlook, whereas its ideal of purity and clarity attracted some very dull minor followers whose names today are very little known. There is no doubt that John acted at the time with integrity. In 1943 he wrote to Paul Nash:

> After an abstract period what a release one feels! The avenue at Stadhampton, or the watercress beds at Ewelme are seen with such new intensity! But if one abstracts them finally, so that the posts are areas of colour, and the waterfall into the watercress bed becomes like a Ben [Nicholson] relief, then the result can be hung perhaps in Cork Street, but not hung against one's heart.[55]

His turning aside from abstraction does not devalue what he and Myfanwy achieved in the 1930s. In the pages of *Axis* and through the exhibitions with which they had been involved, they had helped focus attention on one of the defining issues of the decade—abstract art—the cause of sectarian dispute and, for a few years, symbolic of an international commitment to the modern. Without the Pipers' contribution, the debate surrounding modern art in England would have been less interesting and less informed, and the art produced visually the poorer. The young John Craxton was aware of this in 1942, when John invited him to Fawley Bottom and showed him his studio. This visit, Craxton recalled, 'did more than anything at that time to strengthen my purpose when it was most needed'. So he wrote to Myfanwy, after her husband's death, adding:

> I acknowledge a great deal of gratitude to you and John for you were both a small but very important group that in the thirties recognized and fought for what would be called the Modern Movement ... and that at a time in England when it required great courage and faith.[56]

10

Decrepit Glory, Pleasing Decay: 1938–9

'What would the world be, once bereft
Of wet and wilderness? Let them be left,
Oh let them be left, wilderness and wet;
Long live the weeds and the wilderness yet.'

—Gerard Manley Hopkins, 'Inversnaid'

John Piper's craving for richer solutions than abstract art could encompass was offset by the darkening situation in Europe. In mid-March 1939 Hitler had entered Prague, and the following month Mussolini invaded Albania. With Britain and France pledging support to Poland, Hitler's next objective, war became increasingly inevitable. The possibility of invasion cast English heritage and the English landscape in a different light: both were a source of national identity, but, made vulnerable by the threat of war, they now took on a new resonance. In order to address these subjects, a method of representation was needed that revisited the past through the lens of the present, a present thickened and enriched by awareness of history.

One useful discovery at this time was Christopher Hussey's *The Picturesque* (1927). It was a book much admired by Betjeman and one which John read and re-read with pleasure. He eventually became a friend of Hussey and on several occasions stayed with him and his wife at his home, Scotney Castle, in Kent, which overlooks a picturesque landscape, complete with ruined castle, created by Hussey's grandfather.[1] The Picturesque is a late eighteenth- and early nineteenth-century aesthetic which, in art, architecture, landscape gardening,

and poetry, fostered the pleasure afforded by variety, intricacy, contrast, concealment, balance, and surprise. Hussey made this aesthetic acceptable to a modernist by arguing that its use of artifice marked the first step towards abstract aesthetic values. Through the Picturesque, which he was to translate into modern terms, John found a way out of the modernist strait-jacket. When in 1939 he began to paint landscapes, buildings, street scenes, and townscapes, he did so with an eye for, in his own words, 'magnificent swagger', 'decrepit glory', or 'pleasing decay', phrases that register a connection with the Picturesque.

This change of direction was to have far-reaching repercussions, bringing him into closer alliance with the *Architectural Review*. Since 1936, when he had first published in the *'Archie'*, as the magazine was affectionately known, John had occasionally found himself invited to protracted lunches at which the editor de Cronin Hastings tried out ideas on contributors. John saw that Hastings had 'a streak of genius',[2] and he welcomed the titles that the editor coined for two of what would become his best known essays, 'Nautical Style' and 'Pleasing Decay', the latter phrase becoming a catchword for a picturesque approach to conservation. He was further allied to the *Architectural Review* in his willingness to reappraise the vernacular, an ambition in keeping with Hastings' divergent and sometimes contradictory aesthetic interests, for he wanted the magazine, in its role as an instrument of cultural policy, to promote both modernism and the Picturesque. He especially hoped the latter would sharpen appreciation of the dialogue between architecture and its setting, between the old and the new.

During the late 1930s, John's immediate contact at the *Architectural Review* remained Jim Richards. Both men had embarked simultaneously on family life and this fostered their friendship. Jim and Peggy Richards' daughter Victoria was born the same year as Edward Piper, and the Richards' son Angus, born 1939, preceded the Pipers' first daughter Clarissa, born on 18 January 1942. But the demands of small children could not dislodge their first love. 'There's such a lot I wanted to talk to you about,' Peggy once wrote to Myfanwy, '—but I couldn't get a word in edgeways for Jim and John's non-stop archi-talk.'[3] After his death, Myfanwy hinted at Jim's prickly charm:

> We got to appreciate his very personal style: sometimes gruff to the point of churlishness, a sense of humour that was so throw-away that if you weren't careful you could miss it altogether, a capacity for loyalty that could be obstinate, and a tendency to uprightness that could be puritanical, even priggish. With all this went an insatiable interest in people, places, buildings, and ways of life.[4]

For the purposes of the *Architectural Review*, Jim and John began touring parts of Britain by car, taking photographs, gathering ideas for articles and finding interest in places and things that most ignored or regarded as commonplace. Out of these expeditions, Richards claims, 'came articles (some written by me but most by Piper, and illustrated by his photographs and sometimes his own drawings) on such subjects as pubs, lighthouses, country railway-stations and Nonconformist chapels'.[5] With hindsight, the demotic stance adopted in these articles can be seen as a riposte to the somewhat elitist idealism of high modernism.

The first outcome of their collaboration was Richards' 'Black and White: An Introductory Study of a National Design Idiom', published November 1937 and illustrated with his and John's photographs of black-and-white surface decoration, as found on Belisha beacons, chequered kerbs, road signs, and bollards. This workaday idiom, still popular today, is traced back to a nautical tradition which uses black and white in the painting of boats, notably white lettering on black gunwales, as well as in the paraphernalia found on quaysides: posts, capstans, signal masts, railings, lighthouses, and beach huts. Here we find Rose Cottage, the black-painted house which John had rented on the beach at Rye Harbour, for tar and whitewash are shown to be two principal decorative means in seaside architecture, with lime-washed walls often offset by tarred plinths and black-painted window frames. The restraint inherent in the use of black and white, Richards claims, 'allows the satisfactory geometrical forms from which the buildings are composed their maximum effect'.

This article formed a prequel to the visual culture perspective which John adopted in 'The Nautical Style' and 'Fully Licensed',[6] both of which reached a wide audience, in revised and expanded form, when republished in 1948 in a collection of his essays, *Buildings and Prospects*. 'Fully Licensed', a lavishly illustrated article, enthusiastically embraced gin palaces, public houses, and coaching inns. It drew upon places John and Richards had visited, between 13 May and 8 June 1939, during a tour of East Anglia and the Midlands. It stands in opposition to Ben Nicholson's aesthetic exclusivity, in that the public house, from its modest, functional beginnings through to the vigorous decoration often associated with this genre of building, exhibits not pure form but a functional pragmatism. John delighted in pub façades that displayed a few classical or strongly decorative features as well as characterful, if sometimes clumsy, lettering. He admired the conviction expressed in much pub design, based, as it often is, on a deliberate absence of good taste. ('Good taste is out of date before the "regulars" have got used to it. It is absent from all the best and most successful public houses of any date.'[7]) At one point he walks his readers

around the interior of an average East Anglian pub, noting every detail of its architecture, furnishing, and decoration, with a detachment seemingly akin to a surveyor's report. But his conclusion is pointed: 'The charm of the room is not self-conscious and nobody troubles to analyse it or preserve it.'[8]

Likewise, in his razor sharp essay 'The Nautical Style' he promoted, not the ideals associated with high modernism, but the demotic. Here, again, the underlying intention, as with the Shell Guides, was to make the reader look more intently at his or her surroundings. 'The Nautical Style' praised, among other things, the uncompromising geometry and symbolic colouring of huge, metal, conically shaped buoys. A store-full of these buoys, usually seen half-submerged and far out to sea, was found at Penzance, waiting to be repaired and painted, by Piper and Richards in May 1937, in the course of a ten-day tour round coastal resorts in Devon and Cornwall. They promptly wrote to Trinity House in London, requesting permission to photograph them and delayed they journey in order to do so. Elsewhere in this article, John finds 'coastal gaiety' in whitewashed bollards and in the romance of lighthouses; in coastguard cottages and flagpoles; and in the bay window which, at the seaside, 'blossoms and riots ... in the spirit of a Rowlandson print'. 'No one', commented Timothy Mowl, 'had written from quite such an anarchic, wonderfully persuasive viewpoint before.'[9]

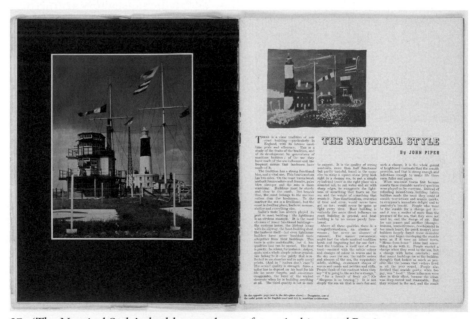

27. 'The Nautical Style', double-page layout from *Architectural Review*.

While extolling the trimness, purposefulness, and swagger of maritime design, John revealed his responsiveness to the seaside manner in all its cultural manifestations. Almost certainly the success of 'The Nautical Style' led to the television programme *A Trip to the Seaside*,[10] which John and Myfanwy devised together for the producer, Mary Adams, then a leading figure in the BBC. Transmitted 10 June 1938, it offered a verbal, musical, and visual kaleidescope: shipping forecasts mingled with quotations from Matthew Arnold, William Faulkner, and Max Beerbohm; photographs of Bexhill Pavilion, Brighton Pier, Porthleven, with an object by Paul Nash and paintings by Nash, Wadsworth, and John; and there were images of gulls, sunbathers, crowds on the front, foghorns, and the contents of a seaside shop, with its shell boxes, bars of rock, and pattern-books, as well as a prop which the Pipers had constructed out of seaweed, mine balls, cork, and stones worn smooth by the sea.

Both this television programme and 'The Nautical Style' were part of John's bid to make people look at things with fresh and unprejudiced eyes. Here he is, insisting that no seaside resort is more full of visual pleasures, contrasts, and differences than Brighton:

> The great yellow and white façade of Brighton is ranged along the Parade, to face the incoming breakers. The piers, the fishing boats pulled up on the shingle, the bandstands and shelters, the Georgian and Victorian and Edwardian hotels and lodging houses all act up. The bow windows and porticoes, the wide pediments and barge boarded bays of Regency Square, the great Black Rock and Brunswick Square curves and sweeps, the late Victorian yellow brick at the far end of Hove—all these keep up the seaside spirit. They make thousands of people remember Brighton, and long to return to it; they are the proper background for popular English seaside life.[11]

Noticing the way the salt in the air takes the freshness off new paint and plaster, he argues that one of Brighton's charms is the way in which the clean rain exposes pale browns and greys, clear yellows and white, 'so unlike the predominant dark stone and general dinginess of Pimlico or Shepherd's Bush'.[12]

Similar shades can be found in the hand-coloured copies of *Brighton Aquatints,* a book of twelve aquatints John published in 1939. In 'The Nautical Style' he had claimed that Brighton's Regency architecture 'is worth fighting for', and the approach and onset of war may have sharpened his nostalgia for this town. The aquatint medium is more usually associated with late eighteenth- and early nineteenth-century topographical guide books, of which Betjeman owned a fine

JOHN PIPER

BRIGHTON AQUATINTS

Twelve original aquatints of modern Brighton
with short descriptions by the artist
and an introduction by
LORD ALFRED DOUGLAS

1939

DUCKWORTH, 3 HENRIETTA STREET, LONDON, W.C.2

28. *Brighton Aquatints*, 1939. Title page.

collection. He had encouraged John to buy the same in secondhand bookshops in Bath, Bristol, and Dublin and then suggested that he should make his own book of aquatints and that Brighton might be a good subject. John had looked at aquatints when young, but in order to acquire expertise in this medium, in which areas of tone are gradually deepened through successive immersion of the copper plate in acid, he went back to the Royal College and took lessons from a technician in the Department of Engraving. His *Brighton Aquatints*, with its mixture of typefaces on the title page and use of coloured paper for the text, reflected Betjeman's intense interest in typography and book design. Published in time for Christmas 1939, its plates were handprinted by A. Alexander and Sons, Ltd., and then passed to the Curwen Press, the book's designer and maker. It came out under the Duckworth imprint, Mervyn Horder, its chairman, taking great pleasure in the book. It made him a close friend of the Pipers and from then on a frequent visitor to Fawley Bottom.

John Betjeman's suggestion that Lord Alfred Douglas should write the foreword was a far from obvious choice. Douglas, once a publicly disgraced

homosexual, had become a largely forgotten figure, living in Brighton, poor and alone, almost friendless, married to a woman he rarely saw though she was living in the same town. His poems had excited Betjeman as a schoolboy, and a letter he had written to their author had begun a lasting friendship, 'Bosie' becoming a regular visitor to the Betjemans at Uffington. Douglas agreed to write a foreword to *Brighton Aquatints*, on the condition that the meeting between himself, Piper, and Betjeman should take place in the vicinity of Victoria Station, in easy reach of his train home. They duly met at Overton's, the famous fish restaurant.

Douglas's text adds another layer of interest and nostalgia to this book. Having lived for ten years in Brighton, he was able to contrast its contemporary reputation for squalor with his childhood recollections of visits to the town in his father's company:

> in the summer months it is invaded by a huge army of 'the unwashed of Ipswich' (that is to say, metaphorically speaking, for, of course, they have no actual connection with Ipswich) and 'the front' becomes almost impassable and quite intolerable. Whereas at the time when my father used to sit nightly with me in the 'lounge' (horrible, but now firmly established word) of the newly-built Metropole Hotel, and when goat-carriages still abounded on the front, it was a place given over to the most profound decorum and placid respectability. It was also intensely 'fashionable'.[13]

Douglas was delighted to discover from John's prints that many of the old landmarks had survived. John, meanwhile, wrote to Betjeman: 'I can, I expect, never thank you enough for getting that foreword for the aquatints. I think it is quite perfect. With what charm of phrase (personal and not antiquated) does he generate the right nostalgia. Better than Max Beerbohm.'[14]

The book opens with the 'magnificent swagger' of the First Avenue Hotel, Hove, with Queen Victoria, in dark bronze, on a pedestal, looking out to sea. 'Victorian architects let themselves go in Brighton; the air and the clients were encouraging,' John comments. Each plate is accompanied by a brief text in which, with wry humour, he draws attention to salient characteristics of the scene. The two piers 'look as if they are trying to project Brighton's swagger half across the Channel'. The Royal Pavilion has, for him, a 'Hindu fancifulness' that inspired its froth of architectural detail and onion-domed skyline:

> It has been called all kind of rude names by generations of residents and visitors, but most people start by laughing and later develop a great affection for it. It has an extravagant beauty, and in some ways reflects exactly the

effervescent spirit of the great holiday resort itself in its most hilarious and human moods. It is at once acutely vulgar and extremely sensitive.[15]

He then passes lightly over the history of this building before remarking: 'During the War it was used as a hospital for wounded Indian troops, who must have found it only vaguely like home.'

His pithy descriptions uphold the wit and grace of the whole. We are introduced to West Pier ('a dazzling white meringue, brittle and sweet'); and shown a view from the station yard, common to many towns ('but in few others is the air so clear, the whole *look* of the place so sharp and clean'), of terraced houses climbing the hillside towards Kemp Town; we are encouraged to admire 'the combined ebullience and restraint' of Regency stuccoed terraces; and generally made aware of the way in which Brighton conveys 'with equal affection its seediness and grandeur, its open frivolity and it surreptitious charm' (Plate 15). John leaves the reader in no doubt as to his own affection for this town.

In one of the prints, *The Chapel of St George, Kemp Town*, pieces of newspaper were added to the plate to create texture, a modernist technique at odds with the old-fashioned lettering and format adopted by this book. Today it has become a bibliographic treasure, but in 1939 its counter-modernity must have puzzled many. In *Time and Tide*, Gwen Raverat, reviewing the book, acknowledged its appeal but questioned the means used: 'I am not quite convinced that aquatint, with its delicate precision of tone, and Quaker reticence, is the right medium for Mr Piper. ... I cannot help wondering whether the freedom and dash of colour-lithography would not have suited him better in his Brighton mood?'[16] Meanwhile Sir Osbert Sitwell, who had himself written a book on Brighton, had received a review copy of *Brighton Aquatints*. As he turned the pages, he found, to his astonishment,

> a complete interpretation of a town—a city, more than a town. It was extraordinary that such vistas, spiritual and physical, could be obtained, with such comprehension manifested, within the light framework of this medium: unbelievable, too, the sureness with which, in a few strokes, he translated to the page the very material wherefrom a terrace, a portico, a church was fashioned and conveyed the weather in which they were suspended under a canopy of blue, imbecile sky or stampeding sheep-like clouds, or among the bell ropes of the rain.[17] (Plate 16)

His full-page review in *The Listener* observed that Piper's drawings manifested 'all the quality, the ease and speed, of beautiful handwriting'.[18] 'Naturally,' John later admitted, 'I was as pleased as a dog with several tails.'[19]

Soon after *Brighton Aquatints* had been published, John persuaded Mervyn Horder that his next subject should be Stowe. He had first visited this eighteenth-century landscaped garden in the early 1930s, less than ten years after the founding of Stowe school in 1926. At the time he encountered 'much more untidiness, more dilapidation of buildings and more "pleasing decay" '[20] than he ever found again, when he began making more or less annual visits, always carrying with him the letter, granting him permission to use the park 'without let or hindrance', which the first headmaster, J. F. Roxburgh, had provided.[21] But it was in 1939 that Stowe, with its grand house and menagerie of carefully sited buildings, its huge south lawn, lakes, Palladian bridge, glades and streams, and ever-shifting views, cast its irredeemable spell on him.

Looking back on his earlier visits John realized that he had encountered Stowe at its most romantic, when the trees were at their prime and the buildings in a state of decay and as yet unrepaired. Stowe, Mark Girouard writes, had 'acquired an edge of drama and intensity',[22] for behind its dilapidation lay a tale of pride and aggrandizement leading to ruin. In the eighteenth century Stowe had been a site of national importance, both politically and aesthetically, and the family had climbed to a Dukedom. But mounting debts had obliged the 2nd Duke of Buckingham in 1848 to auction the contents of the house in a sale that lasted eight weeks. His descendants lived on in the house, in shabby gentility, but in 1921 the house and what remained of its surrounding estate and contents were sold, this sale lasting nineteen days. This event is memorably recorded in a two-volume sale catalogue, the first, dated 4 July 1921, offering as one lot: 'Stowe House with Kitchen Gardens, the Temples and Fixtures specified in the particulars, Gardens and Grounds, Six Lodges or Cottages and Corinthian Arch'. But it was the second of these two catalogues, 'with its gorgeously gloomy, brown photographs of the Doric Arch, the Temple of Ancient Virtue, the Grenville Monument and so on, all clutched by unlopped branches and approached across the foregrounds of unmowed grass'—which, John claimed, powerfully caught the atmosphere of the place when he first saw it.[23]

War interrupted his desire to do a book of prints based on Stowe. And though this ambition was revived in the late 1940s,[24] it did not come to fruition until many years later, and then in an extremely lavish, slightly overblown form. But it was at Stowe, as John admits, that his attitude to landscape and to architecture changed.[25] Here he experienced a tension between the ideal and the changing, between order and decay. Behind the creation of Stowe lay the notion of Christian Paradise and classical Elysium or Arcadia.[26] Whether or not

the visitor recognizes this topos, it is impossible not to respond, on entering this landscape, to the sense of an enchanted world. It is, however, a world not removed from time, but subject to it and, affected by natural forces. If aerial photography had encouraged John's interest in the layering of history, Stowe stimulated further this interest by offering in its landscape and in its buildings a museum of Georgian styles. ('Stowe has been a great education to me,' John acknowledged, many years later.[27]) It also demonstrated how our awareness of the past in the present is mediated by time, weathering, and decay. From now on these agencies were to become significant ingredients in John's paintings of buildings and landscape.

In August 1939, shortly before war began, John and Myfanwy took a holiday in Wales, leaving Edward in the care of Myfanwy's mother in London. They visited many places, including Welshtown, Tregaren, and Aberaeron, but mostly stayed on a farm near Pontrhydfendegaid in Cardiganshire, on the edge of the so-called 'Great Desert' of Wales, an area of undulating upland where nothing grows and there are few roads. Its 'weird solitudes', as one guide book remarks, either depress or fascinate, for 'in its sterile grandeur this strange region suggests some primitive forgotten land'.[28] Driving round in his old Lancia, John admired the peat bogs and the lakes, especially the Teifi Lakes, found high up amid these bare hills.[29] This arid scenery seems to have encouraged experiments with watercolour and with painting on glass, which he then transferred to paper as a monotype print. This method reinforced the abstract features in the landscape, encouraging a deliberate flatness in the presentation of the imagery. David Fraser Jenkins has observed that the emptiness of this landscape had a particular appeal: 'His art needed to be built again from a place where nothing existed.'[30] John himself wrote: 'It is a landscape to be seen in summer evening light, with its grey stone patches, its deep brown gashes of peat in the bog and occasional peat stacks, and its small dark blue lakes.'[31]

This holiday afterwards seemed to Myfanwy 'the most enchanted fortnight we have ever spent'.[32] A record of the churches, inns, and landladies they encountered, and the food they ate can be found in the journal she kept, in gazeteer language similar to that used by John in his travel diaries. They stopped at Hay, then Clyro where Kilvert had been curate, before reaching Hafod, the house and estate which, in the late eighteenth century, had achieved supreme status as an example of the Picturesque, largely owing to George Cumberland's book, *An Attempt to describe Hafod* (a copy of which John owned). During their initial reconnoitre, John and Myfanwy discovered that

29. Hafod in 1939.

Wyatt's church had burnt down and been rebuilt and expensively furnished in 1932. 'Absolutely hideous, filthy taste—worse than Mother's Union,' Myfanwy grumbled.[33] That first night they stayed at the Miners Arms at Pontrhydygroes. The next day they journeyed to the remote Strata Florida Abbey, which John painted. They also learnt that accommodation was available on the road back

to Pontrhydfendegaid. They found the house, arranged to stay, and filled their room with books they had bought, then went off and bought more in Aberystwyth, in a bookshop which happened to be selling a collection that had once formed part of Hafod's library. They also saw the agent for Hafod who gave them a permit to go where they liked. And the following day they set off with sandwiches to explore what John described in a letter as 'a most beautiful estate in Cardiganshire now in a state of dereliction'.[34]

Few fail to respond to the romance and tragedy of this isolated folly. Though today all that remains of the house—blown up with dynamite in 1958—is a pile of stones, half-buried beneath grass and weeds, its history lives on in Elisabeth Inglis-Jones's book *Peacocks in Paradise* (1950) for which John designed the book jacket. She describes how Thomas Johnes discovered this mountainous region in the upper part of Cardiganshire while travelling the area as its MP. An educated man who had spent two years journeying around Europe, he was overcome by its great natural beauty, its sweeps of moorland, racing streams, and flashing waterfalls. After the death of his first wife, he returned to this area determined to transform Hafod, which means 'summer dwelling', into an earthly paradise, by means of the Picturesque. By 1785 he was living there with his second wife and their daughter, Mariamne, and the following year the foundation stone of a new house was laid. It was built between 1786 and 1788, in Gothic style by the Bath architect Thomas Baldwin on a plateau near the bottom of the valley, looking across the River Ystwyth. Later, Johnes commissioned an extension from John Nash, which included an octagonal library, capped with a Moorish dome and connected to a conservatory, to house his magnificent collection of books.

Johnes's munificence was not confined to the house. Intent on 'making the wilderness smile', he planted over two million trees on the mountain sides. He commissioned garden statues from Sir Francis Chantrey and created a Garden of Eden at the end of a shady path above the river, ornamented with two archways and Coade Stone heads of Adam and Eve, as well as another walled garden, crowning a high knoll, specifically for his daughter. He cared also for his labourers and built cottages, roads, bridges, a church, and two schools in this 'Happy Valley', as he called it. In the cultivation of his estate he was guided by two leading authorities on the Picturesque—Richard Payne Knight, who happened to be his cousin, and Uvedale Price, both of whom came frequently to Hafod. But there was no end to the novel adornments that Johnes devised: at one point a flock of peacocks were loosed in the woods.

The library was filled with his ever growing collection of rare books. In addition, he bought a printing press and for six years ran the Hafod Press. He

also translated Froissart's *Chronicles* and Monstralet's *Memoirs*, and received many visitors, for the fame of Hafod had spread widely. But at the same time he watched in agony as his daughter, Mariamne, suffered an illness that left her imprisoned in a deformed and humpbacked body. Then in 1807, a fire, thought to have been caused by a warming pan in the housekeeper's bedroom, reduced the house to a charred skeleton. Story has it that the heat was so great it carried Johnes's books into the air and tossed them over the mountains. Stunned and under-insured, Johnes was not, however, beaten, and within three years Baldwin had reconstructed the house. But tragedy was to strike again, with Mariamne's untimely death. After this, Hafod began to lose its hold over Thomas Johnes, who died in 1816.

Hafod had been frequently visited by artists, including Turner and the topographical draughtsman John Smith (a great favourite of Lord Warwick, whom he had accompanied to Italy, with the result that he became known as Warwick Smith). John at some point acquired a book of Warwick Smith's *Tour of Hafod*, containing views of the house and the surrounding scenery. In his own watercolours and drawings of waterfalls and the surrounding landscape, he deliberately adopted an antiquated style, akin to that of an eighteenth-century topographical draughtsman. The house, which he photographed and painted, had been altered after Johnes's death by Sir Henry de Hoghton, who had employed Nash's pupil Anthony Salvin to build an Italianate wing. Hoghton went bankrupt before this part of the building was completed, and it remained un-floored and unplastered, as John found it in 1939 'a cavernous shell in which bats tumble and rats scuttle'.[35] But it added to Hafod's clash of styles which caused George Borrow to marvel at what he saw in the mid-nineteenth century:

> A truly fairy place it looked, beautiful but fantastic, in the building of which three styles of architecture seemed to have been employed. At the southern end was a Gothic tower; at the northern an Indian pagoda; the middle part had much the appearance of a Grecian villa. The walls were of resplendent whiteness, and the windows, which were numerous, shone with beautiful gilding.[36]

Almost a century later, the Pipers, leaving behind the tourist-ridden Devil's Bridge, found the house derelict and forgotten in this valley of trees. 'John drew all day,' Myfanwy recorded.

> I sat about, surveyed the prospect, walked to Pontrhydygroes for cigarettes and back. We climbed the knoll across the river (beer coloured, fast flowing, no fish because of lead poisoning) and looked down on the house. Decided

it would be wonderful to buy it and pull down new Italianate and live in Nash's part. Rare and beautiful geranium still sadly in the orangery. Sheep peering from every urn and pillar on the terrace.[37]

The two of them had spent several days exploring Hafod, in sunshine and rain, seeking out aspects of the estate that are a part of the Johnes' family story, including Mariamne's flower garden with its robin's grave. 'Woods here very pendant,' Myfanwy noted, 'wonderful atmosphere of decay and sadness.'[38]

'Hafod is a dream,' John wrote to Betjeman, triumphantly telling him of their discoveries:

> There is also a Soane-esque obelisk to the Duke of Bedford looking over a torrent and 2000 acres of larch and beech. Also an artificial gully blasted out of slate and rock down which the Ystwyth pounds, and three gothic arches looking over it. I slipped on a rock there yesterday, and my sketchbook fell into the rapids (containing a week's work). It was swept away, but the wonderful Myfanwy hearing my shrieks bounded downstream for half a mile and saved it. We dried all the drawings under the beech trees in that empty fastness for the rest of the afternoon. We will try to find out the price, but I fear 7000 acres and 14000000 decrepit trees. But its beauty and remoteness! Only 2 aeroplanes since we came here, and they were going their peaceful way to Ireland. Yours in the name of the Lyn Fryddyu Fâch by the Cribbyn Du.
>
> William Blake Richmond
> Lady Windermere sends her love and her fan.[39]

Their explorations of Hafod alternated with visits elsewhere, to the coast and up into the hills where they bathed in cold and terrifying lakes, mindful of serpents or weeds that might snatch them into unseen whirlpools. 'Incredibly lovely views all day,' Myfanwy recorded after one expedition, 'crumbling green mountains, small rare graystone outcrops, peat brown gashes in the bog and a few stacks.'[40] John spent one evening correcting proofs of the Shell Guide to Shropshire. Another day was spent at Aberaeron, a small Georgian harbour town which they both admired. 'Drank at the Feathers Royal Hotel,' Myfanwy's diary records, '—well known to us as one of the nicest bars in the country— walls and ceiling painted thick beer and varnish colour. Shining brass, brown patterned mugs—also pewter. Stout dark friendly barmaid.'[41] The longer they stayed in this part of Wales and talked with the locals, the more they learnt about Hafod and its hidden treasures. And they bathed regularly in lakes or the tumbling Ystwyth.

Afterwards John wrote two articles on Hafod, one for the *New Statesman and Nation,* another for the *Architectural Review.* The first tells of 'gorges blasted through rock, moss walks through groves, and a tunnel giving on to an impressive cascade and whirlpool,'[42] as well as architectural ruins while the second continues the threnody:

> Tragedy, on the whole, has triumphed at Hafod. In the house some of the original Gothic fireplaces remain. Most of the fittings are Victorian. Plants wither in pots on the decaying shelves in the Gothic glass-house. The woods up the valley are dishevelled; their paths overgrown and often impassable because of the trees that have fallen across them. There is no game in the woods and the river has been polluted by the lead mines at Cwmystwyth, higher up, so it holds no fish. The lead mines, in their turn, are dead. But the beauty of the whole place in decay is overpowering.[43]

Everywhere the trees, he notes, were in a state of 'decrepit glory', a phrase identified by de Cronin Hastings as the title for this essay.

On their return from Wales the Pipers went to London by train, to collect Edward, and were met by Jim Richards at Paddington, where they gossiped over coffee in the station buffet. Richards learnt that one of John's pictures had just been bought for the Contemporary Art Society by Kenneth Clark, Director of the National Gallery, and that the Leicester Galleries had promised him a show in the spring of 1940.

The painting chosen by Clark, and subsequently given by the CAS to Leeds City Art Gallery, was *Dead Resort Kemptown.* A transitional work, it shows the artist engaging with an architectural scene in such way that the abstract nature of colour and form are not denied. Each shape is clearly demarcated, contributing, jig-saw-like, to the composition as a whole. In places he has scratched into the top layer of paint, for atmospheric effect and to enhance our awareness of the picture's surface and the artifice of art. This need to acknowledge art's dual role was something he admired in Walter Sickert's work. His paintings showed a 'double sensitivity … to paint and to the thing seen'. It was this, he felt, that gave them style.[44]

Kenneth Clark's acquisition of *Dead Resort Kemptown* affirmed the direction in which John's work was moving. A powerful figure in the art world, suave and cultivated, Clark had studied under Bernard Berenson and had published *The Gothic Revival* as well as a scholarly study of Leonardo. Such was his energy, erudition, and personal charm, he had, in 1933, at the age of thirty, been offered the Directorship of the National Gallery. He stepped into this role on

1 January 1934, also by then having become Surveyor of the King's Pictures. In 1937 he was knighted. Looking back on the years 1932–9, Clark recollected that he and his wife, Jane, were borne on the crest of a social wave, in demand everywhere. 'The Great Clark Boom', as he referred to this period in his autobiography, succeeded in making him a Maecenas, with a wealth of connections. This, combined with his enthusiasm, knowledge, and taste, made him very persuasive and gave him far-reaching influence. His acquaintance with the Pipers had begun when the Calders took John and Myfanwy to tea at his house and Myfanwy had challenged Clark's negative views on abstract art. His antipathy to abstraction explains why, despite his commitment to contemporary British art, Clark had previously shown no interest in John's art. But in choosing *Dead Resort, Kemptown* as a CAS purchase, Clark validated John's decision to make the built environment and topography the locus for his thoughts and feelings. It was a timely piece of encouragement, for the announcement, in September, that Britain was at war with Germany gave additional urgency and purpose to the direction in which his art was moving.

11

'The Weather in Our Souls': 1939–40

Tension and uncertainty followed the announcement of war. Myfanwy offered to support the Red Cross, John joined the Home Guard. Aware that some form of service would soon drastically circumscribe his creative life, for he was not a conscientious objector, he also approached the Central Air Photograph Interpretation Unit run by the RAF at nearby Medmenham and let it be known that he was willing to join up. In the lull that followed he read a life of John Sell Cotman, thought long and hard about the nature of English art, and embarked on a series of topographical watercolours. To Sir Michael Sadler he explained:

> The war has driven me to do a thing I have for long wanted to do—draw some old churches in Oxon and Berks. Also I have been reading Kitson's life of Cotman, and these things have made me think very much of your Cotman drawings of Norfolk churches. Would you let me see them again? John Betjeman is coming tomorrow to stay with us until Wednesday evening, and it would be delightful if we could both come over for an hour one afternoon. He recently found in Bristol a copy of the Cotman Norfolk etchings, so he is equally interested.'[1]

This same month, October 1939, the two friends journeyed to Mildenhall, near Marlborough, to see a church untouched by the Victorians, with late Georgian Gothic furnishing, two three-decker pulpits either side of the chancel arch and box pews.[2] Betjeman was also pleased to be given a fine view of his church at Uffington for he admired in John's watercolours of churches 'a rapidity and accuracy, an affection and humour, a feeling for texture and surrounding landscape'.[3] They were, he told Kenneth Clark, the best modern

149

watercolours he had seen. 'He can do Gothic Revival or genuine Norman or the most complicated Geometric tracery with equal facility, he gets all the texture of lichened stone and no niggliness and lovely deep recessions.'[4]

Behind this work lay Cotman's example. In Sydney D. Kitson's biography of this artist, published in 1937, John had found a serious, engaging book. It is still essential reading on Cotman, despite the fact that Kitson's emphasis on this artist's austere vision and instinct for pattern-making has been overtaken by a greater interest in the sociopolitical connotations of his subject matter.[5] But for John, who had recently returned to the painting of landscape and architecture, it made enthralling reading, for he could follow in Cotman's wake and share in his discovery of decayed, ruined, and sometimes unrecorded churches. He not only registered Cotman's passionate enthusiasms, so vividly expressed in his letters,[6] but also found a quotation by Ruskin, on Turner's *Wethercote Cave*— 'Of all the drawings I think those of the Yorkshire series have the most heart in them, the most affectionate, simple, unwearied finishings of truth'—which he incorporated into one of his *Spectator* reviews.[7]

His empathy with Cotman first emerged in written form in the November 1940 issue of the *Architectural Review*, in 'Towers in the Fens', an article sumptuously illustrated with Cotman's etchings as well as his own photographs of churches, spires, and Fenland skies, many of them taken during his May 1939 East Anglian tour with Jim Richards. His theme is again beauty in decay, as seen through the painter's eye.

The best churchyards in the Fens have long grass, bent in the wind, tangled and brown here and there between the grey and ochre gravestones, matted round the base of the church walls. New green grass eddies with the breeze into the angles of the tower buttresses. These buttresses have been worn by the weather into shapes with contours that Cotman was a master at representing. From a distance their upright outlines are straight enough, but straight and upright with an unaccountable richness. Closer, they are seen to have dissolved away round their stratified core of stone as if they had been under water or had been sand-blasted by a vague and artistic mechanic. The serrations in the surface of each block of stone are as deep as the gaps made in the joints by the weather, and so the substance of the wall has become a sculptural whole, its surface carved by nature with infinite feeling and mastery. It is incised and pitted by the weather; lichen stars or spreads it with yellow and gold; the mouldings of windows and arcades have become encrustations of curving ribs.

John Sell Cotman set out to etch 'all the ornamented antiquities in Norfolk' in 1811. Most country churches were then at an extreme of beauty.

Ready to drop like over-ripe fruit, they were in an exquisite state of decay. In almost every village church a derelict wicket gave onto a porch strewn with straw, and a creaking door led into a nave full of worn grey box pews. The walls were patched with new plaster in places; in other places scored stonework was visible where the old plaster had fallen away and had not been renewed. Clear glass windows let in the sunlight that streamed over the faded umbers, ochres and greys of the walls, furniture and floor, and the whole scene was enriched by the splash of brilliant red of the tattered hangings on the high pulpit. There was, too, the jewelled colour of fragmentary glass in the tracery lights.[8]

He goes on to praise Cotman's ability to capture the clear light of East Anglia and his understanding of the relation of the church to the landscape: 'The archaeologist and the topographical draughtsman had not been struck by this last point. Cotman was: and his drawings are still alive and real in consequence.'[9]

Two years later, the centenary of Cotman's death gave John a further opportunity to write on this artist in the *Architectural Review*.[10] By then Cotman's love of ruins and feeling for the picturesque seemed very much in sympathy with the tide of romanticism that had once again entered English art. He had become something of a cult figure and this year the *Burlington Magazine* published a special number devoted to his art.

The work of Cotman, Turner, and others had shown John the place that medieval ruins occupy in the romantic imagination. Aware of their cultural significance, he had begun recording the desolation in ruins before any bomb fell on Britain. As a young man he had recorded Netley Abbey in an antiquarian style. In 1939 he began painting ruined abbeys, including Lacock near Melksham, Byland in Yorkshire, and Llanthony and Valle Crucis, in Wales. Edward Pugh's *Cambria Depicta*, a book John knew well, describes the awe and almost religious fear which Valle Crucis Abbey inspires: 'The beautiful ash and other trees which fill the area of the building add to it an air of solitude and melancholy, strongly denoting it a place wasted and forsaken by man.' Something similar can be felt in front of Piper's wartime images of derelict cottages and ruined barns, some so decayed they seemed to be returning to nature. As symbols of vulnerability and impermanence, they too played into the mood of wartime melancholy.

Ruined abbeys, cottages, and barns all invited rich treatment of the picture surface. To make this possible John began preparing his canvases with an irregular gesso coating, afterwards applying thin coloured glazes as underpainting. It had become his habit to draw on the spot with pencil, black and coloured inks, chalks (both pastel and greasy crayon), watercolour, and gouache, and

151

to turn to oils only when he was back in the studio. There he had time to reconsider and to arrive at images with greater deliberation. Around 1941 he also embarked on a series of erotic nudes —('G'lox [Myfanwy] posed well, though grumbling a lot,' he wrote to Betjeman)—which initially he intended incorporating into views of ruined buildings,[11] as if wishing to emphasize the naturalness within decay.

One friendship of importance to John at this time was that with Geoffrey Grigson. Now employed as Talks Producer at the BBC, Grigson had been moved from Evesham to Bristol, whence he bicycled each day from Chewton House in Keynsham, Wiltshire, leaving Bertschy, his second wife, alone with two small children. John visited them there, and, Grigson, in turn, stayed at Fawley Bottom Farmhouse. For a period it became the Grigson family base, for Bertschy, finding Wiltshire in wartime lonely and dispiriting, decamped to the Pipers, whence Geoffrey joined them at weekends.

Both men were at this time immersed in the Romantics. John read Wordsworth, Coleridge, Gerard Manley Hopkins, writers on the Picturesque and Ruskin's *Modern Painters,* and, in 1942, Dorothy Wordsworth's *Journals* when for the first time a complete and unabridged edition was published in two volumes. The following year he recommended them to Colin Anderson ('No gentleman's library is complete without these. Dot I believe a great genius').[12] Grigson, whose wide reading made him a genius as an anthologist, was compiling a collection of writings by the Romantics. A stimulating companion, his special enthusiasm for Samuel Palmer's unfettered romanticism spurred on John's interest in British romantic artists. When he published a book on this subject in November 1942, the copy he gave to the Grigsons bore the inscription 'to G. and B. with much love and acknowledgements for facts and fancies pinched wholesale'.[13]

In turn, Grigson's anthology, *The Romantics,* also published in 1942, is dedicated to John, in acknowledgement of their shared enthusiasms. Under the dedication, Grigson named places of special importance to them both—Bupton, Clevancy, Hafod, Fawley, and Snowhill[14]—and some of which they visited together. When traveling on his own, Grigson developed the habit of sending John almost daily letters, recounting his journeys on foot or bicycle through the countryside. His intense responsiveness to nature took in landscape formations, rocks, caves, flora and fauna, weather conditions, and effects of light, while at other moments he looked at landscape through the lens of his aesthetic predecessors, particularly those who were inheritors of the legacy of William Gilpin and the Picturesque.

John, too, did this when he and Myfanwy returned to Wales in the summer of 1940, to the picturesque area around Denbigh in the Valley of Clywd, where he drew the same stretch of the vale that Girtin had painted. When Sir Michael Sadler bought this work, John sent him a postcard of a Girtin watercolour in the British Museum, with the explanation: 'His gap in the hills (looking towards Chester) is the gap on the left in my drawing.' While in Wales he was also seized by a desire to draw waterfalls and found twenty-two in all.[15] 'Wales is heaven,' Myfanwy wrote to Betjeman. 'We are bicycling up and down mountains and waterfalls.'[16]

But it was still Cotman who remained foremost in John's mind. At a time when bomb-damaged buildings had become a prominent wartime feature, he wrote of Cotman:

> He was much obsessed by death and decay in old buildings. ... He saw a des-ecrated chapel or a decrepit brick wall toppling above long grass as a symbol full of meaning. For he saw in such things the symbolic flames of his own life from which he hoped (with increasing despair) that a phoenix would rise.[17]

Cotman's example was to inform John's own wartime pictures of ruins. In all these the human figure is noticeably absent, for the drama belongs solely to the damaged building, John having learnt from Cotman that an empty building or ruin can be powerfully redolent of human emotions.

Soon after the war began, Peter Watson, a 'thin, sad-looking young man with an endearing smile and an unobtrusive manner',[18] visited Fawley Bottom Farmhouse in the company of the young painter John Craxton. Cyril Connolly had persuaded this dilettante and arts patron, whose fortune was based on margarine, to finance a new highbrow literary journal, *Horizon*, which that autumn sat on the drawing board. Watson's own interests lay more with modern painting than with literature, and, during the 1930s, while living in Paris, he had amassed an impressive collection of paintings. At his request, John designed the cover for *Horizon*. He chose for the title on the

30. *Horizon*, cover design by John Piper.

cover page a fine, old-fashioned font, Elephant Bold Italic, and had the layout framed within an ornate border. The result was severe, elegant, dignified, and far removed from the taut modernist design and sans-serif lettering that he had used on the cover of *Axis*. Its freedom from modernist orthodoxy aligns the cover of *Horizon* with *Brighton Aquatints*; it also chimed with the stance adopted by Connolly and Spender in their first editorial. This claimed that a magazine should be the reflection of its time, and 'the moment we live in is archaistic, conservative and irresponsible … civilization is on the operating table and we sit in the waiting room.'[19]

The first issue, which carried an advertisement for *Brighton Aquatints* ('an ancient process revived to fine effect by a modern artist'), sold out within a week, immediately becoming a collector's item. But its contents and cover were criticized for being 'old-fashioned and Georgian'. In riposte, the next editorial insisted: 'The Cover is intentional. It is not old-fashioned but out of fashion because the editors believe that the fashionable cover, a functional applied-abstract design which incorporates photography and heavy sans-serif, is as out of date as a rubber topped chromium table in a neon lit cafeteria.'[20] Another critic compared it to the 'dowdy outside of an old-fashioned restaurant where you knew you could eat well'—which the editorial quoted with approval, for it implied that *Horizon* was where you knew you would read well. Though John's cover flushed a different hue every month, its design remained unaltered. When, after six months, change did occur, in the summer of 1940, the cause was not dissatisfaction with the original but a change of printer, the former one having been called up. The move to the Curwen Press, where Oliver Simon's fastidious eye held sway, inevitably brought alterations. Connolly remained one of John's supporters, illustrating his work in *Horizon* and, in 1946, asking him to design a dust jacket for a revised edition of *The Unquiet Grave* by Palinurus (a pseudonym adopted by Connolly).

The onset of war had left the Pipers in need of additional income, for, with the drying-up of dividends, John's mother could no longer give him the allowance which he had received ever since he had abandoned law. As luck would have it that autumn, one art critic, Anthony Blunt, joined the army and another, Roger Hinks, disappeared to Liverpool, thereby creating an opening in journalism. 'I am (for the moment) *Spectator* art critic,' John wrote to Betjeman on 21 November.[21] His first piece, published 1 December 1939, grappled with Graham Bell's pamphlet 'The Artist and His Public', which he thought intelligent, well written, but largely nonsensical in its conclusions. He was on happier ground the following week when he wrote about churches, still more so when he had the opportunity to praise Paul Nash's famous war painting *Totes Meer*.

'If this sounds pompous,' he apologized to Nash, 'it is no more pompous than one ought to be to one's artistic father.'[22]

Later in life he frequently turned down requests for articles, claiming he found writing difficult. But during the war, he produced occasional journalism for *Horizon*, *The Listener*, the *Architectural Review*, and the *Observer*, while churning out pieces on a regular basis (thirty-two in his first year) for *The Spectator* up until 1944.[23] His ability to produce copy on time earned him the nickname 'Old Reliability' and he was jealously guarded. 'We value your contribution to the *Spectator* so highly,' wrote J. Wilson Harris in October 1942, 'that I should be reluctant to see too many of them in the *Observer*, as I said to Connolly when he first raised the matter.'[24] If much of this journalism is lightweight, it nevertheless contains telling aperçus. Though antagonistic to a Francophilia which he associated with Bloombsury, he had always been an admirer of Duncan Grant, on whose work he had written with ardour in 1931.[25] He now wrote a just appreciation of Grant's art when pictures, intended for the 1940 Venice Biennale which had been cancelled, were shown at Hertford House.

> His decorative sense has always been strong; his experiments always intelligent. If anyone doubts his great powers let him look at the small *Snow Scene* in this show, simple, effortless and acute, and then at the *Farm in Sussex*, which is none of these things but shows a determination that few English painters muster.[26]

A further source of income for John was the 'Recording Britain' scheme, first announced in *The Times* on 29 September 1939. It came under the auspices of the Ministry of Labour, with funding from the Pilgrim Trust, a charity set up with the two million pounds given by the American Edward Harkness for the benefit of Britain and the British people, and it paid artists to catch the look of pre-war Britain, as embodied in its ancient buildings, its landscapes, rural industries, and prehistoric monuments. Directed by Arnold Palmer from an office in the National Gallery, it resulted in a unique collection of 1,539 watercolours (now in the Victoria & Albert Museum), and the making of four illustrated books.

In the preface to the first of these, Lord Macmillan explained that artists had been commissioned to make 'topographical water-colour drawings of places and buildings of characteristic national interest, particularly those exposed to the danger of destruction by the operations of war'. He then went on to acknowledge that hostile forces could be found within as well as without:

155

Quite apart from the havoc wrought by the enemy and by our own necessary defensive measures, and despite the protective work of the National Trust, the Council for the Preservation of Rural England, and similar bodies, the outward aspect of Britain was changing all too quickly before the War at the sinister hands of improvers and despoilers.[27]

Anxiety over the pace of development in England had escalated during the interwar years. A good example of this is Clough Williams-Ellis' *Beauty and the Beast* (1937), an anthology of essays examining the threat to England's country-side of modern industrial society, in which he berates the destruction wrought by speculators.[28] *Recording Britain* was therefore not merely an exercise in nostalgia; it was also a protest against indifference and loss. Its emphasis on architectural heritage made the British public aware of its state of decline and its vulnerability to enemy attack. Such reappraisal of the past had implications for the present and the future, for it highlighted national character and showed what Britain was fighting for. As a result, historic buildings gained a new prominence, becoming beacons of national identity and cultural continuity.

Kenneth Clark, an influential trustee, was asked to identify four categories of endangered subject and included among these parish churches. They deserved attention, he said, because many were in a bad state of repair and 'will fall down or be ruined by restoration'.[29] Aware of Betjeman's letter praising John's recent watercolours of churches, he brought Piper in, making him the only pre-war modernist to take part in this pictorial 'Domesday Book'. He must have been one of the first to be commissioned, for he was hard at work in October 1939 drawing historic buildings in Buckinghamshire, Berkshire, and Oxfordshire.

Seven of his drawings appear in volume I of *Recording Britain*, and five in volume II. His pictures not only record the appearance of buildings, but in some instances imitate earlier antiquarian styles in their pursuit of topographi-cal accuracy. Nevertheless, their authority makes them stand out among the competent but often mediocre work found in these four books. He was invited to supply notes for his own illustrations, for a short text accompanied each plate. Though merged into house style by an editor, these texts are revealing. At one point he likens a seven-hundred-year-old tithe barn, built by the Cister-cians at Great Coxwell, to the solemn splendour of a cathedral. Elsewhere, he tells how, in order to reach the thirteenth-century church at Faxton cut off by fields from any road, he followed a farmer's advice and borrowed a pony and trap. 'The interior, damp and forlorn from disuse, retains its simple beauty.'[30]

All this was a far cry from the clean surfaces of high modernism, for it was the fragilities and vulnerable beauty within Britain's architectural heritage that

were now his concern. Though he may have contributed to the mood of war-time nostalgia, he did not decry change and ruination. He noted that Cotman, when making drawings of Norfolk churches for Dawson Turner, found 'rich beauties in every building he visited', however ruined or decayed.[31] Like him, John looked at churches and other ancient buildings with a painter's eye, not that of an archaeologist, and did not wish them to be overly restored, fixed, and trapped in a particular period. He also regretted the fact that guide books encouraged people to look at churches as objects of interest rather than objects of beauty, a situation he tried to redress in his journalism. In December 1939, by which time many public galleries and museums had been evacuated and closed, John had urged his readers 'to comfort themselves by visiting some country churches and discovering some of the unexpected and unlabelled beauties that almost every church in England has to show'.[32] Earlier that week he had toured the borders of Bedfordshire and North Bucks, not an area, as he admits, famed for any special features in church building, yet in three days he had looked at twenty-five churches, with 'enough good features to feed an architect, or a museum-visitor, with beauty of colour, texture and form for ten years.' He singled out for special mention Wavendon Church, for its 'rich and lovely Victorian interior'; Hulcote[33]—'a small church built entirely in Elizabeth's reign—a rarity'; and Lidlington, some seven miles from Bedford, which for him was pure Cotman.

> As the door of the old, almost ruinous church swung open the cold December light revealed a damp grey floor from which rose a forest of box pews, dominated at one end by the pulpit and the clerk's desk, and at the other by the gallery, the colour raging from steel-grey through pink to faded yellow—the colour of many Cotman watercolours. And what a subject for Cotman! Ivy crawls through the broken windows; the tower is too unstable for the bell to be rung. There are still a good many buildings with this character in England, ruinous and less ruinous, awaiting discovery, and waiting for aesthetic taste finally to ratify a liking for Georgian building and furniture.[34]

This almost missionary desire to broaden appreciation of the overlooked was shared with Betjeman, now working in the films division of the Ministry of Information. Though petrol rationing limited their freedom of movement, the two friends still went church-crawling whenever they could. Betjeman, John noted, would often ignore a church (or any building and even a poem), if its beauty was well known:

The unloved, the deprived, the aesthetic outcast were what he went in for; but never if they were not conceived in love and in sincerity. He was not, as many people claimed (especially in the early *enfant terrible* years) a lover of the second rate. He was a lover of the human spirit, and not only in its finest flowering.

Meanwhile this 'unashamed church-gazer', as John had referred to himself in *Oxon,* could not ignore the purposes to which these buildings were put, especially when travelling with Betjeman who, whenever he could, took himself off to early morning communion. For Betjeman, the Church of England represented not just a set of beliefs but a social and spiritual entity rooted in English soil that demanded his loyalty and allegiance. It pained him greatly when his wife converted to Roman Catholicism. John, on the other hand, understood his friend's stance and was sympathetic to it. Though Betjeman shrugged off the suggestion that he had infected John with his Anglicanism ('It was probably all those fonts'), he did send the Pipers a specific request:

> Will you both seriously consider joining the C. of E. If you give me the word, I will approach the Bishop, though really any clergyman could receive you in now without the Bishop's consent. We could then get going on saving English churches from Faith House, Cachemaille-Day [ecclesiastical architect] and Dr Eeles [Secretary of the Central Council for the Care of Churches]. ... The Lord bless you. Athelstan Riley [an Anglican layman active in ecclesiastical affairs].[35]

But it was more likely the buildings themselves, with their silent witness to ritual and prayer, their history and variety, and the evidence they bore of decay, alteration, care, or neglect, that moved John more than any creed or personal testimony. He and Myfanwy were prepared for confirmation by the Revd F. P. Harton, the Anglo-Catholic vicar of Baulking, near Uffington, author of *Elements of the Spiritual Life: A Study in Ascetic Theology* and spiritual adviser to the Betjemans. The Pipers were less impressed, Myfanwy forming the opinion that Harton was lazy. Nevertheless she and John were received into the Church of England in February 1940, by the Bishop of Oxford. Myfanwy had more doubts than John, and, though a regular communicant for many years, she admitted after her husband's death, that, in other circumstances, she might not have been confirmed.[36] However, both were unexpectedly smitten when the rector at Fawley sent a letter from the Bournemouth Hydro, welcoming them into the Church of England.

It had by now become apparent that in Sir Kenneth Clark the Pipers had found a powerful ally and sympathetic friend. Previously, in 1935, he had been opposed to the kind of work that John produced, openly criticizing 'advanced art' in the pages of *The Listener* for being 'out of touch' with reality and finding in abstract art 'the fatal defect of purity'. But in 1940, as will be mentioned, he was instrumental in turning John into a war artist. And now that his antipathy to abstract art was no longer an impediment to friendship, he could share with the Pipers his admiration and feeling for certain traditions within English art. In May 1941 he gave a talk on the Overseas Service which was afterwards published in *The Listener*. His starting point was a line by the Spanish American philosopher George Santayana: 'What governs an Englishman is his inner atmosphere, the weather in his soul.' From this Clark coined his title, 'The Weather in Our Souls'.[37] He proceeded to argue that the English weather has had a determining influence on English painting, on poetry, and even on English thought. In his view, the English landscape artist needs 'very unusual gifts of patience or persuasion' in order to pierce the soft, luminous atmosphere found in England. Nor was it wise to set off, in despair, for France or Italy, for as he warns: 'Even great painters like Turner and Cotman did their best work at home, and the wisest, Constable, never left the country.' Clark did not propose that painters should cut themselves off from European art: but he was convinced that English painting must grow out of deep intimacy with the countryside and the weather.

At a time when there was little to see in London other than work by native artists, this article had given a special boost to John's thinking about what constitutes and sustains the English vision. 'I was very much moved by your article on the Weather in Our Souls,' John wrote to Clark. In the same letter, he thanks Clark for helping find an outlet for his thoughts.

> I have had a letter from W. J. Turner asking me to write a vol. in the Britain in Pictures series on English Imaginative Painters (or possibly English Romantic Painters). Thank you very much for arranging this. Is there ever a chance of your having time for lunch, or an evening here, for me to show you a plan for it and ask advice before I get too far?
>
> I had a satisfactory (local) interview with the RAF and now wait to be called for another at the Air Ministry.[38]

Clark replied:

> I am so glad that Collins, the publishers of 'Britain in Pictures', have at last agreed to let you write the volume on English romantic painters. Could you

lunch with me in London next Monday so that we can talk it over. If this suits you, will you come to the Ministry at quarter to one? [...]

It is kind of you, to say that you enjoyed my short broadcast.[39]

Clark took an active interest in John's book, published under the title *British Romantic Artists* in 1942. He read the proofs and advised on corrections and also, as John admitted,[40] suggested its famous opening line: 'Romantic art deals with the particular.' This led on to John's claim that Bewick's particularization about a bird's wing, or Turner's about a waterfall or hill, is 'the result of a vision that can see into these things something significant beyond ordinary significance: something that for a moment seems to contain the whole world; and, when the moment is past, carries over some comment on life or experience besides the comment on appearances.' Seventeen years later, when invited to select drawings by Gerard Manley Hopkins to accompany a revised edition of his *Journals and Papers*, John again banged this drum. Hopkins 'was one who ... converged on the local and the special as giving the best evidence of the whole and of God.'[41]

The purpose of the 'Britain in Pictures' series, under the general editorship of W. J. Turner, was to give as comprehensive a picture as possible of British achievement in arts and sciences.[42] It included Lord David Cecil's *The English Poets*, Edith Sitwell's *English Women*, Vita Sackville-West's *English Country Houses*, and Elizabeth Bowen's *English Novelists*, among a great range of subjects and eminent authors. Because these slim books were aimed at the intelligent reader yet also intended to be popular, authors were advised not to assume too much knowledge on the part of their audience. John was told to lay down some general principles and then illustrate them with references to specific works of art, much as he had done in a recent lecture he had given at Morley College.[43] He was offered a fee of £50 for all rights, payable fourteen days after publication. His text was to be 12,000 words and there were to be twelve colour illustrations and twenty (twenty-eight in the final book) black and white. Collins, the publisher, gave the pre-publication work to Adprint where text and images were combined in an accessible format which became the blueprint for the 'World of Art' series later published by Thames and Hudson, whose founder, Walter Neurath, a Viennese émigré, was working in the early 1940s for Adprint.

At intervals over the next year John produced a text that is not only a miracle of compression but which also reclaims an English identity for art, his book appearing in the same year that Pevsner began lecturing on 'The Englishness of English Art' at Birkbeck College, cultural nationalism having become the

frame for the rewriting of art history. John argued that the modernist accent on design, form, and structure, and the suppression of literary interest and atmosphere, had 'tended to squash all that was most natural in English painters, and produced a new and artificial academism'.[44] In its place, he wanted to promote a broad Romanticism, one that encompassed Blake's visionary art and Fuseli's 'hankering after the strange and terrible', on the one hand, and, on the other, Thomas Bewick who 'registered what he saw with precision' and 'had that rarest of qualities—normal, unhampered, unclouded vision'.[45] The linking ingredient is an interest in the particular and in 'The Weather in Our Souls', a phrase here used of Turner's willingness to see the universe in a rainstorm, and all life in an effect of sun slanting through clouds. Though John talks about 'contemporary romantic painting' in relation to the work of Nash, Hodgkins, and Sutherland, he does not seek to promote a new movement, as Raymond Mortimer did this same year by coining the term 'neo-romantics' while reviewing the exhibition 'New Movements in Art'.[46] Aware that certain native characteristics were beginning to revive, John nevertheless fought shy of the word 'neo-romantic'.[47] Not until 1944 did he confidently assert: 'The English are better when they do not compete in the grand style ... when insular artists are driven in on themselves, they make original and poetic statements. ... There is such a thing as the English vision, and war, luckily, is only one stimulus that affects it.'[48]

12

Fawley Bum

When Stephen Spender brought his second wife, Natasha, to Fawley Bottom for the first time, Myfanwy opened the door with her small son, Edward, held in one arm and in the crook of the other, a bowl of eggs, which she was whisking with her free hand. Her management of food, family, husband, and guests, with the minimum of fuss, astonished many. But in between the cooking, the laundry, and the ordering of food, she filled a page in *The Listener* with exhibition reviews for Joe Ackerley, suggested to Betjeman that he should join her in editing Prokosch's verse,[1] and reviewed children's books anonymously for the *New Statesman* ('they're awfully easy to do: smelling them is almost enough').[2] Her name came up at a dinner party given by Colin and Morna Anderson when Kenneth Clark mentioned the idea of commissioning modest books on contemporary artists. Some time was spent discussing who should write on whom. Myfanwy's name was paired with that of Frances Hodgkins, in a putative list that almost matched the eventual 'Penguin Modern Painters' series.

Faced, like others with food shortages, rationing, and other wartime restrictions, Myfanwy formed an alliance with her former chum at infant school, Penelope Chetwode, now Mrs John Betjeman, exchanging gifts of eggs, jam, garden produce, and tips on rural life, both women also having sons of a similar age. Though Penelope's father had been Commander-in-Chief of the British Army in India and she was at home among grand society, she had immersed herself in village life, its fetes and church services. She had a no-nonsense manner and a heart of gold but, as her daughter Candida Lycett Green has observed, 'did not know the meaning of the word embarrassment'.[3] Not only did she leave the door open when using the lavatory, even when guests were present, she pursued blistering rows with her husband in public and turned

a cloth ear to the congregation when she tried to assist with divine service. 'I frequently have to take the seat at the harmonium here,' she wrote to the Pipers from Uffington, 'and I must say performance is unaccountably deteriorating ... once our rector came down from the altar to say I was playing the wrong tune but actually I was playing it in the wrong time so he did not recognise it.'[4]

Myfanwy never forgot her first visit to the Betjemans at Uffington on 11 March 1938. As John came out to greet them, Penelope could be heard shouting, 'You can't have sherry, lunch is ready.'[5] Sherry was had nonetheless, but, aside from Penelope's forthright character, it was the food that impressed Myfanwy, and the organization with which she ran domestic life and trained two girls to help in the kitchen. Nor did it escape Myfanwy's notice that the house was even more untidy than their own.

From then on, many visits were made to the Betjemans at Uffington, and later to the homes they made at Farnborough and Wantage. They stopped at Uffington in August 1939, en route to Wales, Myfanwy recording every aspect of the weekend in her diary, from the raucous songs and hymns sung after dinner on Friday night to the mass at Baulking the following morning ('practically R.C. ... hard to follow'). On Friday afternoon, while the two Johns worked together, Penelope and Myfanwy collected a pig for the village fete, to be held the next day. That evening they went along to the church hall to hear John Betjeman, in a pair of red sailcloth trousers, give a talk on countryside poetry to the Swindon WEA. There was much scraping of chairs on the hollow wooden floor as people straggled in from the station. Myfanwy noticed that the 'slightly nervous ennui, not boredom, in people's faces brightened and turned to excitement as John's enthusiasm penetrated.'[6] The following day she went to the fete and watched a children's concert at which the girls, whom John Betjeman had been teaching, recited. ('He characteristically on his toes with waving arms.'[7]) That evening Sherlock Holmes was read aloud after dinner. On Sunday all went to the 10 o'clock service at Uffington, after which the two Johns again settled down to work, Myfanwy making calls with Penelope and helping her clean riding tackle. The next day they drove in a horse and cart to Kingston Lisle for lunch, and on the way home Major Hulme Kelly, a local figure, chatted to them while keeping pace with the cart on his bicycle. 'Very Victorian rural,' wrote Myfanwy. 'Left Uffington after tea. Rich and moving and exciting visit.'[8]

With Penelope's help Myfanwy obtained a small black pony with a round belly, aptly named Tadpole, so that she too, during the war, could travel back and forth to Henley by means of a horse and cart. Guests sometimes found themselves met at the station by Myfanwy, holding Tadpole's reins. After the

birth of the Pipers' second child, Clarissa, in January 1942, Penelope offered to find the Pipers an Irish nurse-housemaid, for by then she had followed her husband to Dublin, where Betjeman acted as Press Attacheé to Sir John Maffey, British Ambassador. As Penelope explained to Myfanwy:

> Tell J.Piper it is most important that he should come and lecture here and bring in GOD a lot as the Irish are so damned patronizing about Pagan England, so that if an English intellectual came over and lectured on art from a Christian standpoint it would do a tremendous amount of real good. He needn't get nerves, I'll write the lecture for him as I know the line to take and can patter of [*sic*] art jargon as well as Clive Bell.[9]

Penelope's husband's eccentricities took a different form. Easily moved by female attractions, especially wholesome creatures who excelled at swimming or tennis or wore tweeds, Betjeman felt it necessary to extol Myfanwy's erotic qualities in verse. After Edward's birth, he celebrated the young mother she had recently become:

> Kind o'er the *kinderbank* leans my Myfanwy
> White o'er the play-pen the sheen of her dress,
> Fresh from the bathroom and soft in the nursery
> Soap-scented fingers I long to caress.

He also fantasized about the schoolgirl she had once been:

> Were you a prefect and head of your dormit'ry?
> Were you a hockey girl, tennis or gym?
> Who was your favourite? Who had a crush on you?
> Which were the baths where they taught you to swim?[10]

And from this moved on to the Oxford undergraduate he had never known:

> Kant on the handle-bars, Marx in the saddlebag,
> Light my touch on your shoulder-blade.[11]

A similar manner entered his correspondence. 'My darling Prefect' begins one letter to Myfanwy:

> I am so glad you like the verses. It is most odd how you have undone an unpublishable gush of verse in me. ...

I can't be grateful enough to old Karl Marx [J. M. Richards] for introduc-
ing me to John Piper, the best photographer and topographer I have ever
met, nor can I thank J.E.C.P. enough for bringing you into my life. ...
Ever your adoring fag, JB[12]

The nickname he coined for her was Goldilocks, or variations upon it. He en-
joyed swimming with her in the Thames at Henley and in Ireland thought how
nice it would be 'to see swelling, sturdy Goldilox again, the golden swimming
blue'.[13] She entered his subconscious, or so he implied:

Darling Goldilocks,
 At the analysts I went right back to the pram and thought I would like
to be wheeled by you up Swain's Lane past the Cemetery Chapel round by
South Grove and down West Hill and round Merton Lane, along the edge
of the Heath and back to West Hill by Brookfield Lane. Then I would like
to be taken out and breast fed. Then I would like to be led to school at
Byron House by you and get into a scrape. Now I had better stop.
 I enclose the Preface for my new poems which I would like you and John
Pahpur to see and let me know what you think. Cut and criticise ruthlessly.
The opening sentence is, so far as you are concerned, a lie.[14]

One of his letters to her is entirely written in verse, part of which is marked
with blue pencil and the words: 'Specially designed to shock the censor who
has taken to reading our letters.' The passage reads:

Oh darling Goldilegz I write this down
Dunsany-wise, straight off, so full of sex
That as I write even my fountain pen
Becomes symbolic to me. Goldilegz
Still do you snip your short hair off your brow?
Still do you run, barelegg'd across the yard?
Still would you pillow with athletic curves
My bald, grey head upon your ample breasts?
Your stalwart body still excites me much
The thought of you, now Spring is coming on,
Requires that I should exercise control.[15]

His crush on her, if it was serious, may have been an outlet for sentiments
which his own marriage frustrated. But she was, after all, a safe target, being
so completely bound up in her marriage with John, their growing family, and
Fawley Bottom; and it was never likely that his adoration would turn her head.

Nor did it. When questioned after Betjeman's death about his feelings towards her, she dismissed outright any notion of love.

Betjeman's two Myfanwy poems were included in *Old Lights for New Chancels: Verses Topographical and Amatory*, published in 1940 and dedicated to the Pipers: 'AD | M. ET J. PIPER | FELICES ET DULCES | APUD | VILLAM FAWLIENSEM PROFUNDAM | HENLEY | HIC LIBER | CUM | GRATIAIS ET FIDELITATE.' Though Myfanwy inspired some of the amatory content, the majority of these poems celebrate topography, for Betjeman was fast becoming, as Harold Acton observed, 'the genius of the *genius loci*',[16] and his ability to articulate his passion for places was one reason why the Pipers so hugely enjoyed his mercurial company.

Absence played its usual trick: after moving to Dublin, John Betjeman wailed: 'Oh God! I miss you both. Do both pour out your hearts to me at the above address.'[17] On his return visits to England on Ministry business, he stayed with the Pipers, for he had grown to love Fawley Bottom farmhouse which, in his lingo, became Fawley Bum. 'PLEASE see a lot of us in October,' Myfanwy wrote. 'You always say you will—then are too busy rushing about. F.Bum is yours.'[18] John echoed her sentiments:

> We look forward to June and your visit. However much you miss the Bum, the Bum reverses the compliment. There is nobody in this country who can understand my class of sentiment and church nonsense. We had Cyril C.[onnolly] here at weekend. Very nice, but he likes France and smartish Georgian houses. … He is a good new lit. editor and pleased with the *Observer*. But oh dear it needs your appreciation. I don't like this country without you now that I've known it with you.[19]

Betjeman was one of many visitors during the war. The Pipers not only gave house-room to the Grigson family for a while, but also provided refuge for Peggy Angus and her two children after the Blitz began. Casual visitors included S. J. Woods and his wife, living near Henley during the winter of 1939–40, and Ruthven Todd, who shared John's interest in Fuseli and other underrated figures in British art,[20] and dedicated his book *Tracks in the Snow* (1946) to him and Grigson. Another who often appeared at weekends was Mervyn Horder, who shared the Pipers' love of oysters, chocolate, clotted cream, claret, hymns, Elizabethan songs, and Mozart operas. Horder usually arrived unheralded, on a pushbike in full uniform or on a scooter, billowing with protective clothing, for he was stationed at the Central Air Photograph Interpretation Unit at nearby Medmenham, sometimes with the letter-cutter and wood-engraver Reynolds

Stone in tow. The Pipers quickly got to know Stone and helped him through a period of depression. Two others who became close and lasting friends at this time were John (Jock) Murray, head of the distinguished publishing house, and his wife, Diana. On the Murrays' first visit to the Farmhouse John and Myfanwy had such a violent row that Diana assumed divorce must be imminent.

Behind Fawley Bottom and over the hill is Stonor Park where the Camoys family had lived for nine hundred years, remaining staunchly Catholic after the Reformation. They had withstood persecution and huge fines and had hid Father Campion, the Elizabethan martyr, in a priest's hole. Mass is said to have been celebrated without a break in the household chapel from the Middle Ages to the present day. During the 1939–45 war the Elizabethan mansion was let to National Benzol, and Lord Camoys, from whom the Pipers had initially rented Fawley Bottom, had moved into a house just up the road, 'Bosmore'. His son, Sherman Stonor, who became Lord Camoys after his father's death, also lived nearby, at Assendon, and gradually he and his wife Jeanne got to know the Pipers.

Sherman was a broad, heavy, affable, sweet-natured man, knowledgeable about many things including wild flowers. He shared John's interest in church architecture and had a fine turn of phrase. If, on his visits to the Pipers, he sometimes drank more than he intended, he spent the night on the sofa, for Jeanne, with her pale face, jet black hair, green-painted fingernails, and blue-tinted spectacles, was by nature quarrelsome. She was a small woman with a

31. Jeanne Stonor and John Piper, 1948 (photograph: Janet Stone).

powerful voice and an abundance of malice which made her, in John Mortimer's opinion, excellent company.[21] But a meal at Stonor could be disputatious and, as Alastair McAlpine has observed, seldom ended as it had begun, with the same people seated at the table.[22] The family, conscious of its position within British history, had good connections, and their guests at Sunday lunch might include ambassadors, visiting statesmen, and cabinet ministers, as well as leading cultural figures. At one point, when the chapel was being restored and redecorated, John advised on the colours. He was also to design jam labels for Stonor. In times to come there was much coming and going between the two families. On Christmas Day the Pipers several times bicycled round or walked over the hill and down through Stonor Park, to attend the annual giving of presents.

Another visitor to Fawley Bottom, Osbert Lancaster, arrived almost speechless, having overestimated his powers of endurance and bicycled twelve miles. 'I'm Osbert Lancaster', he said. 'Of course you are,' replied John, immediately recognizing the author and cartoonist, social and architectural satirist, whom he had met once before at a cocktail party given by Jim Richards. The bicycle was flung aside and they settled down to a conversation and many jokes that continued for the next forty years, Osbert's wife, Karen, becoming one of Myfanwy's closest friends. The Lancasters, who had sent their children for safety to America, were both working in London and to escape the air raids came to live with the Pipers. Outwardly, Osbert's working day in London seemed light, involving a round of visits to various clubs and to his publisher, Jock Murray, for tea, but on his return to Fawley Bottom he set to work on his cartoon for the *Daily Express*. It had to be completed in time to be thrust into the hand of the guard on the eight o'clock train to London, where it was collected at Paddington. Myfanwy later recalled: 'If all went well, the idea, the caption and Osbert's pen all worked together for good and the terrifying blank paper was filled in half an hour flat. But when it didn't, all was hopeless, helpless, barren, the paper menacingly empty, time ticking by and the air thick with soundless groans.'[23] From then on, the Pipers always took the *Daily Express* among their newspapers for they delighted in Osbert Lancaster's ability to register, with meticulous accuracy, telling details in an array of subjects—architecture, fashion, social life and street life, including the most fleeting of facial expressions.

The Lancasters eventually left in November 1941. 'The journey [to London] is too much for both of them I think,' Myfanwy told John Betjeman, 'and I have used my pregnancy as an excuse rather to promote than to prevent their departure. We've had happy times with them with no rancours or squabbles. They *are* funny. But in the end they are a bit of a spiritual burden, Osbert so

sophisticatedly helpless and Karen so enervated.'[24] A strong friendship continued to unite the two families, and later, in the early 1950s, the Lancasters moved to Henley-on-Thames, partly to be near the Pipers and to enjoy summer evenings with them, hiring a punt and bathing in the river, afterwards eating a cold supper of dressed ham, liver sausage, and peppermint creams.

'John and I are going to be <u>quite</u> ALONE tonight for the first time since before the war. I don't know how we shall stand it,'[25] so Myfanwy wrote to John Betjeman, finding herself suddenly without visitors. The amount of labour they caused was considerable, for a farmhouse, with no electricity or gas, lit by candles and Aladdin lamps and heated by open fires, was hard work, and the Pipers, at this time, strove to be self-sufficient, making wine in their own vat and keeping chickens and a pig, Myfanwy becoming a member of the Turville Heath Pig Club. The setting, however, could be idyllic: in spring the beech woods filled with bluebells and in the orchard opposite the house grew cowslips and other wild flowers, while in summer the surrounding fields were sprinkled with buttercups and daisies. But at other moments torrential rain left the kitchen floor covered with six inches of water, or the pig broke its sty and the frightened chickens got into the house and hid under the sofa and in the larder. While the Lancasters were present, six kittens escaped one night and kept everyone chasing around in the dark. (The following morning the vegetable garden looked rather squashed.) In more peaceful moments Karen Lancaster helped Myfanwy bottle cherries and make jam.

Stationed at Medmenham with Mervyn Horder was Stuart Piggott, the archaeologist, whom John had first met at the Betjemans'. Having begun his career in the early 1930s, Piggott had been greatly excited by Kenneth Clark's *The Gothic Revival* and by Christopher Hussey's *The Picturesque*, both of which had encouraged him to look at his own subject in a new way. He had also worked at Avebury with Alexander Keiller, who fostered Piggott's interest in the antiquarian William Stukeley, of whom he was to publish, in 1950, a celebrated biography. Piggott, who went on to become Professor of Prehistoric Archaeology at Edinburgh, became a close friend of the Pipers. John, aware that fields were being ploughed which had not been in use since Domesday, suggested that he and Piggott should collaborate on a book on prehistory. 'I am most excited by the idea of that book we talked of,' wrote Piggott in July 1941,

> with your drawings we ought to be able to exploit a new angle—prehistory
> not only as an essential part of history but as an important contributor
> through its monuments to the English scene, and see it in relation to the

landscape of which it is a part. I think the idea has enormous possibilities and it would be such fun to do. It would obviously have to be dedicated to Stukeley.[26]

Sadly, nothing came of this venture.

Piggott witnessed the paper games played at Fawley Bottom all through the war. These drew on the architectural knowledge of those present. Piggot, though well up on the Picturesque and the Romantic Revival and other aspects of English taste, limped behind the other players if Jim Richards, John Betjeman, John Summerson, or Osbert Lancaster were present. One game involved the drawing of a church, from east to west, in sections, each player folding the paper, before passing it on, in such a way that the only clues to continuity were the roof and ground lines:

> I could just get by with my amateur draughtsmanship, but what could you do with the west end of a nave, knowing that John on the hidden fold had just drawn a stunning western tower, and Osbert Lancaster, eyes rolling and looking like Canon Fontwater, was waiting to pounce with an egregious transept or outrageous chancel.

Another game, the 'Guide Book Game', required players to demonstrate their familiarity with the phraseology and value judgements found in dim county guidebooks. Each player compiled a parish entry, giving place name, location, church, manor, local families, and so on. Piggott records: 'Myfanwy was the acknowledged expert on Local Customs, where under the flat prose dark hints of unimaginable rustic obscenities could be glimpsed.'[27] A third game, not mentioned by Piggott, was a form of church consequences in verse. A player was given a line to which had to be added two or three more that rhymed before it was passed on again. Mervyn Horder, a Wykehamist, proved good at this, but Betjeman was supreme, and could not resist tidying up other people's lines, to improve the rhyme or metre.

Musical entertainment was another feature of life at Fawley Bottom. In the dining room, John sat at a battered black upright piano stacked with old music hall song sheets and improvised freely on any theme, be it jazz, a Mozart opera, a hymn tune, or popular song.[28] Whatever he played, his gaunt, grave face reminded Oliver Simon of a saint out of a stained-glass window. 'The whole atmosphere', Simon has written, 'was one of brimming vitality, made additionally attractive by babies and children. Myfanwy, blonde and intelligent, with a fine sculptural head, took all in her stride; children, cooking, making beds, dispensing hospitality to a house-full of people at the weekends, participating

in our talk and finding time to edit *Axis*.'[29] And though *Axis* was, by this time, a thing of the past, Myfanwy still found time to write an article on Trollope, as well as occasional reviews of novels and children's books, for the 'Shorter Notices' section in the *New Statesman*.

'It was as jolly and rich a rustic, bohemian interior as we could have imagined,' wrote Colin Anderson, the shipping magnate, collector, and friend, mentioning also that John looked 'like an Old Testament prophet (but without the beard) painted by Greco'. Anderson made a stab at pigeon-holing Fawley Bottom's unique style:

> The farmhouse, which they were to later greatly improve as far as creature comforts were concerned, was still as they found it, though transformed by their own possessions. These were far from smart contemporary stuff. Everything except the pictures … tended to be Victorian or Edwardian, and much of it to have been saved from bar-parlours and pubs. It was a genre that was later to be much imitated and vulgarised, but, to us, it was original.[30]

Here social life and work mixed. Visitors included the literary editor Joe Ackerley, who occasionally persuaded Myfanwy to write for *The Listener*, while T. D. Kendrick brought Mrs Katherine Esdaile, whose pioneering work on church monuments had contributed to John's *Oxon*. One attraction was Myfanwy's cooking. It was not only that she made inventive use of garden produce, but she also followed Boulestin's maxim—that instinct and taste are more important than measurement. Evening meals were lit by a forest of candles in white holders, for the house still lacked electricity, and seemed to some unbearably spartan.

The collection of books at Fawley Bottom was especially rich during the war for the Curwen Press Library had been sent there for safe-keeping, as had a complete set of the John Murray Guides.[31] Up in the attic, where a huge down-mattress lay on the floor, were 147 volumes of books and albums of drawings, stacked on their sides in piles six or seven high, and which had been sent for safety to Fawley Bottom from Burlington House by the Society of Antiquaries.[32] These leather-bound folio volumes were the only furniture in this room. On the floor below, one of the guest bedrooms doubled as a library and was filled with John's books on topography, architecture, and the Picturesque, with Piranesi etchings, seventeenth-century books on Oxfordshire, and great folios full of engravings as well as classic twentieth-century books on art, architecture, and taste. John was ahead of his time in his book collecting and had managed to pick up things before they became expensive and highly

sought after. Betty Hussey had difficulty winkling her husband, Christopher, out of this room which she described as 'more books than bed'. Kenneth Clark also enjoyed sleeping here:

'To stay with the Pipers at Fawley Bottom, to poke the ashes of the dying open fire, while the children rammed one in the stomach, to sleep in a room full of dark brown books on Gothic churches, with a heavy heraldic banner on the bed; to enjoy Myfanwy's cooking, a bottle of wine and the conversation of two of the most completely humanised people I have ever known, was the perfect antidote to life in London.[33]

* * * * *

Despite war, new opportunities continued to come John's way. His mural for Francis Skinner's Highpoint flat had brought him an invitation to join the Society of Mural Painters and sit on its committee. At one meeting, Bishop Bell's suggestion that modern artists should do work in churches in his diocese gave rise to discussion. Betjeman sent a secondhand, almost certainly embroidered account to Ninian Comper: Piper did not at first like the idea of modern artists disfiguring modern churches, and was still further angered when the 'bogus moderns' began talking about getting money from the Church. 'Are any of you believing Christians?' he asked. This was instantly refuted amid a great deal of mirth. John then said they had no right to take money from the Church, 'and he left the meeting saying he was going to offer his services *free* to any bishop who might like to use them, and that he would see to it that none of them were employed.'[34]

Meanwhile *Brighton Aquatints,* following Osbert Sitwell's review in *The Listener* (14 January 1940), had caught the public's attention. Two months later John's one-man show at the Leicester Galleries sold out. 'After that I became one of the boys,' he recollected.[35] Premonition of such success had come in February 1940, at a mixed exhibition at the Lefevre Gallery. His painting *Octagonal Church, Hartwell* (Usher Art Gallery, Lincoln) had initially been reserved for the Chantrey Bequest, then, when the Chantrey did not take it, bought by Kenneth Clark and bartered for by a lieutenant commander, Sir Michael Culme-Seymour, who owned many fine paintings at Rockingham Castle. Culme-Seymour had long wanted to add a contemporary painting to his fine collection and, on seeing John's picture, felt it was exactly what he had been waiting for. But it was the Leicester Galleries show in March which consolidated his fame as a topographical artist. There were twenty watercolours on view, many of Hafod, and fifteen oils (now selling at between thirty and

forty guineas), among them *Autumn at Stourhead* (Plate 13), *Brighton Pavilion*, and *Cheltenham Fantasia* (Cheltenham Art Gallery and Museum) as well as another composite painting of this spa town which reworked an architectural panorama he had made to accompany an article on Cheltenham by Betjeman.[36] It was bought by the ship owner Colin Anderson.

Suddenly, at the age of thirty-six, John found himself a success, praised in the *New Statesman* for 'reasserting national characteristics'.[37] Two years later, the same critic, Raymond Mortimer, as has been mentioned, linked his name with that of other 'Neo-Romantics'—Sutherland, Hitchens, Moore, and Frances Hodgkins.[38] He was fast becoming a key figure in this Romantic revival. But, owing to Kenneth Clark, he was to end the war a household name, one of the most famous British artists of the day, for through Clark he was to gain some of the most challenging commissions he ever received.

PART

IV

13

War Artist

Darkness and light divide the course of time, and oblivion
shares with memory, a great part even of our living beings; we
slightly remember our felicities and the smartest stroaks of
affliction leave but short smart upon us.

——Thomas Browne, *Urne Buriall*

A rt suffers badly during wartime. Whereas music can still be played and
books read, paintings and sculptures disappear into depositories for
safe-keeping. While John Rothenstein stripped the walls of the Tate Gallery
and boxed up statues, Kenneth Clark dispatched the largest pictures in the
National Gallery to Penrhyn Castle, near Bangor, smaller ones to the National
Library of Wales at Aberystwyth, the University of Wales at Bangor, and Lord
Lee of Fareham's stately home in Gloucestershire. Initially, Clark had envis-
aged sending the most important paintings to Canada, but Churchill vetoed
this suggestion: 'Hide them in caves and cellars,' he ordered, 'but not one pic-
ture shall leave this island.' After the German air raids began in August 1940,
increased anxiety over security, combined with problems that had arisen with
some of the refuge houses, caused the paintings to be moved again, to the caves
at Manod, a vast abandoned slate quarry near Penrith in North Wales. Clark,
who had a great love of the Welsh landscape, made many journeys to inspect
the pictures. On one visit, he took John with him. They stayed with Janet Adam
Smith, formerly of *The Listener,* to whom John had given two Contemporary
Lithographs at the time of her marriage to the poet Michael Roberts. She so
relished the talk her visitors provided that she persuaded them to stay two
nights. It may also have been on this trip that John made drawings of Manod.

With little to do at the National Gallery, Clark was seconded to the Ministry of Information at Senate House where he acquired a cluster of jobs. By far the most significant of these was the War Artists' Advisory Committee which he chaired, ably assisted by its secretary, E. M. O'Rourke Dickey. Inspired by the Canadian war artists' scheme in the 1914–18 war, the aim of the WAAC was to create a 'record' of war, on the battlefield and on the home front. 'Certain important but fleeting emotions aroused by war', Clark argued, 'can only be given permanence through the medium of art.'[1] Alongside this ran his unspoken intent to save artists from call-up and possible loss of life by giving them alternative employment. The WAAC became a vigorous patron: some 10,000 items had been commissioned by the end of the war, when the collection was divided up. The most important items went to the Imperial War Museum and to the Tate, after which the rest were distributed to public galleries all over Britain and the Commonwealth. Inadvertently, the scheme did much to enhance the reputation of British artists, many of whom emerged from the war better known.

Having shown himself willing to work for *Recording Britain*, John welcomed an approach from the WAAC, and on 26 April 1940 was interviewed by Dickey. Two days later a letter, signed by Leigh Ashton, confirmed that he had been asked to undertake for the Ministry of Information a series of pictures based on the Air Raid Precaution Control Rooms at Bristol, for a fee of up to 100 guineas. A standard caveat followed: 'It is agreed that in consideration of the above fee the property in your pictures and all rights of reproduction in any form shall be vested solely in the Crown.' The contract also stipulated that he would receive travelling expenses and a maintenance allowance at the flat rate of £1 a day.

John went immediately to Bristol, to the top-secret environment of the ARP, with its underground rooms and passageways, its arid environment harshly illuminated by electric light. The two oil paintings that he produced made use of an almost surreal blend of 'abstraction, observation, patriotism and high security'.[2] Another art historian, Stuart Sillars, who is in other ways critical of Piper's war paintings, finds one of these paintings—*Passage to the Control Room*—'clinical, classicial and (in the literal sense) inhuman' and therefore 'an appropriate reflection of the reality it records, a control room set apart from the realities of suffering'.[3] Despite this congruence of form and treatment, John soon tired of the subject and asked if he could fulfil the rest of his commission by painting 'transport subjects'. Clark agreed: September 1940 found John sketching at Swindon locomotive works for the Ministry of Transport. He did further work at York, but his drawings failed to impress the WAAC. On 11

October 1940 Dickey wrote to him: 'Would you be good enough to consider the possibility of switching to something in line with the Committee's ideas?'[4]

Again, Clark stepped in. He invited John to paint a church at Newport Pagnell, in Buckinghamshire, which, damaged in a raid, had overnight become a dramatic ruin. As the bombing continued and ruined buildings became a feature of the wartime landscape, the WAAC decided to commission from John a series of pictures of damaged churches for a fee of 50 guineas, the Newport Pagnell church to be included in this batch. A letter to this effect was sent to him on 9 November 1940. He did not immediately reply. In the meantime, the German air force, having previously made London its chief target, turned its attention to the more compact targets offered by provincial cities, and on 14 November Coventry was blitzed. It was only after he witnessed this savage destruction that John answered Dickey's letter. 'I am sorry not to have officially accepted the commission to paint bombed churches before,' his letter began. 'I do accept it, with all my heart.'

On 16 November 1940 the *Birmingham Gazette* carried the headline 'Coventry—Our Guernica'. What followed was one of many reports on the raid which, lasting eleven hours, had destroyed two-thirds of the centre of Coventry during the night of the 14–15 November. The comparison with the destruction of Guernica on 26 April 1937 was not entirely just: it implied that Coventry, like Guernica, was a peaceful, civilian city, whereas it was active in the manufacture of armaments and aircraft. The undeniable similarity lay in the use of blanket bombing and the unprecedented scale of the raid: 500 German aircraft had dropped 543 tons of high explosive bombs and incendiaries. At Coventry, where industry, housing, and public buildings were all contained within a central area of between one-half and one-third of a square mile, the effects were devastating: within an hour the centre of the town was a sea of flame: 568 people were killed, 863 severely injured.

At a time when detailed information on enemy air raids was withheld, Coventry received unprecedented news coverage.[5] An element of propaganda figured in some reports, as the tragedy of this event was turned to the Allies' advantage. Many accounts gave prominence to the burnt-out husk of the cathedral. Its tower had escaped destruction, but a photograph, taken for the *Daily Mirror* from a high-up window in the tower, revealed that the great medieval guild church, St Michael's, which had been elevated to cathedral status in 1918, now lay open to the skies, its interior reduced to smoking rubble. This sudden ruin was seen to convey both vulnerability and defiance. The *Birmingham Gazette* pronounced: 'The proud spirit of Coventry Cathedral yesterday stood sentinel

32. The ruined Coventry cathedral, looking eastwards towards the apse.

over the grim scene of destruction below.'[6] Still heavier symbolism was invested in the destroyed cathedral when a photograph, looking eastwards across piles of rubble to the apse, appeared in the *New York Herald Tribune*. Here it became 'the voiceless symbol of the insane, the unfathomable barbarity which has been released upon western civilisation'.[7] Louise Campbell has recorded how the Coventry raid, if first discussed as a crime against humanity, 'soon became aestheticized as a crime against the city (symbolized, as in Victor Hugo's *Notre-Dame de Paris*, by its cathedral) and thus as a simultaneous blow to religion, architecture and history'.[8]

John arrived the morning after the raid on 15 November 1940. He had been staying nearby in Northampton and received instructions by telephone to go immediately to Coventry and make a record of the cathedral for the War Artist Advisory Committee. Retrospectively, Clark acknowledged Piper as 'the ideal recorder of bomb damage'.[9] But when he arrived in Coventry nothing he had so far seen or done had prepared him adequately for what he encountered. Many years later, in conversation with Peter Fuller, he recollected a scene of horror: bodies were being dug out of the rubble; the firefighters were still at work; and the smells were dreadful.[10] Initially he was at a loss to know what to do; the mood among the bystanders was grim and left him wary of pulling out a sketchbook and seeming to take advantage of others' misery and disaster. 'He didn't know how to approach it all,' Fuller records, 'until he saw an open door, with a solicitor's plaque outside, and a flight of steps going up to the first floor.'[11] Once inside this office, in Priory Street, which faced the east end of the ruined cathedral, he explained that he had been ordered to do some drawings. A secretary offered him her place and moved her typewriter to the other side of the room so that he could sit by the window and sketch.

From this 'port in a storm',[12] he began the aesthetic process which Christopher Hussey associated with 'the Picturesque' and referred to as 'feeling through the eyes'.[13] Some of the ingredients which fed John's imagination, as he responded to the ruined cathedral, can be found among the impressions he published a year later, in the *Architectural Review*:

> Roads blocked, warehouses still burning. Not a pall of smoke, but a thin fog of smoke and steam like a concentration of the blighted November weather

with that strange new smell that this war has produced—mixture of the smells of saturated burnt timber and brick dust with the emanation from cellars and hidden places. The ruined cathedral a grey, meal-coloured stack in the foggy close; redder as one came nearer, and still hot and wet from fire and water; finally presenting itself as a series of gaunt, red-grey facades, stretching eastwards from the dusty but erect tower and spire. Outline of the walls against the steamy sky a series of ragged loops. Windows empty, but for oddly poised fragments of tracery, with spikes of blackened glass embedded in them. Walls flaked and pitted, as if they had been under water for a hundred years. Crackle of glass underfoot. Inside the shell of the walls, hardly a trace of woodwork among the tumbled pile of masonry, stuck with rusted iron stays.[14]

The first painting, which evolved from notes, sketches, and photographs made in this office, is an external view, showing the apse with its tracery dissolving like wood-ash (Plate 17).[15] In fact, as photographs taken at the time confirm and visitors to the ruin today can see, the tracery had remained intact. But in the painting the broken tracery heightens the impression of shimmering heat, which the rich colours uphold. A large part of the tracery is outlined sharply against a shaft of white which, one art historian points out, is positioned directly above the altar and suggests a spiritual presence.[16] It may, however, have a more material origin, in the 'thin fog of smoke and steam' mentioned in Piper's written record, while its strong formal role also weighs against any too literal interpretation of its symbolic meaning. Nevertheless, it is primarily through its smoldering colour that this picture speaks. Christopher Woodward is surely right in saying that in this scene, which is wholly devoid of figures, John succeeds in projecting human agony through the intensity of the colours and by scratching into them for expressive effect. 'Their conviction', Woodward argues, 'can only be explained by the pain he felt'.[17]

Piper, who once argued that figures can only ever be incidental in landscapes, was fully aware of the tradition that associates the frailty of ruins with human decay and knew well that an empty building or ruin can be redolent of human presence. Those who criticize his Coventry paintings for being too much like stage sets, empty of human drama, fail to see that these are precisely the qualities which he turns to good effect, the ruined cathedral becoming a stage upon which history has walked. In the second of his two oils, *Interior of St Michael's Cathedral, Coventry, 15 November 1940* (Plate 18), which looks eastwards towards the apse, Piper uses a stage flat, mottled pink and grey, down the left-hand side, to lead the eye into the picture. Though he claimed that every colour he used in these two pictures could be found in the actual

scene, they are nevertheless intensified, made non-realistic for dramatic purposes. They recreate the feeling of desolation and destruction. In this second painting a white light reappears, this time in the east window, glinting through from outside; and again the artist has scratched through in places so that the black background breaks through with sombre effect. As the eye moves round the scene, it encounters abrupt alterations of hue which climax in the acid lemon yellow at the centre of the picture, its sharp note held in position by the nearby umber and the charcoal grey in the opposite side of the apse. The umber, or muted gold, continues in a circular sweep on the floor of the cathedral, an idea first registered in a pastel study for this work (Ashmolean Museum, Oxford).

Stuart Sillars has criticized these and other of John's paintings of bombed buildings for offering only a mismatch between the desolation of the actual scene and the artist's rendering of it.[18] He argues that we are not given any moral response to the scene or sense of outrage, compassion, or loss. For Sillars, the 'accidental romance in and beyond the horror',[19] or what has been termed the 'strange beauty' of war-damaged ruins,[20] is presented by Piper in simplified terms which move towards abstraction and fail to involve us in the horror itself.[21]

This, however, was never his intent. Not only would the censors have vetoed material of this kind, but the chief concern in his Coventry paintings was not the human ordeal endured during the night of the raid but the architectural ordeal, and all the anguish associated with it. He had to confront the intense drama of a ruin manufactured in one night, its stone calcined by fire which had achieved the effect of centuries of weathering. The fact that the WAAC also commissioned the architectural draughtsman Randolph Schwabe to go immediately to Coventry to record the ruined cathedral suggests that it expected John to produce something very different from Schwabe's topographical accuracy. The informative detail that fills every corner of Schwabe's drawing of the ruins is precisely that which Piper omits or summarizes into less particularized units. Nor was he interested in the kind of reportage informing the series of watercolours, now in the Herbert Art Gallery, Coventry, which Walter Ashworth, then head of the local art school, executed after the raid at the request of the city council. Ashworth recorded, for example, the firefighters training their hoses on the burnt-out shell of the cathedral and the snake-like crowd passing through the ruins the following morning, like tourists in their own city. His watercolours are topical but prosaic, wholly devoid of the heightened awareness and intensified emotions that accompany the experience of destruction and loss. Nowadays, they offer little more than period interest.

Devastation can be sudden and immediate, but a painting, if it is to last, seeks a larger narrative, a greater duration; it may initially be inspired by acute emotion, as in the case of *Guernica*, but the meaning of this painting was only discovered by Picasso as he drove it towards greater economy, precision, and compression. John had seen *Guernica* in the Spanish Pavilion at the World Fair in Paris, in July 1937; he saw it again in the exhibition, devoted to this painting and its preparatory studies, which was shown in the winter of 1938–9 in London, at the New Burlington Galleries in the West End and afterwards at the Whitechapel Art Gallery. There could have been no better demonstration that engagement and protest did not preclude detachment, for after the initial flood of emotion which Picasso released in his early studies, he rigorously and dispassionately analysed and rethought every part in order to arrive at a broad, universal statement. Though John's Coventry paintings were very different in intent, scale, and ambition, they shared some of the imperatives behind *Guernica* and were likewise the product of intense, concentrated effort in the wake of disaster. He completed his external view of the cathedral within two weeks of the raid. It was transported to the Ministry of Information by John Betjeman and, for propaganda purposes, was immediately translated into a postcard. It sold widely and was seen as an expression of British resilience. In this way, John's first Coventry painting became for Britons what *Guernica* had been for loyalist Spaniards.

It was, however, Schwabe who pointed towards the future, for within his drawing of the ruined cathedral can be discerned two tiny figures already at work shifting rubble. There is no hint here of the encroaching darkness or brooding melancholy which characterize Piper's interpretations of this ruin. Four years later, when Muirhead Bone produced his impressive, large watercolour of the same subject (Herbert Art Gallery, Coventry), and by means of skilful foreshortening incorporated into the image the entire tower, still further emphasis was given to the human activity that now went on within the ruin. Not only is repair work under way in the north-west corner but civilians and servicemen stroll through the interior, while in the foreground the Bishop and Provost in clerical garb are shown seated in the foreground on the rubble, discussing plans for rebuilding. It was Muirhead Bone's watercolour, not Piper's work, which was chosen to illustrate the 1947 *Harlech Report*, which reported on the future of the cathedral scheme, as well as Provost Howard's 1949 guide to the cathedral: 'it helped convey', Louise Campbell argues, 'as Piper's did not, that dream of reconstruction which clergy, planners and politicians briefly shared.'[22]

However, when all the debates concerning reconstruction finally climaxed, in August 1951, with the announcement of a competition for the design of a

new cathedral, it was John's painting of the interior of the ruin that was used to signal the intended modernism of the new building and of the works of art to be commissioned for it. His picture hung in the office of the Reconstruction Committee (formerly the Building Committee and effectively 'the client' for the new cathedral) and could be seen there, behind the Provost, in the 1958 BFI film, 'Coventry Cathedral'. Still more significant is the fact that, in 1962, it was reproduced on the cover of the Official Souvenir Guide to the new cathedral. For though it represents a ruin, the stark forms and rich colours combine to create a resilience, and the hope of reparation.[23] In this and other ways, Louise Campbell writes, 'the nostalgia surrounding the ruins of the bombed cathedral at Coventry was effectively harnessed to the project to build a new one; the resulting ensemble became a powerful symbol of the cultural, religious and social regeneration of post-war Britain.'[24]

Even before he experienced scenes of devastation, John had begun painting his skies black. Encroaching darkness may seem an apt expression of the wartime mood, but, for him, these skies were justified on perceptual grounds.

> If I paint a sky black, it is because I see skies very often as black. If not black in themselves black in relation to pale or startlingly white or strangely lighted buildings. ... The point is, that in painting a scene only a few important visual points can be got across at one time, and in order not to obscure these, certain elements must be stressed, so that, whatever scientists or meteorologists may say, a sky sometimes *is* black in relation to certain very light objects in front of it.[25]

His use of 'only a few important visual points' kept factual illustration at bay. It enhanced the immediacy and impact of his work and encouraged the use of a selective palette, as can be seen in the devastation scenes that he painted at the request of the WAAC, in the wake of the Blitz in Bristol and London, in, for example, his *St Mary-le-Port, Bristol* (1940; Tate Collection) and *Christ Church, Newgate Street, after its destruction in December 1940* (Museum of London). An acid yellow recurs, as does a deep pink, in dissonant relationship with each other. 'War damage was noisy, sudden and dramatic,' comment Rigby Graham and Michael Felmingham, 'and Piper's paintings of war damage were equally dramatic.'[26] But his method of working with discrete, almost abstract areas of colour can also be found in his country house and parkland scenes of this period, such as *Park Place, Henley* (acquired 1941 by Aberdeen Art Gallery) and *Holkham Hall* (1939–40; Private Collection).

Meanwhile, his position with regard to war service remained uncertain. In March 1941, E. M. O'Rourke Dickey, hearing that John would shortly be in the army, announced 'we are anxious that you should carry out more work before you actually join up.'[27] Further devastation kept the army at bay, for in June 1941, when the Houses of Parliament were bombed, John was again harnessed to the WAAC, through the Ministry of Home Security. He was sent, with the necessary pass, to the House of Commons Council Chamber, its floor a jumble of twisted girders, and the Aye Lobby, and painted three large oils which were widely praised. [28] 'Tragedy', wrote Stephen Spender, 'is exalting because it opens up a future, and indeed a present, at the very moment when it destroys past achievements. ... John Piper makes us more directly aware of a great architectural tradition burning up with a sunset fire which our civilisation has neglected.'[29] But as soon as this commission was fulfilled, John was once again in line for call-up, until the Ministry of Aircraft Production recommended an underground aircraft factory, in a chalk cliff near Henley-on-Thames, as a possible subject for his art.[30] This new task gave him 'Civil Servant, Professional and Technical Grade' status, which entitled him to protection under the Schedule of Reserved Occupations during the war period. After this, though never wholly free of uncertainty, his call-up was deferred so long as he was employed as a war artist.

Scenes of devastation made John a household name. His work began to enter public collections and featured prominently in *Recording Britain* and war art exhibitions at the National Gallery. His reputation was further boosted by CEMA, the newly created Council for the Encouragement of Music and the Arts, which not only put WAAC pictures into wide circulation but also worked with the British Institute of Adult Education on 'Art for the People' exhibitions. His interior of Coventry Cathedral, shown at Oxford and elsewhere in one of these shows, attracted much praise and was reproduced by Cyril Connolly in the January 1941 issue of *Horizon*.[31]

Yet that which sealed his success at this time was the exhibition which opened in July 1941 and ran for two months at Temple Newsam, a Jacobean house outside Leeds. It was masterminded by Philip Hendy, Director of Leeds City Art Gallery and it focused on three artists, Piper, Henry Moore, and Graham Sutherland. In fact John was represented by a mini-retrospective for it contained forty-two of his oils as well as watercolours and collages and two aquatints, and covered a nine-year period. As many as 52,000 people saw the exhibition at Leeds, and afterwards it travelled to Leicester, Harrogate, London, and Cambridge, a tour that highlighted this triumvirate as leading

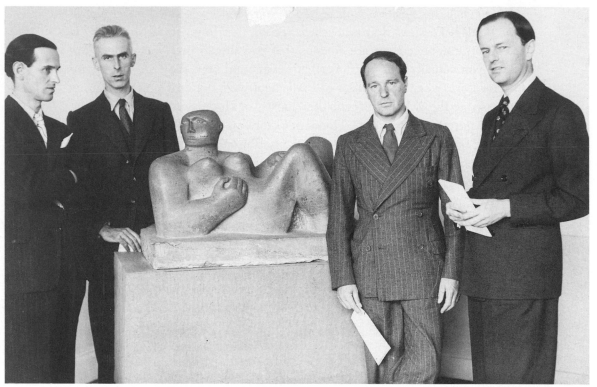

33. Graham Sutherland, John Piper, Henry Moore, and Kenneth Clark the morning after, at Temple Newsam, Leeds. 1941.

figures within the art world. At Leeds, Philip Hendy, later to become Director of London's National Gallery, had invited Clark to open the exhibition. As a result Kenneth and Jane Clark, the shipping magnate Colin Anderson and his wife, Morna, and the three artists and their wives all travelled together to Leeds by train. It proved to be both a hot day and a merry occasion. Jane Clark gifted all the men with braces decorated with mermaids and raffia-covered bottles of Orvieto Secco were drunk without ceremony out of the bottle on the train. The entire party arrived in a very relaxed mood.

This same year Jane Clark involved John in designing decorations for a British Restaurant at Merton in Surrey. These restaurants had sprung up, under the auspices of the Ministry of Food, in hastily commandeered or newly erected buildings, to improve the wartime diet and to supply the nation with its midday meal. Clive Gardiner was appointed to oversee their decoration, and murals became the chosen medium, with local art students undertaking much of the donkey work. Lady Clark had taken an interest in this scheme, and in allocation

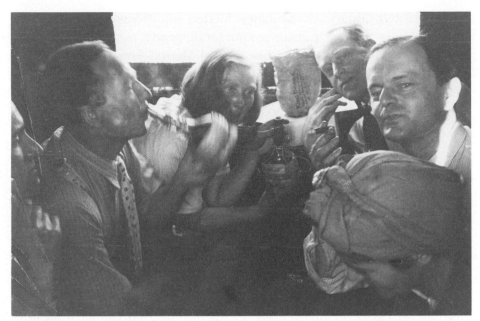

34. Train journey to Leeds on a summer's evening. Graham Sutherland, Philip Hendy, Myfanwy Piper, Colin Anderson, Kenneth Clark, and Jane Clark.

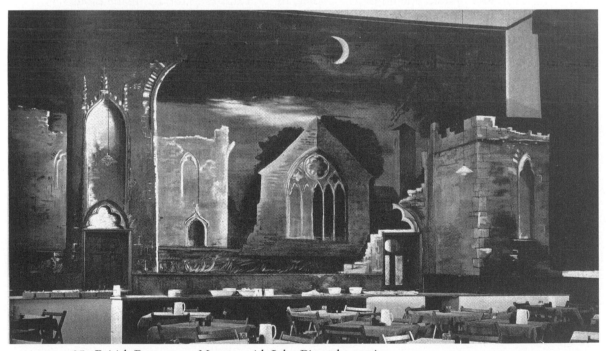

35. British Restaurant, Merton, with John Piper decorations.

of commissions. Given the Restaurant at Merton, John designed pictures based on buildings in the area, filling one entire wall, as well as the cased-in water tank in one corner, with a stage-like view of Merton Abbey, a sickle moon, and stars overhead. Students from the Slade undertook the translation of his designs, working under the eye of Vladimir Polunin.

Entirely consonant with the mood of his work at this time was the commission, received in 1941, for a cover and title page to ornament a reissue of the last chapter of *Urne Buriall*, the famous meditation ('Life is a pure flame, and we live by an invisible Sun within us') on immortality and death. It came from John Carter, specialist in fine printing and who ran the rare books, first editions, and manuscripts part of Scribner's of New York from offices in Bedford Square. John worked up three or four versions of his design for the cover, based on archaeological pots. When shown the layout, he requested four refinements, including the use of a different yellow, as that which he had initially chosen had turned out too '*jolly*' and 'not *burnt* enough'. Carter passed his recommendations on to his printer-brother, Will, with a sigh: 'Here are Piper's illustrations. Do artists always cause so much trouble? It will be a lesson to me.'[32] Though conceived and designed in 1941 and initially intended for Cambridge University Press, it was not until 1946 that it was printed in pamphlet form, in a limited edition of 175 copies, by Will Carter at the Rampant Lions Press.

Because John had a sharp sense of the times, he admired this quality in the work of others. He found it in paintings by Frances Hodgkins at the Lefevre Galleries in 1940. 'Broken in form, subtle and rich in colour, their beauty is like that of unrestored ruins: ruins in which nobody takes any interest, whose crumbled walls are draped with mosses and lichens, stonecrop, valerian and tufts of tasselled grass.'[33] The following year, in *Horizon,* he not only extolled Hodgkins' sense of place, but now went so far as to claim her recent work as 'war art':

> It is not of tank traps or of gun emplacements, but she has found in the much-quarried man-disturbed ground of Purbeck Island subjects that are symbolic enough: railed-in areas, concentration camps, of rusting milk-cans, farm implements in disuse or dereliction, a man plucking a fowl in an outhouse. Described, these subjects are apt to sound simply 'modern'. In fact they are of the times and timeless. They are powerful and extraordinary, and are about humanity and its fate.[34]

Like Hodgkins, John uncovered symbolic resonances in his paintings of derelict cottages and barns, some overgrown with lichen and moss, others

splintered and wrecked in a manner akin to bomb damage. In 1942, as a form of indirect protest, he sent two barns, a painting and a drawing,[35] to an anti-Fascist exhibition held at 2 Willow Road, Hampstead, the home of the architect Erno Goldfinger. As it was mounted on behalf of 'Aid to Russia', a fund set up by the National Council of Labour, a portfolio of prints—*Salvo for Russia*—was also produced. Again John contributed a derelict barn, a small print close in mood and style to Samuel Palmer. His interest in this artist may have been stimulated by Grigson's article, 'Samuel Palmer: The Politics of an Artist', in the November 1941 issue of *Horizon*. So great was John's sudden enthusiasm for this artist that he travelled to Lullingstone Park, near Shoreham, in order to draw the trees that Palmer had drawn.

Grigson's celebration of Palmer acted as a prequel to John's *British Romantic Artists,* published November 1942. The book not only promoted Palmer, illustrating his *Cornfield at Night* (then in the possession of Sir Kenneth Clark and regarded by some in his circle as a touchstone of romanticism) but also reaffirmed the visionary element in British landscape painting, in a pithy style both informative and engaging. It acted as a riposte to formalism and reasserted the romantic tradition. It sold so well that by 1944 he began to receive pro-rata payments for sales in excess of 20,000 copies. The poor quality of the colour reproductions drew criticisms at proof stage, but Adprint made no changes and many were disappointed by this aspect of the book. But, in general, it was widely admired. The young Lawrence Gowing, painter and art historian, thought it 'perhaps one of the best pieces of writing on English painting to be found—because of the illuminating and painterly enthusiasm it diffuses where antiquarianism and condescension have been the rule.' He also thought it beautifully written.[36] To John himself, Gowing wrote: 'I can't help feeling extraordinarily proud of a country where all this sensitive learning together with fifty odd photographs and as many drawings can be put out for ninepence.'[37]

Something of John's enthusiasm for British romantic art evidently spilled into a lecture he gave to an art club, while in Bath in the spring of 1942. Helen Binyon was present and afterwards told Ravilious that John's lecture had given out after half-an-hour, so he solved the situation by showing all the slides again and asking questions. 'They were an odd collection,' Helen remarked of the slides, '—all to prove how the new romantic movement (as ex[em]plified in John's work) had ancestors in English architecture, art, printing, etc.'[38] Rediscovery of this tradition meant that he no longer belonged to the nation-less, placeless world of international modernism, but had instead begun to coin a sense of national identity. 'Englishness', however, is a term that has no fixed meaning but is instead made and re-made in and through history. What is

certain is that while pursuing churches, painting a Turneresque view of Salisbury Plain, or photographing wrought-iron lamps, bargeboards, pub lettering, or station hotels in fading brick, John now discovered some aspect of English heritage wherever he went, wherever he looked.

14

Stormy Weather

In June 1941 John Piper was invited to Blagdon, near Morpeth in Northumberland, the country seat of the 3rd Viscount Ridley. While there, he painted a portrait of the south front of the house which had been built on the site of a much older manor between 1735 and 1752.[1] The picture remains in the possession of the Ridley family, and, in itself, would have justified his visit. However, the commission appears to have masked an ulterior purpose.

John's introduction to Ursula, Lady Ridley, came through the Viscount's uncle, the financier Sir Jasper Ridley, a director and eventual chairman of both the National Provincial Bank and Coutts' Bank. Ridley had bought *Approach to Fonthill* at John's Leicester Galleries exhibition in 1940 and later added two more Pipers to his collection.[2] He was a quietly powerful figure in the art world, sat on the committee of the Contemporary Art Society, served as a trustee of both the National Gallery and the British Museum, and in 1941 became chairman of the Board of Trustees of the Tate Gallery. In this last role he was valued by the Tate's director, John Rothenstein, for his 'firm grasp of practical affairs, his wide social connections, his imperious charm and his personal disinterestedness'.[3]

A long-standing friend of Queen Elizabeth, the Queen Consort, Ridley advised her, on an informal basis, on paintings. She was not only an enthusiastic collector in her own right but, in the short period between her husband's accession to the throne in 1936 and the outbreak of war, had adopted the custodianship of the Royal Collection to such an extent that Clark, in his role as Surveyor of the King's Pictures, advised his deputy, Benedict Nicholson, on his appointment in 1939, that he would be dealing directly with the Queen. She had a particular interest in the work of contemporary artists and was encouraged in this by both Clark and Ridley. In a private letter to the Queen, Clark

191

wrote: 'May I say how extremely valuable to all of us who care for the arts is Your Majesty's decision to buy the work of living painters. It is not too much to say that it will have an important effect on British art in general.'[4]

In the summer of 1941 she conceived her most ambitious commission—a set of watercolours of Windsor, comparable in range to those in the Royal Collection painted by Paul Sandby during the second half of the eighteenth century. Ever since Buckingham Palace had been hit by a bomb on 9 September 1940, the Royal Family had resided at Windsor, the Princesses remaining there for the duration of the war, while the King and Queen continued working in London, but sleeping each night at Windsor during the Blitz and at other dangerous periods. As is well known, their habit of visiting London's bomb-damaged sites, of appearing suddenly and without formality among the rubble and ruins, had brought about a sea change in the public's attitude to the monarchy. Three days after the first hit, Buckingham Palace suffered a further attack when it was struck by six bombs during daytime, one falling in a quadrangle only some thirty yards from where the King and Queen were talking to the King's Private Secretary, Alexander Hardinge. The psychological effect of this incident on the King and Queen is said to have been very great,[5] but their tours of bombed areas continued. Then, on 14 November, Buckingham Palace was warned by the Air Ministry that the 'X' beam of the advancing German Air Force passed directly over Windsor Castle. As there was no means of telling how far along the beam the raider's objective lay, the ARP team at Windsor was alerted and later that night watchers on the battlements saw an unprecedented number of enemy aircraft stream overhead, en route for Coventry. Windsor had escaped but remained a likely target. The possibility of it being damaged or destroyed lay behind the Queen's desire to commission a set of watercolours, even if the initial idea may have come from the Librarian at Windsor, Owen Morshead, who was at this time compiling a 'Windsor view album'.[6] Ridley and Clark were in agreement that Piper was the right man for the job. But protocol required John to be vetted: a visit to Blagdon was arranged.

It was John's habit to research the places he visited. He did so now and discovered that Blagdon was in easy reach of Vanbrugh's Seaton Delaval which, in the course of its history, had twice suffered from fire. A friend recommended it as 'very melodramatic, like the backcloth of a theatre'.[7] The house was then in a ruined state, almost unvisited, and, like many other country houses at this time, faced an uncertain future.[8] Vanbrugh, despite a persuasive recent biography by Laurence Whistler, was not greatly admired at this time; his buildings were thought 'heavy' and so little regarded that very little fuss was made during the war when three of his greatest—Castle Howard, King's Weston, and

Eastbury—suffered serious damage. But Jasper Ridley affirmed John's interest in Seaton Delaval: 'That Northumberland country, if you happen to catch its atmosphere, is magnificent; Seaton Delaval is about nine or ten miles north of Blagdon and should give you scope.'[9]

Whereas other artists, such as Rex Whistler and Algernon Newton, painted country houses as timeless curiosities, John was keen to show them in the here and now, affected by age, weather, and decline. In his hands they become, not embarrassing symbols of elitism, but a democratic expression of national identity, the epitome of English style, and subject, as much as anything else, to the dangers and privations of war. At Blagdon, he caught the feel of the blustery Northumberland climate as well as the house, shown from the water garden side. Here, in 1937, Sir Edwin Lutyens had designed for his daughter, the 3rd Viscountess Ridley, a broad canal, or 'sky mirror', some 580 feet long, which shoots away from the house, tapering towards the far end, so that it creates an illusion of greater length, before expanding into a round pond in which is set John Lough's statue of Milo fighting the wolf. Piper showed the pale building offset against the dark sky and reflected in the canal surface (Plate 19). He creates drama and movement by scratching into the surface of the paint and by adding a burst of white and pure ultramarine in the sky, thereby suggesting gusty winds and sudden illumination, the changeableness of an uncertain clime. His method became still more romantic when faced with Seaton Delaval, for, when first shown the house by Lady Ridley, he responded immediately to the grandeur and melancholy of its ruined central block.

Typically, he took in not only the building but also its surroundings. The house sits on a plateau at Seaton Burn, above Seaton Sluice, high enough up for Adm. George Delaval, who commissioned it in 1720, to look out to sea from a grand attic room. Some two hundred years later the area had become dominated by coal-mining which blackened the soil, dotted the landscape with pyramids of colliery tips, and criss-crossed it with more railways than can be found today. John noted the pubs, the nonconformity, the terraced dwellings, and 'the mechanics-institute urbanness' nearby. In front of Seaton Delaval, he watched the miners with lamps on their hats walking home to Seaton Sluice. He noticed that the forecourt to this great house had been used to grow grass for hay and was incongruously dotted with haystacks.

Today this grassy forecourt serves as a car park in season and offers a distant view of the wind propellers marching into the sea at Blyth. Nothing, however, detracts from the dramatic encounter with the house, proud and gaunt, its colonnaded wings embracing it on either side. Its formal gardens have been restored, and its central block, gutted by fire, has been reroofed, reglazed,

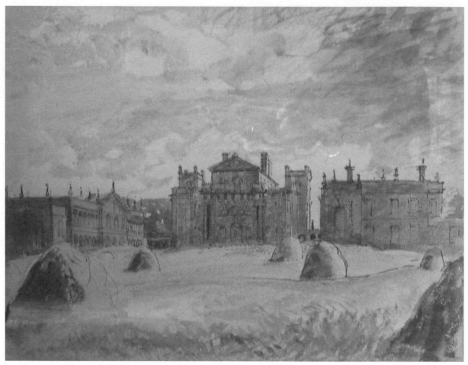

36. *Seaton Delaval*, 1941, pencil, ink, and wash, 64.7 × 55.8 cm (private collection).

and slightly tamed, but its ruined grandeur is still impressive. Pigeons explode from crevasses and rise up through the two-storey entrance hall into the attic room which once ran the full depth of the house. Statues linger in the niched walls while nearby cast-iron balustrades hang perilously in the stairwells. Even without knowledge of the history of the house and its family, several of whom suffered violent or unnatural deaths, it is possible to intuit something of the violence, splendour, and debauchery associated with it. Then, too, as John remarked in an essay he later wrote about Seaton Delaval, though the landscape is nowhere more than a hundred feet above sea level, it seems high and plateau-like, 'as in so much of Northumberland, the Northumberland of gradual slopes and wide sweeps of sky'.[10]

At Seaton Delaval, he not only celebrated the rhetoric of baroque architecture, but also brought to his task the angry defiance of the wartime mood. His finest painting of Seaton Delaval was bought by Kenneth Clark from the Leger Gallery in the spring of 1942 and given by him, through the Contemporary Art Society, to the Tate (Plate 20). It remains one of the best examples of Piper's skill at recapturing past monuments for present-day imagination. In several

places, he has scratched through the top layer of paint with the wrong end of the brush so that the black underpaint breaks through, in a manner suggestive of the damage caused by fire and weathering. The smouldering colours in the building match the description of the house which he wrote for the magazine *Orion*, at Rosamond Lehmann's request, after she saw some of his preliminary sketches at Blagdon. 'I know you share my passion for this house,' she wrote, 'and nobody is better qualified than you to evoke its incredible imaginative reality'.[11] Her instinct proved correct.

> Ochre and flame-licked red, pock-marked and stained in purplish umber and black, the colour is extremely up-to-date: very much of our times. And not the colour only. House and landscape are seared by the east wind that blows from Germany, and riven with fretting industrialism, but they still withstand the noise and neglect, the fires and hauntings of twentieth-century life. Its main block an untenanted shell, the Hall is somehow alive, unlike many stately homes. This palace, this drop-scene for melodrama in four dimensions, this vast old war-horse of a house was built with a splendid sense of drama and acts up. Fires it has turned to its own account; it encouraged grand-scale practical jokes in the eighteenth century, adapted itself to the specialised romance of the nineteenth, and knows how to toe the line in our own arid, military times by behaving as a barrack and store, by keeping furniture dry under dust sheets and by providing an ablution-space for troops in gorgeous stables. Vanbrugh the man of the theatre was at least as operative here as Vanbrugh the architect. In this last work he created a rich stage which, when the foot-lights were turned down and the smart audiences gone, would adapt itself to any kind of ham acting and if necessary would carry on with the play itself.[12]

His familiarity with stories about the Delaval family extends to their love of pantomimes, dancing bears, bull baitings, gambling, tilts, and tournaments.[13] 'Four thousand people would assemble to witness rope dancing; there was a constant stream of guests, constant shouting and bellowing laughter. At nights beds were lowered into tanks of cold water, or partition-walls of rooms drawn up to disclose the inmates in giggling dishabille.'[14] Aware that the house 'has suffered so much—and has swaggered so much', it could, he concedes, put up with most things. But he dreaded the arrival of the National Trust with its litter baskets and all that they implied. 'May its surrounding grass never be mowed by the smooth Atco,' he concludes. 'As to suitable contemporary treatment, the poor best that could be provided after the war would perhaps be permanent bank holiday crowds, with much shouting, steam organs, and plenty of fireworks at night.'[15]

* * * * *

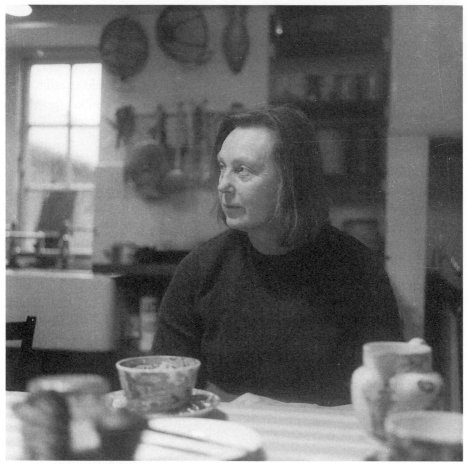

37. Myfanwy in the kitchen at Fawley Bottom.

As a war artist John had officer's rights, which ensured Myfanwy a place in an Oxford nursing home when it came to the birth of their second child, a daughter, Clarissa, born 18 January 1942. 'Our Clarissa is enchanting,' Myfanwy wrote to John Betjeman seven months later. 'John loves her dearly.'[16] In time, Clarissa and Edward were to run wild among the huge weeds in their rampant garden, while the Mother Earth aspect in Myfanwy's character began to come to the fore. The woman who had previously edited an avant-garde, intellectual art magazine now heaped up mounds of home-grown vegetables on her vast kitchen table. Everything about her seemed close to nature, or so Colin Anderson thought, for he noted that she not only cooked on a wood stove, but also used wooden utensils, 'many of which might have been of the Tudor period'.[17] A key presence in the home, Myfanwy was also often sitting

in the background while John painted. 'John was ruin-hunting as usual,' she wrote to Penelope Betjeman in May 1941. 'Edward and Tadpole behaved beautifully.'[18]

Back in November 1940 Eric Ravilious had visited at Fawley Bottom, bringing a Bewick book for Edward. Afterwards he had kept in touch by letter, writing in the autumn of 1941 from Dundee, where he was drawing seaplanes and regaining his faith in war painting. The Pipers agreed to spend Christmas that year with Ravilious and his wife and family in Essex, but in November Myfanwy's doctor advised against it, as it would have taken her too far from Oxford during the last stage of her pregnancy. As a result they never saw Eric again, for in September 1942 he was reported missing in Iceland. News of this tragedy reached the Pipers in November through J. M. Richards: 'He got to Iceland all right, and then set off for a trip on a coastal patrol plane which failed to return.'[19]

An understated but prevalent vein of melancholy in John's war art made it attractive and topical. Betjeman noticed the disparity between John's growing success and Myfanwy's daily grind; he played on this when news came through that John had been asked to paint views of Windsor Castle, turning this royal commission into a fairy tale in a series of comic drawings. In these, Clark, the magician, waves his wand and makes artists' dreams come true; John paints in the Home Park, while the Queen peeps out from behind an arch; Myfanwy, Cinderella-like, stays at home, sighing and weeping into the sink as she washes the dishes.[20]

Clark's wand-waving had indeed brought the Queen to the National Gallery to see an exhibition of *Recording Britain* watercolours, in the hope that she might find an artist suited to the Windsor commission. 'Personally', Clark wrote, in advance of her visit, 'I think that by far the most suitable would be John Piper, who is a really beautiful romantic watercolourist, & a sort-of reincarnation of Cotman and Cozens without being at all "Ye Olde"—I mean artificially old-fashioned.'[21] Five days later he informed John verbally (written confirmation arriving the following day) that the Queen had commissioned him to do 15 watercolours of Windsor Castle and Great Park, in return for which he would receive a fee of £150, this sum to include expenses. After speaking with John, Clark informed the Queen that Piper was 'honoured & delighted to carry out Your Majesty's command'. He added: 'I do hope Your Majesty will be pleased with the result; it inspires me with more confidence than most projects of the kind.'[22]

Involvement with this great medieval stronghold, which occupies some thirteen acres and is also the oldest royal residence in Britain, filled John with anticipation. John Summerson supplied him with information on the Castle's

architectural history and Penelope Betjeman told him how to address the Queen. He kept a bicycle at Slough so that he could travel up by the 8.48 train and stop off at a bookshop he liked at Eton. To John Betjeman he wrote:

> [Kenneth Clark] is sending me to Windsor to do watercolours for the Queen. … Took her round the Galleries to show her my works and has apparently got me deferred from H.M. Armed Forces indefinitely. I am to do 15 to start with and, if they are approved, 100 or so. Grottoes etc. at Frogmore, interiors and exteriors of the Castle, etc. I am naturally excited. … I follow unworthily in the footsteps of Paul Sandby, who did 200 watercolours for George III which I am instructed to look at before starting.[23]

Certainly Sandby had set a precedent that could not be ignored. 'Windsor was for Sandby what Venice was to Canaletto,' Jane Roberts claims.[24] His famously serene views record aspects of the Lower and Upper Wards, the Round Tower, and the North Terrace. Enlivened with small figures, they catch the relaxed life inside the curtain walls of the Castle at that time—the result of prolonged absence on the part of the Royal Family, for George I and George II had shown a preference for Hampton Court. Paul Sandby's brother, Thomas, who excelled at architecture and perspective, may have assisted with certain scenes, including the famous panorama, *The Lower Ward seen from the base of the Round Tower, ca.1760*, which combines great breadth of vision with exquisite skill in the handling of light and careful attention to minute detail. Nothing could be further removed from John's neo-romantic style. What, then, did he gain from studying the work of Paul Sandby?

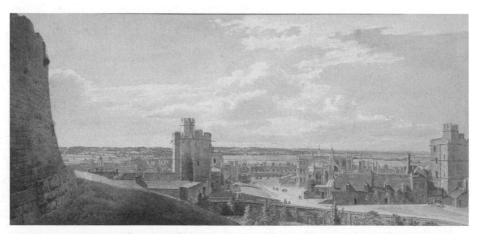

38. Paul Sandby, *The Lower Ward seen from the base of the Round Tower, ca.1760*, watercolour with pen and ink over graphite 28.1 × 60.9 cm.
(The Royal Collection © 2008 Her Majesty Queen Elizabeth II)

It's possible that the serenity of these drawings and watercolours only confirmed John in his determination to adopt a more dramatic interpretation, for he wanted to catch as distinctive a period mood as Sandby had done in his day. Sandby's clear and accurate architectural record also set a benchmark which John did not ignore, for the moodiness in his work never obliterates topographical accuracy, as can be verified by standing in the same spot whence he painted his scenes. But a significant strategic difference between these two artists is that whereas Sandby's views of Windsor are all painted on the level, from a grounded point of view, John was keen to work from high up. He may have seen in the Royal Collection Wenceslaus Hollar's *Bird's Eye View of Windsor Castle with view of the Castle from the south-east, ca. 1660*, a supreme imaginative feat which perhaps stimulated his desire to climb towers, walk along the top of the exterior curtain walls, or over the roof of the Chapel, to gain fresh perspectives from these high vantage points.

Sandby had wandered around the Castle at his ease. John needed to do the same. His charm and talkativeness helped achieve this. On his first visit to Windsor in September 1941, in the company of Kenneth and Jane Clark, he was introduced to the librarian, Owen Morshead, who knew the Castle well. After lunch Morshead and John walked together in the Great Park. A fortnight later John returned and, with Morshead, began looking for viewpoints. From then on he seems to have gained access to any place he wished to go. He climbed up a narrow circular staircase onto the lead roof on top of St George's Chapel and painted the Round Tower as viewed across the receding perspective of the sanctuary roof (Plate 24). From this vantage point he also looked down into the Dean's Cloisters. At the other end of the Chapel he peered out, over the Horseshoe Cloister and past Curfew Tower to the view of the town beyond, with the railway lines on one side and the river on the other (Plate 23). 'Windsor is befogged these days, but enjoyable,'[25] he wrote to Ravilious that autumn. He appears to have accepted whatever weather conditions prevailed, journeying to Windsor in January when it was covered with five inches of snow. In time, his tour of the Castle took him up the Queen's Tower, the George IV Tower, and the Prince of Wales Tower whence, between a gap in the crenellations, he constructed a wide-angle view of the magnificent Quadrangle, with its great sweep of space and its equestrian statue of Charles II at the far end (Plate 22). He also gained access to a high-up room in the Round Tower so that he could paint the Quadrangle from the opposite end, looking east. He painted the Middle Ward from a window in the Upper Library, and another

scene from the same place looking along the curtain wall to Winchester Tower and down on to the North Terrace below. He went inside the royal apartments in the Edward II Tower and painted a view of St George's Gate and Castle Hill; and from Lancaster Tower he looked across the Quadrangle, with the Round Tower on the left. Even when painting the Castle from the outside, he continued his policy of adopting a high vantage point, persuading a shop on the corner of Castle Hill and the hotel across from the Guildhall to grant him access to an upper floor.

In December 1941 Morshead was shown five watercolours. Afterwards he wrote, not to Queen Elizabeth but to her mother-in-law, Queen Mary. He admitted being somewhat taken aback that such a nice man as Mr Piper had produced drawings 'hot and violent, deriving in feeling from Samuel Palmer, or even William Blake'. He added: 'I don't think they will tell posterity very much, other than just how Windsor struck the turbulent mind of Mr. Piper. The Queen has not seen them yet, and I have asked him to do one or two purely topographical ones before he shews any up.'[26] It was probably then that John painted his views of the Quadrangle, looking west and east, as these two paintings are stylistically slightly at odds with the rest of the series, being noticeably stiffer, more static and more straightforwardly topographical. But if he restrained his artistic leanings, these are, nevertheless, masterly drawings. They show what Sandby could not—Windsor as it became after Sir James Wyatville, between 1823 and 1840, increased the height of the Round Tower, gave the Upper Ward a new silhouette, and transformed the Castle into a palace once again fit for a king.

Morshead's anxieties point to a tension within this commission, which Susan Owens has defined as 'the claims of charm and verisimilitude on the one hand, and the need for a powerful evocation of a building under threat on the other'.[27] Clark did his best to support John. After seeing a dozen watercolours in February 1942, he told the Queen's Acting Private Secretary, Sir Arthur Penn, that they were 'well up to expectation … the best things he [Piper] has done.' He also asked the Queen if, when she saw them, she would permit some to be included in a second *Recording Britain* exhibition. The following month John took his drawings to show the Queen. She consented to some being exhibited, but she also invited Piper to make further drawings of the Castle in summer, perhaps hoping for a lightening of mood, as Sir Arthur Penn subsequently wrote to Clark: 'The Queen wished me to ask you, when writing to Piper, to tell him that the Gothic arbour in the Frogmore Garden is at this moment covered with wisteria in full bloom. If he has the opportunity to record its beauty, the result might repay his pains.'[28] John did paint the stable block and the gothic ruin at Frogmore (which had been the retreat of King George III's consort,

Queen Charlotte), as well as the ruins from Leptis Magna at Virginia Water, but he ignored the wisteria and persisted with his dark skies.

Instructions were given, by Sir Arthur Penn to the Keeper of the Privy Purse, for him to be paid for his first set of drawings:

> A slightly melancholy artist, who appears to regard nature through a glass darkly, has recorded, by arrangement, some remarkably sombre presentations of Windsor.
>
> His name is PIPER & the agreed fee is £150. At the Queen's direction I am telling him to send a note of this fee to you and I warn you of this transaction in the hope that he may be rewarded by a cheque rather than a dirty look.[29]

If John suffered from quizzical remarks and jokes at his expense, he also had to combat Morshead, who still wanted more topography and less art. 'I have been having a very nice time on the roof at Windsor,' Piper wrote to Betjeman in the summer of 1942. 'Society up there much nicer: housemaids cleaning tennis shoes with Blanco. Several good rows about art with O.Morshead lately, but he is lending me the transcript of the Farington diary to bring home vol. by vol.: very good train reading, and makes me look as if one's working for M.I.32B.'[30] Meanwhile Morshead was writing to Queen Mary:

> I went to the 'Recording Britain' exhibition at the National Gallery two days ago to see Mr. John Piper's series of Windsor drawings, done for The Queen. They make a striking display on a wall to themselves across the head of the room. They are sombre, dramatic, macabre; the work of a modernist powerfully moved by architecture of the past. All very interesting as an example of XXth century art, which it is excellent that The Queen should be seen to patronize. But as a topographical representation of what Windsor actually looked like in the early 1940s they will be of no service at all to future generations. ... Paul Sandby may be less of an artist; but he is more of a topographer.[31]

Clark did what he could to support John. He praised the Windsor drawings shown him in the winter of 1942, and gained the Queen's permission to reproduce John's views of Windsor in a King Penguin book. For reasons unknown, the book was never produced. (Later, in 1948, a Piper lithograph of Windsor Castle became one of the Penguin Prints. These had only limited success, as few bookshops had enough space to display them.) But, if his Windsor drawings by the end of 1942 were beginning to find a degree of approval, they were

still felt to be too dark. 'I have told Piper he must try a spring day and conquer his passion for putting grey architecture against black skies,' Clark wrote to the Queen.[32] But his advice was to no avail. Almost as if to tease Clark, John wrote to him the following summer: 'I have been enjoying some wonderful thunderstorms piled behind Windsor Castle … Dark grey scudders rising against pale dove colour, and pinks and dingy purples.'[33]

It was a bright Sunday morning when John drove to Windsor, in 1945, to show the King and Queen his second series of pictures. The Queen made several appreciative remarks as she looked through them, but King George VI looked on in silence, until the rich blacks, which run like a threnody through the series, drew from him his famous remark—'You seem to have very bad luck with your weather, Mr Piper.'[34]

In the summer of 1943, when John was halfway through his second batch, the Queen commissioned Claude Muncaster, a highly conventional topographical artist, to paint the Castle, with results that have been described as 'competent but unexciting'.[35] She may have done so to please Owen Morshead, for the Librarian remained only a qualified admirer of John. He told the Queen:

> Mr. Piper himself is one of the most interesting and agreeable people I know, with a well-furnished mind and a quiet, kindly outlook on men and things; a great reader and a very competent writer. Strange indeed that such turbulent draughtsmanship should come from so placid and well-balanced a mind. When I laugh to, and at, him about his drawings he accepts it with unruffled humour. I tell him frankly that our successors in 2043 will want to know what the Castle looked like to-day, whereas his designs only tell us about the internal stresses within his own curious mind. Still they have a great vogue and they constitute a really important accession to the Royal Collection.[36]

The Queen herself is unlikely to have shared Morshead's view. She savoured a more sketch-like approach to painting and would have been aware of the English romanticism in Piper's work. There is no doubt that she grew to enjoy his paintings of Windsor and continued to hold him in high regard. On moving into Clarence House in 1953, she devoted the Lancaster Room, a reception room on the ground floor, entirely to his watercolours, hanging all twenty-six of them on the walls and showing them proudly to visitors. They remained in that room for almost fifty years, and still today feature prominently in Clarence House, representing, as they do, the most significant royal commission given to a British artist in the twentieth century.

15

Renishaw and the Sitwells

'You see,' said Sir George Sitwell to Evelyn Waugh, surveying the view from the terrace at Renishaw Hall, 'you see, there is no one between us and the Locker-Lampsons.' The Locker-Lampsons lived at Barlborough Hall, two miles away, on high ground to the E. In the valley at their feet 'half hidden in mist, lay farms, cottages, villas, the railway, the colliery and the densely teeming streets of men who worked there. They lay in the shadow; the heights beyond were golden.'

—Henry Thorold, *A Shell Guide: Derbyshire*,
quoting Osbert Sitwell's *Laughter in the Next Room*

The melancholy that pervades Piper's Windsor series reappears in his views of Renishaw, the home of the Sitwells. It seems appropriate that Sir Osbert Sitwell, whom John always referred to as his 'patron', owing to the large number of pictures he stimulated, was a close friend of Queen Elizabeth and a frequent weekend guest at Windsor Castle, where he spent time in the Print Room and the Library, studying the Sandbys as well as drawings by Leonardo, Claude, and Poussin. He wrote to John in April 1940, more than a year before the Windsor commission was conceived, and received an enthusiastic reply.

> Your very exciting letter has reached me. I am delighted with the idea of painting Renishaw Hall and of staying there with you. Its beauties look very great from the postcards you send, and I look forward with enthusiasm to seeing it and you. [...]
>
> I should have written to you, but for diffidence, at the time of your charming review of my *Brighton Aquatints*. It was very gratifying—the sort of thing one dare not hope for.

As to fee for the picture: £10 (water colour) 20, 30, 40, (oil) according to size and difficulty; but I should be very surprised if we could not arrange about fee easily.

[...] Thank goodness opportunities like this can still occur for painters. This one is (like your review of my book) the sort of thing one lives and works for.[1]

Sitwell was convinced that in relation to architecture John had 'an exceptional gift of understanding'.[2] He was equally certain, having fought in Flanders twenty years earlier, that with the onset of war the whole of life was dissolving into chaos and 'the days of liberty were drawing in'. In protest he embarked on a multivolume autobiography which would celebrate his forbears as well as the halcyon days and certainties of his youth.

I *want* my memories to be old-fashioned and extravagant—as they are;—I *want* this work to be as full of detail, massed or individual, as my last book, of short stories, was shorn of it—had to be shorn of it because of its form; I *want* this to be gothic, complicated in surface and crowned with turrets and pinnacles, for that is its nature.[3]

He also wanted John's paintings to act, like other pictures in the family's possession, as illustrations. Writing from the point of view of a scion of a country house in an area rich in ancestral homes, he was all too aware that this aspect of England's heritage was in decline.[4] Piper, he hoped, would render the essence of a building, the rhythm of the surrounding landscape, and the presence of nearby industry. At his behest, in July 1940, John visited the publishing firm Macmillan's, in connection with the design of a dust jacket for *Two Generations*, a book containing two nineteenth-century memoirs written by members of the Sitwell family which Osbert edited and introduced. Its descriptions of Renishaw gave John his first glimpse of the house. 'I like the book enormously,' he told Osbert.[5]

Despite this promising start, John did not visit Renishaw for another two years. Professional commitments detained him, as did illness, for in January 1942, soon after the birth of his daughter, Clarissa, he was knocked out for an entire month by influenza and jaundice. Then came the destruction of Bath and once again, under the auspices of the WAAC, he was busy with war damage.

He arrived in the city on 30 April 1942, and found the tragic devastation caused by one of the 'Baedeker raids' (so-called because the historic towns were thought to have been selected by means of the famous German guidebooks) following the concentrated incendiary attack by the British in March

1942 on the Baltic port of Lübeck, an ancient town, and on Rostock. As Bath had relatively few defence measures, the German air force had been able to dive-bomb and machine-gun in a specially savage way. Fires had broken out in several places; the elegant hillside terraces had been badly damaged, left charred and broken, their delicate balconies and verandahs hanging twisted and crooked. All Saint's Chapel (now destroyed), built in fields below Lansdown Terrace as a 'proprietary chapel' for the residents in the great terraces above, had been hit by a bomb and its tower had collapsed. John painted a watercolour showing its rubble-filled interior illuminated as if by a stage spotlight amid the surrounding darkness. Nearby, in Lansdown Place East, the ashlar facing had been stripped from the walls by the blast, revealing the rubble construction and rough wooden lintels beneath. Further on, in Somerset Place, the façades remained in

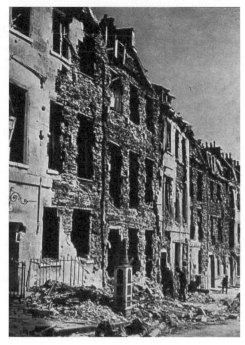

39. Bath, after the Blitz.

place but behind them houses had been gutted and reduced to shells, as can be seen in a Piper watercolour that catches both the external sweep of the terrace and the internal dereliction (Tate Collection), for by the time the King and Queen arrived to inspect the ruins, he was already hard at work, registering this architectural calamity.

Within a fortnight he had completed three large paintings in return for his 30 guineas commission. Another four brought him an additional fee of 25 guineas, while one of Cavendish Place entered the collection of Kenneth Clark. When these Bath paintings were shown at the National Gallery, in October 1942, in an exhibition of war paintings, they caught the attention of many, including Edward Wadsworth who thought them 'the outstanding feature of the whole show … grand in every way'.[6]

In Bath, John had been spotted by Helen Binyon. A little shocked to see him turning disaster so rapidly into art, she spent an evening in his company and enjoyed it enormously. 'He is a nice creature,' she reported to Peggy Angus, 'one of the nicest I know, but I don't think I really like his paintings.'[7] The uneasiness she felt over the task that had fallen him was shared by John. Though warmed by the hospitality he received from Clifford and Rosemary Ellis, who

ran the local art school and already had a houseful of evacuees, he was devas-
tated by his experience of the bombed city, as a letter to Betjeman reveals:

> I went to Bath to paint bomb damage. I never was sent to do anything
> so sad before. I was miserable there indeed to see that haunt of ancient
> water-drinkers besmirched with dust and blast ... 326 killed. 1800 houses
> uninhabitable. Might have been worse but not much. ... But the air of Bath
> still there, and the back alleys and raised voices in courtyards, only all talk-
> ing about how they'd escaped. Churches not too bad. ... My God I did hate
> that week.[8]

From Bath, he revisited Bristol. He stayed in Clifton and walked back from
the city centre one evening, under a great amber moon, in the company of
John Summerson. 'Bombing does not destroy towns,' he reflected, in a letter
to Betjeman. 'They get even more of their own character to compensate.'[9] But
in the wake of his exposure to such widespread destruction, anger and despair
now coloured his emotive reponse to architecture.

It must have been a pleasurable surprise, on his return from Bath, to find
Osbert Sitwell's renewed invitation. Again John accepted, proposing a visit
to Renishaw in the middle of June, when he could foresee two to three days
escape from his duties with the Home Guard. By then, Osbert had published
in *Horizon* an incisive, entertaining character study of Edmund Gosse, which
John read with admiration.[10] There followed a further discussion of fees which,
rather like an auction in reverse, gave John an opportunity to lower his prices
without losing face. His excitement over this project meant that money was not
an issue. And his first visit fully justified this decision, for Osbert took him on
a tour of Derbyshire houses which left indelible images in his mind. 'My dear
Osbert,' he afterwards wrote:

> I got home, with my head full of black-trunked trees, scythed grass, the
> tumbled beauty of Renishaw park, Bolsover in the mist, Sutton Scarsdale
> in drizzle and Barlborough in fitful sun. Now that I've had a day or two
> to brood I can see some paintings coming. I have worked on some of the
> sketch book drawings and will try to get it into a state suitable for an occa-
> sional table. It was all a wonderful experience, and I hope to goodness you'll
> have me again. I've never had such a series of subjects for real inspiration
> of every sort, not such congenial surroundings. I was overjoyed to find you
> such a madly enthusiastic topographer and sightseer.[11]

Though Renishaw is in Derbyshire, a county associated with green hills and
dales, it is also seven miles from Sheffield, the capital of South Yorkshire. In-

dustry, in those days, in the form of coal mines and iron works, was very much in evidence. Owing to the vision and imagination of Osbert's father, Sir George Sitwell, the gardens at Renishaw had been converted into a dream of beauty, or, rather, a flawed paradise, for Sheffield's smoking factories had encrusted the garden statues with industrial soot and coal dust blackened the artificial lake.

The Sitwell name had been associated with this particular pocket of England since the fourteenth century, but it was in the seventeenth century that an H-shaped manor house, which forms the nucleus of the present central block, was built by a George Sitwell at Renishaw, largely on the fortune acquired from the making of iron nails. Joseph Badger of Sheffield enlarged the property in the late eighteenth and early nineteenth centuries at the instigation of Sitwell Sitwell (1769–1811). He himself designed the mock-gothic battlements that ornament Renishaw, as well as a magnificent stable block, a temple in the garden, and an archway in a ravine, while adding to the house an elegant dining room, drawing room, billiard room, and ballroom. The ceiling in the ballroom is decorated with the Prince of Wales's feathers, to commemorate a ball given in honour of the Prince Regent, who afterwards made Sitwell Sitwell a baronet. Thereafter decline set in. Sitwell Sitwell's son, the first Sir George Sitwell, married a Scottish woman whose relations descended on Renishaw and contributed to the burden of expenses that eventually ruined Sir George. A drop in farm rents, an expensive election, and the failure of the Sheffield Bank in 1847 obliged him to sell part of the estate and most of the contents in the house. In time, the family fortunes revived, owing to stringent economies, prudent stewardship, and the discovery of coal below the southern fringes of the park.

In 1914–15 a huge family scandal had been a formative influence on Osbert Sitwell, and his two siblings, Edith and Sacheverell. Their mother, the improvident and rather vapid Lady Ida, had fallen into the hands of a crooked moneylender whose dealings dramatically enhanced her debts. Some of these her husband paid off, but not all, for he was aware that in one instance the moneylender had acted illegally, and had Sir George paid up, the transaction would have been condoned. At the first trial, judgement was given in Lady Ida's favour, but, though honour was upheld, the moneylender was found to be an undischarged bankrupt. The debt, therefore, remained unpaid, and the heirs of the original lender threatened to prosecute. Sir George called their bluff, with the result that Lady Ida was charged in the Central Criminal Court for conspiring to cheat and defraud another person. Indicted by letters she had written, she received three months imprisonment and went to Holloway jail. Osbert, then stationed in France, had been obliged to attend the court proceedings. Afterwards, the whole family withdrew to Renishaw, including Sacheverell, still

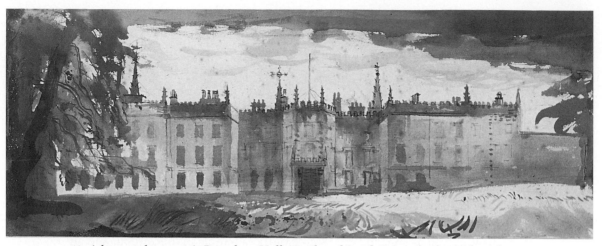

40. *(above and opposite) Renishaw Hall: North and South Fronts*, both in ink and wash, 50.2 × 19.8 cm (private collection).

at Eton, who had been given leave of absence by the headmaster, in order to come to terms with what Osbert called 'our private calamity'. On the night they arrived, a great gale struck Renishaw. 'Never', wrote Osbert, 'have I known such storms as those which now battered the old house, until it seemed alone on its table and in a world of fury.'[12] Osbert did not forgive his father for failing to protect his family from such public disgrace. But, with his siblings, he realized that, because publicity can wound, it must therefore be courted and turned to one's own advantage. From then on Edith, Osbert, and Sacheverell, in their public roles, presented a united front. During the 1920s, their readiness to do battle in the press, combined with their literary and entrepreneurial talents, earned them a dazzling position in the world of arts and letters.

During the interwar period Renishaw, with its long corridors and empty rooms, had mostly been used as a summer home. Sir George and Lady Ida spent much of the year in Italy, restoring and refurbishing Montegufoni, a castle in Tuscany which Sir George had bought in 1909. Eventually they moved there permanently, Sir George making over Renishaw to Osbert and another family home, Weston, to Sacheverell. Once the Second World War began, Osbert, now in his late forties, retreated to Renishaw, partly to protect it. Edith, in her fifties, also took refuge in the old weather-beaten house, with its vast unoccupied rooms which were said to be haunted. It was uncomfortable, was barely heated, and had no electric light. But with its many treasures, including five Brussels tapestries, its four-poster beds, its huge mahogany doors, chandeliers, and procession of rooms, it seemed to Piper 'marvellously rich' with

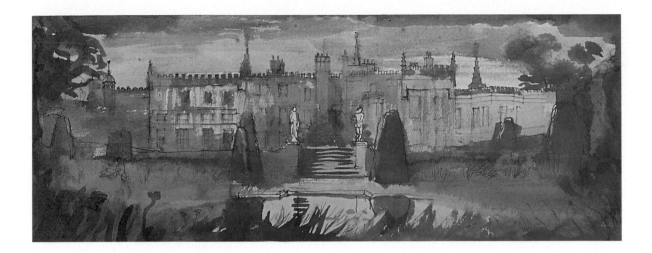

'enormous log fires and splendid food from the estate'.[13] Log fires heated the bedrooms and light was provided by Aladdin lamps inside and storm lanterns out of doors. Osbert insisted that the proper way to put out Aladdins was to flap a paper from side to side over the top. 'Use the *Spectator*, John,' he would say. 'That's heavy enough to put anything out.'[14] Upstairs, a battery of white Victorian candlesticks stood on the chamber-pot cupboards.

Over the next two or three years John made his way to Renishaw at infrequent intervals by any means he could—train and taxi or bicycle, or by car on the minute petrol ration that he was allowed, eventually discovering a colliery train that ran between Nottingham and Eckington and brought him to Renishaw in time for dinner. In winter he took with him thick vests. He quickly grew extremely fond of both Osbert and Edith, whom he found kind and generous, and he basked in their affection. John later reflected,

> In a sense, they answered a fairly desperate need of mine at the time, for sophistication, for lively conversation, for some constructive and slightly abrasive experience of literature and painting and music and indeed life, after the fairly dim public school, and no university, of my past. And they were frightfully funny. I never laughed so much as in those early days at Renishaw.[15]

He enjoyed Osbert's waspish remarks about the critic Raymond Mortimer (whose book of essays *Channel Packet* was renamed *Chanel Paquet*) and Kenneth Clark's wife. No doubt the 'huge glasses of neat gin', which John recalled,[16] fuelled Osbert's acerbic banter, through which he unleashed his paranoia about

Americans, coal dumps, and everything that seemed to threaten the things he held dear. 'I long for news of continued defeat of Renishaw's enemies, and progress of autobiography,'[17] John wrote, in August 1942. He was about to take off for the Pennines and Gordale Scar in Yorkshire, and added: 'I shall restrain myself with difficulty from getting out at Sheffield, and shall cast sheep's eyes on Renishaw trees from the carriage window.'[18] At other times he looked forward to seeing Renishaw with a sharp frost on the ground.

John especially enjoyed listening to Osbert talk.

> Later I realised that he was trying out his stories on me for the book, but he seemed infinitely knowledgeable and wise, with endless anecdotes about a world that I had never known—the Asquiths and the Keppels and the hostesses and artists of the time. He had a particular way of speaking and such a lapidary style that almost anything he said sounded like an epigram.[19]

So greatly did he enjoy Osbert's stories about his father, he began to hope that Sir George might die soon so that these tales could see the light of day, though when his death did occur, it struck him with a great blow, as he sadly realized that he would now never meet this most unusual man.

Both Osbert and Edith kept their links with London, made return visits, and invited guests to Renishaw. Evelyn Waugh arrived in June 1942 and noticed how the unmown lawns and ragged hedges made the house look deserted. Inside, however, he was pleasantly surprised to find banks of potted plants and bowls of roses, no evacuees or billeted soldiers, no dust sheets except in the ballroom, piles of new and old books, delicious cooking, and 'an extremely charming artist called Piper'.[20] Charles Ryder in Waugh's *Brideshead Revisited* may be partly modelled on John who was asked by the author, after the book appeared, to illustrate the manuscript with imaginary landscapes as a gift for his wife. John agreed, then changed his mind, perhaps because he preferred illustrating specific places.[21] More fruitful was his meeting at Renishaw with the publisher John Lehmann for whom he designed a dust jacket for Henry Green's *Loving*. Here, too, he met L. P. Hartley and first heard Bartok's 6th quartet when the Griller Quartet, having performed in Sheffield, turned up in RAF uniforms and played to Edith, Osbert, and John.[22] Piper himself provided entertainment in March 1944 when he gave a talk on 'Topographical Illustration' in Sheffield and afterwards paid ten shillings into the Sheffield Art Collections Fund. Osbert chaired the occasion. More usually evenings at Renishaw found John operating the EMG gramophone with its enormous papier mâché horn and its fibre needles. One particular favourite was the Debussy quartet.

There were also long periods when nothing happened in this melancholy, soot-blackened house with its unending chain of rooms, the management of which was largely the responsibility of Osbert's soldier-servant John Robins and his wife, and where the winter mists added to the gloom. Evidently, only a few rooms were in use: Osbert's lover, David Horner, who, after a stint with the Air Ministry in London, was posted as an Intelligence Officer nearby, resented the fact that his room doubled as a guest room during John's visits. For much of the day the quietness remained unbroken. Nobody came down for breakfast which was brought to the bedroom, the crab-and-elder jelly becoming a memorable part of the day. Edith remained in bed all morning, writing, and did not appear downstairs until late afternoon.[23] When not writing, she knitted; John received in all three sweaters made by her, all of which were too large. Osbert shut himself away in his study in the oldest part of the building where, at a richly coloured table bought from Roger Fry's Omega Workshops, he spun out convoluted prose descriptions of the people, places, and anecdotes that formed his ancestral past and which became woven into his Sitwell mythology. In time, this room, which looks over the gardens, was to be hung three deep with Piper's paintings. Because both siblings regarded Renishaw as a place of seclusion in which to work, visitors found they had hours on end in which to do exactly as they liked, a routine that well suited John. 'It is such a stimulus being there,' he wrote to Osbert in 1943, 'and working unhindered by the police and the Home Guard, and I always enjoy it so much.'[24]

Though left to his own devices, he was not ignored. Osbert became accustomed to this 'energumen at work' and one Christmas gave him a large leather-backed folder for his drawings. He wrote:

> Should a surviving owner of a country house in any part of England, look out of [the] window and remark the presence of a tall, sunburnt man, of distinguished aspect, with an air both smiling and somewhat ascetic, of rather spare figure, with pronounced features and a high-bridged nose, with grey hair, older than himself, dark eyebrows and grey-blue eyes of a remarkable acuteness and precision of glance, lying, hatless, on a mackintosh in his park, in an attitude abandoned, but to him familiar discomfort ... and wonder who he will be; it will be Mr John Piper making short-hand notes for a painting.[25]

This same man willingly undertook tasks for the family, designing a dust jacket for Osbert's *Selected Poems* in 1943,[26] another for Sacheverell Sitwell's *Selected Poems* in 1948, bookplates for both brothers, and for David Horner some

headed notepaper and a Christmas card, as well as a label for Montegufoni wine bottles. For Edith, he designed for a new performance of *Façade* a drop curtain with the suggestion of a Gothic house, follies, a garden, lake and moon, and a sculpted bust in the centre, with an open mouth through which the megaphone could protrude. He also did a book jacket for one of her poetry selections, *Façade and Other Poems 1920–1935*, and, in 1948, agreed to write a tribute to her for an American symposium published in her honour, Edith having included his name in a list of those she would best like to contribute.[27] She evidently shared Osbert's affection for John. After the first year of his association with Renishaw, she wrote: 'Osbert and I do hope you are coming here again, very soon. You seem to be part of the life of the house.'[28]

As with Seaton Delaval, John found at Renishaw, with its Stuart and Regency past, a house that had undergone many vicissitudes. The marks of the cannonballs fired by the Roundheads while the house was garrisoned for the King

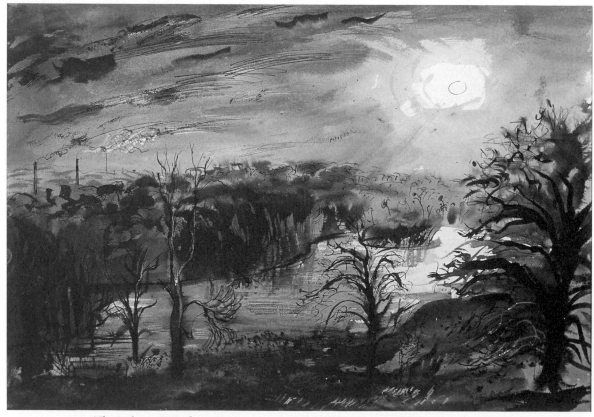

41. *The Lake at Renishaw, at sunrise*, ink and wash, 53.3 × 40.7 cm (private collection).
(Courtesy of the late Sir Reresby Sitwell)

during the Civil War were still visible on the stone parapet. Situated on top of a hill, with the Vale of Rother to the east, it offered a view south of open countryside, punctuated by industrial chimneys, while the bedroom windows facing due north looked out on to 'grey seas of winter sky'.[29] In summer months, the south front, with its recessed centre, was covered with crimson and white roses, clematis, honeysuckle, and other flowering creepers. For John, the house and its setting proved to be rich in incident. Aside from a drawing of the domed recess in the dining room, he ignored the grand rooms and concentrated entirely on external views. He painted the north (Plate 25) and south fronts of the house, the stables, the stables' courtyard, many views of the lake, the folly, the Gothic temple, the arch in the ravine, the garden with its statues and ramparts of yew, the figures of Achilles and Athena (eighteenth-century copies of French

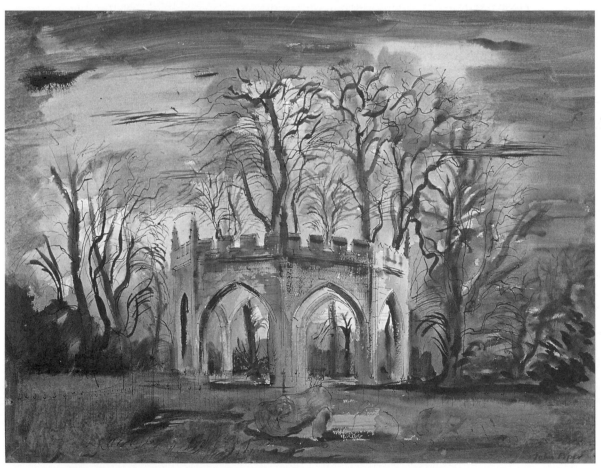

42. *The Gothic Temple*, ink and wash, 50.8 × 40.9 cm (private collection).
(Courtesy of the late Sir Reresby Sitwell)

originals) which guard the entrance to the Wilderness on the east side of the house, the Orangery, and the Kennel cottages in the north wood at the bottom end of the drive. He went further off for distant views of the house, and also climbed onto the roof where, as at Windsor, he found walkways that threaded their way between menageries of chimneys and mock-Gothic pinnacles and which supplied him with the opportunities for roofscapes. Lightning sketches served as notes for the final work, in which he employed rapid handling and rough surfaces to suggest the texture of weather-beaten stone, the movement of wind, or spasmodic effects of light.

It was not just at Renishaw that subjects proliferated. Osbert's claim—'In this wide country the most typical feature is the splendour of its houses'[30]—proved correct. But the survival of this splendour was endangered and coloured by its close relationship with industry.

A colliery village had crept right up to the entrance of Sutton Scarsdale which had then become, as it still remains today, a largely forgotten ruin. John painted its stone façade, with its elegant Corinthian columns designed by Smith of Warwick, opening onto a gutted interior (Plate 26). Built in 1724, it had fallen into decline in the 1920s and by the 1940s, owing to the removal of its Venetian plasterwork ceilings and marble chimney pieces by a speculator, foxes had begun making their earths in this 'eyeless and roofless ruin'.[31] Built on a hillside, with a commanding view, it overlooked what Pevsner called 'the depressing untidiness of open-cast coal-mining', while in the far distance, across the valley (now sliced through by the M1), could be seen the keep at Bolsover Castle, 'whose casements', one Sitwell writes, 'always shone like fire in the evening'.[32] This, too, in the 1940s, was in a ruined state. Situated on a spur of land above a precipice, which drops two to three hundred feet onto another level, it nowadays overlooks, not the park where in the seventeenth century deer were bred for hunting, but, to the north-west, coalite, coking, and chemical plants. Among congeries of buildings at Bolsover, John chiefly favoured the palatial Italianate block, built for the entertainment of Charles I and his court when Ben Jonson's masque *Love's Welcome* was performed. But every part of Bolsover would have fed his romantic imagination, for it then stood gaunt and empty on its crag, 'abandoned to weather and shaken and riven by the mines beneath'.[33]

Two other houses that stirred his imagination were Hardwick Hall, the great Elizabethan house built for Bess of Hardwick, with its huge height and enormous windows (Plate 27), and Barlborough Hall. John made individual studies of all these buildings, but he also combined them into a twelve-foot panorama, *Derbyshire Domains*, which, together with its pendant piece, a large roofscape,

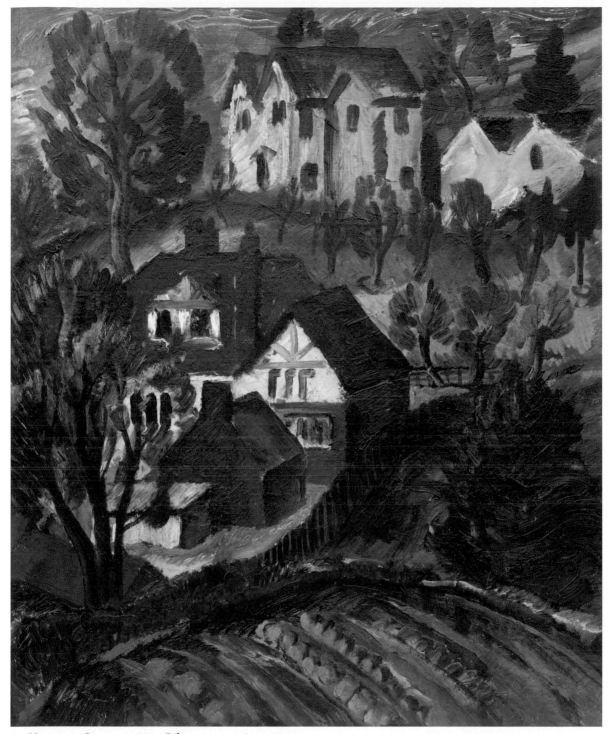

1. *Houses in Surrey, c.*1928. Oil on canvas, 61 × 50 cm.
(Private collection)

2. *The Stoning of Stephen.* Stained glass, Grately Parish Church.

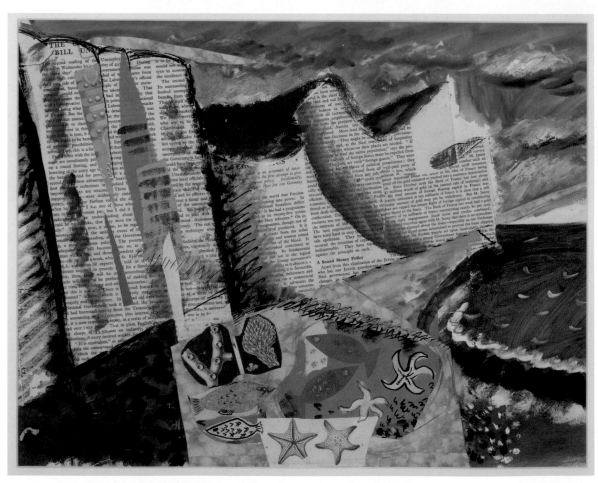

3. *Beach with Starfish*, 1933–4. Ink and gouache with collage, 38 × 48.5 cm.
(Tate, London)

4. *Houses on the Front*, 1933. Watercolour with collage and stencil, 37.5 × 46.3 cm.
(Private collection)

5. *String Solo,* 48 × 58 cm.
(River and Rowing Museum, Henley on Thames)

6. *The Harbour at Night*, 1933. Oil on paper, collage and sgraffito, 50 × 60.5 cm.
(Private collection)

7. *Foreshore with Boats, South Coast*, 1933. Oil on canvas with collage, 63.5 × 77 cm.
(Private collection)

8. *Abstract Construction*, 1934. Oil with sand on wood, 53.3 × 62.8 cm.
(Whitworth Art Gallery, Manchester)

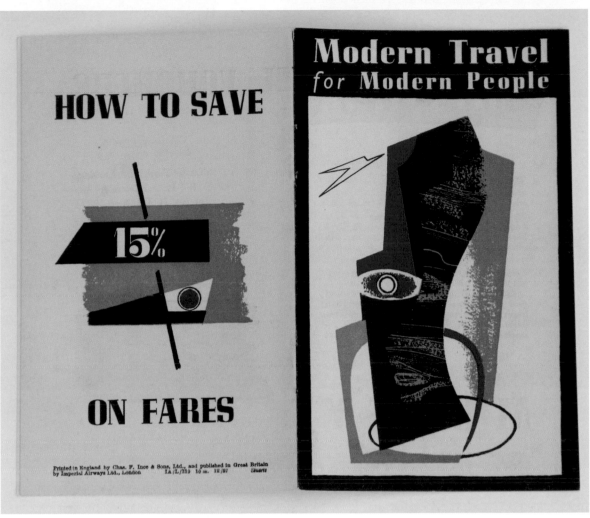

9. Imperial Airways brochure, designed by John Piper.

(Private collection)

10. *Painting*, 1935. Oil and ripolin on canvas on board, 29 × 48 cm.
(Private collection, courtesy of Jonathan Clark and Co., London))

11. *Newhaven*, 1936. Collage, gouache, oil, black ink and scrim, 37 × 50 cm.
(Private collection)

12. *Forms on Dark Blue*, 1937. 75 × 27.5 cm.

(Courtesy of the Pym's Gallery).

13. *Autumn at Stourhead*, 1939. 63.3 × 76.2 cm.

(Manchester City Art Gallery)

14. *Nursery Frieze I and II: Seascape and Landscape*, 1937.
Lithograph, 46 × 121.5 cm.

(Private collection)

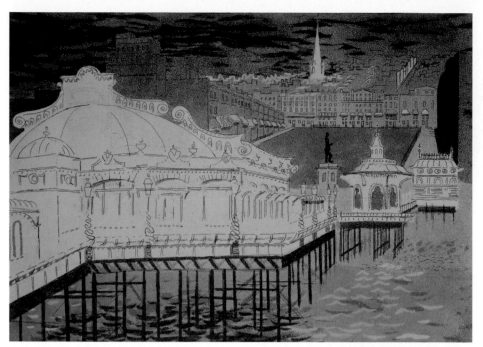

15. *Regency Square from the West Pier,* from *Brighton Aquatints*, 1939. 21.2 × 29.2 cm.
(Private collection)

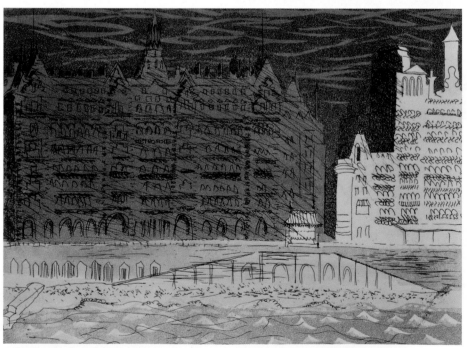

16. *The Metropole Hotel from the West Pier,* from *Brighton Aquatints*, 1939.
21.2 × 27.6 cm.
(Private collection)

17. (*opposite*) *Coventry Cathedral, 15 November 1940,* 1940.
Oil on canvas, 76.2 × 63.5 cm
(Manchester City Art Gallery)

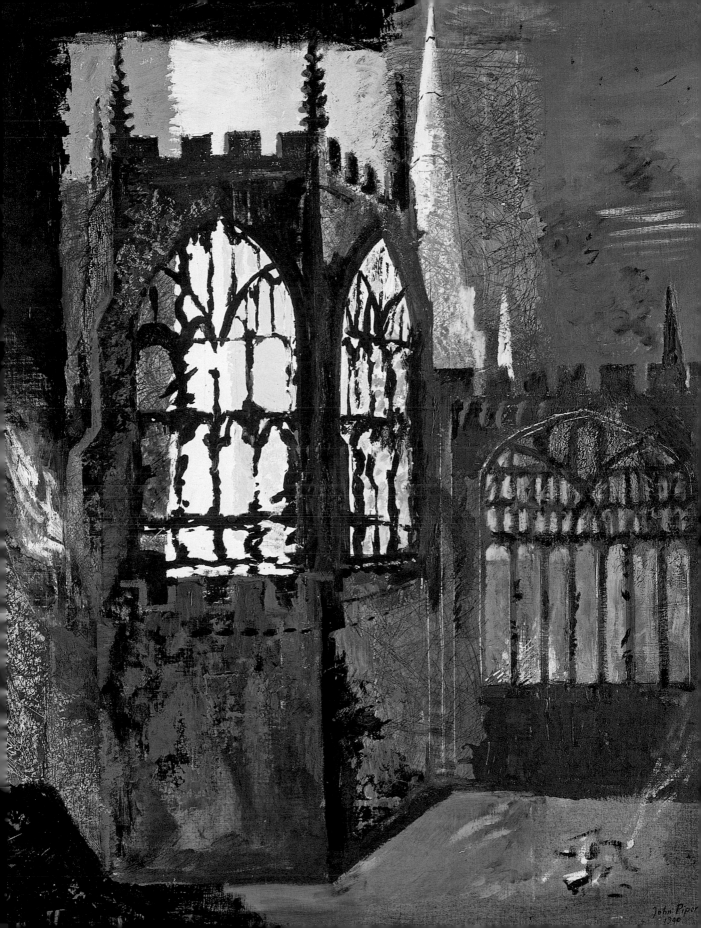

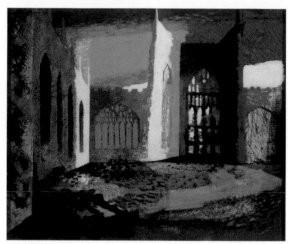

18. *Interior of St Michael's Cathedral, Coventry, November 15th 1940*, 1940.
Oil on canvas laid on board, 50.8 × 61 cm.

(Herbert Art Gallery and Museum, Coventry)

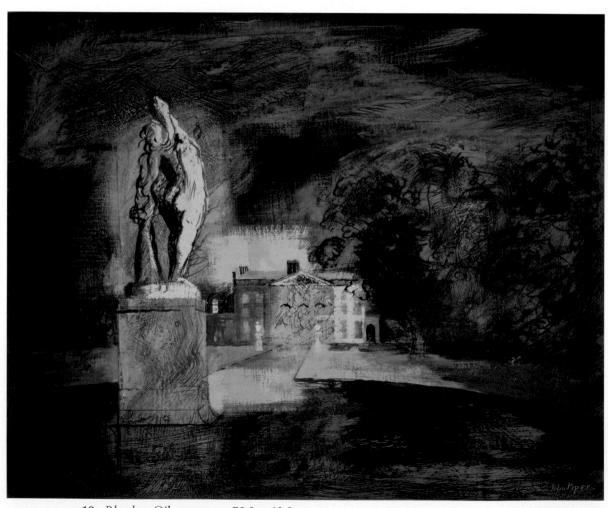

19. *Blagdon*. Oil on canvas, 72.3 × 62.2 cm.

(Private collection)

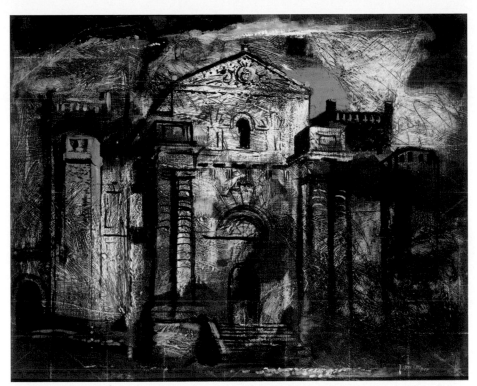

20. *Seaton Delaval*, 1941. Oil on wood, 71.1.× 88.3 cm.

(Tate, London)

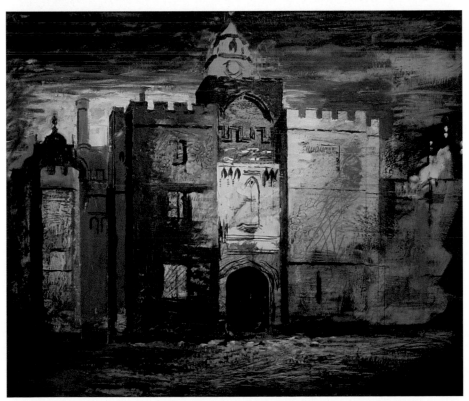

21. *The Gatehouse, Knole*, 1942. Oil on canvas laid on board, 63.5 × 50.8 cm.

(Private collection, courtesy of Offer Waterman & Co.)

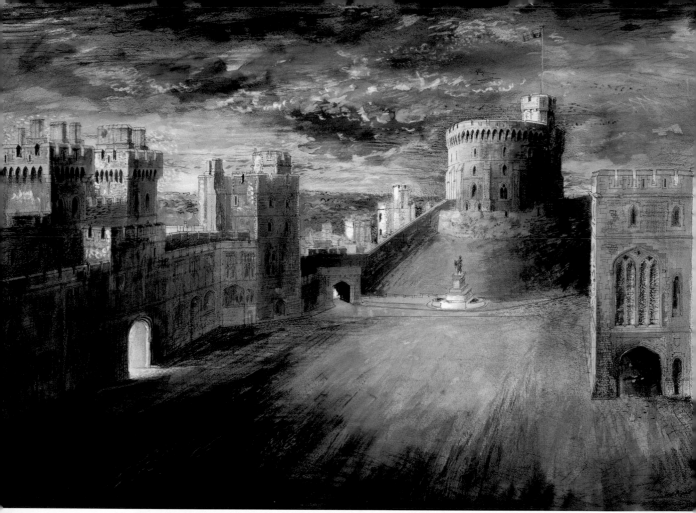

22. *The Quadrangle, Windsor Castle, looking west, c.1941–4.* Pencil, pen and ink, watercolour, bodycolour and pastel, 55 × 75.1 cm.
(The Royal Collection © 2008 Her Majesty Queen Elizabeth II)

23. (*Opposite, top*) *Windsor town, railway and the Curfew Tower and Horseshoe Cloister, Windsor Castle*, *c.*1941–4.
Pencil, pen and ink, watercolour, bodycolour and pastel, 42.5 × 54 cm.
(The Royal Collection © 2008 Her Majesty Queen Elizabeth II)

24. (*Opposite, bottom*) *The Round Tower from the roof of St George's Chapel, c.1941–4.*
Pencil, pen and ink, watercolour, bodycolour and pastel, 40 × 54.3 cm.
(The Royal Collection © 2008 Her Majesty Queen Elizabeth II)

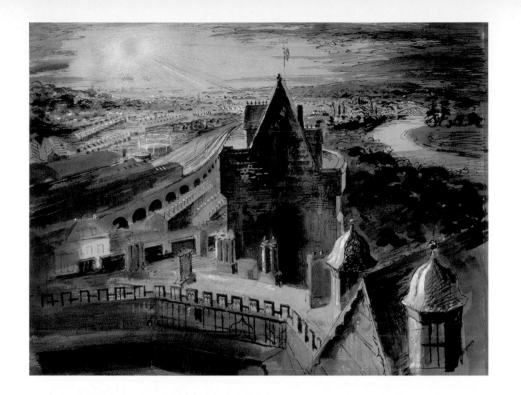

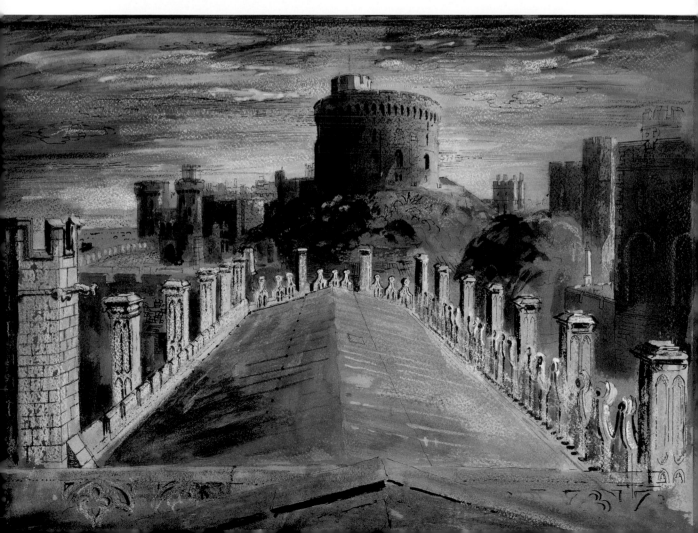

25. *Renishaw, the north front, c.*1942–3. Oil on canvas, 43.2 × 73.7 cm.
(Courtesy of the late Sir Reresby Sitwell)

26. *Sutton Scarsdale.* Watercolour, *c.*1942–3. 63.5 × 50.8 cm.
(Courtesy of the late Sir Reresby Sitwell)

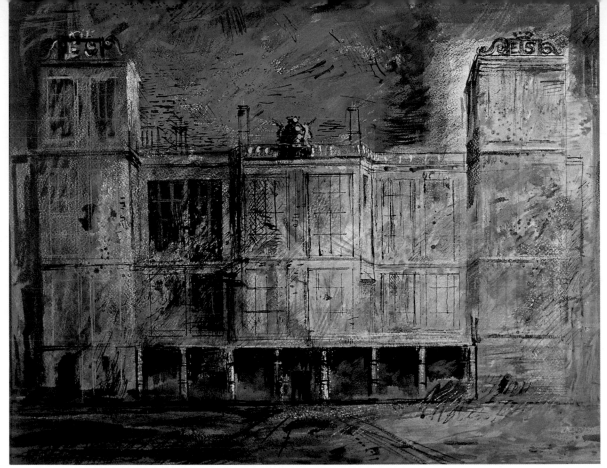

27. *Hardwick Hall, c.*1942–3. Watercolour, 68.5 × 52.1 cm.
(Courtesy of the late Sir Reresby Sitwell)

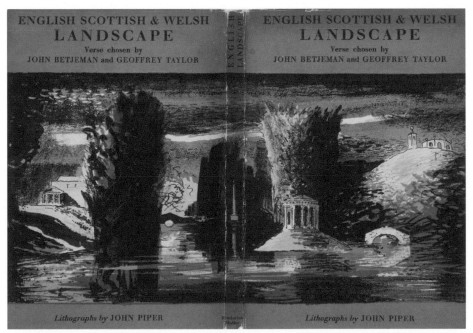

28. Dust jacket for *English, Scottish and Welsh Landscape Poetry, 1700–c.1860.*

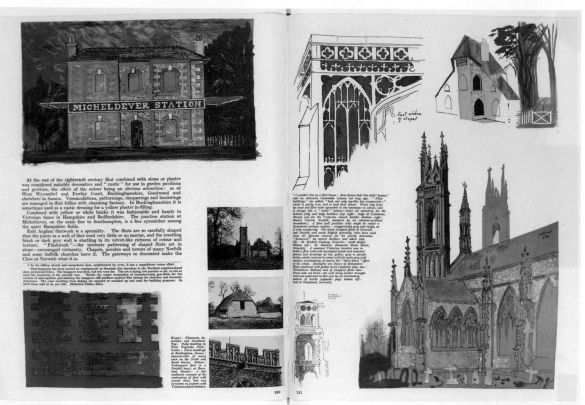

29. Double-page spread from *Architectural Review* 96 (November 1944), showing John Piper's article on 'Flint'.

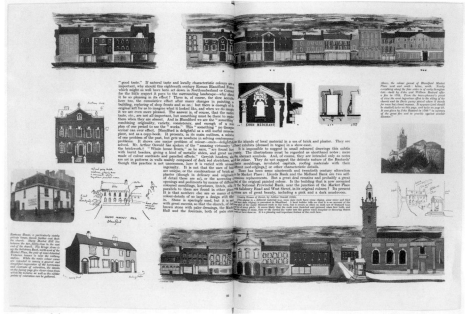

30. Double-page spread from *Architectural Review* 96 (July 1944), showing John Piper's article on 'Blandford Forum'.

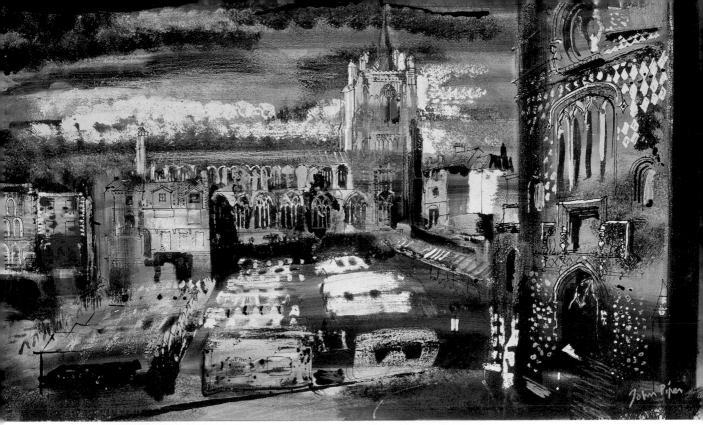

31. *Norwich Market Place*. Watercolour and chalk, 41.4 × 69.5 cm.

(Norwich Castle Museum and Art Gallery)

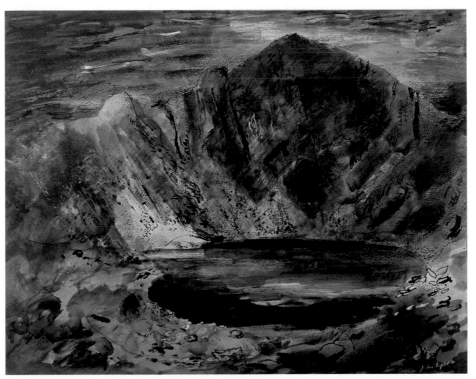

32. *Cader Idris*, *c*.1944. Ink and wash, 64.7 × 52 cm.

(Courtesy of the late Sir Reresby Sitwell)

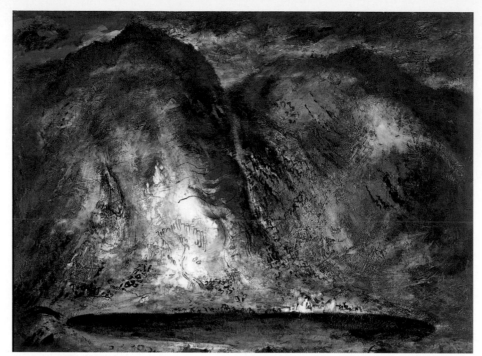

33. *The Rise of the Dovey*, 1944. Tempera and gesso on canvas mounted on board, 69.5 × 87 cm.

(Private collection)

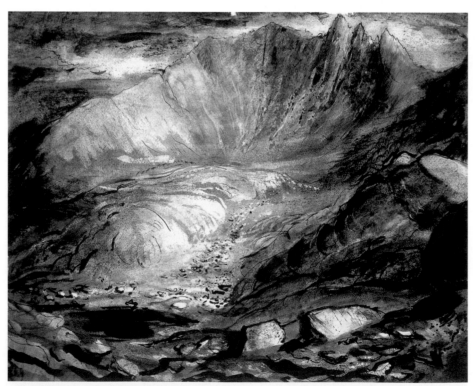

34. *Welsh Mountain Landscape*. Pen and ink, watercolour, chalk, coloured chalks and scratching out, 55.5 × 68.5 cm.

(Private collection)

35. *Rocky Valley, North Wales*. Oil on canvas, 91.5 × 122 cm.
(Private collection)

36. *Rocks on Tryfan*, *c.*1948. Watercolour, gouache, chalk, pen and ink over wax resist, 56 × 71 cm.
(Private collection)

37. (*below*) Act I, Scene 1, illustration by John Piper based on his original design, for *The Rape of Lucretia.*
(Bodley Head, 1948)
38. (*below*) Lucretia's House, illustration by John Piper based on his original design, for *The Rape of Lucretia.*
(Bodley Head, 1948)

39. The drop curtain for the Chorale Interlude in 'The Rape of Lucretia', from *The Rape of Lucretia.*
(Bodley Head, 1948)

40. (*Above*) *Chapel at Montegufoni with relics*, 1947. Mixed media, 25.4 × 35.6 cm.
(Private collection)

41. (*Opposite*) *Cheltenham. Composite of Houses in Priory Parade and elsewhere*, 1949.
Oil on canvas, 197.5 × 123 cm.
(Government Art Collection)

42. (*Opposite*) *Bath: Grosvenor Crescent*, 1949. Oil on canvas, 197.5 × 123 cm.
(Government Art Collection)

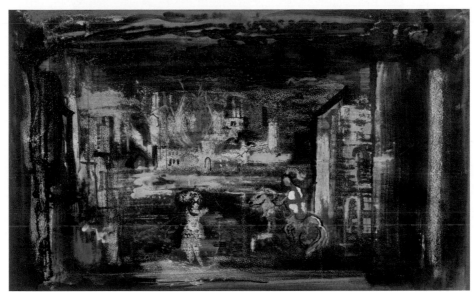

43. Textile backcloth designed for *Il Combattimento di Tancredi e Clorinda*, 1951.
Indian ink and body colour, 33 × 54.5 cm.

(Victoria & Albert Museum)

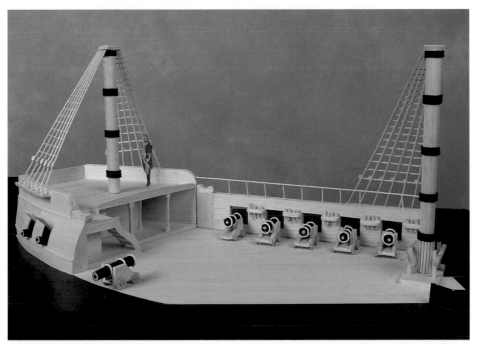

44. *Billy Budd*. Model of the *Indomitable*'s upper deck made by Michael Northen to
John Piper's design.

(Britten–Pears Library, Aldeburgh)

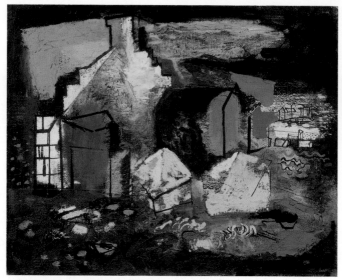

45. *Portland, c.*1954. Oil on canvas, 61 × 75 cm.
(Private collection; courtesy of Jonathan Clark)

46. (*Above*) *Foliate Heads*, 1954. Textile designed for David Whitehead.
(Victoria & Albert Museum)

47. (*Opposite*) *Northern Cathedral*, 1959. Textile designed for Arthur Sanderson & Sons.
(Private collection)

48. (*Above*) *Arundel*, 1955. Textile designed for David Whitehead.
(Private collection)

49. (*Opposite*) Stained-glass windows in the apse of the chapel, Oundle.
(Photograph: Sonia Halliday)

50. Mayo Clinic mural. 1036.3 × 304.8 cm.

(Mayo Clinic, Rochester, Minnesota)

51. Morley College mural, 1958. Oil on canvas mounted on board, 254 × 571.5 cm.

(Morley College, London)

52. 'Landscape of the Two Seasons', mural for *Oriana*, 142 × 920 cm.

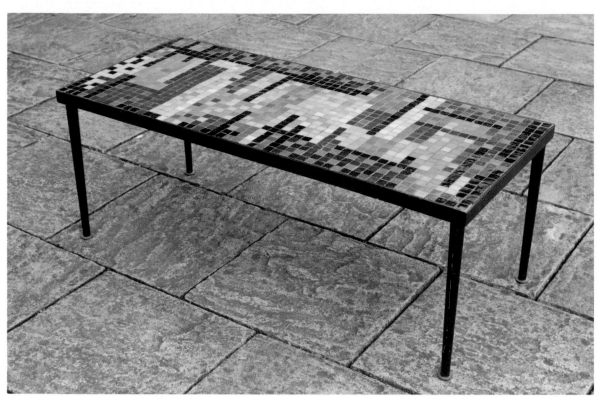

53. Mosaic-topped table.
(Private collection)

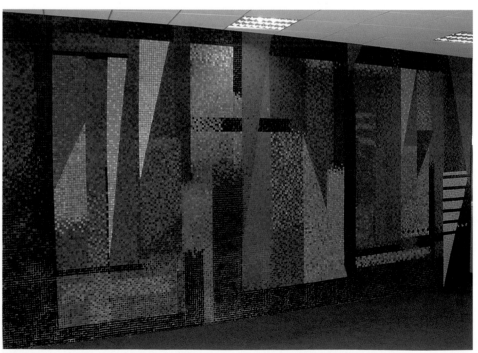

54. Mosaic Wall, 1958 (Chamber of Commerce, Birmingham).

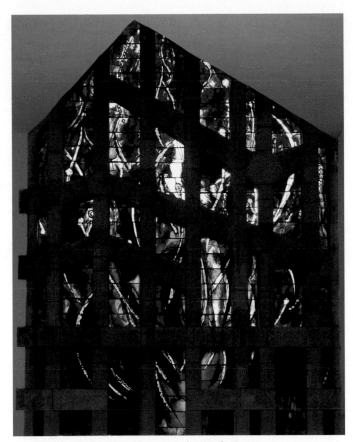

55. Stained Glass representing the Holy Spirit
(St Mark's, Broomhill, Sheffield).

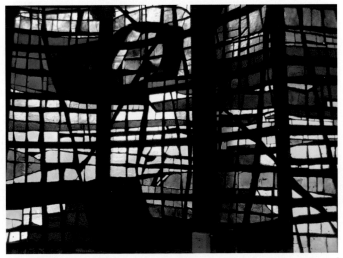

56. Section of wall from the Baptistery at Audincourt, Montebéliard,
showing stained glass by Jean Bazaine.

57. The Baptistery Window, Coventry Cathedral.
(Photograph: Sonia Halliday).

58. *The Forum, Rome*, 1960. Oil on canvas, 106.5 × 152.5 cm.
(Tate, London)

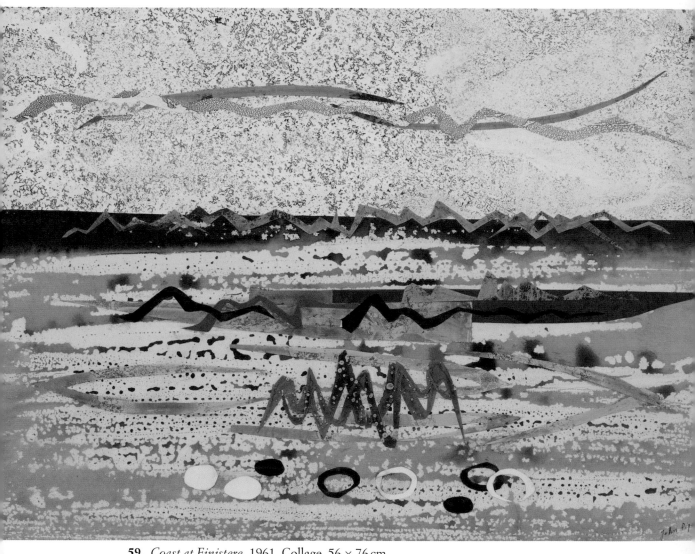

59. *Coast at Finistere*, 1961. Collage, 56 × 76 cm.
(Private collection)

60. Detail from stained-glass window, 1967–8 (St Andrew's, Wolverhampton).

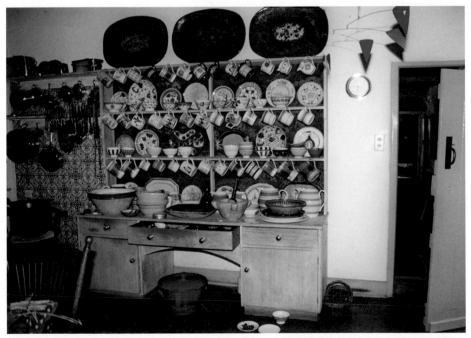

61. The dresser in the kitchen at Fawley Bottom, with a red bread crock by Geoffrey Eastop on the floor, and platters decorated by Piper along the top of the dresser.

62. Seven-panel tapestry for Chichester Cathedral.

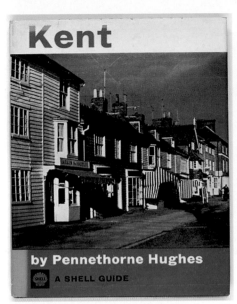

64. Cover designs for *A Shell Guide to Kent* and *A Shell Guide to Shropshire.*

63. *Architectural Fantasy.* Tapestry, 450 × 234 cm.

(Government Art Collection)

65. *Harlaxton (Blue)*, 1977. Screenprint, 57.5 × 101 cm.
(Courtesy of Goldmark Gallery, Rutland)

66. *Stones & Bones, XXIII*, 1978. Screenprint, 50.5 × 70 cm.
(Private collection)

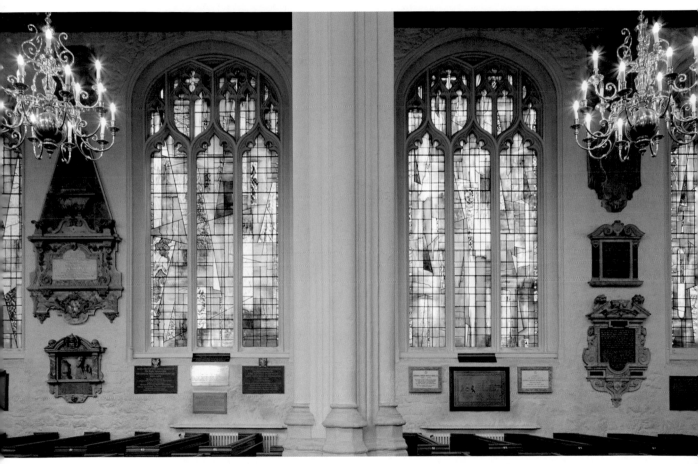

67. John Piper windows in the south wall of St Margaret's, Westminster, 1968.
(Copyright: Dean and Chapter of Westminster).

68. The lantern representing the Holy Trinity, at Metropolitan Cathedral of Christ the King, Liverpool, 1965–6.

69. The lantern, other internal views.

70. External panel decorations originally commissioned by the Gas Board for showroom, in Peterborough Road, Fulham, 1961–2

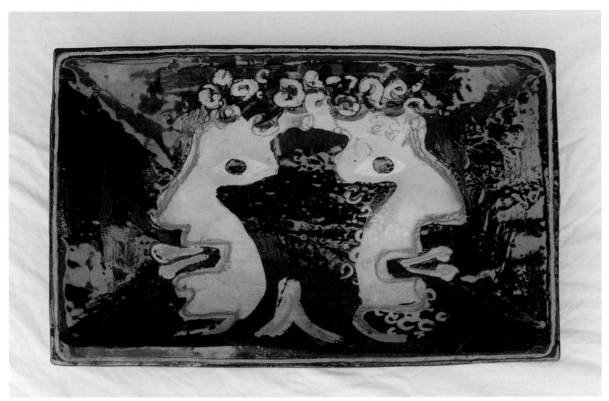

71. John Piper ceramic.

(Private collection)

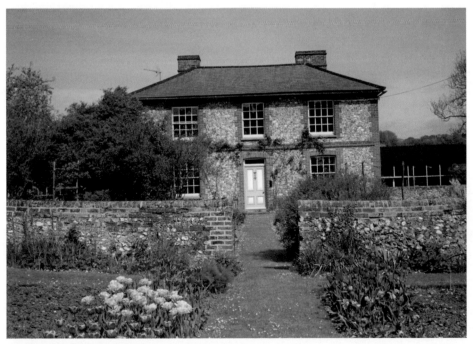

72. Fawley Bottom Farmhouse.

(Photograph: Jean Seward Uppman)

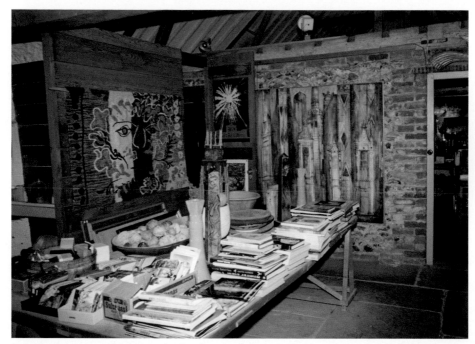

73. The anteroom between the kitchen and the cowshed studio at Fawley Bottom

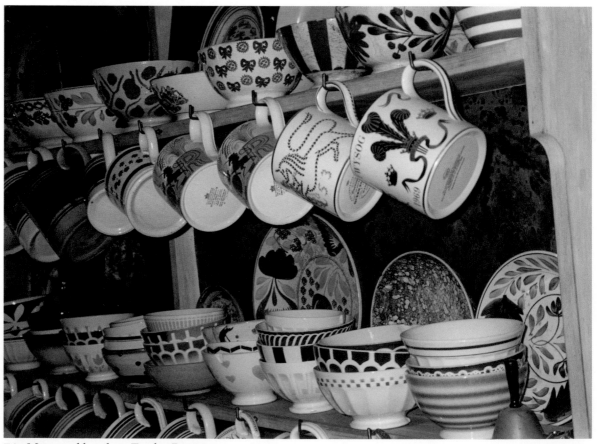

74. Mugs and bowls at Fawley Bottom.

75. *The Light of the World*, 1978–80. Stained-glass window, Robinson College, Cambridge.
(Photograph: Sonia Halliday)

76. Stained glass in the ante-chapel at Robinson College, Cambridge, 1978–80.
(Photograph: Sonia Halliday)

77. Benjamin Britten memorial window, Aldeburgh parish church, 1979.

78. Churchill Memorial Window, 1973–4 (National Cathedral, Washington, DC)

79. *Rowlestone Tympanum with Hanging Lamp*, 1965. Lithograph, 51 × 68 cm.
(Private collection)

80. Edward and John Piper in the cowshed studio at Fawley Bottom.

(Photograph: Jason Shenai)

81. *Flower Piece*. Watercolour, 50 × 60.5 cm.
(Courtesy of Simon Jenkins)

82. Myfanwy Piper.
(Photograph; courtesy of Clive Duncan)

83. *Suffolk Towers: Alpheton and Stansfields*, 1969. Oil on canvas, 122 × 122 cm.

84. *Death in Venice*, design for interior of St Mark's. Mixed media, 47.2 × 87.5 cm.
(Britten–Pears Library)

he painted for the front hall at Renishaw, having first measured the space available, with Robins' help.

In time, he produced some seventy pictures for Osbert. Among these are paintings of the south bay at Scarborough, the fashionable nineteenth-century resort where Osbert had spent much of his childhood at another family house, Wood End. There are other places he painted, not in the vicinity of Renishaw but associated with the Sitwell family. Nevertheless, pictures of Renishaw dominate his output. Some sepia views suggest that he was thinking in terms of another set of aquatints, though none exist. Nevertheless, his many oils and watercolours of the house and its setting have a unity of mood that enabled him to do for the Sitwells at Renishaw what Turner did for the Egremonts at Petworth.

John's fascination with this area is evident from a passage in his 'travel diaries', dated 16 November 1942:

> Day beginning with fog and ending with a 19th century sunset. Such a fireball in the fog, and Renishaw rising from ground mist, only the top storey visible. Blue trees round orange folly temple. A grey scabrous wreathing on the swimming pool and lake (a young man here convinced it was a slimy uprising from the bottom). Stationary swans. Burnt-out grass, colourless. Midland refuse tips and blackened trees at their best in the disappearing mist. Sheep in the park retain traces of their recent verdigris-coloured dipping (owing to something going wrong with war-time sheep dip): the colour of stucco on council houses at Eckington and Stavely.
>
> To Bolsover: as wonderful as could be, commanding the fog-soaked, colliery-sodden landscape. The riding schools pale in its hill toplight: ruined gate and brown trees at end of terrace dark. Buildings greenish and naples and pink grey rather than ochre and pink.[34]

These impressions were allowed to shake down in his mind before they re-emerged in drawings and paintings in the studio. Unlike other artists, John did not dread the nights lengthening, for, as he told Osbert, 'there is always the delight of working on drawings by lamplight, which against all art-school rules, I love.'[35]

Despite his enjoyment of Derbyshire country seats, John had no wish to become known as a country-house painter and tried to resist invitations to continue in this vein. With Osbert the go-between, he felt obliged to accept Stanstead Hall, at Halstead, Essex, the home of R. A. Butler, in the 1940s. The association with Vanbrugh may explain why he painted Castle Howard and

its architectural follies, in 1942; and Knole, the ancestral home of the Sackville-Wests near Sevenoaks, was done at the request of Eddy Sackville-West, the music critic (Plate 21). He commissioned John to produce an album of drawings as well as four large oils of the house. News of this reached Vita Sackville-West, who had been prevented by her gender from inheriting the house. She wrote, asking for first refusal on any painting or drawing of Knole, after Eddy and his father had had their say. Three years later she again approached John, asking him to undertake illustrations for a special edition of her long poem *The Garden*. He declined, on the grounds that the poem required semi-symbolical imagery and his interests at that moment lay with purely factual illustration.

In John's mind, no one could surpass Osbert as a patron. Generous with his time and attention, passionately interested in places, he was both stimulating and blessedly uninterfering. Occasionally, he directed John's attention towards subjects in his autobiography. Mostly, John was free to seek out views that pleased him.

Many of his Renishaw watercolours adopt a melancholy near monochrome palette, in keeping with the wartime mood. He was drawn repeatedly to the main lake at Renishaw, in all seasons and weather, while the arch in the ravine evoked his nostalgia for the Picturesque. But it is the staunch façades of these embattled Derbyshire houses, their keeps and stable blocks, and what Christopher Hussey called 'their aura of boding tragedy'[36] that drew from him the most vehement response. His preferred medium for these architectural subjects was oil paint. Before painting, he covered parts of the canvas with gesso, to create texture and to make possible an abrasive treatment. Often a black underpaint remains visible beneath the bursts of white, gold, ochre, orange, electric blue, and red. In those places where he has scratched into the paint surface with the wrong end of the brush, the dark breaks through, scarring the picture surface with a network of sharp lines and knotted squiggles. This treatment heightens the drama of these scenes, is suggestive of weathering and decay, and seems to carry a memory of the building's imagined past. Compared with his paintings of bomb-damaged Bath, John's paintings of Renishaw seem less mournful, less detached; more full of anger and passion. It is as if the feelings he experienced in the face of the architectural destruction at Bath could only properly surface later, in the greater freedom that Renishaw offered.

When *Left Hand, Right Hand!*, the first volume of Osbert's autobiography, appeared, its verbal extravagance, gargantuan nostalgia, and brooding sense of loss had immediate success with an audience accustomed to wartime austerity. Reproductions of John's pictures added to the appeal of all five volumes, published between 1945 and 1950.[37] His paintings also acted as a curtain raiser,

for, in January 1945, a few months before the first book appeared, the Leicester Galleries mounted an exhibition of forty-seven of his paintings of Renishaw and nearby subjects. It sold out in two days, the *Evening News* reporting that thirty-eight had been bought by Sir Osbert Sitwell.[38] The majority of these pictures were then shown again, first at Chesterfield Library and then, in April, at Derby Museum and Art Gallery.

In the preface to the catalogue Osbert claimed that Piper had found at Renishaw 'a territory peculiarly suited to his sombre yet fiery genius'. He continues: 'These battlements splinter with their ancient glory the black clouds and golden lights that come so naturally to this painter's brush, and in the landscapes he renders precisely the darkness and illuminated splendour of the countryside, its curious and lovely melancholy, and the occasional rage of it.'[39] 'Too flattering, but perfect,' John wrote, adding that Myfanwy thought Osbert's introduction 'brilliant'.[40] But Osbert had in fact distilled his 700-word preface from a much lengthier essay, 'The Art of John Piper', which remains unpublished.[41] In this, he reminds us again that the drama of this landscape lies in its dual life: 'for under the age-old surface processes of farming, forestry and the like, runs the cramped, subterranean existence of the mines.'[42]

Edith evidently shared Osbert's enthusiasm for John's pictures: on her visit to the exhibition, she broke with her usual sedentary routine and stood for two hours. 'They have so much force, fire and personality,' she said of the exhibits.[43] Another admirer was Christopher Hussey, who claimed in *Country Life* that John was the first artist technically and psychologically equipped to transform the essence of a country house into a work of art.[44] Perhaps still more welcome was a letter from the artist Cecil Stephenson, who, like John, had engaged with abstraction in the 1930s. He admired the colour, dramatic force, and masterly execution which he found at the Leicester Galleries and insisted that John had 'enhanced the English Tradition' by his skill and industry.[45]

16

Topographical Mania

John Piper had a passion for local guidebooks, no matter how ramshackle or intensely personal they were. He immediately recognized a sophisticated gem when, in 1942,[1] he read *Shakespeare's Country*, a newly published guidebook in Batsford's 'The Face of Britain Series'. Its author suggested that owing to the countryside's new impermanence, the best way to view it is 'not with the golden-wedding tenderness of the local writer, but with impatient, if delighted analysis'. He also admitted that the two best county guides in recent years had been written by John Piper and Paul Nash. The former wrote:

> Dear Mr Russell,
> Congratulations on writing the best topographical book for years: one that will make reviewers look foolish for having so much misused phrases like 'at once readable and informative' and 'of equal interest to the student and the layman'. You have given Batsfords such a lesson! Please do insist next time on choosing all your own illustrations, for I cannot believe you lightly allowed the inclusion of some of the line blocks (wartime difficulties apart). Please forgive this intimacy from a stranger, but your writing induces unusual sympathy in a topographical maniac.
> Yours sincerely,
> John Piper[2]

Shakespeare's Country was John Russell's first book; and this letter, arriving out of the blue, meant a great deal to him. Soon afterwards he began reviewing for *The Sunday Times* and, in 1949, became its art critic, a role he filled until 1974 when he moved to America and the *New York Times*. But in 1942 he told Piper that it felt particularly satisfying 'to think that I have returned some small part of the pleasure which I have for several years taken in your work, and I

shd. like to think that from this constant association I have picked up some of the gaiety and intelligence which animate it.'[3]

Thus began their lively exchange, mostly on art and the art world, for Russell was soon sharing in-jokes about *The Archie*, going to drinks parties at John Murray's office at 50 Albemarle Street, buying pictures from John and sharing his pleasure in Laurence Binyon's *Landscape in English Art and Poetry*. Before long Russell came frequently to Fawley Bottom on weekend visits, brimming with gossip.

Mutual regard permitted healthy disagreements. Russell read *British Romantic Artists* as soon as it appeared. He appreciated its definite point of view and firm historical line, but resisted John's dismissive view of Bloomsbury. He further demurred over John's views on Wyndham Lewis: 'all that I have read of his seems to me sham tough writing and destructionism. Despite all the surface noise, flak and so forth there is rarely any genuine penetration of the subject.'[4]

To Myfanwy, Russell turned for personal advice. 'I'm much in favour of marriage,' she replied, 'but look on it as serious and final.'[5] Not long afterwards he married Alexandrine Apponyi, niece of the society hostess Maud Russell, at whose home, Mottisfont, they first met. They moved out of London to Mount Hall at Great Horkesley, near Colchester. Thence, in 1946, John sent Russell congratulations when their daughter Lavinia was born. He advised Russell not to get ill as he always did, out of jealousy, whenever Myfanwy had a child, and agreed to become Lavinia's godfather. But after this the two men saw each other infrequently, until 1951 when Russell wrote: 'I should be delighted to resume our acquaintance if you find the prospect congenial. Bereft of your sturdy injunctions, I have been getting terribly froggy in recent years.'[6] Thereafter, if contact remained intermittent, their friendship continued. After Russell moved to New York in 1974, his return visits to England almost always included a trip to Fawley Bottom to see the Pipers. 'Our dialogue was dear to me,' he later recalled.[7]

A voice of authority in the art world, Russell contradicted the suggestion that John's fertility made his work facile. ('His alacrity is rather the mark of a very keen, very true mind, kept always in racing trim.'[8]) He was equally impressed by Myfanwy. Perceiving her stature as a critic, he arranged matters in the 1950s so that when he was on holiday or abroad, she stood in for him at *The Sunday Times*, for, like others, he was aware that she was a woman who did not volunteer an opinion unless it was grounded in thought, experience, and feeling. 'The laconic, understated character of their exchanges on matters of importance,' Russell has recalled of the Pipers, 'was a lesson in life to those who witnessed it.'[9]

Another of Myfanwy's admirers was Eddy Sackville-West, who had commissioned John to paint Knole. He visited Fawley Bottom on several occasions, fell in love with both Pipers, and, though homosexual, told Graham Sutherland: 'Myfanwy seems to me the ideal woman and I wish I were married to her!'[10] Betjeman, too, remained a fan, and could not resist adding, when sending Osbert Sitwell John's address, 'His wife is v nice—a blonde Roedean beauty.'[11] Evidently the Sitwells thought so too, as before long, Myfanwy was being treated as a friend. With John, she followed the saga of Renishaw where, as Edith reported, Osbert was getting gout, 'all the workers seem heading for a hospital for incurables, and there was a moment when I thought I should have to join them' and overall there was 'a general Wuthering Heights gloom'.[12]

Gifts of books went back and forth between the two households, Myfanwy achieving a coup with a copy of *The Painter's Object* which sent Edith wild with excitement. 'The book has arrived and I feel as if I had been having electrical treatment and oxygen.'[13] Later that month, she told John: 'It is far and away the most interesting work I have ever read of its kind, full of illumination, and open to endless vistas of thought. What a valuable work to have produced. ... Myfanwy should have a statue built in her honour, for having edited this work. Really, it is an enthralling work.' It left her determined to plague, pester, and bore Myfanwy into starting another book of this kind.

Maternal and domestic responsibilities at Fawley Bottom meant that Myfanwy only rarely visited Renishaw. Her meetings with Edith mostly took place at the Sesame, a London club in Grosvenor Street, where the Pipers were invited to luncheon and tea parties. 'I can't tell you how much I look forward to seeing you,' Edith wrote to Myfanwy in October 1944.[14] She also felt warmly towards John at this time, for supplying her with notebooks in connection with an anthology she was making, for, as she told him, 'I am not a movement-addict' and 'instead of having to leap to my feet and reach for other books, I can keep what I am working on together.' She promised to send the outcome their way, 'because I hope it will stir Myfanwy up to produce a new book'.[15]

As it happened, Myfanwy *was* persuaded to work on a book at this time. She and John became involved in a brave venture into illustrated anthologies of verse, conceived by Walter Neurath and produced at Adprint, edited by W. J. Turner and Sheila Shannon and published by Frederick Muller, under the generic title 'New Excursions into English Poetry'. All were attractively produced with full-page colour lithographic illustrations and wrap-around designs on linen covers. The first five were issued in 1944 and 1945, and among them was Myfanwy's *Sea Poems*. Its illustrations, by Mona Moore, are attractive in a slightly impressionist style, but do not match in interest the prickly designs

which John Craxton produced for another volume in this series, Geoffrey Grigson's selection of visionary poems, *The Poet's Eye*. There is, however, nothing soft or fudged about Myfanwy's introduction:

> Here there is not a single 'row, sailors, row,' not a lady of Spain, nor a bosun's mate, not a comb nor a glass; scarcely an oilskin or a Drake or a Trafalgar. Apart from this, these are the best poems or parts of poems I know that describe the sea (and seaside) or illustrate it in its relation to humanity.[16]

Her selection justifies her claim. It moves through Blake's 'A Letter to Thomas Butts' and Crabbe's 'The Borough', to less well-known items such as Thomas Hood's long poem 'A Storm at Hastings', and unexpected passages from *Pericles* and *Paradise Lost*. She shared with John Betjeman her delight at finding a passage in Robert Browning's 'Red Cotton Night-Cap Country' which she incorporated. As a whole the anthology tells of remarkably wide reading and an assured literary taste. It ends unforgettably with the whispering dead in James Elroy Flecker's 'The Welsh Sea'. The fee paid Myfanwy was £40.

John's work for Muller proved equally felicitous. He had previously designed dust jackets, frontispieces, and title pages. Now, for a fee of £50, he had the opportunity to stamp his mark on the feel of an entire book in this 'New Excursions' series, with twelve full-page colour lithographs (using four colours in addition to black and white), and a wrap-around cover for *English, Scottish and Welsh Landscape Poetry, 1700–c.1860* (Plate 28). John Betjeman selected this anthology, with his friend the Irish poet Geoffrey Taylor. Graham Sutherland had been proposed as illustrator, but John stole the task, telling Betjeman: 'It came over me after you had gone that the anthology was the best of its kind ever made and that G. Sutherland would miss the point. ... I wanted to do nothing else so much.'[17]

He made these lithographs in an East End printers surrounded by the noise of heavy machinery. The typographer Oliver Simon designed the layout. 'I think it looks jolly nice,' John told Sheila Shannon, 'and feel proud to be associated with you and it and O. Simon (hats off to his part, I feel?) and all in it.'[18] His designs turned their back on the brittle elegance associated with contemporary wood-engraving, in favour of a rougher and more spontaneous style. His lithographs, with their sombre colours and bursts of light against rich, velvety blacks, have a moodiness in keeping with wartime neo-romanticism. The reader looking for connections between text and image will not find them: 'Just do whatever pictures come into your head,' Betjeman blithely suggested. 'They will be the same as the poems we have submitted.'[19] Though Jim Richards thought the

illustrations added to the poetic nature of the book, others were disconcerted by an obvious stylistic discord: between the mostly late eighteenth- or early nineteenth-century Picturesque verse, much of it by clerics, celebrating the gentler aspects of the English countryside, and 'the black theatrical landscapes' which, Edward Hodnett remarks, 'are scenes of desolation, inhospitableness and ruin, completely out of sympathy with the poems'.[20] *The Studio* likewise thought the illustrations a mistake: 'There are twelve sinister lithographs by John Piper, livid and menacing, which would have frightened Richard Jefferies away from a book he would otherwise have enjoyed.'[21] Yet it sold out almost immediately. And in 1946, this anthology, together with *Brighton Aquatints*, was among the fifty titles chosen by the National Book League to represent Great Britain at an International Book Illustration exhibition, held in New York.

Aware of the poor quality plates that had marred his *British Romantic Artists*, he lobbied for improvements in colour illustration in the summer of 1943, by writing an article on this subject for *The Listener.* Interestingly, he used as the platform for his case the four King Penguin books which had just appeared. He tells his readers that this series 'is now edited by Dr. Nikolaus Pevsner, whose learning, and whose furtherance of good causes in art and architecture, are already well known'.[22] In time, he and Betjeman were to regard Pevsner as different and other to themselves, as the scholar-pedant, sold on facts and unresponsive to atmosphere or the sense of place. But John had reason to be grateful to Pevsner who was currently filling in for Jim Richards at the *Architectural Review* and had begun commissioning articles from him. In time Pevsner would also invite him to do a King Penguin on Romney Marsh.

Caves and waterfalls were John's two obsessions at this time. They figure in the Betjeman/Taylor anthology and in his 'Notes from a Yorkshire Journal', in the December 1942 issue of the *Geographical Magazine*.[23] His purpose in this article was to show the contemporary relevance of the late eighteenth-century concepts of the sublime, the beautiful, and the picturesque. He travelled to West Riding by train, cheek by jowl with hikers prepared for pot-holing, with torches, coils of rope, and alpenstocks. But even the 'unathletic tourist', he wryly observes, 'who has no intention of being lowered or raised anywhere that his feet will not take him easily, can find, in exploring these regions, the beautiful pleasantly combined with the "sublime".'[24] He then takes his readers from Yordas Cave to Weathercote and Easegill, Ribblesdale and Alum Pot, Malham and Gordale Scar. The last, a monstrous chasm, is one of the grandest and most breath-taking scenes in Britain, its massive scale and hanging walls, which

43. *Gordale Scar*. Illustration for the *Geographical Magazine*, December 1942.

project out from the base, give rise to sensations of fear and amazement. Owing
to a nearby curving wall of rock, the site is closed in, making it impossible to
obtain a more distant view, such as that found in James Ward's great painting
of this scene or that in the eighteenth-century guidebook *Views of the caves*

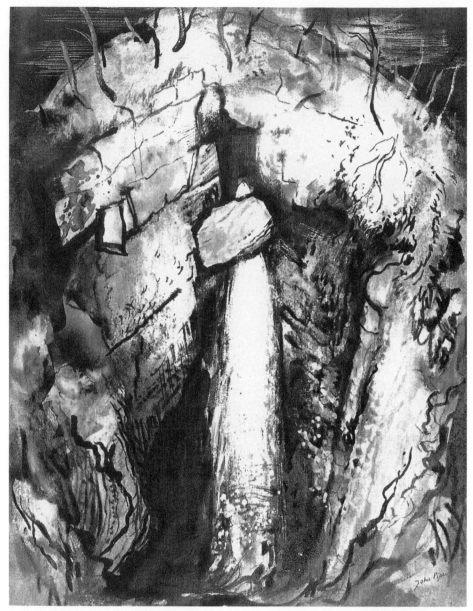

44. *Cave Entrance in Easegill*, 1942, pen and ink, 53 × 41 cm (private collection).

near Ingleton, Gordale Scar and Malham Cove in Yorkshire by William Westall, a friend of Wordsworth. 'Gordale Scar very fine,' reads a postcard John sent Betjeman, 'though James Ward and Wm. Westall both cheated in drawing it.'[25] To Osbert Sitwell, he wrote: 'Yorkshire caves are all the same and all nice,

except Gordale Scar which is first class and better than James Ward made out. But by God it rained.'[26] Nevertheless, standing in the lee of the rock, he drew a close-up view of Gordale Scar, afterwards working up an oil painting which entered Kenneth Clark's collection. It is dramatic but not awesome. With hikers larking about, trying to plug the torrent with stones, terror and sublimity had seemed noticeably absent.

John shared his passion for caves and waterfalls with Geoffrey Grigson. They conceived of doing a book together on this subject, an abortive project but which got them reading John Hutton's *Tour to the Caves* (1798), among other things. When John returned to Yorkshire in April 1943, it was in Grigson's company. They put up at the Hill Inn, Wethercote, near the famous Wethercote Cave, which John both illustrated in the Betjeman/Taylor anthology and painted in oils. He sought out more caves and waterfalls later this year when he, Myfanwy, and the children visited the Neath Valley in Wales, in this instance drawing inspiration from William Young's *Guide to the Beauties of Glyn Neath* (1835). A third trip took him and Grigson that summer to Cornwall, where they cycled round the countryside, looking at churches and holy wells. Here John took pleasure in slate tombstones in long-grassed churchyards, and in the lichen on pale Cornish granite, with its 'whites, pale Naples and blue greys in round overlapping spots and scabs'.[27]

The 'Travel' diaries that he kept contain gazetteer-like descriptions of what he saw. These not only aided his phenomenal recall of places and buildings but also amounted to word pictures, revealing an eye alert to effects of light, weather, and seasonal atmosphere. 'Are you still collecting skies?' John Russell once asked, elsewhere remembering that John penciled into his copy of C. R. Leslie's *Life of Constable*, 'Please return. Always needed.'[28] But he did not need to travel to take pleasure in the natural world.

Fawley Bottom. Jan 13 1943

Shape of the fields here as good as anything about the place—combining a careful following of the hill-figuring with arbitrary straight hedges and diagonal cuts.

Spring-like day. Grass bent low and tangled and matted with past rain. Washed out in colours, curling over pinkish chalky earth, and itself folded over by umber and madder nettle and thistle stalks. Two mullens in the wood up the lane, in growing condition, with heavy buds—in the middle of the path. The elm trunks in the cleared wood pale and chalky-green against umbers and neutrals of Bosmore hill.

Fawley Bottom. Feb 6 1943

One of a succession of extraordinary days, in this greenest of winters. NW wind, while large clouds and intermittent cool clear sunshine. Windy pools of water and thin mud. Floods at Henley, slowly falling. Towards nightfall, yellow cumulus clouds in the east backing the orchard hill, and later a thinnest of new moons in a clear blue-grey sky. Later, the thin shaving brightening, the body of the moon visible in dim lightness. Venus, intense, below and to the right; all in a yellow flood against velvet brown-black fields by six. No other stars visible in the west. The moon and Venus unusually vivid. The yellow west unusually yellow. Bars of cloud, grey black, to the south.[29]

Landscape was, for him, not only inspirational but also restorative. Once, when distracted by the onset of flu, he took himself off to Woodstock for two days, in order to draw at Blenheim where war-office huts temporarily nestled against the Palace in the forecourt. 'Saw the park by moonlight,' John told Osbert Sitwell, 'which is as good as anything I've seen and much better than the Campagna, and sat in the bar at the hotel and listened to RAF conversation. I am pleased to find that aerodrome slang has hardly changed in 25 years ("wizard" is still favourite word).'[30]

Soon after his return from Woodstock, the choreographer Freddie Ashton came to Fawley Bottom to work with John on costumes for the ballet *The Quest*. Kenneth Clark, in his omnipotence, had obtained Ashton leave of absence from the Air Ministry to choreograph this work. *The Quest* is based on the legend of St George, as found in Book I of Spenser's *The Faerie Queene*, and it gave expression to the neo-romantic preoccupation with spiritual quest. The scenario for this ballet had first been devised in 1938 by Doris Langley Moore, who called it her 'St George ballet', but at that time Ashton had dismissed it as 'too literary'.[31] Then in 1942, he changed his mind: the conquest of evil forces by England's patron saint now seemed to him entirely appropriate for the times.

William Walton, friend and associate of the Sitwells, had been persuaded to compose the music and Ashton asked John to design the sets and costumes. This triumvirate—Ashton, Piper, Walton—should have guaranteed the ballet's success. Instead it was encumbered with problems: the scenario was overpopulated and its episodic nature unsatisfactory; and, though John found Ashton both inspiring and very practical, and his advice—when he gave it— always right, there was no easy flow of collaboration. Ashton had limited leave from the RAF and Walton had only five weeks in which to compose forty-five minutes of music. Walton bribed train guards to carry parts of the score to

wherever Ashton happened to be. While he was at Fawley Bottom, five or six pages of music arrived, but proved too difficult for anyone to play. The lack of a complete score until near the end may explain why Ashton's choreography seemed 'distinctly forced'.[32] The ballet aficionado Beryl de Zoete complained that *The Quest* had no 'spiritual depth',[33] and in one history of the Sadlers Wells Ballet the ballet is described as 'complicated and inconclusive'.[34]

But when the curtain went up on Act I Scene 1, the opening glade made a strong visual impact, plunging the spectator at once deep into the heart of a tangled wood. John had made no attempt at period decor or costumes. Ideas had come to him from the wood near his home, from places he had visited or painted, from Walter Crane's illustrations to *The Faery Queene* and from stained glass. The costumes for the Virtues were suggested by early stained glass at Canterbury, and St George's costume by slightly later glass at Tewkesbury. His backdrops, he admitted, were based on pictures he had painted or hoped to paint, on rock studies made in the limestone region of West Riding in Yorkshire, on studies of eighteenth-century Gothic Revival churches ('aided by references to Batty Langley and Pugin'), and on paintings he had done at Stourhead and Stowe.[35] John Betjeman later noticed allusions in John's backcloths to West Wycombe and Blenheim as well as Renishaw, while David Fraser Jenkins has put on record John's debt to a book of Inigo Jones's theatre designs which he found at Renishaw.[36]

His designs were damned with faint praise. One critic found them 'noteworthy more for their promise than anything else' and his Palace of Pride merely 'mediocre' owing to too much fiddly detail.[37] The final scene was the most memorable, with a backcloth based on the lake at Renishaw. Beside it sat the House of Holiness, a spectral castle beneath a pink sky, the whole set, with its ritualistic and religious mood, brilliantly offsetting Robert Helpman's dancing.

Performed by the Sadlers Wells Ballet at the New Theatre, Shaftesbury Avenue, *The Quest* opened on 6 April 1943. The central weakness of the ballet has been indentified by Julie Kavanagh: 'By turning it into a celebration of national glory, Ashton misinterpreted Spenser, but he was only being true to the times: fighting the war by drawing upon English literature and history at a time of emergency, as Laurence Olivier was to do in his famously propagandist *Henry V*.'[38] More disconcerting is Walton's remark that Robert Helpmann, who played the patron saint in garish make-up and an Afro wig, looked more like the dragon than St George.

From now on John always welcomed the opportunity to collaborate with professionals in other fields. He was less comfortable among amateurs. This same year, 1943, he was invited by Leonard and Dorothy Elmhirst to visit the

recently restored Dartington. He accepted, despite reservations about its artistic community. He met there the artists Cecil and Elizabeth Collins, afterwards thanked them for 'brightening and lightening my stay',[39] and helped Cecil achieve an exhibition at the Lefevre Galleries in London. But he could not escape the feeling that Dartington was slightly bogus and backwards looking, stuck in the ethos of the Arts and Crafts movement. He played up this feeling in a letter to Osbert Sitwell:

> Dartington was wonderful. The most Godless place I have ever been in; chief possible crimes while an inmate to drink too much and to go to church, especially the latter. Queues for meals and rota washing-up; hundreds of bad musicians with red ties and flannel bags, H. N. Brailsford, several failed artists (though art is not quite the thing) and dozens of girls talking in whispers and either on holiday from unartistic mothers or escaping from doing factory work, or deciding whether they were conscientious objectors. ... Every person there I should say has at some time or other advertised on the back page of the New Stateswoman, or else has won a This England Competition with a cutting. Situation saved by Stephen Spender to whom I gossiped for many hours, and his wife Natasha played the piano in a great over-restored Hall with good taste white and green glass windows and rush mats from Heals. Dorothy Elmhirst is a much maltreated and very intelligent woman who, unlike her poseur of a husband, retains an attractive American accent, and ought to (and would with encouragement) kick over the traces and throw everybody out on their ears. The whole thing is indeed an interesting survival, very much dated. There ought to be a Batsford book written about it in the 'British Heritage' series, with coloured photographs of the bronzed inmates and the beautifully hideous rolling red-earthed fields that surround it on all sides, punctured by the concrete walls and flat roofs of the houses all round that were designed by the now-forgotten famous architects of the early thirties. I slipped off on a borrowed bicycle for an afternoon and looked at six old churches in a Devonshire drizzle, which was very enjoyable.[40]

To Myfanwy he added complaints about the inadequate lavatory accommodation, the lovely old fourteenth-century walls 'pickled with new cement pointing',[41] and even the beautiful gardens. 'Every path in the garden the scene of 100 illicit and very unhappy affairs. The ghost of an unhappy affair accosts you round every rare shrub.'[42] These are the words of a man more usually distanced from the muddle and mess of human relations by his focus on more distant markers, on the landscape or the built environment. It is therefore an irony that around this time an affair, or something akin to an affair, was unsettling his own home.

17

Sly Liaisons

When Kenneth Clark agreed to edit 'Penguin Modern Painters', a series of books on contemporary artists, Myfanwy's name had immediately been paired as author with that of Frances Hodgkins. Their association came through friendship and the fact that both Pipers had praised Hodgkins' work, Myfanwy, in *The Listener*, John, in *The Spectator*. Her pictures had reminded Myfanwy of her initial discovery of modern art.

> To walk into the Lefevre Galleries and see the pictures in gouache by Frances Hodgkins is to experience again that first thrill. Once again one is overwhelmed by a dazzlingly live quality. One's imagination is caught by the single-mindedness of the professional painter. It is not only the beauty of the paintings but the independence and passion of the vision that produced them that is so moving. The objects that are built up into the lucid pattern of Frances Hodgkins' pictures—boats, flowers, wreckage, litter—are so truly re-created and given new functions that every sign of their ordinary life is shed. So the paintings are aloof and self-sufficient: they rely on no sly liaisons with the rest of the world for their effect.[1]

Hodgkins was delighted. 'I was made so very happy by what you and John wrote about me,' she wrote to Myfanwy, 'and I owe you very particular thanks—it gave to my show all the success I could hope for.' Her letter ends: 'Goodness and Beauty must persist dear Myfanwy, and Love is the keynote.'[2]

The idea for 'Penguin Modern Painters' had been Allen Lane's, the founder of Penguin Books. At a time when British art was in the ascendant and work by Piper, Sutherland, Pasmore, and other artists was entering the collection of the Tate Gallery for the first time, Lane had identified a need for affordable, definitive texts on contemporary artists, in a modest format. He envisaged a

229

series of short illustrated monographs, and told Clark that his ambition was to try 'to do the same sort of work for the modern British artist as we have been doing for their opposite numbers, the authors, in introducing their work in a far wider field than had been attempted hitherto.'[3] Confined, at the start, to native artists, 'Penguin Modern Painters' was a product of war, part of the patriotic need to celebrate British culture.

Clark took on the role of General Editor, interesting himself largely in matters of aesthetic interest, while Eunice Frost, Lane's right-hand woman, saw to the financial and practical arrangements. Among the earliest commissions were Raymond Mortimer on Duncan Grant, Edward Sackville-West on Graham Sutherland, Geoffrey Grigson on Henry Moore's 'shelter' drawings, John Betjeman on Piper, and Myfanwy (the only female author in the entire series) on Frances Hodgkins. As soon as John heard that Clark was writing to Betjeman, offering a fee of £50 for 3–5,000 words, he fired off his own letter: 'I have no idea that you would much want to do it. The single advantage to me would be that nobody else understands half as much what my pictures are about, and it is nicer not to have balls written about one by V. S. Pritchett or R. Mortimer.'[4]

While John liaised with Betjeman, Myfanwy pursued Hodgkins. 'I had a most adventurous time—for me [she boasted to John Betjeman]—the other day and went, having abandoned John and the infants, all by myself to Corfe and back to see Frances Hodgkins. Stayed one night at the Greyhound and walked about those beautiful arty pool-pottery streets and thought about Hardy. Very nice it was.'[5] Some six months later Hodgkins learnt that letters she had written to her close friend Dorothy Selby had, without her permission, been handed to Myfanwy. 'I dislike intensely my private life being brought into any sort of prominence,' she told Selby, who would no doubt have duly warned Myfanwy. However, in March 1943, her text received Hodgkins' approval. 'Not quite quite me—but near enough as may be—Pleasantly salted with malice—as it should be. Very readable—very credible—really d——d good by your leave.'[6]

There followed a long period of waiting. The book failed to appear in 1944 when the first four volumes were published, and then slipped further down the schedule, owing to problems with colour reproductions. Myfanwy went in person to see the photographer-printer, to try and hasten the necessary adjustments to the plates. After further delays, the book was finally published in December 1948, by which time John and Myfanwy had attended Frances Hodgkins' funeral, for, on 13 May 1947, she died in a mental hospital near Dorchester.

Among those who admired Myfanwy's small book on Hodgkins was Bryan Robertson, the critic and curator, who thought it one of the most incisive

monographs ever written.[7] It encapsulates the artist's development, her art and character, with piercing intelligence and great percipience. Myfanwy argues that the 'worship and exaltation' which places and objects evoked in the young Hodgkins could very easily have become a trap, as, in her opinion, it did for another of her compatriots:

> Katherine Mansfield was a lost literary Frances Hodgkins: she had the same honesty, the same energy, the same capacity to remain entirely uncluttered by tradition and habit—an intellectual nakedness that was not poverty— and the same delicate apprehension. But her ecstatic clinging to every thing and every moment was deadening. At her best she produced only tender, hedonistic half-truths.[8]

Myfanwy's essay tracks Hodgkins' journeying as she moves from New Zealand to England, to Cornwall, sojourns in France, Spain, and then Paris, before the Second World drove her back to England.

> She had always fled as often as she could from England: from its mists, from its lack of zest, from its coldness towards experiment, from its power to underline personal isolation until it becomes a melancholy and a mania. But at last, forced to stay here, she was overcome by the beauties of its changing light, by the delicacy and depth of its colour, and by the strength of its unemphatic form. She said finally that it is the only place to paint.[9]

Hodgkins was, Myfanwy concludes, 'largely without gods, and was not oppressed by the painting of the past. She did not suffer from the ambition that burns up many gifted women. She kept herself mentally and emotionally unencumbered; and so up to a few months before her death she was painting better than she ever painted.'[10]

Writing this monograph gave Myfanwy considerable pleasure. 'She is delighted to be regarded as authoress by the noble Lord,' John wrote to Betjeman, 'and thinks and talks of nothing but MY BOOK on Hodgkins.'[11] One outcome was that she saw Kenneth Clark on a one-to-one basis, lunching with him and sometimes visiting a museum in his company. 'There is a poetical beauty in your love of individual works of art and your capacity to talk about them that is far greater or rather more important than your knowledge of them', she told him.[12] Looking after small children, she herself had little time to read and sometimes found she did not want to read. Clark, recognizing her intellect and gifts, urged her not to let domestic responsibilities drown her talents and her ability to write. His encouragement stimulated what is arguably the most original text in the 'Penguin Modern Painters' series.

231

If Clark quickened Myfanwy's intellect and emotions, this is not surprising. Part of his feline charm was his willingness to acknowledge vulnerability. Many were aware that he was married to a difficult woman, though Jane Clark was, Myfanwy thought, not phoney but pretentious, someone who did not know how to manage riches. Sympathy for Jane was perhaps diminished further by her absence, for Clark had moved out of London, taking Upton House, at Tetbury in Gloucestershire, where his wife remained during the week while he was in London. In her absence, he felt a need for female company, and Myfanwy was one, among others, whom he enjoyed entertaining. 'I wish I saw you more', Myfanwy was soon writing, '—but the whole thing takes on the faintly illegal quality of hot *hors d'oeuvres*. But I don't care.' Her emotional involvement with him made for a painful time at one of Edith Sitwell's literary lunches, for she found herself in sight of Clark but unable to speak to him: 'How infuriating it was to be able to look at you from between those two literary trolls (who were both simply charming) at Edith's lunch. I always think of the Sitwell's as trolls don't you?' At another moment, on a train to Wells, while a part of her mind was concerned for her husband, then crossing the Irish sea, she wrote to Clark, 'You enchant me.' Yet this same letter suggests that something had been withheld. 'Think of me and know, if it is any consolation for you, that it is rare for you to be altogether out of my thoughts, and most of the time you occupy a great deal of them.'

Despite her teasing remark—'I say what a bad reputation we must have with the doorman'—it is hard to tell whether their *amitié amoureuse* became a full-blown affair. 'It would be awful', she writes at one point, 'if a sense of guilt intruded into a relationship which has been one of pure delight—so forget it ... I have indulged the whim, though it is not my habit, of keeping this sentimental (I use this word in the most moving sense, dear K) adventure to myself.' But it was perhaps inevitable that John would learn of her feelings, either from Myfanwy or through her transparent pleasure in Clark's company. After lunching with Clark in Henley, she wrote: 'I never enjoyed such gaiety and friendship with you before—yes of course I have a thousand times but it was lovely.' In this same letter she admits: 'I can't ever decide whether John is frightfully patient and angelic and puts up with more than anyone else would tolerate for a moment—or the reverse. I must say life is jolly difficult—but whatever I give up I shan't give up loving you my dear so have no fear.'

Whether or not Myfanwy knew about Clark's concurrent affairs with other women, in particular with Frederick Ashton's married sister, Edith, or with the painter Mary Kessell, she appears to have felt, as they all did, that she and he enjoyed a special relationship. And her feelings for him lasted some years, as is

evident from one letter written when the war ended. 'It suddenly came to me … that I have never known you in peacetime; and now that there is nothing that can destroy you. … it seems safe to say, though scarcely necessary, how glad I am that nothing did.' In gratitude, she adds: 'I have admired your lack of fuss and your calm and your continual sweetness of temper.'

In the absence of any evidence to the contrary, it must be assumed that John's reaction was indeed patient and angelic. The only indication of irritation or submerged anger is a slight change of tone in his mention of Clark in his letters to Betjeman. He sometimes prematurely raises Clark to the barony, in a sardonic allusion to his power and social prestige.

> Lord Clark and Lady Jane have just been for a weekend with Allen and a dog. J. a bad bore about British restaurants and corrupt Borough Councils but not so superior about the house as she used to be, and talked a lot about the influence of Debussy on Willie Walton. Lord C. gave us a lecture on portrait painting, I showing his slides in the enlarger—practising for one he had to give this week to the Courtauld [Institute]. V. enjoyable though battery gave out.[13]

Another cause of antagonism was the way in which Clark, without consulting author or artist, chose most of the colour illustrations for the Piper monograph in his series, behaviour that seemed to John very high-handed. 'I am glad you didn't see Lord Clark again,' he told Betjeman.

> He would only be meddling and in any case you will do the book twice as well as he would himself. I caught him just in time yesterday before he had had most of the coloured pictures finished without asking me. He will persist in thinking he knows more than any writer or artist about anything. He has had done two Windsors, 2 Bath drawings and a bombed House of Commons, and I have now planted on him 3 churches for colour (Fotheringay, Hamsey, Inglesham), Goldilox nude twice, two abstracts, and the Vale of Clwyd. More of our ideas to follow.[14]

At the end of the month, he received Betjeman's text which pleased him greatly. 'I know not what Lord C's remarks will be and care not,' he threw out,[15] still irritated with his high-handed editor. Meanwhile Myfanwy's infatuation with Clark may have reawakened memories of another awkward period in their relationship, when John had to extract himself from marriage to Eileen. Both Pipers empathized with the librettist Eric Crozier who, unhappily wed, wanted to ask for a divorce so that he could marry the singer Nancy Evans, but

felt unable to do so because of his first wife's 'depressive hopelessness'.[16] After a visit to Fawley Bottom in December 1946, Crozier wrote to Nancy:

> The Pipers were greatly sympathetic about our problems, which they too had over a longish period of time—and both are people with whom one can be quite frank, without embarrassment on either side. I like them very much—partly because they have fought their way to a condition of happiness and mutual love that we shall reach, too, in the end. They know the miseries and darker times and stupidities; but they have grown through and beyond them.[17]

The sheer amount of work that John did during the war years may have contributed to the strain of his marriage. His many commissions, extensive travelling, regular journalism, and occasional talks, including a lecture in 1944 on 'Topographical and Archaeological Illustration' to the Society of Antiquaries, made heavy demands on his time and attention. 'We are overworked but well,' he admitted to Colin Anderson this year. 'The children bouncing; and we fight for time when we can see each other and spend a night away alone, childless, which occurs once in a blue moon with pink spots.'[18] On one occasion, in September 1944, he returned to Fawley Bottom just after the Clarks and their three children left. 'Myfanwy says Jane behaved very nicely,' John told Osbert Sitwell, 'but 5 children did make rather a bear-garden.'[19] All his life John readily acknowledged his debt to Clark, not least for making him the subject of a 'Penguin Modern Painters' monograph which, when published in December of that year, aroused envy in some of his peers. Ivon Hitchens linked John's success with social climbing. Ben Nicholson, angered that he had been brought in to the 'Penguin Modern Painters' series late in the day, thought the book showed John tinkering 'with the surfaces of ideas', while Betjeman's introduction, he said, 'would go well in the gossip column of the *Ladies Home Journal*.'[20] And the *Studio* deplored Piper's 'preoccupation with a narrow, literary romanticism'. Nevertheless the book did well, its initial print run of 41,000 sold out in just over three years, making necessary a reprint in 1948. Certainly, by the end of the war, John had—thanks in no small part to Clark—become one of the best known artists of his day.

18

Stern Watching, Mysterious Sympathy

Our churches are our history shown
In wood and glass and iron and stone.
——John Betjeman

Invited to submit an entry to *Who's Who* in 1943, Piper listed, not music, but 'church architecture' as his sole recreation. If the Shell Guides had reawakened this interest begun in childhood, friendship with Betjeman quickened it further. 'Dear ecclesiologist,' one of his letters to Betjeman begins,[1] for in their correspondence they talked mostly about churches. Both thought box pews a necessity of civilization, registered with delight three-decker pulpits and west galleries in good order, and went church crawling whenever circumstances and petrol permitted. In November 1944, they took bicycles on the train to Nottingham and then rode miles through the suburbs to Tollerton, and the next day to Papplewick, in search of two churches said to be untouched since the late eighteenth century. To Betjeman's annoyance, both had been 'mucked up' in the twentieth century.[2]

John now looked at English churches wherever he went, often researching beforehand the prime examples in the area, for, though neither an antiquarian nor an architectural historian, he was rapidly becoming one of the most knowledgeable persons of this genre. (Asked by the painter John Doyle in the 1980s if he knew every church in England, John replied, 'At one point I almost thought I did.')[3] He was also aware of the impress of others' looking. 'There is nothing so beautiful', he once remarked, 'as 19th century topographical

drawings of churches.'[4] One favourite was the church at Llan-y-Blodwell in Shropshire, rebuilt in the mid-nineteenth century by the Revd J. Parker ('a genius'),[5] who had done much of the decoration with his own hands. The Pipers had attended evensong in 1941, and ever afterwards, John would go fifty miles out of his way to revisit it. Then, too, he particularly enjoyed forgotten churches in remote places, where the pervasive spirituality belongs more to the building's relation with the surrounding landscape than to any activities of its congregation. Always he was interested in the relationship of architecture to its setting. Once, en route to Renishaw, having saved up his petrol rations, he wandered into hitherto unexplored tracts of the Midlands and found Breedon-on-the-Hill. To his friend Basil Creighton, he wrote:

> An isolated, large, monastic-looking church with a tall, dark, lichened tower standing on a hilltop by itself, rising out of a sea of slate tombstones, and with a churchyard view over ½ Derbyshire, ½ Leicestershire (in which it is) and bits of Warwick, Worcs, Gloucs, Northants and Notts. Why don't the guidebooks tell us about these places? Thank goodness they don't however, or they would be as popular as Avignon.[6]

On another church crawl, in 1941, John and Mervyn Horder managed to see thirteen churches in Northamptonshire in one day, the latter noting in his diary: 'Not a very inspiring lot, I thought, but he likes the dim and unassuming.'[7] In his own work, John captured the expressive content of churches, their subtle diversity, and the melancholy that haunts both the humble and the grand. Over the years, through his writings, editing, painting, printmaking, and photography, he did more than any other artist to encourage people to look again at this aspect of English heritage.

Though he often sketched, took photographs, or made terse notes, his visual memory was phenomenal. In 1944 Jonathan Cape commissioned a frontispiece and a title-page decoration for an abridged edition of *Kilvert's Diary* (1944).[8] It was five years since John had visited Clyro, where Kilvert was curate for seven years, but he had no difficulty in weaving an image of its church into one illustration, and one of the church at Hardenhuish, where Kilvert was born, into the other. His interest in this genre of building was now so dominant that when Adprint suggested he edit a new series of books, he conceived of doing one himself on parish churches. Photographs were taken towards this end, but the project never reached fruition.[9]

He was aware that churches relate both to the past and to present needs. In 1940, while reviewing a book on churches, he noticed two things: that cathedrals adapt themselves to the spirit of an age more quickly than parish

churches ('There is more money, and so the new taste has its say sooner'[10]), and that most guidebooks encourage conservatism by turning their backs on modern developments: 'they refuse to realise that the cathedrals and the parish church are buildings that serve a contemporary religion in any age, and they continue to regard them as having been handed down to us as nothing but museums.'[11] Wanting to effect change, he agreed to work with CEMA on the selection of an exhibition, 'The Artist and the Church', which opened in May 1943, in the north transept of Chichester Cathedral.

His aim was not a survey of sacred art through the ages, but something that would evoke the great tradition of English church art, and thereby suggest that, when the war ended, the link between the church and the artist could be re-established and new art employed in the reconstruction of bomb-damaged churches. 'The objects in this exhibition', John's preface begins, 'have been selected by a painter who is also a churchman and a lover of churches, old and new.' They not only reflected his personal taste, but were deliberately biased towards the unfamiliar, with an emphasis on twelfth-century carving and thirteenth-century glass. He acknowledged that since the end of the nineteenth century, church art had become 'on the whole etiolated, provincial and over-traditional'. If the artist was partly to blame, by being 'unco-operative and indifferent', so too was the Church for 'its lack of discrimination and its loss of artistic conviction'. He hoped, in 1943, that 'with practice and trust the artist will regain his confidence in working for the greatest and most fruitful of all patrons in history, and that the Church will regain its commanding conviction about the arts.'[12]

So that it could tour large churches and cathedrals, the exhibition was confined to ten double-sided screens. But it nevertheless managed to be wide-ranging, taking in paintings by Rouault; copies of ancient stained glass; photographs of old and new stone carvings; textiles by Phyllis Barron and Dorothy Larcher; designs by William Morris for tapestry, wallpaper, and chintz; and fine lettering and printing, including specimen sheets for Bibles, prayer books, and other service books printed by Cambridge University Press, Oxford University Press, and the Curwen Press. There was in addition a section on mosaic work and church restoration. And in order to make the exhibition up to the minute, Piper borrowed drawings for the controversial murals at Berwick Church in Sussex by Duncan Grant and Vanessa Bell. Peggy Angus remained unimpressed, finding these Bloomsbury sketches 'miserable beside the robust old traditional stuff'.[13] Sir Eric Maclagan, Director of the Victoria & Albert Museum, agreed to launch the show but was evidently a bit bewildered by what he called 'Mr Piper's whimsical enthusiasms'.[14]

One entire section was devoted to the work of the ecclesiastical architect Ninian Comper, to whom John had been introduced by Betjeman, at that time the architect's principal advocate. Comper had begun as a medievalist and went on to originate elaborate screens, altar furniture, chapels, and entire churches mostly in a late Gothic style. The historicist nature of his work places it, at first sight, at a far remove from the Modern Movement. Some dismiss it as pastiche, while others praise his studious avoidance of originality, the clarity of his plans, the splendour of his decoration and attention to detail, and the central importance that he gives to the altar, for him the meeting place of heaven and earth. Fundamental to his work was the belief that beauty acted as a divine imperative, and that the interior of a church should 'move to worship, to bring a man to his knees, to refresh his soul in a weary land'.[15]

Piper was at first completely smitten by this maverick figure. Comper's uneasy relationship with the establishment had led him to turn down honours and rejected advances from the RIBA and other bodies. To rectify the situation, John twice offered to type up Comper's reminiscences. ('I hardly felt justified in accepting this,' Comper told Betjeman. 'Also my narrative is in itself so damning of the R.I.B.A. as well as the DAC [Diocesan Advisory Committees] that, if by any chance it got into hostile hands it might share the fate of "the atmosphere of the church", and any chance of publication would be taken away.')[16] Later, Piper was to engage with architectural projects very different in style to Comper's, but, at this stage, he did all he could to promote his work, urging Osbert Sitwell to take a taxi to St Mary Magdalen, Paddington, to see Comper's crypt, 'the finest thing of its kind in the country'.[17] Even after his enthusiasm for this ecclesiastical architect cooled, he continued to share Comper's belief that a really good church interior should 'bring you to your knees'.[18]

The CEMA exhibition identified John as a potential bridge-builder between artists and the Church and caught the attention of many. The following year he helped Miller's Gallery, in Lewes, with another show of religious art. More importantly, he caught the attention of Walter Hussey, the vicar at St Matthew's, Northampton, who had recently commissioned for this Victorian church a 'Madonna and Child' by Henry Moore, and in other ways was becoming a significant church patron, obtaining music by Britten, Tippett, Rubrra, Finzi, Malcolm Arnold, and Lennox Berkeley for his patronal festivals. He invited John and Myfanwy to the unveiling of the Henry Moore in the spring of 1944, at which Benjamin Britten conducted his *Rejoice in the Lamb*, a festival cantata commissioned two years earlier for St Matthew's jubilee. Two years later, the Pipers were present at the unveiling of another Hussey commission, Graham

Sutherland's *Crucifixion*. John termed it 'the best modern work in a church yet, and worth seeing'.[19]

Hussey was to become Dean of Chichester Cathedral, in which role he gave John, as will be mentioned, a major commission. Another cleric and academic to make use of his talents was Moelwyn Merchant, who in 1946 wrote, asking for an article on the artist and the Church for his quarterly magazine *Cymry'r Groes*. Merchant, then a lecturer in English at University College, Cardiff, and later Professor of English at Exeter University, enjoyed collaborating with artists and musicians and, in time, became a close friend and adviser of Piper. Both he and Hussey proved excellent allies in the attempt to rebuild trust between the artist and the Church.

No other writer voiced so well the complex mesh of feelings that architecture and Picturesque weathering aroused in John than Ruskin. He told Peter Fuller that Ruskin's *Modern Painters* had been 'my favourite book from early years'.[20] During the war he recommended Ruskin's *Praeterita* to Betjeman,[21] and himself read *The Poetry of Architecture* and *The Seven Lamps of Architecture*, with the result that Ruskin impacted significantly on his thinking about the built environment. One passage moved him greatly:

> The greatest glory of a building is not in its stones, nor in its gold. Its glory is in its Age, and in that deep sense of voicefulness, of stern watching, of mysterious sympathy, nay, even of approval or condemnation, which we feel in walls that have long been washed by the passing waves of humanity. It is in their lasting witness against men, in their quiet contrast with the transitional character of things, in the strength which ... connects forgotten and following ages with each other, and ... concentrates the sympathy of nations: it is in that golden stain of time, that we are to look for the real light, and colour, and preciousness of architecture.[22]

His own watchfulness informed a spate of articles on architecture which he wrote between 1942 and 1947. The best of these were reprinted in 1948, with earlier essays, in *Buildings and Prospects*, published by the Architectural Press. Most were written for the *Architectural Review*, where Pevsner was now acting as assistant editor while J. M. Richards served in the army. Before leaving, Richards had given Pevsner a few lessons on editorial procedures and the mysteries of layout, and had encouraged Hastings (nicknamed 'Obscurity' Hastings, owing to his shyness, by Betjeman) to come out of his Sussex retreat and take a more active role in the *Review*. Hastings did so, and, having great respect for artists, whom he regarded as experts on visual relationships, he

invited contributions from John, Edward Bawden, and Kenneth Rowntree, especially if their views fitted in with his editorial policy which had begun to promote 'the Picturesque' as an emancipatory aesthetic, a means by which to counter the rigidity within certain modernist discourses and the homogenization associated with modern design.

The broader mission of the *Architectural Review* was still to enhance the layman's interest in the environment, to encourage notice of things normally overlooked. John did just this in July 1943 by writing 'A Cubist Folk Art', an essay on painted quoins. These are usually the flat cornerstones that decorate the edge of a building but which, when painted with four triangles, can give the illusion of three-dimensional articulation in weighty stone. It intrigued him that this vernacular style had evolved from diamond rustication which originated, so Pevsner told him, in Italy.[23] After this, he turned his attention to 'the gratuitous semicircle', as he referred to semicircular windows.

> The semicircle with a horizontal diameter is a piece of plain-man's self-assertion. On a four-square building it asserts four-square character, by means of the simplest kind of contrast. It denotes a misunderstanding and approving nod at Classicism, and a disapproving nod at anything Gothic or 'fancy'. It is an enemy of good taste, and its allies are ungainliness and bad proportion, which add to its swaggering self-assurance. It has nothing to do with the refined fan-light over the front door … and it has little to do with the round-headed door and window. … As a decorative element it is both simple and vulgar, and as unfunctional as the top hat.
>
> It has, in other words, all the qualities that simple, native English architecture has lost. … It is forthright, and of 'good quality'; that is, it is plain, direct and proud of the fact.[24]

Hastings welcomed John's independent voice and commissioned a series of articles on colour in old buildings, in the belief that a painter's, rather than an architect's, observations, would help revive a 'picturesque' approach and thereby rebut the 'schematic inhuman treatment of contemporary architectural problems'.[25]

The *Architectural Review* had first promoted the Picturesque in its January 1944 issue. Here it was suggested that the principles of this aesthetic—variety, curiosity, intricacy, contrast—could be applied to the modern urban landscape. The aim was not to encourage imitation of Tudor half-timbering or Georgian pediments but to revisit the ideas of Uvedale Price and the Picturesque movement with a modern eye, in order to counter the drabness, uniformity, and anonymity that standardization and regimentation had brought to cities, towns

and model villages. The editorial urged 'intricacy as against easy visibility, and roughness of texture as against the crystalline smoothness of the classical façade'.

John argued that colour is an ingredient in the Picturesque. He showed how picturesque villages make use of local materials which, in hue, echo the geological features of a neighbourhood and give the impression that the village has grown from the soil. But he also praised colours that are in violent contrast with their surroundings, instancing cottages in the Vale of Neath, in Wales, where the dark grey moorland stone and weathered slate roofs are sometimes offset by whitened or apricot-coloured walls, strong accents that jog the eye and memory with their assertion of the man-made character of buildings.[26] In pursuit of 'colour in building' he looked at vernacular materials, praising the beauty of flint and encouraging his readers to think about the modern potential within this material, normally regarded as antiquarian (Plate 29).[27] In these essays, he used his own paintings, drawings, photographs, and lithographs to illustrate the text, the layout creating a pleasing congruence between word and image.

He also took this idea elsewhere and for *International Textiles* (no. 8, 1944) wrote an eight-page pamphlet, 'The Colour of English Country Houses', illustrating it with eleven lithographic reproductions. This same year the *Cornhill Magazine* commissioned his 'Letter from Devizes'. In this, he walks the reader around the town, drawing attention to 'good minor architecture' as well as the museum, the brewery, the tobacco factory, the branch-line railway, inns and bars, the handsome canal, churches and chapels, and the town's good-looking inhabitants. While there he took the opportunity to re-join the Wiltshire Archeology Society and sheltered from a biting north-easterly wind in a tea shop:

> And so, taking coffee and a bun over the baker and confectioner's next door but two to W.H.Smith & Son's, while the east wind blows across the Market Place, one looks out of the window on to a rarity: an English town that has not been spoiled and not been preserved artificially.[28]

His distrust of conservation made him think a great deal about ageing and weathering processes in relation to buildings. In an essay entitled 'Colour and Texture', he drew attention to the fact that modern materials used in architecture often have very little life of surface, in part because steel, concrete, glazed tiles, asbestos, and plastics do not promote the Picturesque effects attendant on weathering. Architecture, he notes, that is built for immediate show often resents the effects of weather and wind.

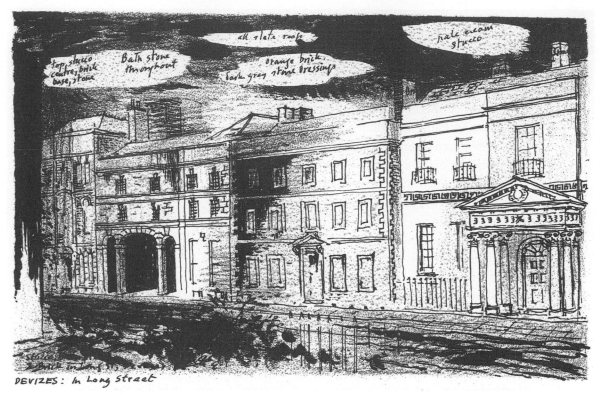

45. *Devizes.* Illustration for the *Cornhill Magazine* (1944).

But where there is no lichen', he warns, 'there will be dirt. … Rain-stains on white walls are only desirable if the surface is highly irregular, as in the case of a rural, and especially mountain, cottages; only, that is, if the building is of the kind that will go, with the years, back to nature.[29]

He did, however, approve the materials used in neo-Georgian banks and town halls, with their red brick and yellow stone dressings, which, he said, in time would develop a charm of texture.

Hastings, having encouraged these Picturesque leanings, was shocked at what he took to be a reactionary vein. When John sent in an article on the Georgian town Blandford Forum (Plate 30), in Dorset, praising the way its ingenious use of brick gives the town a distinctive character, Hastings wrote in protest.

Your Blandford article … will be hailed by the Old Guard as a sign of the *Archie's* return to the good sense of Blomfield and Baker. I hope you will

see how important it is to avoid this … it would be a tragedy … to make them feel that the modern movement is only a flash in the pan, and that if they stick to their Bank of England stuff, it will come back to that. You may see vaguely what I mean if you read your notes on Texture in the February issue. They read like a hostile attack on the Modern Movement by one who prefers decent period stuff.[30]

There is no doubt that John was, to some extent, undermining the International Style. His 'Colour in Building' series encouraged a revival in the use of ochres, browns, creams, and apricots in cottage, pub, and shop architecture, hues that had begun to fall out of use, in part because they did not belong to the modernist doxology. Likewise, his praise of vernacular styles and local materials upheld the native and indigenous over the imported. Visual appeal, rather than ideological correctness, was the driving spirit behind these articles, and the lesson he wished to impart. 'Sensibility', he once argued, 'to visual excellence in old buildings—as opposed to practical and historical-associational considerations—is still thinly spread. Certainly we love old buildings, but we love them for what they stand for rather than what they look like.'[31]

He brought to his promotion of the Picturesque aesthetic a highly cultivated understanding. Not only did he have in his library books by all the major theorists of this movement, but he also knew which nineteenth-century artists and poets were connoisseurs of picturesque effects. He shared Wordsworth's belief that a house should harmonize with the surrounding landscape, and he had both Wordsworth and Ruskin in mind when he asserted that 'ruggedness and friability of material are the two qualities that encourage the "golden stain of time".'[32] Both mentors are quoted in his article on 'Colour in Building' in which his own paintings of cottages showed 'far-gone effects of weathering … where derelict and half-derelict buildings become almost one with the flora and geology of the landscape.'[33]

The ultimate expression of his ideas was his seminal article on ruins, 'Pleasing Decay', first published in the *Architectural Review* in September 1947. The title was coined by de Cronin Hastings from a phrase employed in the essay. Here John explains his belief that an ancient building has as much individuality as any human being, and therefore, when an issue of restoration arises, it cannot, in his opinion, be judged by any general policy but needs to be individually treated. He reminds us, too, that the architect John Soane had made drawings of proposed buildings as they would look in a state of ruin; 'indicating that men should make buildings, as God made men, to be beautiful in age as well as in youth'.[34] Pleasing decay, he implies, is a natural state; he instances Calais Tower

which, in Ruskin's words, 'completely expresses that agedness in the midst of active life which binds the old and the new into harmony'.[35] These arguments touched a nerve and the phrase 'pleasing decay' entered debates about heritage and conservation. Aware that restoration often destroyed the character of a building, he preferred the organic or 'Picturesque way' which left buildings alone, both to live and to die. He hated the tidying up of ruins, the modern habit of flattening, mowing, and rolling the ground around them, the iron railings put up to protect them and the cast-iron noticeboards punctuating the best view of the site. He knew full well that the artist's view had lost out to the archaeologist; and that, as a result, Rome, a city once full of visual poetry, had been turned into 'a city of antiquarian interest and political propaganda'. He ends with a clarion call: 'The policy of the official bodies is one of preservation at all costs—even at visual cost, and they are sometimes unnecessarily obtuse about it. And this is the reason we must re-establish the appreciation of ruins, and decay, *visually*.'[36]

While John was writing these articles, the National Buildings Record, set up during the war, was compiling a photographic archive on all types and kinds of architecture. John Summerson acted as its deputy director and may have encouraged John to write about it in the pages of *The Listener*. 'The excitement', Piper explains, 'is in the little-noticed buildings that have been looked at with an unprejudiced eye and recorded with a sensibility that shows.'[37]

His own unprejudiced eye is best seen in his 'topographical letters' for the *Cornhill Magazine*, for in addition to Devizes he wrote on Norwich and Middlesbrough. From Norwich he wrote to Jock Murray: 'We are here, and have visited 20 churches in 48 hours, and one Unitarian meeting house, one Friends Meeting House, a Museum of Ecclesiatical Art and the old Water Gate. Have also walked up Gas Hill. Will communicate about cover on return.'[38] His article on Norwich shows his grasp of the city as a whole as well as his awareness of individual buildings (Plate 31). It is also astute on the issue of preservation, and reveals the depth of his concern.

> Guide-books still rail at the Victorians for their destructive 'restorations.' But it is hard to realize that conservative, well-informed, restoration is almost as much of a menace now. The sense of history is an apology for the absence of the sense of beauty: it is no substitute for it. ...
>
> There is nothing to be done about it. If after the war English towns and cities are to sink finally under the strain of fighting easy transport, international architectural styles, commercialism ... if they are to loose the last vestiges of their own character, so that you cannot tell, walking in a

suburb, whether you are in Clapham or Newcastle—well, they must sink. A super cinema and a crèche are either more or they are less fitting as contemporary amenities than a moot-hall and an old church. We cannot go on, for ever and ever, having both. No other age has ever expected to have its cake and eat it, in the way that we do about our architecture. One of the troubles is that we dare not destroy all the buildings of the past because then there would be nothing left to copy. So we fight to keep some, with the development-schemers grumbling, and we grumble ourselves over those we cannot keep. The forces of the two factions will continue to fight: those whose policy would in the end make England into a continuous housing estate and those whose policy would make it into a continuous museum, in which all the exhibits are catalogued, and quite dead. The war has arrested the rot of 'development', as we knew it in the 'twenties and 'thirties. But it has not done anything to solve this problem, which will soon be becoming acute again. There is one thing we can do in the meantime—decide for ourselves which *are* the beautiful buildings, new and old, that we already have (not simply the historical buildings, and the imposing buildings, which any guide book tells us). It means using our eyes, and taking nothing for granted.[39]

Towards the end of the war, neo-romanticism began to lose its relevance. John himself was still working in this vein, producing a dramatic rendering of Fonthill Abbey, after John Martin, for the cover of the June 1944 issue of the *Architectural Review*.[40] But at the same time, he admitted to Colin Anderson that the style was in danger of becoming academic. Asked what he thought of the work of Keith Vaughan, John confessed he had so far only seen reproductions, but these had clarified his expectations of new art. For with a young artist he hoped for something that at first glance he would dislike, not initially seeing its point, but which would force him to make an effort of appreciation. Still more, he wanted 'to see people <u>liking</u> things, and having a passion for things that they paint and draw ... and I don't want it always to be a passion of fear and hatred.'[41]

This dictum is repeated in the booklet, issued by the Army Bureau of Current Affairs in June 1945, *The Artist and the Public*, containing passages by James Boswell, Piper, and Giles, the cartoonist. John's plea—that it was necessary for an artist to love his or her subject—had wide relevance. Here illustrated is one of the three watercolours he made, at the instigation of the WAAC, of bomb-blasting experiments on shelters. As with all his war art, he manages to combine the need to 'record' with his own personal style, but whether he really did 'love' this subject is a moot point. Back in August 1944,

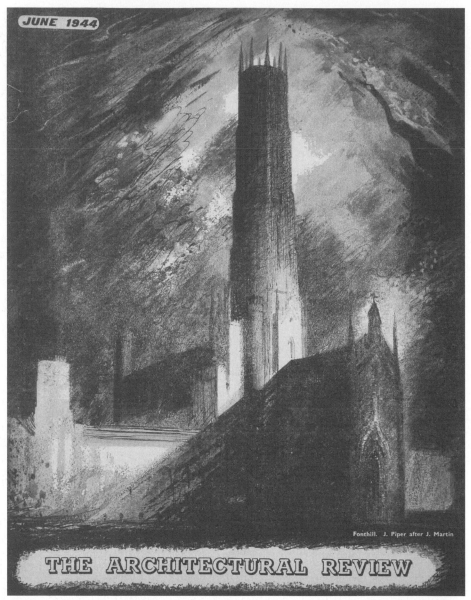

JUNE 1944

Fonthill. J. Piper after J. Martin

THE ARCHITECTURAL REVIEW

46. *Fonthill*. Design by John Piper for cover of *Architectural Review*, Vol. 95, June 1944.

while reviewing Camille Pissarro's letters to his son Lucien, he quoted approvingly Pissarro's distrust of too much immediate realism, noting that his preference was for something more akin to Wordsworth's emotion recollected in tranquility: 'I am more than ever for the impression through memory, it renders less the object—vulgarity disappears, leaving only the undulations

of the truth that was glimpsed, felt.'[42] So greatly did John admire Pissarro's penetrating remarks about nature, art, and honesty of purpose that he sent a copy of this book to Osbert Sitwell. 'That Pissarro book', Sitwell satisfactorily replied, 'is profoundly interesting and a great joy. No gift could have brought me more pleasure.'[43]

Another reason John wanted to return to his own interests was that he was failing to produce enough work to satisfy his dealers.[44] He belonged to no particular stable, though by 1943 the Redfern Gallery had become his chief outlet, its director, Rex Nan Kivell, keeping a list of impatient customers wanting to buy one of his paintings. His inability to satisfy demand may explain why he initially resisted overtures from the dealer Victor Waddington. But, after a very good lunch, he agreed to show at Waddington's gallery in Dublin. When it opened, in November 1944, ten works, including two oils, sold on the opening night.

In the spring of 1945 he and Myfanwy agreed to meet Osbert Sitwell in Scarborough so that John could draw more subjects for Sitwell's autobiography. Their final destination, however, was Middlesbrough, on which John was to write for the *Cornhill Magazine*.[45] While driving through Rutland, he noted fields full of cowslips, the churchyards full of beautifully engraved slate tombstones, and the churches full of Mrs Esdaile's monuments. In Middlesbrough, he was equally admiring of the mountainous slag-tips created by refuse from iron ore which, owing to a colour range that ran from rust red through maroons and purples to blue and grey, glistened across the Tees, either in the rain or from their own iridescence.[46] In his *Cornhill* article, he mentions Middlesbrough's rapid transformation, from a dreary, swampy parish, containing four farms and a population of 40, into a large industrial city. Its history owed much to the building of the Stockton and Darlington railway line, the creation of a coal port, and, when the coal trade fell off, the manufacturing of iron. In order to observe the town's development and spread, John travelled around it on the top of a bus. He then walked over the slag heaps which brought him distant views of the city, the docks and the estuary, the giant works belonging to Imperial Chemical Industries, and the derricks of salt working in the cornfields facing the sea.

> If there is not enough romance in the sight, there is in the sound, that drifts across the flats, of whistlings, clangings and rushings. On a siding near here, and not far from a derelict Assyrian-style building that belonged to the Port Clarence Iron Foundry, stand some early railway wagons of beautiful design. They are quite possibly Stockton and Darlington originals; at any rate

they are of the authentic early East Coast design, which grew from the old 'corf' which was drawn by human beings (often females) on wooden tram-lines in the main roads underground. At least two of them should be put in a museum before they disintegrate: two, because the shape of the space between them as they stand buffered together is of a studied Hansiatic [*sic*] elegance.[47]

With an eye devoid of prejudice, he turned from early railway wagons to grand municipal buildings to the rich elaborateness of Middlesbrough's public houses ('the rise of the gin palace coincided with the rise of Middlesbrough, and its pubs deserve a monograph'), but it is, overall, the atmosphere that he strove hardest to recreate. It is this which he advises the visitor to this 'smoke-pickled place' to search for: 'the atmosphere of the years of forced and awkward growth will soon be felt; the background of Victorian compassion and cruelty, of aspiration fogged by commercialism that belongs to this over-developed, half-decayed place. Gissing could have done it justice.'[48]

Previously paid on a piecemeal basis as a war artist, according to the commissions he received, John ended the war on a regular salary. In January 1944 the WAAC switched his attention to recording land reclamation. The following month the Ministry of Information offered him £270 over the next five months

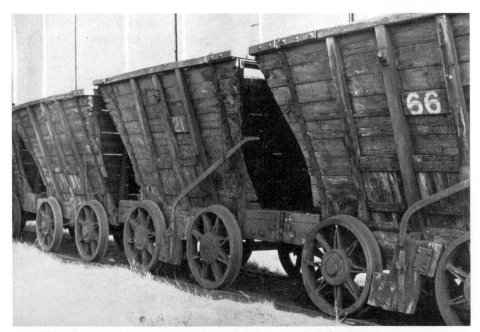

47. Old railway wagons in Middlesbrough (photograph: John Piper).

in return for general subjects. 'I am going about up and down this dismal land in search of subjects that will do for war art, in order to be a (nominally full-time) war artist,' he wrote in desultory fashion to Osbert Sitwell. 'I hope in a few months the Ministry of Labour will forget me again. I was <u>very</u> nearly called up, but after all have no business not to have been peeling potatoes for the past three years.'[49] In June, he moved to the Ministry of War Transport, on a salary of £690 per annum, plus a war bonus of £49.11s, a salary that remained in place until November 1945. In this role he made subjects relating to Inland Transport and the Merchant Navy. He painted American locomotives awaiting trans-shipment on the foreshore at Cardiff, warships being repaired and repainted after return from the beaches, the train ferry in Dover Harbour, and the Great Western Railway's marshalling yard at Yarnton, Oxford, among other subjects, all in a still fiercely neo-romantic style.

As a sideline, he occasionally did work for the Publications Division of the Ministry of Information. For them he produced, in 1942 and 1943, cover designs for the pocket series 'War Pictures by British Artists'. These small pamphlets *Blitz*, *Army*, *RAF*, *War at Sea*, *Soldiers*, *Women*, *Air Raids*, and *Production*, once so topical, have nowadays become collector's items, cherished wartime mementoes, the fragile deposits of a brutal conflict.

In May 1945, shortly before the surrender of Nazi Germany, John found in his post a copy of *Left Hand, Right Hand!* This first volume of Osbert Sitwell's magisterial autobiography filled him with gratitude and moved him deeply. He found it grand in conception and rich in detail. Osbert had in fact sent two copies of his book, one for Myfanwy.

Earlier that spring Myfanwy had noticed more white violets in the garden at Fawley Bottom than ever before. The house itself had survived the war unharmed. Over the years there seemed to be no lessening in the creativity it fostered. And in 1945, the heyday of the Farmhouse was yet to come.

PART

19

Return to Peace

At Fawley Bottom Farmhouse, wartime shortages had encouraged a degree of self-sufficiency which continued after the return of peace. Myfanwy now only occasionally made her own bread, but vegetables continued to be home-grown, John planting, with the help of a gardener, almost every kind available to him, some in a variety of species. With this garden produce Myfanwy did delicious things. She introduced Jane Grigson, cookery expert and second wife of Geoffrey, to sorrel soup, impressed others with her boiled partridge, her gazpacho, and her baked fennel with cream cheese, spinach, pine kernels, and tomato sauce.[1] Meals at Fawley Bottom, if mostly simple, were always good. Starters might be courgette flowers dipped in batter and fried, or an anchovy on a fried egg. Patés were homemade, and so too, at a later date, was Myfanwy's pasta. Evening meals were eaten in the dining room at a well-scrubbed white maple-wood table with a forest of candles in white holders clustered together, for electricity was not installed until 1958. When, in 1946, a crisis threatened owing to a candle shortage, Christopher Hussey sent fresh supplies from Harrods. When not in use, the candle holders encrusted with wax stalactites stood on top of the piano, like a forest of petrified white trees.

Among the new faces at Fawley Bottom in peacetime was Basil Coleman, the theatre director, with whom Myfanwy was slightly in love. He later recollected her saying that it was no longer enough for artists to be good at their work: they had also to perform on the social front. This she helped John do with the minimum fuss, by offering easy hospitality to all who came to the house. Another visitor, Basil Creighton, enjoyed the croquet, the jokes, and laughter. 'You are wife, mother, hostess to us all,' Jock Murray wrote, in a postscript to Myfanwy, '—I am ever one of your many admirers.'[2] Though Myfanwy would refer to 'the usual disorder of my life',[3] she in fact kept the house and family

in good shape. Her steadiness of character provided the stability and structure within which John could create and experiment. Happiness is the note that

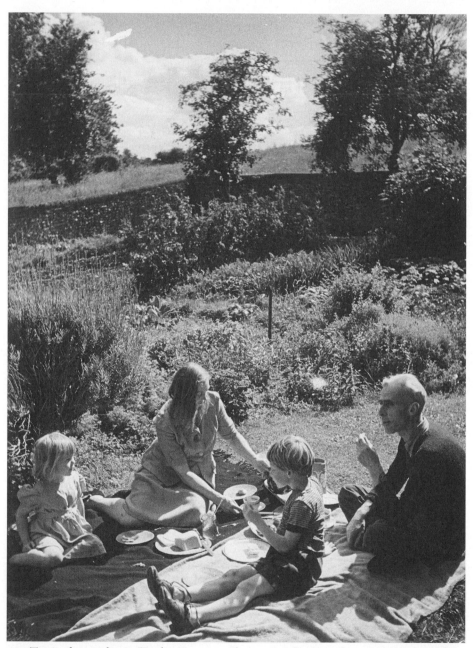

48. Tea in the garden at Fawley Bottom, Clarissa, Myfanwy, Edward, and John Piper. c.1945.

sounds in many of his letters. 'We are enjoying a week at home uninterrupted,' he wrote one November, 'and it is most pleasant in this open sou-westerly weather, torrents of rain alternating (as at the moment) with white flying cirrus clouds on a blue ground. Tea in the wood.'[4]

The house itself underwent alterations in the post-war period. Cupboards were removed from the dining room and the space filled with a second piano, a Bluthner grand lent by Mervyn Horder which made possible duets, he and John together playing Mozart piano concertos. In time the kitchen acquired an oak dresser made by a local craftsman to John's design, which was lined with dark blue marbled paper to set off the burgeoning pottery, bottles of herbs, and strings of onions. One day a near disaster occurred when part of the kitchen ceiling fell to the floor, narrowly missing the head of their three-year-old daughter Clarissa. A second disaster resulted from her playing, in the summer of 1946, with a box of matches in the barn. It sprang into flames and burnt down, leaving in its place, for many years, a semi-charred ruin. In Clarissa's memory, neither of her parents expressed anger at what she had done.

Three years later the cowshed at one end of the house was converted into a studio. It was entered from the kitchen, via a small connecting room, and was crossed by massive and irregular wooden beams. The ceiling went right up into the rafters where high windows, let into the roof, provided a generous amount of light. John soon turned this airy space into an artist's den, filling it with easels, artist's chests, a small printing press, and work tables on which his rows of paint tubes, boxes of pastels and crayons, brushes, and assorted tools were laid out with foresight and precision. The room was heated by an old iron stove and round it gathered an assortment of armchairs, among them a Charles Eames chair and stool. Pictures hung on the walls, were stacked on shelves, or were mounted on easels. Here, too, was a musical treasure trove—John's ever-growing collection of records to which they listened, in the evenings, on a wind-up gramophone, graduating to a more up-to-date machine in 1956.[5] The collection included both classical and jazz. Here John's godson, Lionel Grigson, found a set of George Shearing recordings, felt vindicated in his interest in jazz, and was further pleased when John gave him a generous tip towards a new trumpet. John Betjeman, mindful of the pleasures offered by the studio at Fawley Bottom, would say, 'We've finished dinner, darling. Shall we go out to the nightclub?'

In his professional life, John made an easy transition once peace returned. His final wartime commissions had been done under duress; now he turned willingly to lighter tasks, producing in 1945 two scarf designs for *Harper's Bazaar* as well as posters for two films made at Ealing Studios: *Pink String and*

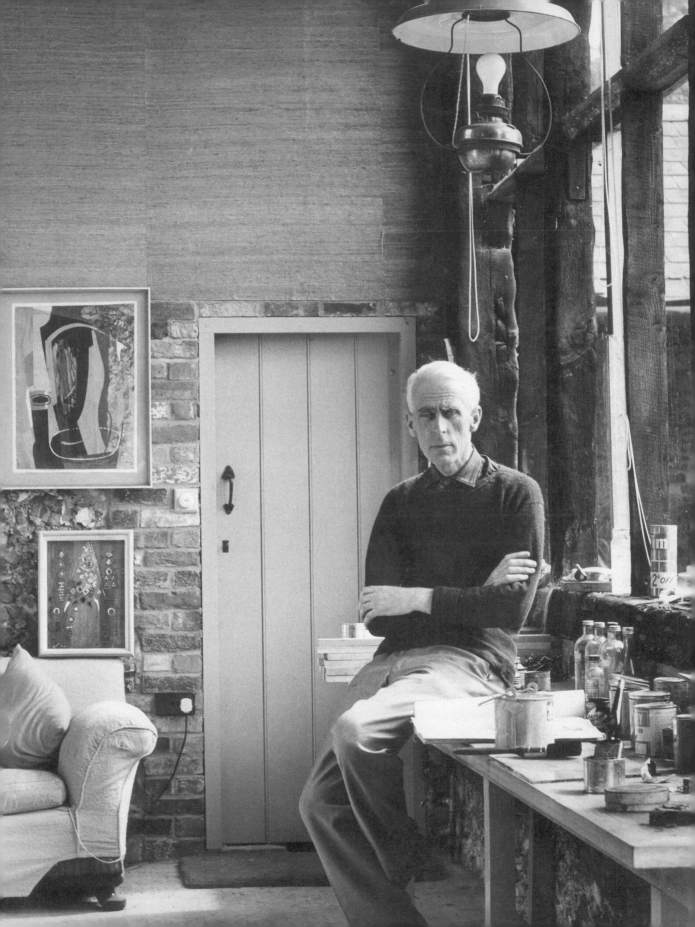

Sealing Wax and *Painted Boats*, the first containing an echo of *Brighton Aquatints* in the street perspective against which is offset a photographic image of Googie Withers. He was also much in demand as a writer, receiving invitations to produce books, articles, and reviews, becoming for a while a regular contributor to the *New English Review,* launched in May 1945. An article he wrote for this magazine, lamenting the poor quality of current book illustration, was read by Richard de la Mare, at Faber's, who asked him to illustrate his father Walter de la Mare's long poem *The Traveller* (1946). This John did, matching the poet's imaginative landscapes with a series of coloured lithographs, pungently evocative of mood not place. The editor of the *Penrose Annual,* on seeing them, wrote: 'So often the artist turns out illustrations regardless of how they are to be reproduced, but you are among the few who wherever possible reverse the order of things and in this way obtain originality of expression.'[6] More descriptive are the lithographs he did in 1946 for J. M. Richards' *Castles on the Ground*, putting a drawing of his mother's house on the cover. This book challenged the received view of suburbia by locating its origins in the Picturesque. John Russell, in *The Sunday Times*, pronounced it a love story, 'for there can be no doubt that Mr Richards feels for Ealing and Streatham as other men used to feel for Mary Pickford.'[7]

The following year John was one of twelve British artists represented in the Victoria & Albert Museum's celebration of the 150th anniversary of the invention of lithography. Some of his designs were for book jackets. In 1947 J. M. Dent and Sons commissioned him to do the cover for Norman Hancock's autobiographical story, *An Innocent Grows Up*. Both author and editor had seen a copy of *Brighton Aquatints* and had concluded that a Piper drawing of the draper's shop in the story would be just right. In 1949 he designed a generic cover for three Shakespeare volumes published by Winchester Publications, as well as book jackets for Peter Quennell's *Byron: A Self-Portrait: Letters and Diaries*, Anthony West's novel *A Dark Night*, and for a novel by Sir Michael Sdaleir's son, Michael Sadleior, *Forlorn Sunset*. This same year, the collector Brinsley Ford, who had bought some of his work, introduced him to Charles Ede at the Folio Society. He turned down the invitation to illustrate *Wuthering Heights*, but Ede's next suggestion, Gilbert White's *Natural History of Selborne*, he later accepted.

Meanwhile requests poured in from the Church, for talks, articles, advice on stained glass, drawings for leaflets, and posters for anniversaries. He gave

49. (*opposite*) John in his barn studio, 1962 (photograph: Jorge Lewinski).
© The Lewinski Archive at Chatsworth.

two lectures in 1946 at St Anne's Church House, in London's Soho, which had been set up three years earlier as a Christian centre of cultural interpretation. Lichfield Cathedral requested a poster to mark its 750th anniversary, as the Dean explained. 'As soon as I saw the first picture of Seaton Delaval in your beautiful book,' he wrote, 'and looked further on, at the Farmhouse Chapel and Fotheringay Church, I knew where I could get the very best, if the artist could be persuaded!!'[8] As the Dean was very charming and the Bishop of Lichfield happened to be Reynolds Stone's father-in-law, John found himself designing not only a poster but also a cloth to cover an ugly reredos during festal seasons.[9] Mostly, however, the pressure on him to accept such invitations arose from his love of architecture. Having written movingly in *Oxon* about Dorchester Abbey, it was inevitable that he would find himself a founder-member of its Association of Friends, later doing a print of the abbey, to be sold in aid of restoration funds. Ecclesiology now crept into many things, including the Christmas card he designed for Faber and Faber in 1951, making a collage out of sheet music and marbled paper, based on London church spires and the dome of St Paul's Cathedral.

Having emerged from the war a public figure, one of the great and the good, he now gave his name to deserving causes and sat on committees. An active member of the Friends of Friendless Churches, he drew specific churches to benefit appeals. As a Fellow of the Ancient Monuments Society he stood witness, with Osbert Lancaster and Ivor Bulmer-Thomas, at a public enquiry into the proposal to demolish the Catherine Wheel Hotel in Henley-on-Thames, Piper and Lancaster making such hits that the inspector was unable to restrain the audience's vociferous cheering. Later, in 1959, he joined the Royal Fine Art Commission, a government-appointed body which acted as a watchdog, and for the next eighteen years he helped examine proposals for new buildings and public monuments of all kinds, with an eye to their quality and suitability. He brought to this committee an unmatchable knowledge of English towns, villages, and landscape, astonishing a fellow commissioner, Sir Anthony Cox, with his power of almost total visual recall which enabled him to provide information frequently omitted, either carelessly or carefully, from the drawings submitted. And his tenacity was impressive. He once advised a vicar:

> It is no use being overpowered by those knighted Georgian flat-building architects. Just go on bleating (I always do) and protesting, and getting oneself down in the Minutes of the meeting as in a minority of one. You'll get a decent window put up in the end and they will all come round telling you that it's not quite as bad as they expected. Meantime NO to everything bad you can.[10]

His suits were now tailor-made by Hall Bros in Oxford's High Street, and on his forays to London and elsewhere he always looked dapper. In the course of the next ten years, he sat on the Governing Body of the Bath Academy of Art, at the request of Clifford Ellis; acted as external examiner at Newcastle School of Art; undertook the annual chore of judging the Rome Scholarships; and did occasional teaching at the Slade. In 1946 he accepted the Prime Minister's invitation to become a trustee at the Tate Gallery. He joined this Board at a time when the National Gallery was requesting the transfer to Trafalgar Square of some of the Tate's best French paintings. This gave rise to a heated debate. Some handwritten notes remain of the thoughts he contributed:

> Don't treat the Tate as a rich rag-bag—give it a raison d'etre worth having. … I don't like galleries that are exclusively of masterpieces: I feel bullied by them. I haven't the stamina and I don't believe anyone else has either. I want galleries of good paintings, large and small, dim and important, rising here and there in the peaks to masterpieces—only then do I know what <u>are</u> the masterpieces of the period, and what the ambitions and potentialities of painters of the period.

During his first period of office the Tate underwent a Treasury enquiry into accusations that the Director, John Rothenstein, had been culpable of mal-administration of trust funds. Despite the amount of time the so-called 'Tate affair' took up, John agreed to a second term of office, after which he became, in 1967, a trustee of the National Gallery, in which role he encouraged the board to take a firm stance against admission charges in the early 1970s. He also agreed in 1967 to act as the National Gallery representative on the Tate board.

Still more time-consuming in the post-war years was the work he did for the Oxfordshire Diocesan Advisory Committee. This he joined in 1950. For the next thirty-eight years he helped maintain and preserve the fabric of churches in this region, giving his attention not just to matters of aesthetic interest but to every aspect of church maintenance, from stone floors, heating systems, the washing of alabaster monuments, and the cleaning of ancient brasses. In his *Who's Who* entry, which begins by identifying him as 'artist and writer', the very next thing he mentions, in the string of major achievements that follows, is his membership of the Oxfordshire DAC.

As this shows, he gave generously of his time and energies to a host of public concerns, small and large. But he was also a highly professional artist and exceptionally focused. This made it necessary, in these post-war years, for him

to seize opportunities, whenever he could, to paint what he wanted to paint, regardless of others.

In the immediate aftermath of war, Myfanwy, too, found time amid the routine of domestic life to conceive of new projects. She obtained from the publisher Messrs Home and Thal a contract for a short book on George Gissing, for a series provisionally titled 'The English Novelist'. Though she read or re-read the whole of Gissing at this time, nothing came of this project, but her fascination with this author fed into what is still a very fine essay on Gissing's life and work—her introduction to the Watergate Classics 1948 edition of *The Whirlpool*. The force and clarity of her writing, the articulation of themes, relationships, and Gissing's changing point of view are impressive, as is her analysis of this particular novel. She concludes:

> *The Whirlpool* was a cry of despair, of different despair from that in Gissing's previous books, because it contained the first suggestion that the intelligent man might hold in himself, rather than in his situation, the seeds of his own downfall and the first hint that a denial of the primitive in man's and woman's nature is not a virtue, but a failure to face up to reality.

Her writing, however, had to be fitted around family life. In 1947, while Tom Kendrick looked after Edward and Clarissa in a house in the country, Myfanwy went into Henley and gave birth to Suzannah who emerged with a shock of jet black hair. With three children in their care, the Pipers solved the difficulty of obtaining domestic help by renting from Sherman Stonor a nearby empty cottage. 'We feel that 100yds of country lane is *almost* as good as a green baize door,' Myfanwy told Osbert Sitwell.[11] She was grateful, however, for the arrival of Mr and Mrs Carter, who helped in house and garden, and even more for Elsie, who bicycled out from Henley, aged fourteen, to look after Edward and continued to do so until she was nineteen. Later on, there was Rena, a young Italian woman who lived for a while with the family, but Myfanwy still did most essential things herself, running up clothes for the children, cooking, and organizing the running of the house.

In 1946 a German émigré gave her the opportunity to once again edit a magazine which, at John's suggestion, was named *The Pavilion*. Hans Juda had come to England in 1933, after being beaten up by a storm trooper while working as a financial journalist in Berlin. He took up the London editorship of the Dutch-based magazine *International Textiles*, and in this role persuaded clothing manufacturers to give clothes to the dancers when the ballet went to

New York during the war. A large ebullient man, he became, after the war, editor and owner of *The Ambassador*, a glossy export magazine for the promotion of British materials and clothes. Juda always conceived of this as more than a trade journal, and for a time Laszlo Moholy-Nagy acted as its art director, while his wife, Lucia Moholy, the Bauhaus photographer, took on Hans's wife, Elsbeth, as an assistant and pupil. Elsbeth's photographs later contributed to the stylishness of *The Ambassador* which every now and then featured an illustrated article by John.

It was no small achievement to have gained Juda's financial support for *Pavilion*. Myfanwy told Osbert Sitwell:

> I have been asked by a substantial fellow (in more senses than one ...) to edit a new and sumptious Art Mag. (What another). It is to be ostensibly about English contemporary art with suitable diversions and excursions. ... It is to concentrate on many and large and colour reproductions in any and every process. I look forward with some shoe-shaking but a great deal of pleasure to running a paper without having to economise either in fees or printers or blocks.[12]

Her decision to focus on contemporary English art was perhaps unwise, for the return to peace had terminated Britain's cultural insularity and a more international outlook had begun. John may have been correct in saying, in 1947, that the Hogarth, Blake, Constable, and Turner exhibition at the newly re-opened Tate Gallery was 'the most important one [exhibition] of British Painting ever held',[13] but for many artists the most influential show in the immediate post-war period was the Picasso and Matisse exhibition at the Victoria & Albert Museum in the winter of 1945–6. It effectively put an end to the neo-romantics' inward-looking nostalgia and brooding melancholy and replaced it with a new decorative strength, a greater tautness in the handling of the picture surface which made much neo-romanticism seem fussy and passé.

Myfanwy, who had earlier put her finger on the pulse of contemporary art, appears to have ignored this aesthetic shift. She may have been partly under John's influence, for he was at this time berating the 'absurdly Francophile' stance of English art critics and regretting the 'half-hearted' publications on English art.[14] Myfanwy, though ahead of her day in her interest in Victorian stained glass and architecture, had in effect turned her back on the contemporary and sought copy for *The Pavilion* on easier subjects. She obtained a semi-autobiographical article on Arles and Vézelay from Anthony West; indulged Betjeman's desire to publish at length on the Irish architect Francis Johnston; quoted an instance of Ruskin's outspokenness in his denigration of a

Millais painting; extracted an article on stage design from Robert Medley, and permitted Grigson to pen a pedantic, supercilious essay criticizing the picture collection in the City of Birmingham Art Gallery for its lack of historical completeness. Worst of all was a directionless effusion from Wyndham Lewis on the motley nature of the contemporary art scene. (This last had been obtained with difficulty, by means of meetings, telegrams, telephone calls, and many gins.) There were illustrations of stained glass, two of them copies by John, alongside a short essay by him in praise of this under-rated medium. Myfanwy had also requested drawings from Edward Bawden, who sent some nicely humorous snails. But, overall, *The Pavilion* is a heavy, unbalanced collection of curiosities. Myfanwy herself is most eloquent on the dangers of inauthenticity:

> Exploring the things that affect the vision of English artists and writers, it is easy to be either chic or dowdy, easy to give a slate quarry a smart allure, or to weave the subtle colours of lichened stone into a lovely home-dyed, hand-woven dream. What is difficult is to arrive at an unsentimentalised, unfashionable, yet interesting statement.[15]

But overall, she provides no very clear advice as to how this is to be achieved. And though further volumes were promised in which would appear 'the unknown with the accepted, the past with the present', the first proved to be the last issue of this magazine.

In 1947, the British Council commissioned a series of small books on the contemporary arts in Britain. One of these was Robin Ironside's *Painting since 1939*. It was the first publication to deal seriously with the emergence and development of the neo-romantic spirit. He reproduced John's oil *Gordale Scar*, then in the possession of Kenneth Clark, and argued that his 'neo-romantic' vision was most in tune with the national heritage.

> It is a vision that has revived the possibilities of the 'picturesque' in the painting of landscape and architecture, possibilities which embrace the most dramatic of nature's effects and which Piper had developed with an unruffled skill and a vivid theatrical treatment. Perhaps the most successful instance of the dramatic topography at which Piper excels is the series of water-colour drawings of Windsor Castle commissioned by the Queen in 1941. ... Piper's responsive interpretation has succeeded in imposing upon the useless battlements and turrets, with his dark skies and flashes of yellow light, an almost Spenserian magic. More recently, he completed a group of drawings of Renishaw Hall, in Derbyshire, full of a kind of Brit-

ish *morbidezza*, but in which the theatrical element was somewhat more crudely staged than in the Windsor series. As a painter of landscape, Piper has recently preferred the wilder aspects of the English scene, those to some extent in which James Ward also delighted, and his oils of Gordale Scar ... display a vigour and excitement that we do not always experience in looking at his paintings in the same medium, of architecture, in which the wilfulness of strong colour contrasts is sometimes too apparent.[16]

Such recognition paved the way for wider interest in his work.

Sutherland, Moore, and Piper were the leading names in English Art at the end of the war. The British Council enrolled them as cultural emissaries by sending their work abroad. Paintings by John went to Paris, in September 1945, in a mixed exhibition which afterwards toured various European capitals. In 1946, he was part of an exhibition of 12 contemporary British artists which, under the auspices of the British Council, toured seven major centres in America, ending at the Metropolitan Museum in New York. Lillian Somerville, the Director of Art at the British Council, informed John that any advice he might wish to give them, regarding this tour, would be welcome.

His art had earlier been shown in New York, at the Buchholz Gallery, 32 East 57th Street, owned by Curt Valentin. A refugee from Hitler's Germany, having emigrated from Hamburg in 1937, Valentin had become Kahnweiler's New York representative and Picasso's American dealer. Known as 'the Vollard of America', he was a person of considerable charm, with the reputation of being the best salesman on 57th Street. A close friend of Alfred H. Barr, the director of the Museum of Modern Art (MOMA), and Max Beckmann's dealer, he gave Henry Moore his first New York exhibition in 1943 and began selling watercolours by Piper in 1944.

He also devised a touring exhibition of watercolours, 'Contemporary British Artists', which included John's work and was shown in New York in the spring of 1945. Stylishly presented, its catalogue carried an introduction by James Thrall Soby. 'In general', he wrote, 'the tendency now seems to be toward a fuller use of national heritage. England's suffering in the war has naturally intensified the meaning of this heritage, and has aroused among artists a romanticism which reflects the nation's valour, dignity and historical certainty.' Piper shared a gallery with Moore and Nash, at a time when the New York art world was humming with interest, owing to Mondrian and Rouault retrospectives at the MOMA, and exhibitions of the work of Klee, Kandinsky, Matta, and Jackson Pollock elsewhere. In this context John's work struck a distinctive note, with its display of poetry, order, intellect, and lyrical virtuosity. It caught the attention of leading American collectors, among

them MOMA's architect, Philip Goodwin, who bought a painting of Rievaulx Abbey.

John benefited greatly from his association with Valentin. His work was favoured by Duncan Phillips, who was collecting for his Phillips Memorial Gallery (now the Phillips Collection) in Washington, DC; Stephen C. Clarke, MOMA's president and one of the best collectors in New York; and Alfred Barr, the museum's founding director and curator. After his move, in 1947, into new premises which from then on bore his own name, Valentin continued to mount exhibitions of John's work in New York, and to send it on tour, in 1948, to Washington, DC; Buffalo; and San Francisco. After Valentin had become Henry Moore's American dealer, he began making three visits to England every year. In 1949 he spent Christmas Eve at Fawley Bottom Farmhouse, for he was especially fond of the Pipers and of good wine (in reverse order, John thought). He not only earned John considerable sums of money, sending him a cheque for £1900 in 1947 to cover sales over the previous six months, but he also helped get his work included in MOMA's 1948 collage exhibition. Piper's reputation in America climbed further in 1949, when his designs for the opera *The Rape of Lucretia* were shown in New York. But the high point was probably 1950 when Valentin mounted a solo exhibition of his work, which was visited several times by Alfred Barr as well as by Osbert Sitwell and his sister, Edith, who happened to be in New York. Valentin's hopes of selling work to MOMA were fulfilled and the *New York Times* labelled John 'the laureate of the picturesque, the poet-painter whose thunderous mountain-sides and crumbling churches, seen in the glare of a lightening flash or under sickle moon, fix a pure Celtic essence within the four sides of a canvas.'[17]

John was fortunate, too, in having a further advocate in America in Sir Kenneth Clark. He had assisted Robin Ironside with the selection of 'British Art: The Last Fifty Years 1900–1950', an exhibition which toured America in 1950 under the auspices of the English Speaking Union of the United States. Clark lent two pictures and wrote persuasively in the catalogue.

> The chief value of the revived romanticism has been the sense of freedom with which English artists now feel able to express their imaginations. The English mind is encrusted with poetical associations, and to scrape them off in the interests of clear construction is greatly to impoverish it. Painters like John Piper, or Francis Bacon, in very different ways, can enrich their work by associations which are outside the range of direct painting, although only brought into being by pictorial means.[18]

When the exhibition reached the Phillips Memorial Gallery in Washington, it was supplemented by paintings already in Duncan Phillips's possession and an entire stair wall was hung with Pipers, among them 'Stone Gate, Portland', a recent acquisition. Soon after, the Gallery mounted a solo exhibition of John's work, as it had done for the first time two years earlier.

This mounting success in America was abruptly terminated by Valentin's sudden and unexpected death in August 1954. The year before he had not only commissioned John to make some lithographs with the French printmaker Mourlot, for sale in America, but had also committed himself to taking 700 copies of the first full monograph on John's art, then in preparation. John could not have wished for a more loyal supporter, and his death was a great blow. Valentin had scheduled a Piper exhibition for February 1955, which his executors intended to honour. Pictures were sent out and arrived January 1955, but by then the business was in the process of liquidation. Durlacher Bros at 11 East 57th Street stepped in and mounted the Piper show which received a fulsome review in the *New York Times* (17 February 1955) and sold well. As a result, John stayed with Durlacher Bros at the request of its director, George E. Dix Jr, for the next seven years. Though they sold his work in New York and Washington, DC, including one picture to Eartha Kitt, his reputation as a ruin painter began to stymy further success, for an American audience found it difficult to follow when his art changed. In 1961 Dix mounted a show of John's Venetian pictures, together with an entire wall of his industrial scenes, treated in a semi-abstract manner. It received good notices, but few works sold. The following year, by now convinced that America was out of sympathy with English painting, John moved to the Albert Landry Galleries run by James H. Glanville at 111 East 79th Street. Lady Dean, wife of the British Ambassador to the United Nations, opened the show, but social cachet failed to stem the steady decline in Piper's American reputation.

Living in a small hamlet, in unspoiled countryside, at a distance from London, the Pipers led a life that was busy and far from parochial. Many of John's commitments took him to London, but he mostly returned home the same day. John Rothenstein suggested he should join from a club and offered, with Tom Kendrick, to propose him for the Athenaeum. John declined, claiming he would not use it enough to justify membership; 'and indeed, I become less and less of a clubman as I get older and more morose.'[19] Instead, while living at Fawley Bottom, he yearned for greater remoteness, for the kind of settings that inspired some of his best pictures and where he could work without interruption on subjects that were his own choice. He had, in fact, found what he needed in North Wales, in the summer of 1945.

John's first visit to the mountains of North Wales is said to have been occasioned by a commission from the WAAC to paint the cavern inside Manod, where a good part of the National Gallery collection was being stored.[20] While there, he was determined to visit Pistyll Cain and other sites in the region painted by Richard Wilson. One of these was Cader Idris, in Caernarvonshire. This brought him into close proximity with the Rise of the Dovey, its lake surrounded on all sides by steep mountains. Though it is difficult to reach the edge of the lake, John must have done so, and the subject, which he afterwards worked up in oil in the studio, remains one of the finest pictures he ever painted (Plate 33). The canvas is once again coated with gesso in order to complicate and enrich the surface of the painting, but in this picture he also finds ways of capturing a new sensitivity to ephemeral weather conditions, to mist and passing shadows which here turn the greater part of the lake black. The sense of scale, the restrained drama of light and atmosphere, and the originality in the handling of colour all tell of his admiration for late Turner.

In the second half of the 1940s John returned repeatedly to North Wales, to pursue his fascination with mountains. He drew and painted them compulsively, without any need to satisfy a commission or to keep abreast with contemporary trends. In the changeable mountainous terrain of Snowdonia he uncovered a vein of work that proved the language of paint could be renewed and extended: it was here that Piper fully attained re-entry into the great tradition of English painting.

In the summer of 1945, with still only two children in their care, the Piper family set out for Caernarvonshire. They stopped en route at Chester where the antique shops were cheap and rummaged for jugs, mugs, and other bits of pottery to add to the collection on the kitchen dresser. Their destination was the Nant Gwynant, a valley in Snowdonia with two lakes. There they stayed in the Pen-i-Gwryd Hotel, popular with hikers. Behind lay the Glyders, Glyder Fach with its curious stacks of rocks, and Glyder Fawr, its serrated peaks creating 'The Castle of the Winds' as well as other rock sculptures. John admired the colour of the mountains in the perpetual drizzle and told Osbert Sitwell: 'A hundred subjects meet the eye at once.'[21] He shared his interests with his seven-year-old son Edward, who had inherited a love of drawing and often sat happily beside his father recording a building or a view.

On a trip to Caernarvon John was delighted to find that he could buy old-fashioned notepaper, decorated with engraved vignettes of local scenes, such as the Vale of Ffestiniog in dark and stormy weather. But he wanted more than this and before long began looking around for a house to rent. He found

'Pentre', a small simple cottage, which a Richard Evans sublet to him for £35 per year.[22] Not far from Bethseda, it is situated halfway down the Nant Ffrancon valley which is over half-a-mile long, walled in by steep hills, and through which winds a small river. Glacial rubbish lay strewn over the hillsides and created heaps of loose blocks in the valley, beneath which, in places, could be heard the tinkling sound of water. On a sunny day, the hillsides flow with fast moving shadows as the clouds pass overhead. They rapidly lose their serene beauty under adverse weather conditions and take on an estranged melancholy bleakness. In 1945 the road running through the valley was an unmade track, barely usable in winter. Even today this stretch of beautiful but inhospitable landscape is occupied by only a handful of isolated buildings.

Wanting to understand the geological formation of the area, John read A. C. Ramsay's *The Old Glaciers of Switzerland and North Wales* (1860) and in this way learnt that the huge boulders, found in seemingly inexplicable fashion perched precariously on the top of a ridge, had in fact been gently deposited there by a disappearing glacier, as had the rocky debris in the Nant Francon valley. Before long he knew passages from this book by heart, among them Ramsay's description of vanished glacier traces in Llanberis Pass. When he began to draw the mountains repeatedly, he noticed that the shape and tilt of big rocks near to hand often echoed the shape and tilt of those in the distance. By the middle of August, John was writing to Osbert Sitwell: 'We had a lovely time among the mountains (how I hate them, really) and I have done a lot of work which may I think not be a retrogression.' He went on:

> 'I think we have taken a house in Wales, too remote for anyone else to take, and up too bumpy a road (Edith will certainly never see it) but I'm not sure if we shall ever hear from the farmer or landlord. But it might be useful if the anatomic [*sic*] bomb gets really busy … Have we beaten the Japanese?[23]

In the third week of August they returned to Fawley Bottom where they spent the rest of the summer. In October John went off to Ireland for a week, on a bicycling tour of country houses with the writer Frank O'Connor. The British diplomat Reginald Ross Williamson, who was UK Press Attaché at the British Embassy in Dublin and a friend of John's, may have arranged this tour. 'I saw wide expanses of bog', John told Osbert Sitwell, 'under skies not unlike Renishaw's and some fine ruined and unruined country houses.'[24] It was one of the few occasions he took photographs, not just as an end in themselves, but to assist him with the oils he afterwards produced, based on the houses he had seen. In these small paintings the character and style of the building is distilled

with sensitivity in an unfussed, allusive manner. At least four were sold through Curt Valentin in New York, along with a number of his Welsh paintings.

From Ireland, John returned to Snowdonia where Myfanwy joined him, leaving the children at Fawley Bottom in the care of S. J. Woods and his wife, Dorothy, so that three weeks could be set aside to make Pentre habitable. Myfanwy told John Russell:

> There is an immense amount to do still and our time is very short as we have to go back to reclaim our infants. Plastering, painting, distempering and rubbing down is very exhausting and in a house so very shabby and damp-stained as this very slowly rewarding. But it is rewarding and to have a house of one's own in this bare and stony place makes the landscape less instantly holiday-like. If you go out you have time to notice the blown holly trees and the scrub and can ignore the mountains if you feel like it and if you don't go out you can settle in and make your own well-known private muddle. Not a very laudable ambition.[25]

At the same time John was writing to S. J. Woods.

> The house is now reasonably habitable, though still lacking a sink and lav. in working order. Our hands are smothered with minor blemishes which bleed profusely, clouds drift over the opposite mountains, and neither my nor my neighbour's (farmer Jones') car will start, and they have been towed down a stony road by a Welsh mare.[26]

In most of his letters, the mountains are to the fore. 'Clouds whirl round the mountains in the gale and at night a full moon comes out in fits and starts above the mountains,'[27] he told Robert Simon, who had asked him to give a paper to the Double Crown Club. More dramatic was the description sent to Paul Nash. 'There was a gale here this week which made the clouds whirl round the mountains in circles and lifted the water off the river in spray and flung it over our rush-grown water-meadows. I hope you will see the place one day.'[28]

The Pipers and their two children returned to Pentre early in January 1946, to spend an entire month in this remote valley. Apart from the first few days, the weather was benign, 'with the most remarkable clear golden light that more than justifies Wilson's Italianising of the mountains,' Myfanwy told John Russell.[29] It also made possible several visits to the small seaside resort of Beaumaris, which looks across the Menai Straits to the mountains on Angelsea. But during a stay at Pentre in the summer of this year the weather proved almost unbearably grim. John worked on regardless. 'JP is doing a drawing in a churchyard in a howling wind,' Myfanwy wrote to Eric Crozier, 'and both

children and I are in the car and they are either shaking or shouting or asking me for a pencil or paper or hurling insults at each other and its frantic and my feet are cold.' The weather continued to be unspeakable and a fortnight later John was having to slide down wet rocks and climb mountains in roaring gales in order to find the subjects he wanted to paint. Yet they remained dug in until the end of September. Pentre was situated at the foot of a very steep hill, and, after one downpour, water poured in at the back of the house and out the front door.

By 1949, the difficulties associated with this house led them to abandon the Nant Ffrancon valley in favour of 'Bodesi', near Capel Curig. This was their landlord's 'hafod', or summer abode, and therefore available to them for much of the year but not during the summer months, an arrangement that continued until around 1956. The house is situated near Lake Ogwen, facing Tryfan. To Moelwyn Merchant, who had once ministered in a church at Capel, John wrote: 'We have been enjoying ourselves in the valley between Capel Curig and [Lake] Ogwen so much that I haven't been attending.'[30]

John's initial guide to this area had been Edward Pugh's *Cambria Depicta* (1816), with its seventy hand-coloured aquatints, a copy of which he had found in a second-hand bookshop in Hereford before the war. It had formerly belonged to a book collector on the Welsh border who had stuck in extra engravings and then had it rebound so that, big and fat, it looked like a Family Bible.[31] Pugh died three years before this book was published and is said to have taken ten years to complete the illustrations. One of his intentions was to lead the painter to numerous subjects:

> whether his genius incline him to the mountain's craggy side, the cwm's [valley's] solemn profundity, the frightful brink of the cataract, and the rocky margin of the sea: or to the milder features of Nature, observable in the shadowy recesses of the grove, the cultivation of the expanded valley, and the tufted banks of the serpentine *afon* [river], he will here find frequent and tempting opportunities of indulging and exercising it.[32]

John visited many of the sites Pugh illustrated or described, and, as Pugh had done, he turned also to Thomas Pennant's *Journey to Snowdon* (1781), which excited him with its clear and accurate reports,[33] and whose original observations, he soon discerned, had been copied by other writers for over a century. He shared his enthusiasm for Pugh and Pennant with Reynolds Stone, whom he brought to this area and found wonderfully stimulating in his knowledge of illustrated books.

50. Reynolds Stone and John Piper on the Glyders, 1949.

Reynolds became a regular visitor to the cottage at Nant Ffrancon, bringing with him field glasses through which he and John watched professionals climbing Tryfan, the triple-peaked mountain at the end of the valley. Together they explored Snowdonia, its magnificent scenery arousing in them a desire to do a new guide to the mountains, illustrated not with practical photographs for climbers, nor with picturesque photography, but with engravings by Stone based on John's paintings. The intention was to go beyond their external form in search of greater authenticity. Nothing came of this idea, but many years later, in 1968, ten pictures by John which Reynolds Stone had engraved were used in *The Mountains*, published by the Rampant Lions Press in a limited edition, with an essay by the poet R. S. Thomas. John had been aware in the late 1940s that it would be hard to find a publisher for their guidebook, but he was convinced that he was

> seeing the mountains for the first time, and seeing them as nobody had seen them before. This was partly due to the feeling of release after the confining of the war, partly to a 'spurt' in my capacity to observe more clearly at that particular time. Each rock lying on the grass had a positive personality; for the first time I saw the bones and structure and the 'lie' of the mountains, living with them and climbing over them as I was, lying on them in the sun and getting soaked with rain in their cloud cover, and enclosed in their improbable, private rock-world in fog.[34]

These words are justified by the work he produced in North Wales in the late 1940s. He worked on small pen and ink sketches as well as large oils, Turneresque in their refulgent colour and breadth of treatment (Plate 35). He also took photographs, some of which he later used in the Shell Guide to North

Wales, often choosing a dramatic angle or a characteristic point of view. But of crucial importance to all this work was Ruskin's promotion of landscape art in *Modern Painters*, especially his take on geology as 'visible dramatic action expressing the tragedy implicit in the human condition'.[35] A similar pathetic fallacy can be found in John's mountain scenes, especially those using mottled or textural effects achieved by washing watercolour over areas loosely rubbed with wax crayon or the stub of a candle, the surface of the paper being then further enriched by gestural use of chalk or pen and ink (Plates 34 and 36). His response to the otherworldliness of these rubble-strewn hillsides contains a tenderness and a subtle poetry, while his fascination with the effects of extreme weather and the various rock formations brought out his interest in the sublime. Because his work is culturally conceived *and* carefully observed, we find him searching for the new while fully conscious of tradition.

In the years to come, John experimented variously in front of landscape, but never with quite the same intensity and originality that he brought to the mountains in North Wales.

20

Working for the Stage
and with Britten

If we knew nothing about John Piper except his work for the stage he would still be an influential figure in the post-1945 period. He had ended the war 'with the Diaghilev bug still biting', for he had not forgotten the thrill of the *Ballets Russes*—'the excitement—the tinge of exultation—in the dancing married to modern music and modern art which worked in my blood and bones as it did for many of my generation'.[1] He was now to discover the thrill of doing a small drawing and seeing it blown up by a scene painter, skilled at interpretation. He could now satisfy, with every new commission, that which he had first experienced at the age of twelve—'the feeling for an empty stage that wanted filling'.[2]

The use of artists as stage designers was a recognized practice on the Continent, especially in France and Germany, but not so in England. By infiltrating the theatre with a painter's visual sense, John set a precedent, on which David Hockney and others could later build. He enjoyed the collaborative nature of this work and rapidly came to the fore as one of England's leading stage designers. And at the heart of this achievement sits his association with Benjamin Britten, for, from 1946 onwards, he designed all Britten's major operas, in this way helping to raise British opera as an art form to a new level.

His ability to create an imaginative terrain had been recognized in 1943, the moment the curtain rose on *The Quest*, with its tangled wood and Gothic palaces. At the time, he claimed to know little about stage design; but when Colin Anderson asked him what literature was available on this subject, he told him exactly where you could find colour reproductions of sets and costumes by

Picasso, Matisse, Rouault, Bakst, and Larionov and which shops in and around Charing Cross Road were good for books on ballet.[3]

His first opportunity to work again for the stage came in 1945 when he designed sets for *Oedipus Rex*. The costumes were by Marie-Hélène Dasté. Michel Saint-Denis directed the Old Vic Theatre Company and the production opened in October at the New (later the Alberry) Theatre. For his sets, John received a fee of £100. But when a telegram arrived summoning him for rehearsals, he tarried in Wales for he was busy renovating Pentre. 'I had great fun referring to "essential work at Liverpool" and have managed by my behaviour', he boasted to Osbert Sitwell, 'to get the first night put off a fortnight, which I think must be a triumph for a scene designer.'[4]

John was aware that the success of the *Ballets Russes* owed much to the way the artist-designers were permitted by Diaghilev to draw on their own personal styles. He himself had done the same in his backcloths for *The Quest*. But whereas this ballet had needed a more or less empty stage, *Oedipus Rex* invited the use of free-standing scenery, so, from drawings of Stowe, he extracted a few stark classical forms: a large rostrum, a portico, flights of steps and free standing statues, all offset by the kind of excitingly dramatic sky cloth that was to become one of his hallmarks. His sets, freely painted and lit with a variety of strong contrasts, made it seem as if all the action was taking place in a work of art. John Russell never forgot the 'blinding clarity' of John's set, in which Lawrence Olivier famously loosed two legendary howls, one offstage and another as he entered with blood streaming from his eyes and splattered over his hands and garments. Osbert Sitwell likewise admired this grim tale of a patricidal, incestuous king, and wrote to Myfanwy: 'I haven't enjoyed an evening in the theatre so much for many years, and as always, am under the spell of John's genius, always so powerful and congruous. And what an extraordinary play it is, like Stonehenge or some stone-age wonder.'[5]

In 1939 there had been talk of John doing designs for a new *Don Giovanni* at Glyndebourne, the opera house which John Christie had set up in the grounds of his home in East Sussex with the encouragement of his wife, Audrey Mildmay, a soprano who had sung with the Carl Rosa touring company.[6] However, owing to the deteriorating political situation, all new productions in 1939 were embargoed. Six years later, Rudolf Bing, Glyndebourne's General Manager, tried again to engage John, in a production of *Carmen* for the 1946 Glyndebourne Festival. A couple of meetings took place, at one of which John met the producer Carl Ebert and agreed to send drawings to Ebert at his home in Turkey, for approval. But once again the project collapsed as it proved impossibly difficult, in the immediate aftermath of war, to obtain the necessary travel

permits to bring singers to England. Instead, Bing began to turn his mind to home-grown talent. He promised to honour John's initial fee and remained keen to involve him in the 1947 Festival.

True to his word, in January 1946, he asked John for his reactions to Ronald Duncan's synopsis for *The Rape of Lucretia,* a new opera by Benjamin Britten. This led to more detailed discussions, Bing confirming that scenery and costumes would be needed by the first week of June, which meant that designs had to be in the hands of the contractors by mid-March, giving John two months to work on his ideas after consultation with the producer Eric Crozier and with Britten. John asked if a meeting with these two could be arranged soon and if he could be informed of Britten's and Crozier's whereabouts.[7] The following month he received from Bing stage plans of Glyndebourne and the theatres at Manchester, Liverpool, Edinburgh, and Glasgow, as it was hoped that *The Rape of Lucretia* would tour. A complete typescript of the libretto arrived in February and this same month Britten and Peter Pears stayed with the Pipers at Fawley, while giving a concert in Henley-on-Thames.

Having previously worked together for the Group Theatre, Britten and Piper were familiar with the ideal of unity stemming from a close collaboration between playwright or composer, producer, designer, and cast. Their creative partnership built on this. And as it developed, John recognized in Britten a 'restrainedly violent character', which, he added, was 'a type I've always liked',[8] perhaps recognizing in it an aspect of himself. He was also aware that Britten's *Peter Grimes* had redefined the landscape of opera. And so, in March 1946, when he accepted a fee of £150 for his work on *Lucretia*, he embarked on what Donald Mitchell has called 'one of the most influential and productive of professional and personal relationships'.[9]

Its success owed much to John's versatility, his ability to adapt his style or ideas to the opera or ballet in question, whilst always working in a vein recognizably his own. His flexibility mirrored Britten's approach to opera: when quizzed in 1946 about his changeableness, the composer replied that he saw no reason to 'lock myself inside a purely personal idiom, I write in the manner best suited to the words, theme, or dramatic situation which I happen to be handling.'[10] What did remain constant in Britten's operas were certain themes. A concert tour which he and Yehudi Menuhin had made of German concentration camps, soon after the launch of *Peter Grimes*, not only reinforced his pacifism but proved to be an experience that coloured everything he subsequently wrote.[11] Despite the success of *Peter Grimes*, its production had proved difficult. The decision to reopen the Sadler's Wells Theatre with a new opera in a strange

idiom had not been welcomed, and back-stage, an atmosphere of disharmony had prevailed. Yet in the course of *Grimes*, there gathered around Britten talented individuals, among them Crozier, the tenor Peter Pears, and the soprano Joan Cross. This left him keen to devise operas on a more intimate scale and with greater control and the idea arose of an independent company which would commission new work and each year perform for a season, in London, the provinces, and on the Continent. In December 1945, Crozier took this idea to Bing at Glyndebourne, together with the promises he had already received of financial support from Leonard and Dorothy Elmhirst, the owners of Dartington, and from the Arts Council, as some £10,000 was needed for capital investment. Owing to the problems Bing was having with singers from abroad, he agreed to promote this venture and the 'Glyndebourne English Opera Company' came into existence, with John Christie taking overall financial responsibility for the first season. Bing pressed on Britten the young Kathleen Ferrier, whom he wanted to bring to Glyndebourne for the title role, as well as the Swiss conductor Ernest Ansermet.

The Rape of Lucretia, with which Glyndebourne reopened in 1946, involved only eight singers and twelve soloist musicians—a string quintet, wind quintet, harp, and percussion. The Greek chorus was confined to two singers, one male and one female. The story is that of the famous legend: Lucretia's husband, Collatinus, at a soldier's camp, extols his wife's virtue and purity, and Tarquinius, the son of the Etruscan King who rules over the Romans, is so incensed by this boasting that he rides out to Collatinus's house at night and rapes Lucretia, who, stricken with shame sends a message to her husband, and, on his arrival, publicly exposes Tarquinius's crime before committing suicide. The libretto, supplied by Ronald Duncan, was based on an amalgam of sources, the principal one being André Obey's play *Le Viol de Lucrece*, and the opera was premiered on 12 July 1946. It ran, with two alternating casts (Kathleen Ferrier and Nancy Evans playing Lucretia) for fourteen performances before moving to London.

Britten had begun this work before John was brought in as designer, but his preference, which became more insistent over time, was to know what would be happening on stage before he began to compose. (In turn, John would object that he could not begin to design a set until he knew what the music was going to sound like.[12]) Having written incidental music in the mid-1930s for the Group Theatre and for the GPO Film Unit, Britten knew how to achieve dramatic effects with limited resources and how to convey both overt and covert messages, all things that stood him in good stead when writing opera. Above all, it had given him experience of everyone working together in close

contact from the start. As a result, *Lucretia* represented a genuine experiment in the making of opera, even if the collaborative ideal was, as yet, imperfectly achieved.

John's designs again favoured textural effects. Hans Schneider, who assisted with the costumes, found in a Leicester factory a hoard of cream-coloured pure jersey silk from which all were made and dyed by the John Lewis Partnership. The robes of the Male and Female Chorus were enlivened with multicoloured loose hatching, for it had been agreed that these two figures, in their role as observers and commentators, would occupy a permanent fore-stage and remain present throughout. The colours of their robes, therefore, had to set the visual key for the rest of the scenery. John welcomed the continuous presence of the Chorus on stage as they reduced its width, and, in larger theatres or opera houses, helped reinforce the intimacy of the drama. He also began, with Crozier's encouragement, making small models of the actual sets and these delighted Britten: 'I cannot say how pleased and excited I was. ... I think they are absolutely masterly.'[13]

Some of his designs may have preceded the music, but, overall, John's conceptions show careful attention to the musical ideas: in the first scene, for instance, the brooding sense of stifling heat conveyed by the music was intensified by his storm-laden background and brilliantly illuminated scarlet tents (Plate 37). He strove to avoid anything too naturalistic, thereby avoiding the superfluity which had marred Kenneth Green's sets for *Peter Grimes*. At John's request, Willi Soukop was commissioned to make the freely modelled dancing statues that ornamented the arcading in the hall of Lucretia's house, the inspiration for which had come from D. H. Lawrence's *Etruscan Places* (1932) in which the ease, naturalness, and abundance of life in Etruscan tomb decoration is praised. The house appears twice, in Act I, Scene 2, where part of the arcade is enclosed, and again, after the rape, in Act II, Scene 2, where the arcading is fully open and flooded with early morning sun (Plate 38). Here John used a vivid primrose yellow sky to convey the freshness and relief that follows a storm. But when *Lucretia* moved to Covent Garden, he was away, and in his absence the primrose sky was replaced by the kind of vulgar blue associated with musical comedies.

His initial designs were almost finished when, in April 1946, he received new material from Britten. An Epilogue had been added and an Interlude between Scenes 1 and 2 in Act II. Britten, it seems, was worried by the moral ambiguity left by Lucretia's suicide. His new passages introduced Christian themes and a redemptive interpretation that unequivocally equates Lucretia's suffering and death with Christ's Crucifixion.[14] These passages were criticized at the time

and continue to arouse controversy.[15] But when Crozier suggested a drop curtain for the Interlude, John immediately recognized that the Christian moral needed a scenic equivalent (Plate 39). He brooded on this at length in North Wales, and solved the problem by incorporating into his design allusions to thirteenth- and fourteenth-century images of Christ in Majesty, such as that found in a tympanum at Vézelay, and by using echoes of the colours that had appeared in previous scenes. He wanted the kind of simplicity and intensity that is found in stained glass, and which he hoped would equate with Britten's music.

Throughout the opera he tried to align colour with meaning, in order to further the visual and emotional unity of the opera. The colours in the hatching on the robes worn by the Male and Female Chorus resolved into a muted brown, so that, when silent, they could merge with the background, becoming as static as the statues in the arcades. Not so the other characters:

> About the colours of the other costumes Crozier and I had few doubts. Collatinus, we said, must be red, like the generals' tent in which he is first disclosed—a good, positive, constant red that would proclaim itself in a dim or strong light. Junius, the trouble-provoker, should have a pictorially trouble-provoking pink; Tarquinius a scurrilous, blue-bottle greenish blue. Lucretia, before the rape, must be in white; and the bedroom, we said, should be—partly, at any rate—in a disturbing purple, and after the rape Lucretia should be coloured by this purple of the bedroom until her death. Her servants, being subordinate, should have some of their scene-colour in their clothes, and their yellows seemed to heighten Lucretia's whiteness and to acidify her (later) purpleness.[16]

Critical reactions to the opera were mixed. Ernest Newman, in *The Sunday Times*, disliked the 'pseudo-poetic purple patches' in Ronald Duncan's libretto.[17] Cecil Gray in the *Observer*, however, thought the libretto 'an ingenious and effective mixture of disparate elements', and that the composer had likewise played with incongruous styles: 'at one moment writing like Stravinsky, at another like Puccini; now like Bach, then like Mozart, and so on.' Gray was, however, unambiguously in favour of 'the superb sets designed by John Piper, who here shows himself to be in the first rank of contemporary stage designers.'[18] In the drab post-war period, John's colours had a startling eloquence. *The Times* praised the sets as 'simple in design and rich in effect',[19] while the *Manchester Guardian* called them 'sombre and handsome'.[20] Desmond Shawe-Taylor, in the *New Statesman and Nation*, admired their contribution to the dramatic tension. Strange, he remarked, 'that we should have had to wait all

this time to see a stage decorated by so evidently a dramatic painter!'[21] Equally unforgettable, in Moran Caplat's opinion, was the impressive hand-dyed dress which Myfanwy wore on the first night.[22]

The rule at Glyndebourne was that productions were made on the spot and everyone involved had to live either in the house or nearby. John and Myfanwy stayed with Peggy Angus and her two children, at 'Furlongs', a cottage she had rented at Beddingham, near the foot of the South Downs. It proved a timely visit for Peggy's marriage to Jim Richards had recently ended, leaving her feeling 'hopeless and ready to die'. [23] John mended the fireplace in one room and encouraged Peggy to paint again, himself recording the Seven Sisters cliffs. He also went off daily to Glyndebourne on a pushbike and expressed dislike of all the fuss there. Nevertheless, he was proud of *Lucretia* and willingly redrew some of the costume designs for the lavishly illustrated book on the opera published in 1948. The previous year, Leigh Ashton, Director of the Victoria & Albert Museum, had made it known that, if the model for Lucretia's House survived, the Museum would like to have it. 'I am always fairly suspicious of works that I see have been "given" to museums by artists themselves,' John replied to the curator James Laver,[24] but after visiting a display of theatre models in the museum, he donated it. ('It will indeed be in honourable company.')[25]

After playing at Glyndebourne and in London, *Lucretia* toured the provinces for three to four weeks and then went on a short tour of the Continent, eighty-three performances being given in its first season. John could not get to the opening at Manchester as both Edward and Clarissa had measles and high temperatures. Bing urged him to make the Edinburgh performance, because he wanted to hold a meeting there with Britten, Crozier, Ebert, and Duncan. The Pipers were at Pentre in Wales. Knowing this, Bing insisted that if he could not make Edinburgh, he must make a meeting in London on the 16–17 August. John replied:

> No; I can come neither to Edinburgh nor to London until the end of September. I believe the only way to design reasonably for the stage is not to think about it *all* year round, but to try and improve oneself as a painter and use the fruits of the improvement (if any) on the stage—not too often.
>
> I should adore to work with you all again, but if a meeting is *essential* before the end of September, then I cannot. But surely it isn't?
>
> Do try and believe that what I say about this is sensible, if trying.[26]

A handwritten note followed, repeating the above but in a more accommodating tone. He tells Bing that, owing to his need to do some continuous work as a painter, he has just turned down an invitation to do a job at Covent

Garden; he expresses the hope that they will work together again, but also states that he cannot afford to do so if his fee remains the same. He also insists that if Hans Schneider works again on the costumes, he must be acknowledged in the programme.[27]

While *Lucretia* was in production, John Christie's reactions had been so enthusiastic that he had invited Britten and Duncan to conceive of a second opera, to be premiered at Glyndebourne the following year.[28] The understanding was that Carl Ebert, Glyndebourne's artistic director, would be its producer. Various ideas were discussed, including Joan Cross's suggestion of a 'comedy of manners' based on Jane Austen's *Mansfield Park*. Ronald Duncan began work on a libretto and Britten showed Ebert a copy of *Brighton Aquatints*, in order to convince him that John should do the designs. However, though both Cross and Britten were keen to see Austen's elegant urbanity translated into musical drama, the idea fizzled out.

Meanwhile, difficulties between Britten and Christie began to emerge. The 'Eton Schoolmaster and upper-class eccentric turned opera house-proprietor'[29] soon revealed himself to be wholly out of sympathy with what Britten was trying to achieve. His attempts to impose Ebert on the 'Britten-Group' had been resented, and in turn, Ebert complained to Bing that there was no place for him in this 'All-British' group which, he said, cared more for nationality than for quality.[30] Then Christie performed a sudden volte-face: he called everyone together after the dress rehearsal of *Lucretia* and announced that the opera was 'absurd and inadequate, and the music incomprehensible'.[31] He criticized the sets and costumes, evidently wanting precisely the kind of detailed realism John sought to avoid, for he complained that the arches in *Lucretia's* house lacked reveals.[32] *Lucretia*, it seems, was far from his taste, for he preferred opera grounded in the grand Continental tradition and sung in foreign languages, not a chamber opera that grew out of a sensitivity to the English language. A few weeks later Christie further complained that the tour of *Lucretia* had been a financial failure and he disliked Glyndebourne's name being used by a touring company in theatres ill-equipped and where performances suffered. A parting of the ways had become inevitable and, in October 1946, Britten and Crozier sent Christie a letter announcing their intention to set up a non-profit-making opera company of their own. Christie was thanked for the courageous and vital part he had played in helping to crystallize their ideas. If he wished it, both the new opera and a revival of *Lucretia* could be staged at Glyndebourne the following year, but the new company would retain control over administration and artistic direction and the right to cater for audiences wherever they could be found.

In this way the English Opera Group (EOG) came into being in 1947, with a board of directors chaired by the Countess of Cranbrook, and with Britten, Crozier, and Piper as its three artistic directors. It drew on a core of loyal supporters, singers, and musicians, among them Joan Cross, who resigned her role as director of the Sadler's Wells Opera Company to give this venture her full support. It was predicated on the belief that English artistic life was impoverished by the lack of native opera, and that the best way to address this problem was to establish a repertory of chamber operas requiring limited resources but which could be played in large or small opera houses. The intention was to mount an annual season in which contemporary English operas would be combined with revivals of certain classical works, including masques by Purcell and others. The EOG would encourage young composers to write for the operatic stage and poets and playwrights to tackle the problem of writing libretti in collaboration with composers. The financial problems faced by this new company were acute. The Arts Council, which had given a £3,000 grant towards the production of *Lucretia*, came forward with another £3,000 for the new opera, and a further £2,000 came from a private subscriber (Dorothy Elmhirst), but in all, this year, a total sum of £12,000 was needed to provide the EOG with working capital. Despite this, work on a new opera was soon underway.

The Rape of Lucretia showed John just how time-consuming the theatre could be. In September 1946, he turned down an invitation from the producer John Moody to design *Otello*, explaining that he could not 'take on more than one designing job a year, at most. I must paint.'[33] He had first met Moody through the Group Theatre and greatly admired his work. In time, they were to work together on *Simone Boccanegra* and *The Pearl Fishers*.

In the autumn of 1946 Eric Crozier gave Britten a Penguin edition of Guy de Maupassant's *Boule de Suif* with the suggestion that the last story, 'Le Rosier de Madame Husson', set in Normandy, might make an excellent companion-piece to *The Rape of Lucretia* and would also provide splendid parts for Joan Cross and Peter Pears. Britten took to the idea and before long it was agreed to translate, not just the story, but also the setting and characters so that everything could be English. 'And', as Crozier remarked, 'England for us meant Suffolk.'[34]

Britten now dropped Duncan as his librettist and asked Crozier to work on a draft. The comedy unfolds after Lady Billows offers a prize of £25, as an encouragement to virtue, to a 'May Queen'. When no suitably chaste girl can be found, Albert Herring, a young greengrocer who works in his mother's shop, is crowned 'May King' at a village fete and when called on to make a

speech can only stammer and hiccough in reply. But afterwards, overhearing Sid and Nancy discussing his domination by his mother, he disappears for a night on the razzle. After his wreath is found crushed in the road and his death is assumed, a mourning threnody is sung. In the original story Maupassant's hero disappears for a week of debauchery and never reforms (eventually dying of *delirium tremens*). Crozier's Albert, however, returns after only one night and, encouraged by Sid and Nancy, gives his Mum and the local worthies a cursory rebuff.

Crozier sent his initial draft to the Pipers. John replied:

> M and I find this libretto absolutely brilliant—both of us, after careful read-ing and prolonged thought, as well as on a rapid judgement.
>
> Lady B's speech especially good and Sid and N's 'your hand in my pocket' wonderful—but it is all so good that really I have nothing to say against it or about it. I wish I knew more about unattached libretto-reading. Because as I am I find this the most efficient and exciting libretto ever written, and I suppose that isn't reasonable! And yet I know not why not.
>
> One note only: last verse of Albert on Sid (Act 2 Scene 2), you can't *aim* at a target with *tenacity*, I think: metaphors in last two lines of verse might be reversed
>
> > 'trades ontenacity
> > Aims at......audacity'
>
> But it's a very minor point.[35]

Crozier had in mind, for the setting of this opera, an area he called Britten's country, around Ufford, Orford, Iken, and Snape. The name Albert Herring was taken from a grocer at Tunstall, while John adapted the name Loxford from Yoxford, which is on the road from Snape to Peasenhall. He wandered a little further for one of his backdrops, producing a capriccio based on Wood-bridge which incorporated its Dutch-gabled Shire Hall, its Jubilee pump, and some of its churches. Because the opera explores the conflict between Albert's inner needs and outward social oppression, Loxford becomes a place where parochial attitudes breed fear of life and change, and where, perhaps, Britten could explore the anxieties surrounding his own sexuality.

Again, John made models for all the sets, for Mrs Herrring's shop, Lady Billow's house, and the inside of the marquee. They were conceived in a very different style to *Lucretia*, being gaily but not fussily realistic, for, whether designing for a comedy or tragedy, John disliked any too lavish display of scenery or too much clutter on stage. Instead he preferred a succinct use of prop or detail. (His role model in this was Picasso, whose stage designs, for

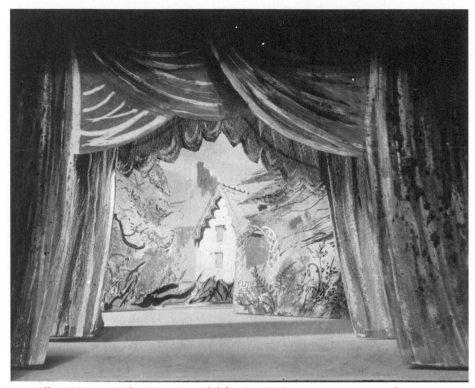

51. *Albert Herring*, John Piper's model for Act II, Scene 1, vicarage garden.

him, embodied Jean Cocteau's remark: 'I want to write a play for dogs, and I have got my scenery. The curtain goes up on a bone.'[36]) As always, John readily handed over his designs to the scene painters, placing his confidence in their professional expertise and powers of translation.

Designed for the specialized forces of the new English Opera Group, *Albert Herring* was scored for 12 singers and 13 players and premiered at Glynde-bourne on 20 June 1947. A short season was also planned for the Royal Opera House, Covent Garden, with a provincial tour and two Continental music festivals (Amsterdam and Lucerne) also in mind. The producer, Frederick Ashton, who had stepped in when Ebert backed out, had interpreted the story in the spirit of burlesque, making the characters all slightly ludicrous. Crozier had objected to this, wanting them played straight and at one point Ashton had prepared to withdraw from the production, but the cast protested. His interpretation was well received at the dress rehearsal as there was a great deal of laughter. But aside from the fun offered, it was John's sets, Crozier's libretto,

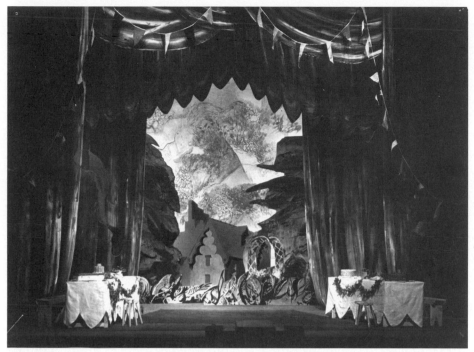

52. *Albert Herring*, Act II, Scene 1, vicarage garden with tables.

and Britten's music that made it sensational. Norman Scarfe has instanced the villagers' lines

> It was took on the Pier at Felixstowe
> When Dad was alive, in a studio—

as the kind of deceptively prosaic stuff which Britten had set to music of 'breathtakingly fluent sophistication and beauty.'[37] Not all the critics agreed. 'An expense of spirit in a waste of brittle giggling—I could not see much more in *Albert Herring* than that,' wrote Martin Cooper in *The Spectator*.[38] Again, John's sets were praised: Desmond Shawe-Taylor greatly enjoying their 'stylised late-Victorian profusion'.[39] But critical reaction to the opera as a whole was mixed. The *Telegraph* critic, Richard Cappell thought it amounted to no more than a snigger. Frank Howes, the renowned music critic for *The Times*, dismissed it as 'a charade' and suggested that, in choosing to write for a small orchestra, Brittten was wasting his time and advancing up a blind alley.

But the Britten–Piper collaboration had once again been a success, as was confirmed by an exchange of gifts. Crozier collected sufficient donations to

commission from John an oil painting based on his drop curtain for the opera. On the night that *Herring* was premiered at Glyndebourne, the painting was presented to Britten on stage, during the dinner interval.[40] At around the same time, Britten gifted John with the score of *Albert Herring*, the three acts separately bound and inscribed: 'For dear John P. with affectionate admiration—lots of it—and everlasting thanks for his great work on Albert Herring. June 20, 1947, Benjamin B.' It seems that Britten recognized in John a sensitivity to texture and nuance that matched his own and that the two men took mutual pleasure in each other's work, John once saying that Britten's music had sounded right to him the first moment he heard a few phrases played. To another, he said of Britten: 'I've never known anyone who left me so much alone on the job or was a better supporter when it was finished.'[41] In all, he was to work on eight operas and one ballet with Britten.

In 1948, when the English Opera Group printed a new leaflet, it bore a Piper cover. It could now boast that Britten's three operas, *Peter Grimes*, *Lucretia*, and *Albert Herring* had placed England 'in the front rank of opera-producing countries'.[42] That year the Arts Council increased its grant for a version of *The Beggar's Opera*, re-scored by Britten and produced by Tyrone Guthrie. Guthrie called in a young actor to assist him with the direction, thus introducing to the EOG Basil Coleman, who went on to direct the first productions of *Billy Budd*, *Gloriana*, and *The Turn of the Screw*.

The previous year the EOG had taken *Herring* on tour to Holland and Switzerland. Owing to the expense of touring singers, sets, musicians, and instruments, the company lost, in the course of twelve performances, £3,000. On the journey home it had been suggested that the Group would do better if it established a festival of its own. As Britten had recently moved into Aldeburgh, a small seaside town on the Suffolk coast, taking Crag House where he worked in an upstairs room looking out onto the sea, this area was proposed. Britten acted on this suggestion, gaining support from the Mayor and the county set, and in 1948, the first Aldeburgh Festival of Music and the Arts (as it was then called) took place. (Neither then, nor later, did anyone express concern that fifty per cent of the Festival's catchment area was covered by the North Sea.)

John was supportive of the Festival but in the early years a little removed from it. The first opened with a performance of *Albert Herring* in the Jubilee Hall, for which he adapted the sets as all the scenery had to be modular, portable, and not more than 12 feet high. But at the same time he was involved with designs for the ballet *Job* at the Royal Opera House. Like others, he loaned a small sum of money to the EOG to help cover its essential annual

costs; and he also toured East Anglia, collecting pictures for the Festival exhibition, 'Contemporary Paintings of East Anglian Artists', held in Alde House, off Church Hill. But when the Festival Committee decided to produce an annual programme book, containing articles relevant to the Festival, East Anglia, art, music, literature, topography, history, or distinguished figures associated within the region, John again had to qualify his support:

> I would do anything, with the greatest pleasure, for the Festival programme that I can do *from here*, but I have such a bout of work on that I cannot move, even for a day. (I am awfully pleased not to have had to go even to London lately!)
>
> If anything is possible (in the way of abstract design, or writing from existing information or imagination!) I will do it, but I must build up a stock of enough paintings to feed all our clamouring mouths. Suzannah's is especially clamouring at present.[43]

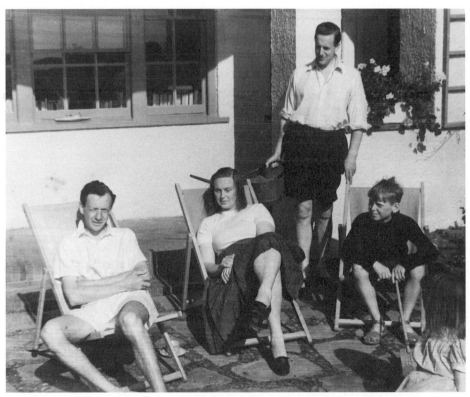

53. Benjamin Britten, Myfanwy, Peter Pears, Edward and Clarissa at Crag House, Aldeburgh, c.1947.

On seeing the first programme book, he recognized the amount of work that had gone into it and praised it highly. He also felt frustrated that work, bad weather, and minor illnesses within the family had kept him at a distance from Festival affairs this first summer. 'By being selfish,' he admitted to Crozier, 'I have done quite a lot of painting, and got around *Job* without too much heartburning.'[44] But even at a remove from the first Aldeburgh Festival, he recognized that it would become 'a permanent and important English Institution'.[45]

In the years to come, he and Myfanwy became regular attenders of the Festival, and, when not staying with Britten at Crag House, and later the Red House, made use of the Wentworth Hotel for accommodation and for meals. As the Festival went from strength to strength, so too did the EOG. After only seven seasons, it had given nearly 550 performances—in Switzerland, Holland, Belgium, Scandinavia, and Germany, as well as in many towns and at many festivals in Britain. And by then, it was looking forward to the première of *The Turn of the Screw*, at the Venice Biennale in September 1954, the opera today widely regarded as one of Britten's greatest achievements.

21

'A firm shape among shadows'

John's insistence that 'the only way to design reasonably for the stage', as he told Bing, 'is not to think about it *all* the year round' affirms his determination to hold fast to his vocation, as painter and writer. Going places remained essential to his creativity. The late 1940s and early 1950s found him painting at Dungeness, Portland Bill, and other places, while at the same time he developed a particular fascination with Jacobean and Georgian church monuments. His capacious sympathies and alert eye inform a letter he wrote to John Russell in December 1947, after a two-day visit to Cambridge.[1] There he found certain celebrities (George 'Dadie' Rylands, Noel Annan, and Michael Oakeshott) in fighting form '(though not an eye among them: or was that mere self-comfort?)'. E. M. Forster, he noticed, 'comes and goes like an old bat, sometimes hanging up, and sometimes not there (and his door always ajar)'. He attended a candle-lit carol service in King's College Chapel, and, with his insatiable visual curiosity, searched out the Morris tiles in Queen's College, the Norwich Union Insurance Company building (in neo-baroque style by G. L. Skipper, since demolished), Rickmann's New Court at St John's (a Gothic Revival building which John thought 'underrated'), and H. M. Brock, an elderly topographical illustrator living in Cambridge.

His own spare frame caught the attention of many. David Piper once described John's facial expression in repose as 'austere, even severe'. But he went on:

> The smile, however, when it comes is astonishing as spring sunshine, and the atmospherics are those of modesty informed by an unconscious but real authority; of a gentleness and courtesy that nevertheless sheath a purpose of steel. Flexible, tempered steel, certainly not rigid iron, though also, I suspect, susceptible to some arrogance despite the modesty.[2]

It was a description that Myfanwy recognized and acknowledged.[3]

Always on his return home there were numerous small tasks to do. 'We have both been very wrapped up in work and Fawley Bottom life,' John once apologized to Crozier, when he and Myfanwy, through sheer oversight, missed an English Opera Group party.[4] After the birth of Sebastian in 1950, there were four children in their care, a responsibility that lightened when the elder two became weekly boarders (Edward at Lancing, a famous High Anglican school on the Sussex Downs, and Clarissa first at Wycombe, then at Oakdene, both in Buckinghamshire). Nevertheless, John had to earn enough to pay school fees, to keep everyone fed, the house and garden in good order, and visitors happy.

In September 1947, he had spent a month with Osbert Sitwell at Montegufoni, the hill of the screech owls in Tuscany, some 19 kilometres from Florence. Here, in 1909, Sir George Sitwell had found an ancient fortress which he had bought in the name of his elder son, though Osbert, then aged seventeen, did not see the Castello for another three years. Nor could he claim his rights on it until after his father's death in 1943, and by then it had become a refuge for some of Italy's most famous works of art, including Botticelli's *Birth of Venus*. His first return to Montegufoni after the war was in 1947, in John's company. A large and sprawling building, in which the medieval mingled with the Baroque, the Castello offered John many subjects, with its chapel housing a large collection of saints' relics (Plate 40), its shell-lined seventeenth-century grotto ornamented with statuary, its great courtyard and salone. Everywhere he looked there seemed to be something to delight the eye, and he enjoyed the terracotta walls, the decor of the rooms, even the combination of grandeur and rusticity that penetrated the lavatories and bathrooms as well as everywhere else, in what he called a 'homey' way. He captured the Castello's decorative encrustations with brio and exuberance. Some of its aspects reappeared later that year in the dust jacket he designed for Evelyn Waugh's novel *Scott-King's Modern Europe*.

While in Italy, John fell in with Osbert's routine. Both men worked all day and then went for a tramp through the vineyards, talking endlessly. He who, on the whole, disliked parties, did not mind the absence of society and initially enjoyed the reclusive life ('nice, too, not to be rung up by the British Council and asked to lecture').[5] But after three weeks he wrote:

> Myfanwy dearest, do please try, for the remaining time, to write a little more often, if only PCs. Life here is very lonely and only tolerable thus. In 3 days I shall have been here 3 weeks, and have only had 2 letters, one of which was very late being under-stamped and 1 postcard to say it was understamped. I know writing and posting to be difficult, and posts incalculable, but at least

every other day would help. Night and night the post comes with no news of England at all, or you or Suzannah or E[dward] or C[larissa]. I am sorry to grumble, but do have a heart.[6]

At home, Myfanwy sometimes acted as a buffer between him and the children, for he could be sharp. He was at his best when the children took him on his own terms, helped mix his paint, and joined him in making marbled papers in the bath. Energy flowed through him like electricity. When painting or drawing he worked at speed and with astonishing technical control in a variety of media. He could shoot rabbits on the run with a Home Guard pistol, as the local farmer Pat Cheriton attests, or dismantle a car engine without fuss, for he was adept at many things. To his friends it was obvious that he never stopped working. Even so, he sometimes hankered after the privileges associated with a previous age.

> How nice it would be if we could all—say, for a year—lead the life that G. E. Street,[7] or some other late Victorian architect, led as to everything except work. Getting up at 6, with brass cans of hot water to greet one and cups of Victorian tea, followed by an hour's correspondence before a decent meat breakfast, then proceeding to the day's work without a thought of shopping or rationing or washing up. Myfanwy & I have been complaining a lot lately that we are not Victorian architects, sunk in a well ordered, rich, selfish, stately, opinionated, creative life. But we aren't, and the difference is the difference between Millais and Ben Nicholson, or Mrs Humphry Ward & Mrs Humphrey Spender.[8]

One outcome of the late 1940s was the small book on Reynolds Stone which Myfanwy began writing in 1948, when Suzannah was a year old. It was published by Art and Technics in 1951 and earned her £50.[9] Polished into limpid clarity, her essay neatly encompasses Stone's career to date, his apprenticeship as a printer under Walter Lewis at Cambridge University Press, the influence on him of Stanley Morison, his friendship with Eric Gill, and his decision to become a full-time wood-engraver. 'It was', she writes, 'the one thing that could combine his positive talent for neat, microscopic workmanship, his instinct for elegance, and his desire for the rich flowering of an artist.'[10] Stone is then positioned within the history of wood-engraving and linked with Bewick, owing to the fact that both used 'white' and 'black' lines in their fine handling of rural subjects.[11] As always, Myfanwy's prose contains sharp asides: Gill's legacy of taste to the Church, she notes, 'has been used to advocate a prim and false

medievalism that can be worse than the vulgarity it replaces.'[12] Osbert Sitwell rightly declared the book a gem.

It is also a testament to friendship. During the war, Reynolds, with his diffident, gentle, and fastidious nature, regularly visited Fawley Bottom while making models for the RAF photo-interpretation unit at Medmenham. After the war he and his wife, Janet, whom he had married in 1938, became lifelong friends of the Pipers, for though Reynolds was by nature reclusive, a lover of trees rather than people, his wife was not. A descendant of Elizabeth Fry, the prison reformer, and brought up in an ecclesiastical family, the daughter of the Bishop of Lichfield, Janet Stone, with her social curiosity, zest for life, her handsome appearance and stylish dress (her wide-brimmed hats were often veiled to protect her delicate skin), became renowned as a hostess in the old-fashioned style. In 1953 the Stones settled at Litton Cheney, in Dorset, where Reynolds added letter-cutting to his skills and Janet organized picnic outings to Chesil Beach or lunch in the arbour, her guests also enjoying fires in the bedroom and books read aloud in the evenings. Her skill as a photographer produced two memorable portraits of John and Myfanwy, later published in her book *Thinking Faces* (1988). If the Pipers and Stones both shared a creative approach to life, they were also linked in other ways, Janet becoming godmother to Suzannah Piper, Myfanwy, godmother to Emma Stone, also taking an especial interest in her sister Phillida.

Myfanwy's soundness was valued by many. In the winter of 1947–8, Jock Murray, who was preparing for publication Betjeman's *Selected Poems*, sought her opinion on John Sparrow's introduction. A friend of the poet, also a barrister and Oxford don, Sparrow had written a deliberately provocative piece. Myfanwy especially disliked his suggestion that Betjeman had made 'fashionable' Victorian Gothic. She insisted: 'it wasn't a question of creating a *taste* for Gothick or anything else that J.B. makes fashionable because he, J.B. is really, not just fashionably, in love with his subjects and that love is greater than taste.' Some of Sparrow's remarks seemed to her a gift to Betjeman's critics. His observation that 'satire is not his *forte*' because Betjeman lacked the gift of indignation she refuted. In her view: 'J.B. doesn't satirize things because he doesn't hate them: what he does satirize is the absence of love which he does savagely.'[13] It was an acute riposte. Betjeman, when shown her letter, wrote: 'I always knew you were a *clever* girl, but pondering over what you said about Spuzbury's [Sparrow's] Preface, I am enthralled to find that you are not merely clever but profound.'[14]

A few years later she helped Betjeman select essays and talks about architecture for his book *First and Last Loves* (1952). The title was also her invention.

Illustrated with a pull-out lithograph of Cheltenham by John and illustrations by him of Nonconformist chapels, the book further testifies to the deep affection that bound the Pipers and John Betjeman.

With the Shell Guides on hold and their future uncertain, the two Johns were keen to find an alternative outlet for their topographical interests. Back in 1943 Piper had begun chivvying Jock Murray with the suggestion that he should revive the *Murray Guides*. Originated by John Murray III (1808–92), the son of Byron's publisher, John Murray II (1778–1843), these red-covered handbooks for travellers had been discontinued since the First World War. John loved these compendiums of topographical and pertinent information and encouraged his friends to collect them. He himself had taken one on his first visit to north Wales in 1943. Immediately before this trip, he, Betjeman, and Murray had met to discuss what form a new guide should take. John followed up the proposal eagerly:

> The cover will have to [be] altered, and I would suggest that the whole thing hangs round a distinctively-lettered title, as does *Blackwood's* and *The Motor*, and as doesn't *Everybody's* and the *Architectural Review* It all depends on how much or how little it is to look like *Horizon* and other unimportant upstarts. I think you would probably design a better cover than I would, but could it not be done together, with a 1827 Figgins typebook which I will bring? Who is to print it? Or did I ask you that and did you say R.& R. Clark or Billings of Guildford?[15]

Murray agreed to a trial run: three counties—Buckinghamshire, Berkshire, and Lancashire—would be revised in an up-to-date format under the generic title *Murray Architectural Guides*.[16] John fought hard, with no success, for more attention to scenery than this title suggests.[17] He nevertheless buckled down, working with Betjeman on *Buckinghamshire* and astonishing Murray with the manuscript they produced. 'The Bucks glossary is a stupendous work! I am full of admiration for your energy and learning!'[18]

At this stage, all were unaware that the idea for a similar project had occurred to a young lecturer from Göttingen University who, on his first visit to England in 1930, had felt the lack of an architectural guide comparable with George Dehio's Handbücher series. Shortly after settling in England for good, in 1935, he had taken this idea to Cambridge University Press which declined to get involved with guidebooks. Not until 1945 was Nikolaus Pevsner able to return to this idea, now with the support of the publisher Allen Lane, and this same year a schedule was drawn up for a county-by-county architectural

guide to the buildings of England. Pevsner, in conversation with Murray, established a gentleman's agreement to keep away from the three counties under revision. But he kept an eye on their progress, and when *Buckinghamshire* was published, wrote again, asking for confirmation that *Lancashire* and *Berkshire* would follow. Nothing by him, he assured Murray in turn, was to be published immediately: Pevsner, now a lecturer in history of art at Birkbeck, was reckoning on two years preliminary research before setting out on a tour of Middlesex in connection with what would become the first of forty-six volumes entitled 'The Buildings of England'.

Betjeman and Piper would have been aware of the challenge that Pevsner presented. In 1942 he had published his *Outline of European Architecture*, which had ended with an attack on the lack of serious study of English architecture and a comment—'in England what attention is paid to Victorian buildings and design is still, with a very few exceptions, of the whimsical variety'—which has been taken as a glancing attack on Betjeman's want of academic standards.[19] At the same time the book's confident grasp of the history of Western European architecture had gained Pevsner a position of leadership among architectural historians.

The advancing shadow of Pevsner may explain the burst of energy and erudition which Betjeman and Piper poured into *Buckinghamshire* and *Berkshire*. Compared with the Shell Guides, these Murray volumes register a wider range of buildings, with more detail and greater attention to building types and materials. They had the benefit of a preliminary survey, done by Marcus Whiffen, who also wrote captions for the illustrations to *Buckinghamshire*. These John polished up, telling Murray:

> I have been through the captions with a great deal of care and find them on the whole 1st class. Style exactly right, and I don't agree with J.S. [John Sparrow] that too much erudition is demanded. Everyone is getting so much better educated that they will criticize if some erudition is *not* demanded? And otherwise they would read like the captions in the weekly sketch.[20]

However, he would not permit the octagonal church at Hartwell, his favourite building in the entire county,[21] to be labelled an 'engaging oddity', and he filtered out a few clichés. One of John's captions for an elaborate Victorian villa—'It is one of a group called "The Seven Deadly Sins" by those who think decoration immoral'—has been praised by Timothy Mowl for neatly running 'a spear of common sense not only through Pevsner but also through the entire dreary history of Puritan simplicity in English art.'[22] Occasionally John corrected Betjeman. 'Scott I should think', wrote Betjeman of Coleshill church,

in the notebook they shared. 'No, Street,' Piper added. It was also John who noted in Cookham church a mural tablet by Flaxman (1810) to Sir Isaac Pococke, showing him being 'suddenly called from this world to a better state whilst on the Thames, near his own home'.

Though Betjeman and Piper had some happy finds, for instance, uncovering information on the architect Edward Swinfen Harris from a manuscript in his grandson's possession, their chief strength was not original research. Rather, it was what both authors now had in abundance—a depth of knowledge, range of experience, perceptiveness, and wit, which could turn some entries into a virtuosi display of fact, opinion, and anecdote. The best example is Piper's eulogy on Berkshire's unlovely Reading. It begins:

> This, the capital of the county, is a much maligned town. Too many people see it only from the railway and dismiss it as a modern place as they glide past a china orchard of electric transformers, the gay colours of Sutton's seed beds, Huntley & Palmer's biscuit factory and the castellated red-brick gaol (1833) where Oscar Wilde languished. Motorists horrified by the hideous villa-dom along the road from London after Waterer's Floral Mile, infuriated by the long traffic wait at the Grecian Cemetery gates (H. Briant, 1842) with Doric chapels among the tombs, are too upset to notice the noble lines of late Georgian terraces along the London Road. They only recover in time to see the curious curve of villas on the by-pass to the Bath Road. Even shoppers along Broad Street and Oxford Road, now the main shopping streets of the town, can hardly fail to be startled by McIlroy's fantastic building designed at the beginning of this century by Mr Frank Morris, an affair of stepped gables and corbelled balconies in red and yellow glazed bricks and granite all resting, apparently, on two tall storeys of plate glass. It was Mr Frank Morris who designed in yellow terra-cotta the even more amazing Pearl Assurance buildings in Station Road. His hand may be seen in the new streets that run from Broad Street to the station. ... Eventually, he became a follower of the Rev. J. H. Smyth-Piggott and quitted Reading with his family to take up residence in 'The Abode of Love' in Somerset.
>
> Thus with its railwayside industrialism, its miles of hard red suburbs and the weird commercial architecture at its centre, Reading at a superficial glance seems hideous. Yet the space between the London Road on the south and the railway on the north is full of decent architecture as befits the capital of a county. It is mostly Georgian and early Victorian. No town in the south of England hides its attractions more successfully from the visitor.[23]

The stance is typical of the two Johns, mingling scholarship with quirky information. Still keen to provide not only facts but also their reactions to

buildings, towns, and villages, Betjeman and Piper announced: 'We believe that houses and churches do, and should, inspire love and hate, and that it is worth while recording the reactions of two observers, instead of making a cold catalogue.'[24] But Betjeman's whimsical interest in the unloved and obscure, combined with John's capacity to find visual interest wherever his eye rests, can lead to excess. The entry on Windsor town tells us that 'the smaller inns in the side streets are brick, with well-dusted and revered trophies of military exploits, and sets of cigarette cards showing uniforms or service medals are framed, along with portraits of the Royal Family, on the walls.'[25] More justifiable, perhaps, is the touch of melodrama in the description of the elaborate Mausoleum to the Prince Consort at Frogmore: 'The Queen's grief still sobs through its interior as though she had left her sorrow on earth to haunt this rich, forbidding temple to her loneliness.'[26]

Though Pevsner did not entirely exclude personal opinion, his policy was to avoid any opening comment of admiration or denigration that would colour the facts. He shared Betjeman and Piper's desire to promote Victorian design and architecture, but he differs markedly from them in that his focus was on buildings, as objects in themselves, and not on their relation to the environment. And yet, if Pevsner stimulated in Betjeman and Piper greater scholarship, they, in turn, may have influenced Pevsner's Buildings of England. The Murray guides were innovative in their use of short essays on building types and decoration particular to the county, on Romanesque, early Gothic, brasses, pre-Victorian painted glass, medieval stone carvings and medieval woodwork, early Gothic revival, classic revival, and so on, in a manner that Pevsner was to adopt.

The first three volumes in the Buildings of England series appeared in 1951. Pevsner held off Berkshire until 1966, and, even then, his entry on Reading is so dry that it merely confirms the town's reputation for dreariness. In recent years, with the revision of the Pevsner Guides, as the Buildings of England series is now called, there has been a certain change in tone which permits more use of comment and opinion. And there is a nicely ironic admission, in the 1993 *Pevsner Guide* to *Buckinghamshire*, that 'the most enjoyable guide to the buildings of Buckinghamshire is still Betjeman and Piper's *Murray's Buckinghamshire Architectural Guide* (London, 1948).'

Photography is a major ingredient in both the Murray and Shell Guides. A third of the photographic illustrations in *Buckinghamshire* were taken by John, and in *Berkshire* 135 of the 170 photographs are, the authors tell us, 'by ourselves', that is, mostly by John but with Betjeman giving advice on point of

view or lighting and sometimes even taking hold of the camera himself. And in the *Shell Guide to Shropshire* almost the full complement of illustrations are by 'the authors'. They took pains to find the right angle or view of any building and to photograph it at the best time of day. In a notebook which they shared on Berkshire,[27] the words 'morning shot' can be found beside information on certain churches or buildings. They also devised a colour code: yellow for morning shot, blue for 'any time', and red for evening shot.

John now wanted his own darkroom, in order to have greater control over the developing and printing of his photography, and to be less at the mercy of commercial printers. This was not possible at Fawley Bottom Farmhouse, which still had no electricity, so Sherman Stonor offered him the use of an old bathroom above the stables at Stonor which was to remain his darkroom for some ten years. John wrote excitedly to Murray: 'I have bought a GRAND new enlarger, and have installed the same in a grand ENLARGING ROOM at Stonor Park with a 150 watt lamp and all proper devices. ... Much look forward to seeing you soon.' (He was also pleased to report that the reference in *Buckinghamshire* to a Georgian pulpit in the church at Newton Blossomville had prevented its replacement by a new one.[28])

Everything seemed propitious for the success of the Murray Architectural Guides. *Berkshire* appeared the same year as John's *Buildings and Prospects* which affirmed his authority as an arbiter of taste. But sadly, after the publication of the third of these Murray Architectural Guides—Peter Fleetwood-Hesketh's *Lancashire*—the series collapsed. 'One lays down this guide with gratitude', wrote the reviewer of *Buckinghamshire* in *The Listener*, 'for the richness and depth of this county which a book of this kind reveals.' But they did not please everyone. Raymond Mortimer (John's bête noire), reviewing *Berkshire*, regretted the absence of quotations from histories, poems, and novels concerning the places described ('I like to see the querulousness of Smollett set beside the gush of Symonds'). His prejudices were still more apparent when he broached the subject of the authors' taste:

> Messrs Betjeman and Piper are themselves ringleaders in the newest architectural vogue. They are connoisseurs in Baptist Chapels; they revel in the vagaries of Victorian Gothic; nor does their enjoyment falter even in front of the riverside residencies of the Boer War period, upon which white-painted balconies, oriels, gables and cupolas jostle one another so obstreperously ... sometimes I am filled with avuncular alarm by their unbridled appetite for the polychrome brickwork, Purbeck pulpits, alabaster reredoses, encaustic tiles and stained glass, whether violent or insipid, on mid-Victorian churches. ... Messrs Betjeman and Piper are insular in their standards and

sometimes in their missionary enthusiasm confuse the curious or the 'amusing' with the beautiful.[29]

Though Murray had been generous with the number of illustrations, the format of the books is somewhat clumsy and unbalanced; the sharp division between the lavish section of well-captioned photographic plates and the gazetteer, meanly printed on less good paper, makes for a lack of integration. John's dust jacket, with its casual mix of collage, drawing, and lettering, is recognizably his, yet lacks popular appeal. And Timothy Mowl rightly points out that the gazetteer in *Buckinghamshire* is dull in places.[30] The introduction stresses the need to capture the individuality of each county, but does so in words that lack force.

In the long view, neither the Shell Guides nor the Murray Architectural Guides can compare with the monument to scholarship that Pevsner achieved. The problem was not any lack of enthusiasm or knowledge; at proof stage

54. Cover Design for the *Murray Architectural Guide to Berkshire*.

with both *Buckinghamshire* and *Berkshire*, Betjeman and Piper had assistance from Howard Colvin, a Fellow of St John's College, Oxford, who had worked at Medmenham during the war and been introduced to the Pipers by Stuart Piggott. He not only became a lasting friend of the Pipers but also one of the most distinguished architectural historians of his day. But Pevsner's dry acknowledgement of his sources, his referencing of lists compiled by the Ministry of Housing and Local Government, his use, from the start, of two German refugee research assistants, his structured information and Germanic thoroughness—all made Betjeman and Piper seem, by comparison, amateurs.

It did not help that Murray, who had been generous with the number of illustrations, charged a high price for his three guides: at 18s a copy they were considerably more expensive than the pre-war Shell Guides, which had sold at 3s 6d, as did Pevsner's Buildings of England volumes when they began to appear in 1951. For Piper and Betjeman it was some consolation that in this same year the long-shelved *Shell Guide to Shropshire* finally appeared, Shell having established a partnership with the publisher Faber and Faber. This marked the onset of a further stream of Shell Guides, some thirty new volumes and many revised editions appearing over the next twenty-seven years. Betjeman remained the chief editor, a role he began sharing with John in 1962, both upholding the stance outlined in *Shropshire*: 'We have mentioned, usually, when a village has been affected by new houses, pylons, gas works, reservoirs, main roads and conifers. And particularly we have remarked on previously unnoticed examples of good Georgian, Victorian and even Edwardian architecture and planning.'

Though both men resented the position that Pevsner had seized and the method he employed, it was Betjeman, not John, who attacked him publicly, notably in his review of the Durham volume in the *Times Literary Supplement* in 1953. He resented Pevsner's reliance on information that others provided and the slips that occasionally got in. In addition, as Mowl points out, Betjeman thought that Pevsner's inventory approach to churches represented a kind of blasphemy that it was his duty to attack.[31] In years to come, Betjeman never altered his belief that the eye and heart must be in use as much as the brain. When in the mid-1960s Juliet Smith began work on the *Shell Guide to Northamptonshire*, Betjeman told her: 'It is no good trying to write a comprehensive, impersonal catalogue. That is already being done in Pevsner's *Buildings of England*, and does not tell you what the place is really like … it is eye and heart that are the surest guides.'[32] Many others agreed. When Alec Clifton-Taylor, the architectural historian, journalist, lecturer, and close friend

of Pevsner for some forty years, was interviewed on *Desert Island Discs* and asked which book he would take with him if castaway, he chose, not Buildings of England, but a complete set of Shell Guides.

The decision to exclude a sense of place from the Murray guides had disappointed John. No such limitation mars his *Romney Marsh* (1950), one in a distinctive series of books, commissioned (ironically) by Pevsner in the late 1940s, in his part-time role as literary editor of King Penguins. These charming little picture books were closely related to the Insel Verlag publications which had been popular in Germany since the beginning of the twentieth century. Aimed at the popular market, they have nowadays become collector's items.

John had first visited Romney Marsh as a teenager on a camping holiday. He would have crossed it repeatedly when as a young man he rented Rose Cottage on Rye Harbour as a weekend retreat. He had also gone back to Dungeness on several occasions: in January 1946, he and Myfanwy spent a fortnight exploring the Marsh, staying at Hythe and Rye, and they often returned to it as a place for recuperation. Yet to the average visitor, this flat, uneventful, and seemingly nondescript landscape—marshland which has been drained and ordered and turned into pasture for grazing sheep—lacks any obvious picturesque or dramatic appeal. But, at odd moments, it reminded Henry James of the Roman Campagna, and its spreading light, its sense of remoteness and distant history combine to give it a special poetry which John caught in both words and images.

He was acutely aware that, in this landscape, you are seldom out of sight of a church, though many are hidden behind screens of trees. Some are very ancient and contain unusual features, but as a group they are perhaps most remarkable for their setting, Fairfield church, for instance, being situated in the middle of a field. John made these churches the dominant feature of his book. His brief, gazetteer-like texts are informed by a painter's sensibility. Of Old Romney Church, he writes:

> An irregular buttressed structure in fields neighboured by a large dark yew, which enhances the beauty of the warm yellows and browns of the lichen on the pale umber and silver stonework and shingled spire. The structure is largely of the thirteenth century. The interior is one of the best and least spoiled Georgian interiors in the country, giving an excellent idea of what a village church was like a hundred and fifty years ago.[33]

Some years later, in 1981, when Romney Marsh Historic Churches Trust was founded, the painter John Doyle persuaded John to do further paintings of

Romney Marsh churches so that, in all, ten of his paintings could be turned into postcards and sold in aid of the Trust, Myfanwy giving the plates to Doyle after her husband's death. Doyle also recalls John telling him how he and Betjeman had once walked from Dungeness to Littlestone, making a record of all the names given to the retirement homes en route.

In *Romney Marsh* John once again balances nostalgia for the past with a keen awareness of the present. The small book is dedicated to Osbert and Karen Lancaster, perhaps because Osbert's approach, his accretative blend of social and architectural observation, is here employed of Dymchurch.

> It has found the new character of seaside surburbanism, which is too easily despised, and which is the commonest seaside character in England today. The radio shops, the Tudor teahouse with stained beams, 1930 inglenook, and uncut lawn at the back; the antique shops, the restored pubs, the double-decker bus service, the headlights on the tarmac and the constant sound of distant wireless, all are there. So are the relics of the past—just enough to distinguish it from a coast village in Lincolnshire or West Sussex—the restored, tiled Kent church, the weather-boarding and tile-hanging of the older cottages, showing between the pollarded trees. And on each side stretch suburbs, strung out thinly under the sea wall or on the level of the beach, looking jaunty but afraid of the breakers, temporarily shattered by war, waiting for the rare peace and sun and summer.[34]

Romney Marsh and the Murray Architectural Guides deepened further John's love of churches, church monuments, and stained glass. The notebook on Berkshire, which he shared with Betjeman, testifies to his affection for West Hendred—'the ideal village church with its plastered walls, symmetrical arcades, old glass fragments … lovingly leaded into old-fashioned window glazing, and seventeenth-century font cover',[35] and to his regret over Shrivenham: 'The interior, despite many beautiful furnishing and monuments, disappoints because the walls have been stripped of their plaster and repointed with cement, and too much money in about 1900 was spent cutting down box-pews, altering the woodwork and displaying heating pipes'.[36] It was he, too, who hated the glass in the east and west windows at Buckland: 'The lowest possible ebb of rich taste responsible for E window … w window AWFUL colourful 1923 job.'

Similar feelings animate the drawings of church interiors which he did for Betjeman's slim volume, *Poems in the Porch* (1953), as well as the discussions which both men had, amid much laughter, while Betjeman was compiling the *Collins Guide to English Parish Churches*. Ever afterwards, John regarded Betjeman's introduction to this book as his very best piece of prose.[37]

The involvement with churches brought him friendships with men of the cloth, among them Moelwyn Merchant who, while lecturing in English at University College, Cardiff, wrote programmes on contemporary art for Welsh radio and television.[38] After commissioning from John in 1946 his article for *Cymry'r Groes*, Merchant began receiving invitations to John's private views. In 1946, he attended one at the Leicester Galleries, and concluded that the Tate trustees must have met that afternoon as a great many of them and other eminent figures in the art world were present, including Philip Hendy, director of the National Gallery. That night Merchant was taken back to Fawley Bottom where he slept on a bed in the studio. He woke to find himself surrounded by forty or fifty of John's pictures, and realized, more strongly than he had done in the show the previous day, the impact of their intense vitality.[39]

At Rupert Hart-Davis's suggestion, John and Moelwyn agreed to undertake an illustrated edition of Wordsworth's *Guide to the Lakes*. In the autumn of 1950 they explored the area together. John, though knowledgeable about art and literature, adopted a slightly belligerent attitude towards the Lakes, finding the scenery much less to his taste than north Wales. Rather unusually, he made Merchant do the homework. Each night Moelwyn read up eighteenth- and early nineteenth-century guides, and in the morning was quizzed by John. 'Who painted here? Who lived here? What poems were written here?' Merchant later realized that the artist's 'curiosity was integral to the drawing; the traditions informed and shaped the technique'.[40] Watching John at work, Merchant saw him stop out parts of the paper with a sharpened candle or greasy crayon, then wash over it with diluted ink. Next he drew swiftly on top of this or added bits of collage. He was astonished to see John dip his thumb into a water-filled knot-hole in a bench, then press it into the still wet Indian ink and proceed to spread foliage over naked branches. When Merchant exclaimed at this, John replied, 'Ah, you should see the effects I get with butter!'[41]

Echoes from his earlier work resurfaced in John's art. Memories of Renishaw and Montegufoni are replayed in the lithographic illustrations which, in 1949, he made for the Dropmore Press's reissue of Sir George Sitwell's book *On the Making of Gardens*. In Moelwyn Merchant's edition of *Wordsworth's Guide to the Lakes* (1951), he revived the use of sheet music in the collage he made of Wray Castle, Windermere, one of the six mixed-media drawings found in this book.

In December 1948, it came as a relief when his exhibition of recent work at the Leicester Galleries proved a success. Earlier that year his former ally Geoffrey Grigson had suddenly attacked him, denigrating his work in 'Authentic and False in the New "Romanticism"' in *Horizon*. The cause of his venom may have been John's association with the Sitwells, whom Grigson loathed, as well

as his recent success. 'Piper regrets, but does not destroy,'[42] Grigson remarks
witheringly, alluding to a vein of nostalgia in John's work which is compared,
to his detriment, with the romanticism of Graham Sutherland. Very different
was Philip Hendy's interpretation of John's work at the Leicester Galleries.
For him the paintings were 'fresh and real', and the artist 'an extraordinary
master of technical effects'.[43] He recognized in John 'a scholarly painter' and
pronounced him 'the leading watercolourist of the day'. Such high regard from
an establishment figure like Hendy would have contributed to the offer, in
1949, of a CBE. 'Reluctantly,' John replied (with some help from Betjeman) to
the Private Secretary,

> I must refuse the honour for which the Prime Minister has in mind. This
> refusal is not made out of disrespect to the Order which the Prime Minister
> proposes to recommend for me to His Majesty, nor out of any lack of recog-
> nition of the kindness that prompted it. My feeling is that my own develop-
> ment as a painter will be best helped by my remaining as independent as
> possible and by foregoing the too comforting sense of personal achievement
> that such an honour would confer.[44]

There followed an extremely busy period. Over the next three years, he was
rarely without a commission for stage design. He exhibited at the Whitechapel
Art Gallery in London, at Birmingham, in 1950, in 'Six Contemporary British
Painters', and under the aegis of the British Council. He held two further major
shows at the Leicester Galleries, in 1951 and 1952, titling the first 'Stones and
Flowers' because of the predominance of pictures of vases of flowers beside
carved fonts. Here too could be seen his oil pairing the Rowlestone Tympanum (a
photograph of which hung in his studio) with a hanging lamp. These are striking,
high-keyed pictures, but they are less original than some of his 1940s work. John,
himself, noticed at this time that his topographical interests were no longer to the
fore in his paintings. In both his shows at the Leicester Galleries transcriptions of
Old Masters were included. After a lengthy period of working for the stage, he
had turned to these as a way of regaining confidence in painting.[45]

His reputation, however, was still high. It was noted that the thirty-one oils
and watercolours in his 1952 show were all sold or spoken for soon after the
exhibition opened.[46] Some reviewers, nevertheless, thought his subject matter
lacked surprise. His attention had snagged on the idiosyncratic (a village pump,
a lime kiln), landscapes, churches, and fonts (again with large vases of flowers
nearby) and everywhere he revealed a sharp and knowing eye. But it was his
colours that drew more comment, the swatches of bright yellow and bone white
against russet and black, the dark planes against which fiery pinwheels of yellow,

white, and red stood out. S. J. Woods claims that when John was painting ruins, he listened a lot to Tchaikovsky, in order to achieve 'a romantic abandon that barely avoided the melodramatic'.[47] This may or may not be true as later, in 1983, when he took part in *Desert Island Discs*, he said that, though he listened to music a lot, doing so while working was too distracting. Nevertheless, a change in his palette in the early 1950s may relate to a change in his musical taste. And around this time he developed an obsession with the music of Rachmaninov. Rather hesitantly, he mentioned this composer's name to Britten. 'Ah, there's a great composer,' came the reply, after which he never looked back and bought all the Rachmaninov records that he could find. What is certain, however, is that, in his painting, the darkly brooding wartime mood was a thing of the past, and the motivation behind his choice of subject and style was less clear.

John Russell, reviewing John's 1952 exhibition, looked for the effects of his 'long vagabondage in the world of the theatre'. If he was preparing the reader for adverse remarks, they did not follow. He found no dispersal of attention in John's work, noting instead that 'the grand preoccupations have not altered' and the handling of paint was as brilliant and emphatic as ever. Only in his closing remarks is there a hint of equivocation: 'The note of chamber-music is rarer in these pictures; the excitement is that of oratory, rather than of conversation; but it is a real excitement, and Mr Piper is a real painter, a firm shape among shadows.'[48]

John was by now master of many styles. While admiring the dun colours of Romney Marsh, he was also painting five panels, in high-key colour, for an ambassador's private dining room in a new embassy designed by Robert Prentice in Rio de Janiero. On learning that the room was to be furnished in Regency style, he based his designs on Regency architecture, mixing lively reminiscences of Brighton, Cheltenham, and Bath with an apposite degree of abstraction (Plates 41 and 42). Each panel was five by seven feet in size and painted on canvas. In November 1949, before travelling to Rio, they were shown at the Victoria & Albert Museum where their pale yellows, richly offset with orange, magenta, and blue, glowed like stained glass. According to one critic: 'Mr Piper's hot colour—brilliant yellow façades and undulating balconies have every appearance of fantastic stage settings from a land of architectural make-believe.'[49] The panels remained in their setting until the early 1970s when the British Embassy moved, with the capital of Brazil, to Brazilia. His panels were then returned to London, to become part of the Government Art Collection. (At the time of writing, three of the panels hang in the British ambassador's residence in Washington, DC, and the other two in the British ambassador's residence in Brussels.)

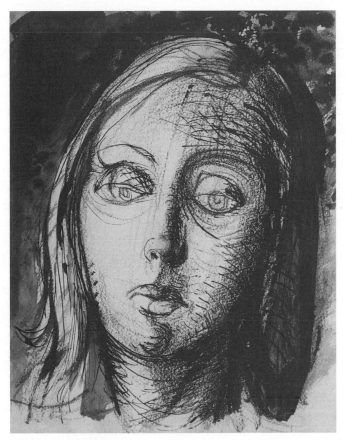

55. Head of Myfanwy Piper, charcoal, pen, brush and ink, 34 × 28 cm (private collection).

Different again is the enormous architectural panorama which John painted on laminated board, supplied by a contractor to Fawley Bottom, with help from a young woman called Joy Mills, in a more demotic style, to hang as a mural outside the Homes and Gardens pavilion on London's South Bank during the 1951 Festival of Britain.[50] This national event celebrated Britain's victory in the war as well as its cultural and industrial achievement. But it was also intended to cheer a ration-weary populace. Celebrations took place all over the country but the focus was primarily on London's South Bank and the thirty-seven acres within Battersea Park allocated by London County Council for the creation of a Fun Fair and Festival Gardens. Russell Page designed the Gardens, and a Grand Vista was created at a slight slant from the river.[51] John Piper and Osbert Lancaster were invited to ornament the site with fantastical architectural structures in a mixture of styles—Brighton Regency, Gothic,

and Chinese, together with ornamental bowers and figures, the latter made by Ursula Earle and seemingly drawn in the air, but in fact made out of bent cane, all of which were intended to remind visitors of London's eighteenth-century pleasure gardens, Vauxhall, Ranelagh, and Cremorne.

It is hard to be precise with this project as to who did what. The Festival Catalogue credited the two men with 'the Grand Vista including Entrance Towers, Arcades, Rotundas, Tea Houses, Lakes and Fern House'. When interviewed for 'A Tonic to the Nation', a 1976 exhibition that looked back at the festival of Britain, John remembered that the LCC would not allow them the Fern House though they did devise a cane screen (behind which fireworks were to be let off) based on the façade of the 1851 Crystal Palace. He also admitted that 'bits of his [Lancaster's] ideas got incorporated into my design and vice versa'.[52] Some of Osbert's ideas were translated into models by his wife, Karen, but in the summer of 1950 the Lancasters disappeared to Italy, leaving John

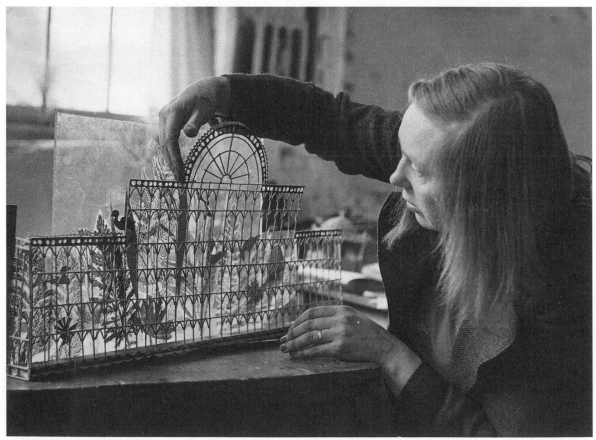

56. Myfanwy with a model for The Festival Gardens, 1951.

57. Page from *Picture Post*, 6 January 1951, showing John Piper and Osbert Lancaster at work on models for the Festival Gardens.

and Myfanwy sitting up till midnight making the rest. Their designs had to be interpreted by an architectural firm, the chief partner of which was called Dex Harrison, which John thought a marvellous name. His intention at Battersea had been to supply the crowds with a gigantic folly, heavily influenced by the architectural fantasies associated with Monsū Desiderio (a name used of two obscure French painters working in Naples in the seventeenth century whose identities became conflated) to which John had been introduced by Osbert Sitwell. He was proudest of the two Romantic Gothic towers, painted crimson, ochre, and black and made out of bamboo, plywood, and tubular steel, which framed the steps that led into the Piazza from the landing stage, where many visitors arrived by boat from the South Bank. Further on were colon-

nades designed by Osbert Lancaster, who also suggested the fountains for the ornamental canal—soon turned off as stallholders complained that spray from them damaged their goods. Models for all these fantastical structures were made in the studio at Fawley Bottom. When recreated full size, these phantasmagorical constructions gave visitors to the Festival Gardens the impression that they had entered a theatrical set.

The making of these Gardens was troubled by financial problems and foul weather and, as a result, they opened three weeks late. It continued to rain heavily, the pound was devalued, and the Korean War broke out, but the Festival proved a success, with some 8,500,000 people visiting the South Bank and almost as many the Gardens. If the Battersea project brought Lancaster and Piper a vast audience, they were also now linked in the theatrical world, for, earlier that year, John had recommended Osbert as a designer to John Cranko, the choreographer who had invented the comic ballet *Pineapple Poll*, based on W. S. Gilbert's *The Bumboat Woman's story*. Music was selected and arranged from Sir Arthur Sullivan by Charles Mackerras, and this combination of Gilbert and Sullivan with Lancaster's designs—a very English mixture—made *Pineapple Poll* a huge hit, with the result that Lancaster's sets remained in use for the next forty years. 'The scenery and costumes', Myfanwy averred, 'were exactly right: clear, absurd, bright. It was a success because it was perfect of its kind and left no loose ends.'[53] But it was the mercurial Johnny Cranko who had masterminded this entertainment. He now moved firmly into the centre of the Pipers' circle, stimulating John to further inventions for the stage.

22

Cranko and Britten

John Cranko had arrived in England from South Africa in 1947. Not yet twenty, he knew no one, except a young dancer from Cape Town in the Sadler's Wells Theatre Company. 'But he knew exactly what he wanted and why he had come,' wrote Myfanwy, six years later, in a profile of Cranko for the music review, *Tempo*: 'He intended to be a choreographer and wanted to work, to that end, as a dancer in a first class company.'[1] As a precocious youth, he had, at the age of fifteen, created a new version of Stravinsky's *The Soldier's Tale* for the Cape Town University Ballet. At Sadler's Wells, his interest in choreography was encouraged by Ninette de Valois, who gave him an introduction to John Piper. They met in 1949, in connection with Cranko's first major ballet, *Sea Change*. The South African was very aware that John had been the talk of last year's season, with his designs for *Job* and the sets he had produced for John Moody's *Simone Boccanegra*.

The simple scenario of *Sea Change* had been inspired by a holiday at Cassis, the small fishing village in the south of France. The ballet begins with fishermen bidding farewell to their families as they set out on a night's work. A storm occurs and the women wait anxiously on the quay. The boat returns but one of the crew has been lost and his young pregnant wife weeps inconsolably. John agreed to design the sets, and, with the minimum of means, evoked the environment of the fishing community, using touches of strong red, black, and blue to offset a backcloth full of romantic gloom. It was unintrusive, yet had a brooding quality and a beauty in its own right. De Valois invited Tyrone Guthrie to work out a lighting plot. His solution for the night scene brilliantly heightened the dramatic tension, for the waiting women were illuminated by the slowly turning beam of a lighthouse. The ballet was premiered in Dublin on 18 July 1949, then went on tour.

John discerned in Cranko, as he had done with Britten, a person whose sensibility was in tune with his own. Amusing, sharp, alert, and clear thinking, the younger John enjoyed the elder one's quirky humour and his fund of imaginative whimsy. Over the next few years the two men worked together on eight productions. Cranko, with his wide expressive eyes, lively mind, and boundless enthusiasm, soon began making visits to Fawley Bottom, often in the company of a young Australian psychiatrist who worked at the Maudsley Hospital, Frank Tait, with whom he set up house in Alderney Street, both men becoming lasting friends of the Pipers. Cranko's taste and judgement were, in Myfanwy's words, 'both penetrating and imaginative'; since arriving in England he had 'never stopped looking, listening and absorbing'. Those who met him 'were exhilarated by his ardour, his generosity and his receptiveness'. More importantly, 'he knew how to extract ideas and information from people without making them feel sucked of vitality—because he never failed to give as much as he took.'[2]

In turn, Cranko was steadied by his friendship with the Pipers; having watched his parents divorce, he found John and Myfanwy's life-style reparative. But though he achieved a fistful of successes, he never lost an inner restlessness, a *dépaysé* quality that left him prone to melancholy. Nor did he ever really feel accepted in England. In 1959, by which time he had become a friend of Princess Margaret, he was fined for 'importuning men for an immoral purpose', and though the Princess remained a friend, palace officials implied he was unsavoury. This may have contributed to his decision in the early 1960s to move to Stuttgart where he was idolized.

Soon after *Sea Change*, John put everything in abeyance in order to spend ten days designing and painting scenery for a pantomime, at the request of Captain Pullein-Thompson, a strong supporter of the Kenton Theatre at Henley-on-Thames. Then, in the summer of 1950, when up to his neck in work for the Festival of Britain Gardens, preparing for an exhibition in America, and doing a book jacket for the story of Hafod, *Peacocks in Paradise*, John, and Myfanwy (again pregnant), allowed the Henley parish church pageant to take 'days out of, if not *off*, our lives'.[3] The pantomime had proved great fun. 'I enjoyed it madly,' John afterwards told Osbert Sitwell, 'I did it for experience, in order not to be bullied by people in the professional theatre, who will never believe that painters working on scenery know what they are talking about.'[4] He also made a new friend: walking into the auditorium one day he called out to a figure on the stage, dressed in dungarees and wearing a hat, who was painting a set. 'Oh! I thought you were a boy!' he said, when an attractive young woman replied.

After this, Joy Mills became his assistant with major projects; his 1951 *Don Giovanni*, his Festival Gardens models, and his Festival of Britain mural, which the two of them painted in sections in the courtyard at Fawley Bottom. Joy's father had been a great handyman, and, as a child, she had enjoyed being his sidekick, so was able and ready to undertake a variety of tasks. When John first met her, she was recovering from the trauma of a miscarriage and her marriage was on the rocks. He invited her to live at Fawley Bottom Farmhouse, which she did for a period. Present when Sebastian was born, she became his godmother. She was also aware that John found her very attractive, and that Myfanwy knew this. One attraction for him was the fact that Joy sang in the church choir at St Mary's, Henley. 'What fascinated me about you,' he told her, 'was that you were churchy.'[5] She eventually left and married for a second time, again disastrously. Alone in Sussex with a son, who was barely two, Joy received a letter from Myfanwy, urging her return to Henley and adding that she had found her somewhere to live. So Joy Mills returned to Henley, which thereafter she never left. Many years later she observed that 'Myfanwy was a very wise woman.'[6]

John had a knack for turning disaster to his advantage. While *Sea Change* had been in rehearsal at the Theatre Royal, Hanley, the building had gone up in flames, and this gave him an idea for his next set design. He devised for Cranko's *Harlequin in April*, a ballet commissioned for the Festival of Britain with music by Richard Arnell, a burnt-out proscenium arch with tattered curtains to frame the dancers and behind it, a 'sky of hope'. The theme of this ballet was the search for perfect love and the inevitable frustration this brings. 'April is the cruellest month,' T. S. Eliot reminds us, and the first ten lines from his *The Waste Land* preface Cranko's synopsis, though he later claimed the ballet bore no relation to the poem. After Harlequin is reborn, rising from blindfold plant-like forms, he is given his multicoloured coat and magic bat, by Pierrot, a comic character, and realizes his full strength. A unicorn, the traditional guardian of chastity, leads him to his ideal love, Columbine. When the unicorn falls asleep, he and she explore their awakened feelings. Jealous Pierrot wakes the unicorn which magically multiplies in order to protect Columbine. They carry her away, leaving an effigy in her place. The plants return and Harlequin sinks back into the earth, abandoning his magic coat. Pierrot retrieves it, and the magic bat, hoping, in vain, that their power will work for him too. Described as an 'obscure but moving allegory', the ballet was full of hints and symbols never made explicit. Instead narrative was conveyed through movement rather than any too obvious story line. John's stylized *Commedia dell'arte* costumes added a sophisticated pungency to the romantic mood, while his masks for the

58. John Piper's set for *Harlequin*.

unicorns prefigured those he would later produce for Alun Hoddinott's *What the Old Man Says is Always Right*. When first performed at Sadler's Wells on 8 May 1951, *Harlequin in April*, despite its ambiguities, was praised as a successful collaboration between choreographer, artist, and composer.[7] To celebrate the ballet's success, Myfanwy knitted Cranko a Harlequin sweater.[8]

This same year, 1951, John designed a romantic backdrop for the EOG's production of Monteverdi's sung and mimed narrative *Il Combattimento di Tancredi e Clorinda* (Plate 43), performed at the Lyric Theatre, Hammersmith; and, at the request of Moran Caplat, he produced some highly successful designs for Carl Ebert's production of *Don Giovanni* at Glyndebourne. This last commission he had originally turned down, despite the fact that it was his favourite Mozart opera, owing to pressure of work. 'I would have loved to do it but <u>must</u> not,' he told Caplat.[9] But five months later, when Oliver Messel fell out owing to illness, John changed his mind. On 17 February 1951 he signed a contract letter, agreeing to design sets and costumes for a fee of £350 plus £150 expenses. As usual, he had to accept to a schedule that included supervisory work at Glyndebourne during the rehearsal period, and also, in this instance, at Edinburgh in August. The premiere took place on 11 July

1951 and, according to Caplat, John's sets were used in all some forty-six times.[10] Changes were made to the sets and some of the costumes when the opera went back into production in 1954. John's fee for the redesign was £300.0.0, inclusive of all expenses and any payments he might make to his lighting expert. The following year, while refusing further payment, he made yet more changes for the 1955 production, and still felt there were things he could improve. His obsession with this opera also led to a statement he made in the Festival programme:

> I believe that Mozart can teach any artist who is at all open-minded ... a great deal about form. The last three symphonies, the late piano concertos, *Così fan tutte* and *Don Giovanni* leave no doubt in one's mind that some at least of Mozart's music was in a strange way pre-ordained; that it was the result of some kind of revelation of perfection rather than (like most art, good and bad) the result of man's striving for perfection. ... For me this sense of a revelation of perfection is also present in the works of Cézanne, and (in our own time) by Picasso and Braque ... it seems to me important to recognize a pre-ordained quality in the work of *some* artists of the past and the present, so that a man can recognise God working directly through other men, if not through himself. And I have always believed Mozart to be of that company.[11]

Shortly after completing *Don Giovanni*, John read Kierkegaard's *Either/Or*, the first volume of which contains an extended reflection on this opera's dramatic unity. 'I found it wonderfully good,' he told Moelwyn Merchant. 'He comes to the same conclusion as I did when I had finished the designs recently—that the opera is such a unity that it is best done without any scenery at all. Alas, he is right. Black curtains. It is only feeble theatrical conventions that make scenery for D.G. necessary at all.'[12]

As the designer, the chief challenge to the designer of this opera lies in the way the libretto calls for a great many changes of scene. John's knowledge of architecture proved a useful strength. No one knew better than he how to hint, with lightness and grace, at the pattern and rhythm within a baroque facade or a curved apse topped with classical statues. But he also carried out an ingenious sleight of hand: two large houses were designed in three dimensions with subtly false perspective and set on trucks so that they could be moved to various positions on the stage. Wherever they were placed they married with the perspective on the backcloths and it was never obvious that the same architectural units were being used several times. His costumes benefited from the beautifully coloured silks made by Nicholas (Miki) Sekers at West Cumberland Silk Mills

which Rosemary Vercoe, then wardrobe manager and later designer, turned into costumes.[13] Dramatically, the most impressive moment is said to have been the supper scene in the last act when the gigantic shadow of the Commendatore rose threateningly at the head of the central staircase. Scarlet and crimson flames appeared, as Don Giovanni disappeared into hell, and were succeeded by the grey light of dawn which heightened the effect of the final sextet.

To achieve these effects, John needed the help of a skilful lighting expert, and earlier this summer he had spotted the ideal person at Glyndebourne: after watching Michael Northen light some of Oliver Messel's sets, he had told Carl Ebert that he wanted the same man to light *Don Giovanni*. It was a shrewd request, for Northen was no mere technician but the first person in this country to earn the title 'lighting designer' and, as such, to see his name included in programmes. And the total effect of *Don Giovanni* drew much comment from the critics, *The Sunday Times* admiring the low lighting, the glowing colours, and the 'baroque luxuriance of John Piper's settings'.[14] The *Manchester Guardian* referred to 'handsome, gloomy sets',[15] while *The Times* thought they had a 'sombre magnificicence'. However, it voiced the criticism that his scenery 'had the effect of crowding the stage'.[16]

While working on *Don Giovanni*, Northen discovered that any light falling directly on John's freely painted scenery tended to destroy the atmosphere that the artist intended. He therefore decided that the scenery should be entirely lit by overspill from the acting areas. Though John followed *Don Giovanni* to Edinburgh,[17] afterwards taking a brief holiday in the Highlands before traveling to Coventry, the opera's next port of call, he simultaneously began work on another opera, Britten's *Billy Budd*. Again he involved Northen with the lighting and the making of stage models (Plate 44). Now familiar with John's lowering skies and brilliant flashes of colour, Northen went down to Fawley Bottom to see his initial designs and was taken completely by surprise. Aside from one sky cloth, intended to suggest fog, there was otherwise no hint of expressive painterliness of the kind Northen had expected. Instead John had envisaged an entirely built set, using unpainted timber and a completely black surround. Dramatically lit and offset by the brilliant blue of the sailor's costumes, it affirmed his intuitive sympathy with the theatrical idiom.

Britten had first tried to interest John in this opera in 1949, when the Arts Council commissioned it as part of the Festival of Britain (though it was not performed until after the Festival was officially over). It was to be on a bigger scale than his chamber operas, marking a return to the 'grand' operatic style of *Peter Grimes*. John, however, at first seemed unwilling to commit himself to something so far off, but Britten persisted and asked him to read the libretto

which E. M. Forster and Eric Crozier had extracted from Herman Melville's posthumously published novella, *Billy Budd, Sailor*. Britten had himself landed on this tale, possibly as a result of a new edition of the text published in 1947, which Forster had reviewed on the radio. He sent the libretto to John, adding: 'I am terribly keen to have you working with us—not only because I am always so happy with the results, but because the working together is in every way lovely.'[18] Their association was to be reinforced in the public mind when publishers and record companies began approaching Piper for cover designs for Britten's sheet music and his recordings.[19]

Although the Pipers had missed the first performance of *Peter Grimes*, they now went out of their way to hear Britten's music, journeying to Cheltenham in July 1949 to see his *Let's Make an Opera*. This determined John to take a firmer line, in his role as artistic director with the EOG, and he did so the following year, at a time when the birth of Sebastian left him unable to undertake designs for Purcell's *Dido and Aeneas*. He told Britten:

> I drop out with a twinge of regret: because to design a classical opera of some kind is one of the things I feel is most necessary for me—and would have done no harm before *Billy Budd*. Sophie F. [Fedorovitch] is the answer to the producer's prayer, but it is no use pretending that she is a feast for the eye, as a rule. She 'knows about the stage' but is not a good enough painter. And one other point—I do think the artistic directors ought to have an opportunity of making suggestions about designers before the producers put their feet down. The children's opera didn't look good enough, and I think could have looked better at the same cost (at least one stage design student at the Slade would have given his ears for the chance of doing it, and would have made a more handsome job of it). Don't let these comments worry you about Dido and Fedorovitch, too much—she'll be all right. But I think it of real importance that future works you have a hand in should look fine, and out-of-the-way, if you know what I mean. Sophie is *in*-the-way, if anyone ever was.
>
> Myfanwy and baby are flourishing and life here is back to normal more or less. A lot of fires burning and a lot of work going on. I long to hear some more of *Billy Budd*.[20]

Friendship between the two men was now so well established that Britten had become Suzannah's godfather. As the years went by, he increasingly regarded John as a trusted friend. He and Pears were slowly forming a fine picture collection which in time embraced a number of Pipers, including a watercolour of Aldeburgh church and a major oil of Clymping.[21] Britten shared John's interest in churches and together they went on church-crawling expedi-

313

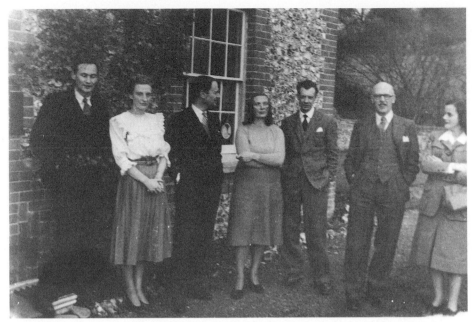

59. Suzannah Piper's christening. From left to right: Reynolds and Janet Stone, Kenneth Clark, Myfanwy, Benjamin Britten, T. D. Kendrick, Jeanne Stonor. 1948.

tions in Suffolk, in the course of which the composer would talk about the difficulties and complexities of his life. John later told Alan Blyth that he had learned much from Britten, 'not only about music, but about life, about being an artist, about integrity, about tolerance and intolerance'. He recognized that vulnerability and a need for protection lay behind Britten's habit of creating around him a close circle of associates; and though it was easy to offend him and fall foul of his code of behaviour, John never did. 'There was never any rift, or even coolness, between them,' Blyth records.[22]

'What a dear John is,' Britten wrote to Eric Crozier,[23] after the Pipers stayed with him at Crag House in August 1950. He, John, and Crozier had spent time discussing the design of *Billy Budd*, and John had bathed in the sea three times within the first twenty-four hours.

It was recognized that *Billy Budd* would be a major musical event. For this reason the magazine *Tempo* ran an issue largely devoted to the opera in the autumn of 1951, in advance of its first performance at Covent Garden in December of that year. Alongside essays on Herman Melville's *Billy Budd*, a synopsis, and an article by Crozier on the British Navy in 1797, it carried a transcript of a conversation between John and Basil Coleman, the producer, about the staging of the opera. John worked closely with Coleman who, in 1950, had been

elected an artistic director of the EOG in the wake of Crozier's resignation.[24] Both men were determined not to lose sight of the fact that the whole story is told in recollection and takes place in Captain Vere's mind. Hence Coleman's expressed desire for scenes fading in and out, to give the illusion that they had been called up by Vere. He also thought that painted sky cloths should surround the ship. John, however, suggested, perhaps with Kirkegaard in mind, that the background should be completely black, with even the floor covered in black felt so that the audience would not be troubled by the sea or the lack of it. Coleman immediately agreed ('Much more exciting and limitless'). The conversation ends with the recognition that they will 'suggest, and not portray, the sea and the ship'; they were confident that 'the absence or presence of particular details would not be noticed, so long as the shapes themselves are all intensely *ship-like*.'[25]

The extent to which they achieved their aims is questionable. John later acknowledged that, more than any other opera by Britten, *Billy Budd* needed a degree of naturalism.[26] The story is set in 1797, at a time when the British navy had begun impressing convicts and seizing merchant sailors, like Billy Budd, to serve on naval frigates. The ship therefore had to be of the right date and character. To get an idea of what the conditions were like on a man-o'-war, Piper and Coleman visited HMS *Victory* at Portsmouth and the Greenwich Maritime Museum, in Greenwich, for, however abstract their intentions, they needed concrete particulars for the two main sets, the *Indomitable*'s upper and lower decks. They started work on the latter, realizing that the problem here was how to reproduce the cramping effect of six-foot headroom yet allow the audience in all parts of the house to see the action clearly. It was solved by avoiding any ceiling and instead building the between-decks scene in open work, like the ribs of a half-built ship. For the above-deck scenes, the ship in all its essentials was simply presented, but without its structure becoming too dominant or its details too insistent. The two masts and rigging were set at an angle to the front of the stage, to give an impression of space and distance. Northen took home John's drawings and began making model sets in balsa wood, John making frequent visits to oversee their progress. The completed sets were displayed in a model theatre, with all the lighting and paraphernalia of an actual theatre, which Northen had built in a downstairs room in his house on Cheyne Walk. Seeing the models lit, and liking the colour of the balsa wood, John insisted that not a drop of paint should be used on the sets. Their stark simplicity against the black ground suited the designer and producer's abstract intent.

The restrained realism of the design gave imaginative space to the moral ambiguities inherent in this parable of good and evil. These centre upon Captain Vere's disciplinary dilemma, his duty to uphold the law and his recognition of Billy's essential innocence, for, in its use of a prologue and epilogue the libretto departs from Melville's story in order to give Vere additional focus. Britten stated: 'I think it was the quality of conflict in Vere's mind ... which attracted me to this particular subject.'[27] Claire Seymour refers to Vere as 'the opera's central consciousness, the narrator and the source of moral truth', and points out that the B-B♭ dissonance, which runs throughout the opera, first occurs in the Prologue where 'the sea embodies the eternal flux of human emotion and experience which cannot console man with unequivocal moral hierarchies.'[28]

The story begins when Billy Budd, impressed like others, arrives on board the *Indomitable*. His physical beauty, evident goodness, and eagerness to serve arouse complex feelings in the master-at-arms, John Claggart, who determines to destroy him. He tries to frame Billy and falsely accuses him of inciting mutiny. Brought before Captain Vere, Billy is hampered by his stammer and in his frustration and anger strikes out at Claggart who drops to the ground and dies. Because of the ship's proximity to the enemy, Billy must be tried at once. He is found guilty and is led off to be hung from the yardarm.

Britten's hatred of cruelty is an important ingredient in *Billy Budd*. It was also crucial for the success of the opera that Billy's goodness should shine out in contrast with the darkness in Claggart. Britten had initially wanted Geraint Evans to sing Billy Budd but the singer felt the part was too high for his voice. As no other baritone could be found who fitted Melville's description of Billy, David Webster, the Administrator at Covent Garden, held auditions in America and discovered the singer Theodore (Ted) Uppman, whose shock of blond curls and lean muscular frame (the result of hauling equipment in an aviation factory immediately before auditioning of *Budd*) gave him just the kind of unselfconscious radiance needed to convey Billy Budd's openness, eagerness, and naive trust. As with John Cranko, the Pipers took to him immediately and made lasting friendships with him and his wife Jean.

John's designs for *Budd* were so unexpected they surprised many. Christabel Aberconway sent him a letter of praise:

> From the moment when the great mast became visible, and the first scene was then revealed, I knew that you had created something of enormous symbolic beauty. The 'set' of the lower deck seemed to me to be made from the great bones of whales or some vast monster. ... The black undistracting sky was a help to the ear as well as the eye, and the symbolism of light and darkness embraced the whole story.[29]

Philip Hope Wallace, on the other hand, in *Picture Post* (December 1951) found the production 'pedestrian' and Piper's sets 'dark and claustrophobic', though the latter phrase caught exactly the effect that John was after. His decision to place a brilliantly lit set against a dark background has since become one of the stocks-in-trade among opera and theatre producers. In *Billy Budd* it assisted the creation of a hostile, oppressive, uncomfortable environment. Among the enthusiastic reviews was Winton Dean's apt comment in *Opera* that imagination had been 'brilliantly welded' to historical accuracy. John himself told Moelwyn Merchant: 'I think it is a very great modern work, and am proud to be associated with it.'[30]

In 1952 *Billy Budd* was broadcast in America on NBC-TV, in slightly condensed form, with Ted Uppman again singing the title role, and later that year the opera was premiered on stage in the USA at Indiana University. It was not revived in London until 1964, when Covent Garden mounted a new production for which Britten revised the opera into a more compact two-act version.[31] At the same time John was asked to rethink the designs. Britten now felt there had been too much shipboard detail in the 1951 production and so the sets were duly stripped and simplified. But, in 1978, a performance of *Budd* at the War Memorial Opera House in San Francisco amounted, more or less, to a reconstruction of the 1951 production, with sets that successfully replicated John's original designs. At the same time, the director, Ande Anderson, opted for an understated mood that closely reflected the tenor of the original production.

John's unrelenting work schedule began to impact on his earnings. In the financial year that ended 5 April 1951, his gross earnings came to £4,019 9s 9d.[32] Though this would be equivalent to almost £90,000 by today's standards, it was hardly the kind of fortune needed to resurrect a theatre. But early in 1952, while Michael Northen and his friend Robert Camac were staying at Fawley Bottom, John announced that he wanted to show them something in Henley. He drove to New Street, flung open the door of the Kenton Theatre, and took them inside the musty auditorium, explaining, as he did so, that he had just taken over the lease of the building, in partnership with his friend Alan Hartley, a Henley doctor. The decline of repertory companies had left the theatre unused and it was sadly neglected. Northen casually asked which contractors would be carrying out the task of renovating the theatre. 'Well, for a start there is Myfanwy,' John replied, 'then the Lancasters, Edward and Clarissa, Robert and yourself and me.'[33] And this was indeed more or less the team. Myfanwy wrote to the Arts Council Drama panel, asking for support. John redesigned and built the proscenium arch, while the rest cleaned and

repaired the auditorium and painted the dressing rooms. In the evenings all returned to Fawley Bottom for one of Myfanwy's magnificent suppers, after which John entertained them on the piano.

Once the building was redecorated, John asked Johnny Cranko to stage a dance programme. He agreed. In the summer of 1952, he invited six dancers he knew, including Kenneth MacMillan, Peter Wright, and Yvonne Cartier, to Henley during their summer vacation for a two-week season during the second half of July. The company stayed at Bosmore, the big house, then empty, near the Pipers, to which furniture was lent by local residents. In the evenings they ate there or at the Pipers', after which there was often music, anything from Mozart to Gershwin, Cole Porter, and 'Guys and Dolls'. The whole project was undertaken with very little money, the dancers helping to make their own costumes and Cranko, himself, going round the dressing rooms at Covent Garden begging for spare ballet shoes.[34] Everyone did what they could, John and Osbert Lancaster working the curtains for the performances; Cara, the Lancaster's daughter, coming down from London to act as a dresser for the dancers.

For the programme, Cranko revived three short pieces (one of which, *Beauty and the Beast*, had new designs by John), also creating two new, more substantial pieces. One was *The Forgotten Room*, set to Schubert's *Fantasia in F major* with sets by Osbert Lancaster, and the other was *Dancing*. This was a set of variations performed to records by the jazz pianist and composer George Shearing, with scenery by John. He set it in an attic room, and filled it with junk found in the theatre or in the yard outside, old ropes, a battered piano, a ladder, a broken column, and an old gramophone horn that had been lying round his studio, while the wall behind was enlivened with a few splashes of brilliant colour and Northen's lighting. John Percival recounts:

> The curtain rose on Macmillan, wandering morosely about the room and whistling. Finding a gramophone record, he put it on an antique player with a giant horn and began to dance. The music of the next record he found summoned up Hana, and the other discs brought on the rest of the cast for solos, duets, trios and a finale which sustained their exhilarating mood right through, until the end when MacMillan, alone again, departed whistling.[35]

The mood of this piece suited the informality of the event. The summer evenings made it possible for the audience, some of whom came from London, to wander out in the intervals and enjoy the character of this small riverside town. Myfanwy recollected that the 'freedom and absurd gaiety' of *Dancing* startled many ballet enthusiasts and began Cranko's interest in weaving abstract or formal variations around a story of human interest. Her description of the role Cranko had created

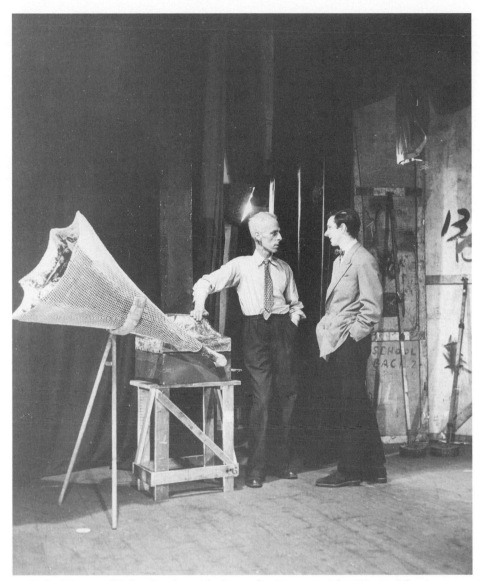

60. John Piper and John Cranko with the set for *Dancing* at the Kenton Theatre, 1952.

for MacMillan—'lonely, imaginative, a natural clown, puzzled by the appearance and disappearance of the dancers, and longing to be one of them'[36]—reveals her empathy with the choreographer's intentions. When the two-week run ended, parties were held in John's studio, which even he, a non-party man, enjoyed. To Osbert Sitwell, he wrote: 'The dancers have gone and I have been homesick

319

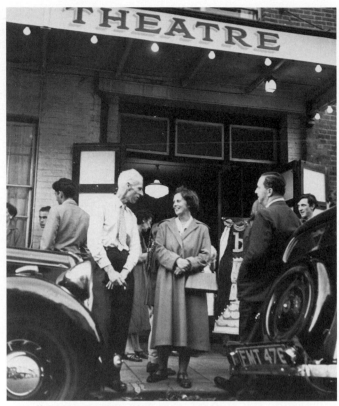

61. John Piper talking to Penelope Betjeman outside the Kenton Theatre, Henley-on-Thames.

since they left here, and we look forward to seeing them again next year. I adored working as a stage-hand every night, and learned a lot.'[37]

In the immediate aftermath they received numerous requests from people wanting to use the theatre for one reason or another. But in the long run it proved uneconomical and after two years the lease was not renewed. John Gorst, who acted as manager, some thirty-five years later reminded John that 'the financial results ... were disastrous.'[38]

The Kenton Theatre experiment did, however, deepen the Pipers' friendship with Cranko. John worked again with him, in 1953, on his ballet *The Shadow*, which was premiered at Covent Garden on 3 March 1953. Again the theme was the pursuit of love, for it showed a young man attracted to a beautiful and virginal young woman, but kept away from her by a dark menacing figure. When finally he summons up courage to attack the figure, his fears are shown to be illusory for it proves to have no substance and cloak and hat fall empty to the ground. It was the least successful of their collaborations, perhaps because,

as John Percival suggests, the music (Cranko had used Dohnányi's Suite in F sharp minor, after being persuaded that Bartok's *Music for Strings, Percussion and Celeste* was unsuitable) had an 'irrelevantly folksy flavour' and may have encouraged John's decision to evoke an unspecific milieu, 'a sort of romantic no-man's land'.[39] His designs, almost Chinese in their select use of a few details, were loosely evocative of a park, pillar, and house.

To celebrate the Coronation in 1953, the Arts Council mounted exhibitions of the work of Gainsborough, Graham Sutherland, and John Piper. This last took the form of a retrospective shown at the Arts Council Gallery in Cambridge and at the Cecil Higgins Museum in Bedford. For John, however, a more laborious contribution to this national event was his work on the scenery and costumes for Britten's opera *Gloriana*.

Based on the life of the young Queen's namesake and predecessor, it required, so Britten told the librettist William Plomer, 'lovely pageantry'[40] and included many grand scenes showing the Queen in the context of those she ruled. The focus of the opera, however, was Elizabeth's relationship with Essex, and, at Lord Harewood's suggestion, the libretto was based on Lytton Strachey's *Elizabeth and Essex*. That Britten should choose to celebrate the coronation with an opera based on Strachey's Freudian view of Elizabeth I is, as Philip Brett comments, 'surely an ambivalent act of homage and aggression'.[41] No such observation was made at the time and *Gloriana* was premiered at a Royal Opera House gala in the presence of the Queen and Prince Philip, with Joan Cross as Elizabeth, Peter Pears as Essex, and John Pritchard conducting.

John persuaded Britten and the director, Basil Coleman, that Cranko should choreograph the masque and ballroom dances in *Gloriana*. This created an awkward situation as the success of the Royal Opera House after the war had been bound up with the Sadlers Wells Ballet Company, and there was considerable resentment that an opera rather than a ballet had been chosen for this gala event. Requests for the famous ballerina, Beriosova, were repeatedly refused until Coleman and Cranko went to see Ninette de Valois. After an hour's interview, she reluctantly gave in, with the result that the dances helped lift the opera out of time and into enchantment, while also giving it a barbaric quality that seemed entirely appropriate.

Another difficulty with this huge production was that there was very little time for preparation: John and Coleman worked on each scene separately, as it arrived from the composer and only at a fairly late stage obtained an overall idea of the opera. The opening scene was made memorable with its circle of colourful tents, but equally impressive was the Norwich scene (Act II Scene 1)

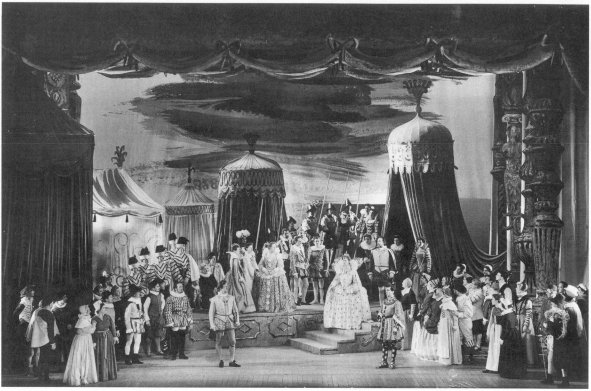

62. *Gloriana*, Act I Scene I, 1952.

which suggested that the action was taking place beneath a high canopy. It had a spring-like feel and made much use of white. Another scene, set in the garden of Essex's house in the Strand, was composed entirely of gauzes which John had painted in shades of green, using loose suggestions of leaves to suggest creeper and foliage.

The costumes ate up months of his time. Because the characters and plot are historically accurate, Coleman and Piper felt they had to go for an authentic visual impression of the period. But, in addition, the various state occasions meant that every member of the main chorus had to have three changes of costume. Further clothes had to be devised for the small chorus of ladies-in-waiting, and the Old Men and Boy's Chorus in the street scenes. On top of all this, Queen Elizabeth's own wardrobe is said to have been legendary, and each of her entries had to be spectacular. The drawings John made for individual figures give little insight into the richness of effect achieved, for when the costumes mingled in their hundreds on stage, they fused together in subtle changes of colour harmony. Auden pronounced John's sets 'superb'.[42] Eric

Blom declared in the *Observer:* 'none may ever witness anything so gorgeous at Covent Garden.'[43]

The critics floundered obtusely about the music but were unanimous in their praise of John's decor and costumes. On the opening night he received more than one standing ovation, and admiring letters came flooding in, including one from Britten: 'There is such a great noble sweep in it all, and the impact of the colour is tremendous. Especially I liked the criss-cross of green in the garden scene, and the screen at the end is a stroke of genius.'[44] Piper's designs had again been assisted by the lighting skills of Michael Northen,[45] working with Kenneth Rowell, both of whom John insisted should be acknowledged in the programme. But the huge cast and seemingly unending number of costumes left him drained of energy. After *Gloriana*, with the exception of *The Turn of the Screw*, John refused to do more costume designs and thereafter only did the sets. This division worked well for Bizet's opera *The Pearl Fishers*, which Basil Coleman produced in the spring of 1954 for the Royal Opera House, with sets by John and costumes by Walter Goetz, but the results were not always harmonious. In 1955, when John designed the sets for *The Magic Flute*, again using gauzes, Leigh Ashton noticed that the costumes seemed, by comparison, very undistinguished.

Gloriana earned Britten royal approval—on 1 June 1953, a week before the gala, he was made a Companion of Honour. At the gala performance, the opera house was decorated to the hilt by Oliver Messel, with a royal box, ornamented with a cloth of gold, specially constructed for the occasion. Nevertheless *Gloriana* was also, in Lord Harewood's words, 'one of the greatest disasters of operatic history'.[46] Though Britten had used Elizabethan music as a source of inspiration, he avoided pastiche, and, far from delivering a rumbustious celebration of Merrie England, had allowed the tragic nature of the story persistently to undercut the pageantry. The audience, many of whom were not opera-goers, became noticeably restless, and the applause, partly because of the white gloves which were then a part of evening dress, was very muted. Nevertheless, for those who listened, and especially in such places as the last scene where the Queen, torn between love and duty, grapples with despair, there could be no doubt that Britten had once again transformed opera into a vital means of dramatic utterance. It can also be argued that Britten aptly caught the mood of the day; that the darkness with which *Gloriana* ends was in keeping with the anxieties of the period, with the early phase of the Cold War and the disappointments and uncertainties that had led to the defeat of the Labour Party in 1951. In Robert Hewison's view, 'Britten was more in touch with his time than the pomp and circumstance of a Royal gala might lead us to suppose.'[47]

23

The Turn of the Screw

Adaptors have to tidy up. Creators needn't and sometimes shouldn't.

—E. M. Forster[1]

'I am re-reading the *Screw* with great enjoyment and getting lots of ideas, so *do come.*' Benjamin Britten's invitation to Myfanwy, on 11 May 1952,[2] marks the start of one of the most remarkable collaborations in the history of opera. Yet when she embarked on a libretto based on Henry James's *The Turn of the Screw*, she had no experience in this field and faced a seemingly impossible task. Patricia Howard rightly remarks: 'To transfer to the operatic stage a story so meticulously constructed to manipulate the responses of a reader poses enormous problems.'[3] Yet, through the writing of this and two other libretti, Myfanwy made a central contribution to the achievement of this great musical dramatist.

At the time when *Peter Grimes* was first staged, Britten had announced that he wanted 'to try and restore to the musical setting of the English language a brilliance, freedom and vitality that have been curiously rare since the death of Purcell'.[4] The English Opera Group had been founded to further this aim: an English style, one of its publicity leaflets explained, 'must come from a musical setting which is based on speech rhythms, the shapes and colour of the English language itself.'[5] By 1952 Britten and the EOG had done much to uphold this aim in the performance of opera.

The relationship between words and music had fascinated Britten ever since he was a boy and heard his mother sing. In 1935, he had the good fortune, while writing music for the General Post Office film unit, to find himself col-

laborating with W. H. Auden, one of the scriptwriters, who became a close friend. Working with Auden on *Coal Face* (1935) and *Night Mail* (1936), and afterwards in connection with the Group Theatre, had further stimulated his interest in the power and magic of words and sharpened his exceptional attentiveness to their sound. Furthermore, composing incidental music for films and the theatre had taught him much about the pacing and characterization of dramatic events. It was while working together on *Coal Face* that Auden first became aware of Britten's extraordinary musical sensitivity to the English language: 'One had always been told that English was an impossible tongue to set or sing. ... Here at last was a composer who set the language without undue distortion.'[6]

Myfanwy, too, realized that Britten, as a composer, gave to words much greater exactness of expression than is usual in opera. She had sat through rehearsals of *Lucretia*, *Herring*, and *Billy Budd* and had become used to hearing words set to Britten's music. Occasionally he had asked her advice on a phrase or choice of expression. She would also, almost certainly, have read Crozier's advice on libretto-writing in the book on *Lucretia*. Here he warns that 'small faults of diction, mannerisms in vocal production, untrue emotion—all are shown in their nakedness.[7] In this same book Ronald Duncan, writing as a librettist, testified to Britten's desire for a greater austerity and clarity of form ('He told me of his ambition to write an opera which would return to the limitations and economy of means which, since Mozart, had been lost in the Wagnerian circus'[8]), and in the foreword Britten himself stated that if poetry is to be suitable for music, it must be 'simple, succinct and crystal clear'. Opera demands conciseness, and composer and librettist must search for the apt phrase. Here, too, Myfanwy would have read Britten's views on the problem of continuity, or degrees of intensity, development of character, and situation. She would also have encountered his claim that if the composer and librettist are in sympathetic unity 'then the timings and inflections of the dialogue can be fixed exactly and for ever—a thing not possible in any other medium.'[9] Myfanwy could not have wished for clearer encouragement for the task that lay ahead.

In January 1895, when Henry James was in the depths of depression owing to the failure of his play *Guy Domvillle*, the Archbishop of Canterbury told him the outline of a haunting tale that became *The Turn of the Screw*. Two children are left in the care of servants in an old country house. The servants, wicked and depraved, corrupt the children, turning them bad and full of evil. Though both servants die, they return as apparitions to haunt the children.

They beckon to them, invite and solicit them, and seem to want to get the children into their power. 'It is all obscure and imperfect,' James commented, 'the picture, the story, but there is a suggestion of strangely gruesome effect in it.'[10] It remained lodged in his mind for two-and-a-half years before he began work on it. When he first published his tale in 1898, it appeared in serialized form, in *Collier's Magazine*. Wanting to attract a new audience for his writing, James made each episode as frightening and dramatic as he could, with such success that when he came to read the proofs of the story he was so disturbed by it that, he told his friend Edmund Gosse, he was almost too frightened to go upstairs to bed.[11]

Much has been written about this novella and its significance within James's career; how his father's preoccupation with the theosophy of Swedenborg had been an early influence on him, and how he himself believed that the denials and privations of life must be made to enrich it. Thus, though *The Turn of the Screw* promotes no definite moral stance but remains ambivalent as to whether the evil is imagined or real, the concept of evil was, for James, not an amoral subject. His story reflects a powerful awareness of how, whether actual or imagined, it can become a destructive spiritual force. Cleverly employing the psychological principle that the indeterminate, the unspoken, the veiled, or the mysterious can incite the imagination to run riot and give rise to a sense of terror, James obliges readers of this moral fable to confront the insidiousness of evil: the central theme, for James, as for Britten and Myfanwy, is the violation of innocence.

Britten first encountered this tale on the wireless in 1932. His diary records that he had heard 'a wonderful, impressive but terribly eerie and scary play "The Turn of the Screw" by Henry James.'[12] He immediately read the novella, noting a few days later that it was 'an incredible masterpiece'. The story then lay dormant in his mind for almost twenty years. It was Myfanwy who refocused attention on this tale: at a time when there was talk of the EOG making money through film, she attended a fund-raising gala performance of a film of *The Tales of Hoffman*, which she disliked, and, meeting Peter Pears in the foyer, said: 'If Ben's got to do a film, why doesn't he look at *The Turn of the Screw*?' Nothing immediately happened, but a little later, when Britten was casting about for ideas, Pears, who had just read the novella and remembered Myfanwy's remark, told Britten of her suggestion. When asked by Humphrey Carpenter why she thought it might be right for Britten, she replied: 'I just thought it was. I knew he was interested in the effect of adult, or bad, ideas on the innocence of children. I also thought it was densely musical prose, which would suit his work.'[13]

Thus Myfanwy brought to this opera an understanding of Britten that went beyond his musical interests. Among the Pipers' circle of friends were enough homosexuals for her to be familiar with the tensions bred in a person whose sexuality defied social norms. In Britten's case, she was aware of the hurt caused him by a senior civil servant and his concert pianist wife when they placed an embargo on their son Humphrey's visits to Crag House, after Britten had done much to encourage this 'cello-playing teenager's musical interests and had dedicated *The Young Person's Guide to the Orchestra* to Humphrey and his sisters'.[14] Britten talked openly with Myfanwy about his attraction to boys: 'He would go for long walks—I remember one occasion when he did [talk to me about boys], perhaps two—and he would say that it was very upsetting for him, worrying. He found it a temptation, and he was very worried about it.'[15] In bringing James's novella to his attention, she was, in effect, offering Britten an outlet through which to explore the conflicts in him between adult desires and childhood innocence. As if in recognition of this, in 1953 Britten dedicated to John and Myfanwy his *Winter Words*, eight songs, based on poems by Thomas Hardy, all of which play upon corruption or innocence. The final one contrasts a time 'Before the birth of consciousness | When all went well' with another era when 'the disease of feeling germed | And primal rightness took the tinct of wrong'. These lines, Humphrey Carpenter rightly remarks, could well serve as an epigraph for *The Turn of the Screw*.[16]

As none of his previous operas had been sourced by prose as complex or dense as this, Britten asked Myfanwy for suggestions as to how James's text should be treated. At this stage the idea was that someone else, perhaps William Plomer, would write the libretto. But when ideas began to flow, they decided to proceed without the help of anyone else. In this way, Myfanwy became a librettist.

Britten's first intention was to premiere *The Turn of the Screw* at the Venice Biennale in 1953. But along came *Gloriana* and in December 1952 he warned Myfanwy that the *Screw* would have to be delayed. He now realized that it was 'not a work one can throw off easily; it is much too serious, and it seems to me to need a new kind of manner and style that I don't know about yet.'[17] As a result, its Venetian premiere was postponed a year.

Working with Britten, Myfanwy later admitted to Alan Blyth, had been easier than she had expected. Both shared a love of words and a desire for simplicity. She hated inversions. He once claimed: 'Music for me is clarification. My technique is to tear all the waste away; to achieve perfect clarity of

expression.'[18] Then, too, Myfanwy observed, he knew what he wanted and 'was quite definite'.[19]

Her initial task was to extract the essentials from James's story, from very indirect prose which deliberately inculcates doubt and hesitancy. 'When Britten and I first discussed *The Turn of the Screw*', she later recollected,

> an analysis of the Henry James tale made it clear that although there was a series of dramatic happenings each of which carried the story a step further these incidents were held in a web of non-events—feelings, fears, dreams, imaginations: things half-heard, half-understood but also in that web were sparkling drops of pleasure, the charm of the intelligent children, the tranquillity and beauty of Bly, the old house, the trees, the lake.[20]

Necessary to this web of non-events was the sense of time passing. When in 1952, soon after she had embarked on her libretto, she went to see the play based on James's novella—William Archibald's *The Innocents* (translated in 1961 into Jack Clayton's film of the same title)—she admired Flora Robson's performance as the Governess, but the tidying up of the story, the confining of all the action to a single day, for her destroyed 'the sense of time passing, the shifting of places, the gaps in the action, the long months when nothing and everything happened'. By laying it on thick and fast, the play, for her, 'lost the ambience and the drama as well'.[21] She also felt that the speed with which the Governess becomes frightened and breaks down prevents the build-up of repressive tension and fear. Without this, the tale loses its point: 'Nothing that happens is significant without the accompanying density of offered feelings and facts, echoes and memories.'[22]

This density was enhanced by Britten's decision to link the scenes with a set of variations. These carry the listener forward, offering a foretaste of what is to come and opening up time and space in which the drama can develop. As they move through various keys, employing a series of alternate rising fourths and falling minor thirds, their musical form describes the turning of the screw. Britten seems to have first realized this when they tried to find a different title for the opera. 'Thank you for your suggestions of titles,' he wrote to Myfanwy. 'I do not quite feel that we have arrived yet, although something to do with "Bly" is hopeful I think. … but I must confess I have a sneaking, horrid feeling that the original H.J. title describes the musical plan of the work <u>exactly!</u>'[23]

In October 1953, when concentrated work on the opera was about to begin, progress was hampered by bursitis in Britten's right shoulder, and, though he managed to write letters with his left hand, he nevertheless used his illness as an excuse to put the opera to one side. It has been suggested that he was nerv-

ous about turning his attention to a subject which had homosexual overtones at a time when Sir David Maxwell-Fyfe, the Home Secretary, had announced 'a new drive against male vice'. Sex between consenting adult males was still at this time a criminal offence, and Britten himself was one of the people in the autumn of 1953 whom Scotland Yard interviewed in connection with this crackdown, in the wake of the defection to Moscow of Guy Burgess and Donald Maclean, both of whom had associated with homosexuals. Nevertheless the pain in Britten's shoulder was debilitating and, when it refused to heal, he underwent an operation. As a result he did not compose a note until 30 March 1954, by which time the preview was just five months away.

At an early stage in the making of this opera, Britten gave Myfanwy crucial advice. After she had shown him her first tentative attempts at words, he said: 'Don't colour them, the music will do that.'[24] She immediately realized that, with the music providing 'the psychic dimension', she could steer her way through the story with a lean economy, employing, for the most part, a plainness of diction. His advice, she admits, helped remove anything high-flown, over-descriptive, self-indulgent, or imprecise. It led her to understand that whatever was being articulated through speech had to be 'as much part of the music of the voice as the note itself: the word and the note is one thing, not two'.[25] Myfanwy's job was to extract from the tale, with the necessary concision that a libretto requires, a development that matched James's unfailing sense of theatre. The concentrated drama that she achieved is one reason why the *Screw* is Britten's most tightly organized opera. As Wilfred Mellers has observed: 'No opera of Britten, or perhaps any composer, is so claustrophobically close-knit.'[26]

Myfanwy took time to get going. At the start of 1954 she apologized to Britten for having been slow and neurotic before Christmas, for allowing the fish and the laundry to squeeze out her creative life. But she had evidently turned a corner:

> This is to wish you a happy new year and a happy return to work. I do hope my dear that, even if the arm is not as much better as you hoped (so Peter said) that you feel calmer and less worried. You will be relieved to hear that I am getting on like a house on fire and that by the time I speak to you on the telephone, soon please, I shall have got something down for every scene. The last act is thrilling I think and I long to get down to slashing, cutting and altering according to your needs. Basil [Coleman] has been here for nearly a week, very relaxed and the most charming and encouraging company. He has been working with John and Walter Goetz [costume de-

signer] during the day and very sweetly gone through *Screw* problems with me in the evening—I must say it has been the greatest stimulation to have someone to talk to as I do it. But since I skipped the nebulous problems of the ghost's dialogue and went on to the action it has gone wonderfully well because it is all so much in my ear and I know the dramatic content of each scene—also there is a great deal of excellent dialogue in the James all ready for selection.[27]

There followed a fertile period for both Myfanwy and John when they spent a month as near neighbours to the Stones at Litton Cheney, in Dorset, in a cottage that looked up the flooded valley to Kingston Russell manor. Most days John drove to the coast, to draw and paint Portland, sometimes standing on the roof of his car in order to get the view he wanted of this long thin peninsula which—almost an island—is connected to Dorset by a road, railway, and a long bank of shingle, Chesil Beach. He had discovered this area around 1929, and brought Myfanwy here in 1934, soon after they met. They had stayed at Abbotsbury, nine miles from Weymouth, and had walked for miles along the shingle on Chesil Beach. His interest, recently revived, in this area led to a large body of paintings based on this slightly sinister landscape, where stone had been quarried, sometimes by convicts, to dignify many London buildings, including St Paul's Cathedral, Bush House, and the Adelphi, as well as to create the forlorn nobility of Portland's St George Reforne church. Even the lintels, mouldings, and gateposts in the vicinity had a surprising purity.

63. John Piper, Chesil Beach, 1954 (photograph: Janet Stone).

64. Page from John Piper sketchbook of views at Portland.

Here quarrymen uncovered petrified trees, ammonites, fossil oysters, and Roman coins. Observing this, John became aware that the area conveyed a sense of long occupation, of habits felt rather than known. A grandeur clung to the large chunks of stone that littered the landscape and they filled his mind with 'a dream-like architecture of marine simplicity'.[28] He was aware that the Dorset-born surgeon Sir Frederick Treves had regarded Portland as 'a dismal heap of stone standing out into the sea', the island as 'ever wind-swept, barren and sour, treeless and ill-supplied with water'. But for John this desolation added to its romance, and everywhere he looked—at the huge harbour, the rows of neat houses, the great strips of common land, or a tangle of electricity wires and forests of television cable—he found things to interest him. 'A poet to-day', he claimed 'can see it as a little English Greece available without air travel, a blue sea-engirdled white-stone island combining ferocity and romance in its scenery. Beauty of work and independence of spirit—both of these can exist here.'[29] Later that year, when he became the subject of a television programme made

65. John Piper sketching at Portland Bill, 1954 (photograph: Janet Stone).

by John Read, he was filmed drawing and painting Portland. In a voice-over he explains that instead of copying what he saw he rearranged things so as to make an 'elaborate symbol of the place; not a view, but a history' (Plate 45).

While John roamed Portland, Myfanwy completed a scene synopsis for *The Turn of the Screw*. 'At last we have a plan,' she told Britten at the start of Febru-ary.[30] Two weeks later he visited her at Fawley Bottom and afterwards wrote: 'My!—how you do work! I don't understand really <u>how</u> you manage to get it all in.' He added: 'I think it is in a very promising shape now, and I am longing to get down to finding the right notes. At the moment I am hunting for the right kind of singing game for the two children; have you had any inspirations about this?'[31] A solution was found in two nursery rhymes, 'Lavender Blue'

66. Myfanwy composing *The Turn of the Screw* libretto, Portland Bill, February 1954 (photograph: Janet Stone).

and 'Tom, Tom the Piper's son', neither of which Myfanwy chose and the first of which she actively disliked, but two others—Flora's song to her doll and the Cat's Cradle song—were both her invention. ('I suddenly had an inspiration ... and was frightfully pleased.'[32])

When questioned, she could not remember whether she or Ben had suggested the lesson scene which, though not in the novella, could be derived from a reference to the schoolroom. As very few words are spoken in the book, much of the dialogue had to be invented, though Myfanwy was adept at incorporating telling words and phrases used by James.

The evolution of the opera can be traced through their exchange of letters, Myfanwy's notebooks, and draft librettos, all now in the Britten–Pears Library at Aldeburgh. The story was condensed, reconceived, and in places reinvented as it gradually resolved itself, like a series of cinematic flashbacks sandwiched between musical interludes, into an opera in two acts, each with eight scenes. Britten regarded revision and rewriting as a natural part of its evolution.[33] In this way, libretto and musical ideas grew together and nourished each other. However, Myfanwy could not work at the same desk as Britten, as Ronald Duncan had done, nor with the same proximity that Crozier had experienced during the writing of *Albert Herring* ('he liked to have me within arm's reach'[34]), for she was moored by domestic responsibilities to Fawley Bottom. At times, Britten found this trying: 'Goodness—how *difficult* it is to write an opera with the librettist so far away,' he complained in May 1953 to Basil Coleman. 'She is so good, but is so occupied with being a wife and mother.'[35]

Imogen Holst's diaries record meetings between Ben and Myfanwy at Fawley Bottom, in London, at Britten's Chester Gate house, and at Aldeburgh, for there were times when he needed Myfanwy's actual presence. But for the most part they managed to progress the work through the exchange of letters and then telephone calls, the latter becoming more frequent as the opera neared completion. At one stage Myfanwy received almost daily requests for changes of words or phrases.

Over time, Myfanwy was to produce three libretti for Britten, all based on sophisticated texts, 'highly developed literary works' which, she observes, 'depend on the poetic build-up of atmosphere and of mental apprehensions, on accumulated moments of word-filled suspense, on evocations of the authors' belief in the active magic of places to give force to the stories that they tell.' All three texts presented difficulties, but none of them were due to the richness of the original. 'The richness was, rather, a help,' she claimed.[36] However, one particular difficulty with the *Screw* was the lack of analysis, on the part of the author and his characters, of inner motivation. 'What we are told is going on in the characters' heads', writes Edmund Wilson in his classic essay on this tale, 'is a sensitive reaction to surfaces which itself seems to take place on the surface.' Nowhere do the characters grapple with their problems in concrete terms. Instead what we encounter is something, Wilson observes, 'as much arranged by James to conceal, to mislead and to create suspense as the actual events presented.'[37]

Ideas for the dramatic development of the opera came from both composer and librettist. At one stage Britten wrote to Myfanwy:

The end of the first act could be something like this:

At the climax Mrs Grose appears at the window and the Governess at the porch. Quint and Miss Jessel disappear as Mrs Grose drags Flora away and Miles runs down to Governess.
 Gov. Miles! What are you doing?
 Miles. You see, I am bad, aren't I?
 Curtain.

I like Miles['s] last remark because it is clear, bright, and in short phrases, which I think its right for the boy's character and his manner of singing.[38]

These simple words are replete with sadness and resonant with ambiguity, for the precise nature of Miles's badness remains unclear. Britten was aware that, with Miles, he was composing for a small immature voice and limited musical

experience. He therefore asked Myfanwy whether the boy could have 'a short, very simple song, the tune and echoes of which could steer him through the work'.[39] With this task in mind, Myfanwy looked through a lot of old rhymes. She turned to folklore and to an early anthology by Auden but could not find what was needed. She decided to invent a 'fool-song' that would be both innocent and enigmatic, and her notebooks show her experimenting with a poem in this vein. Britten, however, did not take to it, nor was she herself greatly pleased with it. In conversation with Peter Porter, she recalled: 'And then we were looking through this Latin book, which I got from an aunt of mine … and then I think Ben, or perhaps I, suggested the 'Malo' mnemonic. I certainly pointed it out to him and I think he decided to use it.'[40] The source for the 'Malo' song was not Kennedy's *The Shorter Latin Primer*, which had provided the list of Latin names for the *Benedicite*, but a modern edition of Brewer's *Phrase and Fable*, and the aunt in question was Lena Playll, who had spent her working life teaching history and Latin.

This verse gave Miles ('I found it') a Latin nickname for himself, for one of the meanings of 'malo', as a noun, is 'a disaster, a mischief, a punishment', while 'malum', the adjective, means bad, evil. As a verb 'malo' translates as 'I prefer, wish', while the noun 'malus' stands for an apple tree.

> MALO: I would rather be
> MALO: in an apple tree
> MALO: than a naughty boy
> MALO: in adversity

Whether she or Britten chose the verse, it was Myfanwy who perceived how telling it would be if Miles's song were to recur in the final scene. When sung initially, it shows Miles, like any growing boy, exploring his own potential for good and evil. ('You see, I am bad, aren't I?') But it takes an adult mind to hold together the full range of associations, as the Governess does, when she recites the song again at the end of the opera. The opera moves relentlessly, like the remorseless turning of a screw, towards the denouement when Miles is forced by the Governess to name Quint, after which he dies in her arms. Myfanwy recalled: 'Long before the many attempts to find the right words had been written and discarded … I conceived the idea that the song, hitherto only sung in Miles's childish voice, should be sung in the mature and tragic accents of the Governess, when she discovers that he is dead.'[41] Translated into Britten's music, it proved a masterstroke, bringing the opera to its bleak and poignant ending.[42]

In creating a sense of indefinable evil, Henry James had been helped by the ghosts' silence. ('Only make the reader's general vision of evil intense enough', he wrote, 'and his own experience, his own imagination, his own sympathy ... will supply him quite sufficiently with all the particulars.'[43]) But with the opera, where there are only six figures, two of them children, it was musically necessary to make the ghosts sing and therefore to give them words. Myfanwy, daunted by the task of inventing speech which would enable the ghosts to communicate with the children, put off writing Act I Scene 8 as long as she could. Her task was guaranteed to offend purists, but adaption, for its success, often requires a bold move. The problem here was how to give the ghosts words without making their evil more precise and thereby diminishing its horror. She was aware that James does not specify any definite wickedness or impropriety. Instead he points to the apparent fascination which the ghosts exercise over the children.

Britten and Myfanwy agreed that whereas the rest of the libretto was to be written in prose, except for the children's rhymes, 'here was the place for verse, so as to separate the dead, even more, from the living.'[44] In this night scene, Quint calls from the tower, his coloraturas ringing out like bird-calls, to Miles, who has escaped into the garden in his nightdress, after which Miss Jessel addresses Flora. Among those who admire Myfanwy's handling of this scene is Peter Evans, who praises the way in which the ghosts 'throw the children into an ecstasy of compliant terror because their words, of a heady "poetic" quality on which a child's mind can feed, are intangible yet luring'.[45] The verses given to Miss Jessel are noticeably less effective. The problem here was that James tells us little about Miss Jessel other than the fact that she was attractive to Quint, but not attractive enough to hold his attention. 'And so,' Myfanwy admits, 'rather lamely, I invented the bitterness and the anti-male note.'[46] Quint's Yeatsian siren song, on the other hand, ripples with allure, containing just the kind of mystery that stirs the boy's imagination.

> QUINT: I am all things strange and bold
> The riderless horse
> Snorting and stamping on the hard sea sand,
> The hero-highwayman plundering the land.
> I am King Midas with gold in his hand.
> MILES: Gold, O yes, gold!
> QUINT: I am the smooth world's double face
> Mercury's heels
> Feathered with mischief and a god's deceit.
> The brittle blandishment of counterfeit

> In me secrets and half-formed desires meet.
> MILES: Secrets, O secrets!
> QUINT: I am the hidden life that stirs when the candle is out
> Upstairs and down, the footsteps barely heard
> The unknown gesture, the soft persistent word
> The long sighing flight of the night-winged bird.
> MILES: Bird!

It was this scene which Britten, on a visit to Fawley Bottom in May 1954, played through on the piano. He had reached a passage of very violent and exciting music when a loud thunderclap was heard outside. To his listeners, it seemed entirely appropriate.

To balance Act I Scene 8, the opening of the Second Act again presents the ghosts, now in conversation together. Britten suggested to Myfanwy that it might be useful to look at Verlaine's *Colloque Sentimental*, in which two lovers taunt each other with their past. She did so, but gained little from it, other than an enhanced awareness of the need to emphasize the ghosts' unhappy self-absorption. By now fully attuned to the story, she had concluded that its central fascination lay not in

> the sin that lies beneath the fine mist of evil, nor yet the Governess's unful-filled love, which it was at one time the Freudian fashion to make respon-sible for the whole affair, but the vulnerability of innocence at all ages. The children's inquiring innocence is assailed from outside, the young woman's is attacked from within by her own fears and imagination and from without by the evidence of her bemused senses, which she constantly mistrusts.[47]

This destruction or ravaging of innocence was, Myfanwy recognized, as it had been in *Lucretia* and *Herring*, a central theme. She therefore identified a line in W. B. Yeats' poem 'The Second Coming', with its mingled anguish, terror, and exaltation, which seemed to epitomize the story and the theme of the whole work—'The ceremony of innocence is drowned'—and which is sung in the opera fortissimo and in unison by both ghosts. Moreover, because the line is so famous it carries with it an echo of its setting: 'Mere anarchy is loosed upon the world, | The blood-dimmed tide is loosed, and everywhere | The ceremony of innocence is drowned.'

Earlier in this scene there had been a hint of Yeats and the swans at Coole Park in the exchange between Jessel and Quint. ('Why did you call me from my schoolroom dreams?' she asks, and he replies: 'I call? Not I! You heard the terrible sound of the wild swan's wings.') After their colloquy the lights fade

out, and then rise again on the Governess who offers a reprise of the central theme: 'Lost in my labyrinth, I see no truth, | only the foggy walls of evil press upon me. | Lost in my labyrinth I see no truth. | O innocence you have corrupted me, | which way shall I turn?'

The ghosts were not the only difficulty which Myfanwy faced. Pears worried that the phrase 'made free with everyone', in connection with Quint, was too sexy and might cause a scandal in Venice, and though no alteration was made to this phrase, Britten felt it necessary to stress that they must 'keep together in these anxious days'.[48] At a late stage, Myfanwy introduced the Governess's letter to the guardian in Act II which suddenly seemed necessary to the unfolding of the tale. But she was at a loss to know what to do when Britten asked if the churchyard scene could begin with the children singing a parody of a hymn, until a clergyman friend said 'It must obviously be a "Benedicite".'[49] But the worst crisis came in April 1954 when Basil Coleman, the producer of the opera, began to fear that it was too short. Up to this point it had no prologue, but Britten now insisted it was necessary and asked Myfanwy to see what could be done. He himself drew up a scenario, giving the Governess a soliloquy. At the same time Myfanwy tried to extract a prologue from the dinner party scene with which James's novella begins. She quickly realized that its realism jarred with the rest of the drama, and she set to work on an alternative, more on Britten's lines.

The new prologue, which perhaps fulfilled other needs as it did not significantly alter the opera's length, was set as a recitative. It follows the spread chords on the piano with which the opera begins and takes the form of a short soliloquy delivered by a male narrator, the singer also doubling as Quint. The words summarize the circumstances in which the Governess is offered the job by the children's guardian. Her acceptance is given with the words 'I will', a phrase chosen by Myfanwy to allude to the marriage vow, thereby hinting at the romantic element in the Governess's attitude to her employer.

After all this labour there was no small sense of pride in her remark, in May, to Moelwyn Merchant: 'Ben thinks it is his best work and is I think much pleased.'[50] There were still minute adjustments to be made, but the opera was more or less finished. In the relief that followed, Myfanwy could acknowledge her husband's resentment of her obsession with the *Screw*. 'John reminded me in bitter tones the other day', she told Britten, 'that Mrs Trollope used to get up and write <u>her</u> novels from 5 o'clock till breakfast time every day. They were awfully bad. But Trollope did the same and his weren't.'[51] After hearing a play through of the finished work for the first time, she wrote again to Britten.

> I'm very much aware of how you have made use of every scrap of feeling and
> suggestion that has been given you in this script, and also of how much these
> feelings and suggestion have been the product of your generous, patient and
> imaginative sympathy with me in the early fumbling stages. I only hope that
> my part is good enough to carry what you have given it.[52]

In terms of financial reward, Myfanwy was to receive a third of the 12½%
royalties payable to the composer on the sheet music and from mechanical,
broadcasting, and performing fees. However, questions of copyright, unre-
solved at the time of first performance, prevented Boosey and Hawkes from
publishing her libretto until 1955. For a while, all she had were three sets of
typed proofs, one of which she sent to the actress Peggy Ashcroft, another to
the Danish actor Erik Mørk, who had become a boyfriend of Johnny Cranko,
and the third she kept as her working copy, afterwards lending it to Moelwyn
Merchant and others.

She was present at the Scala Theatre in London when the young David
Hemmings was chosen to play Miles. Hemmings' memory of this audition was
of himself as a small boy in the middle of a vast stage, very conscious that in the
audience sat the finest living British composer and that beside him was Peter
Pears. 'With them was perched the eccentric, vibrant and scatty Imogen Holst
... huddled in conversation with Myfanwy Piper. ... Myfanwy and Imogen had
an alarming, witch-like presence and would have looked quite at home in the
Scottish play, crouched over a cauldron, casting spells with eye of newt and
adder's fork.' Also visible to the small boy when the house lights came up was
the producer, Basil Coleman, 'sitting aloof in a tweed jacket, tie and cords, a
symphony in autumn colours, curly-haired and tall, protruding above the seats
as if he were standing.'[53] Hemmings for a period abandoned his schooling and
moved to Aldeburgh to sing professionally for the EOG. He stayed with Brit-
ten in Crag House during rehearsals.

The debates around the *Screw* often focus on its ambivalence. Composer
and librettist had followed James in building up a sense of evil without ever
stating what that evil is. Myfanwy insisted that neither she nor Britten had
intended to 'interpret' the work. Lord Harewood, on the other hand, claimed
that Britten had decided 'there was something malign at Bly':[54] therefore the
possibility that the evil was merely a construction in the Governess's mind must
be ruled out. When questioned about this, Myfanwy expanded on her original
claim, in a letter to Patricia Howard:

> I don't think Ben really took sides. ... That evil exists whether in life or
> in the mind ... and is capable of corrupting—or perhaps not necessarily

corrupting but causing the loss of innocence—he was, I think, quite certain. The Governess's good intentions were destroyed by her experiences, whether real or imagine, and her love of Miles was corrupted, in that it became possessiveness and she was aware of it. Hence the last words 'What have we done between us?'[55]

In a conversation with Peter Porter, she said that Britten was 'bothered by interpretations', and that her own feeling was 'if you interpret something like that then you destroy it.'[56] More recently, Claire Seymour has suggested that it was the absence of moral absolutes in James's tale that appealed strongly to Britten.[57]

This lack of fixity found an echo in John's set designs for this opera. He had learnt from television that if too much is shown, the sense of mystery evaporates. He therefore made deliberate use of understatement, thereby allowing the imagination to grow as the tale proceeds. Furthermore, he realized that, with an opera which did not require a lot of movement, it would be possible to use a series of painted curtains and transparent gauzes which could be pulled back one by one to reveal more of the set as the tale progressed.

At first John's ideas were too elliptical for Britten: though the music clearly enunciates the arrival of the coach in Scene 1, he worried that an audience unfamiliar with his musical idiom might be at a loss without an actual coach.

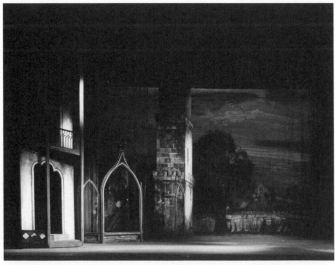

67. Scenery for *The Turn of the Screw*, combining items from several scenes (production photograph).

Such realism would have been inappropriate, and 'foreign to the evocative and atmospheric sense of the scenery'.[58] Basil Coleman solved the problem by using the motion of someone sitting in a coach, while the vehicle itself was suggested by the merest whisper of a wheel and a door panel in the painted gauze. This settled the matter to everyone's satisfaction.

When the Governess arrives at Bly, all that is initially shown is the front door. With the removal of further curtains and gauzes, more architectural features were revealed, solid but still sketchy, including the tower where Quint makes his first appearance. There were also a few easily moved properties—a schoolroom desk, a bed, a garden seat—to complete the scheme. What was impressive was the way these simple ingredients and vaguely indicated forms somehow 'composed' into a picture and into a seemingly solid and satisfactory environment that was at the same time evocative of uncanny evil.

The appearance of the ghosts within these well-contrived Gothic sets was to send a momentary shiver down the spine of *The Times* critic on the evening of 14 September 1954, when the work was premiered at the Fenice in Venice and simultaneously broadcast live in England and all over Europe. The Italian audience was so impressed by this macabre music drama that it held back from applauding at inappropriate moments. The lead-up to the opening night had been full of tensions: there were difficulties with the Italian stagehands who were unfamiliar with flimsy gauzes and more used to sound-muffling velvet curtains; rehearsal time granted by the Fenice had been limited to only two weeks; and in Venice Britten's increasingly strong attachment to Hemmings so flattered the boy that he became nervous of letting the composer down and his singing suffered. Meanwhile Edward and Clarissa Piper, who had been taken out of school in order to accompany their parents to Venice, bought the food each day for the lunchtime picnic which Britten and Pears, the Pipers, Basil Coleman, and Basil Douglas, then director of the EOG, ate sitting on the steps of a bridge or in the courtyard at the back of the Fenice. Meanwhile two carloads of friends—the Stones and three of their children, Cranko, Frank Tait, Mervyn Horder, and the glass-engraver Laurence Whistler—were en route, arriving in time for the premiere.

On the first night a rose was placed on every seat in the house. John looked very dapper in white tie and tails and Myfanwy wore a magnificent gold dress. When the curtain came down after the final chords there was initially complete silence but then such a tumult of clapping and shouting could be heard that it startled the stagehands who thought a demonstration had broken out. In fact it was a massive standing ovation. Afterwards the Mayor of Venice hosted a reception for all the cast. This was followed by a late night meal in a restaurant,

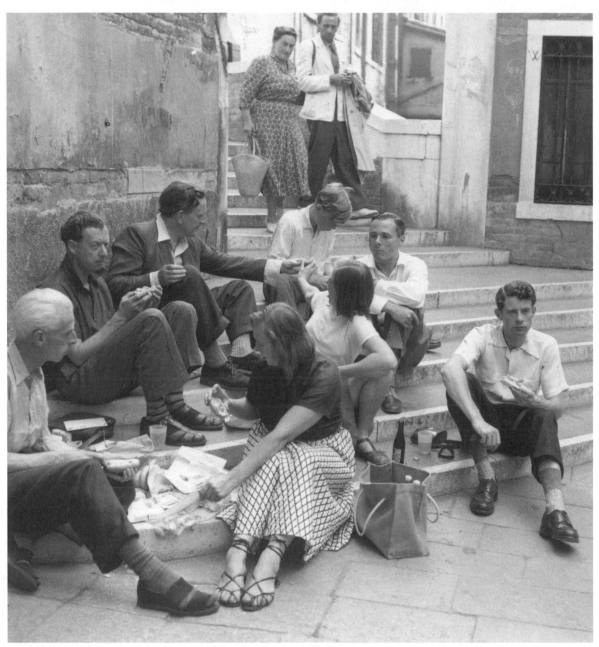

68. Lunch in Venice on the steps, John and Myfanwy, Britten, Pears, Basil Douglas, Edward and Clarissa, and Basil Coleman.

69. John Cranko, Reynolds Stone, Mervyn Horder, Lawrence Whistler, and Frank Tait, en route to *The Turn of the Screw* in Venice (photograph: Janet Stone).

and when they walked back across St Mark's Square, the only noise was that of melancholy little café bands packing up. 'Suddenly', Myfanwy recalled, 'there was a wild and beautiful sound: Arda Mandikian (Miss Jessel) cast off her stage cloak of gloom and sang, at the top of her voice, the folk songs of her native Greece all the way back to the hotel. A perfect ending.'

Myfanwy's distillation of James's novella had given Britten the means by which he could explore the oscillation between innocence and guilt, good and evil, fantasy and truth. And according to Erwin Stein, Britten had brought to these ambiguities a musical idiom of wide scope: 'The harmonics are bolder than in any of his previous works. Bitonal passages, whose strands represent different keys, are frequent.'[59] Though radio listeners found it hard to distinguish between the voices of Miss Jessel and the Governess, and the unpunctuality of the Italian audience had caused an unfortunate delay in transmission, this first performance of *The Turn of the Screw* has gone down in history as an outstanding musical event. Maestro Piovesan, director of La Fenice Opera House, spoke proudly of it, and even Italian critics, more used to big choruses and large orchestras, acknowledged the technical perfection of the music, the setting, and the performance itself. 'Music-lovers and musicians from all over Europe', wrote the *News Chronicle*, 'gave a triumphal reception tonight to Benjamin Britten's new opera *The Turn of the Screw*.' Musicologists, critics, and music lovers continue to agree that it is among Britten's most outstanding achievements—in the words of Donald Mitchell, 'the summit of Britten's chamber-opera concept'.[60]

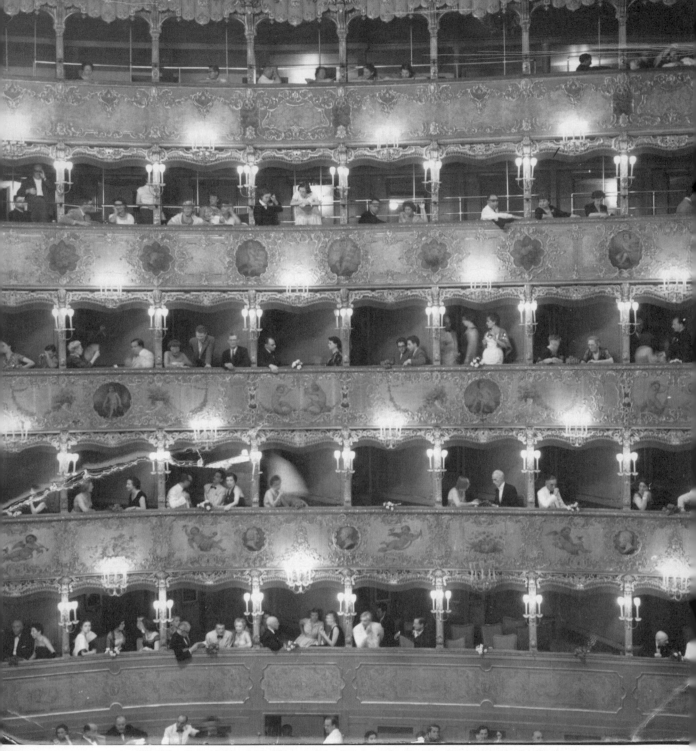

70. The first night of *The Turn of the Screw* at the Fenice, Venice, with the Pipers in the second tier of boxes.

24

Delegated Art

Myfanwy's Person from Porlock, while struggling with the prologue for *The Turn of the Screw*, was S. J. Woods. He badgered her for advice on the essay he was writing for the first major monograph on John's art. 'What a magnificent sweep there is right through the years,'[1] Britten remarked, when the book appeared, under the Faber and Faber imprint in 1955, for, though described by Woods as an 'interim report', it captured for posterity the expressive intensity and range of John Piper's work. But the wealth of illustrations it contained (244 black and white illustrations, eleven in colour, eight reproductions of line and tone drawings in four colours, as well as four lithographs and one aquatint, the last five designed specially for the occasion) merely irritated Douglas Cooper, a wealthy and knowledgeable collector of Cubism who had scant patience for anything in a romantic vein and became a notoriously savage critic of modern British art. He set to in the *Times Literary Supplement*.

> Mr Piper is clever, and has a quick eye for the theatrical, the stately, the quaint, the picturesque and the decorative. But his eye is essentially that of a cultivated man, an illustrator and an antiquarian versed in the fluctuations of taste. His vision is by nature conventional, but as one turns the pages of this book one can watch him straining to conceal this by bringing into play all sorts of technical devices, by conjuring up a melodramatic semi-gloom, and by imposing an identical formula of personality on everything in order to create the illusion of a striking or impressive painterly effect.[2]

Cooper's attack reprised the doubts raised by Grigson in 1948. The two men established a vein of criticism that recurred whenever John's verve and brio dipped into factitious liveliness.[3] But anyone looking at Woods' monograph with unprejudiced eyes will encounter, as Britten did, a fertile creativity, a vital expres-

siveness. Cooper's scorn failed to dent the popular esteem in which John was held, as David Piper discovered. The two men sat together on the Royal Fine Art Commission, 'consolidating satisfactorily a little block of Pipers that from time to time said no to architects'.[4] At parties David Piper came to recognize a certain smile, 'gratified and adulatory' homing in on him, and before its owner began to speak he would quickly say, 'No, I'm terribly sorry but I am not John Piper.'[5]

Nevertheless, by the second half of the 1950s, Piper had lost the centrality he once had in the art world. Curt Valentin's sudden death had removed an influential supporter in America; association with the Tate Gallery as a trustee during the so-called 'Tate Affair' indirectly damaged his standing; and while Nicholson continued to regard him as a 'traitor', he was sidelined by the British art establishment which now favoured William Coldstream, Lawrence Gowing, and others. He had evidently been worried by a loss of status as early as 1948, as it emerged during a visit he made that year to Renishaw. Edith, angry with John for not rising to her support when Geoffrey Grigson attacked her in the press, now turned against him, writing to her close friend Pavel Tchelitchew:

> Throughout his visit, his whole conversation was about how one person or another—an artist or writer of his magnitude—'was not fairly treated' by one paper or another. Some reviewer had said his work was not as good as his previous one!!! Can you conceive of such coarseness? He was here for three days. … O[sbert] sees through the man perfectly,—or at least, nearly perfectly—but still clings to him and gets him to produce watercolours as representations of Renishaw and Montegufoni!!! But he knows perfectly that the man is very coarse and an utter egoist, and cares for nobody but himself.[6]

Few artists or writers are free of egotism. In the late 1950s many found their position altered by the arrival in Britain of Abstract Expressionism, American art and theory bringing about a sea change in the artistic climate. A loss of status quickly translates into a loss of earning power and John now sometimes accepted commissions which, in other circumstances, he might have declined. Nevertheless there is an indivisibility to his outputs, owing to the fact that all took their lead from his painterly interests. He also enjoyed what he called 'delegated art', handing over to craftsmen designs for the stage, for fabrics, tapestries, mosaics, or stained glass, in this way transferring motifs, techniques, and ideas from one medium to another, in a fertile cross-disciplinarity.

Though *Pavilion* had been a costly disappointment, it did not lose the Pipers the friendship of Hans Juda, the six-foot-four German émigré, large and ebul-

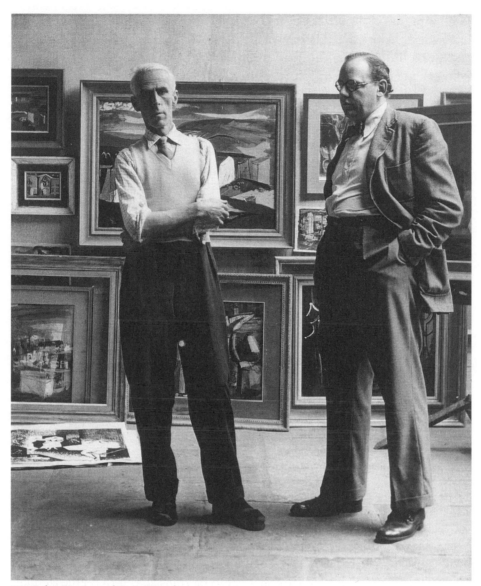

71. John Piper and S. J. Woods.

lient, who gave John's illustrated articles generous space in the *Ambassador*, a glossy British export magazine with subscribers in ninety countries. Many of the photographs for it were taken by his wife, Elsbeth, who accompanied John to the Cotswolds, in connection with his article 'A Wool County',[7] also to Portland for another issue, and to Blackpool in an abortive attempt to mount a feature on this seaside town. At the parties which the Judas held in their

penthouse flat, in a Wells Coates block in Palace Gate, the Pipers enjoyed, like others, their hosts' life-enhancing buzz. When, in the early 1960s, three cottages a little way up the road from Fawley Bottom Farmhouse were condemned and demolished, John suggested to the Judas that they buy the land and build a country retreat. They did so, employing the architect Lionel Brett (later Lord Esher), who lived nearby and with his wife Christian saw much of the Pipers, John becoming godfather to their daughter Olivia. The new house, however, did not greatly please John, nor did he like the moneyed types that descended on the Judas at weekends and altered the atmosphere of this tiny hamlet. Nevertheless, he remained indebted to his new neighbours, not least for the openings they brought him in textile design.

He had sold his first fabric design through the Central Institute of Design during the war years, to a buyer from John Lewis and Co.[8] Nothing appears to have come of this, but further opportunities arose when the *Ambassador* magazine sponsored an exhibition held at the ICA, from 21 October to 14 November 1953, entitled 'Painting into Textiles'. It was the Judas' idea that artists should send in original works of art which manufacturers could use as inspiration or interpret as textiles, in collaboration with the artist concerned. John, one of twenty-five artists paid to send in designs, based one of his two foliate heads, a motif he had been studying in medieval sculpture and roof bosses for a series of pictures made that year.[9] As people were beginning to tire of the pseudo-scientific imagery made stylish by the Festival of Britain, which had been debased by commercial exploitation, the exhibition proved a great success.[10] 'Painting into Textiles' is said to have given 'greater strength and depth' to the industry for the next fifteen or so years.[11]

One manufacturer excited by this exhibition was David Whitehead Ltd, which had mills at Rawtenstall, Rossendale, in Lancashire. Under John Murray the firm had achieved a go-ahead reputation, but in 1953 he handed the firm over to his friend and fellow architect Tom Mellor. It was he who, with the managing director and the head of studio, went to see John at Fawley Bottom, intent on finding more paintings that could be translated into textile designs. It proved a successful partnership. John's familiarity with abstraction gave him an instinctive feel for the formal properties inherent in any image. He now extracted from representational subjects motifs and patterns which could be repeated across the surface of cloth in such a way as to enhance pleasure in the texture of living. One of his designs took up the theme of foliate heads (Plate 46). Two others that went into production in 1954 were based on paintings he had made of church monuments at Exton and the gates at Blenheim, and another, the following year, revived the vocabulary of his 1930s abstracts. He

continued to work with this manufacturer until the firm was sold in 1970 to Lonrho.

However, his relations with the textile industry reached its zenith in 1959, when Sanderson's, famous for its wallpapers and furnishing fabrics, commissioned five textiles from John as part of its centenary celebrations in 1960. Again, he turned to motifs already within his oeuvre for five new textiles—rocks in North Wales (*The Glyders*), Sheffield Cathedral (*Northern Cathedral*; Plate 47), the Venetian church St Maria Salute (*Chiesa de Salute*), and some stained glass that he had recently completed for the chapel at Oundle school (*Arundel*; Plate 48). Most popular of all was his Cubist interpretation of the city of Bath (*Stones of Bath*) which, if turned into curtains or chair covers, created an effect of great richness and warmth. These centenary fabrics were taken up and widely used by Trust House Hotels. Screenprinted on Sandelin, a high-quality satinized cotton, they have rightly been described as 'magnificent, outstanding in their coherence and as a group'.[12]

During the war John had visited York Minster. He found it strangely dimmed, for all the stained glass had been removed. 'It was', he said, 'as if half the orchestra had been silent during the performance of a symphony.'[13]

Since the age of nineteen he had taken an almost scholarly interest in stained glass, reading Philip Nelson's *Ancient Stained Glass in England 1170–1500* and searching through Methuen's *Little Guides* for further windows of note. In his twenties, as we have seen, he began copying stained glass, and in his forties, when writing the Murray Architectural Guides, he had paid especial attention to its ancient tradition.[14] He noticed that over the past hundred years it had been the recipient of very little experiment; much had been executed within a predictable and familiar vein. Dull war-memorial windows, and stereotyped Edwardian and Victorian saints 'standing bored on their pedestals against pink and green seaweed or ivy-leafed backgrounds ... have conditioned our eyes for so long that anything less formal and more personal tends to look like a wilful hurt and aggression.'[15]

Another enemy of stained glass is the desire for more light. It was this that caused Wyatt, when he restored Salisbury Cathedral, to throw out the thirteenth-century glass into the town ditch. But in front of the best examples—at Chartres, Canterbury, Tewkesbury, Fairford, and Malvern and in the chapels of certain Oxford and Cambridge colleges—John had realized that gifted artists of all ages had used stained glass 'to provide a dimmed and jewelled light; a light where yellow is richer than burnished gold, where intense reds can be real wounds and even dimmed ones are rich silks, while

blues can have the depth and magnitude of night skies and of Heaven itself.'[16] In the early 1950s he came across a remark by the painter Alfred Manessier, to the effect that he had come to think of stained glass, less as a design than as 'the simultaneous creation of a light-filled architectural unit'.[17] This realization that stained glass is inextricably bound up with architecture and with light was to direct and determine all John's designs for this medium. Diverse though his work is, it upholds his belief that 'the function—the flesh and blood and bones of stained glass—its whole *being*—is to qualify light and to intensify atmosphere in a room or a building, not necessarily to provide colour or a message'.[18]

Few artists add a whole new dimension to their careers after the age of fifty. But in the mid-1950s John's involvement with stained glass burgeoned, as his preoccupation with the stage diminished. Within remarkably few years, he had become England's most outstanding stained-glass designer, a position which, during his lifetime, remained unsurpassed. He continued working with this medium for thirty-four years, and, in the course of almost sixty commissions, proved to be remarkably innovative, versatile, and expressive in the solutions he found to fit the needs of various buildings and individuals. His achievement is all the more remarkable given the conservatism surrounding stained glass. 'Nobody', he once said, 'can move the body of stained glass practice and expertise at a faster rate than it wishes to be moved; and it is the servant of a very slow-moving tradition. It is the traction engine of the crafts.'[19] June Osborne's pioneering study of his stained glass,[20] with its many illustrations, offers a glimpse into the imaginative energy that he poured into this medium, but his stained-glass work can only properly be seen and experienced in situ. Of critical importance to his work in this field was his association with the craftsman Patrick Reyntiens, for between them was to unfold a creative collaboration comparable in importance to that which Myfanwy, as a librettist, shared with Benjamin Britten.

Born 1925, of Russian and Flemish descent, Patrick Reyntiens had trained at Edinburgh School of Art, where he had met a fellow painter Anne Bruce, who became his wife. As a maker of stained glass, he had apprenticed himself to J. E. Nuttgens at High Wycombe and was living nearby, at Flackwell Heath, when a repair that he did on a church window brought him to the attention of John Betjeman. Penelope Betjeman also met him at this time, in Nuttgens' studio, and was surprised to discover that, rather unusually for a craftsman, Reyntiens knew and admired the work of Matisse. She mentioned this fact to the Pipers.

The Betjemans knew that the year before, in 1953, John had been invited by Major L. M. E. Dent, a trustee of the Sanderson Memorial Fund which the Grocer's Company administered, to submit designs for three traceried windows in the apse of the chapel at Oundle School in Rutland. 'It is an exciting possibility!' John had replied. 'I would love to visit the chapel again with you and John B[etjeman, a friend of Dent's], and perhaps we can defer taking any positive steps till then. But it seems to me it might be foolish for somebody else *and* me to submit *complete* schemes'.[21] The project was part of the school's four-hundredth anniversary celebrations. The Chapel, built by Arthur Blomfield, had been consecrated in 1923, and at first Harry Clarke, the Irish stained-glass artist, had been named in connection with the apse windows, but this idea had been dropped. More recently, the headmaster, Graham Stainforth, had hoped that Hugh Easton, who did the prosaic and slightly sentimental windows for the ambulatory behind the apse, would undertake the job. Easton had pulled out and other names were being discussed when the Major, probably on his friend John Betjeman's advice, brought Piper in, even though he had so far designed nothing for this medium.

Initially, he thought that he could make these windows himself at the Royal College of Art, but this, Betjeman pointed out, was impractical. Not only was John busy designing sets for Bizet's *The Pearl Fishers* and Britten's *The Turn of the Screw* in 1954, he was also preparing for exhibitions the following year in New York and at the Leicester Galleries; in addition he had a 19-inch glass platter which he had agreed to design with a frieze of dancers for the American firm Steuben Glass; and, once embarked on the glass at Oundle, he was to curate an Arts Council stained-glass exhibition, to be shown at the 1955 Aldeburgh Festival and elsewhere. Then, too, he had various small commissions in the pipeline, a menu for the Double Crown Club, book illustrations for Anthony Blond, and a limited-edition lithograph for the Cambridge Contemporary Arts Trust, based on a rooftop view of the city and of King's College Chapel, for which his vantage point was a room high up in Trinity's Whewell's Court.

Nudged by the Betjemans, John invited Patrick Reyntiens to lunch, showed him a drawing of two crowned heads in a semi-Cubist style and asked if he could translate it into glass. Reyntiens took the drawing away and six weeks later returned on his Vespa, with a stained-glass version of this drawing held between his knees.[22]

Already, it seems, John had devised a scheme for the windows in the chapel apse at Oundle, each of which had three lights. In consultation with his old friend the Revd V. E. G. Kenna, he had decided to portray the nine aspects of Christ: as the Way, the Truth, and the Light; as the True Vine, the Living Bread,

and the Water of Life; and as Judge, Teacher, and Good Shepherd. The aim
was to show graphically the majesty and radiancy of God's glory. The tall thin
lights encouraged the use of elongation and the kind of stylization found in
twelfth-century sculpture. Carvings at Chartres had been a major inspiration,
though the faces also contain echoes of the Turin Shroud and the undeviating
frontality of foliate heads. John took gouache drawings of the nine figures to
show Major Dent and pinned them to his office wall. He also agreed to them
being hung in the Grocer's Hall where they were seen by a select few. After
this, one lancet was commissioned, as a trial window to show to a committee
for approval. When finished, 'The Shepherd' was exhibited at Phaidon Press
and at the Grocer's Hall,and was swiftly recognized to be a most outstanding
piece of stained glass, Betjeman telling John that it was 'your masterpiece to
date'. [23] This may have given John the confidence to resist suggestions for al-
terations, some of which were said to come from the boys. 'John Piper was very
charming but adamant,' Dent wrote to the Headmaster. 'Apparently the only
three people whose aesthetic judgement he really respects are those of his wife,
Kenneth Clark and Betjeman … and being a person of great artistic integrity
he is not going to compromise.'[24] He rejected the Headmaster's suggestion that
some of the heads could look inwards, as this would have destroyed the drama
created by a row of mask-like, hieratic faces which stare directly at us. Their
severe formality is offset by the softer lines of the robes which swing across and
down the bodies of each figure and are punctuated by the arms and hands and
the objects that they hold. Reyntiens, having shown in his trial panel of two
heads how an area of form can be shot through with a brighter colour, now
dramatized these figures of Christ, pressed together in a continuous frieze, with
dancing touches of yellow, and swoops of Prussian blue or turquoise or salmon
pink. The crowns sing out, especially at dusk, for Reyntiens made much use of
linear trails of light on a dark ground, with the result that the figures seem to
grow out of the background and disappear back into it, never revealing them-
selves whole and entire and separate from the surrounding darkness. This adds
to the sense of remoteness and enigma that the frieze conveys. The composi-
tion helps move the eye towards the centre, for the directional lines in the outer
two windows lean slightly inwards, giving a surging upward swing to the design
as a whole. Nothing comparable with these windows had been attempted in
England before: at one stroke, Piper had married an ancient medium with
contemporary art, the medieval with the modern (Plate 49).

To celebrate this achievement, the *Architectural Review* asked him to design
a cover for their August 1956 issue. John made a drawing based on the top half
of Christ as the Living Bread, the symbolic figure that occupies the central light

of the middle window. The magazine commented that Piper had managed to fulfil the difficult architectural role of enlivening a dull building. A photograph of the windows appeared in *The Times*, and a booklet was produced, written by Hugh Caudwell, a master at the school, to accompany the dedication ceremony on 26 May 1956. It was performed in the presence of the Queen Mother by the Bishop of Fulham, who had been a housemaster at Oundle some twenty years earlier. Three days later the chaplain Hugh Williams found an Old Boy of the pre-1914 generation standing by the chancel steps after early morning service, moved to tears by the beauty of these windows.[25] As the light sank in the evening the colours became richer and, as the figures darkened, their eyes shone. More recently, additional stained glass has been added to the chapel by Mark Angus, to the 36 windows running down the north and south sides of the nave. As a result, echoes of the colouristic drama with which John enriched the apse now filter their way down the entire length of the building.

The success of Oundle was swiftly recognized. Within a short space of time Piper and Reyntiens received major commissions from Eton College Chapel (a fifteenth-century building whose Victorian stained glass had been blown out during the war); the new Coventry Cathedral; and St Andrew's, the fourteenth-century mother church to the diocese of Plymouth, burnt out by incendiary bombs during the war and being rebuilt by the architect Frederick Etchells. These commissions took time to set up, approve, finance, and execute, and therefore overlapped with each other. A glance at John's appointment diaries reveals the extensive travelling and organization necessary to his whole enterprise. What is impressive is not only the scale on which he and Reyntiens worked, in several instances, but also the innovative solutions they uncovered. But, so far, this stained glass has received scant critical attention, an omission partly explained by the fact that stained glass has historically been regarded a 'minor' art form. But, as John Piper once observed, art is only minor when it is mediocre: when it is good it is major.

Related to his work in stained glass were the summer tours around France which the Pipers began making, sometimes moving also into Germany and Italy. At first John and Myfanwy took with them only the two elder children, leaving the younger two in the care of Myfanwy's mother. In the summer of 1954, they visited, among other places, Bourges and Chartres, so that John could deepen his understanding of twelfth- and thirteenth-century glass, with its use of deep blues and splinters of colour to penetrate the gloom. The following year he again visited Chartres, also Beauvais, Le Mans, Albi, Cahors, Charente, and the Dordogne, taking in ancient churches and cathedrals, and in particular the

Romanesque, en route. ('We saw such a lot! 3500 miles in all.'[26]) From now on the Romanesque was an influence that constantly resurfaced in his work.

The example of Chartres and Bourges lies behind not only Oundle but also the fifteen-foot-high five-light window which John and Reyntiens began making in 1957 for St Andrew's, Plymouth, to commemorate William Waldorf, 2nd Viscount Astor: *The Instruments of the Passion and the Cross of St Andrew*.[27] When shown in London before being put in position, it confirmed John's status as a major artist in this medium. Employing clear transparent colours, its composition sweeps boldly across the vertical stone mullions, reconciling abstract relationships with illustrative qualities. The symbols associated with the Passion, among them the crown of thorns, the pieces of silver, the dice, the nails and hammer, the crowing cock, are deftly spread around the five lights while the ladder, reed, and spear are arranged across the central three in the form of a St Andrew Cross, the whole having a searing intensity. 'It is a very exciting subject,' John told Moelwyn Merchant, 'like illustrating a gay (and a bit frightening) book for children.'[28]

All this busyness and productivity took place amidst family life. Only very rarely did John lose his temper but when he did it was, Frank Tait recalls, 'awesome'. 'Get that child out of here,' was a phrase sometimes used when there was work to finish and daylight was fading. For when things turned difficult, or there was mess and dirt, it was Myfanwy who was sent in to bat. Decisions on schooling, however, were made jointly, but were often rather unfortunate. The small local school, Rupert House, which had been found for the two younger Piper children had proved reasonably successful, but it is hard to understand why Suzannah followed Clarissa to Oakdene in Buckinghamshire, which, as a result of a new headmistress, had been far from satisfactory and where Suzannah proved a disruptive and awkward schoolgirl. Because Edward had been unhappy at Lancing, Sebastian, in 1963, was sent to Clifton College, Bristol, where he, too, found it difficult to conform. All were sent to boarding school but often came home at weekends. And though they were bright and talented, not one succeeded in the course of their education in obtaining a single 'A' Level. Schooling seemed to have less influence on them than home life, for visitors to Fawley Bottom sometimes observed that the children seemed intent on imitating their parents. But, in time, a degree of revolt emerged in the two younger ones, both Suzannah and Sebastian occasionally showing a need to get away from their intelligent, liberal parents.

John's relationship with Reyntiens could also have been a source of conflict, for there were differences in age, character, social background, and religious affiliation. Though Reyntiens remembers the collaboration, in its early years,

72. Piper family, 1952 (photograph: Janet Stone).

as being 'largely one of obedience' to John's ideas,[29] there quickly developed between them a mutual trust. John confidently handed over to the younger man his cartoons to be translated into the medium of glass. He gave no indication where the lead lines should go, leaving Reyntiens free play with these. And in time he came to rely a great deal on the younger man's suggestions and on his ability to construct 'a convincing argument on an extended scale in glass from my ink and water-colour vocabulary'.[30] It helped, Myfanwy noticed, that Reyntiens, an enthusiast and a beginner, did not try to thrust technical ideas on John.[31] But the exuberant Reyntiens soon acted as a foil to John, spurring him on with suggestions and ideas, and translating his designs into glass with complete confidence in his own abilities and taste. In the opinion of the stained-glass artist Brian Clarke, Reyntiens brought great life to John's windows.[32] 'There is rather a queue for Patrick and me now, owing to our Oundle and Plymouth jobs, I suppose,' John acknowledged, in February 1958, 'and we *are* more expensive as I have to be paid a fee on top of his.'[33]

A practising Roman Catholic, with family silver in his background and a cultivated mind, Reyntiens perceived that John's Anglicanism was uncomplicated, unfanatical, rather nineteenth century in its middle-of-the-road ethos, and underpinned by a great feeling for the place of Anglicanism in English history. Reyntiens also noticed that John seemed free of religious doubts but was not ostensibly devout. If John had any view on Reyntiens' Catholicism, it was simply, the younger man felt, that it was 'rather a bore'. Their creative partnership, if not always easy, kick-started Reyntiens' own career, for he soon began receiving commissions in his own right. A witty, eccentric personality, he once declared something 'as sly as the Gothic Revival'. This was in the garden at Fawley Bottom, and Myfanwy, picking up a tray of things to carry into the house, was heard to murmur, 'What on earth is sly about the Gothic Revival!' for she found Reyntiens intellectually bogus. Nevertheless, the gifts that he brought to the Piper–Reyntiens collaboration would, in time, place it on a par, in the history of stained glass, with that between Matisse and Paul Bony, Chagall and Charles Marq, Léger and Jean Barillet.

*　　　*　　　*　　　*　　　*

Stained glass appears to have stirred John's interest in other forms of public art. In 1954 he was asked to design a mural for the new Curzon Cinema in Mayfair. Though nothing came of this, the following year one of the Mayo Clinics, in Rochester, Minnesota, a philanthropic medical centre, commissioned him and eight other painters to create murals on the theme of 'a Mirror to Man'. John was the only English artist and his huge mural (34ft × 10ft) was originally hung in the main waiting area of a new building (Plate 50). (Since then, the building has been remodelled and the mural is no longer on display.) His subject, 'Man and Nature', offered a panoramic view of the landscape and beach at Clymping, sufficiently schematized to give it a decorative appeal but with a range of ingredients that suggested the combined influence of man and nature on the formation of the landscape. Aware that the finished work would have to be rolled on a drum for transportation, he took advice from the National Gallery as to what ground he should use. The recipe he was given involved eggs and linseed oil in equal quantities, with water and powdered titanium white added to the creamy mixture. He painted this mural in February 1955 in the barn across from the house which had been reroofed but was still open to the elements down one side. He worked against time, from two drawings, on a scale of one inch to a foot in the final layout. These he preferred to full-size cartoons as, when working from the latter, he found that emotion and feeling got lost in the process. The short commentary which he wrote to accompany the mural acknowledges the seeming war between man and nature but ends with the affirmation that all change is ripeness and not destruction.[34]

Three years later he produced a second large mural for an enormous common room in a new building at Morley College, London (Plate 51). Here he employs a more abstract style, inspired perhaps by the recent arrival in England of American Abstract Expressionism. This mural is based on a drawing of Nailsworth Mill in Gloucestershire and shows the mill pool with the mill and other buildings immediately behind, the town in the middle distance, and the Cotswolds, with some trees and houses, beyond. Very few of these ingredients are clearly recognizable, for, as he claimed in a statement he wrote, their forms and colours were merely the pegs on which the composition was hung. In order to harmonize with the mural, the room, which had large windows, was furnished with linen curtains in shades of rust and green, for it was hoped that the ensemble would create the warmth of atmosphere which the College wanted to provide, visually as well as spiritually.

There was some anxiety as to whether the mural would arrive in time, for the Queen Mother had agreed to open the new building, and by 10 a.m. of the day before nothing had appeared. At 11 a.m. a lorry drew up bearing a huge canvas on a wooden stretcher. John also presented himself. The glass entrance doors had to be dismantled, so that four men could carry the mural inside. When lifted into position in the recess in the Common Room it was found to be too large. According to the Principal, Denis Richards, John asked for a hammer and saw, undid the canvas at one end, sawed off a chunk of wood top and bottom, nailed the end piece on again, and restretched the canvas, now slightly reduced in length. Quite unperturbed, he threw out, 'No-one will ever miss a few inches from a picture this size.' But it *is* noticeable that the composition of the mural ends too abruptly on the left-hand side, leaving the picture unbalanced. The mural has since been moved to the Holst Room, a smaller space where it fills almost one entire wall.

A third mural was made for the liner *Oriana,* launched in 1960 (Plate 52). It was one of a range of ships which Colin Anderson's firm, the Orient Line, had begun before it merged that year with P&O, in a determined attempt to break with the old-fashioned baronial style of most ocean liners. Brian O'Rourke acted as Consultant Architect for the public rooms where a modern look was to be reinforced by the work of numerous artists and designers, all of whom were coordinated by the Design Research Unit. Its team included Mischa Black, who was instrumental in getting John to paint a freely suspended panel, 4 ft 8 in. × 25 ft, for the Princess Room. Whereas at Morley College he had accepted a fee of £500, roughly the sum he now earned for an oil painting, his fee from the P&O—exclusive of materials and cost of travel—was £1000. The panel was to be installed September 1960, but shortly before this, it had to be hung in the P&O boardroom so that it could be viewed by the directors. In the *Oriana* it did double service, acting as a dividing wall, when viewed from the large lounge, and sheltering a bookcase for the library on its reverse side. The original idea had been that it would suggest the four seasons, but in the mural the landscape merely suggests a change of clime as the eye journeys from one side to the other—a particularly apt visual experience for travellers moving from one continent to another—and was titled *Landscape of the Two Seasons.* The ship was launched by Princess Alexandra, who was given, at the directors' request, two large sketches for this mural as a memento. (Following the ship's decommission, the mural is now on long-term loan to the River and Rowing Museum in Henley.)

This was the last of his painted murals, for mosaic had by then become his preferred medium. In 1957 he had formed an association with Dennis M.

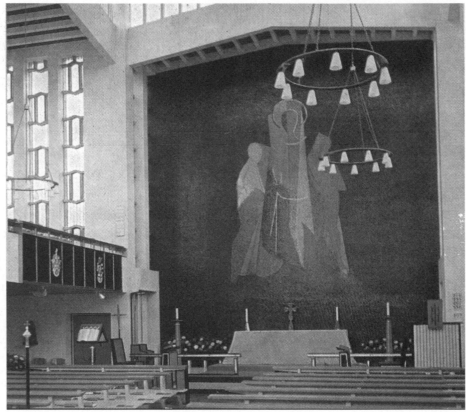

73. St Paul's, Harlow, showing John Piper's mosaic reredos.

Williams Ltd., a firm in Kingston, London, keen to revive the use of mosaic in modern decoration. John not only designed mosaic tops for metal-framed dining tables and smaller coffee tables (Plate 53), which were sold at Heal's, he also agreed to do large wall decorations on commission. With Williams's principle assistant Grace Grover, John worked in 1958 on an enormous wall mosaic which acts as the reredos behind the altar at St Paul's Harlow, a modern church designed by Derrick Humphrys for the town centre. The theme of the mosaic—the recognition of the risen Christ at Emmaeus—was suggested by the vicar, Donald M. Knight. Here the motif offers a knot of interest within a large expanse of dark green mosaic which acts merely as wall covering. With subsequent commissions John became more ambitious in his use of mosaic, for he realized that the firm imported many different kinds of marble, from Italy and elsewhere, rough, smooth, and glassy, and that the medium could be used to create an interesting surface texture. He also realized that it was necessary in places to mix coloured tesserae to break up large areas of a single

colour. He therefore began designing abstract wall murals in mosaic, one, in 1959, for a huge area of wall above the reception desk in the entrance hall of New Television Centre, Wood Lane, Shepherds Bush, and another, in 1961, for the entrance to the Chamber of Commerce in Birmingham (Plate 54).[35] In both, the wall surface is broken up into semi-geometric rhythmic patterning, offset by the play with colour and light. In this way he made vibrant busy but potentially anonymous architectural settings.

When interviewed in connection with the Television Centre mural, John extolled the utilitarian advantages that makes mosaic an excellent wall facing both indoors and out, for it is washable and permanent and has an agreeable surface quality. For John, it had a natural affinity, physical and almost spiritual, with much modern architecture. He told a reporter:

> I am particularly excited by the decoration of architecture and feel that the painter in his own medium of oil paint is at a disadvantage unlike the sculptor, whose bronze and stone go with the architecture: the stained glass man, whose coloured glass can be part of a building: and the mosaic worker who is (as it were) using chips of the whole block, the same kind of material.[36]

One constant in all this diversity was the continuing involvement with stained glass. At Eton College John found himself working in the wake of Evie Hone, an artist he admired for her 'sincerity, humility and conviction'.[37] In 1943 he had included two cartoons for stained glass by her in his exhibition 'The Artist and the Church', and two years later, 1945, in Dublin, he acquired an ink drawing by her, based on an ancient stone carving in Kildare Cathedral which he later reproduced in his small book on stained glass. The fact that, at around the same time, Hone bought a drawing of his from a London exhibition underlined 'the fellow-feeling I instinctively felt for her'.[38] Her powerful East Window in Eton College chapel (commissioned 1949, installed 1952) he equated with Léger's glass at Audincourt, in other words a modern masterpiece, more true to the medium of stained glass than the glass by Matisse or Braque.[39]

Yet Hone's East Window also presented him with a problem. Its statuesque majesty resides partly in the fact that all the figures are non-active and firmly contained within the vertical divisions, but it is further enhanced by bold use of pure red, yellow, blue, and green. These strong bursts of colour required the flanking windows, on the north and south side of the chapel, to have an equal strength. When they came to be renovated, Hone herself was invited to propose a solution. Her view was that the East Window would be best offset by abstract designs, but she died before doing anything more than some small, rough sketches, too slight to be of service to others.

John was brought in on the initiative of Robert Birley, Eton's Headmaster who had visited the 1955 exhibition of stained glass which Piper and Reyntiens had selected for the Aldeburgh Festival. The following spring he and the Vice-Provost and the Provost at Eton came to John's studio, to see one of the Oundle windows, encouraged to do so by the housemaster Oliver Van Oss, who had recognized in John a scholarly antiquarian and a sincere Anglican. In May, it was formally agreed that John Piper should be asked to produce designs for the two windows on either side of the east end. (This was shortly before the discovery of death-watch beetle in the chapel roof. Its replacement led to the making of a fan vaulted ceiling, based on that at King's College Chapel, Cambridge, and constructed, not in stone, but steel and concrete.)

John's ideas for the Eton windows unfolded slowly during the second half of 1956, amid preparations for an exhibition of his work at Kunstzaal Magdalene Sothmann, in Amsterdam, designs for a Covent Garden performance of *The Magic Flute*, and sets for the Covent Garden ballet *The Prince of the Pagodas* (Desmond Heeley did the costumes). Choreographed by Cranko to music

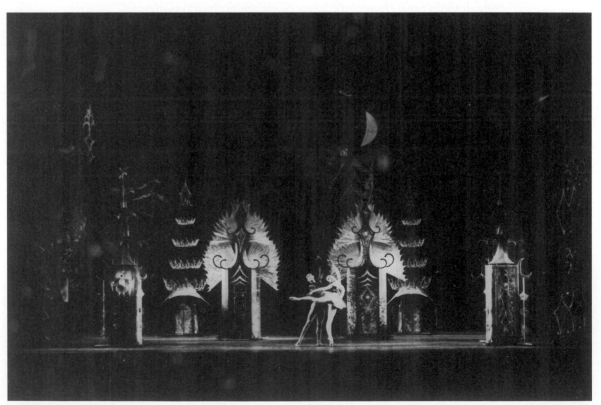

74. *The Prince of the Pagodas.*

composed by Britten, it was premiered on New Year's Day 1957, with Britten conducting. Cranko, who had decided to revert in style to a nineteenth-century classic, had constructed a fairy-tale plot out of *Cinderella*, *Beauty and the Beast*, and *Sleeping Beauty*, with a touch of *King Lear* thrown in, as a basis for mime, solos, pas de deux, and ensembles. The ballet was thought 'too clever to be effective'.[40] The same critic remarked: 'The décor by Piper, which included unsuccessful trick effects, did not blend with Desmond Heeley's costumes and the choreography was ostentatiously modern.'[41] Frederick Ashton, annoyed that he had not been asked to do the choreography, was also critical of its complicated hotchpotch of fairy tales. The musical score, however, continues to be highly rated.

When finally, in March 1957, John presented a stained-glass scheme for Eton College chapel, it was based on the idea of sacred and profane love. It received scant enthusiasm. While he thought up fresh ideas, doubts began to be voiced as to whether he was the right man for the job. Yet the commission came through in November 1957, with the agreement that he should design not just two but eight of the 35 ft × 15 ft windows in the eastern half of the chapel. At this point he insisted, as he had done at Oundle, that no other artists were to be approached for sketches while he was at work on his designs. On 1 February 1958 the Provost and Fellows were shown new drawings, some symbolic and others based on miracles and parables. They chose the latter and were suitably impressed, not only with general design but also the underlying conception. Some alarm was expressed at the strength of certain colours, but this did not impede discussion of fees. It was agreed that he would be paid £1000 for each window, to cover sketches, cartoons, and supervision during the period of making and a contract was drawn up. Normally John neither asked for nor signed any contracts. He was like royalty with money, having nothing to do with invoices and bills which he left to Myfanwy.

What he did know was that stained glass can be overburdened with meaning, subject matter, theology, or moral purpose. He would remind others of Chartres. 'The messages of the windows at Chartres—their meaning as a Bible for the illiterate—has little significance for us in comparison with their transforming effect on the architecture of the interior, their creation of an enclosed, escapist world of colour and modified light.'[42] The imagery may be of consequence, but greater significance is to be attached to the beauty of colour and line as it interacts with light. With medieval examples in his mind, he often found modern stained glass disappointing, feeble in drawing, and arty in colour: 'It sometimes seems as though the medieval glass-painter could not go wrong, and that the glass-maker of today cannot go right: that

we cannot in these days recapture the magic of the creation of jewelled light by a clear design.'[43] So he wrote, sadly, in 1979, as if wishing, in his own work, to challenge this conclusion.

Given this stance, it is ironic that sermons have often found a starting point in his stained glass, and nowhere more so than at Eton. The complex iconographic scheme was devised with help from Moelwyn Merchant. Because John told Merchant of his desire not to 'overweight the design by the idea',[44] the four parables and four miracles were chosen according to the degree of abstraction that could be brought to their realization.

In the end result the miracles fill four windows on the north side, balanced on the south side with the parables. The tall windows are divided in two, with the proposition in the lower part and the resolution—the victory over failure and the fulfilment of Christian hope—in the upper half. (The model for this may have been the glass in King's College Chapel, Cambridge, where the viewer is invited to make connections between the Old Testament scenes in the upper register and New Testament scenes in the lower.) At Eton, the designs closest to the East Window are the most abstract and the most richly coloured, though within them can be found allusions to 'The Raising of Lazarus' and 'The Light under a Bushel'. The remaining six are more representational, making use of effective patterning and stylization of motifs. This massive project obliged Reyntiens to travel to France and Germany in order to obtain the necessary glass, for both Eton and their work at Coventry. Because of the overlap with Coventry Cathedral, these eight windows took, in all, five years to complete, the final installation taking place in 1964. They are a magnificent achievement, offering a coherent iconographic programme, but less successful as a decorative ensemble than Oundle, for certain details, too insistently illustrative, disturb the unity of the whole. Yet such obvious handles on meaning are, perhaps, exactly what young boys during dull sermons need.

Inevitably, the design of stained-glass windows involved John not just with aesthetic issues but also liturgical needs. Having read G. W. O. Addleshaw and Frederick Etchells's *The Architectural Setting of Anglican Worship*, he was aware that church architecture and decoration cannot be divorced from liturgical arrangements. Liaising with churchmen and architects, he became interested in the Liturgical Movement, which came late to Britain and only began to impact on church planning in the late 1950s and early 1960s. Inspired by the study of early Christian worship, it sought to engage the congregation in more active participation and created a move towards greater church unity. This development, begun in France in the nineteenth century, had played an

influential role in church building in France, Germany, and Switzerland in the interwar years. Its influence on church building in Britain came later and owed much to Peter Hammond, the rector of Bagendon, Gloucestershire, who had studied art before his ordination and was zealous in bringing liturgical ideas to an architectural audience. In April 1958 the *Architectural Review* carried his 'A Liturgical Brief', a provocative look at new church planning, which he followed with two seminal books: *Liturgy and Architecture* (1960) and *Towards a Church Architecture* (1962). He stressed that church architecture must 'rediscover its true function as the handmaid of liturgy'[45] and dealt with what had already become a key issue—the position of the altar. In many churches this was brought forward, away from the east end of the church, so that the ministers face the people across the altar. ('The physical and psychological barriers are broken down,' Hammond argued, 'and all are drawn into the action which is taking place.'[46]) In general, the Liturgical Movement brought about an entire rethink on church planning in Britain, among all denominations, at the time when all were said to be searching for a common liturgical expression. This is one reason why the late 1950s and early 1960s proved to be an exceptionally inventive time for church architecture.[47]

One architect with whom John particularly enjoyed working was George Pace. They first met him in 1957, in connection with a window for Llandaff Cathedral. Pace was unusual in that he brought to his work a passion for the Arts and Crafts movement *and* an appreciation of the Modern Movement, in particular the work of Gropius. But he was also deeply imbued with an understanding of the principles of Gothic architecture and therefore well placed to act as architect in relation to bomb-damaged churches and cathedrals. His deeply cultivated knowledge of historical styles, together with his awareness of contemporary liturgical needs, was, in time, to make him a major figure in post-war church architecture in a modern style.

His most controversial move at Llandaff was the introduction of a rood to mark the transition from nave to choir. This took the form of a parabolic concrete arch spanning the nave, carrying a pulpitum which housed part of the organ and on which was mounted Jacob Epstein's *Majestas* in unpolished aluminium. This creates a visual stop, preventing the eye from seeing all at a glance, at a high level, but permits an uninterrupted view from west to east at low level. It also partially obscured a small roundel over the Sanctuary arch which John persuaded Pace not to block up. Immediately below, but still very high up, is a Piper–Reyntiens window on the theme of 'Supper at Emmaus' (1961–2), which makes the most of its remote position by employing strong colour and stylized figuration. Pace felt it had been carried out in line with

the self-effacement to which, he believed, all who worked for a cathedral must submit, as such work was essentially an act of worship.

The second project John did with Pace connected him with a new church in Sheffield, where Pace had become Diocesan Surveyor. In this role, he had to build three new churches, one of which was St Mark's, Broomhill, where the original church, except for its tower and spire and the south porch, had been destroyed by incendiary bombs on 12 December 1940. Though Pace had to modify a larger scheme owing to a financial shortfall, the end result is one of his finest achievements. By then he had fully adapted his ideas to the requirements of the Liturgical Movement: the altar is free-standing, there are large areas of communion rail, the choir is placed close to the organ on the north side where it does not intervene between the congregation and the altar, and there is unrestricted sight of the liturgical areas from all the pews. At the west end of the church a large narthex contains rooms and facilities that satisfy community needs. The use of reinforced concrete enabled Pace to pierce the north and south sides of the church with glazing, left uncoloured and filling the church with light and simplicity. The east end is similarly pierced, its asymmetrical array of lights filled with stained glass by Harry Stammers and giving visual correction to the irregular hexagonal plan of the church. The smaller west window, over the entry to the narthex, is also asymmetrical, its chunky concrete divisions similar in feel to those in the Baptistery window at Coventry.

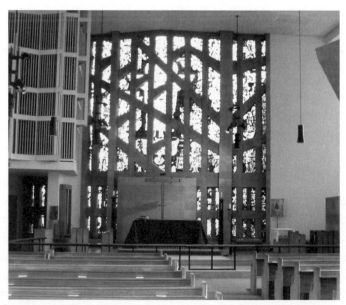

75. St Mark's, Broomhill, showing the east window by Harry Stammers.

John worked on this with Reyntiens between 1961 and 1963, soon after his experience of Coventry, and drew upon the simplicity and directness of approach that he had learnt there. The brief he had been given at St Mark's was that the window should offer an interpretation of 'Pentecost and the Holy Spirit blessing and guiding the work-a-day world'.[48] He conceived the window in terms of 'flames, yellow on blue, with their sparks and tongues of red and orange',[49] making an abstract pattern that spirals up through the lights. His simple and evocative design, symbolic of the Holy Spirit (Plate 55), also contains a reminiscence of the different kind of fire which destroyed the earlier building. Though subsequent alterations to the building have slightly diminished the amount of light entering the lower corners of this window, its purpose and mood are in keeping with the plan, elevation, and arrangement of the church itself.

The final project on which John worked with Pace, and for which, in 1967, he temporarily put aside a commission from the Worshipful Company of Bakers for a three-light window in their Livery Hall, was the King George VI Memorial Chapel, the first structure to be added to St George's Chapel, Windsor Castle, since 1504. Within the extremely restricted space available, Pace managed to combine a mortuary chapel with a liturgical chapel, the latter leading off the former, at a slight twist, with the result that visitors, peering through the wrought-iron gates which are kept locked, cannot see the full extent of the Piper–Reyntiens glass. The two windows behind the stone altar are predominantly pale blue, offset with white flower motifs and dots of strong red, the colours growing in intensity towards the centre line, thus helping to focus attention on the altar in the far chapel beneath the corona-like tower. On the east side, and invisible to the public, are greyish windows which affect the quality of light flooding in across the chapel, while, above, the clerestory windows in the corona are basically golden. When the chapel was dedicated on 31 March 1969, Pace thanked John for 'the discipline which has enabled you to create the glass so that it is part of the whole and yet, at the same time, your personal experience.'[50] But it is Pace's adoption of an aesthetic approach – twentieth century in style yet in sympathy with the spirit of late Gothic that makes this chapel such a refreshing surprise. 'He was a great man,' John wrote of Pace after his death, 'and the effect of his sensibility and scholarship will live on. We are all grateful for his life and influence.'[51]

One large-scale commission of questionable success is the enormous stained-glass wall which Piper and Reyntiens produced in 1960 for Sanderson and Sons' centenary. The problem here was that the space behind the window did not allow for sufficient light and the window had therefore to be lit artificially

from behind. Secondly, one flight of the main staircase crosses the window, cutting it into two halves. And thirdly, though John again made use of abstract shapes, which are full of invention, richly coloured, and vaguely suggestive of plant forms, the end result is hard and unsatisfying, the colours poorly coordinated and the whole curiously empty of feeling. A similar disappointment is experienced in front of the screen of foliate heads which Piper and Reyntiens did in stained glass and fibreglass for a new Trust House (now the Wessex) hotel in Winchester, which, again, in its present position, has to be artificially lit.

There is no doubt that John did his best work in stained glass for the Church, where the setting gives it focus and purpose. But the Church was not always easy to please. The authorities at St Woolos Cathedral in Newport dithered and fussed over a painted reredos which he devised, and over the rose window which they had commissioned. 'Really I do find high-up commissioning clergy jolly difficult sometimes,' he complained. Nevertheless Piper and Reyntiens were fortunate to be working at a time when there was a great deal of renovation of old and building of new churches. Yet, though 283 churches of all denominations had been lost during the war, the scarcity of building materials and the control of these materials by means of building licences meant that only 41 Anglican churches were consecrated during the period 1945 to 1956. This is one reason why the building of the new Coventry Cathedral became the flagship of the Church's revival. But it had progressed quite far before Piper and Reyntiens were called in to design the gigantic Baptistery window. Not only was this new Cathedral the first major public building to be completed since the war, it was also driven, to a large extent, by a certain romanticism and grandiosity of intention which had formed in the architect when he first saw the ruins of the old cathedral. Not surprisingly, therefore, the Baptistery window presented Piper and Reyntiens with their greatest challenge.

25

Coventry and Cranks

Fifteen years after he had experienced the destruction of Coventry, John was called back to the city to design the new cathedral's Baptistery window. In the course of the competition to find the right architect for this building, Basil Spence had been the only contestant to propose keeping the ruined cathedral untouched. His winning design placed the new at right angles to the old, with one of the main public walkways leading into the commercial centre of the city running between the two. Visitors leaving the old cathedral by means of the steps leading down from the north side of the ruin, cross this walkway and encounter at the entrance to the new cathedral a sheer glass wall engraved by John Hutton with figures of saints and angels. It catches reflections of the old cathedral at the same time that it offers a view through to the Graham Sutherland tapestry on the far wall. Once inside this glass façade the Baptistery occupies an angled bay immediately to the right.

The commission for this window came relatively late in the day. Funds for the new cathedral came from the Government's War Damages Commission, and Spence, wary that budgets might be cut owing to rising costs, had at an early stage commissioned tapestry, stained glass for the nave windows, and engraved glass. His aim was to achieve an integration of art and architecture, a precedent for which had been laid down in France where an adventurous policy of artistic patronage had been set in motion, largely by the Dominican Father Marie-Alain Couturier and Pie-Raymond Régamey, who edited the influential magazine *L'Art sacré* from 1937 until 1954. Couturier had been responsible for commissioning work from Léger, Bonnard, Braque, Chagall, Matisse, Rouault, and Germain Richier for the church Notre-Dame-de-Toute-Grâce at Assy, had acted as adviser for the chapel designed by Matisse for the Dominican nuns at Vence, and had been influential in obtaining for Le Corbusier the opportunity

to design the chapel at Ronchamp. These and other examples had set a new model for church commissioning which more usually erred on the side of caution and tired tradition. Couturier upheld the principle of artistic freedom, declaring that it was better to commission geniuses without faith than believers without talent. He also demonstrated that modern art of the highest order could be accommodated by the Church.

At Coventry, Spence's initial idea was that the huge Baptistery window should be filled with very pale glass, 'almost white, with a slight tint of rose and pale blue'.[1] By 1954 his perception of it had slightly changed; he was now planning 'to have stained glass designs representing the saints in infancy'; these would be translated into windows 'carried out in the clear pure colours of birth and innocence'.[2]

Needless to say Piper and Reyntiens were having none of that. It was not only the absurdity of the concept that they deplored, but, as John immediately realized, the near transparent entrance wall made it necessary to work with rich colour and strong contrasts. However, Spence would have been prepared for this different approach after seeing some of the glass that Piper and Reyntiens were in the process of making for Oundle.[3] In July 1955, he proposed to the Reconstruction Committee that John be approached to design the Baptistery window. As a result, it was arranged that the Provost, R. V. Howard, and Basil Spence would visit John in order to discuss the subject of the window and to ascertain on what terms the commission could proceed.[4]

The visit to the studio took place in October 1955. Immediately afterwards John sent Provost Howard an outline of his ideas for the window. Just over a week later, on 7 November 1955, Spence, who was in the process of negotiating a second contract with the Reconstruction Committee, at a time when a deficit of £200,000 seemed probable, judged it an inopportune moment to put forward John's estimate which at this stage had been based on £15 per square foot and came to £25,680. Spence's letter, therefore, concluded: 'There is, however, every intention that you should complete this window, the only question-mark is, when.'[5]

'This was not too discouraging,' John recalled, 'and Provost Howard and I went on hopefully talking about possible subjects.' He added:

> I first met Provost Howard, the kind and generous begetter of so much of the new cathedral, this same year, 1955. His letters to me show how the origins of the idea were not at all simple. My old clergyman friend Victor Kenna, who had an important and lasting influence on my life, combining as he did (and alas so few other clergymen do) an understanding of the

authority of the church and the authority of form in paintings and sculpture, had made several suggestions about the window.[6]

On the basis of Kenna's suggestions, John had initially proposed dividing the window into four sections, coloured green, yellow, red, and blue, in which the waters of the Ark would be contrasted with that of Baptism, and the fire of Sinai with that of Pentecost. But evidently this was not clearly conveyed to Provost Howard, who was puzzled as to his intentions. 'I wonder whether you could elaborate,' Provost Howard politely responded:

> The Ark is obviously the symbol of salvation. Sinai; I seem to remember that here the idea is the period of discipline and obedience through which the child must pass on the way to full free personality. Baptism. Is this the Baptism of our Lord? If so, it must be clear how this connects with Pentecost? Is it that the Holy Spirit was given to our Lord at his baptism and to the church at Pentecost?[7]

In order to help clarify the search for suitable imagery, Howard sent John a summary of what he conceived to be the fundamental truths of Baptism.

In the final solution theology was a less significant determinant than the stone mullions. The bowed window, which is 85 ft high (21.9 m) and 56 ft wide (approx. 1.8 m) contains 198 lights. Patrick Reyntiens remembers John at one point flinging out the despairing remark that even if he put an elephant or whale in the window it would be broken up by 'that nutmeg grater'.[8] Reyntiens also moved John away from his initial design by pointing out that the division into four differently coloured quarters brought to mind the packaging on a popular brand of tobacco.[9] At the back of Reyntiens' mind, though he admits he may not have mentioned it at the time to John, was the *Cathedra Petri*, where Bernini, in order to resolve the intractable problem of what to do with the intricacies of the design left by Michelangelo for the apse of St Peter's, Rome, threw in, above the chair and above the putti carrying the tiara and keys, a bundle of gold rays, a burst of angelic glory, in the centre of which a transparent dove, signifying divine inspiration, guidance, and protection, gives meaning and focus to the whole as it competes with the gigantic dimensions of the surrounding architecture. Directly or indirectly, Bernini's example fed into the subsequent discussions about the Baptistery window and the growing awareness of the need for a central unifying motif.[10]

Throughout 1956 the commission remained on hold, owing to the financial crisis faced by the Cathedral authorities. During that time the nave windows, designed for the new cathedral by Lawrence Lee, head of the stained-glass

department at the Royal College of Art, and his pupils, Geoffrey Clarke and Keith New, went on show at the Victoria & Albert Museum. Seeing these windows encouraged Piper and Reyntiens to conceive of their design in more abstract terms. The brief which Basil Spence had given Lee and his colleagues reflected his awareness of the way in which the *Art Sacré* movement in France had involved leading artists, such as Maurice Denis, Fernand Léger, Jacques Villon, and Henri Matisse, in the making of stained glass. Spence's intention was that the windows, which were planned as a sequence of pairs leading up to the sanctuary, should symbolize, partly through colour, a progression from birth to afterlife and should do so in abstract or semi-abstract terms. This was a bold idea at the time, for, as John later recalled, between 1953 and 1956, when the planning and design of the Cathedral was underway, 'abstract ideas were not at all easily accepted by public or clergy or committees in general.'[11] Lee and his designers eventually decided that 'abstract windows were not appropriate' and that 'some Christian symbolism should give a recognizable content for the spectator.'[12] John has put on record his and Reyntiens' response to these windows:

> We admired these a great deal, and I think we learned a lot by seeing and 'feeling' the size and nature of our undertaking in relation to their's before embarking on it at all. I remember feeling a bit worried about the elaboration of some of the symbolism in these windows, and I think I reacted from it a bit, instinctively.[13]

It seemed to John that at this time new ideas were beginning to boil. In 1956, the same year that he did the decor for the Observer Film Exhibition, celebrating sixty years of film, he witnessed a sudden revival of interest in abstract art, stimulated by a show of American art at the Tate Gallery in which the final room was devoted to Abstract Expressionism. Both Piper and Reyntiens were immensely intrigued by this show, and it was after seeing it that Reyntiens, with Bernini's *Cathedra Petri* in mind, began talking of the need for an 'explosion' in the Baptistery window, a solution which John immediately recognized.

The excitement caused by the first big American exhibition at the Tate became linked in his mind with the success of *Cranks*, a slightly Beckettian and Pinterish small-cast revue, devised by John Cranko, for which John had designed sets. Verbally and visually witty, it had been premiered on 19 December 1955 at the New Watergate Theatre Club, a tiny auditorium in Buckingham Street, off the Strand near Charing Cross. Cranko's idea had been to recreate the cabaret atmosphere he had discovered in little cellar theatres in Paris. The

cast of four sang and danced a series of numbers to John Addison's music without pause, with lyrics that, in manner and metre, were modelled on Edith Sitwell's *Façade*. The three men wore shirts and jeans from Vince Man's shop (one of London's first boutiques) while the woman was dressed in a black leotard and fishnet tights. John designed minimal decor and devised an assemblage of objects which the cast were able to arrange themselves for the various numbers and when playing different roles. Though the set was fixed it had splashes of colour on which Michael Northen's subtle lighting played with good effect, thereby changing the look of the stage between items. *Cranks* proved a great hit, at first with a cult audience, then with the wider public. Princess Margaret went to see it three times.

When *Cranks* transferred to the larger St Martin's Theatre in the West End, it gained a more elaborate but still informal set, and two wind parts were added to the score. It also helped make Annie Ross's name when, almost unheard of, she replaced Marcia Ashton. As the theatre was not available for long, *Cranks* transferred in May to the Duchess Theatre, and again in July, when it moved to the Lyric, Hammersmith, before going on tour round Britain. It won an award for the best musical of the year, extracts were shown on television, and a long-playing record cut. But when shown on Broadway it was not a success. Nevertheless, when Cranko left England in 1961, to become artistic director of the ballet in Stuttgart, it was *Cranks* the *Evening Standard* recalled before going on to claim that he had 'irrigated the London theatre with a sparkling stream of new ideas and techniques'.[14]

A willingness to try out novel ideas lay behind Reyntiens interpretation of John's cartoons for the Coventry window. Looking at the translation of his ideas into glass, John realized that, though Reyntiens' craftsmanship was traditional, the ideas that he brought to this work were new. 'He took contemporary painting—and this meant Pollock and Guston—as his immediate influence, my cartoon as his pattern for operation and what he had learned about stained glass as his means of action.'[15]

Negotiations over the Baptistery window reopened in March 1957. At Spence's invitation, John submitted a revised estimate which had been drawn up at just under £16 per square foot. This now amounted to £27,000 and, according to Louise Campbell, money was found by a schedule of savings.[16] Official authorization was finally granted by the Reconstruction Committee, Capt. N. T. Thurston, Secretary of the Committee, writing to John to this effect on 10 May 1957. A letter written the following day, from Provost Howard to John, usefully summarizes the stage which they had reached in the course of the previous year.

I have often thought of the evening we spent together here planning the lay-out. I have told our new Bishop [Cuthbert Bardsley] about the tentative and partial conclusion we came to. He agrees that I should take it up with you again from that point.

As far as my own memory serves me, the upper part of the window was to be in the form of a dove with spread wings, symbolizing the gift of the Holy Spirit in Baptism. The centre was to be a large sun with flaming rings, symbolizing Christ, the 'Sun and Righteousness' who fills and enlightens the Christian. The bottom part was to symbolize in some way yet not specified the response of man to the approval of the gift of God.

There was nothing final about all this, and you may have other ideas in your mind now. The next definite step is for you to prepare a maquette of the design which could be submitted to the Cathedral Chapter for their approval.[17]

In his reply, John hinted at the direction in which his ideas were moving. 'I wonder how much detail of a subject we shall treat … across all that stone-work. I think … it may be that we shall have to be more abstract than we first imagined—that there may have to be a pattern of colour rather than one of line or form.'[18] After this, he spent a good part of the summer brooding and sketching.

He also went abroad. Whereas in 1956 he had visited Charente, Moissac, and Toulouse, in 1957 the main purpose of the Pipers' summer holiday was to see modern churches and modern stained glass in France. This trip in fact began in Milan, in connection with a performance of *The Prince of the Pagodas*, which the Italians adored and clapped like mad. Afterwards Britten accompanied the Pipers to see the symbolic and heraldic windows by Léger and the richly coloured stained-glass baptistery by Jean Bazaine (Plate 56) in the small suburban church at Audincourt (a suburb of Montbéliard where Peugeot cars are made), as well as Corbusier's chapel at Ronchamp, which John thought a little self-conscious. Convinced that references to painting were a necessary source and norm for stained glass, he was keen also to see Matisse's work at Vence.[19] In the course of his extensive travelling it appears that his experience of modern stained glass—especially the powerfully emotive handling of colour by Marguerite Huré at Notre-Dame du Raincy, in the suburbs of Paris, by Léger and Bazaine at Audincourt, and by Matisse in his famous Chapelle du Rosaire at Vence—encouraged him to conceive of the Baptistery window as having no dove, nor any other representational symbol: instead the window would convey its message solely through colour; it would be colossal, theatrical, and uncompromisingly abstract.

John telephoned Provost Howard on 16 September 1957. The following day Howard informed the Cathedral Chapter of Piper's decision to work entirely in the abstract and encountered a very positive response. Looking back, John reckoned that 'the whole thing came in on a wave of public acceptancy of abstract visual ideas.'[20] A fortnight later the Provost and his wife visited John in order to see the sketch he had produced. It showed his ideas now simplified into the one blaze of light, and though the image was to be developed and refined, this was basically the design of the finished window. Apparently several studies were produced that autumn, one of which, in chalk, watercolour, and gouache, John presented to the Reconstruction Committee, in December 1957. Over it had been laid a black cardboard template, made by his son Edward, to simulate the effect of the stone mullions. Though the Secretary of the Committee records in his memoir that Piper described the design as 'a blaze of light, framed and islanded in colour; a blaze of light symbolizing the Holy Spirit',[21] he was quoting from the article that John wrote four years later for the December 1961 issue of the *Coventry Cathedral Review*. According to Reyntiens when the Bishop, Cuthbert Bardsley, asked John at the December 1957 meeting if there was any symbolism in the design, he replied, 'No, I don't think there is really, apart from the idea of a great burst of light and grace.'[22] From the Bishop's evident relief, on hearing this, Piper and Reyntiens formed the idea that the clergy had had their fill of arcane symbolism in the intricacies of the nave windows. The Minutes of the meeting record that the Bishop saw the design as 'an expression of the faith in an entirely new way with the subject emerging through the glory of the colour'.[23] One member of the Committee voiced a complaint—that the blue at the top of the window was too heavy— but it was quashed by Spence and the Bishop's enthusiasm.[24] Another moment that John never forgot was when Spence, proudly aware that the Baptistery window was larger than the east window in Gloucester Cathedral ('perhaps the first glass wall to be created in England'),[25] silenced the committee with his remark: 'Gentlemen, this cathedral is my *life*, and I know this design is right for it.'[26]

Work began on the cartoons for each individual light the following year. In order to judge the effect of his designs for the glass at Oundle, John had made use of Henley Town Hall where he could stand in the gallery and look down at his work. Now he brought in Justin Blanco-White to convert the half-ruined barn on the far side of the yard into a studio with a glass wall and sliding doors in its south elevation. ('I am trying to face up to Coventry,' he told a friend, 'and am going to have to restore the big barn to cope with it. Patrick says I shall get buried if I try to do it in this studio.')[27] This same year Edward

bought a motorbike, rather against his father's wishes, and electricity invaded Fawley Bottom. When the new barn studio was finished it made an excellent place for parties. The first of many to be held there was for Paul and Candida Betjeman and the Piper teenagers. John spent all Sunday afternoon practising with another pianist and a drummer, with Paul Betjeman occasionally on the saxophone. Nobody got to bed until four in the morning.

Meanwhile the sheer scale of the Coventry project made it hard to conceive of the design as a connected programme, for even in his new studio John could only lay out on the floor and hang on the walls twenty to thirty cartoons at the most, a small section of the total work. Reyntiens suggested that what was needed was a trial model of the total window. He constructed a 12-ft-high wooden frame and fitted it with stained-glass panels.[28] 'New studio smashing and Cov. model arrived,' John told a friend, excitedly, for the latter, which weighed half a ton, proved an immense stimulation: not only could John now see his ideas translated into glass, which brought a new intensity to the design, but it also gave him the opportunity to visualize each section in relation to the whole. The influence of Abstract Expressionism is more obvious in this model than in the final window, for, on this scale, Reyntiens was able to play with needles of red across green and to move around the design with great freedom, the model offering an exultant demonstration of how powerful colour can be. John recalled spending a long time looking at this model, and for many years it continued to sit on the floor of his studio by the window.

> Some of the sections consist of a single piece of glass, others are quite elaborately cut, fired and leaded: but they all have a living, excitable quality that is no mere copy of a cartoon but an exciting contribution to a major task—one important step on the route—that was stimulating in the right way at the right time, and carries over some of its inspiration in perpetuity. Stained glass seems to invite painting to be done—under its influence the painter sees a firefly and trails along in its wake; but in order to keep its spark alive it has in fact to trail along in the wake of painting.
>
> [...] Soon, I began to hand over the cartoons to Patrick which related to top sections of the windows (we began at the top, because scaffolding—essential for installation ... and an expensive item in a building programme—is removed from the top first) so that without the model, and its indications, I would have been lost.[29]

During the making of the actual window Piper and Reyntiens were continuously in and out of each other's studios, though they were ten miles apart. Alterations and adaptions occurred all the time, some suggested by John, some

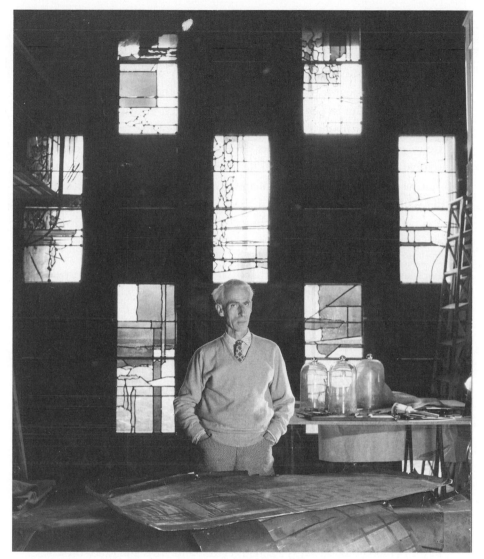

76. John in Patrick Reyntiens' studio, working on the Baptistery window for Coventry.

by Reyntiens, as their mood dictated for at no time did the design become fixed, the work never becoming a reproductive activity but remaining always interpretative. Fixing the panels in place began in May 1961. As there was no place where both men could erect much of the glass at any one time, they did not properly see the results of their labours until the lights were in position. Much thought had been given to the variety and size of the pieces of glass, for both were aware that the eye, after the first cursory glance, could easily tire in

absorbing detail unless it was allowed to rest here and there on larger plain areas, uninterrupted by the jarring effects of small lead-lines. The effectiveness of the whole owed much to the care that had been taken over every part but this only became clear as the window gradually unfurled (Plate 57). 'Your Baptistry window begins to glow very gloriously,' the Precentor, Canon J. W. Poole, wrote to John in June 1961.[30] He himself felt enormous excitement at this unfurling, after four years spent on the design of the window. He praised Reyntiens' energy and ingenuity, his patience and care—'and more than that, the creative intelligence with which he interpreted the designs'.[31] At one point John had wanted to introduce lilacs and greys in the lower part but Reyntiens had dissuaded him, as no echoes of these colours could be found elsewhere. There is no better guide to the orchestration of the complete window, and to his debt to the thirteenth century, than John himself:

> Ever since I was taken to Canterbury Cathedral as a child, my heart beats faster when I see blue glass in church windows, especially when it predominates in a window in the thirteenth-century manner. Since then I have been to Lincoln and Chartres, Bourges and Le Mans, and to many a country church where I knew there was a panel of thirteenth-century glass; and the magic never fails to work! That excitement, that heightening of emotion always occurs: the blue seems to be *there* in the window, firmly there in its painted glass form, and yet not there at all, except as a symbol of infinity, but infinity that has become intensely real instead of an abstraction. This is what one hoped to convey by the mass of blue at the top of the window, with its star-like and comet-like splinters and echoes of yellow and red. The blue here, of course, is intensified in its blueness by the red of the outer borders, which counterchange downwards, through purples, to blue at the bottom, against the cushion of reds and browns in the main lower part of the window. The central blaze of white and pale yellow is also cushioned by the dark yellows, ochres, golds, umbers and siennas that surround it. These in turn graduate downwards again into green and greys and other browns. The extreme outside edges of the window borders, on each side, are a direct derivation from the thirteenth century: it was a favourite device of these early glass designers to use white or pale-coloured spots or blobs in rows, in order to stop the colour jumping outwards, as it were, and making the design look diffuse. Here, the runnel of spots climbing the window on each side performs the same function.[32]

While the Baptistery window was being erected, John agreed to act as consultant in connection with six sets of new vestments.[33] He had previously designed two copes, one of which had been for Walter Hussey shortly before

his move to Chichester. The Hussey cope has large, simple shapes, cut out of felt, in soft shades of yellow and orange, appliquéd on to pale gold silk. John is said to have gone to his friends in the theatre to get it made, with the result that it was too heavy for its purpose and soon began to show signs of wear and tear.[34] More professional was the cope, commissioned by H. T. Sekers and made by Winsome Douglas, which he had designed, using red, blue, gold, and yellow appliqué on white silk, for the exhibition of British Artists Craftsmen sent round America by the Smithsonian Institute, 1959–60.[35]

The pleasure he had taken in both these copes explains why, on 11 February 1960, he readily attended a meeting at Basil Spence's house, at which it was agreed that the colours of the Coventry vestments should declare unmistakably the varying moods of the liturgical seasons and that any ornaments they bore should be bold and lucid in order to tell across the large distances within the cathedral. John's experience of designing for the theatre and his knowledge of materials well equipped him for this task. He did not actually design the shape of the garments, which were inspired by forms brought back into use by the French liturgical movement, but he chose the colours, selecting silks made by West Cumberland Silk Mills at Whitehaven, and he also designed the appliqued shapes with which they were decorated. These have no specific symbolism, but are evocative of growth and movement, of leaf or flame forms or exploded crosses. Aware that these garments would be seen in movement and would fall in folds, he was aware that whatever forms he used would be broken up and the image only partially glimpsed. More than half the total number of vestments had to be ready for use at the time of the consecration of the Cathedral on 25 May 1962, while the vestments for Lent and Passiontide had to be completed by January 1963. It was feared that ecclesiastical tailors would allow convention to dilute and debase the designs. However, John recommended Louis Grossé, a London firm of Church Craftsmen and Vestment Specialists established in 1783,[36] where the director, Louis Billaux, was so thrilled with the commission that especial care was taken with the realization of Piper's ideas.

As the Baptistery window came near completion, John's attention was momentarily given to a commission from the North Thames Gas Board, which had a showroom in Peterborough Road, Fulham, and wanted a set of mural designs for its outside walls. Though the building has now been turned into a block of flats with a gym attached, the striking decorative scheme which John devised, employing thirty-two decorative panels, each some 14 ft high and 9 ft wide, is still in place (Plate 70). The authorities at the Gas Board approved the abstract designs John showed them in collage, though at the time he had no idea as to how they would be executed. But he went to see a show of large fibre-

glass panels and other objects made by David Gillespie and Tony Manzerolli, two young men who had recently left the Royal College of Art. He then took two men from the Gas Board to see this show, after which the young men were commissioned to make the necessary panels for the showroom. Their method involved wax moulds into which was poured molten coloured resin, reinforced with glass fibre. Similar moulds were also made for the collaged motifs, with their recurrent use of the elongated spiral. John was present at Coombe Hill in Surrey when the panels were made and assembled, and where a giant tent had hurriedly to be improvised when a thunderstorm threatened, as the panels were not yet dry. 'Fun, ingenuity, as well a good deal of sensitive art', John once argued, are necessary for this kind of delegated art, when ideas are translated from one medium to another.

> In this case, the character of my original derived very largely from the scissor-cut shapes of my pieces of coloured paper. The character—that is, the hand-made look—of their finished work derives mostly from the knife-cut relief of the shapes, the knife-cutting into the wax which made the moulds for these coloured shapes. There is nothing mechanical about these shapes—they are felt, and they look as if they have been enjoyed, or anyway experienced, in the making.[37]

John used the same young men to assist him with a subsequent decoration for the main assembly hall in the new Corn Exchange, in Exeter. The city architect wanted a 29-ft-long panel for the opposite end of the room to the stage. As this did not have to withstand the weather, it was made of softer setting resin which permitted different treatments to the surfaces of the colours used, the black, for instance, being given the shininess of enamel, the work as a whole having greater variety of finish. Again, John was pleased with Gillespie and Manzerolli's interpretation.

In the midst of all this, not wanting to let anyone down, John managed to make three visits to Coventry in April 1962, though he rather dreaded the consecration of the new cathedral on 25 May and 'sitting for 5 hours or whatever it is, while the Bishops process and preen'.[38] It was indeed an elaborate affair, attended by the young Queen, Princess Margaraet, and the Earl of Snowdon, and representatives of more than fifty nations, and full of drama, not least because the Lord Mayor fainted with a terrible clatter of municipal chains and had to be revived by the Bishop of Birmingham. As no one quite knew how to consecrate a new cathedral, something approaching to an entirely new liturgy had to be devised. But the Right Revd Cuthbert Bardsley, Bishop of Coventry, dressed in the golden yellow mitre and cope which John had designed, made the most of his public

duties: 'None who saw and heard Cuthbert gliding majestically from lectern to West Door, from pulpit to font, beseeching the Holy Spirit to "*Be* there! *Be* there!" ever forgot it.'[39] The Archbishop of Canterbury, Dr Ramsey, chose as the text for his sermon Haggae 2.9; 'The latter glory of this house shall be greater than the former, saith the Lord of Hosts, and in this place I will give peace.'

Today, the Baptistery window continues to 'take' the light and the weather of the changing seasons, as John hoped it would.[40] Owing to the fact that the Cathedral is placed at right angles to the old and therefore on a north–south alliance, the window is at its most brilliant early in the morning as the sun rises behind it. Visiting preachers, emerging from early morning communion in the Chapel of Unity, on the opposite side of the Cathedral, often exclaim aloud at its effect. As the sun moves and the day progresses, the window gathers a darkness, but colour still flows and sweeps across it, despite the emphatic architectural divides. Even Reyner Banham, one of the most severe critics of the new cathedral (his *New Statesman* article, 'Coventry—strictly "Trad, Dad" ', famously referred to the Cathedral as a 'ring-a-ding God-box') was impressed by the Baptistery window.[41] *The Sunday Times* declared it 'the one great sure blaze of genius in the Cathedral',[42] and later that year used an image of it on its Christmas card. John found it a reward to the see the central blaze doubled by the morning sun on the floor of the nave, also to see it reflected in the shining black marble floor in cloudy weather.[43] Under certain conditions it also speckles the congregation as it gathers for a baptism round the font, made out of a huge ancient boulder from Jerusalem, the colours of the window becoming part of the liturgy. There are also certain tricks of light when the sun, doubled with the central blaze, seems almost to enter the building. Whether or not the visitor accedes to the symbolism of the light of Christ or the Holy Spirit, this sun-like effect reaches across the divisions often created by religious beliefs in its communication of regenerative, transformative power. The result is a triumphant, but not triumphalist, design. One art historian has suggested that the blaze at the centre of this window contains a reminiscence of the white light illuminating the ruins in Piper's paintings of the old cathedral.[44] What is certain is that a deep logic of reparation and reconstruction connects those 1940s paintings with the elemental trumpet call of the Baptistery window.

PART

VI

26

Ambiguous Venice

At Fawley Bottom, the kitchen was Myfanwy's domain, also the pivot around which the household moved. It could be entered by two doors, one opening directly onto the courtyard. Olivia Brett, daughter of Lionel and Christian, spent much time in the house as a child and usually encountered Myfanwy backview, standing at the Aga, cooking. She watched as Myfanwy made fish risotto, while talking about anything that was in her head, or filled a footbath full of flowers for the dining-room fireplace, as she did in the summer every two or three days. With her domestic skills and ability to cope with a never-ending stream of visitors, she ran a marvellous home, as her daughters attest. But they also admit that cleaning was not her favourite chore and accounts of the house are very mixed. Kenneth Clark claimed his wife, Jane, found a dead mouse in a glass of icy water beside her bed. Christopher Hussey's wife, habituated to a grander way of life at Scotney Castle, thought that Fawley Bottom lacked comfort and warmth. Patrick Reyntiens, on the other hand, recalls an ordered bohemianism.

> On a domestic level, everything had to be in apple-pie order. No bed was ever left unmade, no meal ever went unwashed-up, no clothes were left strewn across the furniture. But this careful regime was not for its own sake; it was seen as the necessary condition to be able, efficiently and economically, to prosecute more important matters.[1]

This description must be taken with a pinch of salt. If the cowshed studio was purposefully arranged, elsewhere clothes *did* lie heaped up, every surface in Myfanwy's sitting room was piled with papers and books and the kitchen often heaved with unwashed plates, for she was a messy cook and saucepans of fruit, left to cool for jam-making, were sometimes found congealed and forgotten. A

high degree of organizational mayhem lay beneath the surface order and was kept in check by Betty Cheriton, who came three days a week to clean and iron, earning a little money and much gratitude. In Suzannah's memory, Myfanwy was never seen with a Hoover.

To Penelope Betjeman, Myfanwy once suggested that they should write a large learned book on the premise 'that the present evils of our civilisation can be mainly attributed to the emancipation of women', in the confidence that it would annoy a lot of people and could be dedicated to Bertrand Russell.[2] She herself might grumble about some domestic tasks, but she never expressed frustration with her way of life. Yet her intelligence and strong personality, her love of words and grasp of ideas made her a first class critic, as is shown by the reviews she wrote for the *Sunday Times* in the mid-1950s, whenever John Russell was on holiday or abroad.

She does not beat about the bush. The Royal Society of Portrait-Painters' annual exhibition is wittily dealt with:

> It would need a Pope to do proper injustice to the acres of simpering, ogling, leering flesh, the yards of expensive silk, on show at the Royal Institute Galleries this month. Here is a world of complacent mutual admiration in which no good deed shines but is smothered.[3]

At a Tate retrospective of Stanley Spencer's work she neatly summarized his religious paintings as 'mixtures of sly observation and naïve imagination', and she rightly discerned a move from 'a natural eccentricity of vision to what seems to be eccentricity for its own sake'.[4] Equally astute are her insights into Wyndham Lewis, again at a Tate exhibition, where she found his Vorticist stance 'unsensual and unlyrical; an art of the intellect and of emotional reaction, violent, calculating and arbitrary'.[5] Yet, when this confident, outspoken woman was invited by *The Sunday Times* to chair a John Betjeman event at the Royal Festival Hall, she declined. 'I don't think it is my role to become an opening literary lady,' she explained to Betjeman. 'It's not for lack of love of you darling: but I simply couldn't—I'd like to come and listen though.'[6]

Her backdrop therefore remained Fawley Bottom Farmhouse, where every nook and cranny contained something of interest. There was no deliberate attempt to impress, for its style was more subtle than that, but it contained unusual features. The main bedroom had deep charcoal grey walls and exposed ceiling joists painted blue, the bathroom, a black-painted ceiling and huge blown-up photographs of French chateaux, taken by John. The wooden chest, which as a young man John had decorated in homage to Braque, sat at

the top of the staircase, beneath a huge metal roundel advertising Bass ale. Everywhere the eye fell on John's fabrics while one of his tapestries hung on an upstairs landing. The strong colours in the pictures on the walls were offset by the greys in the flint walls, the smooth green of the paddock and the quietness of the neighbouring fields. One startling feature in the house was the 5 ft × 9 ft massive slab of polished black Aberdeen granite, some 2 in. thick, which replaced the kitchen table and required a team of tombstone makers to put it in place. To it were added a modern set of black Italian chairs.

In the background lay always the pressure of work. If a commission weighed on John he could be fractious. But he finished work at teatime and most days, for relaxation, took a short walk. In the evenings, his contribution to supper was often the making of soup. He suffered digestive problems around 1963 and, on Britten's recommendation, began seeing Dr Michael Macready, a homeopathic doctor in Belgrave Square, who advised a diet that forbade milk, butter, and eggs. Myfanwy, always ahead of her time in culinary matters, began cooking with yoghourt instead of cream.

Over the years John had begun to feel proprietorial in relation to his immediate environment and when Jackson's Farm, just up the road, came up for sale, he feared that its forty acres, which ran up the hill towards Fawley, might be turned into a pig farm or fall into the hands of a developer. Unable himself at that time to afford it, he persuaded Hans Juda to buy it and then regretted he had done so, as Juda wanted to convert its outbuildings into a studio for artists and musicians. Eventually John scraped together everything he had and bought Jackson's Farm off Juda who, to his credit, sold it for the price he had initially paid.

Commissions, committees, and friends drew John to London on a regular basis. One port of call for him and Myfanwy had become Alfred Hecht's Chelsea flat over his framing shop which served an impressive array of clients, among them Man Ray, Graham Sutherland, Bob and Lisa Sainsbury, and that 'friendly fixer', the lawyer Arnold Goodman. Hecht was known as 'the Madame Verdurin of the King's Road',[7] owing to his homosexuality and his famous dinner parties at which politicians mingled with people from the world of film and theatre. The Pipers were often present at these. Hecht played no small part in giving certain artists useful introductions. He made John one of his executors, but a long illness and expensive and untrustworthy carers left him, at the end of his life, almost penniless.

As Edward Piper grew older, the bond between father and son deepened. He had grown accustomed, as a child, to sitting in the back of the car, rain drum-

ming on its roof, while his father, complaining about the weather, kept drawing nonetheless; to his mother talking endlessly on the telephone to Benjamin Britten; and to persistent discussion of churches between his father and godfather, John Betjeman.[8] Like his father, Edward had become a first-class photographer and a virtuoso jazz musician, often joining John at parties in extemporized piano duets. He also tried his hand at stage design, producing sets for *Journey's End*, the end-of-term play at Lancing, which his father declared 'tophole'.

Leaving school before 'A' Levels, Edward spent a year at Bath Academy of Art, at Corsham, where he was taught drawing by Howard Hodgkin. Then, in 1957, he entered the Slade School of Art where he began working at speed on figurative subjects. His fascination with the sensuality and eroticism of the female figure soon came to the fore, and, on visits to Soho strip clubs, he observed the effects of crude green and red spotlights on female flesh and drew the movements of the strippers. At a student party he met the biochemist Prudence Mackillop, who became a willing model and before long his wife. Their marriage began with Edward driving a tractor part-time in order to have enough money to paint. But this impoverished state ended when Julian Cotterell, who had married into the Stonor family, commissioned him to do the photography for Magimix cookery books, a job that led on to photographic work for *Vogue*, through Betjeman's daughter Candida. But even when settled at the Old Laundry, at Marston Bigot, in Somerset, Edward scarcely let a fortnight pass without a return visit to Fawley Bottom. He had become essential to the running of the place, for he was extremely practical and always busy with something, while his younger brother, Sebastian, was slower and more laconic.

In Olivia Brett's memory, the vibrant creative atmosphere at Fawley Bottom could be felt or sometimes heard almost before you entered the house. In summer, the constant productivity was offset by games of croquet and dips in the swimming pool which the Pipers had built in a field on the opposite side of the road. Unheated and surrounded by wild flowers, it was initially shared with the Judas until they built their own, a covered and heated pool on the far side of their house. The narrow lane that ran between the Pipers' house and their pool saw very little traffic but once a car was obliged to stop while Myfanwy crossed the road, quite unperturbed that her only piece of clothing was a short jacket draped around her shoulders. The sculptor William Pye, after visiting the Judas, never forgot, amid the resounding quiet, the sound of her stentorian voice calling, 'John, John.'

Some visitors found her formidable, for she had a high-voltage brain, a sharp look and did not varnish her words with niceties. Yet to Olivia Brett, a

child from an aristocratic background, Fawley Bottom offered freedom and Myfanwy seemed 'refreshingly honest' and 'perspicacious'. In conversation she was instinctively humane. Those who came to discuss projects with John noticed that she would join in the conversation with views of her own. She also shared her husband's acute response to the places they visited. 'We went to Mereworth,' she once wrote to Britten, after its owner Michael Tree invited John to make a series of drawings of the house. 'It really is a ravishing place, golden stone and stucco, square very Italian villa like, with two pavilions, set in a saucer-like park with what its guides correctly describe as Albano-like hills. The weather was hot and orange trees ripening.'[9] Mutual interests made it possible one Christmas for each to give the other a medieval gargoyle. And both contributed to the sense of abundance at Fawley Bottom, to the relaxed mood and the generosity of feeling which the farmhouse generated. On the broad window sill in the dining room sat a collection of some forty jugs, while the kitchen dresser burgeoned with colourful mugs (Plate 61). Then, too, in summer the garden glowed with huge poppies, peonies, red-hot pokers, deep yellow anemones, petunias, stocks, and irises and overflowed with veg-etables and herbs. Myfanwy's love of good food contributed to this sense of plenitude. In the 1950s, at a time when food was much less plentiful, Clarissa's schoolfriend Margie Campbell was astonished to see an entire salmon, freshly cooked, brought to the table. S. J. Woods never forgot how the Pipers turned up for a picnic lunch at his house in Deal bearing a full circle of Brie.

Myfanwy's sitting room overlooked the garden. An old parlour, with a high black Victorian grate in which in winter a fire was always lit, its chimney breast was covered with a bold, black and white diamond-pattern wallpaper by Ed-ward Bawden and on either side were shelves of books. Her typewriter sat on a table, near a comfy armchair, and in Reyntiens' recollection, there was always a fat, complacent marmalade cat purring by the fireside.

Here, between 1960 and 1963, she wrote every month a column on art for *Harper's Bazaar*. She drew upon her experience of art and artists, referring at one point to 'the ruthlessness without which no creative talent can survive',[10] elsewhere commenting on how much energy is used up in doubt and insecurity. She entered into contemporary critical issues, especially those that continued the debates surrounding abstraction in the 1930s. She was witty and percep-tive in her account of a Sotheby's sale in London of a New York collection of paintings by Picasso, Braque, and others.

> And so we put on our evening clothes and go to watch pictures make money. The clothes are in honour of the money—and of the pictures. Mr

77. Myfanwy's study, Fawley Bottom Farmhouse.

> Peter Wilson, Sotheby's endearing auctioneer, is brisk in the early stages, watchful in the later ones. There is a barely perceptible coax in his voice: 'Fifteen thousand, only.' And then, with a barely perceptible smile: 'Sixteen thousand? On my left, sixteen thousand, seventeen thousand, eighteen …' It runs on smoothly now. Once seen never forgotten, this discreet but astonishing disposal of the heart and guts and passions of a painter.[11]

When a major Picasso exhibition opened at the Tate Gallery in the autumn of 1960, she felt as if she were reliving the whole of her past life: 'So many vanished pictures seen again, and so many pictures seen hitherto only in reproduction viewed properly for the first time.' For her, the exhibition upset the received view that Picasso lacked consistency, was a poor colourist, or was a

mere genius, endlessly pouring out his gifts. Instead, it seemed to her that he was the least careless of painters. 'Nothing is left to chance, there is not an inch of paint, not the most summary looking brush-stroke that is not precise and intended. It is this, more than his vanity, or his brilliance, or his anger, or his wit, that fills his painting with a vitality that shocks.'[12]

In her diary, she wrote:

> No one could sit down in July 1960 and write about painting today without mentioning Picasso. It would be like pretending there was not a lion in the next room when one could distinctly hear its roaring, or that there were nothing going on upstairs when there are shrieks groans and shufflings.
>
> The exhibition at the Tate has opened the door and revealed a lion as a thing of beauty and has forced one to face that lunatic and shown him to be sane—but what is most interesting is that by exposing him for all to see those teeth have not been drawn.[13]

If such observations appeared to come easily to hand, there were other moments when she found it hard to find anything to say. In Rome with John in February 1961, she admitted:

> It is particularly difficult here to force oneself to expression. Pointless, overdone, stale. Anything one says has an echo through the centuries banal as a postcard. And one has only to read Elizabeth Bowen to see what happens if one tries to be different. Horrible inversions of expression and of thought too. Destroying the natural rhythm of response and giving it a staccato affectedness.[14]

At Fawley Bottom, however, her writing often gave way to other tasks, her energies contributing to the creativity within their daily life. When Roy Strong brought his wife, Julia Trevelyan Oman, for lunch, he found the Pipers sitting outside, an open bottle of wine on the table and Myfanwy shelling peas. It seemed to him that he had arrived at a place where life was lived as it should be. To Penelope Betjeman, the garden at Fawley Bottom offered 'a miracle of both beauty and utility'.[15] Graham Collier, Director of Art at Lancing (and later Professor at Western Washington University), acknowledged in his preface to a book on drawing and design 'valuable hours spent at Fawley Bottom with John Piper, where an ineffable sensitivity to the urges of the spirit and an awareness of the sacred elements present in even the simplest things pervade the atmosphere.'[16] Though the house exuded an artistic sense it was never self-conscious. Nor was it confined to Fawley Bottom but spilled over into the homes which the Piper children eventually made.

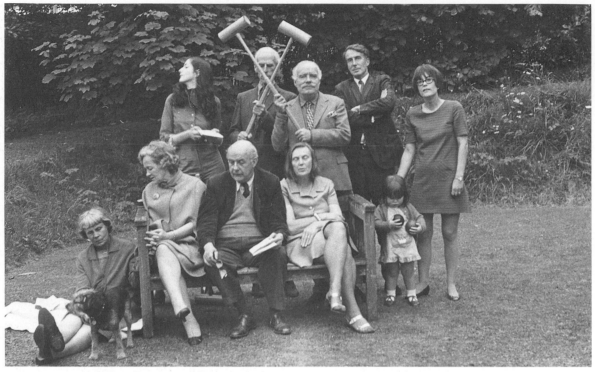

78. Claire Hastings, John Piper, Osbert Lancaster, Frank Tait, Cara Lancaster. Front row: Penelope Betjeman, Diana Murray, John Betjeman, Myfanwy Piper, Louisa (aged 2), Cara's daughter (photograph: Jock Murray).

One who found healing respite at Fawley Bottom was Tony Twentyman, who had survived a prisoner-of-war camp in Singapore. He first approached John in 1947, with a commission to paint his home, Bilbrook Manor House, near Wolverhamtpton. A small, exquisite man, brimming with puns, witty asides, and great enjoyment of life, he had read engineering at Pembroke College, Cambridge, but left before completing his degree in order to enter the family firm of import–export merchants, Henry Rogers and Sons Ltd, Wolverhampton. He referred to this work as 'Grinding at Annie's', for his real desire was to align himself to the Modern Movement as a sculptor and painter. Myfanwy noticed that his letters discussing the Bilbrook Manor House commission fussed minutely about the arrangements, the exact view to be painted, at what time and season, in what weather and when the foliage would not spoil the proportions of the house. Hard upon these letters came the man himself, as she recalls: 'a small, compact, amazingly neat person whose beautiful manners

seemed … to owe less to good, old-fashioned upbringing than to an innate courtesy combined with an extraordinary out-going warmth.'[17] From then on he became a part of their lives. He travelled with the Pipers to France in 1955 and 1960, went on sketching trips with John to Brecon and Radnor in 1959, and visited them on several occasions at Garn Fawr. He and Myfanwy were allied in their love of cats and obsession with limericks. 'We had a good journey home,' she once wrote to him, 'and I succeeded in doing Droitwich which has always stumped me.

> A sinister person of Droitwich
> Had a beautiful wife, but a roight bitch
> And she drank like a fish
> So he murdered the 'dish'
> And got rid of the body without hitch.'[18]

Tony had an almost identical, but slightly taller, brother, the architect Richard (Dick) Twentyman. Myfanwy noticed that the two of them had evolved a private language, 'an amazing concretion of slang, abbreviations, catch-words, foreign and initials, entirely personal to them'.[19] Together they moved in 1958 into a late Georgian or early Victorian house at Claverly, a village some eight miles outside Wolverhampton, where Tony turned an outbuilding into a studio. John and Myfanwy enjoyed visits to Claverly as there was always good food and wine and much conversation. There was also a frequent exchange of gifts, the Twentymans donating a large sun umbrella for lunch parties in the garden at Fawley Bottom.

Inevitably there were moments when Fawley Bottom was far from paradise, when, for instance, woodworm set in and the ceilings had to be pulled down and chaos reigned. In the midst of it all Myfanwy took herself off to see *The Prince of the Pagodas* and found Johnny Cranko suffering from severe hay fever and exhausted by the drugs he took for it. 'I found poor Erik in despair,' she told Britten, referring to Cranko's new boyfriend, the Danish actor Erik Mørk. 'I think those two are going through hell. Erik is having the usual ghastly time with agents and looks pretty strained. However he is very brave and they both seem fond.'[20]

She turned to Mørk for literal translations of passages from Kierkegaard's novella 'The Diary of a Seducer', and for encouragement to depart in some places from Kierkegaard's text when she wrote *The Seducer*, a play in two acts which she adapted from this bleak tale of seduction and betrayal of an intelligent, independent young woman. She had first read the novella in David F. Swenson and Lillian Marvin Swenson's translation of *Either/Or*, which had

also informed John's ideas for *Don Giovanni*. Published by Duckworth in 1958, Myfanwy sent the play to George Devine at the Royal Court, but he rejected it, explaining that the treatment was not sufficiently dramatic for his taste. It never found a professional outlet and was only ever performed by amateurs. Kenneth Clark expressed frank dislike of it, without, however, losing Myfanwy's friendship, for they still occasionally met in London for lunch, after which they might stroll into the British Museum to look at Sung painting or Japanese screens. But her affections were now more given to Mørk who, though a boyfriend of Cranko, was bisexual, also inclined to drink. He later married the actress Susse Wold and became a recitateur specializing in Hans Andersen and Kierkegaard. But for a period there existed between him and Myfanwy a degree of intimacy important to them both. When Erik's relationship with Cranko became troubled, Myfanwy noted in her diary: 'Very uneasy at hearing no words from E.M. Could I have offended?' (14 November 1963). Twelve days later a sheaf of postcards arrived and set her mind to rest.

In that innocence and experience are at the heart of *The Diary of a Seducer*, Myfanwy may have worked on this text in the hope that it would appeal to Britten, for in the aftermath of *The Turn of the Screw*, the possibility of further collaboration with him had been to the fore of her mind. Yet she had no wish to agitate him with ideas. She told him: 'The *Screw* was enough of a success for me to know that if and when the right thing turns up you could want to work with me in spite of the real difficulties you had to put up with last time.'[21]

In some ways the early 1960s were for her a fallow period, as a diary entry in 1963 suggests. 'All the time I write', she admits, 'it is an effort. I find my mind sliding away, bored by the effort of concentrating, or re-living the very strong feelings that I had at the time of things happening. In retrospect so little seems worth recording … everything slides away.'[22] In November of that year she mentioned, in her very intermittent diary, a concert performance of *Gloriana* at the Festival Hall. Afterwards, a party was given by Lord and Lady Harewood to celebrate Britten's birthday at which the shocking news of President Kennedy's death, which broke that day, was never mentioned. Two days later she recorded the happy fact that Clarissa had become engaged to a young paediatrician, David Lewis, whose mother was first cousin to Myfanwy's father. They were married on 15 January 1965, in Fawley Church. Afterwards all sat down to a wedding lunch at a long table laid out in the studio barn.

Venice and Rome were the two places to the fore in John's imagination during the late 1950s and early 1960s. This began with an idea for a book. Early in

1958 John discussed with the critic and painter Adrian Stokes a collaborative venture in which extracts from Stokes's writings on Venice, including the extended essay he had published on 'the city of stone and water' in 1945, would be offered, in revised form, to a publisher, together with illustrations by John. In mid-February, he and Myfanwy and their two youngest children set off, by car, for a month in Venice. Before leaving, John asked Stokes for a list of buildings at which he should look with special attention. 'I propose to draw daily (as much as ice and fog permit) and see what happens … I look forward to trying to paint in Venice with excitement and a lot of apprehension, naturally. If it is the immense flop it may well be I hope we will all forget about it rapidly.'[23]

His desire to paint Venice had been fired not only by Stokes,[24] but also Ruskin, whose *The Stones of Venice* he read and re-read, admiring in particular this author's passionate description of the approach to the city with which the second volume begins. On arrival, they rented a house on the Zattere. By May John could boast to Britten: 'The climbing kiddies are rather a menace to sketching, but I have done a bit, and we have picked up all the bits of sight seeing that we meant to.'[25] His paintings of Venice contrast the white Istrian stone with the greyness of the weather. They also play with the reflections on stone, brick, and water. Many of his oils were painted on coarse hessian, stretched over board, and on top of the loosely defined architecture and bursts of illumination he flicked skeins of white paint, thereby suggesting the dematerializing effect of dancing light. His pictures echo Stokes's texts, drawing attention to contrasts of light and dark, Venetian colours, and the organic relationship between its buildings and water. Stokes's observation—that 'the relationships of oblong, cylinder and curve inspired Venetian Renaissance architecture'—find visual demonstration in John's drawings of the Piazza di San Marco, where, with fluent handling, he caught the repetition of these motifs. Both men, in their different mediums, evoke the rocking movement of the waves and reflections, the architectural richness, the combination of realism and artificiality, the city's salt-encrusted stone, its glitter and decay.

Venice took such a hold on John's imagination that he and Myfanwy returned to the city the following year for the whole of May. They returned again in 1960, spending two days in Germany. This same year the result of his three sojourns in Venice went on show at the Arthur Jeffress Gallery, in Davies Street, London, where the flair and romanticism of these pictures found ready buyers.

Among them was Princess Margaret and after this exhibition, one of John's paintings of Venice hung in her dining room at Kensington Palace. She not only visited the show but was shown more of his Venetian sketches when she

visited Fawley Bottom with Tony Armstrong-Jones (later Lord Snowdon). On this or another occasion the Queen Mother also came to lunch at Fawley Bottom and in the course of the meal offered to wash up. (Nobody called her bluff.) Myfanwy took it all in her stride, but when John Royden, art critic of the *Daily Express*, rang up to talk about the sale of a painting to Princess Margaret, he received from her very short shrift. Jeffress, meanwhile, pleased that all the Venetian paintings had sold, offered John a further slot, suggesting an exhibition based on Rome, to be held May 1962.

John seized this opportunity and spent three weeks painting in Rome in February–March 1961, again working rapidly, excited by its architecture, knowing that he was looking at buildings he was unlikely to see again, also having the stimulus of a specific deadline. The sky was mostly overcast, but the clear grey light emphasized the baked red of the Roman bricks, especially in those monuments which were set against green scrub. As with his Venetian paintings, he used a ground colour, freely applied with a large brush, to suggest the mass of a building or large blocks of light and shade. On top of this he drew details often with an almost violent disregard for accuracy. *The Forum* (Plate 58), for instance, is less concerned with topographical accuracy than with mood and atmosphere, created, in places, by the whip-like movement of Jackson Pollock-style drips onto rough-weave canvas, by bursts of colour and the almost offhand treatment of architectural ruins. When, the following year, it was bought by the Tate, John reduced its price from 850 to 500 guineas (the maximum reduction that Robert Melville at the Arthur Jeffress Gallery would permit), and claimed it was the best of his Roman paintings.[26]

The prelude to these Roman scenes had been a holiday in Brittany in the summer of 1960. Working with ink, gouache, and collage, he produced a series of abstract works based on Brittany beaches at Morlaise, Finistere (Plate 59), Traquier, Dinan, and elsewhere. Here white sand broken by piles of seaweed on the low foreshore and the occasional strew of pebbles or debris gave rise to a play with visual incident against horizontal bands of colour. The summer before, he had employed a different kind of abstraction in paintings of the French landscape, in Provence and elsewhere. Here loose and broken patches of colour, amid a surface armature of mostly vertical and horizontal lines, were strongly reminiscent of his cartoons for the Coventry window. As if to point up this connection, he showed these landscapes alongside studies for stained glass at the Leicester Galleries, in November 1959. But Brittany, whence he returned in 1961, evoked a more liberated abstract style. It was in part a response to a second major exhibition of American art at the Tate, in 1959, which focused on

Abstract Expressionism. Another spur had been his interest in Picasso's use of free-floating colour in his lithographs.

His 'Brittany Beach' paintings could be seen close to home in 1961, at Oxford's Bear Lane Gallery housed in a small lane hidden behind Christ Church. It was run by Elizabeth Deighton, a friend of Patrick Reyntiens and who established the gallery in 1958 as a non-profit-making association, in the hope that grants could be obtained that would allow for expansion. In many ways it was ahead of its time, exhibiting David Hockney's drawings and John Latham's burnt books. Later, it amalgamated with the Oxford Gallery, in a move that created Oxford's Museum of Modern Art. John was one of its founder trustees. Nicholas Serota, its first director, recalls how certain members of the board tried to resist the move to obtain financial assistance from the Arts Council. They turned to John for advice. His insisted that they had to move forward and find support for young artists wherever they could.

His own work was far from stationary, for he was still constantly experimenting with surface tensions and textures in such a way as to make a new and original statement about a beach, a cityscape, a building, or landscape. An extreme cursiveness is found in his series of oils made 1960–1 on northern industrial towns such as Sheffield, Halifax, and Leeds.[27] His concern was not topography in the strictest sense. After visiting Halifax, he devised a composite view in which certain recognizable details—the Parish Church, part of Dean Clough, an old railway goods yard, and North Bridge—are woven into a richly coloured, semi-abstract composition.

Throughout this productive period he retained an interest in Venice. He showed Faber and Faber his and Stokes's book on Venice, only to have it turned down as they were about to bring one out on the city by James Morris. He then turned to Thames and Hudson, but again with no success. Not until 1963 did he find a publisher for the book, the Lion and Unicorn Press, at the Royal College of Art, entering into a joint agreement with Duckworth. Though the book was accepted with enthusiasm, the publishers wanted lithographic illustrations. These made necessary another trip to Venice as, by 1963, John felt that this medium required more immediacy than he could produce from old drawings.

The stage-like feel to these illustrations is a reminder that John was still intermittently designing for the theatre. In 1958 he had worked on Verdi's *Il Ballo delle Ingrate* for the Aldeburgh Festival, also doing colourful sets for Cranko's ballet *Reflections* (or *Secrets* as it is sometimes called), which was taken to the Edinburgh Festival. In 1960 he was busy with Britten's *A Midsummer Night's*

Dream. He rejected the received view that its scenery should be predominantly green, on the grounds that, as he pointed out, it was a Midsummer *night*.

> I had been looking at a lot of Chinese and Japanese brush and wash drawings while hearing Britten's music in early stages on the piano, all of which seemed to me to suggest (as do summer nights) shades of diluted Chinese ink, with sometimes additions of Chinese white, making tones of silver grey. I still find that these, for me, marry reasonably well with this particular music.[28]

In the sets, quickly drawn marks on gauzes suggested shapes found in a wood at night. The opera was premiered at the Jubilee Hall in Aldeburgh. When performed at Covent Garden, the scene painter Peter Courtier rendered the detached, disembodied effect that John desired by blowing the paint on to the backcloth through a stencil, made out of a screenprint mount.

Each morning the mail at Fawley Bottom arrived early; Myfanwy after making a cup of tea would read the post to John while he was still in bed. It usually contained requests that confirmed his role as a public figure. He sat, for instance, on the Advisory Panel that appointed Denys Lasdun to be the architect for the National Theatre; served on the Cathedrals Advisory Committee; became an adviser to the Hammersmith College of Art and to Hornsey College of Art; took on the Vice-Chairmanship of the newly formed Friends of the Ashmolean; and became Vice-President of several local societies. And, though he hated making speeches, he agreed to give talks to art clubs, schools, colleges, in public galleries and cathedrals, to Friends' associations, and for charitable causes, and, on one occasion, he addressed 150 clergymen in Derbyshire on the Coventry window. He permitted Theale Grammar School to name a house after him and gave them some of his prints. If Myfanwy's organization of their daily life made all this possible, he nevertheless gave generously of his time and energy. Only now and then did the instruction to Myfanwy, 'Get rid of him,' of some hapless visitor, reveal a ruthless streak beneath his charm.

Often, when not wishing to travel, he found it simpler to invite people to come to him, opening his studio to the Georgian Society and the Contemporary Art Society. A party of schoolboys from Eton enjoyed such a visit but still more the scrumptious tea which Myfanwy produced. Then, too, his correspondence continued to burgeon with commissions and occasionally included offers of honours and awards. In 1963 he received the offer of a knighthood which, as with the CBE, he politely declined,[29] but he accepted Honorary Doctorates

from the Universities of Leicester (1960), Oxford (1966), Sussex (1974), Reading (1975), Wales, Cardiff (1980), Essex (1984), and Leeds (1985).

A significant development in his professional life was his association with Marlborough Fine Art. This began in 1962 when the firm was the under the directorship of H. R. Fischer, F. K. Lloyd, and H. Lloyd and based at 39 New Bond Street. Representatives from the firm came to see him at Fawley Bottom and to his surprise picked out in his studio the work he liked best. They offered him a show in London in May 1963, and in the meantime arranged for an exhibition of his paintings to be sent, in November 1962, to the Gerson Gallery in New York, where the publicity was overwhelming and the event an enormous success. 'How well we will work together,' Harry Fischer wrote, presciently, in October of this year.[30] Association with Marlborough enabled John to reward himself with a new Citroen (coloured racing green with red trim) a make of car he continued to favour, having found a passionate Citroen enthusiast in a tiny garage in Cookham.

In terms of commerce, he could not have been better placed. Not only did he enjoy at Marlborough good relations with Tony Reichardt, James Kirkman, and the print specialist David Case, but he also benefitted from the firm's glossy catalogues which were sent round the world and placed a number of British artists on the international circuit. Through Marlborough, John had his work shown in America, Canada, South Africa, and Germany, and in London he joined an artistic stable that was to include Moore, Hepworth, Sutherland, Nicholson, Auerbach, Bacon, Kitaj, Pasmore, and Paolozzi. Marlborough was also bringing German Expressionism to England and now and then mounting landmark exhibitions, such as 'British Art in the 1930s' which Tony Reichardt and his wife, Jascia, curated in 1964.

In 1963, the same year that John had his first exhibition at Marlborough, he showed at the Stone Gallery in Newcastle. A growing demand for his work in many quarters meant that an agreement had to be drawn up with Marlborough. In return for two or three exhibitions over the next six years, including a retrospective in 1964 to celebrate his sixtieth birthday, John agreed that Marlborough would be his sole representative, with the exception of the Howard Roberts Gallery in Cardiff and the Bear Lane Gallery in Oxford. The Marlborough also agreed to lend paintings to the Leicester Galleries for sale at 10% on John's net prices, while work sold from his own studio was to be subject to a payment to Marlborough Fine Art at 25% of the selling price. He was to remain completely independent with regard to stained glass, theatre designs, and designs attached to architectural projects. All framing of work that was for sale was to be paid for by Marlborough.

Everything about this arrangement set his work off to good effect and proved financially rewarding. But the art world had undergone a sea change, and the sudden burst of interest in large-scale abstract art made his art look passé. His first show at Marlborough did not please the critics. In among the cartoons for the Baptistery window at Coventry, his Brittany Beach collages, and other works were paintings made in Anglesey and Pembrokeshire, some reduced to simple black or brown scythe-like abstract shapes. John Richardson wrote:

> Piper used to be a past master at conjuring up the genius loci. No longer. Celtic Twilight has been banished from his latest Celtic scenes. At the same time he has cut himself off from the 'picturesque' tradition of the 18th century to which he rightfully belongs and reverted to a slick modernistic idiom reminiscent of his abstract pictures of the 1930s. ... These resemble nothing so much as modern murals for an arty boardroom.[31]

Likewise, his retrospective in 1964, though it opened with a lively party, did not receive critical acclaim. John felt that both he and his contemporary, Graham Sutherland, were being swept into the historical dustbin. But encouraged by his association with Marlborough, there was no diminution at this time in the fire and energy with which he worked.

79. Garn Fawr.

In need of refreshment he turned again to Wales, buying Garn Fawr, a semi-ruined, one-room cottage with a slurry roof, half buried into the hillside at Strumble Head, near Fishguard, Pembrokeshire. It had no amenities other than a breath-taking view, southwards down across fields and pastures to the rocky coastline and the sea's boundless horizon. Though the landscape contains signs of business, not a sound could be heard other than that of the wind and birds. It took its name from a rock that rose to almost 700 ft in the lee of the cottage and which was crowned with an ancient hill fort.

Once again Justin Blanco-White came to John's aid and produced designs for the restoration of the cottage and conversion of a second small cottage, higher up, into a small studio. A couple of years earlier, she had let him know that she would like to own an example of his stained glass. He now designed for her a one-off piece which is almost an anthology of all the effects and techniques available to the glass-maker. It acts as a testimony to the friendship between the two families, and as a reminder that, while maintaining a high profile in the secular world of London's West End galleries, he was simultaneously engaged with numerous church commissions.

27

Dark Glasses at Evensong

The right creative act makes its own laws, and always will do so.

——John Piper, foreword to Enid Verity's *Colour* (1967)

The attraction of Garn Fawr in summer was its peacefulness. John liked it best when hay-making was in progress and butterflies—Ringlets and Meadow Browns—danced in the grass path that led from the road to the cottage. There was no telephone and only one living room, with a platform area that acted as a bedroom and was reached by a ladder. Behind, tucked into the hill, was a small cowshed and, slightly higher up, another tiny cottage which became his studio. There, in June 1964, he did a great deal of work on a commission he had received from Walter Hussey, who, since 1955, had been Dean of Chichester Cathedral.

Hussey, whose taste had been influential on the choice of artists and designers for Coventry Cathedral, was fast becoming one of the most outstanding religious patrons of the twentieth century. Most of the English parish churches and cathedrals which had survived the war had scarcely altered since the nineteenth century. Hussey was boldly intent on innovation. John thought him 'sensitive, perceptive, insistent and imaginative', also a discriminating collector of pictures and sculpture.[1] Robert Potter, Chichester Cathedral's architect and surveyor, found it a pleasure to work with him, in part because Hussey was good at entering into the mind of an artist or craftsman. Others perceived a more conflicted person: a churchman unable to conceal his passion for boys and an aesthete, so passionate in his desire for the best that he could sometimes appear arrogant in his pursuit of it, for he was determined to make the Church,

once more, a leading patron of the arts. Initially at Chichester he had kept a low profile, sensing the atmosphere and garnering support. But before long the Arundel screen was restored to its original position beneath the central tower and the chapel of St Mary Magdalen was redecorated in a modern idiom, Hussey working with Robert Potter and the sculptor Geoffrey Clarke. The finishing touch had been Graham Sutherland's small painting *Noli me Tangere*.

Hussey himself has acknowledged that the biggest challenge at Chichester was the 'rather gloomy and not at all distinguished'[2] high altar and sanctuary which seemed to him the least satisfactory part of the Cathedral. The carved wooden reredos, made in 1910 by Somers Clarke, was poor in detail and badly proportioned. The reinstated Arundel screen, which limited the view from the west of the high altar, made it even more necessary, he thought, to conceive of something vibrant, possibly in enamels, to draw the eye eastwards. Advice was sought from Sir Basil Spence and Henry Moore, the latter recommending Piper, with whom Hussey was already on terms of friendship. He was also aware of John's knowledge and sympathy with old ecclesiastical buildings.

So in January 1964 John and Robert Potter met in the Cathedral to consider the high altar and reredos. The outcome of this and other meetings was that the altar was brought forward a little and the 1910 reredos removed, leaving fully exposed the sixteenth-century Sherburn Screen. Across its seven blind bays John proposed to spread a decorative element. He rejected the notion of enamels, as such finely wrought work would make too small a show in the long view. Instead he proposed a tapestry divided into seven panels, each around 36 in. wide and 15 ft high. (Initially he wanted the buttresses and canopies on the screen behind to be painted and gilded, but he later changed his mind and insisted the wood should be left untouched.) The year before there had been talk of him designing a tapestry for the arch in the Holy Trinity Chapel in St Mary's, Chard, Swansea, but nothing had come of this. At Chichester, the major precedent, very much to the fore of his mind, was the enormous tapestry which Sutherland had done for the east wall at Coventry. Unlike that at Coventry, as he pointed out to Hussey, his would not hang alone on an end wall but, rather like medieval stained-glass figures in their canopied lancets, would relate to the divisions in the screen behind and therefore to the proportions of the sanctuary as a whole.

While Hussey persuaded the Friends of Chichester Cathedral to pay for this commission, John wrote to Moelwyn Merchant.

> I am sure tapestry has been wrongly approached for years. By G.S. at Coventry in too painterly a way ... and by Lurçat et al ... The question is

how much agreement and disagreement of forms (in size—tiny against big, curved against rectilinear, etc, in colour and shape. This has to be solved first in a funny way, even before the subject.[3]

Initially, he inclined towards a series of figures, a scheme similar to the glass at Oundle. But at a committee meeting in May 1964 one of his drawings, in which he had toyed with the Trinity in abstract terms, met with approval. He decided therefore to work chiefly with colour and symbolism. Moelwyn Merchant had first suggested the Christian doctrine of the Trinity, and, on a visit to Fawley Bottom, was flattered to find John exploring his ideas, using a triangle to signify God the Father, a Tau cross, with a symbolic wound to each arm, to portray the crucified Christ, and a shape that can be interpreted as either a wing or flame to suggest both the dove associated with the Holy Spirit (John 1.32) and a tongue of fire (Acts 2.1–4). These ingredients were to fill the three central bays, while the four outer ones (two on either side) were to contain symbols of the Evangelists—St Matthew (winged man), St Mark (winged lion), St Luke (winged ox), and St John (winged eagle)—and abstract depictions of the four elements, earth, air, fire, and water.

Hussey continued to move things along at a cracking pace. By September 1964 an estimate for the cost of weaving had been obtained from the same firm that had made the Sutherland tapestry at Coventry—Pinton Frères at Felletin, near Aubusson, Creuse. In January 1965 John sent in his finished cartoons which, as was his custom with stained glass, took the form of collages. At this point an archdeacon raised the objection that God the Father was only represented as part of a composite trinitarian symbol, whereas the Son and the Holy Spirit had additional, separate representations. Should not God the Father also be denoted separately? John, having crystallized his ideas, was unnerved by this criticism and slightly resented it. He asked for more time, partly so that he could discuss the problem with his old friend Victor Kenna, then rector of Farringdon near Exeter, and 'whose decisions I will take whatever it is, having shown him the design'.[4]

A month later, while travelling in Germany, looking at churches, stained glass, and Grünewald's Isenheim Altarpiece, and visiting Cranko at Stuttgart, John wrote to Hussey. 'The answer to our problem', he proudly announced, 'is: to have a white light on the left.' This device, as Trevor Brighton has remarked, may derive from early Renaissance depictions of the Sacred Name in a glory or sunburst,[5] and is similar to the motif that dominates the Baptistery window at Coventry. John assured Hussey he would be working on this new idea as soon as he returned home, in March.

By September 1965 the weaving of this tapestry had begun. In October a trial piece, based on the winged ox, symbol of St Luke, was sent to Chichester. It delighted Hussey who showed it at a Council of the Friends, placing it in situ so that they could see it inside the screen. The Pipers, meanwhile, had gone to Cologne, where a retrospective of John's work was on view. 'The opening was not only painless but positively enjoyable,' John told Hussey, '—lovely weather, splendid food and kind people. We came back by way of Holland, looking at Van Gogh, Rembrandt and Mondrian.'[6] The following April, they visited Felletin, as by then the fifth strip of tapestry was nearing completion. When all seven were done, they were laid out on the ground in the town square to be photographed. The total work had taken five months to weave, at a cost of £3,269. This same year John Burder made a television documentary on John, and among the twenty-five locations that he used is a glimpse of the Chichester tapestry being made at Felletin.

Hussey prepared for its unveiling by asking John to design the brochure and poster for the Cathedral's 'Flowers in Praise' festival. If this was part of a public relations exercise, so too was the exhibition of John's studies for the tapestry in a new gallery in Chichester, which again helped prepare local people for the appearance of a modern tapestry in an ancient cathedral. It was consecrated at evensong on 20 September 1966 (Plate 62). The immediate response was mixed. One Canon, who was also head of a nearby theological college, conveyed his dislike of it by attending the service in dark glasses. The implied criticism, which others shared, was that the Cathedral's quiet dignity had been damaged by Piper's strong colours. But the alternative view was expressed in a letter Hussey received from a Chichester resident, describing the effect the tapestry had on her. 'I felt here was something that was glowing and alive and symbolic of what the Church must and should be in the present age. It took away the feeling that Christianity is old and crumbling like the Cathedral.'[7] Forty years on, with its warmth and vitality glimpsed in the distance by visitors entering the West Door, the tapestry still looks strikingly modern and highly original. The fluent design, with its careful handling of motifs, symbolism, and colour, all skilfully interpreted by the weavers, distills and emits a remarkable serenity.

The installation of the tapestry did not end John's involvement with the Cathedral. In 1967 he designed for Chichester a set of vestments, using an elongated spiral motif; in 1975 the programme commemorating its 900th anniversary bore a cover by him; and in 1981 he donated a picture to the auction in aid of the Cathedral. The fame of the tapestry spread, aided by a touring exhibition of studies for it, shown at the University of Nottingham and else-

where, while the Lutterworth Press used a reproduction of it on the cover of four religious books for schools.[8] Twenty-five years after it was first installed, Canon John Hester wrote to him: 'It still causes excitements and disputes, all AD MAJOREM DEI GLORIAM! And it still does its original job of drawing attention to the sanctuary from the far west end. We all owe you an immeasurable debt!'[9]

In the summer of 1966, Myfanwy, having suffered from catarrh for some ten years, took herself off to a nature cure clinic at Stratford-on-Avon, partly to lose weight. While there she watched four plays, walked miles along the canal, lost twelve pounds, and most of her catarrh. When she joined John in Pembrokeshire twelve days later, she looked twenty years younger. Her appearance had always been striking, but her love of good clothes became more marked with age. She had an eye for interesting materials and employed dressmakers in her vicinity. She also shopped with zest, Hans Juda having pointed her in the direction of leading designers. Her favourite Karl Lagerfeld blouses were bought at Options, in Henley, and in London she frequented Liberty's, where there was a particular assistant who advised her. It was here, in the latter part of her life, that she bought clothes by Issy Miyake.

Like John, she too had become part of the great and the good. She joined the Arts Council, the funding body for much artistic activity in the country, outside that directly controlled by national galleries and museums or by local authorities. Under its wing came the National Theatre, numerous repertory theatres, all the symphony orchestras, except those run by the BBC, the opera houses, various small art galleries, arts festivals, and a miscellany of minor activities. Myfanwy sat on the governing Council, chaired by Lord Goodman. When her three-year appointment ended, in 1969, he expressed the hope that she would return before too long as her contributions had always been 'so sensible and well informed'.[10] He also paid tribute to her role within the Arts Council in his autobiography, referring to 'the splendid Myfanwy Piper … an open-faced, vigorous intellectual with qualities rarely found in the middle class. Her heart always led her towards the side of justice, the side of progress and the side of liberty, and she was an immensely useful member.'[11] In 1968 she agreed to sit on the Visual Arts Panel for the Museum and Art Gallery at Reading, and accepted an invitation to join the Court of the Royal College of Art, the highest body within this institution but not greatly demanding as it met only once a year.

Her pithy observations illuminated 'Back in the Thirties', an essay, reminiscent of the art world in the 1930s, which she wrote for the winter 1965 issue of

Art and Literature: An International Review. It stimulated a revival of interest in *Axis* and in 1967 she signed a contract with the American publisher Arno Press for a reprint of all eight issues. In 1966 she attempted to transform Trollope's *Cousin Henry* into a radio play. 'We are very happy that you have at last tried your hand at a radio play,'[12] wrote the producer Martin Esslin. But nothing came of this. A degree of innate laziness, mixed with domestic responsibilities, curtailed her creativity. Her catalogue essay for Mary Potter's 1964 exhibition at the Whitechapel Art Gallery is a case in point.

The Pipers had got to know Mary and her husband, Stephen Potter, the writer and BBC producer, through Britten and Pears, at Aldeburgh, and in 1954 had invited them both to Fawley Bottom. The invitation had been deflected because, as Mary afterwards explained in a letter, her husband had the week before announced that he wished to marry someone else and wanted a divorce. Though this began a period of gruesome misery, she had been helped through it by her friendship with Britten and Pears. As the Red House at Aldeburgh was now too large for her, she agreed to an exchange, giving it to Britten and Pears in return for Crag House. There, with her studio on the first floor overlooking the sea, she embarked on a new stage in her work, her paintings becoming more allusive and more abstract. They caught the attention of Bryan Robertson, who offered her a solo exhibition at the Whitechapel Art Gallery and encouraged her to work on a larger scale.

By 1964 Mary Potter had moved again, into the Red Studio which had been built for her in the grounds of the Red House. Here Myfanwy stayed a night with Mary, in August 1964, in order to obtain material for her catalogue essay. She began writing it on her return home. But, after an initial bout of work, she had to turn her mind to other matters, as Betty Cheriton, her char, was ill and masses of washing and ironing needed to be done in preparation for a visit to the Sitwells at Renishaw. 'It's rather wonderful to be in a house with such marvellous things everywhere and really beautiful things, not just country house grandeur and nonsense,' she wrote to Mary from Renishaw. 'But country life is very tiring. There is so much time not doing anything except waiting for the next arrangement—food, drive, sherry, conversation or whatever.'[13] This and other interruptions made the writing of her catalogue essay 'sheer hell'.[14] But the final essay, if not her most outstanding piece of writing, neatly pinpoints Potter's pursuit of 'a kind of suspended extension of the moment' and the sense, in her work, of 'the inescapable and extraordinary repetition of life'. Mary Potter's paintings gradually increased in number on the walls of the Red House, becoming a significant part of Britten and Pear's collection and, in Myfanwy's view, 'pools of perceptive calm in their sometimes rather fraught lives'.[15]

Her own life, too, could be fraught, chiefly with family anxieties. Her mother, living with her two sisters, Lena and Grace, at Upper Addison Gardens in Holland Park, was now confined to a wheelchair and needed carers which Myfanwy arranged. She shared in the torment when Clarissa and David's first child, still only a few months old, became dangerously ill, was transferred from St Thomas's Hospital to Great Ormond Street, lived for some days in an incubator, and then died. There were also tensions within the home at Fawley Bottom where Suzannah's need to break away from her parents had become apparent. At the same time Sebastian decided to leave Clifton College without taking any 'A' Levels, as he found the pressures to conform asphyxiating. Then, in the autumn of 1968 Suzannah began a social work course at High Wycombe where she fell in love with her tutor, Philip Hoggett, who had two children by his first marriage. He and Suzannah were married on 29 March 1969 at St Mary's Church, Fawley, Moelwyn Merchant conducting the ceremony.

When Harold Wilson became Prime Minister in 1964, President Johnson sent a congratulatory message in which he claimed that this victory showed British endorsement of American policies in Vietnam. As Vietnam had not been used by the Labour Party as an election issue, British intellectuals were quick to object. Margaret Gardiner organized a letter of protest to which John, among many others, added his signature.

More usually he remained reticent about his thoughts on politics or religion. When interviewed about his life in 1966 by a reporter from the *Evening News*, his chief admission was a passion for gardening which had set in about four years earlier, as an escape from the pressure of all his commissions. He now kept his seed packets in a kitchen drawer, spent much time in the greenhouse, and saw his herbaceous borders burgeon each year, with vegetables growing in and behind them. In the main flower garden, the path, he insisted, had to be wide enough for two to walk abreast. On another occasion he told a journalist from *Popular Gardening* that he liked a good background of well-grown trees. 'Whereas flowers have a brief, fragmentary life, trees do go on. They burgeon in the summer and die down in the winter and the change is very important. What I don't like are shrubs: they are mostly rather formalist things.'[16] He had found that the chalky soil in the garden had proved good for lilies of the valley, pulsatilla, and red-hot pokers; and he especially enjoyed growing giant heracleum and hoary grey weeds.

To the journalist from the *Evening News* he wryly admitted that an enthusiasm for gardening was often associated with bad artists. But he could boast that he had no television—'such a time taker'—for he preferred listening to music

on the radio. Pressed for further details about his life, he named his favourite dishes (cassoulet, navarin of lamb, and quenelles de brochet), and mentioned that he liked a fairly light Burgundy and adored the more exotic wines of the Jura or a good Traminer. 'I never cease to thank my stars', he told the reporter, 'that I have the way of life I do. My life's my own and I've filled it very full.'[17]

Despite his contentment, Garn Fawr continued to offer a refreshing haven from the routine of his life. 'Wales was looking wonderful last week,' John wrote to Moelwyn Merchant in 1966, 'and we had every kind of storm and tempest among the sunny times—all greens soft and spongy and smell of sea-weed and moss.'[18] Howard Roberts, who showed John's work at the galleries he ran with his wife in Cardiff and in London, visited and with John enjoyed gossiping about friends and enemies in the art world. While in Wales, John's interest revived in Welsh chapels, especially the 'splendidly gloomy' ones in Swansea, some of which he incorporated, by means of photolithography, into a series of prints, *A Set of Six Chapels*, commissioned by Tony Reichardt at Marlborough Fine Art.

From the start, his fresh excursion into printmaking was closely allied with his association with Marlborough. It was a hugely creative development and also commercially highly successful, helping to relieve the difficulties of satisfying the growing demand for his art. The medium of printmaking is particularly challenging to an artist whose methods depend on spontaneity. John had resorted to it at intervals throughout his career, ever since his first woodcuts in the 1920s. But in the Curwen Studio, working extensively with Stanley Jones on lithographs, and also at Kelpra, run by Chris Prater, a specialist in screen-printing, this inveterate experimenter became so enthralled by the wide range of techniques available to him that prints began to dominate his output and the oils he produced each year diminished in number.

Back in the 1950s, when Curt Valentin had commissioned lithographs, he had gone, on Robert Erskine's advice, to Mourlot's in Paris. Knowing that Mourlot was Picasso's printer, he had first looked closely at Mourlot's compilation, in book form, of Picasso's lithographs. On his return, he wrote:

> During my recent visit to France I was made aware of how much better is the lithography situation in that country. And before that, by looking at two wonderful books of reproductions of Picasso's lithographs. Seeing these, one asks oneself how on earth the originals are done—there they are on every page: all the things we have been told we can't do. Rich blacks, delicate, un-chalky yet solid half-tones, fine fluid lines in pen and wash, alterations, transfers, re-drawings and re-etchings all over the place. Picasso is a master, all right, but the printer is a master, too, and there is no doubt

about it, the one could have been lost without the other, all along the line. These lithographs are by Picasso *and* Mourlot, and Picasso would be the first to admit it, and be proud of the fact.[19]

In the 1960s Stanley Jones became John's Mourlot. They had first met at the Slade in the 1950s, where Jones was a student, passionate about lithography, and John a visiting tutor. Jones had gone on to become master printmaker at the Curwen Studio, where the two men met again in the late 1960s. They embarked on a constant reciprocal exchange of ideas. John would arrive at the studio with a watercolour, giving an idea of what he wanted to do. Jones then offered advice as to how the image could be split up for the various plates, colours, and printings. At the proofing of each stage, ideas that may have been imperfect at the start developed further as John responded to what came off the press, one thing leading to another, as the print progressed.

'He had a very flexible mind in image-making—ideas came from all kinds of styles and angles,' Stanley Jones has recalled.[20] To Pat Gilmour, who organized a major print exhibition, 'The Mechanised Image' (1977), in which two of his works were included, John claimed that lithography is 'a medium that needs bashing around,' and that 'a lot has been pinched from Picasso you know from those Mourlot volumes all of which I've got.'[21] Another book in his library was a fine volume of all Vuillard's lithographs, a further source of ideas, as was the sponging and spotting employed on his sets for Britten's *Midsummer Night's Dream*, a technique that entered his printmaking.

This method of working differed from that he was to use in connection with screen prints at Kelpra. The success of this print studio grew out of a contemporary desire to move away from the gestural in favour of the flat anonymous surface that screenprinting achieved. In the course of working with many leading artists, Chris Prater gradually enhanced the means available, a development that was to John's advantage. Not only did screenprinting offer commercial advantages over lithography, it also brought aesthetic benefits, for, in John's view, the interlock between photographic and drawn material worked better through screenprinting than photolithography. It was a combination he used in his 'Eye and Camera' series, a kaleidoscope of high heels, fishnet stocking and suspenders, for which Myfanwy posed. The series offered an outlet for John's interest in the erotic, and through it he showed his awareness of Pop Art. Here too is evidence of the cross-influence between father and son, for if the vibrancy of Edward's art owed much to his father's example, John, in turn, appears to have been stimulated by his son's obsessive play with the female figure.

But economics were equally a factor in John's printmaking. Financial rewards did not always match his public success, and the Pipers, who lived generously and appreciated good food and wine, were still in need of money. At Kelpra the work John produced did not always match in quality his Curwen prints. Screenprinting made possible photographic reproductions of his watercolours without reducing them to mere copies, for the result was parallel with the original, not a facsimile. Nevertheless it cannot be denied that, unlike lithography where depth is achieved by means of several printings and much reworking, photographic screenprinting, by its nature, gives an evenness of representation that flattens Piper's original image. Furthermore, at Kelpra, he became gradually removed from the business of printmaking, doing less handwork as time went on. He would hand over a gouache to be reproduced, photographically, and was sometimes absent when technicalities were discussed and modifications made, the printer becoming more important in the process than the artist. At the Curwen Studio, on the other hand, the demand was that the artist should participate.

His readiness to experiment is perhaps best seen in the portfolio of prints which he made at Curwen in 1964, *A Retrospect of Churches*. Using strong, bright colours, he brought to some of these religious buildings an almost Pop Art quality. Nor was he afraid to use photolithography, as he had earlier done, in one of his *Brighton Aquatints*, and this at a time when artists were only just beginning to convert the public to the idea that photography in printmaking could be art, not merely reproduction. His portfolio on churches was a retrospect in a double sense: of his long-standing interest in churches *and* of his various experiments with the lithographic process. John asked Betjeman to convey as much, in the preface he wrote. He did so admirably, in connection with churches, but he failed to point out that Piper had been ahead of his time in his use of photolithography, one of the first to regard it as a means of artistic expression.

Marlborough, aware that the 'Eye and Camera' series had not pleased the public, pressed John for more prints of churches and landscapes. Despite the commercial ingredient behind the proliferation of John Piper prints from the late 1960s onwards, they also provided an outlet for his exuberant creativity and visual curiosity, for his technical daring and inventiveness (Plate 66). They helped bring to a much wider public the geography of his work, the landscapes, buildings and townscapes, the fonts, monuments, and church interiors. And occasionally he worked not just at Curwen and Kelpra but also with the printmaker David Harding at the arts centre established by Patrick Reyntiens at Beaconsfield under the auspices of the Burleighfield Trust. He

80. *Eye and Camera No 7.* Collage, acrylic, and chalk, 56 × 76 cm (private collection).

also supported Robert Erskine when he sought to revive S. W. Hayter's print workshop, Atelier 17, in London.

The versatility acquired through printmaking influenced his graphic design. He produced a succinct, eye-catching dust jacket for William Golding's novel *The Spire* (1964), with its beam of white light slicing across a corner of a cathedral. His simple but pungent cover for a paperback selection, *Hymns Ancient and Modern* (1969), resulted in the proprietors approaching him again, ten years later, for the supplement, *100 Hymns for Today.* The second design had to be alike yet sufficiently dissimilar to prevent choirmasters and congregations muddling the books, a problem John solved by keeping the original design and merely changing the colours. For several years he was associated with the Oxford Almanack, published by the Clarendon Press, owing to the designs he did for its masthead.

By the late 1960s the strict terms which the Marlborough had tried to impose on the sale of his work had been relaxed, owing to persistent demand for

his work by small galleries in far-flung places. John struck up an association, for instance, with *Oriel Fach* (The Little Gallery) in St David's. He continued to give away much work to friends, stagehands, and craftsmen with whom he worked, while students who visited Fawley Bottom and expressed interest in his art, rarely left without the gift of a lithograph. Meanwhile, in one commission after another, he continued to come up with designs that were fresh and unpredictable, and nowhere more so than in the field of stained glass.

28

Sacred or Superstitious?

When Le Corbusier made a short speech at the consecration of his pilgrimage chapel at Ronchamp in 1955, he remarked that 'some things are sacred and others are not sacred—whether they are "religious" or not.'[1] Awareness that 'religious' content or literary association did not guarantee sacredness in art had made Father Couturier, in France, determined to break with the conventional imagery within the Catholic Church and to employ artists who might not be practising Christians but whose work had integrity.

In Britain, John Piper's career as a stained-glass designer coincided with a period of innovation in church architecture, partly stimulated by Le Corbusier. New ideas about architecture and liturgy, feeding into Britain from the Continent and in Scandinavia, had encouraged an interest in structural clarity and a liking for bare wood and unrendered stone and concrete. Ornament and a conventionally religious atmosphere were being rejected in favour of a new austerity which, in places such as Ronchamp or Matisse's chapel at Vence, had achieved a radiant simplicity. Economic necessity alone does not explain this development: it had been fired in part by the Liturgical Movement which wanted places of worship to recover the Christian qualities of poverty, humility, and simplicity and become once again places of silence, reflection, and prayer.

John followed these developments with interest. He visited Ronchamp in 1957, and, a couple of years later, when work was beginning on Le Corbusier's *Couvent d'Etudes*, a Dominican seminary at La Tourette, Eveux, he had written to his daughter Clarissa, studying nearby at Lyons, asking for news of it. He kept abreast of literature on modern churches and, in 1964, suggested to Tony Twentyman that, for Christmas, he might like to give his brother, Richard (Dick) Twentyman, of Twentyman, Percy and Partners (then building St Gabriel's, Walsall), G. E. Kidder Smith's new book, *The New Churches of Europe*. He

412

81. Ronchamp.

also agreed to design a stained-glass window for Twentyman's next church—St Andrew's, Wolverhampton. The elemental simplicity that he brought to this task reflected the new liturgical climate.

St Andrew's replaced a Victorian Tractarian church which had burnt down. At the time when the new church was on the drawing board, it was thought that the road outside would become a main traffic route. To cut down noise, the building is entirely top-lit, aside from a high and broad window in the west wall. Today, this featureless and windowless church, skirted not by a main thoroughfare but by municipal footpaths, struggles to survive in an area where the local residents are predominantly Muslim. But inside the church the influence of Le Corbusier can be felt in the great height and majesty of the bare east wall, with its rough concrete rendering, while the freshness and unconventionality of John's west window (1967–8) still surprises many (Plate 60). This large landscape-format window breaks through the end wall, offering a great flood of blue in which sweeping black lines and small vortexes swim and float. A similar use of linear movement had begun to appear in his Pembrokeshire and Brittany landscapes. Here, however, as Andrew was a fisherman, they evoke the life of sea, in terms that Myfanwy had once described:

413

When we look at a coloured picture postcard of the sea the vividness of our memory makes it easy to set the absurd, exaggerated blue in motion and experience once more the constant movement of the water, the unceasing swaying of the seaweed, the sucking and breathing of innumerable creatures, clinging, or scurrying or burying themselves, creating an endless pulsating murmuration of life within its power to seize and disturb, to induce melancholy or excitement.[2]

Not surprisingly, this window has proved very popular with children.

John's awareness of the Liturgical Movement can also be felt at Nuffield College, Oxford, where he designed not just the glass but the entire layout of a modest chapel in an upper room. Founded in 1937, the College had been gifted and endowed by the motorcar manufacturer Lord Nuffield, on the condition that it would be dedicated principally to the study of social, economic, and political problems. Designs were eventually accepted by the architect Austen Harrison, in the style of Cotswold domestic architecture. But work on the site did not begin until 1948, by which time inflation had seriously diminished the value of the capital endowment. Certain features in the approved design began to disappear: the chapel was dispensed with and a library complex over the road was at first postponed, then abandoned when, in 1953–4, it was decided to turn the tower into the library. Later still, the idea of a chapel was revived and John Piper's name associated with it. A prime mover behind this commission was 'the Queen of Africa', Marjorie Perham, a Fellow of the college and a pioneer in African studies, with whom John sat on the Oxfordshire DAC. Space was found for the chapel in a room, with small side windows and a steeply pitched ceiling, at the top of one staircase in the lower quadrangle.

Confronted with severe architectural limitations, John nevertheless managed to devise a calm, dignified space that can accommodate about forty people. In the final stages, he insisted on the softening of the lights. The walls of the chapel look white but are in fact a very pale grey,[3] while the pews, painted white, are edged with black, colours echoed in the chequerboard floor. Another dominant feature is the triple north window at the back of the chapel, its opaque grey glass containing the five wounds of Christ, the bleeding feet, hands, and heart. Four small windows, with deep recesses, punctuate the two side walls and are filled with stronger-hued abstract glass, the colours of which stain the recess walls when the light shines through. The altar, also designed by John, is made out of unstained beech, with black ebonised top and matching front panels. Behind it hangs a gold cloth, woven by students at the Royal College of Art. John had wanted Geoffrey Clarke to do the metal work, but he was unobtainable. Instead, he found in an exhibition an abstract sculpture by

John Hoskin, consisting of three vertical panels welded together with a raised vertical feature made out of wire, and this he chose for the reredos. Though Hoskin had not intended any religious symbolism, he came to accept the connotations that others found in it, and, on top of this, agreed to design a cross of welded wire for the altar table. Flanking it, on either side were originally squat, vase-like glossy black, ebonized candlesticks designed by Piper in the opulent Laudian tradition. The chapel was dedicated by Dr Harry Carpenter, Bishop of Oxford, in January 1967, and Nuffield College became the proud owner of one of the most distinguished pieces of modern design in the entire University.

A similar radical simplicity reappears in the baptistery windows which Piper designed for All Saints, Clifton, Bristol, a new church built in 1967 on the site of a former G. E. Street church which had been more or less destroyed by incendiary bombs in December 1940. The commission came through Robert Potter (of the Southampton firm, Potter and Hare), with whom Piper had worked at Chichester Cathedral. Excited by the idea of innovation in churches, Potter, having toured the Continent with Peter Hammond's books in mind, understood the impact that liturgical considerations were having on the design or restoration of ecclesiastical buildings.

While waiting for the go-ahead with All Saints, Clifton, Potter turned to Piper for advice on the restoration of a small church at Tudely, three miles south of Tonbridge, in Kent. Here the two men agreed on the retention of

82. Tudely Church before restoration.

83. Tudely Church, near Tonbridge, after restoration by Robert Potter and John Piper.

significant items from earlier times, but rid the church of its Victorian clutter, thereby releasing a powerful sense of purposeful order, calm, and peace. The initial cause of this restoration had been a commission, on the part of the local

d'Avigdor Goldshmid family, for a stained glass for the east window by Chagall to commemorate the death of their daughter, who had drowned in a sailing incident aged twenty-one.[4]

John was present when Chagall ('a great old charmer'[5]) arrived to view the recently installed window. But when it came to designing windows for All Saints, Clifton, completed 1967, he took as his model of simplicity not Chagall but Matisse. Potter had no difficulty in persuading the Parochial Church Council to commission Piper, nor did its members baulk at his bold treatment of the imagery—the Tree of Life and the River of Life—but serious reservations were expressed about the proposal to depart from the use of traditional materials. Yet had stained glass been used to fill the huge floor-to-ceiling window, bent round the font in the baptistery area at the west end, an area measuring 3480 ft, the cost would have been prohibitive. As a result, this appears to have been the first time in England that translucent fibre-glass and coloured resin were used in a church building. It was a material John also used in two windows he later designed for St Matthew's, Southcote, Reading.

At Clifton, he worked again with David Gillespie, who had set up David Gillespie Associates Ltd at Farnham, in Surrey, and was able to design his Tree of Life and River of Life on a huge scale and with startling simplicity, for the lightness of the material made leading unnecessary, aside from a few horizontal divides at regular intervals. The scale of the windows gives additional drama to John's near-abstract imagery, the River of Life falling in simple waves from a great height and the Tree of Life thrusting out branches punctuated with circular red motifs. The windows make the light in the Baptistery richly sombre, the drama of the whole is further enhanced by the step down into the area, which the architect intended to suggest a sense of immersion, a symbolical dying of the will so that the soul may rise with Christ. But, though liturgically meaningful, this change in level, combined with the dimmed light, leaves the individual underwhelmed, not easily visible to the rest of the congregation, and, in order to give Baptism the focus it requires, some form of artificial light is often felt necessary.

Nevertheless, All Saints is an outstanding example of modern church architecture, of which its current congregation is justly proud. The glass scheme extends to two long vertical strips of red glass on either side of the sanctuary, and on the south side to a large triangular window, which flares across almost the entire gallery wall, and which was filled by John with pure blue. The same colour is found in a smaller scale on the north side. When the sun rises the south window floods the church with colour, a welcome effect, though as the window heats up the fibreglass crackles and spits, with the result that the present incumbent,

while quietly engrossed with either Cranmer or Common Worship, is subjected to a noise much like that of eggs and bacon crackling on the stove.[6]

The pairing of the Tree of Life with the River of Life recurs in John's work: in two lancets for the chapel at Christ's College, Christchurch, New Zealand, in memory of a former Headmaster and Chaplain, Ernest Courtenay Crosse; and again, a decade later, in the two stained-glass windows he designed for the entrance to the chapel inside Charing Cross Hospital, London. They are motifs often associated with transcendence, renewal, and peace.[7] But the Tree of Life is the one that crops up repeatedly in Piper's stained glass, right up to end of his working life.

The Tree of Life figures significantly in the first and last books in the Bible. It is found in Genesis alongside the Tree of Knowledge, where it is left in the Garden of Eden guarded by cherubim and by a whirling and flashing sword. It is an image referred to repeatedly in the Bible, especially in the Psalms and the prophets Isaiah and Ezekial as well as in the final vision of St John's Revelation where it reappears bearing twelve different kinds of fruit as well as leaves that are 'for the healing of the nations'. The sources for this image are also pagan, for it is associated with the sap rising, and closely related to the Green Man and foliate heads which also figure significantly in John's art. But pragmatic reasons may also explain why he favoured the Tree of Life: it is a motif that can be easily translated into a modern icon, and it is one that can be made to spread across a number of lancets or a given space.

We find it, in near-abstract form, in the east window of the chancel at St Giles at Totternhoe, near Dunstable; in the elegantly stylized Churchill Memorial Piper–Reyntiens window in the National Cathedral in Washington, DC (Plate 78); and in the lavishly rich glass memorial to Henry Rainald Gage in St Peter's Church at Firle, in Sussex, its many fruits including the greengage, first brought to England from America by the Gage family. Piper revives the Blakean Tree of Life which had earlier been used in one of his backdrops for *Job*. A year later this image made its final appearance in one of the three lights in the memorial window to John Betjeman at Farnborough, near Wantage, in Berkshire, John's design here, as at Firle, translated into glass by Joseph Nuttgens.

The time spent on all these commissions is incalculable, as many hours were spent liaising with craftsmen, architects, clergy, churchwardens, and sometimes members of Diocesan Advisory Committees. Simon Crosse, who commissioned the glass at Christchurch, New Zealand, in memory of his father, caught a glimpse of the public relations exercise with which John was caught up, for

on visiting him at Fawley Bottom in the 1960s, he found this remote farmhouse buzzing with people and activity. 'I was very pleased to see you the other day,' he afterwards wrote, 'but must apologise for staying so long in the attempt to get in a word between reporters and visitors. What hell it must be for you having so many people at the weekend!'[8]

Then, too, some form of dedication ceremony usually followed the installation of these windows at which John was usually present. At Totternhoe, in 1971, the Bishop of Bedford gave an address which struck him as 'one of the best and most inspirational sermons I have ever heard.'[9] It is possible that in the course of his work for the Church he encountered dreary or dysfunctional or obstructive clergy. If so, he left no more of this than a passing hint.

Colour, the most striking ingredient in John's stained-glass windows, is especially to the fore in those windows that are abstract. There are three windows by him in All Hallows, Wellingborough, and the last of these is the so-called 'Creation' window, designed in the late 1960s, in memory of Constance Elizabeth Chapman, at the request of her sister. The vicar, Canon Methuen Clarke, who had worked as curate under Hussey at St Matthew's, Northampton, had suggested that a source might be found in Constance Chapman's favourite hymn. John replied:

> I love the idea of All things bright and beautiful and (after a lot of doodling) have done it. I do hope Miss Chapman won't find it too surprising. I think there in the chancel it might glint and glimmer on grey days and cast bright and beautiful colours on sunny ones. I hope you like it. Do remind her it is only a sketch.[10]

His initial drawings for stained-glass commissions were always loose and informal. A need for openness prevailed. 'I hope that the DAC may not insist on any more sketching', John wrote to Met Clarke, '—as I have told the secretary, too much sketching destroys an artist's idea, and whittles away his impetus.'[11]

Strong reds and deep blues recur in his stained glass, but he was equally fond of harmonies of white, grey, yellow, and silver, colours which, as Maurice Denis pointed out in 1937, give to French fifteenth-century churches 'an atmosphere of serenity, a French light, analogous to that of the Loire, the banks of the Seine and the Ile de France.'[12] An opportunity to aim at something similar came in 1967–8 when John was invited to design a window for St Margaret's, Westminster, the fifteenth-century church, close to the Houses of Parliament and beside the Abbey, which had lost its Victorian glass in a bomb blast in the war. Opaque bathroom glass had been installed until the War Damages

Commission came up with some money, which was thought enough to do one window. When the incumbent Canon Michael Stancliffe (later Dean of Winchester) showed him the windows in the south wall and said he could choose any one of them, John pointed out that a single stained-glass window would have to compete with the blazingly rich east window, made in Flanders, to commemorate the marriage of Catherine of Aragon to Henry VIII,[13] and that it might therefore be wiser to propose a simpler and relatively inexpensive glazing scheme for the entire south aisle, some eight windows in all (Plate 67). An appeal was mounted and the money raised. Piper, working with Reyntiens, devised an unaggressive screen or filter for the daylight, using rising and falling oblongs and splinters in muted greys, greens, and yellows. These create a grave, serene mood, an atmosphere that in no way detracts from the baroque wall monuments or the grand vista eastwards. They preserve the spirit of the building while retaining their integrity as pieces of twentieth-century glass; yet when first installed, they were criticized for being too modern and over-assertive. Later, however, visitors sometimes failed to notice this glass. John regarded this as a compliment and said he wished there were more opportunities to make such discreet interventions. In fact, the gentle modification of light in St Margaret's is a repetition of what he had achieved, on a smaller scale, two years earlier, through the lightly coloured memorial windows in the school chapel at Malsis School at Cross Hills, outside Keighley in North Yorkshire.[14]

There was nothing discreet about the row that blew up over the chapel at Churchill College, Cambridge. In 1967 John was brought in to discuss stained glass for this building which opened in October 1967, some five years after the main College buildings and after eight years of bitter dispute over whether the College needed a chapel. Founded in 1958 as a national memorial to Sir Winston Churchill, the College's constitution gave special emphasis to science, engineering, and technology. Its Trustees had not originally identified a need for a chapel, but after the student newspaper *Varsity* deplored the absence of a chapel, a small body of opinion began to call for one to be included in the design of the college. A key figure in the debate was the Revd Hugh Montefiore (then Chaplain of Caius but to become one of England's best known bishops). In the *Cambridge Review* on 24 May 1958, he and another college chaplain challenged the Trustees to declare their intentions as regards provision of a chapel. Such pressure resulted in the announcement that a chapel would be built, if funds were available. Montefiore promptly sent £10 towards a chapel fund and got up a campaign among the deans of other college chapels, with the result that Sunday collection boxes rattled with money earmarked for a chapel

at Churchill. Meanwhile he also sought an affluent patron and in 1960 found the Revd Timothy Beaumont, a thirty-one-year-old wealthy Anglican priest, publisher, and Liberal politician, who was willing to put up the entire cost of the chapel. Once Beaumont's covenant had been signed, plans went ahead for a chapel which would have sat directly opposite the sheer wall of the great dining hall, forming the east side of a courtyard. Foundation piles were driven into the ground, but progress was halted by strongly anti-chapel feeling on the part of a few Fellows. And in 1961 the College acquired national notoriety when one of these Fellows, a Nobel Laureate and militant atheist, Francis Crick, who had unravelled DNA, the secret of life itself, resigned his fellowship in protest. 'His basic objection', writes the Revd Dr Bryan Spinks, a former chaplain at Churchill, 'seems to have been that religion was superstitious and outmoded, and a college concerned with science and technology should be completely disinterested in and even hostile to religious affiliations',[15] or, in the words of another historian, that 'in the second half of the twentieth century an institution dedicated to advanced knowledge and free speculation had no business promoting superstitious nonsense'.[16]

As the controversy over the chapel continued, proposals were put forward that would have rid it of any specifically Christian orientation. Aware that the College was in danger of losing Beaumont's benefaction, the Vice-Master and Senior Tutor John Morrison arrived at a pragmatic compromise: a Christian chapel would be built with Beaumont's money, but it would not be integral with the main college buildings; instead it would be positioned at a distance from the College, close to the trees on the western boundary. Moreover it was to be *at* but not *of* Churchill College, and was to be run by a separate board of trustees.

This proposal secured agreement. A free-standing chapel in a remote position offered the architect Richard Sheppard new opportunities. He was gratified when John was brought on board: 'I was pleased', he told John,

> not only because I had always hoped that we should be able to persuade you to design some glass for the chapel but also to get your reactions to the whole range of buildings. I was most interested in your suggestions for the glass and for the general arrangement of the chapel and hope that I may be able to persuade the Committee … to adopt them.[17]

The result was that the chapel caught the spirit of the modern Liturgical Movement.[18] Sheppard abandoned the traditional plan which he had originally envisaged, and replaced it with a Greek cross which permitted a centralized

altar, top-lit by a glass lantern. By the time construction had begun, it had been agreed that the chapel should be interdenominational and ecumenical. At first, most of the furnishings were moveable, to aid liturgical flexibility.

Initially the eight tall thin windows, two on each of the four sides, had temporarily been painted blue. In addition there is a large pane of glass on the west side looking towards a copse, but this end of the chapel was originally intended to have a small committee or meeting room which could be opened up for extra seating in the chapel or shut off by a sliding wall, as and when needed. This, however, was never built and as a result the building has a greater degree of light than was originally intended, for Sheppard wanted the building to create a feeling of withdrawal and stillness, with the prime source of light coming from the glass lantern at the centre of the building. The Piper–Reyntiens glass adds immeasurably to the drama and cohesion of the building. The overall theme is 'Let there be light' (Genesis 1.3), with the blue windows at the east end intended to represent the human search for truth and God's revelation; the gold and green windows north and south, the human search for beauty and love and God's response; and the mauve windows in the west side, human industry and God's creativity. The scheme climaxes in the east windows, which are different in shape from the rest, owing to a stepped movement outwards, so that the east wall can accommodate the organ. The strong blues in these windows sing out, and are bordered by a row of yellow and white dots, in medieval fashion. John had originally hoped that fibreglass, which he felt suited the shape of these windows, could be used, but this idea was abandoned and Reyntiens executed them in traditional stained glass. The total cost, four years later, for the design, manufacture, and installation of the glass came to £6500. John agreed to a fee of £1600 for his designs and for his supervision of the project. The windows were unveiled on 4 October 1970 as a memorial to Sir John Cockcroft, the first Master of the College.

It seems that John turned again to Kenna for advice on these windows, and that drops of blood were suggested. Instead, he made use, once again, of the less precise symbolism suggested by a burst of white light, positioned fairly high up in these windows. Kenna was disappointed, reminding John that without the shedding of blood there is no remission. 'Perhaps after all', he wrote, 'Divine Providence had a hand in it and Churchill got the windows it deserved. They never really wanted Christianity but something like it as an adjunct to College life.'[19] New buildings at Churchill have crept closer to the chapel, but it remains controversial, half-disowned and continues to function at a distance, physically and ideologically, from the main body of the College, its glass windows vulnerable to golf balls and other activities that take place on

the grassy sward, while a more recent conference centre, built nearby, boasts a side building with a glass tower and is frequently mistaken for a chapel.

Ecclesiatical work had become such a feature within John's career that, in April 1967, the Marlborough Gallery mounted an exhibition of his and Ceri Richards' designs and studies for church commissions. It included John's studies for the glass in Liverpool's Metropolitan Cathedral of Christ the King, an iconic building which had that year reached completion and was to be consecrated on 17 May 1967. It was the first cathedral to break with a longitudinal plan and to place the altar at the centre of a circular church, immediately becoming the most famous expression of the new liturgical thinking in Britain.

This was, in effect, the third attempt to build a Roman Catholic cathedral in Liverpool. Back in the mid-nineteenth century Edward Welby Pugin had begun work on a Gothic building, only part of which was ever completed.[20] In 1922 the project had been revived by Archbishop Keating, and by the time of his death in 1936 there was £122,000 in the Cathedral Building Fund. His successor, Archbishop Downey, obtained the nine-acre Brownlow Hill site and coined the slogan, 'A Cathedral in Our Time'. Sir Edwin Lutyens was appointed architect and, drawing upon a variety of sources, he conceived of a massive building, larger than St Peter's in Rome, with dome that would have been higher than that of St Paul's Cathedral. A foundation stone was laid in 1933 and, at the wish of Pius XI the Cathedral's title was changed from 'the Good Shepherd' to 'Christ the King'. Work was begun on the crypt, but it was halted by the war, during which time Lutyens died. After the war, the crypt was completed and brought into use, but its phenomenal scale pointed up how grandiose and hopelessly unrealistic the original scheme had been. By 1955 the cost of Lutyens' design had risen from £3,000,000 to £27,000,000, and so Adrian Gilbert Scott was asked to scale down Lutyens's design and produce a compromise solution. These plans never really left the drawing board and, in 1959, by which time John Carmel Heenan (later Cardinal) had become Archbishop of Liverpool, an open competition was announced for a new Cathedral, to link with the existing crypt. The brief was for a building that would seat 2,000 people and which could be built in five years, at a cost of one million pounds in 1960 terms.

The brief was prepared and the competition held before the Second Vatican council clarified the liturgical arrangements which would bring significant changes in church design. Yet already a liturgical wind of change was sweeping the altar table from the east end towards the heart of the congregation. Whereas the medieval sacramental liturgy had been practically invisible, screened off at

the end of the chancel at the east end, the congregation merely eavesdroppers on a holy mystery, the modern liturgy by contrast placed the minister at the heart of an active congregation, the spirit now communal and vernacular. The letter which Heenan wote to accompany the brief had stipulated the following:

> The high altar is the central feature of every Catholic church. It must be the focus of the new building. The trend of the liturgy is to associate the congregation ever more closely with the celebrant of the Mass. The ministers at the altar should not be remote figures. They must be in sight of the people with whom they offer sacrifice.
>
> Holy Mass is the great mystery of faith. The high altar is not an ornament to embellish the cathedral building. The cathedral, on the contrary, is built to enshrine the altar of sacrifice. The attention of all who enter should be arrested and held by the altar.'[21]

Frederick Gibberd, designer of London airport and Harlow New Town and with a large and prestigious practice, won the competition with a centralized plan—a circle of 194 ft in diameter which would permit some 3,000 people to gather, all within 70 ft of the central sanctuary.[22] Lutyens' massive crypt was retained but was roofed over, creating a platform for the new building and an area for open-air worship, while underground parking was also provided. Gibberd, recognizing that the weakness of a central plan is that it lacks direction, placed the Blessed Sacrament chapel directly opposite the entrance porch, thereby creating a main axis through the building. But what earned him the assessors' approval was the way that the building as a whole 'powerfully expresses the kingship of Christ',[23] for it was designed like a crown: around its walls sixteen reinforced-concrete trusses, shaped like boomerangs, converged into a ring at the foot of the tower, creating a cone over the sanctuary before sweeping upwards to form a great, slightly tapered lantern tower suspended over the central altar. The High Altar is therefore lit by a glazed corona, which, in shape, competes with the tower of Giles Scott's Anglican cathedral, then still under construction. It was accepted from the beginning that any material fit for its purpose would be employed, and there would be no bar on materials not previously associated with cathedral buildings. While the Anglican cathedral, begun sixty years earlier, crept slowly westwards stone by stone, Gibberd's cathedral, employing techniques more often used in industrial construction, was built at speed and virtually completed within four years.[24]

The possibility of doing without pillars meant that all had an unimpeded view and, as Gibberd observed, 'there is a tremendous link between the holy places and the people themselves.' He added: 'It is not like a theatre. People

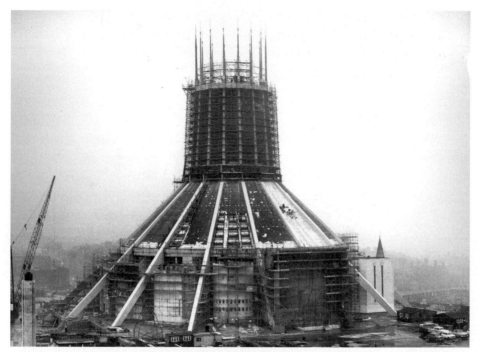

84. The building of the Catholic cathedral in Liverpool.

are not going to watch a spectacle, they are taking part in it.'[25] But it is the stained glass and its effect on the light and atmosphere that pulls this building together and reinforces Gibberd's central aim, for coloured glass not only fills the lantern tower but also the vertical and horizontal gaps around the perimeters of the chapels. Plain glass would have rendered the interior too dependent on changes in the weather. Instead Piper used blues, reminiscent of those intense blues found in thirteenth-century glass, in order to create an otherworldly light, the blue enlivened by small high-up flecks of red said to be representative of tongues of flame. He also framed the broad entrance with a thick band of strong mid-yellow, which is more controversial—some finding it exhilarating, others, garish.

With the lantern tower, Piper and Reyntiens were given just eighteen months in which to produce sixteen slightly tapering panels, each 30 ft tall and about 14 ft wide. A special studio had to be constructed at Loudwater, Buckingham-shire, near Burleighfeld, Reyntiens getting up at 4 a.m. in order to get four hours work done before his assistants arrived. Gibberd had originally envis-aged in the lantern tower a repeat pattern of concrete tracery and glass. But in their search for the simplicity essential to work on such a scale, Piper and Reyntiens evolved a different idea. Their chosen medium was *dalle de verre*,

85. Patrick Reyntiens and John Piper designing the stained glass for the lantern in the Metropolitan Cathedral of Christ the King, Liverpool.

a suitable tough form of glass, being an inch thick (*dalle* is French for 'sett' or pavement light) and in effect a building material in that each section supports the weight of the section above it. This made concrete divisions within

each section unnecessary and instead transverse divisions, horizontal bars, and criss-cross reinforcements were used. John recognized from the start that, as the lantern was some two hundred feet above the floor, the effect of light and colour achieved would have to be simple in character and bold in colour. He was also aware that when the sun was at its zenith, the lantern would throw coloured light downwards, and that 'we must enrich the whole interior without complicating it.' Lastly, he added: 'the lantern must act as a coloured beacon at night in the distant cityscapes of Liverpool.'[26]

Reyntiens at the time was reading Dante's *Paradiso* and, noticing how Dante uses light and colour to symbolize the Godhead, suggested that they too could convey the Trinity by three great areas of coloured light: blue, yellow, and red. John accepted his idea but he also knew that it needed holes of light, through which daylight could pour during the day and through which artificial light could pour out at night. Three white areas were used to symbolize the Trinity, each embedded in one of the three primary colours—red, yellow, or blue with orange, green, and violet graded between them (Plates 68 and 69). One of the many technical problems was the need for a strong bonding ingredient which would be weather-proof and as durable as the Cathedral. John's name was again linked with Shell when this firm's International Chemical Company came up with 30 tons of a specially formulated epoxy resin-based mortar. The mix— epoxy resin, hardener, sand, and carbon black—was applied from a polythene bag, like icing on a cake. To make the lantern capable of resisting any conceivable wind-force, each pinnacle on the tower was made out of a quarter-inch thick fibreglass and epoxy resin tube into which concrete has been poured, the concrete itself stiffened by high tensile steel reinforcement.

Gibberd's firm claimed that the Liverpool lantern was the largest commission for stained glass in the history of the Church. To celebrate its completion, the leading avant-garde magazine *Studio International* published an article on it, written by John and illustrated with two large colour photographs.

The consecration of the new Cathedral took place on 17 May 1967. When it first opened, the Cathedral of Christ the King seemed radical and striking in appearance, but it quickly acquired the affectionate if slightly derogatory nickname 'Paddy's Wigwam' and within two decades it had begun to seem dated. By then, too, the centralized altar had fallen out of favour, as the problems attendant on this arrangement had begun to be felt.[27] Anther factor in the Cathedral's history is that Gibberd had designed only the shell of the building, leaving ornamentation and decoration to be added as and when money became available. And over the years it has become increasingly the receptacle for items that have no congruence with the architecture.

Nevertheless the impact of the central space remains powerful, and the pervading blue and green lights which fill the strips between and around three sides of each of the sixteen chapels are successfully mood-creating, in part a further testimony to Piper's lifelong fascination with the spirituality conveyed by the intense blues in medieval glass. And in 1992 the historian John Nelson Tarn, reassessing the Cathedral, insisted that the climax of the building is still 'high above, in the lantern, the superb, rich, jewel-like glass of John Piper and Patrick Reyntiens [that] immediately draws the eye away from nearly everything else'. He adds: 'At night, lit from the inside, the jewel-like colours of the glass shine out against the pale, floodlit shell.'[28]

29

Owen Wingrave

For what can Warr but endless Warr still breed
Till Truth and Right from Violence be freed.

——From Milton's sonnet on Fairfax at the
siege of Colchester[1]

After the success of *The Turn of the Screw*, almost fifteen years passed before Myfanwy again actively collaborated with Britten. Despite this lengthy gap in time, she never doubted that such an opportunity would arise, for Britten had indicated that he wanted to repeat their endeavour. She had not minded when Peter Pears devised the libretto for *A Midsummer Night's Dream* in 1960, to celebrate the rebuilding of Aldeburgh's Jubilee Hall, as he had told her of his interest in it from the start, and, when asked, she had agreed to write the prologue, though in the end it was not used.[2] This lengthy interval also saw the production of Britten's *Noye's Fludde* and the *Church Parables*, with which the Pipers had not been involved, though they had seen them performed.

In 1967 Britten turned to Myfanwy when BBC2 commissioned an opera specifically for television and which was sold in advance to twelve other international companies for simultaneous transmission.[3] With this opportunity to reach a very wide audience, he needed a story that would be, in his own words, 'both personal and powerful' and which would suit the medium of television.[4] He had been impressed by Henry James's *Owen Wingrave* when he first read it in 1954. As is widely recognized, the tale was to become the vehicle through which Britten voiced his deeply held commitment to pacifism and his hatred of war,[5] beliefs exacerbated at this time by the invasion of Czechoslovakia and

the continuation of the Vietnam War.[6] The story also offers a challenge to the conventions and traditions of militarism, especially those rooted in dynasties.

And so, when Britten mentioned *Owen Wingrave* on a visit to Fawley Bottom, Myfanwy not only recollected that he had spoken of it, before embarking on his *War Requiem* (1961), but she also immediately understood its significance for him, for she had read all James' stories. Asked if she would write the libretto, her response was straightforward. 'I said yes. And that was it.'[7]

Behind *Owen Wingrave* lies the complicated history of Britten's uneasy relationship with television. It is sufficient here to mention that, in 1952, having reluctantly sanctioned the American NBC Opera Company's televised version of *Billy Budd*, which reduced the four-act three-hour opera to a ninety-minute production, Britten thought it 'badly and desperately cut',[8] and was left profoundly suspicious of the medium. Things improved in 1960 when Peter Morley obtained Britten's agreement to an Associated-Rediffusion televised production of *The Turn of the Screw*.[9] This was the first full-length opera by Britten televised in Britain and also the first full-length opera ever seen on Independent Television.

As the suitability of opera for television was thought highly controversial, a publicity brochure was produced carrying a synopsis and comments by those responsible for the opera. All felt a need to be persuasive, none more so than Myfanwy. 'The work is a combination of strangeness and intimacy,' she writes of the *Screw*

> and so for television, at its best in conveying both these, an obviously suitable subject. What surprises and delights is that … the producer has made it seem as though it were specially created for the medium. … It makes me realise how much can be done with the exuberant possibilities of television when they are used with tact and sensibility.[10]

When Peter Morley's film was rediscovered in 1992,[11] it revealed the way in which he had handled the problem presented by the interludes when no action takes place. The appropriate setting for these in the theatre is a darkened stage, but the equivalent on television—a blank screen—would be disconcerting for the audience. Morley therefore commissioned from John Piper, not just sets, which Michael Yates realized for television, but also a set of drawings and watercolours for the interludes. These fizz with vitality and charge the screen with an energy that matches that of the music. Some make use of cursory allusions to foliage, flowers, birds, butterflies, and water, evoking the park at Bly, others are simply abstract. The camera lens now and then tracks in on a configuration,

or cross-fades to the faces of Miles or that of the sleeping Governess, in such a way that the design lingers, enhancing the sense of inner turmoil as well as the interpenetration of the actual and the ghostly. It is an effect used throughout the dialogue between Quint and Miss Jessel in Act II Scene 1.[12]

Though the transmission of this opera had to be spread over two nights, this televised version of *Screw* was an undoubted success. Two further productions for television were the 1966 *Billy Budd*, directed by Basil Coleman, and the 1969 performance of *Peter Grimes*, directed by Brian Large in collaboration with Joan Cross. To avoid the two-studio system used in the first of these, and which separated the orchestra from the singers, Britten persuaded John Culshaw, Head of Music Programmes at the BBC, that *Grimes* should be filmed at the recently converted Snape Maltings. Coleman objected and stood down as director, but the undeniable advantage of this arrangement was that Britten could be closely involved with the filming. This experience left him convinced that television opera must retain a musical intensity that never lets up. At a late stage in the making of *Owen Wingrave*, he told Donald Mitchell: 'the drive forward of the music, the singing of the tunes, the elaboration of the ensembles, must never be forgotten.'[13] He also admitted that he and Myfanwy Piper were adding 'arias galore'.[14]

The loss of Coleman within Britten's charmed circle was unfortunate as he had a particular commitment to opera and especially to Britten's work and Britten had in fact promised that he would one day write for him an opera for television.[15] However, when Culshaw was putting through the commission for *Owen Wingrave*, Coleman was overlooked: the direction of this opera was given to Brian Large and Colin Graham, Coleman only learning of this from Myfanwy when he wrote to her on a different matter and she felt obliged to tell him.

Britten's insistence on collaboration in the making of opera makes it difficult to be certain who invented what. But there is no doubt that in *Wingrave*, as in *The Screw*, certain crucial ideas for the dramatic development came from Myfanwy. Both were based on sophisticated texts, but the chief difference between James's *Owen Wingrave* and his *Screw* is that the former is much shorter. If compression remained at the heart of her enterprise as librettist, Myfanwy also recognized that with *Wingrave* there was more need to invent, to search for words and incidents that would give Britten the vehicle for his musical ideas and which would unfold, with a sure-footed inevitability, the drama of the tale.

She soon discovered, if she did not know of it at the start, how Henry James had arrived at his ideas for *Owen Wingrave*. In Kensington Gardens one summer afternoon, a 'tall, quiet slim studious young man' had sat near him and

'settled to a book with immediate gravity'.[16] Though James had no notion of how he would use this figure, the words 'Dramatize it, dramatize it!' suddenly rang in his ears. Then, in March 1892, he read Marcelin Marbot's memoirs of the Napoleonic wars. He became fascinated with the notion of hereditary military valour, and the way in which, alongside the tradition of personal bravery and honour, ran awareness of the ugliness, blood, and carnage involved. This led on to his conception of a different act of bravery, military recusancy and sacrifice, and out of this grew *Owen Wingrave*, which appeared in the Christmas number of the *Graphic* in 1892, was first published in book form in 1893, and in 1907 was turned into James's one-act play, *The Saloon*. In the course of this development, as Myfanwy astutely observed, 'The peaceful young man in the twopenny chair took on the battle of all conscientious objectors against the pressure of righteous aggression.'[17]

Owen is the last in a family with a long military heritage. Both his parents have died, his father in the Afghan Wars, and at Paramore, the ancestral house, home to Owen's aunt Miss Jane Wingrave and his grandfather Sir Philip Wingrave, the tradition of militarism is grimly upheld. Also living at Paramore is Mrs Julian, whose husband has died in battle, as has her brother who had been Miss Wingrave's fiancé. Taken in by the Wingrave family, Mrs Julian has become, in James's words, 'an unremunerated though not uncriticised housekeeper', while her handsome daughter, Kate, also a dependent on the Wingraves, has grown up amid expectations that she and Owen will marry. However, she, her mother, and the Wingraves all reject Owen after he announces his refusal to become a soldier. He holds firm to his decision despite the battery of objections he encounters. But angered by the accusation of cowardice, he accepts Kate's taunt and agrees to pass a night in the haunted room to prove his bravery. Here one of his ancestors, the Wingrave boy, at the time of Cromwell, was unjustly accused of cowardice and punished by his father with a blow on the head which killed him. When the time came for the father to toll the bell at his son's funeral, he too was found dead, from no explicable cause, on the floor of this same small room. And here, too, Owen, while spending the night in this room, meets a supernatural death. His name has prepared us for this, for 'Owen' in Scottish means 'young soldier', and he wins his grave. 'He looked like a young soldier on a battlefield,' James's tale ends, though in a later version he changed this to: 'He was all the young soldier on the gained field.'

Soon after work on this opera began, Britten observed that something was needed to precipitate Owen's outburst. At the start of James's story, Owen's mind is already made up and he visits Coyle, the tutor who is preparing him for Sandhurst, to tell him of his decision to withdraw from a military career. Britten

wanted, instead, to begin with a lesson. Myfanwy recollects him saying: 'I think it is important to establish the crammer's atmosphere before we break it up, and besides, I've thought of a nice way to do it musically!'[18] She therefore invented the scene in Coyle's Academy. In order to do this, she read widely, turning, as James had done, to General Marbot's memoirs, also going to the London Library for Clausewitz's three-volume *On War*, a systematic philosophical examination of war which had far-reaching influence on Western military thinking. Useful, too, was the two-volume *The Story of a Soldier's Life* by Field-Marshal Viscount Wolseley, whose ancestral inheritance was similar to Owen's, and in general she immersed herself in tales of the Napoleonic wars and of the Indian Mutiny. This reading not only gave her a better understanding of the vainglorious militarism of the Wingrave family and enhanced the language that her characters use, but it also provided her with useful quotations. One example is a letter from Wellington to Lady Shelley which Myfanwy copied into one of her notebooks:

> I hope to God I have fought my last battle. It's a bad thing to be always fighting. While in the thick of it I am too much occupied to feel anything; but it is wretched just after. It is quite impossible to think of glory. … I am wretched even in the moment of victory, and, I always say that next to a battle lost the greatest misery is a battle gained.[19]

This is used to crystallize a dramatic moment in Act I Scene 1. Lechmere, Owen's friend and fellow student, excited by Coyle's instruction on the Battle of Austerlitz, enthusiastically embraces 'the glorious luck of battle'. This moves Owen to condemn the military conception of 'glory' and to damn Hannibal, Caesar, Marlborough, and Napoleon as 'Ruffians all'. 'And Wellington?' asks Coyle. Owen replies: 'Wellington, for all his warlike glory, remember what he said: "Next to a battle lost the greatest misery is a battle gained." ' Elsewhere in the libretto, there is ample evidence of Myfanwy's extensive reading: military metaphors come readily to hand and many of the words used resonate with additional layers of meaning and dramatic irony.

There were other places, aside from the opening scene, where Myfanwy Piper had to expand on James's story, which lacks the same build up of suspense and psychological ambiguity as *The Turn of the Screw*. James, for instance, gives no description of Owen's arrival and reception at his family's ancestral home, Paramore. This is because his story is entirely told from Coyle's standpoint, and, in James's version, it is only a couple of weeks later, when Coyle and his wife, at Miss Wingrave's invitation, descend on Paramore that the reader learns that Owen looks five years older. ' "I couldn't imagine that," said Mr Coyle, "nor that the character of the crisis here would be quite so perceptible." ' In her libretto

Myfanwy Piper decided to invent the drama that lay behind that crisis. And in the opera, as Owen approaches the house, Miss Wingrave, Kate, and Mrs Julian deliberately withdraw, for in their eyes Owen deserves no hero's welcome and must instead 'listen to the house' and speak first to his ancestors, in the form of the family portraits. He therefore enters a silent house and, drawing on his military training, reflects: 'Good soldiers in a mist, we're told, keep silence—no friendly murmurs, no scream of pain betray their position to the enemy! How strange! Here in my own house I stand an enemy.' It is an example of Myfanwy's bold adaption and her acute sensitivity to the opera's dramatic needs.

Further glimpses into Myfanwy Piper's working methods and the progress of her libretto can be found in her notebooks. 'What is the military grace?' she queried, apropos the scene at the dinner table. She scanned James's text carefully for telling words and phrases. The recurrence of 'scruples' gave her the word she needed for the scornful climax directed at Owen in the dinner scene, where, as before with the 'How dare you!' passage, the Wingraves and Julians unite in their stand against Owen and freeze into identical attitudes. 'One knows that there are people like these,' Myfanwy wrote of the Wingraves, 'de-humanized by their own strict and immovable code.'[20] At the same time, she was aware that James had manipulated them in such a way that they were in danger of becoming caricatures. For this reason, as others have pointed out, she filled out the characters of Owen's military tutor, Spencer Coyle and his wife, giving to Mrs Coyle especially a depth of feeling that offers the necessary humane relief.

Her notebooks show her thinking about Kate and what factors may have shaped her character. 'Kate,' she writes, 'she has her own family circle—I mean her own ghosts.' Yet in the opera she remains an unsatisfactory character, and she was, as Myfanwy admitted, a source of argument between herself and Britten, as Britten loathed Kate so much he did not want to make her sympathetic. But to offset her obnoxious scorn of Owen, and to suggest the girl with whom Owen first fell in love, Myfanwy devised a conversation between Kate and Owen in Act II Scene 1 in which they share memories of their childhood through an exchange of shared images. She was trying to give Owen and Kate a life beyond soldiering and cowardice, a moment of possibility in which another sort of life is glimpsed. 'These silent rooms | the mist on the grass | owls in the dark | the broken branches in the park | the dry click-click of antlers', the last being a detail that she got from a neighbour's description of stags fighting in Stonor Park. She also tried to persuade Janet Baker, who sang Kate and never overcame her dislike of her, that she was a victim of circumstances. Even so, the young woman came across as 'bigoted, unimaginative and unsympathetic, black against Owen's white', as Myfanwy herself has observed.[21]

86. Myfanwy in her study (photograph: Jorge Lewinski).
© The Lewinski Archive at Chatsworth.

After a period of gestation, she began work on the libretto in March 1968, letting it take the form, for the most part, of heightened prose. Work had to be fitted in between domestic life, cooking, and entertaining. Among those who lunched that year at Fawley Bottom was Jennie Lee, the first Minister for the Arts. Geoffrey Jellicoe, the landscape designer, once carried a glass of sherry to Myfanwy as she sat in the car outside the Woodstock Hotel in Oxford, composing.[22] She admitted to Britten that her first draft of *Owen Wingrave* was 'a depressing mixture of styles' and very verbose 'but', she adds, 'I feel that it is not right to try to prune and shape it now as I might prune away just the bit that you might find suggestive or even inspiring.'[23] She was aware, at this stage, that her approach was instinctively to think in terms of theatre, but before long both began to give more thought to the medium of television.

BBC2, though it had begun broadcasting on 21 April 1964, could not be obtained at Fawley Bottom. This may explain why Myfanwy found depressing the few things she had seen on television. But she was not averse to the

medium, and now watched it with interest in order to discern its possibilities. Britten, on the other hand, did not own a television until 1973, when Decca gave him one for his sixtieth birthday. Myfanwy tried to keep him up to speed. 'The popular programmes, the news and sport are very well done,' she wrote: 'the awful mess are those that try to be a bit highbrow but still keep the million viewers.'[24]

Nevertheless both took the medium very seriously. Their first discussions of *Owen Wingrave*, Myfanwy claims, dwelt upon the visual, rather than the verbal, presentation of dramatic points in this work,[25] and in one of her note-books she lists 'Strong visual images in the actual story.' The opera begins with an emphasis on the visual, the camera focussing, one by one, on ten family portraits, before ending with Owen who appears in the scheme of things like an eleventh portrait. In addition, four orchestral interludes were devised, all with visual matter in mind. In the first regimental banners 'wave brilliantly'. In the second, Owen reads aloud an extract from Shelley's *Queen Mab*, Book IV, concerning the futility of war, while the screen shows a sequence of faded and tattered flags. A third interlude works as a transition scene from London to Paramore, the ancestral home, while the fourth allowed for preparation of the dinner scene, with servants silently bringing in silver and glass and lighting candles. In the BBC2 film, it ends with all the characters filing in, two by two, for dinner and taking their places at the table.

Wanting to make full use of the resources available, Myfanwy and Britten took advice from those who had a technical knowledge of television. It was agreed that when the ghosts of the Wingrave boy and his father appear, the colour film would revert to black and white, or rather a kind of sepia effect, which conveyed a sense of unreality and another age. However, Myfanwy became irritated by what she privately called the 'built-in TV mind'.[26] Publicly, in her essay for David Herbert, 'Writing for Britten', she regretted the mystique associated with this relatively new medium created by a closed circle of experts. She realized how uncertain those in television were of their audience, and, because of this, discerned 'a tendency to overdo things, to underline them, so that the subtleties of which the medium is capable can easily be thrown away in the interest of making something, already perfectly clear, obvious.' Television, she concluded, was 'a mixture of inventiveness and crudity'.[27] At the Maltings, where *Owen Wingrave* was filmed, when it was time to do the ghost scene, they found a man busily spraying cobwebs onto every surface of the set, as in television, at that date, 'Ghosts meant Cobwebs'.[28]

Both composer and librettist were keen to go beyond what could be achieved in a theatre and do things that could only be done with film. The use of close-up

in order to convey an interior monologue has become a television cliché, but it has to be admitted that it works well in Act I Scene 7, the dinner party scene, where general conversation is intercut with moments of inner reflection, and the tension between the spoken and the unspoken is at its height. The camera, by means of close-up, reinforces the change of mood in the music by shutting out the other characters as it isolates each head in turn. Overall, effects were kept simple, as Britten kept in mind the fact that this television opera would afterwards transfer to the stage. Nevertheless, the dinner party scene is more effective on film than on stage.

Myfanwy had a more elaborate idea for the double scene in Act I, which was intended to expose a dichotomy. While Owen reads in the park —not Goethe's poems, as in James, but, as mentioned, Shelley's 'Queen Mab' for, as Myfanwy realized, it is politically exactly what a young man like Owen would be reading—Coyle goes to see Miss Wingrave in her London lodgings, nearby, to inform her of her nephew's decision. Myfanwy wanted this split scene to be united by a vision of horse guards, riding past in their red uniforms. She wanted both Owen and Miss Wingrave to see the same sight and to be exhilarated by it, but after a few moments Owen was to transform the vision in his imagination into a chaos of falling cavalrymen and horses. In retrospect, Myfanwy admitted: 'it was a typical amateur's idea, over-elaborate and impractical.' The television crew made no attempt to respond to this idea until the last minute and then fruitless hours were spent looking at film sequences of battlefields in Aldeburgh cinema, all, in Myfanwy's recollection, on the wrong scale.[29] Eventually the Royal Military Police Mounted Troop were filmed in black and white at Aldershot and a dim section spliced into the final film. But it appears a vision only in Owen's mind, while Miss Wingrave's eye is caught by a conventional military print hanging on the wall in her room.

In August 1968 Myfanwy took her notebooks to Garn Fawr where, with its view out over fields and pastures, with the sea in the distance, no sounds can be heard other than the wind and birds. 'Lovely peaceful conditions for working; no telephone, no people, not even children this time,' she told Britten.

> I'm finding everyday that problems in O.W. solve themselves. I don't mean the final expression of them because that is fluid of course—but little cross-currents, relationships—echoes—in particular I find a very strong identification of Owen and the murdered boy has taken over and left me feeling much happier about the Ghost's Story and the way to use it.[30]

As Claire Seymour has pointed out, the legend of the Wingrave Boy was originally intended to emerge in the course of a dialogue between Coyle and Owen.

But it appears that in Pembrokeshire Myfanwy conceived of the ballad sung by the narrator at the start of Act II. 'I remember it took me ages to do,' she told Roderic Dunnett, 'ages and ages, and I worked on it a lot in the cottage in Wales, the whole of that ballad, the Wingrave Boy ballad.'[31] The tune returns at the end of the opera, when the final verse is sung, its final line echoing that in James's story.

Right up to December of that year Myfanwy was still reading and re-reading *Owen Wingrave*, together with the play *The Saloon* and coming to new conclusions, finding useful in the latter a conversation between Coyle and Wingrave, the description of the saloon, and Kate's red dress which she thought would work well on colour television. Aware that this play had been rejected by the Stage Society on Bernard Shaw's advice, owing to its abrupt ending and the fact that Owen's death means his noble intentions go unrewarded,[32] Myfanwy remained adamant in her belief that more optimism would have been aesthetically wrong, unsuited to the psychology of the family, and that Owen's death does not invalidate the message of the tale. The hymn of peace in Act II Scene 1, which she wrote for Owen, acts as a kind of coda to Britten's *War Requiem*. It is evident from the many drafts that it too caused much effort before it was structured into something rather like a Psalm or Canticle. When set to Britten's music, it transcends conflict with a moment of great beauty that becomes the opera's climax.

In February 1970 at the Red House, Britten played through the whole of *Owen Wingrave* to Myfanwy and she was greatly moved. The opera benefited from superb casting, with Sylvia Fisher as Miss Wingrave, Janet Baker as Kate, John Shirley-Quirk as Coyle, Heather Harper as Mrs Coyle, Benjamin Luxon as Owen, and Jennifer Vyvyan as Mrs Julian, and was further enhanced by camerawork that makes telling use of close-up, particularly in those scenes where the family's scorn and anger forms a claustrophobic wall of hatred. In November 1970 Myfanwy was present throughout the three weeks of rehearsal at the Maltings and the eight days of filming that followed. Afterwards she wrote to Britten:

> I enjoyed every minute of 'The Month at the Maltings', in spite of the grind, tedium, frustration and the curious grandmother's steps of progress of TV production (or snakes & ladders if you prefer it). It was marvellous to hear the whole work grow and to get to know the singers and watch their enthusiasm—forbearance—not to mention yours. I do think it a great work and I am proud to be associated with it.[33]

She and John returned to Aldeburgh on 16 May 1971, when *Owen Wingrave* was simultaneously seen and heard in thirteen countries, to watch it with Brit-

ten and Pears, on a television set rented for the occasion. And it pleased her greatly when her younger son, Sebastian, telephoned to tell her he had been very impressed.

Two years later, on 10 May 1973, it was first performed on stage, at Covent Garden. On this occasion John designed the sets, taking over from Tony Myerscough-Jones, while Charles Knode did the costumes as he had done for the television version.[34] John had earlier advised Meyerscough-Jones, and for the stage version he retained a similar layout for the sets, working again with hints about the house discoverable in Henry James's short story. However, the staircase and the arches above it, as well as two suits of amour either side of the central flight, were transparent, making use of linear structures similar to those which Piper and Lancaster had employed in the Festival Gardens in 1951. Myfanwy felt the opera worked better with John's transparent set, and that the idea behind it, that the house, despite being so solid and so military, was really insubstantial, was true. Transparency also made possible the more detached, expansive mood created in Act II Scene 1: when the lights were dimmed, leaving Owen centre stage with his hymn to peace, a suggestion of the foliage on the back wall could be seen behind the dark shapes of the suspended portraits and hanging staircase. The central portrait, of the Wingrave Boy and his father, was very similar, if not the same, as that used in the film, but the other portraits offered a considerable improvement on the mawkish originals.

In later years, Myfanwy's enthusiasm for this opera, in comparison with the other two she did with Britten, became slightly modified. In 1997, writing to friend, she admitted: 'I went last weekend to Glyndebourne and saw the first night of *Owen Wingrave*—not my favourite piece but full of good things all the same.'[35] Yet she had helped achieve a musical drama in which each incident and emotional development is carefully structured and dovetailed, one into the next, either by means of contrast or out of narrative necessity. It has been described as 'one of Britten's most economic, tightly organised and finely wrought scores, second in these respects only to *The Turn of the Screw*'.[36] In 2001 a new television film of *Owen Wingrave* was made for Channel 4. But it is the original BBC2 version, despite its slightly predictable sets, over-harsh studio lighting, and other limitations, that nevertheless best displays the dramatic power of this opera, also something of the tact and sensibility that Myfanwy desired.

30

Shell Guides

John Piper's name is readily connected with the Shell County Guides, but few realize the extent of his dedication to this project which brought together an array of talented writers, artists, and photographers. He had in effect begun operating as joint-chief editor long before official acknowledgement of this role in 1962; and he remained at the helm, as sole chief editor, after Betjeman resigned in 1967. By then, the old Shell Guide mixture of photographs and engravings, drawings and labels had been abandoned, partly because this kind of mélange had become a staple ingredient in glossy magazines and partly because John now felt that photographs did not mix well with other media. Generally, he improved the design of the Guides, establishing a cover that had a modern look and a standardized typeface (Plate 64). He was well suited to the task of synthesizing good writing, good design, and telling imagery into an up-to-date, understated, but powerful presentation. When in 1984 the series was terminated, he felt as if he had lost a limb, for these Guides gave him a major vehicle through which to focus public attention on the look of England, on its texture, structure, native customs, and accretive traditions.

With many of these books he was ably assisted, with photography and layout, by his son Edward. Living at the Old Laundry, Marston Bigot, in Wiltshire, with his wife, Prue, and their two children, Luke and Henry, Edward had established a similar lifestyle to that at Fawley Bottom. Sunflowers kept watch over the flowers and vegetables that grew in the walled garden, beyond which, at the end of a field, was a lake which he himself had built. He kept sheep, was in demand as a photographer and graphic designer and had established himself as a painter with a light, intelligent touch (something that was to be echoed in the work of his sons). Prue, meanwhile, had begun her career as a distinctive potter. But the family also lived with the Shell Guides, Edward regularly taking

them all on camping trips to places connected with the needs of the latest volume. With his self-effacing modesty, he worked on these Guides in the shadow of John for some twenty years. He was so familiar with his father's interests that ninety per cent of the time he could predict what he wanted. The other ten per cent remained totally unpredictable.

Since their revival in the early 1950s, Shell Guides had powered a course that avoided the aridity of Pevsner as well as the nostalgic effusions of Arthur Mee in his King's England series. They were clear, concise, and omitted anodyne

87. Robert Adam's church towers, Mistley. *Shell Guide to Essex* (photograph: John Piper).

adjectives such as 'pleasant', 'fine', or 'attractive'. Above all, they were attentive not just to buildings but also to the atmosphere of a place, a stance echoed in the attention-halting illustrations to these books.[1] Aside from the photographs by John and Edward Piper, many were taken by Edwin Smith, whose images helped establish archetypal views of England. But it is the combination of word and image that makes these books bibliographic treasures. By the late 1960s, John was especially proud of *Suffolk*, *Cornwall*, *Worcestershire*, and *Lincolnshire*,[2] but it is Henry Thorold's *Derbyshire*, published in 1972, which can be instanced as a quintessential example, its elegant and percipient text matched by sumptuous illustrations.

In the 1960s Piper and Betjeman had pushed the Shell Guides to such an extent that the art editor at Faber and Faber, David Bland, found they took up most of his time. Piper got on so well with Bland that John became godfather to Bland's son Roger. In turn, Bland, up until his untimely death in 1970, acted as buffer between the editors and authors of the Guides and the authorities at Shell, for working relations could be tricky. And though the men in the Advertising Services Division of Shell-Mex and BP Ltd fawned over Piper, owing to his reputation, they showed little interest in the cultural aspects of the Shell Guides.

Then, too, there were differences of opinion as to what the Guides were intended to achieve. 'Shell, I believe,' John wrote to Bland, 'would prefer the county guides to be more larky, with more old engravings and line drawings, and maybe quotations and humorous drawings—more like they were when they first started. I feel to some extent responsible for the present, possibly over-serious style.' He was also concerned about length. 'I find the cutting-down on pages, when there is fine material, and the general uncertainty, quite intolerable. A guide should be as long—within reason—as it seems to the editors that it ought to be.'[3]

In financial terms, the series was not a success. When commissioning new or revised guides, John warned his authors that they would make no money out of the project. The advance, in 1962, to a Shell author was £100, on top of which came £150 for travelling expenses. The chief editors did no better, John pointing out to David Bland, at one moment, that he had received no payment from Shell for salary or expenses over the previous two years. Nor was this a one-off complaint: some eight years later, a similar letter had to be sent to Bland's successor, as again the chief editor had received no payment over the previous two years.

Though Bland had tried to reassure Piper that Shell approved of the more scholarly type of guide and did 'not want anything "larky" or more ephemeral

to take their place',[4] the real problem remained financial, not editorial. Each time a guide was brought up-to-date—which Piper thought essential to the series—the heavy corrections cost almost as much as a new setting, and in the winter of 1965–6 *Norfolk*, *Suffolk*, and *South-West Wales* were all updated. 'The whole trouble is', Bland explained, 'that the Guides are underpriced even at 18/–.' The correct price, he estimated, should be 30/–. 'At this price they would compare very favourably with other books we publish of the same length. But Shell feel that this would be too great a jump and it will have to be done gradually.'[5]

Another problem was that Shell authors were, on the whole, more outspoken and controversial than Pevsner, and a diplomatic course had to be steered between the Scylla of the author's view on one hand and the Charybdis of Shell's Marketing and Public Relationships, on the other. Shell, for instance, took offence at the entry in *Gloucestershire* which referred to the Eagle Assurance building in Cheltenham as an 'overwhelming visual insult' and insisted that the passage be toned down. The skyscraper was not named and the reference merely read: 'but it is there that an incongruous and enormous block of offices had been allowed'. But when Juliet Smith's *Northamptonshire* contained a similar remark about the Norwich Union Building Society which Shell considered defamatory and insisted be withdrawn, Betjeman resigned on principle. By then, however, John had already taken on most of the chief editor's duties.

He brought to this work great zest, as did many of his contributors. 'We hope you will enjoy the journeying,' he wrote to Henry Thorold, who was about to redo *Derbyshire*. Christopher Hobhouse's 1935 edition had contained a very brief gazetteer, which Thorold refreshed, spicing it with occasional quotations from his predecessor. Though Betjeman commissioned this book, it was Piper who advised Thorold to make a list, as he went, of irresistible views for photography and to look out for a publication on industrial archaeology for the county—'for Derbyshire this would be a blessing, as all those mills and bridges and mill-leats are such a gorgeous feature.'[6] 'And it is Piper who is thanked in the acknowledgements for 'untold help—with memories of much pleasureable hospitality at Fawley Bottom.'

If he spotted inadequate copy, John was quick to suggest ways in which it could be improved. When Dorset was revised in 1964, he remarked of the manuscript: 'It is sensitive but very often describes what an ordinary casual visitor to a place sees, and leaves it at that—which is not enough, because the casual visitor needs to be told what to observe and occasionally how to observe it.'[7] He wanted to know whether a church had texture, charm of colour, and architectural interest, and he always insisted on the importance of its setting.

In the end he decided that the author (Pitt Rivers), though good on towns, would never understand a church, so did them all himself. He stepped in again and completed *Kent* (1969) after the death of its author, Pennethorne Hughes, and he collaborated with J. H. Cheetham on *Wiltshire* (1968), after receiving a disappointing initial manuscript. Not surprisingly, Faber, aware of John's gifts as an author, on two occasions tried to get him to write an autobiography. His many interests and commitments made this impossible.

Most Shell authors were passionate antiquarians, imbued with a deep love and knowledge of architecture and, in the case of Norman Scarfe, a former lecturer, author of three Shell Guides, renowned authority on East Anglia, also up to the minute in the history of town planning, building types, and regulations. Another expert, David Verey, was so involved with the Cotswolds that he did Gloucestershire for the Shell Guides as well as for Pevsner's Buildings of England series. Verey also agreed to take on the Shell Guide to the West Riding of Yorkshire, leaving the East Riding to the architect George Pace, though, for different reasons, neither book was ever published.[8] Another formidable contributor to the Shell Guides was Wilhelmina (Billa) Harrod, the wife of a retired Oxford don and economist,[9] who lived in an old rectory at Holt, in Norfolk, and to whom John Betjeman had once proposed. She was pleased, in 1974, to be asked to redo the Shell Guide to Norfolk ('I know there's no real money in it, but it all spreads the gospel'[10]), but struggled with the task, as it coincided with her husband's illness and death and the manuscript was further delayed by her assistant's nervous breakdown.

In turn, Piper did much to support the Norfolk Churches Trust, which Billa Harrod set up in 1976, when, in the wake of the 1968 Pastoral Measure, several churches in her county became threatened with sale or demolition. Until further legislation was put in place to protect churches, the Norfolk Churches Trust did much to keep them open and in good repair, tapping a strength of feeling towards these buildings that surprised many clergy. Around this time Aleksandr Solzhenitsyn wrote a prose poem describing a journey across Russia, in which he observed that though the steepled and domed churches visible on the plains were being used as granaries or machine stores, while they existed 'old Russia' would not die. Support for the fabric of churches from such a famous Russian writer became an almost miraculous weapon in the hands of the Norfolk Churches Trust and similar bodies, in their efforts to conserve this aspect of English heritage. Dominick Harrod, son of Billa, has recalled: 'Solzhenitsyn provided us with just the moral backing to convert the sceptical.'[11]

Billa Harrod remained to the end of her life one of the most persuasive defenders of historic churches.[12] Another was the aforementioned Henry Tho-

rold, who wrote in all five Shell Guides (*Lincolnshire, Durham, Derbyshire, Staffordshire,* and *Nottinghamshire*) and became a close friend of the Pipers. Kenna provided an introduction, and when Edward Piper failed the entrance examinations to Eton, Thorold suggested Lancing, where he himself was a housemaster, also, for almost twenty years, chaplain and teacher of classics. He left this school in 1968, spent a brief period as chaplain at the Oxford preparatory school Summerfields, then retired to live with his mother, pictures, and books at his ancestral home, Marston Hall, in Lincolnshire. There he continued to pursue his interests in architecture, ecclesiology, and heraldry. He was a great raconteur, and had a penchant for archaic pronunciation, a love of the macabre, and reverence for old families. He whisked his guests round the county in a grand old Bentley, while wearing, a little incongruously, his dog collar, and in retirement became an acknowledged authority on Lincolnshire, publishing books on its churches and houses and compiling *Collins Guide to Cathedrals, Abbeys and Priories*. He has been described as 'a doughty defender of true values and religious traditions, a worthy descendant of 18th century High Tory Anglicanism (though the Thorolds were in fact Whigs)'.[13] Nicknamed 'Squarson of Marston' (though he was never its parish priest), he kept the church open during daylight hours, banished the Alternative Service Book, and ensured that the family monuments in the Thorold Chapel were always clean and their heraldry well burnished.

John and Myfanwy paid many visits to Marston Hall, then renowned as one of the coldest houses in England. After some improvements and embellishments had been made, Myfanwy sent Thorold a letter, thanking him for 'that delicious warm bath—I should say hot bath since warm might imply that it wasn't, but of course it was. Very impressive and though heralded not really believed in until experienced.'[14] Whenever the Pipers visited, Thorold was at his most convivial, arranging dinner parties and outings to churches, though his robust manner screened a sadder individual. His eccentricities ran to founding the Sorrel Society, at the meetings of which every dish eaten had to contain sorrel.

In Thorold's wake, and that of others, John or Edward Piper traversed the relevant county, taking photographs for the Guides. Though authors were invited to suggest views for illustration, John knew England and Wales too well not to have ideas of his own. As a photographer, he always chose his time and season carefully, writing to Norman Scarfe, in connection with the illustrations for his guide to Suffolk: 'Now is the time—winter sunlight on Suffolk flint and stone can be marvellous at the right time of day.'[15] He had little difficulty deciding on the best pictures, but it was less easy to make the chosen assortment consecutively interesting alongside type. And the results did not always please.

88. The Howard Monument at Rudbaxton, near Haverfordwest (photograph: John Piper).

Thomas Sharp, author of *Northumberland*, was greatly angered by John's choice of photographs which he thought showed the county's shabby side, such as derelict cottages in the Dales or backstreets in towns showing slum quarters. Even Scarfe felt reservations about John's fondness for rich black shadows and he jibed at the choice of picture used on the cover of *Essex* (a watermill, its brickwork spoilt with white paint), but apparently it was the only cover picture on which Faber and Shell could agree.

If the Shell Guides were for John a labour of love, they were also a source of heartache and frustration. In 1968 the third edition of *Wiltshire* ran to

89. Wakes Colne church. *Shell Guide to Essex* (photograph: John Piper).

198 pages, but towards the end of 1971, Shell, again in a retrenching mood, announced that from then on no guide should exceed 120 pages. At one point this series appears to have been a cause of upset between Betjeman and Piper. 'Fact is,' John told Betjeman's biographer Bevis Hillier, when they first met, '—we are not on speakers at the moment.'[16] But the series struggled on, underfunded and underpromoted. When in 1976 Roy Strong was invited to do Hertfordshire, his agent opined that the terms offered were an insult to a person of his client's importance. The following year, when Robin Healey accepted the commission to write *Hertfordshire* and Bruce Watkin *Buckinghamshire*, the advance had risen to £500, with an additional £250 for expenses. Even so, the task of taking on a Shell Guide appealed only to a very special kind of antiquarian. This became evident at a luncheon party, given in

1978 at Faber's for the outgoing chairman Peter du Sautoy, to which all Shell Guide authors were invited. Listening to the conversations, Matthew Evans (later Chairman) felt it to be a gathering of individuals the like of which he was unlikely ever to see again.[17]

As chief editor of the Shell Guides, John was frequently invited to support protests over insensitive developments. In 1969 he joined in the battle over the M40 and the Chiltern Hills, partly in his role as Vice-President of the Chiltern Society, and because he believed the decision to cross the escarpment south of Beacon Hill a mistake. (Regrettably, the one reasonable alternative, put forward by the landscape architect Geoffrey Jellicoe in collaboration with Ove Arup, arrived late on the scene and did not win the day.) He also lent his weight to the successful protest against the proposal to build a third London airport—the Wing—at Cublington, near Aylesbury, in Buckinghamshire; he produced for the Wing Airport Resistance Association, which had 61,000 members, a Christmas card based on St Martin's Church, Dunton, one of the many buildings that would have been demolished if the airport had been built.

Further requests flooded in, over proposals to demolish much-loved buildings such as the Lyceum Theatre in Sheffield or Liverpool Street Station, to preserve the oldest arterial highway in England, the Ridgeway, which ran through three counties, Berkshire, Oxfordshire, and Wiltshire, or for support in connection with a whole range of good causes. He gave paintings and prints to be sold in aid of the Norfolk Churches Trust, did drawings of the remote churches at Manordeifi and Llantrisant for use in appeal leaflets for the Friends of the Friendless Churches, and later gave the Ancient Monuments Society his design for the stained-glass window in memory of John Betjeman. He was generous, too, to the Venice-in-Peril Fund, the Norfolk Society, the Avoncroft Museum of Buildings at Bromsgrove, Exhall Grange School (a large residential school for three-hundred handicapped children), the World Wildlife Fund, and the National Art Collections Fund. When Westminster Cathedral mounted an appeal, one of its Canons wrote: 'Your name came up as the obvious guardian angel of all cathedrals and churches in the world of graphics. May I, in the name of the Cardinal, invite you to become a patron?'[18] And he regularly gave paintings to be auctioned in aid of good causes, or, as in the case of MOMA, Oxford, a signed, limited edition print, based on the Radcliffe Camera, to be sold in aid of its Building Appeal. It was inevitable, with his lifelong love of Turner, that he should become in 1975 a Vice-President of the Turner Society, thereby helping to ensure that

a gallery would be built to house the Turner bequest. The outcome was the Clore Gallery at Tate Britain.

Buildings had become the staple ingredient in his art. In 1969 he held an exhibition at Marlborough Fine Art of 'European Topography' in which magnificent Romanesque structures intermingled with loosely painted gouaches of French and English landscapes, vineyards and fields, and the patterns made by hop-poles. These, he claimed in the catalogue, were merely the peg for the emotion generated by a sense of place. He continued to find fresh and vivid ways of rendering barns, houses, churches, or cathedrals, though occasionally his work resorted to a factitious liveliness. 'A melodramatic theatricality vitiates many of the architectural landscapes, with buildings isolated as though by spotlights,' wrote one critic.[19] However, this theatricality well suited the grandiose late nineteenth-century architectural fantasies (such as Royal Holloway College at Egham, Capesthorne, near Macclesfield, and Wightwick Manor, outside Wolverhampton), several of which he exhibited in 1977 at the Marlborough Gallery, under the title 'Victorian Dream Palaces and Other Buildings in Landscape'. His choice of subject matter proved timely as public interest in these buildings had been stimulated by Mark Girouard's *The Victorian Country House*, published in 1971. John, himself, was aware that many of these dream palaces, the building of which had peaked around the 1870s, were, a hundred years later, struggling to survive. One of his favourites was Salvin's Harlaxton Manor, near Grantham in Lincolnshire, which, much pinnacled and encrusted, rises dramatically on the horizon as the visitor heads down the dead-straight, mile-long drive (Plate 65). This exuberant pseudo-Jacobean pile, built in 1837, owes its continuing life to American money, for it became a European campus for Stanford and now belongs to the University of Evansville. Its improbable, fairy-tale quality was still further enhanced by John's decision to paint it an unnatural, near turquoise blue, using a tube of new paint which Winsor and Newton had sent him to try out. He had discovered the house through Thorold, who lived nearby, and it took firm hold on his imagination.

His 'Victorian Dream Palaces' appealed to Betjeman and appears to have healed their relationship. In 1977, the year that they were first exhibited, Betjeman shared with John his pleasure in David Watkin's *Morality and Architecture*, one of the first books to criticize Pevsner's role in the promotion of the modernist movement in architecture in Britain. Betjeman recommended it as 'helpful' and 'sound, serious and funny'.[20] Soon after this, in 1980, Piper was pleased to be asked by Betjeman and Jock Murray to do illustrations for Betjeman's *Church Poems*. The following year he and Myfanwy took part in a BBC documentary on Betjeman made by Jonathan Stedall. All three sat together on

a bench outside Harefield Church, and were filmed laughing and talking about their friendship and mutual interests.

'ABOUT TIME TOO,' Betjeman had written in 1972, when John Piper, having turned down a CBE and a knighthood, was made a Companion of Honour.[21] Public recognition of the esteem in which he was held merely enhanced demand for his art. The following year Marlborough Fine Art found themselves liaising with galleries up and down the country, for in his seventieth year Piper held seventeen exhibitions. There were solo exhibitions at Everard Read's Pieter Wenning Gallery in Johannesburg, at the Marlborough, the Marjorie Parr Gallery, London, and at the Gadsby Gallery, in Leicestershire, while elsewhere, in group shows, he was represented by paintings, prints, stained glass, and examples of church furnishings. Around this time John also began his regular association with the New Ashgate Gallery in Farnham, run by Elfriede Windsor.

In this same year Johnny Cranko fell ill on an aeroplane that was bringing him and the Stuttgart ballet back from America. It made an emergency landing in Dublin, but he was dead on arrival at the hospital. He was forty-five. He had returned to London briefly in 1966, to produce two ballets, and it was probably on this occasion that he turned up at Fawley Bottom wearing a white suit. The loss of this entertaining talker, with his enormous charm and gift for theatricality, was felt by all who had known him. On 3 October 1973 the Royal Ballet mounted a tribute to him at Sadler's Wells Theatre, in the presence of Princess Margaret.

Cranko's inventiveness and effervescent personality had made it impossible to turn stale in his company. Now, owing to the pressure of commissions and the speed at which he worked, John was in danger of over-reliance on familiar methods and techniques. Feeling that both Pipers needed a change, Kenna had sounded a warning note in 1970: 'Although I appreciate your new developments, I begin to see a certain repetitiveness.'[22] In the wake of this criticism, both were fortunate in finding fresh outlets for their creativity, Myfanwy through the writing of libretti, and John through still further diversification of his energies into ceramics, tapestries, and fireworks.

31

Pottery, Tapestries, Fireworks, and Photographs

In 1974, in his seventy-first year, John gave in and joined a London club, becoming a member of the Athenaeum. His term of office as a Trustee of the National Gallery ended this year, but, following a letter from the Prime Minister, he accepted reappointment for a further three years. The Athenaeum, conveniently close to the National Gallery, now offered a welcome alternative to the journey back to Fawley Bottom after evening functions. Among these, on 25 November 1976, was a reunion with the Queen Mother at the Victoria & Albert Museum, at the opening of 'A Tonic for the Nation' exhibition.

In all other respects there is scarcely a hint that his creativity had lessened. He had more solo exhibitions in the 1970s than in any other decade, including three with Marlborough Fine Art, in 1972, 1975, and 1977, all of which earned him financial success and critical acclaim. This firm had become very tolerant of his multiple outlets, his association with Barry Cronan Fine Art, Marjorie Parr Gallery, both in London, and later with the Bohun Gallery in Henley, as well as the numerous small galleries up and down the country who asked for examples of his work to sell. He still occasionally exhibited abroad, at the Pieter Wenning Gallery in Johannesburg and, in 1976, at the Gallery Kasahar in Osaka, Japan. Invited by William (Bill) Servaes, General Manager of the Aldeburgh Festival, to exhibit at the Maltings during the Festival in 1978, he supplied an entire exhibition of new work. It was seen by some two thousand people and there were £4,000 worth of sales.

At the same time, his commissions remained plentiful and diverse. He designed vestments for St Paul's Cathedral; painted four scenes in Henley for its Town Hall, at the request of the Lord Mayor, Denis Moriarty; devised book

illustrations; and engaged with enough stained-glass projects to keep Patrick Reyntiens and his assistants working flat out. He also became involved in the making of firework displays, working with John Deeker, a fireworks maker (and later Chairman at Pains Wessex Ltd). John would sketch out the shapes and colourful effects he wanted, developing further ideas in response to Deeker's expertise.

Their first major collaboration was a thirty-minute firework display over the Serpentine in Hyde Park for the Commonwealth Arts Festival in 1965. It included revolving fountains six inches above the lake, a waterfall of fire from pylons 60 and 100 ft high, backed by another of water from fire hoses. John's aim was to reproduce the effect of some eighteenth-century firework displays, since when, in his opinion, they had been in decline.

On a smaller scale, he designed fireworks for Windsor Castle in 1970 and for the opening night of the Brighton Festival in 1976. For the Queen's Silver Jubilee, on 9 June 1977, he selected the music to accompany the fireworks over the Thames at Millbank. One consultant firework-maker, the Revd Ron Lancaster of Kimbolton, recollects that John chose an all-British array of composers which did not suit everyone's taste. In this instance John liaised with Brock Fireworks Ltd. But when asked to design a firework display over the Thames in 1979, to celebrate the opening of the new extension at the Tate (the long-awaited 'fourth quarter'), he worked again with John Deeker, boasting proudly to a friend, 'I have a pal who is boss of the best fireworks firm in Britain.'[1] So successful was this display that John was invited back by the Tate, in 1987, to celebrate the opening of the Clore Gallery with another of his firework displays over the river. By then, no party at Fawley Bottom was complete without cascades of falling stars and shooting constellations.

In an interview with Martina Margetts for *Crafts Magazine*, John boasted that he had worked in every medium available to him. Malcolm Nix, in Sheffield, begged to disagree and wrote to John, asking if he had ever designed a well dressing. It appears John was not familiar with this Derbyshire tradition of ornamenting village wells in late summer with pictures composed out of natural materials pressed into wet clay, after which they are blessed in the course of a brief processional service. When John admitted that this medium had passed him by, he was asked to design a well dressing, in the summer of 1979, for the village of Youlgreave. He designed a foliate head which, in Nix's memory, ignored much of the advice he had been given and proved quite difficult to execute. John and Myfanwy went up to Derbyshire to see it being made. Bridget Ardley, one of the helpers pressing petals, moss, and bark into the clay, asked John if he minded being involved with such an ephemeral

art form. 'Not at all,' he replied, adding that firework displays have an even shorter life.

The interior discipline that informs all of John's designs is most noticeable in those for stained glass. Martin Harrison, an authority on this medium, argues that, in the 1970s, Piper's work continued to offer 'a refreshing antidote to the banal, lifeless or over austere works of many of his contemporaries'.[2] Towards the end of this decade he embarked on his last major project in this medium—the making of glass for the chapel at the new Robinson College, Cambridge, built between 1977 and 1980.

After the promise of a benefaction of £18 million from David Robinson, an entrepreneur and philanthropist (knighted in 1985), the planning for this college had begun in 1973. It was a surprising initiative, as Robinson, whose fortune came from the television and radio rental business and from horse racing, soon let it be known that he found academics vacillating and unbusinesslike. But he was a local lad

90. Well Dressing at Youlgreave (photograph, courtesy of Malcom Nix).

for whom, despite their denizens, colleges had a mystical appeal. So a prime site was found behind the Backs in Cambridge and in July 1974 nine architectural firms attended initial interviews and discussions. Four were invited to proceed with a feasibility study which would provide sufficient detail for a submission of a planning application. The firm finally selected was Gillespie, Kidd and Coia of Glasgow in which two partners, Andy Macmillan and Isi Metzstein, had recently come to the fore, having made their names with the design of modern churches. Inspired by Le Corbusier, Mies van der Rohe, and Frank Lloyd Wright, Macmillan and Metzstein sought to give the College an innovative design. Robinson is built in brick, not stone, and the internal courtyard or forecourt is irregular and minimized in order to uphold the architects' principle that a building should not reveal itself entire at any one moment but should unfold some aspects while simultaneously obscuring others.

At the planning stage, the pre-elected Fellows of Robinson College, aware of what had happened at Churchill, debated whether a chapel was needed. The majority voted in favour of no chapel. When the Master, Lord Lewis, informed

Robinson of this, he received the reply: 'Very simple, Lewis. No chapel, no college.' As a result the chapel was taken out of the hands of the fellowship and a Chapel Building Sub-Committee was formed, in which Robinson took an active part. The first draft of the brief for the architects was written in March 1976. It emphasized that the chapel had to be a multidenominational Christian building, flexible enough to incorporate future changes in religious practices and changing needs. In the main chapel a sanctuary area would be provided as a means of focus but not in such a form that would fix the position of the altar. It also stated that there would be a small devotional antechapel off the foyer.

The initial plan for the chapel was compared by some of the committee with the chapel at Gonville and Caius College, similarly long and narrow and nicknamed 'the engine shed'. Subsequent drawings gave greater focus and drama to the space by incorporating a bent apse, bulging into the fore court, into which was placed a window, irregular in outline, with 'crowstepped' undersides. Initially this was to be filled with clear glass. Then, in 1977, shortly before a meeting with the architects about the chapel, Robinson saw a television programme about Coventry Cathedral and the next morning insisted that 'the chap who did the glass at Coventry', by which he meant Piper, should be brought in. Initially, it was proposed that John should collaborate with the architects on the design of the chapel, but this, according to Metzstein,[3] was a 'subterfuge' to pacify Robinson, and John's contribution, aside from the design of the glass, was confined to the hassocks and the short banners that hang down over the top of the east windows and slightly soften the light. But in fact he also designed the wooden cross and candlesticks, a 'Deposition' ceramic wall relief, and some altarcloths, and advised on the tiling used in the antechapel where the font and the altar are made out of the same Aberdeen granite as had been used for the kitchen table at Fawley Bottom.

Inside the main chapel, in line with the architects' design principle, the apse window is both revealed and then partially obscured by a section of wall that comes down in front of it and rests on a pillar. As a result the window can only be fully seen from the side, as the visitor enters the chapel. Though John made no comment on the perversity of the architectural setting, it may have determined his choice of subject matter, for 'The Light of the World', here interpreted, as at Coventry, by a circular burst of light, is, perhaps, something that can only be intimated or glimpsed momentarily. What does remain visible even from the centre of the chapel is the window's right-hand side. As it falls away from the burst of light, the patterning loses its abstraction and becomes more earthbound, the colours darkening and the forms evoking foliage and fruit, touches of gold and orange appearing among the rich greens which are

finally transformed into clusters of deep blue (Plate 75). As Martin Harrison has commented, such opulent treatment brings to mind the opalescent stained-glass work of the American Louis Tiffany. This further confirms him in his observation that John may have adopted a slightly *fin de siècle* style after seeing some of the C. R. Mackintosh-influenced features in the chapel.[4]

Because John had, by this date, turned wholeheartedly to figurative styles for his stained-glass designs, the large window at Robinson is an unexpected throwback to his earlier work. Its success owes much to the flair and imagination with which Patrick Reyntiens and his assistants translated John's ideas into glass. Reyntiens promoted a spontaneous approach to stained glass, encouraging his assistants to begin with the shadows and other hand-painting done on the glass and only afterwards to think about outlines and lead-lines. One of these assistants was David Wasley. Having already made a two-light window for John at Wolvercote in Oxfordshire and the tall thin, single-light memorial window to Alan Hartley at Fawley, Wasley did the antechapel window at Robinson, for which John had based his design on the Romanesque tympanum at Neuilly-en-Donjon. It packs into the limited space a layered image of the three kings paying homage to the Virgin and Child above a sleeping deer and lion, while beneath can be found Adam and Eve and the Last Supper. The extraordinary vitality of this window owes much to the depth and beauty of its colours (Plate 76).

By happy coincidence, the Pipers had two grandsons there, Vaughan Lewis and Luke Piper, and on John's recommendation, J. S. Bodfan Gryffud had been appointed its landscape architect. After the chapel windows had been put in place, the College made John an Honorary Fellow and he continued to make occasional visits, as a guest of the Master. Once, when thin and frail-looking, he found the heating more than he could bear, so opened wide a window, unintentionally demolishing a security device intended to defeat the toughest of burglars. The Master, Lord Lewis, not only welcomed his visits, but, in conversation with Myfanwy, recognized her stature. She was surprised and touched to find that, even in widowhood, she received invitations to the College as one of his guests.

In the late 1960s, a kiln had been installed in one of the outbuildings that formed part of the three-sided courtyard at Fawley Bottom. This had been done so that David Lewis, the Pipers' son-in-law, could experiment with the making of pottery, an interest he had developed while living with Clarissa in London and training as a paediatrician. Their weekend visits to Fawley always ended with the excitement of opening the kiln and seeing the results of both his

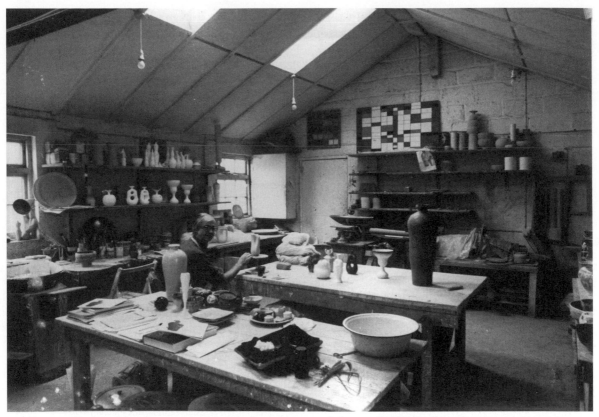

91. Geoffrey Eastop working in the pottery workshop at Fawley Bottom.

and John's work, for David had infected his father-in-law with his enthusiasm. Then in 1968, during an exhibition of his work at Reading Museum and Art Gallery, John met the forty-seven-year-old potter Geoffrey Eastop and recognized in him someone with whom he could collaborate. He offered Eastop the use of the pottery studio at Fawley in return for help and advice. Before long Eastop set up a proper workshop in a nearby milking parlour.

Eastop, on leaving the army in 1949, had initially studied painting before turning to pottery in 1953, for financial reasons. He brought to Fawley Bottom not only the technical knowledge he had acquired at the Odney Pottery in Cookham, Berkshire, and at Aldermaston Pottery, where he had worked with Alan Caiger-Smith, but also a strong interest in integrating surface decoration with the body of a pot. Aware of both the craft and 'fine art' end of ceramics, Eastop, rather unusually at that time, saw the point of both. There was a part of him that regretted leaving behind his ambitions to paint; and when in 1965 he visited the Tate exhibition—'Painting and Sculpture of a Decade '54–64'

which covered the era from American Abstract Expressionism to Pop Art—he immediately wanted to translate the excitement it aroused into ceramics. Even before he met John, Eastop was using clay slip in a painterly manner.

He began working at Fawley Bottom on the days he was not lecturing at Berkshire College of Art and Design. The arrangement was to last fourteen years and it established a lasting friendship between the Pipers and the Eastops, for Geoffrey's wife, Pat, proved to be very understanding of the many occasions when her husband stayed on at Fawley Bottom for dinner, sometimes also sleeping on the bed in the cowshed studio. From the first moment he had stepped into the farmhouse, Eastop felt very at home. But the real joy for him of this association was his discovery of the extent to which he and John shared a desire to experiment and try out new things and how well their talents combined.

Both men wanted to use colour boldly on a large scale, and to create more room for self-expression in this skills-based craft. They turned to earthenware, producing pots and large dishes both thrown and press-moulded. John would show Geoffrey the kind of thing he wanted to do in mixed-media sketches which Eastop then translated, using spectacularly dense yellow, red, and orange glazes and greeny-black, copper-oxide effects. By the mid-seventies quite complex work was being done on platters, bowls, and cylindrical vases. At various stages in the course of making, the ceramic might be covered with coloured slip, engraved, painted, sometimes over a wax resist, brushed with an opaque glaze or sprayed thinly with a transparent glaze. The unconventional techniques and painterly effects which Piper and Eastop developed made these pots stand out from the run of British ceramics, though they had an obvious affinity with some of Picasso's work in this medium (Plate 71). Sometimes glazes were applied so thickly they formed a crusty relief, John delighting in spirals, circles, and crude blobs, devising large dragon flies, nudes, or faces for the large platters, cut and press-moulded to the shapes he wanted. After applying a glaze, he might suddenly scratch into it with a penknife, or he might draw on the ceramic with long thin rolls of clay, achieving the effects he wanted by any means available to him.

This partnership not only generated creative excitement, it also gained Eastop new commissions: he made candlesticks, based on an idea of John's, for Nuffield College and worked with Bodfan Gruffydd on a ceramic mural for a children's garden at the Maudsley Hospital in south London. He also translated into clay John's design for a wall panel for Robinson College Chapel, based on the famous Deposition of Christ carving at the Externsteine, near Detmold, in Germany.

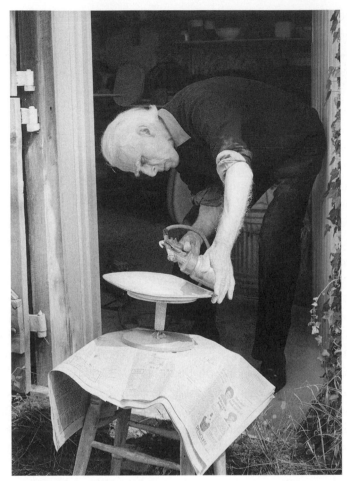

92. John at work on a ceramic.

John's ceramic work—both moulds made to his design and thrown pots made by Eastop—were first shown in one of his solo exhibitions at the Marlborough Gallery, in March 1972. He found a champion in Quentin Bell, a fellow painter and potter. 'Pottery can be used and is very extensively used for the expression of polite sentiments,' Bell wrote.

> Work such as this can receive a wonderful genteel appearance; but ceramics can also be used for a frank declaration of joy. Joy which may use colour, imagery and fantasy, joy which may be brutal or indeed vulgar. All that is needed is a full understanding of the medium, a high degree of aesthetic courage…and, of course, talent. These are the qualities which John Piper brings to his art and brings in generous quantities.[5]

Through Bell, John was introduced to Douglas Woolf, who had set up the Fulham Pottery in the New King's Road, and here Piper indulged his passion for obelisks which could sit on the mantelpiece and which sold well. Nigel Foxell organized an exhibition of John's drawings, ceramics, and prints at the Savile Club in the spring of 1980, after which Dan Klein stepped in and in 1982 invited him to exhibit pottery at his gallery in the Halkin Arcade, Belgravia. There he showed in 1982 a mountain of obelisks, candle sticks, plates, and vases, having worked spring and summer with several technicians and a young French potter, Jean-Paul Landreau, mostly in the studio at Fawley Bottom.

For John, one of the advantages of ceramic work was that it could be done by artificial light, in those hours of darkness when he did not paint. As a result, he began to neglect his correspondence, and it was Myfanwy, now, who sometimes wrote the necessary letter to a patron or collector. However, after the Dan Klein show, John, wanting to turn his attention to other things, announced that he had shot his bolt with regard to ceramics.

This same year his first design for wallpaper, 'Church in a Copse', was printed. One Christmas, while he and Myfanwy went to Garn Fawr, a young woman called Helen Feiler, a close friend since school days of Sebastian's wife, Mary, had come to house-sit. She was already involved with the crafts and, seeing all John's fabrics in the farmhouse, conceived the idea of asking him to design a wallpaper. He agreed and 'Church in a Copse' was hand-printed by Galperin and Davidson, a London firm of wallpaper makers who also did 'Foliate Heads', a second design that John made for Helen a few years later, which worked well as a frieze. Both designs were also turned into lampshades.

But, after his major ceramic show with Dan Klein, the project occupying John's mind was his collaboration with Richard Ingrams on the monograph *Piper's Places*. Ingrams was a near neighbour of Osbert Lancaster and his second wife, Anne Scott-James, and with them had attended a fireworks party at Fawley Bottom on a foggy December night in 1977. John had been one of the first subscribers to *Private Eye* and was keen to meet the man who had been its editor since 1963. That evening Ingrams, dazzled by the array of coloured mugs on the kitchen dresser and by the sensational outpouring of rockets, watched as this gaunt, white-haired man of seventy-four ran to and fro in the dark, ensuring the continuous display of fireworks. Afterwards there was food and drink in the kitchen, and then John was persuaded to play jazzy songs on the piano and Osbert Lancaster sang a solo which was loudly applauded. 'Certain impressions remained from that first visit,' Ingrams later wrote; 'the strength and cohesion of the Piper family; the perfectionism involved in mounting an ephemeral firework display; and the calm and order of Piper's studio.'[6]

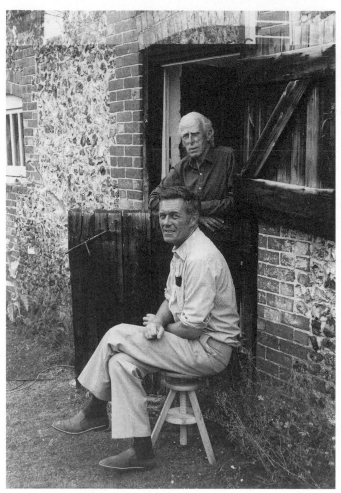

93. John Piper and Richard Ingrams at Fawley Bottom.

Ingrams returned to Fawley Bottom to consult John about a book he was writing on Romney Marsh. Soon after, he wrote an article on the Shell Guides which led to the invitation from Hugo Brunner at Chatto and Windus to collaborate with John on *Piper's Places*. It proved to be a working relationship that turned into a lasting friendship, Ingrams sometimes joining Piper in jazz duets at the piano. The younger man admired, among other things, John's detachment and tolerance, his humour, love of gossip, his inner strength, forbearance, kindness, and generosity. In *Piper's Places* he quotes Mervyn Horder on John: 'He's a marvellous person to talk to if you're thinking of committing suicide.'[7]

Ingrams adds: 'You would not be given any specific advice or counselling but his mere presence would provide reassurance.'[8]

In the wake of publicity surrounding the Chichester Cathedral tapestry, John received several requests for further work in this medium.[9] He returned to Pinton Freres and formed a close relationship with Oliver Pinton, never failing to admire this man's interpretation of his designs, the blending of colours and skilful handling of different kinds of thread and changes in the direction of the weave. With Pinton, he produced tapestries for Barclay's de Zoete (a branch of Barclay's Bank), Rothschilds International Bank, the Grocer's Company, the British Embassy in Helsinki (Plate 63),[10] the New Chancery in Bangkok, Reading Civic Centre, the theatre at Magdalen College, Oxford, and the University of Witwatersrand, in Johannesburg. This last was celebrating its Golden Jubilee with a new library block at the heart of the campus, the Wartenweiler building, and it wanted two tapestries, one representing the fruits of nature and the other the fruits of the spirit. Though John visited Felletin, in order to keep an eye on this commission, and kept in close contact with the South African architect Monté Bryer, the tapestries unfortunately arrived too late for the official opening in February 1972. Nevertheless the superb quality of craftsmanship that went into the translation of his designs turned all these tapestries into lasting works of art.

One currently on public view in England is that which he designed for Newcastle's new Civic Centre, and again it was made by Pinton Freres. His initial idea for this 19-ft-tall by 8-ft-wide tapestry was to portray Roman Newcastle, but it was later abandoned in favour of non-representational imagery. 'The abstract scheme', he wrote, 'is founded on the colour and texture of some elemental features of Newcastle-upon-Tyne's background and structure—granite, basalt, coal and iron.' He also tried to aim at a certain solemnity and grandeur of form which he thought would suit the proportions of the new banqueting hall. Commissioned in 1967, it was shown at the Tate Gallery before going north for the official opening of the Civic Centre on 14 November 1968.

Very different in style is that designed, eleven years later, for the risk and insurance company Sedgwick's. *Five Gates of London*—32 ft long × 8 ft high —was woven by the Edinburgh Tapestry Company and it hung initially at Sedgwick's head office building in Aldgate High Street. (When the company moved to Sedgwick Forbes House—now the Marsh Centre, Whitechapel High Street—the tapestry moved too, but it has since been sold to the Guildhall Art Gallery, London.) This spectacularly successful work brought a high emotional temperature into a bland office interior, charging it with energy

94. Tapestry for Newcastle Civic Centre.

and drama. Piper based his design of the five gates, only one of which still exists, on drawings and prints in the Guildhall Library. Sedgwick's also commissioned an edition of silkcreen prints, based on the original design, with the result that images of this tapestry hung in the international firm's offices around the world.

John used the Edinburgh Tapestry Company again for the long horizontal tapestry which hangs across the organ loft in Sussex University's Meeting House. It is loosely inspired by Psalm 46 from which the University's motto is drawn. This ecumenical space had not been part of the original university buildings but had been paid for by Sir Sydney Caffyn, a former Pro-Vice Chancellor, to whom this tapestry acts as a memorial. Very different are the three Piper tapestries, woven by the Ibenstein Weavers near Dordabis, in Namibia,

for Hereford Cathedral. The link person here was Orde Levinson. In 1979, he arranged for three tapestries, designed by John, to be woven in Namibia, by the Ibenstein Weavers at Dordabis.

These tapestries were to hang in the south transept of Hereford Cathedral, against what is thought to be some of the oldest stone in the building. John therefore chose soft colours which would harmonize with grey and pink tones in the Cathedral's walls. But the weavers had difficulty translating his allusive designs, and, as a result, the three trees—the Tree of Life (drawn from Genesis), the Tree of Zion (a deposition scene), and the Tree of Heaven (based on Revelation 22.1 and 2)—take time to unfold in the mind, their images slowly registering amid the beautifully grave colour scheme.

One source of inspiration at Hereford was some thirteenth-century stained glass which John spotted in the Cathedral's choir. There, in one section, Christ carries an emerald green cross, a colour symbolic in medieval art of all that is lively, fruitful, and productive. Medieval sources recur in his work, more frequently, perhaps, than is recognized. In 1984, when designing four tapestries for the chapel in the Royal County Hospital (now the Royal Surrey County Hospital) in Guildford, he used foliate heads as symbols of the four seasons, deriving his ideas from C. J. P. Cave's book *Roof Bosses in Medieval Churches.* Though finely crafted by West Dean College in Sussex, where the tapestry department prides itself on the skill with which it can merge and mix coloured threads, offering an infinitely subtle range of tones and hues, the four works drew protests from some hospital visitors who found them faintly sinister and frightening.

In London, his tapestries were commercially marketed by Barry Cronan Fine Art, in the form of a decorative image of the church at Long Sutton, Lincolnshire,[11] in an edition of 25. At around the same time Quayle Carpets, Kidderminster, experimented with a John Piper design for a carpet. It sold through Page Limited, in Cavendish Square, London, but at the time of writing its whereabouts is unknown.

Myfanwy often played a significant part in these commissions by offering hospitality to clerics or wealthy patrons who found it exciting to find themselves discussing the project over a meal in an artist's kitchen at a granite-topped table. Myfanwy's cooking was always marvellous but offhand, and never presented with grand *apareil.* Yet for all their simplicity, such occasions could be fairly intimidating to first-time visitors. A large salmon appeared in a fish kettle when Lisa Henderson went to make arrangements for a show at Worcester Cathedral. Other visitors were also

present and everything—the conversation, the setting, John's reputation, and awareness that the Pipers were high-powered people—left her feeling a little overwhelmed. Yet in the course of these lunches, many new friends were made.

Around this time both Pipers sat for bust portraits, with exceptionally good results. The first of John, by Archibald Zeigler, was done in the autumn of 1973. He sat again for this purpose to Anthony Stone and Geoff Eastop, the latter also making a telling bust portrait of Myfanwy, a casting of which can be found in the Britten–Pears Library at Aldeburgh. This willingness to become the object of another's gaze is surprising, in John's case, as he was still very busy and active in many fields. And he was still easy prey for good causes. In 1971, when Lord Harewood decided to sell Titian's *Death of Actaeon*, it became the subject of a National Gallery appeal. John, a trustee of the Gallery, made a variation of this painting for a fund-raising gala performance organized by Richard Buckle at the London Coliseum.

He and Myfanwy gave their support at this time to Tambimuttu, who in the 1940s had edited a leading magazine, *Poetry London*, and was now seeking to make a comeback in the literary world with his Lyrebird Press. Myfanwy agreed to become a director as well as consulting editor for his new series of *Poetry London*. John did lithographic illustrations for Anne Ridler's poem *The Jesse Tree*, which the Lyrebird Press published in 1973, and for *India Love Poems*, translated by Tambimuttu in 1977. The second of these stirred his interest in temple sculptures and painting from India's golden age. Some of his illustrations were based on the temples of Kornak and Khajuraho, but the intention was not to represent the form or colour of the original carvings but instead to catch their spirit and purpose. Each picture was intended to reinforce the sheer physical zest and emotional exuberance of the original verses.[12] Another press for which John worked in the late 1970s was the Keepsake, illustrating a poem by Philip Larkin in 1977 and, the following year, doing a drawing for Peter Porter's poems, *Les Tres Riches Heures*.

John's printmaking, meanwhile, contributed in no small part to his earnings which, in 1974, amounted to £33,796.88, the outcome of intense activity. He was to benefit significantly from Christie's Contemporary Art, a company launched in 1973 by Charles Farrell and Myles Cooke, as a joint venture with Christie's, to promote the selling of graphics in Europe and North America. The first print they commissioned from John had a waiting list of more than 300 people, so they immediately commissioned two more architectural landscapes. Charles Farrell confidently told John that they were tapping a new market for his work and selling to people who did not visit the Marlborough. Meanwhile several

galleries outside London wanted to retail his lithographs and arranged to do so through Tony Reichardt at Marlborough. Many of his prints were bought by Oxford colleges where he was sometimes offered exhibitions or invited to do pictures for outgoing heads of houses.

Holidays at Garn Fawr saw no lessening of activity. There he did a great many paintings of Strumble Head. His spontaneous gestural marks convey the experience of being in the landscape, his work appearing lush, wild, and ravaged by the elements. Frequently, his Pembrokesehire landscapes make use of strong green, which is warmed by the inclusion of earthy colours. It had become the Pipers' habit to spend Christmas at Garn Fawr. They took communion on Christmas Day at St David's, where it pleased John, as he knelt at the communion rail, to see the medieval floor tiles. Removed from Fawley Bottom, he and Myfanwy still acted as magnets for the rest of the family, David and Clarissa and their children often came over from Aberystwyth where David was now a Paediatric Consultant, while Edward and Prue and their boys sometimes made the journey from Somerset.

At Fawley Bottom, all four of John and Myfanwy's children and their offspring were usually present at parties. The Farmhouse had lost none of its appeal and continued to give visitors a sense of the well-lived life (Plates 72, 73 and 74). Bonar Sykes, Chairman of Wiltshire Archeological and Natural History Society, came to discuss a stained-glass window for the Devizes Museum and noticed a marked lack of side or pretension. When the singer Ted Uppman and his wife, Jean, came over from America for a stay in England, they were astonished by the generosity with which they were received, by the unending bottles of wine brought up from the cellar, the various trips to nearby places, the picnic at Blenheim. There John made suggestions to Jean, who was just beginning to take up photography seriously, for views she might take. Jean noticed that Myfanwy's irritation with John—'you old coot'—was expressed in a still loving form.

32

Death in Venice

Who shall unravel the mystery of an artist's nature and
character! Who shall explain the profound instinctual fusion
of discipline and licence on which it rests!

——Thomas Mann, *Death in Venice*

Towards the end of the rehearsals for the television production of *Owen Win-grave*, Britten told Myfanwy that he wanted to make Thomas Mann's *Death in Venice* the subject for his next opera. Her initial response—'wonderful, too difficult, marvellous, impossible'—ended with the realization that if he thought it viable then it could be done. Though work on this opera overlapped with other commitments, she claimed that for the next two years and seven months she thought of little else. But only when she experienced the first night at Snape did she realize what she and Britten had done 'to that long, brilliant cerebral, analytic story to make it live upon the stage'. Not till then, she reiterated, did she know 'what is was that we had done'.[1]

Overjoyed at the possibility of working with Britten again, 'and so marvellously soon',[2] Myfanwy went straight back to Thomas Mann's seventy-page novella which had taken him a year to write. Whereas with *The Turn of the Screw* she had done much of the preliminary thinking on her own, with this opera she collaborated with Britten from the start. In late January 1971, Britten, Pears, and the Pipers went on a fifteen-day tour of France. Pears' ready enthusiasm, the Pipers' familiarity with French architectural treasures, and a series of very good meals made this a memorable trip. As they journeyed south they stopped at Chartres, Albi, and other cathedrals, churches, and Romanesque sites. John drove, Peter map-read; Myfanwy and Ben sat in the back, endlessly discussing *Death in Venice*.

This moral fable, with its multiple ironies and artistic intricacy, taxes analysis. First, Myfanwy and Britten made a list of all the incidents in this dense and disturbing text.[3] Next they reviewed them to see what could be eliminated. (They omitted, for instance, Aschenbach's false start to his holiday, on the Adriatic coast, which, Myfanwy observed, underlined the play of chance and fate but added nothing essential.[4]) Repeated re-reading of the story not only brought out its essentials, but it also revealed how imagery, cross-reference, and the inevitability of sequence would have to structure the opera. By the end of this holiday Myfanwy and Britten had compiled almost identical notebooks in which a synopsis of the novel on the right-hand pages is matched, on the left-hand side, with an outline scenario for the opera. They also identified a list of characters and significant phrases or quotations. On her return home, Myfanwy began drafting the libretto, sending pages to Aldeburgh from time to time for Ben's comments, while discussion of the complex scenario continued.

At this stage both thought that they had eighteen months in which to create this opera, for Britten intended it to be staged at the Maltings in the autumn of 1972. An urgency had, therefore, accompanied their initial analysis of Mann's text, work which they did without any recourse to background information. But in September 1971 Britten decided to postpone the opera till June 1973, a decision that Myfanwy must have welcomed as it gave her the opportunity to deepen her knowledge of Mann's writings and to discover things that would help elucidate the opera. Initial discoveries were further corroborated and enriched through her reading of, among other things, Goethe's *Elective Affinities*, Thomas Mann's *A Sketch of My Life*, R. Hinlin Thomas's *Thomas Mann: The Mediation of Art* and, as we shall see, T. J. Reed's introduction for students to a German edition of *Death in Venice*, published in 1971 by Oxford University Press.

One of Myfanwy's tasks was to unravel the quotations and allusions to other sources which Mann wove into his texts. Mann himself referred to *Death in Venice* as a faceted 'crystal' formed by the pressure of Greek and German philosophies on the real emotional experience at its heart. He made extensive use of phrases, images, and ideas from three Greek dialogues: Plato's *Symposium* and *Phaedrus* and the *Eròtikos* of Plutarch. Philosophical musing is not only central to his tale but also the cause of its verbal richness. Myfanwy had the difficult task of reconciling these qualities with Britten's need for a spare and economic use of words. She treats Aschenbach's interior monologues,[5] which are central to the unfolding tale, with impressive brevity and compression,

while also carefully planting information in places where it is appropriate to receive it.

Mann's story, first published in 1912 in two successive numbers of the *Neue Rundschau* revue, drew upon his obsession, the previous year, with a beautiful Polish boy, who had caught his eye during his holiday in Venice, and on his experience of the 1911 cholera outbreak. In all essentials, Myfanwy's libretto remains true to Mann's tale. The protagonist, Gustav von Aschenbach, a distinguished author whose creativity is flagging, yields to an impulse to travel south. In Venice his attention is caught by a Polish boy, Tadzio, whom he associates with the Greek god Eros and in whose beauty he recognizes what he himself is striving to attain: perfection of form. In this way his homoerotic feelings are sublimated into art. But, insidiously, Aschenbach's aesthetic admiration turns into a sexual passion, and the disciplined habits and artistic ideals which had shaped his life are threatened by a contrary desire for an irresponsible, lyrical outpouring of his long-repressed emotions. Fearing the effect of the sirocco on his health and depressed by the street vendors and beggars who importune him, he tries to leave Venice. The hotel manager says goodbye (in the libretto with the words 'no doubt the Signore will return to us in his own good time'), but at the station his luggage is mislaid. Refusing to leave without it, he returns to the hotel angry, but secretly rejoicing. Having hitherto sublimated his attraction to Tadzio into the worship of beauty, he now receives a smile from the boy, in passing, and discovers that what he feels for him is love.[6] This moment of psychological self-honesty shatters his composure and physical and moral decline sets in. The sirocco returns, the weather is oppressive, and Aschenbach learns from the Hotel barber that a cholera epidemic has reached Venice which the city authorities are seeking to conceal. As a symbol of moral decay, it echoes Ashenbach's progressive disintegration, for his state of mind becomes increasingly desperate. He abandons the pretence of dignity and begins to shadow Tadzio and his family, and instead of warning them of the epidemic which he knows is his duty, he remains silent, realizing that their departure would deprive him of his obsession. After eating infected strawberries, he himself falls victim to the cholera epidemic and dies on the Lido beach, while Tadzio beckons to him from the sea.

Mann's richly ambiguous tale touches on many things: the poignancy of age and decay, the precariousness of the artist's claim to dignity and public respect, the ascendancy of beauty over morality, the inevitable destructiveness within a great artist's career, and the desire for some form of reconciliation or salvation. For Britten, it mirrored the tension in his own life between his disciplined,

creative life and his dangerous obsession with adolescent boys; between the recognition and esteem he had achieved and sexual predilections that, if acted on, could have led to a prison sentence and destroyed his career. Even before recent investigation into his obsession with boys, Britten's *Death in Venice* was recognized as his most overtly personal and autobiographical opera.[7] It was further coloured by his ill health, for, having suffered an attack of endocarditis in 1968, further cardiac deterioration was now diagnosed, making necessary an operation to replace a defective heart valve. Britten decided to put this off until after he had finished *Death in Venice*, which he knew would be his last major work and Pears's last major operatic part, all of which gave to this opera a tragedy and urgency. Some of the words Myfanwy wrote for Aschenbach —'I long to find rest in perfection'—'vacillitating, irresolute, absurd'—'the city growing darker every day like the secret in my own heart'—would have had, for Britten, undeniable autobiographical resonance. Myfanwy's awareness of this was enhanced by the fact that, when writing for Aschenbach, she kept the sound of Pear's tenor voice in mind.[8] She may also have known that Britten had been thinking about *Death in Venice* for a very long time.[9]

Both she and Britten noticed that Mann links certain characters—the Traveller, the Elderly fop, the Old Gondolier, and the Leader of the Strolling Players—by giving them similar attributes—a snub nose, a grin, the broad-brimmed hat, and staff of Hermes, the conductor of the dead across the Styx. In Mann's description of the posture of the Traveller Myfanwy identified a specific reference to representations of Death in medieval German woodcuts. This led to the realization that these characters are both realistic and symbolic, for in addition to their specific roles they all lead Aschenbach on his journey towards his final end, the story operating on three levels—literal, psychological, and mythological. To give this idea dramatic strength in the opera, it made sense to have one singer play all the roles. Britten and Myfanwy also extended this idea to the Hotel Manager and the Barber, though when Britten first suggested that the Hotel Manager should exchange sharp words with a porter, towards the end of the opera, which would reveal him also to be a manipulator of Aschenbach's fate, Myfanwy doubted that this would work. However, when it did, she was again amazed, as she had been when working on *Owen Wingrave*, by Britten's sure sense of dramatic necessity.[10]

At the outset, Britten had written to Thomas Mann's son to see whether the project would be favourably received by him and the author's widow. In this way, he learnt that Luchino Visconti's film based on the novella was currently being made in Venice. Though this was to cause some contractual complications with Warner Bros., it did not deter Britten. He deliberately

avoided seeing the film but no doubt heard about Visconti's identification of Aschenbach with the composer Mahler. Neither he nor Myfanwy considered such an alteration, perhaps because it was all too evident in the music Britten wrote that he brought to Aschenbach's predicament his own vulnerabilities as an established and honoured composer in his sixtieth year. If echoes from the film did reappear in the first production of Britten's opera it was merely in the use of certain poses.

For Myfanwy, the most interesting outcome of the publicity surrounding Visconti's film was that it drew to the fore the original Tadzio, Wladyslaw Moes, who wrote a letter to the *Daily Telegraph*, recollecting the old gentleman (Mann had in fact been only 35) who had taken so much interest in him during a long summer holiday many years ago. His statement, that he and his friends had found Mann funny and not disturbing, aroused in Myfanwy a memory from her own childhood experiences. On holiday, she had been fascinated by two grown-ups (a young man and woman in their twenties) whom she had contrived to meet (reversing the roles in *Death in Venice*) several times a day, on the beach, in the shelters, on the steps, in the narrow seaside town streets, on the town walls, and so on. This recollection gave her a particular empathy with Aschenbach's restless pursuit of Tadzio, the contrived encounters and developing indiscretions.

When contemplating Tadzio, she noted that Mann never tells us what the adolescent thinks about Aschenbach. 'The implication', she realized, 'is that, unlike the ghosts in *The Turn of the Screw*, what he thought or said would have been of no interest to us. Here what needed to be understood was not communication, but the lack, indeed the impossibility of it.'[11] In order to convey this distance she suggested that Tadzio and his family should be cast as dancers, not singers. Again, as Myfanwy observes: 'Only dancers find it natural to be on stage for any length of time in silence and only dancers can express the trivialities and pleasures of human behaviour without speech.' Her ideas for these scenes were shown to Colin Graham, who was to direct the opera, and to Frederick Ashton, who was brought in as producer and choreographer. Graham's queries and response to her notes and her second draft scenario played an influential part in the shaping of her libretto.

This second scenario had been finalized by July 1971, and two months later Myfanwy presented Britten with a draft libretto for the first act. This was followed by a ten-day visit to Venice, Britten, Pears, and the Pipers staying at the Gabrielli-Sandwirth Hotel on the Riva degli Schiavoni. An old friend of Britten's who lived in Venice arranged for them to be taken out by a gondolier who would use all the old traditional cries, ones that Mann would have heard

in 1911 but which had since fallen out of use. In this and other ways they scoured the city for details that would contribute to the opera's authenticity, John sketching and taking photographs in preparation for his sets.

On their return, Myfanwy continued revising and rewriting. In August she urged Britten to read *The Bacchae* again, for the herdsmen's speech had shaped her understanding of the Dionysian element in Mann's text. Meetings continued to take place, and, in early December, Britten and Colin Graham spent three days working with Myfanwy at Fawley Bottom. Britten was now ready to begin the composition sketch, but did not in fact start on this in earnest until 10 January 1972, when he reached Schloss Wolfsgarten, near Darmstadt, the home of his close friend the Princess of Hesse, where he stayed for a month. Here he and Myfanwy had another close and reciprocally productive session, for she joined him for five days in February, taking with her early bits of the libretto which needed rewriting. 'That was a marvellous time,' she afterwards wrote, 'five days full of impressions and things to think about—quite apart from five hard days work. It felt like months in one way though it was over so soon. *Thank* you for arranging your work needs so that I had to come.'[12]

At an early stage she had realized that they could omit the narrator, on the grounds that, because Aschenbach is also Mann, there was nothing that the narrator knew which Aschenbach himself did not know. For her, the essence of the tragedy 'is that we should be aware of Aschenbach's self-knowledge and also aware, as he is, that he will not profit by it.'[13] As Mann realized, Aschenbach's situation parallels that of the aged Goethe whose dignity was undone when, at the age of seventy-four, he fell in love with a girl of seventeen, Ulrike von Levetzow, and determined to marry her. 'Passion as confusion and as a stripping of dignity was really the subject of my tale,' Myfanwy claimed, taking her lead from Mann's phrase 'And passion confuses the senses' in a letter about this story. This made her initial inclination, to treat Aschenbach's obsession as a product of idealism and the positive Greek attitude to homosexual love, inadequate as she saw a need for the element of 'forbidden' love.

At a crucial moment in the development of the libretto, immediately after her return from Wolfsgarten, Myfanwy had re-read Plato's *Phaedrus* and made an interesting discovery which, for her, linked Tadzio's voice with that of Apollo. She wrote to Britten: 'There is no doubt in my mind that Aschenbach was a devotee of Apollo—that Apollo is the God whom he puts up against Dionysus and that Tadzio therefore also can and does represent Apollo in his mind.'[14] These ideas preceded, by some months, her discovery of T. J. Reed's

1971 introduction to the German text which affirmed that Mann's story does indeed pivot on the Apollo–Dionysus axis.

This is first suggested by Mann's descriptions of Tadzio in terms that evoke the language of painting and sculpture. At this stage he represents for Aschenbach an Apollonian ideal, an analogue for the perfection of form that he himself aspires to create. But as Reed points out, Mann, following Nietzsche's *Birth of Tragedy*, argues that art conjures with Dionysian forces as well as the Apollonian principle of order, control, and individuation. In Aschenbach these elements are not in balance, for in the course of a career built on disciplined achievement, control has become repression. At the start of the tale his discipline is exhausted, and it has, in turn, exhausted him. 'My mind beats on and no words come.' This is the opening line of the libretto in which Myfanwy brilliantly distills the sense of artistic deadlock. Feeling presses to take revenge.

Later, when a dream-like mood comes over Aschenbach as he watches Tadzio and his friends playing on the beach, he begins to see everything, in slightly exaggerated fashion, in the form of an Hellenic idyll. Tadzio and his companions, who are also played by dancers, perform acrobatics and take part in a pentathlon in which half-naked boys run, jump, and throw the discus. This deepens Aschenbach's enchantment, and his dream-like mood is furthered by a second dance, the dancers now including the children of the Hotel Guests and the beach attendants. But, in order to bring out this Hellenic aspect of the story, Myfanwy departs from Mann's text and introduces the voices of Apollo and Dionysus. Not only does Apollo appear during the pentathlon and join with the chorus in offering a running commentary, but in the following scene, the final one in Act I, while Aschenbach sleeps, he and Dionysus vie with each other for his soul, Dionysus becoming another messenger of his fate. This scene, which can be one of the most haunting in the entire opera, owes much to the brevity of the dialogue.

> DIONYSUS: Receive the stranger god.
> APOLLO: No! Reject the abyss.
> DIONYSUS: Do not turn away from life.
> APOLLO: No! Abjure the knowledge that forgives.
> DIONYSUS: Do not refuse these mysteries.
> APOLLO: No! Love reason, beauty, form.

However, these dance scenes, as choreographed by Frederick Ashton, seemed to Myfanwy perilously close to sentimentality for she disliked the Royal Ballet style. A modern dance company, she thought, would have interpreted

them differently. Initially, she had envisaged the pentathlon as being played out in silence. But in May 1972 Britten asked for the boys' dances to be interpreted in words, sung by the chorus in the form of madrigals, a demand that upset her but which she took on board. She had also suggested that in the second dance sequence the boys should be naked, so as to remove it slightly from reality, in keeping with Aschenbach's state of mind, which at that point is engaged with a vision as well as an experience. The simple addition of a white beach towel was all that she thought was necessary at the end, when Tadzio mixes again with the grown-ups. Given the homoerotic overtones of the story, her suggestion, if apposite, had to be ignored.

She sought ideas wherever they were to be found, gaining help with the popular Venetian songs in the Strolling Players scene from an Italian professor at Reading University. Another *éclaircissement* came to her in May 1972, after hearing James Bowman sing. This was in a recital at the National Gallery in London on 28 May 1972, at which Britten and Pears also performed.[15] The thrilling quality of Bowman's counter-tenor voice, its capacity to be both tender and fierce, made her flesh creep with terror and delight. She wrote to Britten, suggesting that this kind of strange, unearthly voice could be used at both the end of Act I and during the dream scene in Act II. At much the same time Peter Pears also had the idea that the role of Apollo should be sung by a counter-tenor. Britten had intended giving it to a boy treble, but he now changed his mind.

What cannot be underestimated is the significance of Myfanwy bringing to Britten's attention T. J. Reed's edition of *Death in Venice*, a copy of which she gave to him in July 1972, almost a year after work on the libretto had begun.[16] Reed perceived that deep in the work's conception is the idea that passion—the intoxication of Dionysus—liberates and inspires. Aschenbach, as we know, travels in order to find emotional release and literary inspiration. Tadzio becomes the focus for that release and Aschenbach, in recognizing this, is perhaps merely fulfilling what he has to do. In the penultimate scene in Act II, Myfanwy gives him the following monologue:

> Does beauty lead to wisdom, Phaedrus?
> Yes, but through the senses.
> Can poets take this way then
> For senses lead to passion, Phaedrus,
> Passion leads to knowledge
> Knowledge to forgiveness
> To compassion with the abyss.

Mann was aware, from Greek texts on homosexual love, that it offers both noble possibilities as well as pitfalls, that it can inspire or debase. Hence Reed's emphasis on the ambivalence in the story's closing scene, when Tadzio stands on the water's edge and points to the sea. This configuration, Reed argues, is modelled on a passage in Plato's *Symposium* which describes the progressive initiation of the lover of beauty into higher things. When he has left all else behind, as Aschenbach has done, such a person comes to see in the 'vast sea of beauty' a vision of a single ultimate beauty which embraces all he has experienced. Aschenbach's death, which some see as a moral criticism, is simultaneously his apotheosis. As Reed states: 'Thus *Der Tod in Venedig* remains ambiguous, not just in the sense that its many levels of meaning constitute complexity, but also in that there is a degree of uncertainty in the final impression it leaves.'[17] The ending of the opera returns us to the words that Aschenbach sings on his journey to the Lido:

> Ambiguous Venice,
> Where water is married to stone
> And passion confuses the senses?
> Ambiguous Venice.

Death in Venice again allowed Britten to explore the theme of innocence and its destruction, in a brilliantly condensed form. The final work is fitted into 17 scenes and some 140 minutes of music. Because the average length of scene is no more than eight minutes, action had to be staged with the minimum of realism, so that scenes could dissolve and flow into each other. Critics noted that Britten's score was richer in invention than *Owen Wingrave*, and that it carries within it quotations from some of his earlier operas. Dramatic use is made of the gamelan, the instrumental ensemble which Britten had first experienced in Balinese music during his 1955–6 round-the-world trip, and which is here associated with Tadzio. It added to the 'lyrical enchantment' praised by Winton Dean, who found all the music associated with Venice 'glorious, captivating, yet undermined by decay' and who reckoned Aschenbach one of Peter Pears's greatest performances.[18]

Many people who saw the first production of this opera attest to the ravishing quality of John's sets (Plate 84). It had been no easy task to translate this many-levelled philosophical novel into concrete images that avoided the banal or superficially picturesque. Though he knew Venice well, he made good use of the 1971 trip, capturing well heads, bases of columns, reflections in water, and bits of creeper hanging over fragments of wall, architectural details that

95. *Death in Venice*, Act I , Scene 7.

he thought, 'when helped by Colin Graham's ingenious and quickly-changing production, might add up to a cumulative suggestion of the evasive city'.[19] He also devised a series of vistas down canals, all pressed together to convey the claustrophobia of Venice. These were in deliberate contrast with the beach scene where the empty stage, apart from plain side wings, is set against a golden Turneresque backdrop suggestive of sea and sky and evocative of Aschenbach's loneliness and in harmony with Britten's 'view' theme. At other moments John used slides projected from the side of the stage on to a screen, showing fragments of architecture or glimpses of the colonnades in St Mark's Square. In this way the seductive mystery of Venice was conveyed, and its sheer improbability. When, in 1991, Covent Garden did a new production of *Death in Venice*, they chose to re-use his designs and paid £1,000 for the right to do so.

To coincide with the first performance, John made eight screenprints at Kelpra Studios based on his designs for *Death in Venice* which were published by Marlborough Graphic in an edition of seventy sets, with a further ten retained

96. Myfanwy with Ted Uppman in New York.

by the artist, one of which at the invitation of Roy Strong he gave to the Victoria & Albert Museum. The introductory leaf explains that the artist's intention was to create, through these designs, an illusion of Venice rather than a series of topographical pictures. 'The action of the opera moves from the Lido to Venice and back, from St Mark's to the Merceria, from less frequented piazzas through small canals, and it is important for the atmosphere of the story that the scenery should suggest restlessness.'

In the lead-up to the first performance of the opera, the conductor Steuart Bedford worked exhaustively on the score with Britten and made many of the final decisions as the composer was too ill to attend rehearsals. Nor did

he attend the first night of *Death in Venice* at the Maltings, on 16 June 1973, but he was present when it was performed at the Royal Opera House in October. After the final curtain and the first rounds of applause, a spotlight picked him out, seated in his box. The cast moved to the front of the stage to salute him and the audience gave him a standing ovation. Ill health also prevented him from attending *Death in Venice* at the Metropolitan Opera in New York, where it was premiered on 18 October 1974 and broadcast live. John's refusal to fly meant that he too stayed at home, but Myfanwy enjoyed it to the full and stayed with Ted and Jean Uppman, spending also a day at the home of the Calders in Connecticut. 'I think it's about emotion versus intellect,' she said of the opera, in an interview for the *New Yorker*, the magazine describing 'a handsome woman in her sixties, who has pale-blue eyes, a small, straight nose, and shoulder-length brown hair.'[20] On her return home she received a letter from the manager of the Met. 'All of us at the Met were honoured by your coming over for the premiere. There have been few great librettists. Bito wasn't here for our first *Otello*; nor da Ponte for *Don Giovanni*. But how proud we were that Myfanwy Piper joined us for the first *Death in Venice*!'[21]

Two years later, in December 1976, Britten died. John and Myfanwy were spending the weekend with the Twentymans at Claverley. Aware that Ben's death was imminent, John afterwards apologized 'for fussing a bit about papers and radio—not a natural addiction of mine',[22] but it was Suzannah who broke the news on their return to Fawley Bottom. They attended the funeral in Aldeburgh church on 7 December and spent the night with Mary Potter. Later, a Benjamin Britten memorial window, designed by John, was added to the church (Plate 77). It seems entirely fitting that its subject matter, representing Britten's three Canticles, had been suggested by Myfanwy.

PART

VII

33

Deaths and Entrances

In the 1940s, the sight of Myfanwy driving round Henley in a horse and trap had caught the attention of the barrister (later author and television dramatist) John Mortimer. He did not, however, get to know the Pipers until the 1970s, when he and his second wife, Penelope, began spending time at Turville Heath Cottage, the house which had formerly belonged to his parents. It was then that Mortimer discovered that his neighbour Philip Hoggett was married to the Pipers' daughter Suzannah who now had two children of her own—Ben and Lucy, the latter becoming a school friend of the Mortimers' daughter Emily. Through Suzannah, the Mortimers got to know John and Myfanwy and sometimes sat in the kitchen at Fawley Bottom, while Myfanwy, rather vague and full of chat, without seeming to notice what she was doing, produced extremely good food. John Mortimer admired John and asked him to design the cover for his book *Paradise Postponed*. He also noticed that the couple frequently contradicted each other, bickering gently over small things, who they'd been with, where and when, 'telling each other that they were completely impossible to live with in a way that showed clearly their love had never died'.[1] On one occasion Mortimer brought to Fawley Bottom Laurence Olivier, who was about to play a painter in the film *The Ebony Tower*, so that John might show him the movements a painter might make. The two families got on so well that, in 1983, when John Mortimer turned sixty and John Piper, eighty, they had a joint birthday party at Fawley Bottom. There was a tent full of flowers. A great many children and grandchildren were present and food was served at long tables covered with white cloths, while 'small girls in white dresses ran between the tables and out over the grass as the light faded.'[2] When darkness fell there were fireworks, at the end of which the words 'Happy Birthday John and John' lit up across the sky.

Three years before, in 1980, Suzannah began the process of separating from her husband, with, as her father observed with some asperity, 'the usual repercussions around the family of putting a lot of things somewhat awry'.[3] For a short period her two children were often at Fawley Bottom. John enjoyed having his grandchildren around him and became especially fond of the elder, Lucy. Later that year, in November, she was killed. En route to school one morning, having forgotten her sandwiches, she went back home and, hearing the bus, ran out again straight into an oncoming car. Many friends commiserated with John and Myfanwy by letter. News of their grandchild's death in November 1980 left Mary Potter longing to see them both, but not able to do so as she was not well enough to leave Aldeburgh.

Suzannah's daughter died on the day that Jonathan Miller's production of *The Turn of the Screw* was being premiered by ENO. The Pipers rang to say they could not be there and in fact did not see this production until its second time round.[4] Work continued in the midst of grief. John's habitual roster of commitments included his involvement, as adviser and patron of the church's restoration fund, with St Stephen's Walbrook, a Christopher Wren church, then being reordered around a massive, stone, central altar by Henry Moore.[5] At the same time he was reading, with admiration, Moelwyn Merchant's small book on R. S. Thomas, and his own name was allied with that of another Welsh poet, Dylan Thomas, when he supplied illustrations of mostly Welsh scenes for the Gwasg Gregynog edition of *Deaths and Entrances*. Myfanwy, similarly, had many calls on her attention. Numerous scholars working on Britten asked for her help, and she frequently appeared at study days or gave talks on her work with Benjamin Britten. At Patricia Howard's request, she wrote a formative essay on *Death in Venice* for a handbook on this opera which Cambridge University Press was to publish. She had also begun writing librettos for Alun Hoddinott, the composer to whom she had been introduced by Britten around 1973.

Her friendship with Alun and his wife, Rhiannon, began slowly but steadily deepened. Professor of Music at the University of Cardiff and artistic director of the Cardiff Festival, Alun Hoddinott played a major role in the promotion of contemporary music in South Wales. His own compositions has been characterized by qualities that can be regarded as Celtic—'obsessive drive, sombre brooding, rhetorical lyricism, fiery outbursts'.[6] The Pipers had been aware of his work before they met him, for they had heard his first opera in 1967. The work on which he and Myfanwy initially collaborated was a song cycle, *A Celebration of Flowers*, specially created by Hoddinott for Felicity Palmer and premiered at the Fishguard Festival in St David's Cathedral on 24 July 1976.

This same year Hoddinott was commissioned to write an opera that would give scope to the children of Fishguard School but with a star part at the centre for Sir Geraint Evans, who had connections with the area. This became, at Myfanwy's suggestion and with the help of her beautifully spaced libretto, *What the Old Man Does is Always Right*, based on the Hans Christian Andersen story of an old man who sells his horse for a cow, the cow for a sheep, the sheep for a goose, the goose for a hen, and the hen for a sack of rotten apples. When two travellers in an inn learn what he has done, they are astonished. They warn him his wife will give him a scolding, but he replies that she will simply give him a kiss and say, 'What the old man does is always right.' They take a bet on this—a bushel of gold coins to his sack of rotten apples—and travel with him in their coach to his home where the wife is waiting for his return. He recounts to her the exchanges he has made and she praises each decision in turn. Earlier that day a neighbour had refused to give her herbs, claiming she could not even lend her one rotten apple. When she learns that she now has a whole sack of rotten apples and can give some to her mean-spirited neighbour she laughs and declares 'What the old man does is always right.' The travellers, proved wrong, pour out a bushel of gold coins into a basket that the Old Man quickly produces. The opera was produced by John Moody, designed by John, and premiered at the Fishguard Festival in 1977, in association with the Welsh Arts Council. It built on the precedent set by Britten in his *Noye's Fludde* and *Let's Make an Opera* and was repeated at the Cardiff Festival the following spring.

While working on this opera, Myfanwy wrote in a notebook: 'Suppose the chorus divides in half and one half says to the other—did you see that?' This allowed the children at times to address the audience and each other with a knowing cynicism about adults. ('Did you see that? Yes, we saw it.') She was greatly pleased with this idea, and throughout the making of this work bubbled with gaiety. So Philip Thomas recalls, who worked with her and John on this production, helping to make the animal masks which John designed in the form of large shields held in front of the head. Dressed smartly for his first visit to Fawley Bottom, Philip arrived at Henley station only to have thrust into his arms by Myfanwy a large, smelly parcel which turned out to be the fish for supper wrapped in newspaper. That evening, John recounted how, when designing the glass for Eton, the difficulty of drawing a sheep's head had driven him to buy a flock of sheep which he had kept ever since. He later gave Phil Thomas a highly characterful set of animal drawings, and further intrigued him by designing for the Tavern and the Cottage fairy tale, pop-up picture-book sets made out of cardboard. Though exactly right for the opera, they did not translate into the 1979 television version of *What the Old Man Does is Always*

Right, which Basil Coleman directed and Terry de Lacey produced, and for which new sets were designed by Doug Jones.

Friendship with Alun Hoddinott brought the Pipers each year to Cardiff for its Festival of Music, John showing his pictures in 1978 in University Hall. For Myfanwy, it was enormously gratifying, in the wake of Britten's death, to find herself again working with a composer whose work she admired. 'I have heightened the end a bit,' she wrote to Alun, as the *Old Man* neared completion, 'even perhaps hammed it up. But I think it could be good and gives Geraint a chance for some emotional fireworks. I think the strain of failure having suddenly been withdrawn the Old Man might have become a bit eloquent.'[7] In the course of production, the Hoddinotts noticed how self-effacing John could be, fitting in easily with others, often sitting quietly in company, not needing or demanding attention. Once, while working on a new production of the *Old Man* in Manchester, Alun noticed that while he and Myfanwy sat through rehearsals, John went in search of the old mills in danger of disappearing and produced a painting every day. In Cardiff, the Pipers always stayed with the Hoddinotts who shared their enjoyment of good food and wine and, in turn, made many visits to Fawley Bottom, Alun working with Myfanwy in her parlour and looking on John's cowshed studio as a kind of Aladdin's cave, while Rhiannon loved the smells, of house, garden, and studio, and picked up many tips from watching Myfanwy cook.

The second opera which Myfanwy undertook with Hoddinott was *The Rajah's Diamond*, commissioned by BBC Wales and transmitted simultaneously on BBC2 and on Radio 3 on 24 November 1979, with Sir Geraint Evans in the lead role of Vandeleur. The tale is based on a Robert Louis Stevenson story and Myfanwy tried in her libretto to echo the curiously dry flavour of his words. It worried her, when writing it, that she had not heard a note of the music and therefore had no rhythms in her head, for Hoddinott, not being a pianist, did not perform his work to her as Britten had done.

Nevertheless he filled a large hole in her life, and the opera occupying her mind in the wake of her granddaughter's death was Hoddinott's *The Trumpet Major*. This three-act opera based on a Thomas Hardy novel offered such a proliferation of incident that she had no alternative but to omit and curtail, mindful of Puccini's adage, 'Tagliare, semper tagliare' ('Cut, always cut'). The story concerns Anne and her three suitors, one of whom is the Trumpet Major, at the time of the war with Napoleon. The characters are resolute, inconsequent, moral, and absurd by turns, as Myfanwy observed in a programme note. She struggled to achieve the compression that a libretto demands and was not helped by the time span of the novel which covers more than two years, during

which the threat of invasion comes and goes. While analysing the book she noticed Hardy's tenderness to the changeable, silly, inexperienced, and flirtatious Anne and concludes: 'one of the morals of his tale is that a proper, spirited woman always makes the emotional, not the wise, or expedient or even kind, choice. But at the last ditch his sympathy, and his admiration is for the long suffering and generous Trumpet Major.' The opera was first performed by the Welsh National Opera in March 1981. Basil Coleman was the producer.

In 1979 the long-awaited monograph by Anthony West on John's work appeared, published by Tom Rosenthal at Secker and Warburg. Having agreed to do a coloured lithograph for a limited edition of the book, Piper misunderstood the commission and produced a print that was the wrong size for the book. When this was drawn to his attention he immediately produced another without any fuss. However, the book itself was a limited success, West failing to sustain the attention he gives to John's early years and further distorting his account with divergences into comparative criticism.

In the lead-up to his eightieth birthday, John seemed as busy as he had ever been. He went down to Sissinghurst and painted two pictures of the garden at the request of Nigel Nicolson. At the invitation of the Duke of Marlborough he drew Blenheim, visiting it in 1981 and 1986 and probably several other occasions, treating Vanbrugh's magnificent central block and its side wings with abrasive immediacy. British Railways commissioned two paintings of the Forth Bridge and Saltash Bridge,[8] while Lord Remnant, who had a mini-vineyard outside Reading, asked for a wine label. John continued to attend meetings of the National Gallery Board, the Oxfordshire DAC, the Council of the Museum of Modern Art, Oxford, and the University of Reading's Art Gallery committee, while also remaining a loyal supporter of Pat Speirs at the Bohun Gallery, Henley. Recognizing that she served a clientele who wanted to buy art but found London art galleries daunting, he showed at this gallery every two years, as well as in mixed exhibitions. Watercolours and prints had become his preferred media, for he now only produced four to five oils a year.

In 1982 a young man just out of Cambridge, with an eye for fine printing, turned up at Fawley Bottom. This was James Stourton, who had just re-established the Stourton Press and over lunch, following a suggestion made by Myfanwy, persuaded John to illustrate a famous poem in octosyllabic couplets by John Dyer (1700–58), 'Grongar Hill'. The view it describes, from a hill near Llangathen, Carmarthenshire, overlooking the Towy Vale, is one John knew well. In a foreword to the book, he recollects a camping expedition to Pembrokeshire in his youth, and how it seemed to him then that the Vale of Towy,

between LLandeilo and Carmarthen, was the Promised Land. He returned in the late 1930s, making a collage of Grongar Hill, and a lithograph of the nearby Dryslwyn Castle in the mid-1950s. By then he had discovered Dyer's poem which struck him as 'one of the best purely topographical poems in existence, because it is so visual'. He admits: 'I return to it whenever I feel depressed about the countryside getting spoilt.'[9]

Less happy at this time was his long-standing association with Patrick Reyntiens. In the late 1970s, at a time of inflation, Reyntiens began to resent John's habit of consistently under-quoting for the cost of stained-glass work, without consulting him. 'We're getting very grand,' John parried, when Reyntiens protested that he couldn't do the work for the price quoted. The early 1980s saw them working together on an image of Christ in Majesty for the east window in the small church attached to the Hospital of St John the Baptist at Lichfield, and on the memorial window for Benjamin Britten for the church at Aldeburgh. This latter work, its imagery based on Britten's three Canticles, proved hugely successful, but the labour involved in its making led Reyntiens to add £2,000 to the bill. Though Reyntiens was to work once more with John, on the Churchill Memorial window for the National Cathedral in Washington, it was his assistant David Wasley who now took over as the person who translated John's designs into glass. His work can be seen at Lamberhurst in Kent, where the church has a window showing some startled shepherds, together with sheep and dogs leaping with astonishment, as an angel dive-bombs in bringing news of Christ's birth. The choice of subject was suited to the area, as the church entrance, which nowadays faces on to a golf course, used to overlook fields of sheep.

In 1983, the year of his eightieth birthday, John found himself bombarded by the media in the lead-up to his retrospective at the Tate in November. He and Myfanwy agreed to be interviewed by Anglia Television for a film concentrating on a new production at Aldeburgh of *The Turn of the Screw* and on John and Myfanwy's work with Britten and Pears. At Fawley Bottom journalists and editors came and went, among then Rachel Billington, who did an interview with John for *The Times*. Meeting him for the first time, she found that his expectant energy, jeans, and sweater reminded her of a very young and very clever undergraduate. She noted too that his face had been drawn by the folds of age into extreme elegance, that his eyes were exceptionally blue, and his hair very white. At lunchtime she was given wild duck and salad, and quince-flavoured apple pie.

'Pretty chaotic here at F.B.' he wrote to Clarissa, 'people demanding attention all the time—a terrible accumulation of totally unnecessary dinners lunches etc in Nov. We shall all be dead.'[10] The Tate sent down the curators David Fraser

Jenkins and Caroline Odgers and conservateurs, all of whom were treated, like most of their guests, to ample and delicious home-made food. John's refusal to take it all too seriously was apparent in the barn studio where it amused him to discover that his cartoon for the Chichester tapestry had been partly eaten by field mice. A few moments later, after the conservateurs with gloved hands had gingerly unrolled a large cartoon for stained glass, John, in gumboots, blithely strode across it to answer the telephone.[11]

'I have lived with John for well over half his eighty years,' wrote Myfanwy for the essays collected in honour of his eightieth birthday, adding slyly, 'and think I can say that I have enjoyed every other minute of it.'[12] This book, conceived and edited by Geoffrey Elborn, was printed by James Stourton. Having first been drawn to the Pipers by his admiration of John's work, he got to know them still better after he wed one of the Stonor family. It was Myfanwy to whom he talked when his marriage very quickly fell apart. Like many others, he recognized in her an unusually wise and percipient woman.

To John Piper on his Eightieth Birthday was published to coincide with the Tate retrospective. David Fraser Jenkins had curated a major survey of almost every aspect of Piper's career. Many old friends turned up at the private view and the exhibition was widely reviewed. Its impact was further enhanced by the publication this same year of Richard Ingrams' *Piper's Places*, with which John had collaborated. The book, which focused on his involvement with specific places in England, had been conceived by Hugo Brunner, at Chatto and Windus, after reading a piece by Ingrams on John in the *Sunday Telegraph*, and seeing Piper's watercolours of and at Rousham. It was also Brunner who, when the book was published, made sure that a copy was sent to the Queen Mother. To promote the book, Chatto bullied John into making a South Bank Show television programme with Melvyn Bragg. It proved a quite a major ordeal and took up much of the spring and early summer.

At the same time, John needed a selling exhibition and was preparing for 'Romantic Places', which was held at the Marlborough Gallery in November 1983, again as part of his birthday celebrations. The private view, held 12 to 2 p.m. on 24 November, was followed by a private lunch at the Savile Club in Brook Street. Despite the fatigue caused him by all these activities, John survived well enough to become the castaway on Roy Plumley's *Desert Island Discs* in December. The music he selected included Prokofiev, Rachmaninov, Fauré, Britten, Poulenc, 'Tea for Two' in two different versions, one by the pianist Earl Hines, and the other by Shostakovitch. Surprisingly, there was no Mozart, but he did choose the last movement of Haydn's Symphony No 89, admitting: 'In the last resort I'd rather be left with all Haydn's symphonies than

all the works of Mozart, because I think they're very down to earth, very matter of fact and about my standard musically!'[13] When asked the standard question, as to which book, aside from Shakespeare and the Bible, he would take with him to the Desert Island, he chose the complete works of William Blake.

One of the most enjoyable aspects of this busy year was a renewal of his involvement with Stowe. In 1983 the Hurtwood Press, in association with the Tate Gallery, printed 300 copies of *John Piper's Stowe*, with a foreword by John and a commentary by Mark Girouard. As Stowe School was celebrating its diamond jubilee, it also mounted an exhibition of his work, to which he lent some 50 watercolours of Stowe painted over the past 30 years as well as recent watercolours, four large oils and a tapestry of Long Sutton. John's love of Stowe had never diminished: after the publication of Laurence Whistler's 'The Authorship of the Stowe Temples', in *Country Life* (2 January 1969), he had placed it with three articles on Stowe by Christopher Hussey (*Country Life*, 12, 19, and 26 September 1947) and a painted frontispiece of his own devising, into a specially bound collection. And when Stowe's Gothic Temple ceased to be the School Armoury and was restored and made available for letting by the Landmark Trust, he and Myfanwy spent two short spells there, gaining new views of this well-known terrain from its windows, John also taking a photograph of the shadow cast on the grass by the Temple at five o'clock on a sunny May afternoon. Over fifty years, he had never tired of this contrived landscape that encourages the visitor to perambulate, and enjoy the compositions of trees, shrubs, statuary, and temples that present themselves at every turn, offering also allusions to classical or historical legend or to contemporary politics, the contrast between the ruined temple of Modern Virtue and the intact Temple of Ancient Virtue being an easily understood comment on Walpole's England. Later, in 1989, John became a patron of the Stowe Garden Building Trust.

In the wake of the Tate show, John tidied up a number of things. He gave to the Tate Gallery Archives the remaining drawings and watercolours in the estate of Frances Hodgkins as well as her portrait of the artist Cedric Morris. He also let the Gallery keep *Covehithe Church* which had formed part of his retrospective. The weight of the past did not, however, prevent him and Myfanwy from living in the here and now. They enjoyed friendships with their near neighbours, the artists Richard Hamilton and Rita Donagh, his wife, the two men sharing an interest in good wine which overrode any differences in artistic interests. John also took an interest in Brian Clarke's architectural use of stained glass, wrote admiringly of David Hockney's stage designs for *Art and Artists*,[14] and bought the work of the young sculptor John Davies. But the loss of those who had played a major part in their lives—Britten in 1976,

Kenna in 1978, Kenneth Clark in 1983, and John Betjeman in 1984—made the habit of retrospect almost a professional duty. Myfanwy sat on a panel, with Jock Murray and John Summerson, at an evening event in Chelsea, organized by the English Centre of International PEN, in memory of John Betjeman. John assisted Meryle Secrest, when she visited Fawley, with her biography of Kenneth Clark. The following year, 1985, John Mortimer's first wife, Penelope, acknowledged Piper's help with her biography of the Queen Mother.

In 1984 the publication of Shell Guides ended in acrimony. Faber accused Shell of giving scant help with the promotion of the books in petrol stations, while Shell criticized Faber for not putting more effort into pushing sales at bookshops. So it was reported by 'Peterborough' in the *Daily Telegraph*.[15] Matthew Evans denied these comments, saying at no time had Shell criticized Faber's marketing and that this was merely a protective story. But Shell authors retained the feeling that Faber lacked enthusiasm for the series and had marketed them poorly. And Shell now felt that the Guides did not earn enough to justify their expensive sponsorship. Faber continued to sell those titles still in print, but the moment one went out of print, its rights reverted to Shell.

The demise of the Shell Guides had first been announced in 1980. By this date, the absence of colour photography in these books made them look dull and out of date. Many booksellers had watched the series die on the vine. With hindsight, one journalist wrote: 'These Morris Minor like guides ran out of gas in 1984, coasting sedately on to the hard shoulder of literary endeavour.'[16] Towards the end of their life Matthew Evans, at Faber, had protected John from some of the comments that came from Shell, which had become less and less interested in the cultural impact of these Guides and more concerned with their commercial benefits. What the management at Shell now wanted were guides that included reference to theme parks and picnic sites and which told the reader which country houses had shops, all of which, as Evans knew, would be anathema to John. Even though Edward Piper had now taken over almost all the work involved, the Shell Guides still reflected John's taste. But Shell wanted a different sort of book and a different chief editor.

It was devastating news to many Shell authors. John entered into discussion with other publishers in the hope of taking the guides elsewhere. He welcomed a suggestion from Frank Collieson, of Heffer's in Cambridge, that the bookshop should mount an exhibition in October 1983, to celebrate both the publication of Norman Scarfe's *Cambridgeshire* and 50 years of Shell Guides. Collieson arrived at Fawley Bottom with an empty suitcase. He left, full of gin and tonic, sea bass and fennel, pudding and cheese, his suitcase stuffed with Shell Guides memorabilia. Both John and Myfanwy attended the private view in Cambridge,

as did Peter Walker, then Bishop of Ely and a friend of the Pipers, as well as a great many others. In the immediate aftermath of this exhibition, John thought Collieson had saved the Shell Guides, for there were signs of interest in new quarters and John remained hopeful of finding another publisher. He and Richard Ingrams talked with Chatto and Windus, who were keen but wary of taking on such a big undertaking, capital intensive and slow to show profits. A sponsor was sought but not found.

Whereas Pevsner's Buildings of England series had displayed a certain dryness and an encyclopaedic quality that often obscures the *genius loci*, the Shell Guides had belonged to an indigenous tradition in English topographical writing which goes back to the Romantic period, concerned with the essence of place, not just with buildings but also landscape and literary and historical associations. However, once the rights had reverted to Shell, they took the guides off to Michael Joseph, where they were revived in 1987, with bad colour pictures and matching authors, under the general editorship of John Julius Norwich as 'The New Shell Guides', based not on counties but on the administration of a region. They had colour illustrations and were more downmarket. The series died within a year.

Still vital at this time was the demand for John's paintings and prints. In 1984 Barbara Lloyd at Marlborough wanted to commission still more prints from John as the market for his work often exceeded what was available. It was convenient for him, when people asked to buy a painting or print, to refer them to Marlborough which, in the wake of the Tate retrospective, continued to give his art a great deal of exposure. In April 1985, after another exhibition, he wrote to Geoffrey Lloyd: 'I could not be more grateful than I am for the generous way Marlborough London/New York have treated me, and I send you my thanks and much gratitude for organising the show so beautifully.'[17]

Marlborough Fine Art had long realized that the only way to deal with John's far-reaching popularity was to permit exhibitions to take place in other galleries and in the provinces. In 1985, for example, they sent twenty of his pictures to Windsor Community Arts Centre and another twenty-five to the Bede Gallery, Jarrow. The latter exhibition coincided with the installation of John's small lancet window for St Paul's, Jarrow, his design incorporating the initials of Benedict Biscop, the first man to promote stained glass in this country, as well as a cross, the shape of which echoes that of the Jarrow Cross. The dedication of this window took place in the presence of Princess Diana.

Meanwhile, Kenneth Lindley, Principal of Herefordshire College of Art, conceived of doing a book on John's graphics. Illness prevented him from completing this, and he died young in 1986. An authoritative book on John's

graphic art was, however, written by Orde Levinson, who had arranged for the tapestries in Hereford Cathedral to be woven in Namibia. In 1983, as part of John's birthday celebrations, Levinson's Eightieth Anniversary Portfolio of eight Piper prints was published. Aware that Piper's graphic work had been poorly documented, in 1987 he published a catalogue raisonnée of all Piper's prints. Revised and expanded in 1996, it also listed all John's exhibitions, writings, design commissions, and a comprehensive bibliography. It proved to be a compendium of great usefulness, and an important building block in the structuring of John's reputation.

34

An English Garden

'It is not given to every man,' Sir George Sitwell proudly ends his book on gardens, 'when his life's work is over, to grow old in a garden he has made, to lose in the ocean roll of the seasons little eddies of pain and sickness and weariness, to watch year after year green surging tides of spring and summer break at his feet in a foam of woodland flowers.' But this John Piper did, in the garden at Fawley Bottom which had largely been of his own making and reflected his taste. Its abundant sweet peas, white daisies, sunflowers, poppies, rubeckias, and ligularias demonstrated strong colour grouping, and every year perfumed tobacco plants had been planted to pick up the whites in the pale flint walls of the house. Unlike Monet's Giverny, the garden had never been designed as a subject for paintings. Instead, natural growth and regeneration had been cultivated wherever possible out of respect for the *genius loci*. For many years John had been assisted in the garden by Ted Cook from Bix Bottom Farm,[1] but since Ted's retirement he had been in the hands of the 'very tidy' Grace Lane, a plantswoman who lived at Henley. John respected her knowledge but grumbled at her style of gardening which tidied things up, whereas he preferred unhindered growth, for he loved a sense of profusion. 'In any garden, manicuring is a dead loss; more often, excess means success,' he states in the foreword to Jerry Harpur's *The Gardener's Garden* (1985), a book that celebrated the Englishness of English gardens.

In the mid-1980s, when illness kept him at home, he began a series of pictures based on the garden at Fawley Bottom. At the same time, his obligation to the Marlborough Gallery was weakened by the departure of Tony Reichardt, who had in recent years been his chief point of contact. Though he did not leave Marlborough, it was agreed that James Kirkman, now dealing independently, could organize an exhibition of his work in partnership with Waddington,

which he did in 1986 and again in 1988, when John first showed his flower paintings. The success of this led to a further exhibition of this kind in 1989. Previously, flowers had only rarely appeared in his art, but now he orchestrated seemingly unconstrained, glowing compositions out of moon daisies, hydrangeas, peonies, white, orange, and red poppies, some reminiscent of firework displays for the colours burst across paper and canvas, with flair, spontaneity, and artistic judgement (Plate 81).

This late work took place amid a disintegrating world. 'Anyone dead?' John would ask Richard Ingrams, if he saw him clutching a copy of *The Times*, for the journalist in him relished obituaries. He and Myfanwy were sadly aware that they were losing yet more friends, Osbert Lancaster in 1986, and the following year Jean Hélion. Some ten years after Britten's death, Myfanwy found herself helping Humphrey Carpenter with his biography of the composer, her mind still sharp but suffering occasional lapses of memory. When Louise Campbell visited Fawley Bottom in connection with 'To Build a Cathedral', an exhibition celebrating the post-war Coventry Cathedral, which the Mead Gallery at the University of Warwick mounted in May 1978, she was made welcome; but neither John nor Myfanwy could remember her name, so referred to her throughout the visit as 'our mutual friend'.

By 1987, John, now in his eighty-fourth year, could no longer work as hard as he did. But he could now look with pride at the achievements of his children, for Clarissa, consistently unflappable, was teaching the clarinet in a Welsh comprehensive and, with her husband, David, was restoring their beautiful, semi-ruinous farmhouse in a remote valley not far from Aberystwyth. Suzannah had gone into catering and Sebastian, though keen on electronic music, had become a farmer. But especially pleasing was the fact that, after twenty years of professional life in the shadow of his father, Edward was at last achieving a reputation of his own. He held a solo exhibition this year at the Aldeburgh Festival and, for the third time, showed with his father at the Beaux Arts Gallery in Bath. In connection with the latter, father and son agreed to be interviewed at Fawley Bottom. The journalist from *Good Housekeeping* found them sitting in old chairs round the stove in the cowshed studio, noticed that both had gaunt features and a slightly stiff stance, and, despite the evident closeness in their relationship, treated each other with an almost formal courtesy (Plate 80). After many evenings spent listening to records in this room in the cold, John proudly drew attention to the fact that they now had double-glazing. Edward added that such 'opulence and ease' was new. 'Up until I left home it was all big overdrafts and worn-out cars.' This interview caught John in reflective mood, ready to admit that he had worked too hard for much of his life and regretted

that he hadn't lazed around more and read more. 'I don't regard myself as a success—just scratching along.'[2]

In the summer of 1987 John was made a Senior Fellow of the Royal College of Art. Watching the Convocation ceremony was Lida Lopez Cardozo, the wife of the letter-cutter David Kindersley, who was being similarly honoured. Seeing John's frailty, and knowing that her husband was full of steroids, she reflected that both men were being honoured too late. At the end of July 1987 John had an internal blockage. His doctor Ray David sent him to the Royal Berkshire Hospital in Reading where he was operated on that same day, receiving fairly major surgery for a twisted gut. He returned to a different hospital, just over a month later, for a minor prostate operation. The anaesthetics, and possibly not very good after-care, left him greatly altered. 'It's too old at 84 to be cut about,'[3] Myfanwy complained to Peter Walker, Bishop of Ely. During convalescence John tentatively turned his attention to ceramics, then began painting an hour or two each day. His attention focused on an enormous study in oils of Arbroath Abbey, its elongated red and orange fragments rising in defiant glory against a black and blue swirling sky, a dramatic and disturbing picture which he had thought about while in hospital.[4] Then, during further recuperation, he returned to flower studies. 'I am working slowly—with stops, and enjoying it,' he wrote to Moelwyn Merchant in November. 'But not very moveable—except for 5 days in the Cotswolds, looking at churches. (This all engineered by Clarissa and David, and a great success.) I have put on a few pounds but it is very slow! And I am liable to get very tired when I least expect it!'[5]

That summer Suzannah and Sebastian wanted someone to be on hand at Fawley Bottom while they and their families were on holiday. Roger Vlitos, an old friend of Sebastian's, stayed in his house and called daily at the Farmhouse. Sometimes he sat with John while Myfanwy went shopping or out with friends; at other times he helped with work that John did not have the stamina to do on his own. In particular Vlitos offered to help in the darkroom as the Tate Gallery was preparing *A Painter's Camera*, a book of John's photography, published later that year. In connection with this, John wanted to develop and print some photographs of the grotto and Cascade Bridge at Halswell, as well as the seven arches at Rousham, which he had taken before his operations. The two men also went across the road into the beechwoods to photograph the folly that Piper had erected a while back—an obelisk made out of flints and topped with a copper ball. While looking for this copper ball in a reclamation yard at Syon House, he had found two eighteenth-century stone sculptures which had once formed part of an arch, and they too had been added to the avenue through

the wood. This example of a piece of 'pleasing decay' John now photographed. Vlitos processed the film and printed the images to the exact grade of contrast that John wanted. Shortly after this he gave away his two cameras, one to each of his sons. Photography had been abandoned for the same reason that he gave up stained glass, tapestry, and stage design—to preserve what energy he still had for painting and printmaking.

While hampered by ill health, he had a triumphant success: 'John Piper: Georgian Arcadia' ran from 16 September to 16 October 1987 at the Marlborough Gallery, marking the Golden Jubilee of the Georgian Group and celebrating his interest in Georgian houses and their landscape settings, a vein which had first appeared some fifty years before in his painting *Autumn at Stourhead*. The show proved a grand affair: the patron of the Georgian Group, the Queen Mother, had lent three paintings and the opening was peopled with royalty, ambassadors, and the titled. Shortly before this, Orde Levinson's catalogue raisonée of John Piper's prints appeared. Its publication made visible the full range of his graphic experiments. Although John Russell Taylor, writing in *The Times*, found some of the colours in the recent prints too garish for his taste, he approved the recent Georgian paintings at the Marlborough:

> In the brand new works with which this show ends the refinement and precision of his taste in follies and grottoes remains unmatched. It is becoming the habit to sneer slightly at this or that as 'too heritage' and young fogeyish. But there is nothing in the slightest indiscriminate about Piper's loves; his work is so hauntingly romantic because it is so crisp in its appraisal of its subject matter.[6]

Still more welcome were the new admirers which a shift in the artistic climate now brought him, for young artists began to see that, far from reactionary, his embracing of tradition had offered a positive way forward. Though at the Royal Academy's *British Art in the 20th Century* exhibition, held in 1987, he had been represented only by his abstract work, the following year he figured significantly in the Barbican's ground-breaking exhibition, 'Paradise Lost: The Neo-Romantic Imagination in Britain 1935–1955'. His work was promoted by Peter Fuller, a young renegade critic who challenged the fashionable stances on art and culture adopted by those on the Left, though himself imbued with Marxist principles. Prepared to go against the tide and say what he believed, Fuller had identified in the early 1980s a crisis in art and, rather like John in the late 1930s, had felt a need to stress the importance of tradition and imagination. These themes had emerged strongly in his first collection of critical writings, *The Naked Artist*, published in 1983. This same year he wrote a lengthy review

of John's Tate retrospective, afterwards reprinted in his 1985 collection, *Images of God*. Here he claimed: 'Piper teaches us that modernity in art need not be synonymous with the denial of the past, the parading of mechanism, or the refusal of an imaginative response to the visible present.'[7]

In 1987 Fuller wrote to John, to inform him about *Modern Painters*, an art magazine of which he was the founder-editor. Though delighted to discover that it was named after Ruskin's *Modern Painters*, his favourite book, John declined to review a book but sent an encouraging reply and the two men became friends. In 1988, when Fuller was preparing a lengthy article on John for the *Independent Magazine*, he and his family visited Fawley Bottom with their small son who was given a lithograph. Further exchanges included the gift from John to Fuller of André Masson's eulogy for Paul Klee. This friendship was terminated by Fuller's untimely death. Having survived one road accident in which his car had been written off, he was being chauffeur-driven when, in 1990, he was killed in another accident. A letter from his wife to the Pipers expressed the hope that he and Ruskin would live on in their son, Lawrence Ruskin Fuller.[8]

A revival of acclaim in the late 1980s did not, however, keep the shadows in John's mind at bay. He suddenly painted a cluster of self-portraits, in all of which a hasty image of his own face emerges from darkness, to be balanced on the other side of the paper by the image of a church effulgent with golden light.[9] In the course of his career he had shown little or no interest in self-portraiture but earlier, in 1983, he had contributed to an auction of self-portraits by artists in aid of the Save the Children fund. This had been sponsored by 'Charles of the Ritz', and in keeping with this firm's products, all the self–portraits had been executed in make-up, each artist being supplied with a specially made kit offering an array of colours. Interestingly, the swift likeness Piper produced already has the expressive melancholy found in his later work.

The presentation of his face, in darkness, in contrast with the brightly lit church, may contain a premonition of the mental decline that would cut him off from life. Alternatively, it may express a crisis in his faith, a sense of being removed from grace. When Jane Buxton interviewed him in 1989 for the *Oxford Times Colour Supplement*, he admitted disillusionment with the Church; and to John Deeker he plainly admitted that he had lost his former belief.[10] Troubled by the ordination of women priests, against which he was as much prejudiced as he was against colour photography, he had earlier given vent to some of his disappointment with the Church of England when talking with Rachel Billington. The full text of her 1983 interview for *The Times* reveals that, when religion was mentioned, he rejected the word 'conviction' as being

too strong for his faith and suggested that 'leaning' might be more appropriate. Her notes continue:

> They have stayed in the Church of England ever since [their conversion, owing to John Betjeman] but, I gather, only just. Myfanwy's respect for the English language is offended by the new forms of service and John doesn't much enjoy the people. They look for early morning services. On the other hand John Piper admits to a few 'revelations', hastily amended to 'proofs' which hold him to a belief in God. They are not, this definitely stated, to do with his work.[11]

Such qualifications were no longer possible in the late 1980s, not least because he could no longer voice his thoughts with ease. Peter Khoroche came, to talk with the Pipers about Ivon Hitchens, in connection with a book he was writing on this artist. He noticed that John answered questions with difficulty and needed time to speak. Over homemade pate and glasses of wine, they discussed in some detail the 7 & 5 Society's decision to go abstract in 1935. Ben Nicholson's name came up repeatedly. 'Can't we talk about the other Ben?' pleaded Myfanwy, at one point.[12]

In the spring of 1988, Myfanwy still had hopes that John would recover his former grasp of life. She told Thorold that he was working hard, but sleeping a lot and tired easily. Both Pipers were looking forward to the summer. But in the months that followed it became evident that permanent mental debility had set in. When in 1989 John tried to organize his flower paintings for another exhibition at Waddington's, it preoccupied his mind to the exclusion of everything else, and seemed to represent some hurdle that he had to get over before he could do anything else. The exhibition was a striking success. David Fraser Jenkins, in the catalogue, noted a 'startling freedom' and argued: 'The paintings now shown by Piper are amongst the best of his whole career, for his painterly skills are more evident as the given structures of the subject dissolve.'[13] But shortly after this he stopped working and did not paint again.

Myfanwy made desperate efforts not to let him slide into confusion. He momentarily had good recall and she looked with him at books and photographs in an attempt to keep his memory alive. She continued to cope with the running of things and, John Mortimer thought, seemed 'the world's great stoic'.[14] But she was often impatient, got cross, and evidently felt let down. Her boredom threshold had always been very low, and, despite having herself had four children, often said that babies were 'time-wasters'. Owing to her inventiveness and fund of amusing stories, her grandchildren adored her, but

she had never been a patient woman or a good nurse. Now she found herself laboriously explaining to John that he had not witnessed the coming down of the Berlin Wall, merely seen it on television. In his new state he could not bear the smell of milk that had boiled over, a trivial disaster which frequently occurred when Myfanwy made yoghurt. In January 1988, aware of how easily he became agitated, Myfanwy, having accepted an invitation to speak in November at a symposium in Dallas, Texas, on Henry James and the bringing of his work to stage and screen, cancelled the visit, realizing it was now impossible for her to go abroad.

Early in 1990, when Agnews were preparing an exhibition in aid of Suffolk Historic Churches Trust, John donated *Stansfield Church* and insisted on paying for its framing. But by mid-1990 dementia had such a hold that he only had brief moments of lucidity. Olivia Brett was present at one such moment when, seated with others in the garden, he suddenly announced, 'I do so love an English country garden.' Myfanwy went on her own to Huish Manor Farm, where Betjeman's daughter Candida and her husband Rupert Lycett Green were celebrating the building of a library. At lunch she was seated next to James Lees-Milne. He asked the meaning of her name. 'My darling,' she replied.

Back in 1983, when filming 'John Piper at Eighty' for the South Bank Show, the producer Jamie Muir had been impressed by the speed and urgency with which John worked, for at one point he abandoned his pen and simply drew directly on the paper with ink from the refill bottle. Towards the end of a day's filming, Muir also noticed that, as John became tired, he begun humming to himself. When Muir returned to Fawley Bottom in the early 1990s, he found the humming almost continuous. He watched as John, given a set of proofs to inspect, shuffled through them continuously, unaware there were only four sheets.

Before dementia set in, John had learnt that Edward had cancer. Phillida Gili, daughter of Reynolds and Janet Stone, bumped into him on the doorstep of John Murray's in Albemarle Street, and, on hearing this news, was immediately aware how greatly upset he was. Myfanwy later admitted that ever since she had met Edward off the bus, as a weekly boarder home from preparatory school, she had retained the feeling 'Edward is home, everything is going to be all right.'[15] Others too observed that he had become the family's linchpin, the person who had kept things together. After his illness was diagnosed, he at first reacted well to treatment and his condition appeared to have stabilized. This proved an illusion and in June 1990, aged fifty-one, he died. His final project—

a set of illustrations for Henry James's *The Aspern Papers*—was published after his death and dedicated to his memory.

'It has been a sad blow to us and hard to bear,' wrote Myfanwy.[16] Outsiders wondered whether John had registered Edward's death. To his family, however, it was evident that he missed his son dreadfully. But, in his demented state, it was impossible for Myfanwy to talk with him about their loss. The following winter Prue and her sons, Luke and Henry, joined John and Myfanwy for Christmas. One evening Luke, who had just come back from Africa was showing slides. Clarissa, who was also present, noticed that John looked very low and depressed and took him off to bed. When asked by her what was the matter, he surfaced momentarily and replied: 'It's what we're all *not* talking about.'

Despite John's illness, the family decided to celebrate Myfanwy's eightieth birthday in May 1991 with a large party in the barn. A four-course meal was served with fruit salad presented in bowls made of ice. This same year Robin Healey suggested republishing John's essay 'Pleasing Decay' in book form. Myfanwy replied,

> We have been rather chaotic, and found it difficult to make plans. John, since his beastly operation (a twisted gut removed) in 1987, has never really recovered and has lost his memory and finds it difficult to communicate so it's an effort to make decisions. But I do think it is something that could be done and that would please him.[17]

There was to be no lessening of interest in his work, neither at this time or in the years to come. Bob and Rena Lewin gifted the Ashmolean Museum in Oxford with their collection of John Piper watercolours and drawings which went on show in the summer of 1992. A catalogue accompanied the show with an introduction by David Fraser Jenkins. He had also written the catalogue essay for the exhibition 'John Piper in Wales', mounted two years earlier by the Oriel 31 galleries, in Newtown and Welshpool, and shown also at the National Museum of Wales, in Cardiff. But, meanwhile, the artist who had moved through the years with such creative dynamism now could not find his way around his own home, his facial features betraying his inner collapse. He who had been stimulated by 'going places' now spent most of his time confined to a kitchen chair. Then, in the early summer 1992, further physical deterioration set in and eventually he stopped eating. He died at Fawley Bottom on 28 June 1992. In the days that followed a mass of obituaries appeared, among them the just remark that he had made 'a vast contribution to British sensibility and vision over many decades and in many media'.[18]

35

Myfanwy

The funeral took place at Fawley Church on 2 July. It began with Haydn's 'Pieces for Musical Clocks'. Myfanwy had chosen items for her grandchildren to read, among them George Herbert's 'Virtue' which Clarissa's Emily delivered. John Mortimer gave the address. Those who arrived early enough squeezed into the small church while a small crowd gathered outside. Mortimer afterwards wrote up the event for the *Fawley Parish Magazine*:

> The sun came out and brightened the churchyard. The church was full of flowers from the Piper garden and the gardens of his friends. His grandchildren read poetry, and three tall grandsons and his youngest son carried him to his resting place beside a sunlit field. It was all that John Piper had loved and which he had made the subject of his art: flowers, an English church in an English landscape. The morning of his funeral at Fawley was a continuation of his life.[1]

Susan Hill noticed that at the graveside Myfanwy looked momentarily a little crumpled. But she was soon urging people to make their way down to the farmhouse where a large ham had been cooked and John's paintings hung on the walls and sat on easels. In time Michael Harvey, formerly an assistant to Reynolds Stone, carved 'John Edgerton Christmas Piper' below a sunflower cut in low relief on a headstone for the grave. Previously, his nameplate in slate for the house had so pleased John that it never left an inside mantelpiece.

'For me John died four years before,' Myfanwy admitted to James Kirkman, in a telephone conversation the day that John died.[2] Nevertheless, she had been tired and brought down by his long illness, and after his death looked as if a great weight had been lifted from her. Eventually, a memorial party was held at Fawley Bottom, a huge marquee filling the courtyard between the house and

97. Slab for the Pipers, cut by Michael Harvey when apprenticed to Reynolds Stone.

the barn studio, and 200 guests, among them Barbara Castle, the Snowdons, Jeremy Paxman, and John Mortimer, gathered for a sit-down meal. Afterwards fireworks were let off on a nearby hillside, while music by Sebastian was played. It was a display to end all displays. Olivia Brett told Myfanwy she would never forget the fireworks. 'You weren't supposed to forget them,' came the reply.

In the aftermath of John's death, freed of the burden of his dementia, Myfanwy could return to a more sociable existence and go where she pleased. Auberon Waugh and his committee elected her with acclaim to the Academy Club, then occupying a basement room in Soho's Beak Street. Cara Lancaster made her welcome at her house in Sydney Street, Chelsea, as did Mark and Deidre Simpson, two American admirers of John's work, at their flat in Kensington, and in both places she often stayed the night. And there were trips abroad, to South Africa with Suzannah, to visit her step-daughter, and to Ravello in Italy, whence Myfanwy went every year after John died with the Mortimers. They noticed that, though now in her eighties, she ran up the stairs, dived fearlessly into the pool, drank a great deal at dinner and joined in games of Trivial Pursuit, vigorously disagreeing with the given answers on the cards.

Earlier in the 1980s she had made a friend of Julian Barnes and always enjoyed sitting next to him at dinner at the Mortimers'. He had first encountered her name in Betjeman's poems and had been inclined to believe she did not exist. Biographies and memoirs had taught him otherwise, but it still seemed extraordinary to find himself chatting with a person around whom myths had gathered. He notice that her lined face and lank hair left one unprepared for the vitality and youthful intelligence of her eyes, through which her character was primarily conveyed.

At Fawley Bottom, visitors helped to fill the inevitable hole in her life left by John's absence. Shortly before he died, a young actress, Jean Marsh, had moved into the cottage up the road. A friend of John Mortimer, she was immediately welcomed, Sebastian's wife, Mary, bringing flowers from their garden, other friends, eggs and cake, and John and Myfanwy walking up the road with two of his pictures. Myfanwy enjoyed Jean's light touch, fey manner, and thespian gossip, and, though very different in age and character, they got on so well that Jean regularly popped in for a meal or a chat. Sent down to the cellar to bring up a bottle, she was astonished by the array of fine wines, including the white Burgundy which Myfanwy loved. Marsh was also a scriptwriter who collaborated with Eileen Atkins on the popular television series *Upstairs, Downstairs*, and one day, when Myfanwy rang, turned down her invitation to call in owing to pressure of work. Later that day, when out on her usual afternoon walk, she noticed a sign hanging outside the entrance to Fawley Bottom—'Freshly baked CAKE', which, as Myfanwy intended, drew her in on the way home.

Jean Marsh witnessed Myfanwy's egalitarianism and the pleasure she took in people—the gardener, the tradesman, the cleaner, and Joy Mills, who had reappeared at Fawley Bottom as Myfanwy's secretary and to help with her accounts. Myfanwy told Marsh that Joy was 'one of John's girls'. Marsh badgered Myfanwy to talk about her early life, winkling out of her that there had been a lot of sex in her early life with John, sometimes more than was wanted. Marsh also noticed that Myfanwy was in some ways very undomestic, unable to tell the cleaner how to clean and very unwilling to wash up after dinner. Nor was she interested in talking about illness, and after a cataract operation rang up Marsh to say 'Where are you?' as she was still expecting her to dinner, despite having been operated on that day. She was very cross, and not a little put out, when, after nine years, Marsh decided to leave Fawley. 'You're just a mover,' Myfanwy grumbled, dismissively.

On the other side of the road, however, Sebastian and Mary and their children were now living in the house built for the Judas which had been sold to the Pipers after Hans's death. And Myfanwy still had many visitors, among

them Richard Ingrams, and Kenneth Clark's daughter Colette. She enjoyed being taken out to lunch by the Simpsons or the Hoddinotts, and saw much of James Kirkman, who went down to Fawley Bottom, often with his wife Claire, whenever Myfanwy needed to talk about John's paintings. Once, she rang in advance, asking James to pick up some oysters from Blagdon's, a famous fish shop in Paddington, which they ate with Condrieu, one of her favourite wines. Likewise with bread, butter, and cheese, she always insisted on the best.

Another visitor was Patrick Horsbrugh, who had shown John round Middlesborough in the war. Now resident in the States and a landscape architect, he urged Myfanwy and Clarissa to find some appropriate memorial to John. Such talk may have spurred Myfanwy into action, for she began sorting papers, loaned manuscript drafts of her librettos to the Britten–Pears Library, now established at Aldeburgh, and got in a man from Bernard Quaritch to value John's books. James Kirkman recollects that Myfanwy had the idea, at this time, of writing a series of little books on aspects of John's work. Nothing came of this, perhaps because T. S. Eliot's widow, Valerie, to whom she was introduced by the Simpsons, urged her to write her memoirs. She made sporadic attempts at recollection and had a few passages from her diaries typed up, but, again, made no headway. With John's paints still laid out neatly in his studio, likewise his tapes and records, it was hard to excavate a past that was still so intertwined with the present.

As an artist's widow, she nevertheless had much to do. She assisted David Coke, curator at Pallant House, Chichester, with the 1993 exhibition of John Piper's designs for the stage, and, mindful of her husband's support of Pallant House in its early years, agreed to become a patron of its Gallery Extension appeal. She helped, too, with the 1994 John Piper retrospective held at Waddington's, in association with James Kirkman. It did not do well, and paintings that Myfanwy had hoped to sell were returned to her. Kirkman, aware of this, advised her to contact a young dealer rapidly becoming a leading specialist in early twentieth-century British art, Jonathan Clark, in Park Walk, off the Fulham Road. Myfanwy rang up Clark and soon afterwards appeared in his gallery, clutching an early 1930s painting under her arm which incorporated the word 'BAR' in large lettering. This proved the start of a mutually satisfactory relationship, for Myfanwy needed money and, with the cash and cheques she received, would disappear in a black cab to the wine merchants, Berry Bros., to pay her bill or, in celebration of a major transaction, to drop a couple of grand on Issy Miyake clothes. In turn, through Myfanwy and people she knew, Clark gained access to some of John's best and rarely obtainable 1930s work, paid good prices, and became one of Myfanwy's admirers. 'Such class!'

he recalls, remembering the homemade pate and bread and how she made him laugh on his visits to Fawley Bottom. She was also famously good at finding presents for godchildren and, if she enjoyed a new book, would buy several copies to give to friends.

She set her mind on finding a home for a stained-glass window, left in the studio at the time of John's death. This he had designed in 1982 for the touring exhibition 'Prophecy and Vision'. His source had been a medieval wall paint-ing, based on the legend that on the night of the Nativity the birds and animals gained the power of speech. Myfanwy had drawn attention to this mural at Shulbrede Priory, Sussex, in 1963, in *Harper's Bazaar*, and had compared it with advertising in that both tell a story by means of a pattern of words. At Shulbrede, each creature has an appropriate slogan coming in a loop out of its mouth: the cock—'Christus natus est'; the duck—'Quando, quando?'; the raven—'In hac nocte'; the owl—'Ubi, ubi?'; the lamb—'Be-he-thlehem'.[3] But instead of placing the animals in landscape, as at Shulbrede, John had woven the animals into a Tree of Life. Myfanwy offered this window, translated into glass by David Wasley, to the Revd Peter Judd, the incumbent at Iffley, a church just outside Oxford, which has a Romanesque West doorway. Judd was enthu-siastic, as was the Parish Council, but his initial suggestion, that it should be in-stalled in the apse, proved contentions as it required a Victorian window to be removed. An alternative was found in the lancet window near the entrance, on the south wall where, to fit the given space, the window had to be lengthened. Judd was astonished by the certainty with which Myfanwy rejected one design after another until his daughter produced an idea that approximated to the final solution which Wasley devised. The window was consecrated in 1994 by the Bishop of Oxford, the Rt. Revd Richard Harries, who afterwards obtained Myfanwy's permission to use an image of it for his Christmas card.

There were many occasions when Myfanwy found herself thrust back into the past. In 1993, she spoke at the J. M. Richards memorial evening at the Architectural Association, afterwards writing a piece based on her talk. The following year she appeared at the Cheltenham Festival, in a session connected with the publication of Betjeman's letters. She agreed to do a foreword for a new edition of June Osborne's book on stained glass and assisted her with another book specifically on John's work in this medium. She was interviewed for a film on Kenneth Clark, produced by John Wyver for Illuminations which was previewed at the Tate on 12 May 1993. And in June that year she stayed with Norman Scarfe at Woodbridge and took part in a public discussion at Aldeburgh on *Owen Wingrave*, which preceded a concert recital of the opera, dedicated to the memory of John.

Late in life she began wearing contact lenses which she lost regularly. She also learnt to drive, not very successfully, for she had the dangerous habit of overtaking long queues. After a couple of years, she gave it up and relied on others for trips. On one occasion, when the Simpsons took her out to lunch, they urged her to lock the door to the house. She replied that, not having done so for the past sixty years, she had no intention of starting now.

She continued to take an interest in the writing of libretti. Since *The Trumpet Major* (1981), she had worked with Hoddinott in 1987 on a choral work with orchestra, the cantata *The Legend of St Julian*, based on a tale by Flaubert, the score and libretto of which remain unpublished. Their final project, an opera based on Balzac's *Colonel Chabert*, was, however, never finished, as they could not agree on the ending. Then, in the mid-1990s she became involved with another composer, the Australian Malcolm Williamson, who, in 1975, on Britten's suggestion, had been appointed Master of the Queen's Music. It was a surprising appointment for a man who loved baiting the establishment and, though unquestionably loyal to the Royal Family, was renowned for his inappropriate and sometimes scandalous behaviour. A devout Catholic, erudite, with wide-ranging interests and erudition, he had initially trained as a medical doctor, and had a fondness for salacious gossip and dirty jokes. He may have reminded Myfanwy of Johnny Cranko for he could be petulant, demanding, and easily moved to tears. He was both popular and productive but, after a mild stroke in 1975 which left his speech slightly slurred, rumours spread about a drink problem and his inability to finish work on time. Sadly, though Myfanwy worked enthusiastically with Williamson on a chamber opera based on Strindberg's play *Easter*, it was never finished.

It is not known who suggested *Easter*, but Hoddinott confirmed that the sources for all her work with him, including the cantata, had been her suggestion. When conversation became literary, it soon became evident that Myfanwy was very well read, nor did her interest in books decline with age. She developed a particular enthusiasm for Robert Musil, and recommended his books to friends, while also keeping an eye out for new authors. If her face was now crazed with lines, her mind was as acute as ever. She remained interested in people, talked readily about her involvement with Britten and retained her zest for life, her sense of fun, sharpness, and wit (Plate 82). Yet, while walking round the garden with Myfanwy on a return visit to Fawley Bottom, after a gap in time, Susan Hill realized, with a slight shock, that Myfanwy had become an old lady. With physical frailty came, not the more usual cantankerousness, Phillida Gili noticed, but a change of personality, a marked sweetness of nature.

505

98. Myfanwy (photograph: Mary Calder Rower).

On 1 January 1997, Myfanwy went with Sebastian, Suzannah, and her husband Hugh, to the wedding of her grandson Luke. She had not long recovered from flu and perhaps should have stayed at home as it was a cold day, lunch was in a marquee, and they did not return to Fawley Bottom until the early hours of the morning. Just over a fortnight later, on the 17 January, Clarissa and David, together with Emily and her boyfriend Juan Cruz, whom she was eventually to marry, came for supper. The next day Clarissa and David were leaving for India. While the plane was delayed, Clarissa rang Myfanwy, who at the wedding had seemed shaky and not fully herself. She was up and dressed and having her early morning cup of tea. Later that same day, around noon, Thomas Stonor, who had inherited the title Lord Camoys, came to see her with his son William and a bottle of South African white wine. Fawley Bottom Farmhouse had always been open to callers, and Thomas had developed his father's habit of popping in. Like others, he had always found that the Pipers gave good guidance, Myfanwy especially. To him she seemed a person to whom you could talk about anything, 'so sound' and with 'an incredible capacity to understand'. She had been particularly acute on Stonor family relations, also a person removed from unnecessary judgement. At his request, she had willingly improved the text for the Stonor Park brochure, a small task perhaps, but further evidence of the art she brought to everything she did.

After Thomas and William left, Suzannah, now living up the road at Jackson's Farm, had lunch with Myfanwy. Aside from her general weakness, there seemed nothing to indicate that anything was wrong, other than the fact that she drank and ate very little. After the meal, she got up from the table and moved around, but coming back down the corridor she collapsed and soon after died of heart failure, in her study at Fawley Bottom.

There she had lived for sixty-two years, for most of those years, with John, in a complementary relationship which had permitted two individuals, with different gifts and personalities, to act like pillars of the same arch, creating an axis through which and around which people and ideas came and went. In the wake of her funeral, another party celebrating her life, was held at Fawley Bottom on 2 May, again in high style. There was live music in the barn and a spectacular firework display across the lane in a field. But with the removal of her powerful personality, Fawley Bottom had, for some of the guests, a different, rather dead feel. Many looked around them, at the familiar details of this artist's house, aware that they might be seeing it all for the last time, for something extraordinary had ended. It is unlikely that Myfanwy would have wished it otherwise: having witnessed her husband's long illness, she would have hated a slow decline.

Notes

Chapter 1: John

1 David Piper in *To John Piper on his Eightieth Birthday* (London: Stourton Press, 1983), 62.

2 John Betjeman to JP, 4 April 1964, University of Victoria.

3 Alexander Pope, *Epistle to Lord Burlington*, (1731).

4 JP in 'European Topography 1967–69: Oil Paintings and gouaches', Marlborough Fine Art (London), catalogue, 1969.

5 JP in conversation with Vera and John Russell, *The Sunday Times*, 22 March 1964.

6 In conversation with the Russells (see n. 5) JP claimed that he read this book at age ten. However, a copy of *The Stane Street* was given to his father in 1917, when John was fourteen and it was probably then that he first read it. The book remained in his possession after his father's death.

7 Reference to this novel is also found in the above conversation with the Russells. In the John Piper archive, now in Tate Archives, is a notebook containing stories which John Piper wrote between January and May 1913, at the age of 9, one of which is entitled 'Venezia' and contains a watercolour of the Doge's Palace and a gondola, a further example of his early desire to show what he had seen.

8 Quoted by Stephen Chaplin at the Confirmation of Degrees ceremony at University of Leeds, 18 July 1985, when John Piper was awarded an Honorary Degree. Illness prevented him from attending.

9 Charles Piper, *Sixty-Three: Not Out: A Book of Recollections* (Plaistow: Curwen Press, 1925), 4.

10 This copy of Charles Piper's *Sixty-Three: Not Out* still belongs to the Piper family.

11 JP's *Highways and Byways* are now in a private collection.

12 JP, foreword to F. Palmer Cook's *Talk to Me of Windows* (London: W. H. Allen, 1971), 5. See also original draft for this foreword in a 1970s sketchbook: TGA 20033.

13 Hugh Walpole, *Mr Perrin and Mr Traill* (1911; London: J. M. Dent, 1935), 15.

14 Quoted in the *Evening Standard*, 7 August 1967.

15 Piper, *Sixty-Three: Not Out*, 104.

16 JP to Graham Poupart, 28 October 1981: courtesy of Graham Poupart.

17 JP, *Desert Island Discs* (BBC Radio 4, 16 December 1983) [radio interview].

18 *Architect's Journal*, 22 October 1919.

19 See Anthony West, *John Piper* (London; Secker and Warburg, 1979), 30.

20 Piper, *Sixty-Three: Not Out*, 126.

21 Ibid. 111.

22 Ibid.

23 David Birch went on to have a professional career as an artist and to become Principal of Epsom School of Art.

24 Foreword to *Glass Light* (Borehamwood: Thorn Lighting, 1978), introd. Martin

Harrison. JP estimated his age correctly, for the year was 1913. However, for all but eighteen days of this year, he was aged 9.

25 Again, JP may have been led to Rouault by Roger Fry's *Vision and Design*. Shortly before it went to press in 1920, Fry, invited to look through a folder of this artist's drawings in Paris, had concluded that Rouault was 'one of the geniuses of all times'. (Quoted in Frances Spalding, *Roger Fry: Art and Life* (London: Paul Elek/Granada, 1980), 232). He hurriedly appended a footnote to his essay on the French Post-Impressionists, claiming that Rouault was 'a visionary' with a 'strangely individual and powerful style'. It is evident from this footnote that Fry had forgotten the eight Rouault drawings included in the 'Manet and the Post-Impressionists' exhibition at the Grafton Galleries in London in 1910, for he claims that Rouault had been unrepresented in either of his two seminal Post-Impressionist exhibitions.

26 West, *John Piper*, 10. This is West's phrase. Here and elsewhere in his book West is very informative on John Piper's relationship with his father, on which he must have talked with his subject at some length.

27 See 'The Saint' in John Piper, *Wind in the Trees* (privately printed, 1923).

28 Piper, *Sixty-Three: Not Out*, 118.

29 Ibid.

Chapter 2: 'That's Painting!'

1 Jock Archer to Myfanwy Piper, 26 August 1989: JPT.

2 *The Times*, 24 November 1983.

3 'I always think it was a waste of time. I've always felt I was five years behind everybody else—even now' (JP, interviewed by the *Oxford Times*, 11 May 1979).

4 For a more detailed description of Piper's study of Blake, see Anthony West, *John Piper* (London; Secker and Warburg, 1979), 25–6.

5 Quoted ibid. 26.

6 JP in conversation with John and Vera Russell, *The Sunday Times*, 22 March 1964.

7 *The Times*, 2 February 1927.

8 *Drawing and Design* 3:13, 27.

9 *London Mercury* 21 (1930), 209 and 235. I would argue that *The Pond* is close in style to *Coldkitchen Farm* and therefore slightly later than *c*.1923, the date given it in Orde Levinson's *Quality and Experiment: The Prints of John Piper: A Catalogue Raisonnée*, rev. edn (London: Lund Humphries, 1996), 40.

10 Not 1921 as stated in *John Piper*, Tate Gallery catalogue (1983), 41; and in Levinson's *Quality and Experiment*, 176.

11 This is suggested by letter from the bookseller Frank Lissaver to JP (25 August 1975): 'I am very sorry you wish to forget your early poems' (Piper Archives, TGA). JP made a similar remark on *Desert Island Discs* (BBC Radio 4, 16 December 1983) that his poems were 'pretty ridiculous'.

12 Santa Maria della Salute, many times drawn and painted by JP, also became the subject of one of his fabric designs and is part of wall decoration made by him for the overmantel in the hall at Renishaw. In 1973, it became the subject of a poem by John Sparrow which JP illustrated.

13 In much of the previous literature on JP his father's death has incorrectly been given as 1926. He died aged 64 of cardiac failure and arterio sclerosis.

14 *Evening Standard,* 7 August 1967.

15 I am grateful to Ursula D'Arch Smith (née Frankau)'s son Timothy D'Arch Smith

for this information, also to Ursula's first cousin, the late Diana Raymond.

16 JP, foreword to 'Raymond Coxon: Retrospective Exhibition', Stoke-on-Trent City Museum and Art Gallery, 1987. Some indication of Coxon's teaching can be gained from his book *Art: An Introduction to Appreciation* (London: Sir Isaac Pitman and Sons:1932).

17 See West, *John Piper*, 49.

18 Again, this is a year later than the date inaccurately given in most Piper literature.

19 See West, *John Piper*, 49–50. This story has been further embellished in 'John Piper: A Retrospective', Tate Gallery catalogue (London, 1983), 41, where it states that, while copying this Cézanne, John caught the attention of the young Tate curator, H. S. (Jim) Ede, who invited him to his home in Hampstead and there, in 1927, introduced him to the French painter Georges Braque. There are problems with this. In 1927 John had not yet gone to the Royal College, and if he was then copying a Cézanne, it would have been at Coxon's suggestion, not Rothenstein's. And though he could well have met Ede in 1927, he did not meet Braque until 1934. West states that not long after his meeting with Braque, Piper went to Paris to see a collection of Picasso's *papiers-collés* at the Galerie Pierre in the rue de Seine. This is almost certainly a reference to an exhibition Piper saw in Paris in 1935, which was indeed after he had met Braque. Piper, in conversation with West and drawing on memory, appears to have confused his early enthusiasm for Braque with the actual meeting which took place in 1934, at Ede's house in Hampstead. See also Chapter 5, n. 8.

20 JP, interviewed by John and Vera Russell, *The Sunday Times*, 22 March 1964.

21 In 1960 Kenna published *Cretan Seals*, which remains an authoritative work on the classification and dating of Cretan seals and which included a full catalogue of the Minoan seals in the Ashmolean Museum, Oxford. He also published *A Catalogue of the Cypriotic Seals of the Bronze Age in the British Museum.*

22 John Piper, 'Sidelight: Michael Ernest Sadler: Friend and Encourager', in Michael Sadleir, *Michael Ernest Sadler: A Memoir by his Son* (London: Constable, 1949), 396.

23 Anthony West claims (*John Piper*, 56) that they were fellow students at Richmond School of Art, but Slade School of Art records show that Eileen went from Richmond School of Art to the Slade in September 1927. As she stayed only one term, she may have returned to Richmond before moving on to the Royal College, in which case she would have met Piper before she arrived at the College.

24 Ibid. 57. West here benefits from Piper's memories of Betchworth.

25 Quoted ibid. 58. West does not name the speaker and I have been unable to identify who it was.

26 See ibid. 59.

27 No evidence has been found to support the claim that JP began writing art criticism for the *Nation and Athenauem* in 1928. It is, however, possible that unsigned notices can be attributed to him from 17 August 1929.

28 Orde Levinson's 'Written Works by and Interviews with John Piper', in *Quality and Experiment: the Prints of John Piper* is the best bibliography available on JP, but it does not include his early reviews for the *Saturday Review*, nor those for the *Nation and Atheneaum* written between 7 June 1930 and 14 February 1931. It also omits to mention the mass of reviews

that JP wrote for *The Spectator* during the Second World War.

29 See Richard Ingrams and JP, *Piper's Places: John Piper in England and Wales* (London: Chatto and Windus, 1983), 15.

30 *Nation and Athenaeum*, 7 June 1930.

31 *Nation and Athenaeum*, 3 January 1931. See West, *John Piper*, 66 for the reference to Beaton.

32 Quoted in West, *John Piper*, 67.

Chapter 3: Stained Glass and Coastal Gaiety

1 A list of the watercolours and the letter of refusal can be found in the 'John Piper' file in the Victoria & Albert Musem archives.

2 JP, *Stained Glass: Art or Anti-Art?* (London: Studio Vista, 1968), 19.

3 Ibid. 20.

4 Ibid.

5 This phrase became the title of one of JP's articles for the *Architectural Review*.

6 JP, *Stained Glass: Art or Anti-Art?*, 23.

7 Ibid. 17.

8 Herbert Read, in *Anton Zwemmer: Tributes from Some of His Friends on the Occasion of his 70th Birthday* (privately printed, 1962), 33. Read's typescript on Zwemmer is in the Tate Archives, TA 9992.1.2.

9 JP, in *Zwemmer: Tributes*, 30.

10 Ibid.

11 *The Studio*, 101 (June 1931), 408–15.

12 *The Listener* (5 July 1933).

13 *The Listener* (9 August 1933).

14 'We were both newly ex-students. I greatly respected his serious attitude, especially to drawing from life, and we both did as much of this as we could' (JP, 'A Personal Trinute', in *P. F. Millard*, pamphlet (London: Goldsmith's

College, University of London, 1984), unpaginated).

15 Reproduced in colour in Richard Ingrams and JP, *Piper's Places: John Piper in England and Wales* (London: Chatto and Windus, 1983), 21.

16 *The Listener* (29 March 1933).

17 JP, 'English Sea Pictures', *The Listener* (28 July 1938).

18 JP's 'The Nautical Style' was first published in the *Architectural Review* (January 1938), and subsequently incorporated into his book *Buildings and Prospects* (London: Architectural Press, 1948).

19 Le Corbusier, *Towards a New Architecture* (London: John Rodker, 1927), 102–3.

20 JP, 'The Nautical Style', rpt. in *Buildings and Prospects*, 12.

21 Ibid. 12.

22 Le Corbusier, *Towards a New Architecture*, 95.

23 The starting point for these pictures appears to have been Braque's Dieppe paintings of 1929, two of which were illustrated in *Cahiers d'Art* (1 (1930), 7).

24 *Cahiers d'Art*, 1 (1931), 64.

25 David Fraser Jenkins, in conversation with the author, recollected JP telling him this during the preparations for his 1983 retrospective exhibition at the Tate Gallery.

26 The address given for Piper in the catalogue is c/o Alexander Reid and Lefevre. *The Back Room* is almost certainly the same as that reproduced in West, *John Piper*, plate 11, and *Shells* is reproduced in the *John Piper*, Tate Gallery catalaogue (1983), p. 74, no. 3.

27 *New Statesman and Nation* (16 December 1933).

28 JP, 'Recent Paintings by Edward Wadsworth', *Apollo*, 18: 108 (December 1933), 387.

29 The titles of the works he exhibited are 'Breakwaters', 'English Coast', 'String Solo', 'Sand and Shingle', and 'Seaweed'.

30 The disparate artists within the 7 & 5, even after the purge, were not all equally committed to abstract art, but must have accepted the decision recorded in the minutes book: 'The exact definition of "non-representational" is left to the discretion of the hanging committee, but as a general guiding principle a work will be excluded if it possesses any element dictated only by natural appearances' (Tate Archives).

31 See Iain Buchanan, Michael Dunn, and Elizabeth Eastmond, *Frances Hodgkins: Paintings and Drawings* (London: Thames and Hudson, 1995), 83 n. 73.

32 Andrew Causey, *Paul Nash: Writings on Art* (Oxford: Oxford University Press, 2000), 2.

33 Two had been titled 'Younger English Painters', and the third 'Contemporary English Drawing'.

34 *The Listener* (22 March 1933).

35 *The Listener* (29 March 1933).

36 JP to Ivon Hitchens, n.d. [summer 1933]: courtesy of John Hitchens.

37 West, *John Piper*, 4. His slightly veiled account of what happened this summer is one which Piper must have approved.

Chapter 4: Orchard's Angel

1 Here and elsewhere in my account of MP's early life I have drawn on the tape-recorded conversation between her and Margaret Garlake, made on 21 November 1994, as part of the National Life Stories series: British Library, C466/251/01-03.

2 These titles are recalled by MP in her introduction to George Gissing's *The Whirlpool* (London: Watergate Classics, 1948), p. v.

3 MP to Margaret Garlake, BL, C466/251/01-03.

4 Myfanwy Piper, MS notes towards an essay on George Gissing: Piper Archives, TA.

5 Ibid.

6 MP, Intro., Gissing, *The Whirlpool*, p. v.

7 MP, 'Holiday Guide: Anglesey', transmitted 30 July 1943, transcript, BBC Written Archives, Caversham.

8 Ibid.

9 MP to Margaret Garlake, BL, C466/251/01-03.

10 When working towards my biography of Stevie Smith, who also attended North London Collegiate School, I wrote to MP. Her reply, dated 4 February 1986, is the source for all her comments, here quoted, on this school.

11 MP, 'Myfanwy Piper on Art', *Harper's Bazaar* (April 1962).

12 Freda Charlesworth (née Hesketh-Wright), in conversation with the author, 27 March 2008.

13 MP, *Woman of Action* (BBC Radio 3, 24 November 1973) [radio interview].

14 *Cherwell* (5 March 1932).

15 *Cherwell* (28 May 1932).

16 A phrase used by MP in a conversation with Roderic Dunnett.

17 Franklin Folson to Myfanwy Evans, n.d. (*c.*1932–3): JPT.

18 For a lively record of its activities, see Franklin Folsom, *Days of Anger, Days of Hope: A Memoir of the League of American Writers 1937–1942* (Boulder: University Press of Colorado, 1994).

19 MP, Introduction, *John Piper: A Retrospective* (Waddington Galleries, in association with James Kirkman, 1994).

20 H. F. B. Brett-Smith to Myfanwy Evans, 4 October 1933: JPT.

21 MP to Margaret Garlake, BL, C466/251/01-03.

22 Ibid.

23 MP, *Woman of Action*.

24 Ibid.

25 JP to Bevis Hillier: tape-recorded conversation: courtesy of Bevis Hillier.

26 MP to Margaret Garlake, BL, C466/251/01-03.

27 JP to Bevis Hillier: tape-recorded conversation: courtesy of Bevis Hillier.

Chapter 5: Going Modern

1 J. M. Richards, *Memoirs of an Unjust Fella* (London: Weidenfeld and Nicolson, 1980), 97.

2 As recollected by MP in her obituary of J. M. Richards. Architectural Association Files, 25, p. 32. Transcript of MP's memorial tribute to Richards, delivered 5 November 1992.

3 Richards, *Memoirs of an Unjust Fella*, 97.

4 MP in conversation with Margaret Garlake, National Life Stories series: British Library, C466/251/01-03.

5 JP to Myfanwy Evans, 13 July 1934: TA.

6 Ibid. 26 July 1934: TA.

7 Ibid. 13 July 1934: TA. As mentioned in Chapter 2, John Piper claimed he met Braque in 1927 at H. S. Ede's house. Braque had come to London in 1927, but there is no reference among the guest lists kept by Ede that either Braque or Piper visited his house that year. Braque came to London again in October 1933, but had Piper met him then, he might have not written so excitedly to Myfanwy about their meeting in July 1934, when Ede gave a supper at his house for Braque, and Nicholson, Hepworth, Gallatin, and Hélion, and 'Mr and Mrs Piper' joined them after dinner (Ede's pocket diary for 6 July 1934: Kettle's Yard, Cambridge).

8 JP to Myfanwy Evans, 26 July 1934: TA.

9 *Time and Tide* (21 July 1934).

10 *Week-end Review* (5 December 1931). Quoted in Paul Nash, *Paul Nash: Writings on Art*, ed. Andrew Causey (Oxford: Oxford University Press, 2000), 67–8.

11 JP, 'Recent paintings by Edward Wadsworth', *Apollo* 18:108 (December 1933), 386–7.

12 JP to Ben Nicholson, 9 April 1934: TGA 8717.2.3402.

13 Ibid.

14 I am grateful to Mel Gooding for this information.

15 Anthony West, *John Piper* (London: Secker and Warburg, 1979), 75.

16 JP to Myfanwy Evans, n.d. [late July/ August 1934]: TA.

17 Ibid.

18 MP, 'Back in the Thirties', *Art and Literature: An International Review* (Winter 1965), 136.

19 Ibid. 137.

20 MP, 'Letter to Jean Hélion' in the catalogue *Jean Hélion: Oil and Acrylic Painting since 1960, Works on Paper since 1930* (London: Albemarle Gallery, 1987).

21 Ibid.

22 Ibid.

23 MP, 'Back in the Thirties', 140.

24 Ibid. 139.

25 Ibid. 140.

26 This story, told by John Piper to John Russell Taylor, who told it to the author, is probably more true in spirit than in letter.

27 MP, 'Back in the Thirties', 139.

28 Ibid. 139.

29 The most instructive analysis of the issues surrounding Abstraction-Création and its relevance to *Axis* is by Karen Hiscock, *Axis and Authentic Abstraction*, unpublished PhD, University of York, 2006.

30 MP, 'Letter to Jean Hélion'.

Chapter 6: *Axis*

1 JP to Myfanwy Evans, 5 September [1934]: TA.

2 Ibid.

3 After reading the essay on himself, written by John Betjeman for the Penguin Modern Painters monograph on his work, Piper wrote: 'as to my first marriage we might use the witching word "dissolved" (as she divorced me, and not the other way round)' (JP to John Betjeman, 31 November 1942: Victoria).

4 Eileen Holding held a solo exhibition of her paintings at the Hudson Guild Gallery in New York City in November 1961 and also showed at the New Bauhaus Galleries in Chicago, the Houston Gallery of Fine Art in Texas, the Pennsylvania Academy of Fine Art's 156th annual exhibition, the Mainline Gallery in Philadelphia, the Audubon and Allied Artists in New York, and the Springfield Museum of Art in Massachusetts.

5 Jean Hélion to Ben Nicholson, 17 September 1934, quoted in Jeremy Lewison, *Ben Nicholson* (London: Tate Gallery, 1993), 44.

6 MP to Barbara Wadsworth, 15 January 1985, quoted in Barbara Wadsworth, *Edward Wadsworth: A Painter's Life* (Salisbury: Michael Russell, 1989), 214.

7 Ibid.

8 JP to Ben Nicholson, 2 October 1934: TGA 8717.1.2.3402.

9 MP, Introduction, *John Piper: A Retrospective* (London, Waddington Galleries in association with James Kirkman, 1994).

10 Ibid.

11 These two phrases were used by Paul Nash as the title for an article in the *Weekend Review* 5:105 (12 March 1932), 322–3.

12 Paul Nash, *Paul Nash: Writings on Art*, ed. Andrew Causey (Oxford: Oxford University Press, 2000).

13 MP, 'Back in the Thirties', *Art and Literature: An International Review* (Winter 1965), 143.

14 MP, in a tape-recorded conversation with Margaret Garlake, made on 21 November 1994, as part of the National Life Stories series: British Library, C466/251/01-03.

15 Son of Hubert Wellington who had vetted Piper for entry into the Royal College of Art.

16 MP, 'Back in the Thirties', 143.

17 *Axis* 1 (January 1935), 3.

18 Ibid. 23.

19 Ibid. 26.

20 Ibid. 8.

21 Ibid. 10.

22 Ibid.

23 Ibid. 27.

24 This point was made by J. M. Richards in his obituary of Piper, published in the *Guardian*, 30 June 1992, but written by Richards two years earlier.

25 Broadcast on the Home Service, 22 Jan.1935.

26 By 1994 it had moved to Myfanwy's study.

27 Asked by R. Myserscough-Walker in an interview in *The Artist* (May 1944) whether his abstracts represented any particular subjects, JP replied: 'They were related to the painting I had done immediately before. Since I had been painting a good deal at the seaside—at Dungeness and in Dorset—the abstract paintings were influenced by forms and colours on the beach and cliff, but only vaguely.'

28 As recalled by MP in *Woman of Action* (BBC Radio 3, 24 Nov. 1973) [radio interview].

29 'Aspects of Modern Drawing', *Signature* 7 (November 1937).

30 'The Artist and the Public', *Current Affairs* 96 (2 June 1945).

31 *Britain Today* 166 (February 1950), 39.

32 At the time of writing my essay for *John Piper in the 1930s: Abstraction on the Beach* (London: Merrell Publishers, 2003) these photographs could not be found. They have now been located in the photographic archives in the Victoria & Albert Museum's Sculpture Department.

33 Clapham was author of *English Romanesque Architecture after the Conquest* and secretary of the Historic Monuments Commission for England.

34 As reported by JP in an interview with Bevis Hillier. See Bevis Hillier, *John Betjeman: New Fame, New Love* (London: John Murray, 2002), 97–8. A similar report was earlier given by Piper to Paul Joye, in an interview about his work with photography: Unpublished, undated typescript, Tate Archives.

35 JP, interview with Paul Joyce.

36 *Christian Science Monitor* (16 February 1966).

37 MP, 'Beginning with Picasso', *Axis* 2 (April 1935), 3.

38 Jean Hélion, 'From Reduction to Growth', ibid. 19–24.

39 Myfanwy Evans, unpublished journal for 1935: courtesy of Clarissa Lewis.

Chapter 7: Abstract and Concrete

1 Myfanwy Evans, unpublished diary, 26 May 1935: courtesy of Clarissa Lewis. This passage was later incorporated into her essay for *To John Piper on his Eightieth Birthday*, ed. Geoffrey Elbon (London: Stourton Press, 1983), 13.

2 Ibid. 17 March 1936.

3 Ibid. 20 March 1936.

4 Ibid. 29 February 1936.

5 This had been closed by police in 1933, after persistent harrassment.

6 *Decoration* 7 (December 1935), 40.

7 In *Cubism and Abstract Art: Painting, Sculpture, Constructions, Photography, Architecture, Industrial Art, Theater, Films, Posters, Typography* (New York: Museum of Modern Art, 1936), 200.

8 In some notes made in preparation for an autobiography which he never wrote, S. J. Woods recollected first meeting Piper when he was in the process of splitting with Eileen (typescript notes, in possession of S. J. Woods' widow, Nancy Woods).

9 The illustrations that he used for these five artists were the same as those later used in the book Woods published with Roger Smithells, *The Modern Home: Its Decoration, Furnishing, and Equipment* (Benfleet, Essex: F. Lewis, 1936).

10 *Decoration* 11 (March 1936), 44.

11 Chermayeff, in connection with some work he was doing for a gallery, had asked to borrow a Picasso from a collector in Brussells. Piper had gone to collect it, only to find that its owner had changed her mind and did not want to let it leave the house. She permitted Piper to copy it. Story has it that on his way back, in Paris, he showed the copy to Picasso who liked it so much he asked if he could sign it and did so. After the picture was exhibited in Whitehall, Piper gave it to Chermayeff. Housed in a London depository during the 1939–45 war, it was destroyed by bombing.

12 See Alan Powers, *Serge Chermayeff: Designer, Architect, Teacher* (London: RIBA, 2001), 130.

13 JP to Winifred Nicholson, n.d. [September/October 1936]: courtesy of Andrew Nicholson.

14 In conversation with Candida Lycett Green, in *John Betjeman: Letters*, vol. 1: *1926–1951* (London: Methuen, 1994), 141.

15 'Modern Travel for Modern People', Imperial Airways Brochure: copy in the Tate Archives.

16 A study for it is reproduced in *John Piper in the 1930s: Abstraction on the Beach* by David Fraser Jenkins and Frances Spalding (London: Merrell, 2003), 151.

17 Havinden went on to become one of the most successful designers in advertising working in Britain. Director of the Crawford Advertising Agency, he lived in Hampstead during the 1930s. He also helped Moholy-Nagy obtain the job organizing window displays for Simpson's in Piccadilly.

18 Nicolette Gray, 'Abstract Art', *New Oxford Outlook* (22 November 1935), 252.

19 Myfanwy Evans, 'Abstract Art: Collecting the Fragments', ibid. 260.

20 MP, unpublished diary, 6 January 1936: courtesy of Clarissa Lewis.

21 Ibid. 1 Febraury 1936.

22 J. M. Richards, after visiting the exhibition at the Lefevre Gallery, wrote to Peggy Angus, saying that it was 'the London equivalent of the one that was at Oxford, but <u>much</u> better; better pictures, more of them and far better hung. Really a very good show' (n.d. [April 1936]: East Sussex Record Office).

23 Towards the end of his life Piper forgot that, though it was very difficult to sell abstracts in the 1930s, some of his had found a buyer. He claimed, for instance in an interview with Rachel Billington in 1983, the transcript of which is in the Tate Archives (TGA 8318.27), that he had never sold any, the extent of his hardship in the 1930s having by then become a romantic myth.

24 JP to Ben Nicholson, 5 May 1936: TA 8717:1.2.3403.

25 According to Margaret Gardiner, this idea was 'born in an ABC tea shop' after the three artists had veiwed the International Surrealist Exhibition in June 1936 (Gardiner, *Barbara Hepworth: A Memoir*, 46). A formal meeting to pursue this idea took place on 20 June 1936 (Martin Hammer and Christina Lodder, *Constructing Modernity: The Art and Career of Naum Gabo* (New Haven, CT/London: Yale University Press, 2000), 236.

26 This fact is recorded by Myfanwy in her diary, 3 July 1936: courtesy of Clarissa Lewis.

27 JP voiced this opinion two months later, in a letter to Winifred Nicholson, 6 September 1936: courtesy of Andrew Nicholson.

28 See notes taken by Charles Harrison from Winifred Nicholson's correspondence: TGA 839/3/1/17.

29 JP to Rachel Billington, 1983, transcript of an interview: TGA 8318.27.

30 JP to Peter Cannon-Brookes, and reported by him to the author in a conversation held 30 October 2003.

31 See Tzvetan Todorov, *Hope and Memory*, trans. David Bellos (London: Atlantic, 2004).

32 Powers, *Serge Chermayeff*, 256.

33 JP to Winifred Nicholson, 6 September 1936: courtesy of Andrew Nicholson.

34 S. J. Woods, 'Time to forget ourselves', *Axis* 6 (Summer 1936), 21.

35 JP in Stephen Spender, 'A Talk with John Piper', *Encounter* (May 1963).

36 Richard Ingrams and John Piper, *Piper's Places: John Piper in England and Wales* (London: Chatto and Windus, 1983), 22.

37 JP, in Spender, 'A Talk with John Piper'.

38 JP, 'England's Climate', *Axis* 7 (Autumn, 1936), 5.

39 Ibid.

Chapter 8: 'Look, stranger, at this island now'

1 Some fifty years later Robert Wellington wrote to John and Myfanwy Piper, à propos Contemporary Lithographs: 'How fortunate that John and his mother had the property at Betchworth, and it had come to a parting of the ways with Eileen' (5 November 1988: TA). This suggests that the sale of Chalkpit Cottage helped the cash-flow situation at Contemporary Lithographs after the appearance of Series One.

2 Ruth Artmonsky, *Jack Beddington* (London: Artmonsky Arts, 2006), 32. JP's design is reproduced in *The Shell Poster Book*, foreword by Lord Montagu of Beaulieu (London: Profile Books, 1998), 107.

3 The Curwen Press had initially been favoured owing to the paramount attention Harold Curwen gave to the artist's intention. After he suffered a nervous breakdown, Contemporary Lithographs were made at the Baynard Press where the second set was produced.

4 In *The Times*, 22 January 1937, *New Statesman and Nation*, 23 January 1937, and in the *Architectural Review*, January, 1937.

5 Fifteen, if Piper's *Nursery Frieze* in two parts is counted as two prints.

6 According to a notice in *The Studio* 116 (1938), 301.

7 At JP's request, in December 1937, Sir Michael Sadler also signed a letter to *The Times* on Wyndham Lewis's behalf. It urged national collections to acquire works by Wyndham Lewis and attempted to ginger up interest in this artist while an exhibition of his work was on show at the Leicester Galleries. Lewis's financial difficulties were exacerbated at this time by the fact that he was being blackmailed by his illegitimate son, Peter.

8 JP in a tape-recorded interview with Pat Gilmour, transcript, TAV 47 BB: TA.

9 Recollected by JP in a recording for a documentary on Frances Hodgkins, 1969: Transcript, Piper Archive, TGA.

10 Ibid.

11 Walter Benjamin, 'The Work of Art in the Age of Mechanical Reproduction' (1936), reprinted in *Illuminations*, ed. Hannah Arendt (New York: Schocken Books, 1969), 241.

12 The reference here is to the one in which the author has a flat. The former owners of the house, John and Helen Hulton, were admirers of Piper and in the late 1930s had small children.

13 See Orde Levinson, *'Quality and Experiment': the Prints of John Piper*, pp. 42–3.

14 MP, *Harper's Bazaar* (October 1961).

15 These and other remarks by Myfanwy on their Wiltshire trip come from her diary, 18–20 February 1937: Clarissa Lewis.

16 Sam Smiles has observed that, while 'contemporary abstract art was regularly accused of being inhumane and mechanistic, prehistoric forms showed how the rigours of abstraction need not be associated with the cold precision of the machine aesthetic but could be combined with humane qualities of ritual and purpose'. See his chapter 'Antiquity and Modern Art in Britain c.1930–1950', in David Peters Corbett, Ysanne Hot and Fiona Russell (eds), *The Geographies of Englishness: Landscape and the National Past 1880–1940* (London: Yale University Press, 2002).

17 JP, 'Lost, A Valuable Object', in Myfanwy Evans (ed.), *The Painter's Object* (London: Gerald Howe, 1937), 70.

18 JP, quoted in 'The Arbitrary Eye: A Photographic Discourse with John Piper and Paul Joyce', photocopied typescript article with corrections: TGA 200410/3/4/20.

19 When exactly John Piper began reading this periodical is not clear, as the articles he collected are not pasted in date order and he may have gained access to back numbers, for among them are articles on Stonehenge dating back to the late 1920s. He labelled the two volumes 'Papers from *Antiquity*, special 1927–1940' and 'Papers from *Antiquity*, general 1927–1940': Clarissa Lewis.

20 MP, unpublished diary, 20 February 1937: courtesy of Clarissa Lewis.

21 O. G. S. Crawford, *Archaeology in the Field* (London: Phoenix House, 1953), 51.

22 MP, unpublished diary, 22 February 1937: courtesy of Clarissa Lewis.

23 Ibid.

24 JP, *Desert Island Discs* (BBC Radio 4, 16 December 1983) [radio interview].

25 Quoted by Candida Lycett Green (ed.), *John Betjeman: Letters*, vol. I: *1926 to 1951* (London: John Murray, 1994), 140.

26 John Betjeman, 'Introduction: An Aesthete's Apologia', in *Ghastly Good Taste* (1933; London: Anthony Blond, 1970), p. xxiv.

27 John Betjeman, 'A Spiritual Change Is the One Hope for Art', *The Studio* (February 1937), 56–72.

28 This is acknowledged by Betjeman in his 'The Seeing Eye or How to Like Everything', *Architectural Review* 86 (November 1939), 201–4, an article that contains six illustrations by JP. In the course of this article Piper is asked his opinion on a Methodist Chapel at Longparish, Hants. He points out that Methodist Chapels, though always execrated, 'are often humble but more living attempts at architecture than the most expensive churches of their date'.

29 'I don't think I've ever felt so confident as I did with Mr Piper' (Lycett Green (ed.), *John Betjeman: Letters*, 195).

30 The phrase is Timothy Mowl's. See his *Stylistic Cold Wars: Betjeman versus Pevsner* (London: John Murray, 2000), 103.

31 Frances Carey and Anthony Griffiths, *Avant-Garde British Printmaking 1914–1960* (London: British Museum Publications, 1990), 141.

32 MP, unpublished diary, 15 March 1937: courtesy of Clarissa Lewis.

33 In conversation with Bevis Hillier who incorporates this into his *John Betjeman: New Fame, New Love* (London: John Murray, 2002), 98.

34 Quoted in John Betjeman, *John Piper* (London: Penguin, 1944), 7.

35 Robert Medley, *Drawn from the Life: A Memoir* (London: Faber and Faber, 1983), 162–3.

36 Benjamin Britten, quoted in *Letters from a Life: The Selected Letters and Diaries of Benjamin Britten 1913–1976*: vol. 1: *1923–1939* (London: Faber and Faber, 1991), 452.

37 Recorded in Alan Blyth, *Remembering Britten* (London: Hutchinson, 1981), 28.

38 Michael Sidnell, *Dances of Death: The Group Theatre of London in the 1930s* (London: Faber and Faber, 1984), 231.

39 Clough Williams-Ellis, *Beauty and the Beast* (London: J. M. Dent, 1937), 97.

40 It can be found in the Piper Archive, where it forms part of the relatively few documents that they kept from the 1930s.

41 Lycett Green, *John Betjeman: Letters*, 169.

42 A phrase used by Alan Powers in 'Guides to Betjeman Country', *Country Life* (30 August 1984).

43 Betjeman's authors for the pre-1939 Shell Guides included Robert Byron and Edith Oliver, Christopher Hobhouse, Lord Clonmore, Paul Nash, John Nash, Peter Quennell, and Anthony West, among others.

44 John Betjeman, 'A Shell Guide to Typography', *Typography* 2 (Spring 1937).

45 Quoted in Mowl, *Stylistic Cold Wars*, 58.

46 Piper in particular sought to rebut Ruskin's insistence on the 'falsehoods' to be found in the style and furnishing of Classical churches. 'And, in spite of Ruskin,' he wrote in *The Listener* (5 September 1940), 'it is not that we are simply willing to admire falsehoods nowadays. Eighteenth-century designers often enough took Classical models and copied them, but they used their materials—their false marble, scagliola and stucco—so deftly that their works were always original and often creative.'

47 Powers, 'Guides to Betjeman Country'.

48 'The articles are so witty that it is a pity errors should creep in,' wrote Mrs Irene Whitman Jones, pointing to a 't' omitted in Chastleton, and informing JP that it is Jacobean not Elizabethan and that the entrance fee is 2/– not 2/6 (Faber Archives).

49 Lycett Green (ed.), *John Betjeman: Letters*, 140.

50 Mowl, *Stylistic Cold Wars*, 74.

51 See note 44.

52 Quoted in Lycett Green (ed.), *John Betjeman: Letters*, 170.

53 Richard Ingrams and John Piper, *Piper's Places: John Piper in England and Wales* (London: Chatto and Windus, 1983), 47.

54 John Betjeman and JP, *Shropshire: A Shell Guide* (London; Faber and Faber, 1951, 6–7.

55 John Betjeman, Preface to his *Church Poems* (London: John Murray, 1981).

56 JP in conversation with Sebastian Faulks, *Sunday Telegraph*, 21 July 1984.

57 'We had a riotous time in Exeter looking at 12 churches' (JP to Colin Anderson, n.d. [1943]: courtesy of Catriona Williams).

58 JP to Basil Creighton, 30 November 1943: TGA 989–19.

Chapter 9: Not Playboys but Agents: 1937–8

1 'Died April 1st 1837: John Constable', *Architectural Review* 81 (April 1937), 149–50.

2 Now in the Tate Archives. This unpublished essay, which may have been the basis for a talk, is entitled 'No Movements, No Programnmes'.

3 *London Bulletin* 8–9 (January–February 1939).

4 MP, 'Back in the Thirties', *Art and Literature: An International Review* (Winter 1965), 148.

5 Ibid. 149.

6 Ibid.

7 Ibid.

8 As recollected by MP, in tape-recorded conversation with Margaret Garlake, 21 November 1994, as part of the National Life Stories series: British Library, C466/251/01-03.

9 It is now permanently installed in the Musée d'Art Moderne de la Ville de Paris.

10 These were found tucked into a book in his library and now belong to Hugh Fowler Wright.

11 Le Corbusier's text, dated 14 December

1937, is quoted in *1937—Exposition internationale des arts et techniques*, Musée National d'Art Moderne, 20 June–26 August, 1979, 12.

12 *London Bulletin* 6 (October 1938), 6.

13 MP, 'Back in the Thirties'.

14 Myfanwy Evans, 'The Painter's Object', in *eadem* (ed.), *The Painter's Object* (London: Gerald Howe, 1937), 8, 9.

15 MP, 'Back in the Thirties'.

16 Evans, 'The Painter's Object', 5.

17 *Circle* was supported by 'Constructive Art', an exhibition at the London Gallery in July 1937, in which a John Piper abstract was included.

18 MP to Margaret Garlake, BL C466/251/01-03.

19 Evans, 'The Painter's Object', 9.

20 Ibid. 12.

21 Giorgio de Chirico, 'Gustave Courbet', trans. P. Morton Shand, in Evans (ed.), *The Painter's Object*, 129.

22 Paul Nash, 'The Nest of Wild Stones', in Evans (ed.), *The Painter's Object*, 38.

23 In *Country Life*, (1 May 1937) Paul Nash had published an article entitled 'The Life of an Inanimate Object' in which he records how, after visiting Avebury he became preoccupied with 'the problem of assembling and associating different objects in order to create that true irrational poise which is the solution of the personal equation'. There may be an echo of this article in JP's essay.

24 JP, 'Lost, A Valuable Object', in Evans (ed.), *The Painter's Object*, 72.

25 Ibid. 73.

26 Evans, 'The Painter's Object', 10.

27 This comparison has given rise to the criticism that Piper is here trying to find modernity in the pre-modern and, in so doing, domesticating the modern in his accommodation of the past. See Sam Smiles, 'Equivalents for the Megaliths: Prehistory and English Culture, 1920–1950', in David Peters Corbett, Ysanne Holt, and Fiona Russell (eds), *The Geographies of Englishness: Landscape and the National Past 1880–1940* (New Haven, CT/London: Yale University Press, 2002), 215–20. My own view is that Piper's analogy is far more imaginatively stimulating than this suggests, and that, far from domesticating the modern, he succeeds in making it strangely new.

28 Calder's visit to Mondrian's studio is recorded in his autobiography where he tells how he offered to make the coloured panels that hung on Mondrian's walls move and reports Mondrian's reply: 'No, it is not necessary, my painting is already very fast.' See Alexander Calder, *Calder: An Autobiograohy with Pictures* (New York: Pantheon Books, 1966), 113.

29 Quoted in Charles Harrison, *English Art and Modernism,1900–1939* (London: Allcn Lane, 1981), 259.

30 See Calder, *Calder: An Autobiography with Pictures,* 162.

31 Ibid.

32 And is now in the Tate Collection.

33 'Died April 1st 1837: John Constable', *Architectural Review* 81:2 (April 1937), 149–50.

34 Geoffrey Grigson, *The Crest on the Silver* (London: Cresset Press, 1950), 122.

35 Geoffrey Grigson, *Recollections: mainly of Writers and Artists* (London: Chatto and Windus/Hogarth Press, 1984), 157.

36 Ibid.

37 Ibid.

38 Grigson, *The Crest on the Silver*, 108.

39 See JP 'Henry Fuseli, RA, 1741–1825', *Signature* 10 (November 1938), 1–14.

40 MP to Margaret Gardiner, 21 November 1994, tape-recorded conversation, National Life Stories series: British Library, C466/251/01-03.

41 MP, entry on Paul Nash in the *Oxford Dictinary of National Biography*.

42 JP, 'The Recent Watercolours of Paul Nash', *Town Flats and Country Cottages* 1:8 (1937), 405.

43 Helen Binyon to John Nash, 6 October 1937: TGA 8910.1.2.198.

44 Myfanwy may have encouraged JP in this interest. When reviewing David Bell's *The Artist in Wales* in the *Daily Telegraph* (28 June 1957), she noted that 'in Wales, the civilising influence of medieval religion had come in its most forbidding form, by way of the Cistercian Order, which believed in worship not through art, but through austerity,' and that it had set the pattern for Welsh Nonconformity hundreds of years before Nonconformity arrived.

45 Eric Ravilious to Helen Binyon, 15 February 1938: West Sussex Records Office, Lewes.

46 Paul Nash's introduction was also printed in the *London Bulletin* 2 (May 1938).

47 Before meeting Sweeney, Piper had favourably reviewed his book, *Plastic Redirections in Twentieth-Century Painting* in the pages of *Axis* 2, 30.

48 JP to James and Laura Johnson Sweeney, 23 August 1938. Courtesy of the Calder Foundation.

49 JP to Percy Horton, 24 March 1939 (East Sussex Records: ACC 7828). This letter was evidently written in response to Horton's request for a photograph of the mural. The mural was to be destroyed by the subsequent tenants.

50 JP, 'Abstraction on the Beach', *Vingtième Siècle* (1 July 1938).

51 Quoted in Richard Ingrams and John Piper, *Piper's Places: John Piper in England and Wales* (London: Chatto and Windus, 1983), 22.

52 JP tried to keep in touch with Nicholson: 'It would be nice to hear from you again. ... Could you ever come for a night on your way to, or from, London?' (JP to Ben Nicholson, 1 February 1945: TGFA 8717.1.2.3404). But their friendship was never repaired.

53 JP, *Signature* 7 (November 1937).

54 See Charles Harrison, 'England's Climate', in *Towards a Modern Art World: Studies in British Art I*, ed. Brian Allen (London: Yale University Press, 1995), 215. For an earlier attack on Piper by this art historian, see Harrison, *English Art and Modernism 1900–1939*.

55 JP to Paul Nash, 12 Januray 1943: TA 70-50/1076.

56 John Craxton to Myfanwy Piper, 1 July [1992]: TA.

Chapter 10: Decrepit Glory, Pleasing Decay: 1938–9

1 A measure of the importance to JP of Christopher Hussey is the fact that he spoke, as did others, at Hussey's memorial at St Paul's, Covent Garden in 1970.

2 A phrase he used of de Cronin Hastings, adding 'also a streak of madness', in conversation with Bevis Hillier: Tape-recorded interview, made in the course of Bevis Hillier's research into the life of John Betjeman.

3 Peggy Angus to MP, 29 April 1942: JPT.

4 MP, obituary of J. M. Richards: AA files 25.

5 J. M. Richards, *Memoirs of an Unjust Fella* (London: Weidenfeld and Nicolson, 1980), 138. Some of these journeys can be plotted from Richards' letters to Peggy

Angus, in the East Sussex Records Office. For instance, in January 1939, they visited Marlborough and Bath, and in May 1939, toured East Anglia and the Midlands, taking in also Holkam Hall in Norfolk, which Piper saw for the first time, also Wisbech, Glossop, Bakewell, Derby, Oakham, Leamington, and Stratford.

6 JP, 'Nautical Style', *Architectural Review* 83 (January 1938), 1–14; and *idem*, 'Fully Licensed', *Architectural Review* 87 (March 1940), 87–100. Both were reprinted in JP, *Buildings and Prospects* (London: Architectural Press, 1948).

7 JP, 'Fully Licensed', 87; *Buildings and Prospects*, 49–50.

8 JP, 'Fully Licensed', 88; *Buildings and Prospects*, 50.

9 Timothy Mowl, *Stylistic Cold Wars: Betjeman versus Pevsner* (London: John Murray, 2000), 97.

10 Transmitted 9.30–9.45 pm on 10 June 1938.

11 JP, 'Nautical Style'; *Buildings and Prospects*, 18–19.

12 JP, 'Nautical Style'; *Buildings and Prospects*, 20.

13 Introduction by Lord Alfred Douglas to JP's *Brighton Aquatints* (London: Duckworth, 1939), unpaginated.

14 JP to John Betjeman, n.d. [1939]: Victoria.

15 JP, *Brighton Aquatints*, unpaginated.

16 *Time and Tide* (6 January 1940), 14–15.

17 Sir Osbert Sitwell, 'The Work of John Piper', unpublished essay, typescript, SR.

18 *The Listener* (4 January 1940).

19 JP, handwritten memoir on his association with the Sitwells: courtesy of Suzannah Brooks.

20 *John Piper's Stowe*, with a foreword by John Piper and a Commentary by Mark Girouard (Hurtwood Press, in association with the Tate Gallery, 1983), 7.

21 Kenneth Walsh, a contributor to *Axis*, and later Provost of King's College, Cambridge, provided JP with an introduction to Roxburgh.

22 Girouard, *John Piper's Stowe*, 14.

23 JP, 'Foreword', ibid. 7.

24 S. J. Woods, in 'John Piper as a Topograhical Illustrator', *Image* 2 (Autumn 1949), 3–18, mentions *Brighton Aquatints*, then adds: 'A second book of aquatints with Stowe as its subject is in preparation' (13).

25 JP, 'Foreword', *John Piper's Stowe*, 7.

26 Mark Girouard makes this point in greater detail in his commentary to *John Piper's Stowe*.

27 JP, 'Foreword', *John Piper's Stowe*, 7.

28 Frank Ward, *The Lakes of Wales* (London: Herbert Jenkins, 1931), 220–1. Quoted by David Fraser Jenkins, *John Piper: The Forties* (London: Philip Wilson/Imperial War Museum, 2000), 23.

29 One monoprint, *Llyn Teifi*, was reproduced in *Horizon* 3:13 (January 1941).

30 Fraser Jenkins, *John Piper: The Forties*, 23.

31 JP, 'Decrepit Glory: A Tour of Hafod', *Architectural Review* 87 (June 1940), 207–10; reprinted in *Buildings and Prospects*, 42.

32 Quoted in Richard Ingrams and John Piper, *Piper's Places: John Piper in England and Wales* (London: Chatto and Windus, 1983), 135.

33 MP, 1939 journal: typescript, courtesy of Clarissa Lewis.

34 JP to Sir Michael Sadler, 3 September 1940: TGA 8221.2.133.

35 JP, 'Decrepit Glory', *Building and Prospects*, 38.

36 George Borrow, *Wild Wales, its People, Language and Scenery* (1862; 1977 edn), 433. Quoted in Elisabeth Inglis-Jones, *Peacocks in Paradise* (London: Faber and Faber, 1950), 245.

37 MP, 1939 journal: typescript, courtesy of Clarissa Lewis.

38 Ibid.

39 JP to John Betjeman, n.d. [1939]: Victoria.

40 MP, 1939 journal: typescript, courtesy of Clarissa Lewis.

41 Ibid.

42 JP, 'Barbarous Wales', *New Stateman and Nation* (9 December 1939).

43 JP, 'Decrepit Glory', *Buildings and Prospects*, 38.

44 JP, 'Sickert, and Others', *The Spectator* (15 March 1940).

Chapter 11: 'The Weather in Our Souls': 1939–40

1 JP to Sir Michael Sadler, 22 October 1939: TGA 8221.2.132.

2 'One walks between them … as down a narrow street' (J. H. Cheetham and John Piper, *A Shell Guide to Wiltshire* (London: Faber and Faber, 1968), 132). Almost certainly, as Piper felt Cheetham did not understand churches, these words are JP's.

3 John Betjeman, *John Piper* (London: Penguin, 1944), 14.

4 John Betjeman, *John Betjeman: Letters*, vol. 1: *1926–1951*, ed. Candida Lycett Green (London: Methuen, 1994), 240.

5 See Andrew Hemingway, 'Meaning in Cotman's Norfolk Subjects', *Art History* 7:1 (March 1984), 57–77.

6 One example of his infectious excitement is the letter to his wife which Cotman wrote on hearing, after years of working as a drawing master in Norwich, that he had been appointed Professor of Drawing to King's College, London: 'My views are clear and splendid—never more so. I *must* come in contact with the first men in the country for talent, intellect and integrity. In all this I live, I breathe and feel a Man. This is what I have ever loved and tried to realize. It will now, with the blessings of God Almighty, be accomplished. No man can be more happy, even in prospect than I now am. Proud! proud!! proud!!! and happy Cotman!!!! Ought I ever after this to despair? … Much as I have ever loved London I have never trod its gold-paved streets feeling so much a man of business, and so much *to belong to it*, as now' (Quoted Stanley D. Kitson, *The Life of Cotman* (London: Faber and Faber, 1937), 307).

7 *The Spectator* (1 March 1940). And in Kitson, *The Life of Cotman*, 48.

8 JP, 'Towers in the Fens', *Architectural Review* 88 (November 1940), 131.

9 Ibid. 132.

10 JP, 'John Sell Cotman, 1782–1842', *Architectural Review* 547 (July 1942), 9–12.

11 JP to John Betjeman, n.d. [1941]: Victoria.

12 JP to Colin Anderson, n.d. [1943]: courtesy of Catriona Williams.

13 The inscription is quoted in David Fraser Jenkins, *John Piper: The Forties* (London: Philip Wilson/Imperial War Museum, 2000), 42.

14 The first two places, both in Wiltshire, are so small that Pevsner overlooked them; the next two will be familiar to readers of this book; and the last refers to a cottage Grigson owned.

15 As recorded in JP to Sir Osbert Sitwell, 1 August 1940: SR.

16 MP to John Betjeman, 25 July 1940: Victoria.

17 JP, *Architectural Review* (July 1942), 20.

18 Jeremy Lewis, *Cyril Connolly: A Life* (London: Jonathan Cape, 1997), 333.

19 *Horizon* 1:1 (January 1940), 5.

20 *Horizon*, 1:2 (February 1940), 71.

21 JP to John Betjeman, 21 November 1939: Victoria.

22 JP to Paul Nash, 3 September 1940: TGA 7050.33.

23 Piper's articles for *The Spectator* are not listed in the bibliography of Piper's written works compiled by Orde Levinson in his book *'Quality and Experiment': The Prints of John Piper*, rev edn (London: Lund Humphries, 1996), 176 ff.

24 J. Wilson Harris to JP, 9 October 1942: JPT.

25 *The Listener* (24 June 1931).

26 *The Spectator*, 31 May 1940.

27 Lord Macmillan, Introduction, *Recording Britain*, vol. I (Oxford: Oxford University Press, 1946), p. v.

28 Clough Williams-Ellis, (ed.) *Beauty and the Beast*, (London: J.M. Dent & Sons, 1937).

29 Quoted in David Mellor, Gill Saunders, and Patrick Wright, *Recording Britain* (London: David and Charles, in assocation with the Victoria & Albert Museum, 1990), 10.

30 JP, in *Recording Britain*, vol. II, ed. Arnold Palmer (Oxford: Oxford University Press, 1947), 120.

31 JP, 'Grey tower and panelled pew', *The Listener* (1 February 1940).

32 JP, *The Spectator* (8 December 1939).

33 It is spelt Hulcote in JP's *Spectator* article (8 December 1939).

34 Ibid.

35 John Betjeman to JP, n.d. [summer 1939]: JPT. Betjeman had a lifelong habit of signing letters with names other than his own.

36 MP to Margaret Gardiner, tape-recorded interview 21 November 1994, National Life Stories series: British Library, C466/01-03.

37 Kenneth Clark, 'The Weather in Our Souls', *The Listener* (1 May 1941).

38 JP to Kenneth Clark, 28 May 1941: TGA ss12.1.3.2507. *The Weather in Our Souls* was a broadcast, subsequently printed in *The Listener*.

39 Kenneth Clark to JP, 2 June 1941: TGA 8812.1.3.2503.

40 In an interview with Rachel Billington in 1983, the transcript of which is in the Tate Archives: TGA 8318.27.

41 JP in *The Journals and Papers of Gerard Manley Hopkins*, ed. Humphry House and completed by Graham Storey (London: Oxford University Press, 1959), 455.

42 David Fraser Jenkins points out that this series may have been modelled on the German Blue Book series, and that all the titles had a nationalist interest. Piper's was to be no. 34 in the series. See David Fraser Jenkins, *John Piper: The Forties* (London: Philip Wilson, 2000), 42.

43 Piper lectured at Morley College on more than one occasion. On 29 April 1940 he delivered a talk on 'Cubism, Cézanne, Picasso, Braque', in a series of public lectures entitled 'Art Today'.

44 JP, *British Romantic Artists* (London: Collins, 1942), 46.

45 Ibid. 26.

46 'New Movements in Art' opened at the London Museum, then toured to Leicester, Bolton, Manchester, and Birkenhead. Mortimer coined the term 'Neo-Romantic' in connection with the work of Frances Hodgkins, Ivon Hitchens, Henry Moore, John Piper, and Graham Sutherland.

47 Interviewed in the Oxford University magazine *Isis*, in 1989, he claimed that the label 'Romantic', when used of himself and others, had been 'a silly idea started by one or two people … I never use that horrible word.'

48 JP, *The Listener* (21 December 1944).

Chapter 12: Fawley Bum

1 Although the Pipers lunched with Prokosch in London, nothing came of this suggestion.

2 MP to Evelyn Waugh, 20 June 1942, *The Letters of Evelyn Waugh*, ed. Mark Amory (London: Weidenfeld and Nicolson, 1980), 163.

3 Candida Lycett Green (ed.), *John Betjeman: Letters*, vol. I: *1926 to 1951* (London: Methuen, 1994), 195.

4 Penelope Betjeman to JP, 13 February, [?]: TGA. Similar experiences must have occurred in the neighbouring hamlet of Baulking, as there the vicar terminated Penelope's playing of the harmonium. See *John Betjeman: Letters*: vol. I, 193.

5 Quoted ibid. 195.

6 MP, 1939 journal: typescript, courtesy of Clarissa Lewis.

7 Ibid.

8 Ibid.

9 Penelope Betjeman to MP, 23 May [*c.*1943]: JPT.

10 John Betjeman, 'Myfanwy', in *Old Lights for New Chancels* (1940); rpt. in *The Collected Poems* (1958).

11 John Betjeman, 'Myfanwy at Oxford', ibid.

12 *John Betjeman: Letters*: vol. I, 205.

13 *John Betjeman: Letters*: vol. I, 289.

14 John Betjeman to MP, 23 November 1939: JPT.

15 John Betjeman to MP, 2 May 1943: JPT.

16 Quoted by Bevis Hillier in his foreword to John Betjeman, *Uncollected Poems* (London: John Murray, 1982), 5.

17 JB to JP and MP, 2 March 1941: Victoria.

18 MP to John Betjeman, n.d.: Victoria.

19 JP to John Betjeman, n.d.: Victoria.

20 Todd published 'The Reputation of Henry Fuseli' in *Horizon* (December 1942) and also edited Richard and Samuel Redgrave's *A Century of British Painters*.

21 John Mortimer, *Murderers and Other Friends* (London: Penguin, 1994), 235–56.

22 Alastair McAlpine, *Once a Jolly Bagman: Memoirs* (London: Weidenfeld and Nicolson, 1997), 43.

23 MP, 'Osbert Lancaster', *The Spectator* (9 August 1986).

24 MP to John Betjeman, 6 November [1941]: V.

25 MP to John Betjeman, n.d.: Victoria.

26 Stuart Piggott to JP, 1 July 1941: JPT. Another letter from him to Peggy Piggott returns to this project: 'text by me & drawings by him, on British field archaeology by natural regions in which we could exploit a new angle and a new public by dealing not only with the thing on a sound archaeological basis but also stressing the importance of the field monuments as a part of the English scene and an important feature of the landscape. His extremely sympathetic renderings of the countryside and of the barrows and megaliths and stone circles and hill forts and what-not would I think give a new reality that photographs lack, and would also have the great merit of enticing a new public—the non-scientific literary and artistic world—into the domains of sound archaeology with nothing of the Massingham touch about it' (Letter dated 1 July, 1941, to Peggy Piggott: Oxford Institute of Archaeology). I am grateful to

Sam Smiles for drawing my attention to this letter.

27 Stuart Piggott, 'A Disciple of Leland', in G. Elborn (ed.), *To John Piper on his Eightieth Birthday* (London: Stourton Press, 1983), 33–4.

28 Ormerod and Jessica Greenwood, friends of the Pipers, recollected singing round the piano at Fawley a hymn by Cowper containing the lines 'Sometimes a light surprises | The Christian when he sings; | It is the Lord who rises | With healing in his wings' (Letter to J and MP, 26 March 1982: Tate Archives).

29 Oliver Simon, *Printer and Playground: An Autobiography of Oliver Simon* (London: Faber and Faber, 1966), 128–89.

30 Colin Anderson, unpublished memoirs. Courtesy of his daughter, Catriona Williams.

31 John Murray had offered to let the Pipers keep the Murray Guides if his own set, in London, survived the war. It did so and the Pipers' kept the Guides.

32 These were sent to Fawley Bottom Farmhouse on 19 February 1941 and were returned on the 17 September 1945.

33 Kenneth Clark, *Another Part of the Wood: A Self-Portrait* (London: John Murray, 1974), 255.

34 John Betjeman to Ninian Comper, n.d., quoted in Anthony Symondson and Stephen Bucknall, *Sir Ninian Comper: An Introduction to his Life and Work* (Reading: Spire Books and the Ecclesiological Society, 2006), 216.

35 JP, quoted in Richard Ingrams and John Piper, *Piper's Places: John Piper in England and Wales* (London: Chatto and Windus, 1983), 54.

36 In *Signature* 13 (January 1940).

37 Raymond Mortimer, *New Statesman* (9 March 1940).

38 Raymond Mortimer, *New Statesman* (28 March 1942). Mortimer was reviewing 'New Movements in Art: Contemporary Work in England' at Lancaster House, London, where so-called 'Neo-Romantic' art was exhibited alongside abstract art. By this date, critics had begun to find in the latter work an aridity and lack of contemporary relevance.

Chapter 13: War Artist

1 Kenneth Clark, writing about the WAAC in *Artists' International Bulletin* 68 (December 1941).

2 David Fraser Jenkins *John Piper. The Forties* (London: Philip Wilson Publishers/Imperial War Museum, 2000), 29.

3 Stuart Sillars, *British Romantic Art and the Second World War* (London: Macmillan, 1991), 34–5. Only two pictures in this series were completed, both now in the Imperial War Museum.

4 E. M. O'Rourke Dickey to JP, 11 October 1940: Imperial War Museum.

5 See Louise Campbell, *Coventry Cathedral: Art and Architecture in Post-war Britain* (Oxford: Clarendon Press, 1996), 8–9. Throughout this chapter I am indebted to this pioneering study.

6 *Birmingham Gazette* (16 November 1940). Quoted in Campbell, *Coventry Cathedral*, 9.

7 Quoted in R. T. Howard, *Ruined and Rebuilt: The Story of Coventry Cathedral 1939–1962* (Coventry: Council of Coventry Cathedral, 1962), 18.

8 Campbell, *Coventry Cathedral*, 10.

9 Kenneth Clark, *The Other Half: A Self-Portrait* (London: John Murray, 1977), 24.

10 See Peter Fuller, 'An English Romantic', *Independent Magazine* (10 December 1988).

11 Ibid.

12 Ibid.

13 Christopher Hussey, *The Picturesque* (1927; London: Frank Cass, 1983), 4.

14 John Piper 'The Architecture of Destruction', *Architectural Review* 14:535 (July 1941), 25.

15 There are two known studies for this painting, one in oil and one in watercolour (both private collections), but it seems that Piper relied to a greater than usual extent at Coventry on photography. Interviewed by Paul Joyce, JP recollected that at Coventry, had he been seen using a camera or sketchbook, he would have been lynched. He then claims: 'So I never even took a note in pencil and paper. But I had this Leica and pulled it out of my hip pocket, just like that. It was really being used for information, and it's about the only time I've done that. I didn't *want* to paint from photographs, but it was the only possible way of doing it then' (' "The Arbitrary Eye": A Photographic Discourse between John Piper and Paul Joyce', *British Journal of Photography* (25 November 1983), 1239–43). A typescript of this conversation, which took place in October 1982, is in the Tate Archives.

16 See Fraser Jenkins, *John Piper: The Forties*, 33. See also Christopher Woodward, who states, echoing Fraser Jenkins, 'through the tracery we see white light, as if the high altar is radiating spirituality', in his *In Ruins* (London: Chatto and Windus, 2001), 218.

17 Woodward, *In Ruins*, 218.

18 Stuart Sillars (*British Romantic Art and the Second World War*, 34–5) finds in Piper's paintings of bombed buildings 'an incongruity between the desolation of the subject matter and the simplicity of form and purity of texture'. He continues: 'The distortion wrought by the observing artist is not enough adequately to represent the desolation of the scenes; there seems to be an emotional mismatch between the two.'

19 Sillars is here quoting S. John Woods, *John Piper: Paintings, Drawings and Theatre Designs* (London: Faber and Faber, 1955), 13.

20 A phrase use by Hugh Casson in *Bombed Churches as War Memorials* (various authors) (Cheam, Surrey: Architectural Press, 1945), 22. This book was published in 1945 in an attempt to have certain bombed churches in the City of London preserved as war memorials.

21 Sillars, *British Romantic Art and the Second World War*, 32–3.

22 Campbell, *Coventry Cathedral*, 13.

23 Later, in 1987, this same picture was to be reproduced as a small woven silk picture to commemorate the Silver Jubilee of the new Cathedral's consecration, by the firm J. and J. Cash, famous for its name-tapes. *Interior of Coventry Cathedral* was reproduced in a limited edition of 500, one of which entered the Queen Mother's collection.

24 Louise Campbell, 'To Build a Cathedral', in *eidem* (ed.), *To Build a Cathedral: Coventry Cathedral, 1945–1962* (University of Warwick, 1987), p. xiv.

25 JP in conversation with R. Myerscough-Walker, in 'Modern Art Explained by Modern Artists', *The Artist* (May 1944).

26 Rigby Graham and Michael Felmingham, *Ruins* (London: Country Life Books, 1972), 25.

27 E. M. O'Rourke Dickey to JP, 22 July 1941: Imperial War Museum Archives.

28 Two are illustrated in colour in Fraser Jenkins, *John Piper: The Forties*, 76–7. A third was lost, with a consignment of works belonging to the Ministry of Information, en route to South Africa.

29 Stephen Spender, Introduction, *War Pictures by British Artists: Second Series: Air Raids* (Oxford: Oxford University Press, 1943), 7.

30 JP embarked on this painting but it is not known whether he finished it as it does not appear among the list of paintings in the possession of the WAAC at the end of the war.

31 'I have heard a lot of praise for your Coventry Cathedral,' wrote Cyril Connolly, adding 'I was christened there but do not remember much about it' (Connolly to JP, 22 January 1941: JPT).

32 JP to John Carter, 29 October 1941 and John Carter to Will Carter, 5 November 1941: I am grateful to the late Peter Jollife and Ulysses bookshop in Museum Street for letting me read these letters, while in their possession.

33 *Spectator* (19 April 1940).

34 *Horizon* 4:24 (December 1941), 415–16.

35 *Barn in Oxfordshire* and *Barn in Wiltshire*. Other examples of his paintings of ruined houses, deserted cottages, or derelict barns can be found in the National Museum of Wales; Ashmolean Museum, Oxford; and Bristol Museum and Art Gallery.

36 Lawrence Gowing to John [Betjeman?]: 29 November 1942: JPT.

37 Lawrence Gowing to JP, n.d. [1942]: JPT.

38 Quoted in Anne Uhlmann (ed.), *Ravilious at War: The Complete Work of Eric Ravilious, September 1939–September 1942* (Upper Denby: Fleece Press, 2002), 222.

Chapter 14: Stormy Weather

1 The architect is unknown.

2 Sir Jasper Ridley acquired the watercolour *Welsh Mountains* in 1941 and the oil *Llanthony Abbey* in 1942. His nephew, the 3rd Viscount Ridley, owns *Whispering Mountains*, a watercolour of a Welsh mountain lake painted in 1939.

3 John Rothenstein, *Brave Day Hideous Night: Autobiography, 1939–65* (London: Hamish Hamilton, 1966), 170.

4 Kenneth Clark to Queen Elizabeth, 18 March 1938, quoted in Susan Owens, 'Evocation or topography: John Piper's watercolours of Windsor Castle, 1941–44', *Burlington Magazine* 147:1230 (September 2005), 598.

5 See J. W. Wheeler-Bennett, *King George VI: His Life and Reign* (London: Macmillan, 1958), 469.

6 See Susan Owens, *Watercolours and Drawings from the Collection of Queen Elizabeth The Queen Mother* (London: Royal Collections Publications, 2005), 34.

7 Ken Walsh to JP, 24 July 1941: JPT.

8 Writing in 1938, Laurence Whistler said of Seaton Delaval: 'Few go to see it, though it faces a public way within a few miles of the Great North Road, and before long may not exist to be seen. For in spite of the care of its owners, disaster will overwhelm this ruin that is the crowning ornament of the English style, if steps are not shortly taken to save it. Wired to a column of the chipped and blackened garden front a notice-board proclaims: THIS PORTICO IS DANGEROUS' (*Sir John Vanbrugh: Architect and Dramatist 1664–1726* (London, 1938), 275).

9 Jasper Ridley to JP, 9 July 1941: JPT.

10 JP, 'Seaton Delaval', *Orion* 1 (1945), 43–7.

11 Rosamond Lehmann to JP, 25 September 1944: JPT.

12 JP, 'Seaton Delaval', 43–4.

13 In turn, his painting of Seaton Delaval, in the Tate collection, was used as the dust jacket for Francis Askham's *The Gay Delavals* (London: Hamish Hamilton, 1955).

14 JP, 'Seaton Delaval', 44.

15 Ibid. 47.

16 MP to John Betjeman, 5 August [1942]: Victoria.

17 Colin Anderson, memoirs: unpublished typescript, courtesy of Catriona Williams.

18 MP to Penelope Betjeman, 6 May[1941]: Victoria.

19 J. M. Richards to JP, 3 November [1942]: JPT.

20 The entire set of drawings and their captions are reproduced in *John Betjeman: Letters*: vol. I: *1926 to 1951* (London: Methuen, 1994), 542–51.

21 Kenneth Clark to Queen Elizabeth 9 August 1941: RA QEQM/PRIV/PIC.

22 Ibid. 15 August 1941.

23 JP to John Betjeman, 23 August 1941: Victoria; quoted in Owens, *Watercolours and Drawings from the Collection of Queen Elizabeth The Queen Mother*, where Owens points out that the implication that Sandby was commissioned by George III is incorrect. The Sandby watercolours were executed during George III's reign, but the Sandby collection at Windsor did not begin until the time of George IV.

24 Jane Roberts, *Views of Windsor: Watercolours by Thomas and Paul Sandby from the Collection of Her Majesty Queen Elizabeth II* (London: Merrell Holberton, 1995), 22.

25 JP to Eric Ravilious, n.d., quoted in *Ravilious at War: The Complete Work of Eric Ravilious, September 1939–September 1942*, ed. Anne Ullman (Upper Denby: Fleece Press, 2002), 182.

26 Owen Morshead to Queen Mary, 10 December 1941: RA QM/PRIV/CC48/994.

27 Owens, *Watercolours and Drawings from the Collection of Queen Elizabeth The Queen Mother*, 599.

28 Sir Arthur Penn to Kenneth Clark, 20 May 1942: RA QEQMH/TREAS/QEQMACC/BILLS/1942/215.

29 Sir Arthur Penn to Sir Ulick Alexander, Keeper of the Privy Purse and Treasurer to the King, 19 May 1942: RA QEQMH/TREAS/QEQMACC/BILLS/1942/215.

30 JP to John Betjeman, July 1942: Victoria. Quoted in Owens, *Watercolours and Drawings from the Collection of Queen Elizabeth The Queen Mother*, 604.

31 Owen Morshead to Queen Mary, 2 July 1942: RA QW/ORIV/CC48/1049.

32 Kenneth Clark to Queen Elizabeth, 26 December 1942: RA QEQM/PRIV/PAL.

33 JP to Kenneth Clark, 3 August 1943: Tate Archives, Clark Papers. Quotes in Owens, *Watercolours and Drawings from the Collection of Queen Elizabeth The Queen Mother*, 605.

34 Reported by Benedict Nicholson and recorded by James Lees-Milne in his dairy, 10 July 1945. See James Lees-Milne, *Prophesying Peace* (London: Faber and Faber, 1977), 211–12. JP himself recounted the reactions of the King and Queen to his pictures on this occasion on *Desert Island Discs* (BBC Radio 4, 16 December 1968) [radio interview].

35 Owens, *Watercolours and Drawings from the Collection of Queen Elizabeth The Queen Mother*, 602.

36 Owen Morshead to Queen Elizabeth, 31 July 1943: RA QEQM/PRIV/PIC.

Chapter 15: Renishaw and the Sitwells

1 JP to Osbert Sitwell, 17 April 1940: SR. This letter proves that Piper's memory was incorrect when, at a study day on the Sitwells at the Victoria & Albert Museum in the 1980s, he recollected thanking Osbert for his review and subsequently being invited to paint Renishaw.

2 Osbert Sitwell, 'The Work of John Piper': unpublished essay, typescript SR.

3 Osbert Sitwell, Introduction, *Left Hand, Right Hand! An Autobiography* (London: Macmillan, 1945), p. x.

4 He deplored the fate of those houses that became 'the sterilised, scionless property of the National Trust, so that they are like the faded organisms that, once alive, are now preserved in bottles' (Sitwell, 'The Work of John Piper').

5 JP to Osbert Sitwell, 1 August 1940: SR.

6 Edward Wadsworth to JP, 5 October 1942: JPT.

7 Helen Binyon to Peggy Angus, 6 May [1942]: East Sussex Record Office.

8 JP to John Betjeman, 15 May 1942: Victoria.

9 Ibid.

10 'If the rest of your book is up to the standard of the Gosse extract in *Horizon* it will be a wonderful book' (JP to Osbert Sitwell, 12 May 1942: SR).

11 Ibid. 20 June 1942.

12 Quoted in John Pearson, *Façades: Edith, Osbert and Sacheverell Sitwell* (London: Macmillan, 1978), 95.

13 JP, quoted ibid. 375.

14 JP, memories of Renishaw: MSS, courtesy of Suzannah Brooke.

15 Ibid.

16 JP, quoted in Victoria Glendinning, *Edith Sitwell: A Unicorn among Lions* (London: Weidenfeld and Nicolson, 1981), 219.

17 JP to Osbert Sitwell, 12 August 1942: SR.

18 Ibid.

19 JP, quoted in Pearson, *Façades*, 375.

20 Evelyn Waugh, *The Letters of Evelyn Waugh*, ed. Mark Amory (London: Weidenfeld and Nicolson, 1980), 163.

21 This is suggested by Richard Ingrams in *Piper's Places: John Piper in England and Wales* (London: Chatto and Windus, 1983), 98.

22 Glendinning states that they played Mozart, Bloch, Brahms, Haydn, and Britten when they visited Renishaw in October 1943. See *Edith Sitwell: A Unicorn among Lions*, 229. Piper's memory of hearing Bartok may suggest the Griller visited Renishaw on more than one occasion.

23 When Cecil Collins asked John to inform the Sitwells of his forthcoming exhibition at the Lefevre Galleries in London, Piper immediately agreed to do so, but warned Collins: 'they stick in Derbyshire a good deal, and in bed most of the time' (JP to Cecil Collins, 26 January 1944: TA 923.4.2.1397).

24 JP to Osbert Sitwell, 12 December 1943: SR.

25 Sitwell, 'The Work of John Piper'.

26 'I have had much enjoyment from your "Collected Poems" and shall continue to do so; and its graceful and informative foreword is a model for all' (JP to Osbert Sitwell, 21 November 1943: Sitwell Archive).

27 So he was informed by José Garcia Villa, the editor of *A Celebration for Edith Sitwell* (Norfolk, CT: New Directions, 1948).

28 Edith Sitwell to JP, 18 June 1943: JPT.

29 See Michael Raeburn (ed.), *Sacheverell Sitwell's England* (London: Orbis, 1986), 37.

30 Osbert Sitwell, *Left Hand, Right Hand!*, 105.

31 Ibid.

32 Mrs Campbell Swinton, in *Two Generations*, ed. Osbert Sitwell (London: Macmillan, 1940), 9.

33 Raeburn (ed.), *Sacheverell Sitwell's England*, 39.

34 Sketchbook with 'travel diary': JPT.

35 JP to Osbert Sitwell, n.d. [1943]: SR.

36 Christopher Hussey, reviewing the Leicester Galleries exhibition in which Piper first showed his Renishaw paintings, in *Country Life* (26 January 1945), 153.

37 Nine Pipers serve as illustrations in *Left Hand, Right Hand!*, the first volume of Osbert Sitwell's biography, 15 in the second, 8 in the third, 12 in the fourth, and 6 in the last volume.

38 *Evening News* (6 January 1944).

39 Osbert Sitwell, Preface, *The Sitwell Country* (Derby Museum and Art Gallery, 1945), exhibition catalogue.

40 JP to Osbert Sitwell, n.d. [1945]: SR.

41 A letter from Osbert Sitwell to JP (16 March 1950) suggests that Sitwell approached Duckworth's with the idea for a book on Piper and Renishaw. 'I've no news. The Sitwell Piper Piper Sitwell book has faded out in any case, as Mervyn [Horder] "fears the expense" ' (JPT).

42 Sitwell, Preface, *The Sitwell Country*.

43 Edith Sitwell to JP, nd [1945]: JPT.

44 Christopher Hussey, 'The Twilight of the Great House', *Country Life* (26 January 1945).

45 Cecil Stephenson to JP, 23 January 1945: JPT.

Chapter 16: Topographical Mania

1 John Russell, in a *Guardian* obituary of John Piper, gives the date 1943, but his letters to JP in the Tate Archives show that his acquaintance with Piper dated from the year before.

2 JP to John Russell, n.d.: courtesy of Lavinia Grimshaw.

3 John Russell to JP, 29 May 1942: JPT.

4 Ibid. 20 February 1943.

5 MP to John Russell, 8 August [1943?]: courtesy of Lavinia Grimshaw.

6 John Russell to JP, 12 March 1951: JPT.

7 John Russell, *Guardian* (30 June 1992): JPT.

8 John Russell, *From Sickert to 1948: The Achievement of the Contemporary Art Society* (London: Lund Humphries, 1948), 77.

9 Russell, *Guardian* (30 June 1992).

10 Quoted in Michael De-la-Noy, *The Life of Edward Sackville-West* (London: Bodley Head, 1988), 196.

11 John Betjeman to Osbert Sitwell, n.d.: SR.

12 Edith Sitwell to JP, 12 January 1944: JPT.

13 Edith Sitwell to MP, 10 December 1943: JPT.

14 Ibid. 11 October 1944.

15 Edith Sitwell to J and MP, n.d. [*c.*1944]: JPT.

16 MP (ed.), *Sea Poems* (London: Frederick Muller, 1944), p. v. This book (and Osbert Sitwell's *Left Hand, Right Hand!*) was chosen as among the 59, out of 562 books submitted, for the National Book League's annual exhibition of Book Design in 1946.

17 JP to John Betjeman, 5 November 1942. Quoted *John Betjeman: Letters*: vol. I: *1926 to 1951*, ed. Candida Lycett Green (London: Methuen, 1994), 309–10.

18 JP to Sheila Shannon, 15 July 1944: Stephen Alexander.

19 John Betjeman to JP, *John Betjeman: Letters*, 309.

20 Edward Hodnett, *Five Centuries of English Book Illustration* (Aldershot: Scolar Press, 1988), 276.

21 *The Studio* (December 1944), 192.

22 JP. 'Colour Reproduction and the Cheap Book', *Listener* (22 July 1943).

23 JP, 'Notes from a Yorkshire Journal', *Geographical Magazine*, 15:8 (December 1942), 364–7.

24 Ibid. 364.

25 JP to John Betjeman, [25 August 1943]: Victoria.

26 JP to Osbert Sitwell, n.d. [1943]: SR.

27 JP, 'Place Diary, 1943': unpublished notebook, JPT.

28 Russell, *Guardian* (30 June 1992).

29 JP notes in sketchbook, JPT.

30 JP to Osbert Sitwell, n.d. [1943]: SR.

31 Quoted in Julie Kavanagh, *Secret Muses: The Life of Frederick Ashton* (London: Faber and Faber, 1996), 289.

32 David Vaughan, quoted in Kavanagh, *Secret Muses*, 290.

33 Ibid. 291.

34 Alexander Bland, *The Royal Ballet: The First Fifty Years* (London: Threshold Books, 1981), 71.

35 JP, '*The Quest*: Notes on the Décor', unpublished typescript: JPT.

36 David Fraser Jenkins notes that Piper's backdrop for the final scene of *The Quest*, showing the lake at sunset, was adapted from Inigo Jones' set for Sir William D'Avenant's *Britannia Triumphans*. See Fraser Jenkins, *John Piper: The Forties* (London: Philip Wilson/Imperial War Museum, 2000), 38.

37 Anthony Cowper, 'John Piper', *Dance and Dancers* (February 1952), 8.

38 Kavanagh, *Secret Muses*, 291.

39 JP to Cecil Collins, 12 June 1943: TGA: 923.4.2.1295.

40 JP to Osbert Sitwell, 30 June 1943: SR.

41 JP to MP, 17 June [1943]: TGA. He also writes: 'Stephen has given me all his new poems to read (about 200) by lunchtime. … He and Natasha should be a very successful married couple, because Stephen takes the lead in gigglishness and girlishness, and she comes a good second.'

42 JP to MP, n.d. [1943]: JPT.

Chapter 17: Sly Liasons

1 MP, *The Listener* (18 April 1940).

2 *Letters of Frances Hodgkins*, ed. Linda Gill (Auckland: Auckland University Press, 1993), 504.

3 Quoted in Carol Peaker, *The Penguin Modern Painters History* (Penguin Collectors' Society, 2001), 10.

4 JP to John Betjeman, 1 September 1942: Victoria.

5 MP to John Betjeman, 8 August [1942]: Victoria.

6 *Letters of Frances Hodgkins*, 533.

7 Bryan Robertson, in conversation with the author.

8 Myfanwy Evans, *Frances Hodgkins* (London: Penguin Books, 1948), 10.

9 Ibid. 15–16.

10 Ibid. 18.

11 JP to John Betjeman, n.d. [*c*.1942–3]: Victoria.

12 I am grateful to Bloomsbury Book Auctions for granting me access to MP's letters to Kenneth Clark while in their care and from which all the following quotations, unless otherwise indicated, are taken. Most of her letters are undated which leaves an uncertainty as to the exact time span in which their intimacy flourished.

13 JP to John Betjeman, 7 October 1942: Victoria.

14 Ibid. 5 November 1942.

15 Ibid. 31 November 1942.

16 Eric Crozier is quoted in *Letters from a Life: The Selected Letters of Benjamin Britten 1913–1976*: vol. III: *1946–1951* (London: Faber and Faber, 2004), 366.

17 Eric Crozier to Nancy Evans, [?] December 1946: typescript copy, in possession of the artist Mark Rowan-Hull.

18 JP to Colin Anderson, 22 May 1944: courtesy of Catriona Williams.

19 JP to Osbert Sitwell, 17 September 1944: SR.

20 Ben Nicholson to Margaret Gardiner, see Sarah Jane Checkland, *Ben Nicholson: The Vicious Circles of His Art and Life* (London: John Murray), 227.

Chapter 18: Stern Watching, Mysterious Sympathy

1 JP to John Betjeman, 16 February 1940: Victoria.

2 Quoted in *John Betjeman: Letters*, vol. 1: *1926 to 1951*, ed. Candida Lycett Green (London: John Murray, 1994), 351.

3 Recollected by John Doyle, in conversation with the author, 16 January 2007.

4 JP to Moelwyn Merchant, 1 June 1946: Eton College Library.

5 Ibid. 30 October 1944.

6 JP to Basil Creighton, 21 November 1946: TGA 989.22.

7 Mervyn Horder quoted in Richard Ingrams and John Piper, *Piper's Places: John Piper in England and Wales* (London: Chatto and Windus, 1983), 15.

8 An abridged edition, selected and introduced by William Plomer.

9 He did, however, take responsibility for a book on the English farmhouse, written by Geoffrey Grigson in 1948.

10 JP, reviewing 'The Greater English Church' by Harry Batsford and Charles Fry, *The Spectator* (17 May 1940).

11 Ibid.

12 JP, Preface, *The Artist and the Church*, Council for the Encouragement of Music and the Arts catalogue (1943).

13 Peggy Angus to JP, n.d. [June 1942]: JPT.

14 'I have a lot of fun to tell you about arranging an exhibition called "The

Artist and the Church", about Sir Eric Maclagan, and about Mr Piper's whimsical enthusiasms' (JP to Osbert Sitwell, 4 May 1943: SR).

15 Ninian Comper, *Of the Atmosphere of a Church* (London: SPCK, 1947), 9–10. This pamphlet is reprinted in Anthony Symondson and Stephen Bucknall, *Sir Ninian Comper: An Introduction to His Life and Work* (Reading: Spire Books and the Ecclesiological Society, 2006), 231–46.

16 Ninian Comper to John Betjeman, 14 January 1941: JPT.

17 JP to Osbert Sitwell, 4 June 1943: SR.

18 JP, quoting Comper, in lecture notes on 'Churches of Oxfordshire': JPT.

19 JP to Osbert Sitwell, n.d. [November 1946]: SR.

20 Quoted in *Peter Fuller's Modern Painters: Reflections on British Art*, intro. John McDonald (London: Methuen, 1993), 257.

21 'I can't too highly recommend Ruskin's autobiography Praeterita, about his childhood at Denmark Hill' (JP to John Betjeman, 7 October 1942: Victoria).

22 John Ruskin, *The Seven Lamps of Architecture*, sect. 6, para.10, Aphorism 29. Similar sentiments can be found in Lucy Elisabeth Beedham's *Ruined and Deserted Churches* (1908), from which Piper quotes in 'Pleasing Decay': 'The new building is soulless until the "cry of the human", " the communing of man, the murmur of the passions," had been heard within and around it; it is void and nude until Time which makes History has clothed it with fact and fancy as with a garment, until life has crowned and death has consecrated it" ' (quoted in JP, *Buildings and Prospects* (London: Architectural Press, 1948), 98).

23 JP acknowledges Pevsner as the source of this information in a note at the end of

his essay. See 'The Gratuitous Semicircle', *Architectural Review* 94 (July 1943), 22.

24 JP, 'The Gratuitous Semicircle', *Architectural Review* 94 (October 1943), 112, 113.

25 *Architectural Review* 97 (May 1945), 130.

26 See JP, 'Colour in the Picturesque Village', *Architectural Review* 97 (May 1945), 149–50.

27 JP, *Architectural Review* 96 (November 1944), 149–51.

28 JP, ' Topographical letter from Devizes', *Cornhill Magazine* 161:961 (1944), 9–18.

29 JP. *Architectural Review* 95 (February 1944), 51–2.

30 de Cronin Hastings to JP, 14 March 1944: JPT. The absence of any manuscript or set of proofs makes it impossible to know whether Piper altered his article in response to Hastings' letter. Another instance of a disagreement with Hastings can be found in a letter Piper wrote to John Betjeman: 'I have frightened them [the *Architectural Review*] about box pews, but de Cronin is bald-headedly insisting that churches must be illustrated heavily in an unrestored condition now, so that Dioc. Advisories do not re-point and re-plaster everything immediately after the war. Is he right?' (JP to John Betjeman, fragment of a letter, n.d.: Victoria).

31 JP, *Buildings and Prospects*, 90.

32 JP, 'Colour in Building: Colour and Texture', *Architectural Review* (February 1944), 51.

33 Ibid. 52.

34 JP, *Buildings and Propsects*, 89.

35 Quoted ibid. 100.

36 Ibid. 95–6.

37 *The Listener* (8 June 1944).

38 JP to Jock Murray, 14 October 1943: John Murray Archives.

39 JP, 'Topographical Letter from Norwich', *Cornhill Magazine* 161:961 (1944).

40 The issue contained a lengthy article on William Beckford, who built Fonthill Abbey, by H. A. N. Brockman, who went on to publish a full-length study of Beckford. He asked Piper if he could re-use the June 1944 cover design for his dust jacket.

41 JP to Colin Anderson, 22 May 1944: courtesy of Catriona Williams.

42 JP, 'Camille Pissarro', *The Listener* (17 August 1944).

43 Osbert Sitwell to JP, n.d.: JPT.

44 Geoffrey Grigson, in *Gen. The Services Fortnightly* 59 (20 May 1944), wrote: 'A Bond Street dealer waved a hand the other day at someone who asked for a Piper drawing: "My dear Sir, I've a positive queue for Piper drawings all the way from here down to the Ritz." '

45 JP, 'Introduction to Middlesbrough', *Cornhill Magazine* 161:966 (December 1945), 430–3.

46 Patrick Horsbrugh, then stationed at Middlesbrough with the RAF, recollected Piper visiting the town on more than one occasion and bringing with him, not paints, but a camera which he used, not for any scene, but for details. Horsbrugh shared Piper's fascination with the slag tips (Letter from Horsbrugh to the author, 13 May 2002).

47 JP, 'Introduction to Middlesbrough', 432.

48 Ibid. 432–3.

49 JP to Osbert Sitwell, 8 March 1944: SR.

Chapter 19: Return to Peace

1 The fennel recipe, invented by Myfanwy after eating this dish in an Italian restaurant, is included in *The Artist's Cookbook: Colourful Recipes from the Studios of the Royal College of Art in its*

150th Anniversary Year, intro. Henry Moore (London: Lion and Unicorn Press, 1987), unpaginated.

2 John Murray to JP, 12 September 1950 (postscript to MP): JPT.

3 'The usual disorder of my life has become mildly accentuated by the fact that Edward and Clarissa have had whooping cough' (MP to John Russell, 8 August [1943?]: courtesy of Lavinia Grimshaw).

4 JP to Basil Creighton, 21 November 1946: TGA 989.22, Tate Archives.

5 The cause of this new acquisition is said to have been Myfanwy's frustration at not being able to hear *The Turn of the Screw* whenever she wished.

6 *Penrose Annual* editor to JP, 4 February 1948: JPT.

7 John Russell, *The Sunday Times*, 19 January 1947.

8 F. A. Ironmonger to JP, 12 April 1945: JPT.

9 It is unclear whether Piper did more than one design. The initial one, the Dean told Piper, did not please the weaver: 'he was quite sure that no-one in Bradford could weave that particular pattern in *any* material' (F. A. Ironmonger (Dean) to JP, n.d. [April 1946]: JPT).

10 JP to Moelwyn Merchant, 29 February 1958: Eton College Library.

11 MP to Osbert Sitwell, 3 February 1946: SR.

12 Ibid.

13 *Burlington Magazine* 89 (October 1947), 285.

14 See JP, 'The English Tradition of Draughtsmanship', *The Listener* (8 February 1945).

15 Myfanwy Evans (ed.), *The Pavilion: A Contemporary Collection of British Art and Architecture* (London: I.T. Publications, 1946), 2.

16 Robin Ironside, *Painting since 1939* (London: Longmans, Green, for the British Council), 27.

17 *New York Times* (22 October 1950).

18 Kenneth Clark, Introduction, 'British Art: The Last Fifty Years 1900–1950', The English-Speaking Union of the United States(1950).

19 JP to John Rothenstein, 5 November 1950: TGA 8726.3.11, Tate Archives.

20 See David Fraser Jenkins, 'John Piper and Subjects in Wales', *Transactions of the Honourable Society of Cymmrodion* (1984).

21 JP to Osbert Sitwell, 19 August 1945: SR.

22 Evans lived at Bodesi Farm, Capel Curig, near Bettws y Coed, the address to which Piper moved when he gave up Pentre.

23 JP to Osbert Sitwell, 19 August 1945: SR.

24 Ibid. 14 November 1945.

25 MP to John and Alexandrine Russell, 14 November [1945]: courtesy of Lavinia Grimshaw.

26 JP to S. J. Woods, 8 November 1945: courtesy of Nancy Woods.

27 JP to Robert Simon, 19 November 1945: Morison Papers, XXVIII.236, Cambridge University Library.

28 JP to Paul Nash, 20 November 1945: TGA 70.50/1078, TA.

29 MP to John Russell, 20 January [1946]: courtesy of Lavinia Grimshaw.

30 JP to Moelwyn Merchant, 5 May 1949: Eton College Library.

31 JP describes it thus in *The Mountains*, introduction by R. S. Thomas, with illustrations by JP and wood-engravings by Reynolds Stone (New York: Chilmark Press, 1968).

32 Edward Pugh, *Cambria Depicta* (London, 1816), p. iv.

33 JP comments on Pennant in 'Picturesque Travel: Illustrated', *Signature* 11 (1950), 4–6.

34 JP, *The Mountains.* 8–9.

35 Quoted Anthony West, *John Piper* (London: Secker and Warburg, 1979), 128.

Chapter 20: Working for the Stage and with Britten

1 JP, 'Designing for Britten', in *The Operas of Benjamin Britten*, ed. David Herbert (London: Herbert Press, 1979), 5.

2 JP, in Noel Barber, *Conversations with Painters* (London: Collins, 1964), 59–60.

3 JP to Colin Anderson, 22 May 1944: courtesy of Catriona Williams.

4 JP to Osbert Sitwell, 19 August 1945: SR.

5 Osbert Sitwell to MP, n.d. [1945] : JPT.

6 The only evidence for this is found in a letter from Moran Caplat to JP (9 July 1950: Glyndebourne Archives): 'we are hoping to do a new "Don Giovanni" at Glyndebourne in June 1951 and ... we would naturally hope to resurrect the original idea born, I believe, in 1939, of asking you to design it.'

7 JP to Rudolf Bing, 30 January 1946: Glyndebourne Archives.

8 JP, in *Folio: John Piper at Aldeburgh* (Anglia TV, 27 October 1983).

9 *Letters from a Life: The Selected Letters and Diaries of Benjamin Britten 1913–1976*, vol. I: *1923–1939*, ed. Donald Mitchell, asst. Philip Reed (London: Faber and Faber, 1991), 453.

10 *Observer* (27 October 1946).

11 See Humphrey Carpenter, *Benjamin Britten* (London: Faber and Faber, 1992), 228.

12 JP recollected this altercation in *Folio: John Piper at Aldeburgh.*

13 Benjamin Britten to JP, 25 April 1946: BPL.

14 Claire Seymour, *The Operas of Benjamin Britten* (Woodbridge: Boydell Press, 2004), 86.

15 Claire Seymour, for instance, refers to 'the imposition of an anachronistic, and morally inappropriate, Christian frame', while also acknowledging that Duncan incorporated these passages at Britten's request and that some of the lines were written by the composer himself (ibid. 77).

16 Ibid. 72.

17 *The Sunday Times* (28 July 1946).

18 *Observer* (14 July 1946).

19 *The Times* (13 July 1946).

20 *Manchester Guardian* (15 July 1946).

21 *New Statesman and Nation* (20 July 1946).

22 See Moran Caplat, *Dinghies to Divas* (London: Collins, 1985), 144.

23 Recollected by Peggy Angus in a letter to MP, n.d. [June 1992]: JPT. (By this date she was aged 88, proud of her children and very happy to be alive.)

24 JP to James Laver, 7 February 1947: Victoria & Albert Museum Archives, JP personal file.

25 Ibid. 22 June 1947.

26 JP to Rudolf Bing, 9 August 1946: Glyndebourne Archives.

27 Ibid. n.d. [late August 1946].

28 The 1946 Glyndebourne Programme promised for the next season a 'new contemporary opera'.

29 As Humphrey Carpenter describes him: *Benjamin Britten*, 236.

30 Carl Ebert to Rudolf Bing, 11 October 1946: Glyndebourne Archives.

31 Alan Blyth, *Remembering Britten* (London: Hutchinson, 1981), 30.

32 Ibid.

33 JP to John Moody, 21 September 1946: Burra-Moody Archive. This and 8 other

Piper letters sold at Bloomsbury Auctions, 24 May 2007.

34 Eric Crozier, in *An Opera is Planned* (BBC Third Prgramme, 19 June 1947): transcript, BPL.

35 JP to Eric Crozier, 19 January 1947: handwritten and typescript copies, BPL.

36 Quoted by JP, 'The Design of Lucretia', in *The Rape of Lucretia* (London: Bodley Head, 1948), 68.

37 Norman Scarfe, notes to 'Albert Herring' in *Britten's Corner of England* Calendar, '89 (Aldeburgh Foundation in association with Jarrold and Sons, 1989).

38 *The Spectator* (27 June 1947).

39 *New Statesman and Nation* (28 June 1947).

40 The picture still hangs at the Red House, the house at Aldeburgh which he shared with Peter Pears and which is now in the care of the Britten–Pears Trust.

41 JP in 'Piper at Sixty', *The Sunday Times* (22 March 1964).

42 *English Opera Group 1948*, leaflet in the possession of the BPL.

43 JP to E. Crozier, n.d. [early 1948]: transcript made by Crozier in BPL.

44 Ibid. n.d. [July 1948]: transcript made by Crozier in BPL.

45 Ibid. 26 June 1949: handwritten and typescript copies, BPL.

Chapter 21: 'A firm shape among shadows'

1 JP to John Russell, 19 December 1947: courtesy of Lavinia Grimshaw.

2 David Piper, in *To John Piper on his Eightieth Birthday*, ed. Geoffrey Elborn (London: Stourton Press, 1983), 62.

3 MP, in 'Letter from Myfanwy Piper to Leslie Waddington, December 1993', in *John Piper: A Retrospective*, catalogue to an exhibition at Waddington Galleries, London, 1994.

4 JP to Eric Crozier, 28 October 1948: transcript by Crozier, BPL.

5 JP, Memoir on the Sitwells: MS, courtesy of Suzannah Brook.

6 JP to MP, 15 October [1947]: courtesy of Clarissa Lewis.

7 JP knew well the work of this architect who had been the Oxford Diocesan architect during Wilberforce's episcopate.

8 JP to John Russell, 19 June 1948: courtesy of Lavinia Grimshaw.

9 This publisher also invited JP to do a book on Baroque architecture and he agreed, though nothing came of this.

10 MP, *Reynolds Stone* (London: Art and Technics, 1951), 19.

11 Ibid. 24–5. She also quotes Ruskin as saying: 'the finest woodcutting ignores light and shade and expresses only form and *dark local colour.*'

12 Ibid. 30.

13 MP to John (Jock) Murray, n.d. [*c.*1947–8]: John Murray Archives.

14 John Betjeman to MP, 1 March 1948: JPT.

15 JP to Jock Murray, n.d.: John Murray Archives.

16 *Buckinghamshire* appeared first (1948), followed by *Berkshire* (1949). Both were written by Betjeman and Piper. The third, *Lancashire,* by Peter Fleetwood-Hesketh, did not appear till 1955.

17 His outburst against the notion that they should be solely concerned with architecture can be found in a letter to John Betjeman: 'No ferns on Cornish walls? No view at all of Stuart Piggott, or the Bath Road crossing Salisbury Plain, or the Uffington White Horse? ... I suggested for each county 100 photos of Coolmore [John Summerson, ie, respectable architecture], including details of tombs,

glass, etc, and 50 of everything else … What think you? I could hardly bear it that Gordale Scar should find no place in the Vol. on the West Riding, nor the Military Canal at Appledore in the vol. on Kent' (JP to John Betjeman, n.d. [*c*.1946]: Victoria).

18 John Murray to John Betjeman, 22 December 1947: John Murray Archives; quoted Bevis Hillier, *John Betjeman: New Fame, New Love* (London: John Murray, 2002), 396.

19 See Timothy Mowl, *Stylistic Cold Wars: Betjeman versus Piper* (London: John Murray, 2000), 100.

20 JP to John Murray, 19 August 1945: John Murray Archives.

21 And the subject of an oil painting by JP, now in the Usher Art Gallery, Lincoln.

22 Quoted in Mowl, *Stylistic Cold Wars*, 118.

23 *Murray's Berkshire Architectural Guide* (London: John Murray, 1949), 138.

24 Ibid. p. x.

25 Ibid. 152.

26 Ibid. 153.

27 In the possession of Endellion Lycett-Green. A reference in this notebook to another suggests that it may have been one of several.

28 JP to John Murray, 18 September 1948: John Murray Archives.

29 *The Sunday Times* (7 August 1949).

30 Mowl, *Stylistic Cold Wars,* 117.

31 See ibid. 126.

32 Quoted ibid. 137.

33 JP, *Romney Marsh* (London: Penguin, 1950), 32.

34 Ibid. 14.

35 *Murray's Berkshire Architectural Guide*, 129.

36 Ibid. 143.

37 The making of this book is described by JP in his introduction to Henry Thorold's

Collins Guide to Cathedrals, Abbeys and Priories of England and Wales (1986).

38 In 1960, Merchant attained the Chair of English at the University of Exeter, but he chose to end his career as vicar of Llanddewi Brefi in Dyfed (also Honorary Fellow of the University College of Wales at Aberystwyth). As both cleric and academic, he frequently collaborated with artists and composers, writing several libretti for Alun Hoddinott, who dedicated to him his fifth symphony.

39 Moelwyn Merchant, *Fragments of a Life* (Llandysul, Dyfed: Gomer Press, 1990), 58.

40 Moelwyn Merchant, Introduction, *Romantic Places*, catalogue to a Marlborough Gallery exhibition, 1983.

41 Merchants, *Fragments of a Life*. 59.

42 Geoffrey Grigson, 'Authentic and False in the New "Romanticism" ', *Horizon* (March 1948), 206.

43 *Britain Today* 154 (February 1949), 40.

44 Draft letter from JP to L. N. Hilsby, Private Secretary, 15 May 1949: JPT.

45 Writing to Osbert Sitwell in April 1952, he himself sounded a note of uncertainty about his recent work: 'So much Festival and Stage occupied my life last year that when I began to paint again I looked at Old Masters, with extraordinary results, probably disastrous results' (SR).

46 As reported in *Time* (USA), 1 December 1952.

47 S. J. Woods, *John Piper: Paintings, Drawings and Theatre Designs 1932–1954* (London: Faber and Faber, 1955), 13.

48 John Russell, *The Sunday Times*, 2 November 1952.

49 *Evening News*, 29 November 1949.

50 The panels forming this mural still survive, but are currently in store. They belong to the Harlow Arts Trust. For

a period, the mural hung in Harlow Technical College's main assembly room.

51 See Virginia Liberatore, 'Restoration of The Festival of Britain Pleasure Gardens, Battersea Park', *London Gardener* (2002), 79, to which I am indebted for information on the site and its buildings.

52 Mary Banham and Bevis Hillier (eds), *A Tonic to the Nation: The Festival of Britain 1951* (London: Thames and Hudson, 1976), 123.

53 MP, 'Portrait of a Choreographer', *Tempo* (Summer 1954), 17.

Chapter 22: Cranko and Britten

1 MP, 'Portrait of a Choreographer', *Tempo* (Summer 1954), 14–23.

2 Ibid. 15. Her remarks are also quoted in John Percival, *Theatre in My Blood: A Biography of John Cranko* (London: Herbert Press, 1983), 71–2.

3 JP to Moelwyn Merchant, 26 July 1950: Eton College Library.

4 JP to Osbert Sitwell, 22 February 1950: SR.

5 Recollected by Joy Mills, in conversation with the author.

6 Ibid.

7 Anthony Cowper, 'John Piper', *Dance and Dancers* (December 1952), 8.

8 Cranko is shown wearing this sweater in a profile on him in *The Ambassador* 10 (1953), 92.

9 JP to Moran Caplat, 17 September 1950: Glyndebourne Archives.

10 *Don Giovanni* involved JP in a ten-day stay at Glyndebourne, leading up to the premiere on 11 July 1951. The estimated number of performances with JP's sets is supplied by Moran Caplat in *Dinghies to Divas* (London: Collins, 1985), 167.

11 JP, in the Glyndebourne Festival Programme, 1956.

12 JP to Moelwyn Merchant, 26 June 1951: Eton College Library.

13 Sekers, who had enjoyed performances at Glyndebourne, had written offering to provide all the fabrics for a new production. Moran Caplat had put him in touch with Piper and most of the costumes for *Don Giovanni* were made out of material he provided, specially woven and dyed.

14 *The Sunday Times*, 15 July 1951.

15 *Manchester Guardian,* 13 July 1951.

16 *The Times,* 12 July 1951.

17 It may have been on this occasion that he painted a view of the city from the kitchen of 48 Great King Street, Stuart Piggott's flat.

18 Benjamin Britten to JP, 8 October 1949: BPL.

19 For instance, JP did cover designs for the sheet music for all Britten's *Canticles*. He also did cover designs for record sleeves, the first being for Argo Record Co. Ltd, again in connection with Britten's *Canticles*.

20 JP to Benjamin Britten, 26 November 1950: GB-AL63-9400874, BPL.

21 In order to afford this, they sold a Turner watercolour, as Peter Pears told JP in an undated letter: JP PT.

22 JP, as recorded in reported speech, in Alan Blyth, *Remembering Britten* (London: Hutchinson, 1981), 31.

23 *Letter from a Life: The Selected Letters of Benjamin Britten 1913–1976*, ed. Donald Mitchell, Philip Reed, and Mervyn Cooke (London: Faber and Faber, 2004), 611.

24 Crozier was not only an artistic director but had also become Director of the Festival. He resigned in March 1950 when his proposals for reorganization were rejected by the Festival Finance Committee. Financial difficulties also made it necessary for him to look for a

larger salary than the Aldeburgh Festival could afford and in 1951 he had accepted a job as part-time artistic director of Bournemouth's contribution to the Festival of Britain.

25 *Tempo* (Autumn 1951), 21–5.

26 JP, 'Designing for Britten', in David Herbert (ed.), *The Operas of Benjamin Britten* (London: Herbert Press, 1979), 6.

27 From a BBC transcript in the Forster Papers, King's College, Cambridge. Quoted in Mervyn Cooke and Philip Reed, *Benjamin Britten: 'Billy Budd'* (Cambridge: Cambridge University Press, 1993), 29.

28 Claire Seymour, *The Operas of Benjamin Britten. Expression and Evasion* (Woodbridge: Boydell Press, 2004), 138.

29 Christabel Aberconway to John Piper, 4 December 1951: Tate Archives.

30 JP to Moelwyn Merchant, 4 December 1951: Eton College Library.

31 Jennifer Barnes states that, in Coleman's recollection, he and JP went to Portsmouth to inspect HMS *Victory* prior to this 1964 production, but, if so, this would have been their second visit. See Jennifer Barnes, *Television Opera: The Fall of Opera Commissioned for Television* (Woodbridge: Boydell Press, 2003), 54.

32 In fact JP's gross earnings for the year ending 5 April 1951 amounted to £5,269 9s 9p, but £1,250 of this had to be paid to Osbert Lancaster as his share of the proceeds from work on the Festival Gardens at Battersea Park. His expenses amounted to £1,843 13s7d, which included £104 paid to Myfanwy as a salary as his assistant. His net earnings amounted to £2,175 16s 2d.

33 JP, quoted in Michael Northen, *Northen Lights: A Life behind the Scenes* (Chichester: Summerdale, 1997), 136.

34 As Percival describes in *Theatre in My Blood*, 90–1.

35 Ibid. 91.

36 'Portrait of a Choreographer', *Tempo* (Summer 1954), 18. Also quoted in Percival, *Theatre in My Blood*, 91–2.

37 JP to Osbert Sitwell, 29 August 1952: SR.

38 John Gorst to JP, 1 February 1989: JPT.

39 Percival, *Theatre in My Blood*, 95.

40 Peter Alexander, *William Plomer* (Oxford: Oxford University Press, 1990), 272.

41 Philip Brett, *Music and Sexuality in Britten* (Berkeley: University of California Press, 2006), 211.

42 Quoted, Humphrey Carpenter, *W. H. Auden: A Biography* (London: George Allen and Unwin, 1981), 375.

43 *Observer*, 14 June 1953.

44 Benjamin Britten to JP, 3 April 1953: JP Paperrs, Tate Archives.

45 The following year, in November 1954, Northen was also made an Artistic Director of the EOG.

46 Lord Harewood, *The Tongs and the Bones* (London: Weidenfeld and Nicolson, 1981), 138.

47 See Robert Hewison, ' "Happy were He": Benjamin Britten and the *Gloriana* Story', in *Britten's* Gloriana*: Essays and Sources* (Woodbridge: Boydell Press, in association with the BPL, 1993), 15.

Chapter 23: *The Turn of the Screw*

1 E. M. Forster, in *The Griffin* (1951), i.6.

2 Benjamin Britten to MP, 11 May 1952: JPT.

3 Patricia Howard, 'Myfanwy Piper's "The Turn of the Screw": Libretto and Synopsis', in *eidem* (ed.), *Benjamin Britten: The Turn of the Screw* (Cambridge: Cambridge University Press, 1985), 23.

4 Benjamin Britten, in Eric Crozier (ed.), *Benjamin Britten: Peter Grimes*, Sadler's Wells Opera Book 3 (London: Bodley Head, 1945), 8.

5 *The English Opera Group*, publicity leaflet printed in connection with the 1951 season: BPL.

6 W. II. Auden, quoted in Humphrey Carpenter, *Benjamin Britten: A Biography* (London: Faber and Faber, 1992), 67.

7 Eric Crozier, in *The Rape of Lucretia* (London: Bodley Head, 1948), 59.

8 Ronald Duncan, ibid. 61.

9 Benjamin Britten, 'Foreword', ibid. 7–8.

10 From *The Notebooks of Henry James*, ed. F. O. Matthiesen and Kenneth B. Murdoch (1947), quoted in *Benjamin Britten: The Turn of the Screw* Cambridge: Cambridge University Press, 1985), 2.

11 I am grateful to Colm Toibin's article, 'Pure Evil', *Guardian*, 3 June 2006 for drawing my attention to this detail.

12 1 June 1932. *Letters for a Life: The Selected Letters and Diaries of Benjamin Britten*, 4 vols, ed. Donald Mitchell and Philip Reed (London: Faber and Faber, 1991), i.254.

13 MP, quoted in Carpenter, *Benjamin Britten*, 337.

14 'Ben was *deeply* hurt, he was *terribly* upset', Myfanwy later told Humphrey Carpenter. Quoted ibid. 349.

15 MP, quoted ibid. 354.

16 Ibid. 332.

17 Benjamin Britten to MP, 18 December [1952]: JPT.

18 Benjamin Britten, in Murray Schafer, *British Composers in Interviews* (London: Faber and Faber, 1963), 118.

19 MP, quoted Carpenter, *Benjamin Britten*, 332.

20 MP Notebook, Tate Archives.

21 MP, 'Writing for Britten', in David Herbert (ed.), *The Operas of Benjamin Britten* (London: Herbert Press, 1979), 8.

22 Ibid.

23 Benjamin Britten to MP, 30 March 1954: BPL.

24 MP, 'Writing for Britten', 9. Many instances of this could here be given, but one is the help Britten was given by the percussionist James Blades who suggested that the palpitating of the Governess's heart could by conveyed on timpani. Britten had first met Blades when working for the GPO Film Unit and he welcomed his advice for percussion effects in his church parables. Blades was to become Professor of Timpani and Percussion at the Royal Academy of Music in 1972 and fostered the career of Evelyn Glennie.

25 Ibid. 8.

26 Christopher Palmer (ed.), *The Britten Companion* (London: Faber and Faber, 1984), 147.

27 MP to Benjamin Britten, n.d. [January 1954]: BPL.

28 JP, in 'Portland Sketchbook': TGA

29 JP, 'Portland Stone—Portland Colours', *Ambassador 6* (1954).

30 MP to Benjamin Britten, 2 February [1954]: BPL.

31 Benjamin Britten to MP, 16 February 1954: BPL.

32 MP in conversation with Peter Porter, *Quarto* (August 1991).

33 Once, during a discussion about libretto writing at the Institute of Contemporary Art in London, Myfanwy was astonished to hear Auden claim that, when asked by Stravinsky to write *The Rake's Progress*, he had sent the composer the finished script and Stravinsky had been so delighted with it he had written the opera without altering a word. Myfanwy later

wrote: 'Since the audience rather than the platform were asking the questions I couldn't challenge him. But I suspect that a great deal of preliminary discussion must have paved the way for such an easy passage' (MP Notebook, Tate Archives).

34 Eric Crozier, quoted in Carpenter, *Benjamin Britten*, 245.

35 Britten, quoted ibid. 337.

36 MP, 'Writing for Britten', 8.

37 Edmund Wilson, 'The Ambiguity of Henry James', in *The Triple Thinkers: Twelve Essays on Literary Subjects* (London; John Lehmann, 1952), 123.

38 Benjamin Britten to MP, 31 Jan 1954.

39 MP, 'Writing for Britten', 10.

40 MP in conversation with Peter Porter, *Quarto* (August 1981).

41 Ibid. 10.

42 Musically, the song is also embedded firmly in the opera through its use of minor thirds, for these, as Erwin Stein has shown, relate it to the use of thirds and concealed fourths in the 'screw' theme employed in orchestral passages at the start of each act. Erwin Stein, '*The Turn of the Screw* and its Musical Idiom', *Tempo* 34, 9.

43 Henry James, 'Preface to *The Aspern Papers; The Turn of the Screw; The Liar; The Two Faces*', in *The Art of the Novel* (London: Scribner's, 1934), 169–77.

44 MP, 'Writing for Britten', 12.

45 Peter Evans, *The Music of Benjamin Britten* (London: J. M. Dent, 1979), 204.

46 MP, 'Writing for Britten', 12.

47 Ibid.

48 Benjamin Britten to MP, 26 April 1954: BPL.

49 Quoted in MP, 'Writing for Britten', 11. The controversy that has arisen in recent years over Britten's use of Latin words in this opera is helpfully summarized in Letters for a Life, vol. IV, ed. Donald

Mitchell and Philip Reed (Woodbridge: Boydell Press in association with the Britten–Pears Foundation, 2008).

50 MP to Moelwyn Merchant, 31 May [1954]; Eton College Library.

51 MP to Benjamin Britten, n.d. [1954]: BPL.

52 MP to Benjamin Britten, n.d.: BPL.

53 David Hemmings, *Blow-Up and Other Exaggerations* (London: Robson Books, 2004), 52.

54 Alan Blyth, *Remembering Britten* (London: Hutchinson, 1981), 82.

55 MP, quoted in Howard, 'Myfanwy Piper's "The Turn of the Screw" ', 23.

56 MP in conversation with Peter Porter, *Quarto* (August 1981).

57 'James had provided him with a pre-established unstable ethical field, where both the questions and the answers were shrouded in mists of uncertainty' (Claire Seymour, *The Operas of Benjamin Britten: Expression and Evasion* (Woodbridge: Boydell Press, 2004), 182).

58 JP, 'Designing for Britten', in Herbert (ed.), *The Operas of Benjamin Britten*, 6.

59 Erwin Stein, 'The Turn of the Screw', *The Listener* (9 September 1954).

60 Donald Mitchell, in his entry on Benjamin Britten for the *Oxford Dictionary of National Biography*.

Chapter 24: Delegated Art

1 Benjamin Britten to JP, 26 April 1955: JPA.

2 *Times Literary Supplement* (17 June 1955), 336.

3 Though JP never lost the desire to experiment, from the mid-1950s he did not consistently achieve the same depth and intensity as is found in his 1940s work. Even his admirer Peter Fuller wrote: 'The intensity of Piper's sense of the spirit of

place began to elude him, and a certain theatricality—a fatal facility even—entered into his work. Shifts in colour could be more arbitrary than revealing. His line sometimes fell into stereotyping' (*Peter Fuller's Modern Painters: Reflections of British Art*, ed. John McDonald (London: Methuen, 1993), 261.

4 David Piper, in Geoffrey Elborn (ed.), *To John Piper on his Eightieth Birthday* (London: Stourton Press, 1983), 61.

5 Ibid.

6 Edith Sitwell to Pavel Tchelitchew, 31 May 1948: Edith Sitwell—Pavel Tchelitchew Correspondence, Beinecke Library, Yale (GEN MSS 466).

7 *Ambassador* 5 (1946).

8 During the early years of the 1939–45 war, John had represented the Society of Mural Painters on the Central Institute of Design. Though he resigned from this position in 1942, he remained a member of the Central Institute and in 1945, when a large exhibition for the wallpaper industry was being organized, he was asked by the Institute to write an article on wallpapers for a suitable magazine. No such article has been traced.

9 The catalogue to this show was incorporated into the *Ambassador*, 11 (1953). JP's design is illustrated on p. 79.

10 Modern textile design was in danger of becoming trapped in an aesthetic cul-de-sac, argues Geoffrey Rayner in Geoffrey Rayner, Richard Chamberlain, and Annamarie Stapleton (eds), *Artists Textiles in Britain 1945–1970: A Democratic Art* (Woodbridge: Antique Collectors' Club, 2003), 47.

11 Ibid. 48.

12 Ibid. 81.

13 JP, 'The Artist and the Church', *Cymry'r Groes: a Quarterly Magazine* 2:1 (July 1946), 29.

14 Though the earliest surviving stained glass in situ in England dates from the second half of the twelfth century, we know from archaeological finds and from literary evidence that the great cathedral and abbey churches in Christendom were being glazed with figurative windows from the sixth and seventh centuries.

15 JP, Introduction to 'A Small Anthology of Modern Stained Glass', Arts Council of Great Britain exhibition, shown at the Aldeburgh Festival and elsewhere, 1955.

16 Ibid.

17 So central was this idea to JP's thoughts on stained glass that he quoted Manessier in his book *Stained Glass: Art or Ant-Art* (London: Studio Vista, 1968), 37 and again, paraphrasing his words, in 'Art or Anti-Art', an essay contributed to Brian Clarke (ed.), *Architectural Stained Glass* (London: John Murray, 1979), 60.

18 JP, handwritten notes on stained glass (possibly made in preparation for a lecture): Sketchbook, TGA 20033/6.

19 JP, 'Art or Anti-Art'. 64.

20 June Osborne's *John Piper and Stained Glass* (Stroud: Sutton, 1997) puts on record Piper's work, surveys all his commissions and contextualizes them within the history of stained glass. Despite some minor omissions, the book is an immensely valuable contribution to John Piper studies.

21 JP to Major Dent, 22 May 1953: Tate Archives.

22 Reyntiens was at this time keen on weight-lifting and in this way met a carpenter who, when the Oundle commission came through, offered to make him a studio, knocking up a 50' × 25' × 25' studio in a fortnight for a cost of £149. The only drawback to this studio was that it had doors at either end, one of which Reyntiens had forgotten to lock

when JP and John Betjeman turned up wanting to look at the work he was doing. JP pushed open a door against which two of the Oundle panels were leaning and both were destroyed and had to be remade.

23 John Betjeman to JP, 22 May 1954: Quoted in Osborne, *John Piper and Stained Glass*, 41.

24 Major Dent to Graham Stainforth, n.d. : TGA 9315.1.

25 Hugh Caudwell to JP, 29 May [1956]: JPA.

26 JP to Tony Twentyman, 25 September 1955: Wolverhampton Archives and Local Studies.

27 It was not finished until 1962.

28 JP to Moelwyn Merchant, 27 January 1956: Eton College Library.

29 Patrick Reyntiens, in conversation with the author, 16 January 2007.

30 JP, handwritten notes for talk on the Baptistery Window at Coventry: TGA.

31 MP to Moelwyn Merchant, 31 May [1954]; Eton College Library.

32 In conversation with the author, 29 June 2004.

33 JP to Moelwyn Merchant, 29 February 1958: Eton College Library.

34 'Man is not nature's master, nor is nature man's. They often appear to be at war with each other, because they are always reversing the roles of conqueror and conquered. But once man has made his claim upon the land, and though his kingdom may be overthrown, grown over with weeds, silted up with mud, stones or lava, there is always something to show that he has been there, though it may be the merest indication. The nature that encroaches again on man's work will be just that much different. In a few hundred years man plants trees and alters the

shapes of the hills, ploughs into smooth curves what once was rough moorland or scrub, floods dry valleys, dams rivers and changes their course, builds castles, towns, churches, fortresses. In another few hundred years the trees have resown themselves in a new cycle, the castles have become grass-grown mounds ready again for the plough, the fortresses are tumbled blocks of stone that are almost one again with the long, slow outlines of the hills or coasts they dominated. "And so man ploughs and builds again—man and nature enrich each other always when they seem to our passing eyes to be fighting each other; and all change is ripeness and not destruction." ' I am grateful to the Mayo Clinic for supplying this quotation.

35 Nowadays the main entrance to Television Centre is on the other side of the building, and the former main entrance has become a side entrance. However, at the time of writing, both the Television Centre and the Birmingham Chamber of Commerce are about to move, making the future of these two mosaic decorations an issue of public concern.

36 *Financial Times*, 4 December 1958. In addition to the mosaic murals mentioned here, he also did wall mosaics for Midland Bank and a kitchen belonging to David Gomme (illustrated in *Women's Journal*, May 1960).

37 JP, 'Art or Anti-Art', 30.

38 JP, in *A Tribute to Evie Hone and Mainie Jellett*, ed. Stella Frost (Dublin: Browne and Nolan, 1957), 43.

39 Ibid. 44.

40 Alexander Bland, *The Royal Ballet: The First 50 Years* (London; Threshold Books, 1981), 119.

41 Ibid.

42 JP, 'Art or Anti-Art', 60.

43 Ibid.

44 JP to Moelwyn Merchant, 19 March 1958: Eton College Library.

45 Peter Hammond, *Liturgy and Architecture* (London: Barrie and Rockcliff, 1960), 13.

46 Ibid. 26.

47 See Elaine Harwood, 'Liturgy and Architecture: The Development of the Centralised Eucharistic Space', in *The Twentieth Century Church*, *Twentieth Century Architecture* 3 (London: Twentieth Century Society, 1998), 49–74, for an excellent overview. One of the starting points for new church architecture was Auguste Perret's Notre-Dame du Raincy, east Paris (1922–3), owing to the honesty of its exposed concrete and absence of Gothic detail, but also because its nave and sanctuary occupy a single space, and the altar is separated from the east end by an ambulatory. JP visited this church while working on the Baptistery window at Coventry, in order to see the more or less continuous wall of stained glass around the church, by Marguerite Huré.

48 As by George Pace to JP, 6 December 1961: TGA. The church was consecrated 26 September 1963.

49 From JP's statement for the church guide, quoted Osborne, *John Piper and Stained Glass*, 77.

50 George Pace to JP, 1 April 1969: TGA.

51 JP, letter of condolence to Irna Pace, in possession of Peter G. Pace. Part of it is quoted in his *The Architecture of George Pace* (London: B. T. Batsford, 1990), 144.

Chapter 25: Coventry and Cranks

1 Quoted in Louise Campbell, *Coventry Cathedral: Art and Architecture in Post-war Britain* (Oxford: Clarendon Press, 1996), 170.

2 Ibid.

3 Hans Juda had drawn Spence's attention to the glass for Oundle.

4 The progress of this commission is recorded in an unpublished memoir, 'Coventry Cathedral 1940–62' by Capt. N. T. Thurston, Secretary to the Reconstruction Committee; typescript, Coventry Cathedral archives. I am grateful to John Rathbone (Hon. Archivist) for making this and other documents available to me.

5 Quoted by JP in an unpublished memoir on the Coventry Baptistry Window: JPT. A shortened or expurgated version of this memoir appeared in the *Coventry Cathedral Review* (December 1961), which JP wrote at the request of the new Provost, H. C. N. Williams.

6 Ibid.

7 R. V. Howard to JP, 9 January 1956, JPA, TA.

8 Patrick Reyntiens, in conversation with the author, 23 April 2003.

9 Ibid.

10 Basil Spence, in the Second Gwilym James Memorial lecture of the University of Southampton, delivered at the university on 23 February 1973, claims: 'John Piper designed the Baptistery window, and within the discipline of the stonework I encouraged him to do a burst of light symbolizing the giving of life and strength to the green and red below' (University of Southampton, 1973, p. 11). This does not mean that Spence originated the idea. Patrick Reyntiens (in a letter to the author dated 11 October 1999) claims that it occurred to him that an 'explosion' was what was called for in the Baptistery window. 'John realised that this was the solution, but very sensibly moved the epicentre down to the middle of the window, which demonstrably was the right place for it to be. John then

NOTES

proceeded to do all the colour placement. I did not have any hand in that. The rest is history.'

11 JP, unpublished memoir on the Baptistery window.

12 Lawrence Lee, quoted in Campbell, *Coventry Cathedral*, 114.

13 JP, unpublished memoir on the Baptistery window.

14 *Evening Standard* (1 March 1960).

15 JP, unpublished memoir on the Baptistery window.

16 See Campbell, *Coventry Cathedral*, 172, where she refers to money being saved on the redesigned porch steps and through modifications to the paving and paths around the Cathedral. Patrick Reyntiens, on the other hand, in a lecture delivered in 2001, on the fiftieth anniversary of the competition for the building of the new cathedral, claimed that the Baptistery window was paid for by dexterous buying and selling on the copper-market. Spence told JP that the roof of the Cathedral had worked out far cheaper than expected, and this gave an extra £25,000, which was only £2,000 short of the actual cost, excluding saddle bars and the fitting. JP himself received in total £4,750, paid over three years.

17 Provost Howard to JP, 11 May 1957: Piper Archive.

18 JP to Provost Howard, 14 May 1957: Coventry Cathedral Archives. See Basil Spence, *Phoenix at Coventry* (London: Geoffrey Bles, 1962), 9.

19 'They are the kind of free adaption of his very original *papiers collés*, and are cut from clear, coloured glass without any painted design or modification added: they are thought of as light transmitting from the beginning. And the way their image is doubled on the floor of the chapel in sunshine is one of their prime beauties' (JP, 'Stained Glass: Art or Anti-Art', in Brian Clarke (ed.), *Architectural Stained Glass* (London: John Murray, 1979), 64).

20 JP, unpublished memoir on the Baptistery window.

21 Quoted in Captain Thurston's reminiscence of this event: see n. 32. This echoes the description of the final plan and purpose of the window found in JP's article for the *Coventry Cathedral Review* (December 1961), 7–8.

22 Quoted by Patrick Reyntiens in a letter to the author, 11 October 1999.

23 Minutes of the Reconstruction Committee, 3 December 1957: Coventry Cathedral Archives.

24 Campbell, *Coventry Cathedral*, 173.

25 Basil Spence, *Phoenix at Coventry* (London: Geoffrey Bles, 1962), 9.

26 Quoted by JP, unpublished memoir on the Baptistery window.

27 JP to Tony Twentyman, 9 January 1958: Wolverhampton Archives and Local Studies.

28 In 1964 JP lent this model of the stained-glass window at Coventry to an exhibition of ecclesiastical art in Hamburg.

29 JP, unpublished memoir on the Baptistery window.

30 The Revd Canon J. W. Poole to JP, 21 June 1961: JPT.

31 JP, typescript of lecture on the Coventry window: TGA.

32 *Coventry Cathedral Review* (December 1961).

33 A meeting was arranged at the Athenaeum in Pall Mall in October 1960, at which JP showed his designs to the Bishop of Coventry, the Revd Canon J. W. Poole and his wife and the Hon. John Siddely. He apparently also designed an outfit for Mrs Poole.

547

34 Hussey's cope, though today beyond repair, is stored among the other vestments at Chichester Cathedral.

35 Now in the collection of the Victoria & Albert Museum.

36 Louis Grossé was housed at 36 Manchester St, London, W1.

37 JP, typescript of lecture on Delegated Art: TGA.

38 JP to Tony Twentyman, 23 May 1962: Wolverhampton Archives and Local Studies.

39 Michael De-La-Noy, in his obituary of Cuthbert Bardsley, for the *Independent*, 13 August 2002.

40 *Coventry Cathedral Review* (December 1961), 8.

41 *New Statesman* (May 1962), 768–79. Praise came also from another stained-glass designer, Lawrence Lee: 'The stupendous majesty of your window is such that I had to do something and so—this letter. Congratulations seem trivial for such a heavenly inspiration—you have my admiration, as you will have from the world' (L. G. Lee to JP, 5 November 1961). And Canon J. W. Poole wrote: 'Your Baptistery window is pure joy—incomparably fine: surely one of the loveliest things in Christian Europe, no less. I can never thank you enough for it' (The Revd Canon J. W. Poole to JP, 17 October 1961: TGA).

42 *The Sunday Times,* colour supplement, 20 May 1962.

43 *Coventry Cathedral Review* (December 1961), 8.

44 See David Fraser Jenkins, *John Piper: The Forties* (London: Philip Wilson/Imperial War Museum, 2000), 33.

Chapter 26: Ambiguous Venice

1 Patrick Reyntiens, in *The Oldie* 96 (March 1997).

2 MP to Penelope Betjeman, n.d.: Victoria.

3 MP, 'Portraits', review of Royal Academy Summer Exhibition and of the Royal Society of Portrait-Painters, *The Sunday Times* (27 November 1955), 13.

4 MP, 'Spenceriana', review of 'Stanley Spencer' exhibition at Tate Gallery, *The Sunday Times* (13 November 1955), 7.

5 MP, 'The Enemy', review of Wyndham Lewis exhibition at Tate Gallery, *The Sunday Times* (8 July 1956), 4.

6 MP to John Betjeman, n.d.: Victoria.

7 For information on Hecht I am grateful to conversation with James Kirkman and Derek Grainger.

8 Quoted in 'Not One but Two', a double-portrait of John and Edward Piper, *Good Housekeeping* (July 1987), 83.

9 MP to Benjamin Britten, 5 October [1956?]: BPL.

10 *Harper's Bazaar* (January 1962).

11 Ibid. (December 1960).

12 Ibid. (September 1960).

13 MP, unpublished diary, July 1960: courtesy of Clarissa Lewis.

14 MP, unpublished diary, Rome, February 1961: courtesy of Clarissa Lewis.

15 Penelope Betjeman to MP, 15 November 1985: JPA.

16 Graham Collier, *Form, Space, and Vision: Discovering Design through Drawing* (Englewood Cliffs, NJ: Prentice-Hall, 1963), p. viii.

17 MP, in the catalogue to the Tony Twentyman exhibition, held Wolverhapmton Art Gallery, 1960.

18 MP to Tony Twentyman, 6 October 1976, Wolverhampton Library and Art Gallery.

19 MP, in the catalogue to the Tony Twentyman exhibition, held Wolverhampton Art Gallery, 1960.

20 MP to Benjamin Britten n.d. [June 1957]: BPL.

21 Ibid. 25 November [1954]: BPL GB-Alb–9401058.

22 MP, unpublished diary, 1963: courtesy of Clarissa Lewis.

23 JP to Adrian Stokes, 13 February 1958: TGA 8816-240.

24 See the catalogue to JP's 1964 Marlborough Gallery retrospective, where the chronology refers to his first painting to Venice in 1958 and states 'inspired by Adrian Stokes'.

25 J and MP to Benjamin Britten, 13 May 1958: BPL.

26 See JP to Norman Reid, 22 May 1962: Acquisitions File, TGA.

27 The Vine Press, Hemingford Grey, approached JP to see whether a block could be made from a drawing he made in Sheffield.

28 David Herbert (ed.), *The Opera of Benjamin Britten* (London: Herbert Press, 1979), 7.

29 His draft refusal reads: 'I am very conscious of the honour the Prime Minister would do me by submitting my name to the Queen with the recommendation that he suggests to Her Majesty. I It is with sorrow that I find myself disturbed by the proposal and, while recognising the signal honour that is implied, I hope that he will not put the suggestion forward' (28 November 1963: TGA).

30 Harry Fischer to JP, 5 October 1962: copy, Marlborough Fine Art Archives.

31 John Richardson, *Evening Standard*, 19 March 1963.

Chapter 27: Dark Glasses at Evensong

1 JP, foreword to Walter Hussey, *Patron of Art: The Revival of a Great Tradition among Modern Artists* (London: Weidenfeld and Nicolson, 1985), p. ix.

2 Hussey, *Patron of Art*, 121.

3 JP to Moelwyn Merchant, 25 June 1964: Eton College Library.

4 JP to Walter Hussey, 22 January 1965: West Sussex Record Office.

5 Trevor Brighton, 'The Piper Tapestry' in *Chichester Tapestries*, Otter Memorial Papers, no. 7, 22.

6 JP to Walter Hussey, 8 October 1965: West Sussex Records Office.

7 Ethel M. Burger to Walter Hussey, 23 September 1966: West Sussex Records Office.

8 *Christian Worship*, *Christian Communities*, *Christian Experience*, and *Jesus*.

9 Canon John Hester to JP, 4 October 1991: TGA.

10 Lord Goodman to MP, 6 December 1967: TGA.

11 Arnold Goodman, *Tell Them I'm on My Way* (London: Chapman, 1993), 269.

12 Martin Esslin to MP, 13 April 1966: JPA.

13 MP to Mary Potter, 22 August 1964: courtesy of Julian Potter.

14 Ibid. n.d.[1964]: courtesy of Julian Potter.

15 MP, quoted in Christopher Headington, *Peter Pears: A Biography* (London: Faber and Faber, 1992), 328.

16 *Popular Gardening*, 18 December 1987.

17 *Evening News*, 10 November 1966.

18 JP to Moelwyn Merchant, 20 October 1996: Eton College Library.

19 JP, untitled typescript: courtesy of Clarissa Lewis.

20 Stanley Jones, in conversation with the author, Curwen Studio, 24 March 2005.

21 JP talking about his prints with Pat Gilmour, 11 December 1975: tape and transcript, TGA.

Chapter 28: Sacred or Superstitious?

1 Quoted in Peter Hammond, *Liturgy and Architecture* (London: Barrie and Rockliff, 1960), 156.

oryoryory princeorysthory

2 *Harper's Bazaar* (November 1961). Interestingly, this predates the actual making of the window by some years. A drawing for this window, shown in one of JP's exhibitions at Marlborough in 1967, is dated 1959, but this is incorrect as the gestural marks employed in this drawing belong firmly to the mid-1960s.

3 The precise colour used was Dulux Ash Grey Flat, 1799 matt.

4 Chagall had been so pleased with the result, when the glass was put into position in 1968, that he promptly offered to fill all the rest of the windows in the church. As two of these windows were already occupied by Victorian stained glass there was some opposition to this proposal and it was nine years before Chagall's vision was achieved and the church became a place of pilgrimage for many.

5 JP to Hussey, 19 November 1967: West Sussex Records Office.

6 I am grateful to Father Hoyle for voicing 'a philistine note, by one who will always feel more at home in the Anglo-Catholic interiors of the late nineteenth century' (conversation with the author, 13 April 2007).

7 See June Osborne, *John Piper and Stained Glass* (Stroud: Sutton, 1997), 105.

8 Simon Crosse to JP, 26 April 1965: TGA.

9 JP to Methuen Clarke, 11 May 1971: courtesy of Canon Methuen Clarke.

10 Ibid. 6 August 1968: courtesy of Canon Methuen Clarke.

11 Ibid. 22 April 1974: courtesy of Canon Methuen Clarke.

12 Maurice Denis, quoted by JP in MSS notes on stained glass: Tate Archives.

13 Not to Arthur, Prince of Wales, as was at one time claimed.

14 The chapel at Malsis is tacked onto one side of the school's assembly hall. Partly a memorial chapel, each window bears the name of a boy or master who was killed in the 1939–45 war, together with the colours of their regiments. Piper worked predominantly with greys and greens and pale yellow in order to create a particular quality of light that marks out the chapel as a different kind of space from that of the brightly lit hall.

15 The Revd Dr Bryan Spinks, 'God's "Bordello": The Making of an Ecumenical College Chapel', a paper read at the 1993 Congress of Societas Liturgica, Freiburg, Switzerland: typescript copy, Churchill College Archives.

16 The words are Mark Goldie's. His as-yet unpublished history of the chapel at Churchill College, lodged in the College's archives, has been an invaluable source. It will, in revised form, become part of his forthcoming history of the College.

17 Richard Sheppard to JP, 5 December 1967: Tate Archives.

18 This Sheppard acknowledges in his article 'Churchill College Chapel' *Churchbuilding* 25 (October 1968), 21–3.

19 V. E. G. Kenna to JP, n.d. [1970]: TGA. However, another letter from Kenna reads: 'How kind and good of you to write as you did. And how glad I am that you were able to bring in the drops of blood. If they are as I imagine them to be—as drops they must be factual blood red or white (St John XIX 34). They would provide a creative antithesis to the overall abstract quality. So just like the grace of God Churchill—like me—got much more than they deserved' (V. E. G. Kenna to JP, [1970]: TGA). The only possible explanation is that some of the dots in the borders of the blue glass can be interpreted in a way that would satisfy Kenna.

20 It was assimilated into the Church of 'Our Lady Immacualate', St Domingo Road, a church which was pulled down in the 1980s.

21 Quoted in John C. Heenan, *A Crown of Thorns: An Autobiography 1951–1963* (London: Hodder and Stoughton, 1974), 293. Also quoted in Frederick Gibberd, *The Metropolitan Cathedral of Christ the King, Liverpool* (London: Architectural Press, 1968), 10.

22 Gibberd was a Congregationalist and unfamiliar with the Mass until he attended the solemn opening of a Catholic church built by one of his partners. It was during this Mass that he became aware of a new concept of liturgical space. Remembering that he had registered as a competitor for the Metropolitan Cathedral, he went home and began work immediately on his plans.

23 Gibberd, *Metropolitan Cathedral of Christ the King*, 12. Many of Gibberd's ideas for this building had first been worked out at the small chapel for De La Salle College, Hopwood Hall, near Middleton, Rochdale, built 1963–5.

24 It must be acknowledged that the whole building had to undergo extensive, complicated, and expensive repairs after only twenty-five years had passed.

25 Frederick Gibberd, as reported in the *Liverpool Post.* Quoted in Heenan, *A Crown of Thorns*, 302.

26 JP, 'The Liverpool Lantern', *Studio International* 173: 890 (June 1967).

27 Problems include the siting of the president's chair and the archbishop's throne, as well as the siting of the choir, none of which have been solved with any natural logic, with the result, as John Nelson Tarn observes (see n. 28) the building always seems to lack order.

28 John Nelson Tarn, 'Liverpool's Two Cathedrals', in *Studies in Church History:*

The Church and the Arts (Oxford: Blackwell, 1992), 560.

Chapter 29: *Owen Wingrave*

1 Lines copied out in MP's hand, on a card in the BPL (Poetical Works Oxford edition, 87).

2 A single sheet of manuscript containing her prologue can be found in the BPL.

3 *Owen Wingrave* was a co-production by the BBC and 12 other television stations: Belgische Radio en Televise (BRT, Brussels), Danmarks Radio (DR, Copenhagen), Jugoslovenska Radio-Televizija (JT, Belgrade), national Educational Television (NET, New York), Nederlandse Omroep Stichting (NOS Hilversum), NOrsk Rikskringkasting (NRK, Oslo), Office de Radiodiffusion-Télévision Française (ORTF, Paris), Osterreicheischer Rundfunk-Fernsehen (ORF, Wien), Radio Éireann (RE, Dublin), Sveriges Radio Television (SRT, Stockholm), Swiss Broadcasting Corporation (SRG, Zürich) and Zweites Deutsches Fernsehen (ZDF, Mainz). Within a week of the UK broadcast, several of these stations broadcast *Wingrave*. Britten and Piper received royalties every time the opera was transmitted.

4 This he acknowledges in an interview which formed part of *An Introduction to Owen Wingrave*, a BBC television film for BBC2's *Music Now*, transmitted 9 May 1971 in advance of the transmission of the actual opera. Britten's commission fee of £10,000 went straight into the fund for the rebuilding of the Maltings, which had burnt down in 1969.

5 For an authoritative examination of this theme, see John Evans, '*Owen Wingrave*: A Case for Pacificism', in Christopher Palmer (ed.), *The Britten Companion* (London: Faber and Faber, 1984), 227–

37. It is necessary also to acknowledge here that pacifism and homosexuality are linked themes in Britten's work and that the Wingrave family's oppressive attempts to shape Owen in their own image resonate also with sexual politics.

6 When student protesters were shot by police at Kent University, Ohio, Britten kept a newspaper cutting of this appalling event among his papers.

7 MP in conversation with Roderic Dunnett: typescript of interview, courtesy of Roderic Dunnett.

8 As recorded by John Culshaw, 'The Making of Owen Wingrave', *The Times Saturday Review*, 8 May 1971.

9 In 1955 Independent Television Authority service (ITA), the first commercial station, began broadcasting in Britain. It soon divided into a network of regional subsidiaries. Associated-Rediffusion was the first production company responsible for the London area.

10 MP quoted in '*The Turn of the Screw* by Benjamin Britten', publicity brochure printed to commemorate the Associated-Rediffusion broadcast (W. S. Cowell Ltd Ipswich, 1959): BPL.

11 The story of how this film was resurrected is told in Jennifer Barnes, *Television and Opera* (Woodbridge: Boydell Press, 2003), 48–9.

12 After seeing his sets and drawings translated into the time-based medium of black-and-white television, JP wrote excitedly about the possibilities of this medium in the film's publicity brochure: 'The scenery is a matter of creating atmosphere, not of presenting facts. Scale, texture and a telling disposition of darks and lights are all important. As to texture, I was surprised to find how well it could be realised by the television cameras, and how many new means of suggesting it are possible. The matter of lights and darks I found exciting, because the medium does not so much reflect light, as it allows light to pierce through darkness, as in stained glass. Here again the possibilities seemed enormous. But it is in the matter of scale that I was most interested of all. You can move, for instance, from a small drawing, with some tiny scribbles or spots of darkness on it, to a full-sized theatre cloth with a figure in front of it without any jolt to the eye, so that scale momentarily disappears, and there is the thrill of being in a no man's land of dimension, which can be most helpful in a highly atmospheric work.'

13 Benjamin Britten in conversation with Donald Mitchell. From 'Map Reading', in Palmer (ed.), *The Britten Companion*, 88. The interview took place in February 1969.

14 Ibid. 90.

15 Coleman recollects replying: 'You've always wanted to do *Owen Wingrave* and you've always enjoyed working with Myfanwy,' after which the two men discussed the work in some detail. Quoted in Barnes, *Television and Opera*, 56.

16 James documented the origin of the tale in his preface to 'The Altar of the Dead'.

17 MP, 'Writing for Britten', in David Herbert (ed.), *The Operas of Benjamin Britten* (London: Herbert Press, 1979), 12.

18 Ibid. 15.

19 MP, Notebook for *Owen Wingrave*: BPL.

20 MP, 'Writing for Britten', 13.

21 Ibid. 14.

22 Geoffrey Jellicoe to MP, 14 May 1990: TGA.

23 MP to Benjamin Britten, 7 March 1968: GB-Alb-9401021, BPL.

24 Ibid.

25 MP, 'Writing for Britten', 13.

26 MP to Benjamin Britten, 11 September 1970: GB-Alb-9401041: BPL.

27 MP, 'Writing for Britten', 13.

28 Ibid.

29 The story of how this film was resurrected is told in Barnes, *Television and Opera*, 48–9.

30 MP to Benjamin Britten, 19 August 1968: GB-Alb-9401023, BPL.

31 MP in conversation with Roderic Dunnett, typescript of tape-recording: courtesy of Roderic Dunnett.

32 Shaw was not alone in thinking James's ending too abrupt. Virginia Woolf also felt Owen's death too sudden: 'The catastrophe has not the right relations to what has gone before'. (See her *Collected Essays* (London: Hogarth Press, 1966), 289.)

33 MP to Benjamin Britten, 10 December 1970: GB-Alb-9401042: BPL.

34 It is not clear why JP did not design the television version. In the BPL is a memorandum of an agreement between the BBC and Faber Music, setting out Clause 9 in which the BBC undertakes fully to consult with the Composer before appointing Producer, Directors, and Designer. There is, however, evidence that he was consulted informally. 'Last evening we had a very useful meeting with Colin and the Pipers and many problems have been resolved on Owen Wingrave' (Brian Large to Benjamin Britten (9 Oct. 1970: BPL)).

35 MP to Rhiannon and Alun Hoddinott, n.d.? [1997].

36 Evans, '*Owen Wingrave*', 232.

Chapter 30: Shell Guides

1 JP was so keen to promote a sense of place wherever he found it that at one point he tried to persuade Faber and Faber to reprint Henry James's *Portraits of Places*.

2 Henry Thorold's *Lincolnshire* was also greatly admired by Betjeman in an undated letter to JP.

3 JP to David Bland, 27 February 1966: copy among John Betjeman's papers: Victoria.

4 David Bland to John Betjeman, with copy to JP, 8 March 1966: TGA.

5 Ibid.

6 JP to Henry Thorold, 29 April 1967: courtesy of Dinny Thorold.

7 JP to John Betjeman, 12 June 1964: TGA.

8 Verey's commission came too late and his contract was cancelled when the Guides were terminated, and Pace's work and final lengthy illness prevented him from completing the East Riding.

9 The economist Sir Roy Harrod who had written a biography of Maynard Keynes and advised Churchill and Macmillan on economic policy.

10 Billa Harrod to JP, 9 July 1974: TGA.

11 Quoted in *The Times*, 7 August 2008.

12 Lady Harrod's rallying cry: 'Down with gloom and doom, which are only really there if you want them to be. Think instead of how many good friends we have' (quoted in *Country Life* (15 July 2004)).

13 *Daily Telegraph*, 3 February 2000.

14 MP to Henry Thorold, 7 May 1981: Thorold Papers.

15 JP to Norman Scarfe, 4 December 1973: Norman Scarfe.

16 Recollected by Bevis Hiller, in conversation with the author. The cause of this upset is unknown, though it may have been caused by some photographs that Betjeman disliked.

17 Matthew Evans, in conversation with the author.

18 The Right Revd Mgr. Canon F. J. Bartlett to JP, 5 August 1975: TGA.

19 *The Sunday Times*, 5 May 1975.

20 John Betjeman to JP, 15 November 1977: TGA.

21 'Congratulations old top on CH. Rare and Honourable' (John Betjeman to JP, 5 June 1972: TGA).

22 The Revd V. Kenna to JP, n.d. [1970]: TGA.

Chapter 31: Pottery, Tapestries, Fireworks, and Photographs

1 JP to Graham Hughes, n.d. [1983]: courtesy of Graham Hughes.

2 Martin Harrison, in the introduction to 'John Piper: Painting in Coloured Light', catalogue to an exhibition at Kettle's Yard, Cambridge, 1982–3.

3 Isi Metzstein, conversation with the author, August 2007.

4 See Martin Harrison's catalogue introduction to 'An Exhibition of Stained Glass', Kettle's Yard Gallery, Cambridge (1982), unpaginated.

5 Quentin Bell, introduction to 'John Piper's Ceramics', in *John Piper: The Britten-Pears Collection, and John Piper Ceramics*, Festival Gallery and Gallery 44, in conjunction with the Fulham Pottery Ltd and Dan Klein Ltd, 10–26 June 1983.

6 Richard Ingrams and John Piper, *Piper's Places: John Piper in England and Wales* (London: Chatto and Windus, 1983), 12.

7 Ibid.

8 Richard Ingrams, *Independent*, 30 June 1992.

9 Some of his expertise fed into high places through his membership of the Fabric of Cathedrals Commission. For instance, he advised Southwell Minster on an altar frontal which needed an emblem to represent St Oswald. He suggested the image of a raven, and also colours to be used in the embroidery.

10 This tapestry, originally called *Brighton Fantasia*, was commissioned for the Helsinki Embassy but was never displayed there. In 1982 the Property Services Agency gave it to the Government Art Collection.

11 JP also made a silkscreen print of this church, the sales of which went to its restoration fund, as did the proceeds of an exhibition held at the Fermoy Art Gallery, King's Lynn.

12 His drawings for these illustrations were exhibited at the Parkin Gallery in Belgravia in 1982.

Chapter 32: *Death in Venice*

1 MP, 'Death in Venice', MS essay: BPL. This essay appears to be a longer version of the one she wrote for the Cambridge Opera Handbook: 'The Libretto', in Donald Mitchell (ed.), *Benjamin Britten: Death in Venice* (Cambridge: Cambridge University Press, 1987), 45–54.

2 MP to Benjamin Britten, 11 September 1970: BPL.

3 In Britten's copy of *Death in Venice*, translated by H. T. Lowe-Porter, in BPL, these incidents are indicated by a sequence of circled numerals, handwritten in red chalk in the outer margins.

4 This observation is found in her essay on the *Death in Venice* libretto, a seminal piece of writing for this opera ('The Libretto', 47).

5 At the start Britten considered having these spoken, not sung, to bring out Aschenbach's dryness and isolation, but the chopping and changing between spoken and sung words was thought to be unworkable.

6 The phrase Aschenbach utters at the end of Act I—'I love you'—should be said with a sense of surprise and not sentiment. So MP once commented to Jean Marsh. She disliked the way that Peter Pears pronounced this line.

7 Hans Keller, for instance, referred to *Death in Venice* as an 'operatic testament', stating: 'never before in the history of this uniquely problematic art form had universal significance and personal statement … coalesced without the slightest friction' (*The Operas of Benjamin Britten*, ed. David Herbert (London: Herbert Press, 1979), p. xv).

8 See Christopher Headington, *Peter Pears: A Biography* (London: Faber and Faber, 1992), 314.

9 So Britten acknowledged in an interview in *The Times* (30 December 1974), quoted in Rosamund Strode, 'A "Death in Venice" Chronicle', in Mitchell (ed.), *Benjamin Britten: 'Death in Venice'*, 26.

10 See Alan Blyth, *Remembering Britten* (London: Hutchinson, 1981), 34.

11 MP, 'The Libretto', 47.

12 MP to Benjamin Britten, 28 February 1972: GB-Alb-9401051: BPL.

13 MP, 'The Libretto', 48.

14 MP to Benjamin Britten, 28 February 1972: GB-Alb-9401051: BPL.

15 This was an Appeal Concert, to assist the National Gallery's acquisition of Titian's *The Death of Actaeon*.

16 This copy can be found in BPL. It was accompanied by a letter, MP to Benjamin Britten, 6 July 1972: GB-Alb-94010158: BPL.

17 T. J. Reed, introduction to *Der Tod in Venedig* (Oxford: Oxford Univeristy Press, 1971), 49.

18 *Musical Times* 114:1566 (August 1973), 819.

19 JP, 'Designing for Britten', in Herbert (ed.), *The Operas of Benjamin Britten*, 7.

20 *New Yorker* (4 November 1974).

21 Patrick L.Veitch to MP, 25 October 1974: JPT.

22 JP to Tony Twentyman, 6 December 1976: Wolverhampton Archives and Local Studies.

Chapter 33: Deaths and Entrances

1 John Mortimer, *Murderers and Other Friends* (London: Viking, 1994), 136–7.

2 Ibid. 137.

3 JP to Moelwyn Merchant, 21 March 1980: Eton College Library.

4 When she did see this production, MP's response was mixed. Accustomed to a darkened stage and a complete absence of movement during the interludes, she found what Miller did with the interludes—allowing figures to wander about, meet, and part—'unforgiveable', but she admired the way his direction of the children playing brought out an underlying viciousness.

5 The Grocer's Company, of which JP was now an Honorary Freeman, held the living of this church with Magdalene College, Cambridge.

6 Basil Deane, *Composers of Wales 2: Alun Hoddinott* (Cardiff: University of Wales Press, 1978).

7 MP to Alun Hoddinott, n.d. [1976–7]: courtesy of Alun Hoddinott.

8 The paintings were unveiled at Rail House by Sir Peter Parker and JP was paid £2,500 for each. Saltash Bridge became the subject of a screenprint in 1983.

9 JP, 'Foreword', in John Dyer, *Grongar Hill* (Hackney: Stourton Press, 1983).

10 JP to Clarissa Lewis, n.d. [1983]: courtesy of Clarissa Lewis.

11 As recollected by Caroline Odgers's

husband Christopher Compston, who was present at this occasion, in 'A Lunch with John Piper 1983', typescript: TGA 991.43.

12 MP, in Geoffrey Elborn (ed.), *To John Piper on his eightieth birthday* (London: Stourton Press, 1983).

13 JP, *Desert Island Discs* (BBC Radio 4, 16 December 1983) [radio interview].

14 *Art and the Artists* (February 1984).

15 *Daily Telegraph*, 30 November 1984.

16 Alan Franks, *Daily Telegraph*, 20 March 1987.

17 JP to Geoffrey Lloyd, 23 April 1985: TGA.

Chapter 34: An English Garden

1 On leaving, Ted wrote to JP: 'your kindness I shall not forget': TGA.

2 JP and EP interviewed by Sally Brompton, *Good Housekeeping*.

3 MP to Peter Walker, New Year's Day Greeting [1988]: TGA.

4 The picture is illustrated in colour in 'John Piper: A Retrospective', the catalogue to the Waddington Galleries exhibition, 1994.

5 JP to Moelwyn Merchant, 16 November 1987: Eton College Library.

6 John Russell Taylor, *The Times* (6 October 1987).

7 Peter Fuller, *Images of God: The Consolations of Lost Illusions* (London: Chatto and Windus, 1985), 94.

8 Stephanie Fuller to J and MP, 31 July 1990: TGA.

9 In the collection of Lord Camoys.

10 Recollected by John Deeker in conversation with the author.

11 JP to Rachel Billington, transcript of an interview, 1983: TGA 8318.27

12 Recollected by Peter Khoroche, in conversation with the author.

13 David Fraser Jenkins, introduction to 'John Piper', Waddington Galleries, 1989.

14 John Mortimer, in conversation with the author.

15 MP, quoted in Sylvia Clayton, *Edward Piper* (Newton Abbot: David and Charles, n.d.[1991]), 11.

16 MP to Dr Collier, 11 August 1990: courtesy of Hugh Fowler Wright.

17 MP to Robin Healey, 13 May 1991: courtesy of Robin Healey.

18 *The Times*, 30 June 1992.

Chapter 35: Myfanwy

1 *Fawley Parish Magazine* (September 1992).

2 Recollected by James Kirkman, in conversation with the author.

3 MP, 'Art', *Harper's Bazaar* (July 1963).

Select Bibiography

A bibliography of John Piper's written works and interviews, together with an extensive bibliography of the critical commentary his work has received, has been published by Orde Levinson in his *Quality and Experiment: The Prints of John Piper. A Catalogue Raisonné* (London: Lund Humphries, 1996). What follows here is a select bibliography, specifically related to the facts, themes, and contextual issues dealt with in this book.

Alexander, Peter, *William Plomer* (Oxford: Oxford University Press, 1990).

Allen, Brian (ed.), *Towards a Modern Art World*: *Studies in British Art I* (London: Yale University Press, 1995).

Amory, Mark (ed.), *The Letters of Evelyn Waugh* (London: Weidenfeld and Nicolson, 1980).

Anton Zwemmer: Tributes from Some of His Friends on the Occasion of his 70th Birthday (privately printed, 1962).

Artmonsky, Ruth, *Jack Beddington* (London: Artmonsky Arts, 2006).

Banham, Mary and Bevis Hillier (eds), *A Tonic to the Nation: The Festival of Britain 1951* (London: Thames and Hudson, 1976).

Barber, Noel, *Conversations with Painters* (London: Collins, 1964).

Barnes, Jennifer, *Television Opera: The Fall of Opera Commissioned for Television* (Woodbridge: Boydell Press, 2003).

Benjamin, Walter, 'The Work of Art in the Age of Mechanical Reproduction' (1936), in *Illuminations*, ed. Hannah Arendt (New York: Schocken Books, 1969).

Betjeman, John, 'Introduction: An Aesthete's Apologia', in *Ghastly Good Taste* (1933; London: Anthony Blond, 1970).

—— 'A spiritual change is the one hope for art', *The Studio* (February 1937), 56–72.

—— 'A Shell Guide to Typography', *Typography* 2 (Spring 1937).

—— 'The Seeing Eye or How to Like Everything', *Architectural Review* 86 (November 1939), 201–4.

—— *Church Poems* (London: John Murray, 1981).

—— *John Betjeman: Letters*, vol. I: *1926–1951*, ed. Candida Lycett Green (London: Methuen, 1994).

Bland, Alexander, *The Royal Ballet: The First Fifty Years* (London: Threshold Books, 1981).

Blyth, Alan, *Remembering Britten* (London: Hutchinson, 1981).

Brett, Philip, *Music and Sexuality in Britten* (Berkeley: University of California Press, 2006).

Britten, Benjamin, *The Rape of Lucretia* (London: Bodley Head, 1948).

—— *Letters from a Life: The Selected Letters and Diaries of Benjamin Britten 1913–1976*, ed. Mitchell, Donald, Philip Reed, and Mervyn Cooke (vols. I–III, London: Faber and Faber, 1991–2004; vol. IV, Woodbridge: Boydell Press in association with the Britten–Pears Foundation, 2008).

Buchanan, Iain, Michael Dunn, and Elizabeth Eastmond, *Frances Hodgkins: Paintings and Drawings* (London: Thames and Hudson, 1995).

Calder, Alexander, *Calder: An Autobiography with Pictures* (New York: Pantheon Books, 1966).

Campbell, Louise (ed.), *To Build a Cathedral: Coventry Cathedral, 1945–1962*, exhibition catalogue (University of Warwick, 1987).

—— *Coventry Cathedral: Art and Architecture in Post-war Britain* (Oxford: Clarendon Press, 1996).

Caplat, Moran, *Dinghies to Divas* (London: Collins, 1985).

Carey, Frances and Anthony Griffiths, *Avant-Garde British Printmaking 1914–1960* (London: British Museum Publications, 1990).

Carpenter, Humphrey, *W. H. Auden: A Biography* (London: George Allen and Unwin, 1981).

—— *Benjamin Britten* (London: Faber and Faber, 1992).

Casson, Hugh and others, *Bombed Churches as War Memorials* (Cheam, Surrey: Architectural Press, 1945).

Causey, Andrew, *Paul Nash: Writings on Art* (Oxford: Oxford University Press, 2000).

Clark, Kenneth, *Another Part of the Wood: A Self-Portrait* (London: John Murray, 1974).

—— *The Other Half: A Self-Portrait* (London: John Murray, 1977).

Clarke, Brian (ed.), *Architectural Stained Glass,* with a contribution by John Piper (London: John Murray, 1979).

Clayton, Sylvia, *Edward Piper* (Newton Abbot: David and Charles, n.d. [1991]).

Collier, Graham, *Form, Space, and Vision: Discovering Design through Drawing* (Englewood Cliffs, NJ: Prentice-Hall, 1963).

Comper, Ninian, *Of the Atmosphere of a Church* (London: SPCK, 1947).

Cook, F. Palmer, *Talk to Me of Windows*, with a foreword by John Piper (London: W. H. Allen, 1971).

Cooke, Mervyn and Philip Reed, *Benjamin Britten: 'Billy Budd'* (Cambridge: Cambridge University Press, 1993).

Coxon, Raymond, *Art: An Introduction to Appreciation* (London: Sir Isaac Pitman and Sons, 1932).

Crawford, O. G. S., *Archaeology in the Field* (London: Phoenix House, 1953).

Crozier, Eric (ed.), *Benjamin Britten: Peter Grimes*, Sadlers Wells Opera Book no. 3 (London: Bodley Head, 1945).

Deane, Basil, *Composers of Wales 2: Alun Hoddinott* (Cardiff: University of Wales Press, 1978).

De-la-Noy, Michael, *The Life of Edward Sackville-West* (London: Bodley Head, 1988).

Dyer, John, *Grongar Hill*, with foreword by John Piper (Hackney: Stourton Press, 1983).

Elborn, Geoffrey (ed.), *To John Piper on his Eightieth Birthday* (London: Stourton Press, 1983).

Evans, John, '*Owen Wingrave*: A Case for Pacificism', in *The Britten Companion*, ed. Christopher Palmer (London: Faber and Faber, 1984), 227–37.

Evans, Myfanwy: See under Piper, Myfanwy

Evans, Peter, *The Music of Benjamin Britten* (London: J. M. Dent, 1979).

Folsom, Franklin, *Days of Anger, Days of Hope: A Memoir of the League of American Writers 1937–1942* (Boulder: University Press of Colorado, 1994).

Fraser Jenkins, David, 'John Piper and Subjects in Wales', *Transactions of the Honourable Society of Cymmrodion* (1984).

—— *John Piper: The Forties* (London: Philip Wilson/Imperial War Museum, 2000).

—— and Frances Spalding, *John Piper in the 1930s: Abstraction on the Beach* (London: Merrell, 2003).

Frost, Stella (ed.), *A Tribute to Evie Hone and Mainie Jellett*, with a contribution by John Piper (Dublin: Browne and Nolan, 1957).

Fuller, Peter, 'An English Romantic', *Independent Magazine*, 10 December 1988.

—— *Images of God: The Consolations of Lost Illusions* (London: Chatto and Windus, 1985).

Gardiner, Margaret, *Barbara Hepworth: A Memoir* (Edinburgh: Salamnader Press, 1982).

Gibberd, Frederick, *The Metropolitan Cathedral of Christ the King, Liverpool* (London: Architectural Press, 1968).

Gill, Linda (ed.), *Letters of Frances Hodgkins* (Auckland: Auckland University Press, 1993).

Girouard, Mark, *John Piper's Stowe*, with a foreword by John Piper (Westerham, Kent: Hurtwood Press, in association with the Tate Gallery, 1983).

Gissing, George: *The Whirlpool*, with introduction by Myfanwy Piper, London: Watergate Classics, 1948.

Glendinning, Victoria: *Edith Sitwell: A Unicorn among Lions*, London: Weidenfeld and Nicolson, 1981.

Graham, Rigby, and Michael Felmingham, *Ruins* (London: Country Life Books, 1972).

Grigson, Geoffrey, *The Crest on the Silver* (London: Cresset Press, 1950).

—— *Recollections: Mainly of Writers and Artists* (London: Chatto and Windus/Hogarth Press, 1984).

Halliwell, Michael, *Opera and the Novel: The Case of Henry James* (New York: Ridopi, 2005).

Hammer, Martin and Christina Lodder, *Constructing Modernity: The Art and Career of Naum Gabo* (New Haven/London: Yale University Press, 2000).

Hammond, Peter, *Liturgy and Architecture* (London: Barrie and Rockcliff, 1960).

Harwood, Elaine, 'Liturgy and Architecture: The Development of the Centralised Eucharistic Space', *The Twentieth Century Church, Twentieth Century Architecture 3*, (London: The Twentieth Century Society, 1998), 49–74.

Harewood, George Lascelles, *The Tongs and the Bones* (London: Weidenfeld and Nicolson, 1981).

Harrison, Charles, *English Art and Modernism, 1900–1939* (London: Allen Lane, 1981).

Hauser, Kitty, *Shadow Sites: Photography, Archaeology and the British Landscape, 1927–1955* (Oxford: Oxford University Press, 2007).

Headington, Christopher, *Peter Pears: A Biography* (London: Faber and Faber, 1992).

Heenan, John C., *A Crown of Thorns An Autobiography 1951–1963* (London: Hodder and Stoughton, 1974).

Hemingway, Andrew, 'Meaning in Cotman's Norfolk Subjects', *Art History* 7:1 (March 1984), 57–77.

Hemmings, David, *Blow-Up and Other Exaggerations* (London: Robson Books, 2004).

Herbert, David (ed.), *The Operas of Benjamin Britten* (London: Herbert Press, 1979).

Hewison, Robert: ' "Happy were We": Benjamin Britten and the *Gloriana* Story', in *Britten's Gloriana: Essays and Sources* (Woodbridge: Boydell Press, in association with the Britten-Pears Library, 1993).

Hillier, Bevis: *Young Betjeman*, London: John Murray, 1988

—— *John Betjeman: New Fame, New Love*, London: John Murray, 2002

—— *Betjeman: The Bonus of Laughter*, London: John Murray, 2004

Hiscock, Karen, *Axis and Authentic Abstraction*, unpublished PhD, University of York, 2006.

Hodnett, Edward, *Five Centuries of English Book Illustration* (Aldershot: Scolar Press, 1988).

House, Humphry and Graham Storey, *The Journals and Papers of Gerard Manley Hopkins*, with an essay by John Piper (London: Oxford University Press, 1959).

Howard, Patricia (ed.), *Benjamin Britten: The Turn of the Screw* (Cambridge: Cambridge University Press, 1985).

Howard, R. T., *Ruined and Rebuilt: The Story of Coventry Cathedral 1939–1962* (Coventry: Council of Coventry Cathedral, 1962).

Hussey, Christopher, *The Picturesque* (1927; London: Frank Cass, 1983).

—— 'The Twilight of the Great House', *Country Life* (26 January 1945).

Hussey, Walter, *Patron of Art: The Revival of a Great Tradition among Modern Artists* (London: Weidenfeld and Nicolson, 1985).

Inglis-Jones, Elisabeth, *Peacocks in Paradise* (London: Faber and Faber, 1950).

Ingrams, Richard and John Piper, *Piper's Places: John Piper in England and Wales* (London: Chatto and Windus, 1983).

Ironside, Robin, *Painting since 1939* (London: Longmans, Green, for the British Council, 1947).

James, Henry, *The Art of the Novel* (London: Scribner's, 1934).

John Piper: A Retrospective, exhibition catalogue with preface by Myfanwy Piper (London, Waddington Galleries, in association with James Kirkman, 1994).

Joyce, Paul, ' "The Arbitrary Eye": A Photographic Discourse between John Piper and Paul Joyce', *British Journal of Photography* (25 November 1983), 1239–43.

Kavanagh, Julie, *Secret Muses: The Life of Frederick Ashton* (London: Faber and Faber, 1996).

Kenna, V. E. G., *A Catalogue of the Cypriotic Seals of the Bronze Age in the British Museum* (1971).

Kitson, Stanley D., *The Life of Cotman* (London: Faber and Faber, 1937).

Le Corbusier, *Towards a New Architecture* (London: John Rodker, 1927).

Lees-Milne, James, *Prophesying Peace* (London: Faber and Faber, 1977).

Levinson, Orde, *'Quality and Experiment': The Prints of John Piper*, rev. edn (London: Lund Humphries, 1996).

Lewis, Jeremy, *Cyril Connolly: A Life* (London: Jonathan Cape, 1997).

Liberatore, Virginia: 'Restoration of the Festival of Britain Pleasure Gardens, Battersea Park', *London Gardener* 7 (2002), 79–91.

Lycett Green, Candida: *John Betjeman: Letters: Volume Two: 1951–1984* London: Methuen, 1995.

McAlpine, Alastair, *Once a Jolly Bagman: Memoirs* (London: Weidenfeld and Nicolson, 1997).

McDonald, John (ed.), *Peter Fuller's Modern Painters: Reflections on British Art* (London: Methuen, 1993).

Medley, Robert, *Drawn from the Life: A Memoir* (London: Faber and Faber, 1983).

Mellor, David, Gill Saunders, and Patrick Wright, *Recording Britain* (London: David and Charles, in association with the Victoria & Albert Museum, 1990).

Merchant, Moelwyn, *Fragments of a Life* (Llandysul, Dyfed: Gomer Press, 1990).

Micha, René, *Hélion* (Naefels: Bontini Press, 1979).

Mitchell, Donald (ed.), *Benjamin Britten: Death in Venice* (Cambridge: Cambridge University Press, 1987).

Mortimer, John, *Murderers and Other Friends* (London: Penguin, 1994).

Mowl, Timothy, *Stylistic Cold Wars: Betjeman versus Pevsner* (London: John Murray, 2000).

Northen, Michael, *Northen Lights: A Life Behind the Scenes* (Chichester: Summerdale, 1997).

Osborne, June, *John Piper and Stained Glass* (Stroud: Sutton, 1997).

Owens, Susan, 'Evocation or topography: John Piper's Watercolours of Windsor Castle, 1941–44', *Burlington Magazine*, September 2005, CXLVII: 1230: 598–605.

Pace, Peter G., *The Architecture of George Pace* (London: B. T. Batsford, 1990).

Palmer, Christopher (ed.), *The Britten Companion* (London: Faber and Faber, 1984).

Peaker, Carol, *The Penguin Modern Painters History* (London: Penguin Collectors' Society, 2001).

Pearson, John, *Façades: Edith, Osbert and Sacheverell Sitwell* (London: Macmillan, 1978).

Percival, John, *Theatre in My Blood: A Biography of John Cranko* (London: Herbert Press, 1983).

Peters Corbett, David, Ysanne Holt, and Fiona Russell, *The Geographies of Englishness: Landscape and the National Past 1880–1940* (New Haven/London: Yale University Press, 2002).

Piper, Charles, *Sixty-Three: Not Out: A Book of Recollections* (Plaistow: Curwen Press, 1925).

Piper, John, *Wind in the Trees* (privately printed, 1923).

—— *The Gaudy Saint and Other Poems*, Bristol: Horseshoe Publishing Company, 1924.

—— 'Towers in the Fens', *Architectural Review*, November 1940, 88: 131–34.

—— 'The Architecture of Destruction', *Architectural Review*, No.535. July 1941, 14: 25–30.

—— 'John Sell Cotman, 1782–1842', *Architectural Review*, 54, July 1942, 92:9–12.

—— *British Romantic Artists* (London: Collins, 1942).

—— 'Notes from a Yorkshire Journal', *Geographical Magazine* December 1942, XV: 8,: 364–367.

—— 'The gratuitous semicircle', *Architectural Review*, 94, October 1943, 94: 112–13.

—— 'Topographical Letter from Norwich', *Cornhill Magazine*, January 1944, 161: 96: 9–18.

—— 'Colour in Building: Colour and Texture' *Architectural Review*, 95, February 1944, 95: 51–2.

—— in conversation with R. Myerscough-Walker, in 'Modern Art explained by Modern Artists', *The Artist* (May 1944).

—— 'Blandford Forum', *Architectural Review*, July 1944, 96:21–4.

—— 'Topographical Letter from Devizes', *Cornhill Magazine*, November 1944, 161:190–95.

—— 'The Colour of English Country Houses', *International Textiles*, (pamphlet) 1944.

—— 'Seaton Delaval', *Orion* 1 (1945), 43–4.

—— 'The Artist and the Church', *Cymry'r Groes: A Quarterly Magazine* 2: 1 (July 1946).

—— *Buildings and Prospects* (London: Architectural Press, 1948).

—— *Romney Marsh* (London: Penguin, 1950).

—— 'Portland Stone—Portland Colours', *Ambassador* 6 (1954).

—— *Stained Glass: Art or Anti-Art?* (London: Studio Vista, 1968).

—— *The Mountains*, intro. R. S. Thomas, with illustrations drawn by John Piper and engraved on the wood by Reynolds Stone (New York: Chilmark Press, 1968).

Piper, Myfanwy (= Evans, Myfanwy), *The Painter's Object* (London: Gerald Howe, 1937).

—— (= Evans, Myfanwy), *Frances Hodgkins* (London: Penguin Books, 1948).

—— *No Rubbish Here*, London: Collins, 1936.

—— *Diggory goes to the Never-Never*, London: Collins, 1937.

—— (ed.), *Sea Poems* (London: Frederick Muller, 1944).

—— *Reynolds Stone* (London: Art and Technics, 1951).

—— 'Portrait of a Choreographer', *Tempo* (Summer 1954), 14–23.

—— *The Seducer*, London: Duckworth, 1958.

—— 'The Libretto', in Donald Mitchell (ed.), *Benjamin Britten: Death in Venice* (Cambridge: Cambridge University Press, 1987), 45–54.

—— in conversation with Peter Porter, *Quarto* (August 1991).

—— 'Osbert Lancaster', *The Spectator* 9 (August 1986).

—— 'Back in the Thirties', *Art and Literature: An International Review* (Winter 1965).

Powers, Alan, *Serge Chermayeff: Designer, Architect, Teacher* (London: RIBA Publications, 2001).

—— 'Guides to Betjeman Country', *Country Life* (30 August 1984).

Pugh, Edward, *Cambria Depicta* (London: E. Williams, 1816).

Raeburn, Michael (ed.), *Sacheverell Sitwell's England* (London: Orbis, 1986).

Rayner, Geoffrey, Richard Chamberlain, and Annamarie Stapleton, *Artists Textiles in Britain 1945–1970: A Democratic Art* (Woodbridge: Antique Collectors' Club, 2003).

Richards, J. M., *Memoirs of an Unjust Fella* (London: Weidenfeld and Nicolson, 1980).

Roberts, Jane, *Views of Windsor: Watercolours by Thomas and Paul Sandby from the Collection of Her Majesty Queen Elizabeth II* (London: Merrell Holberton, 1995).

Rothenstein, John, *Brave Day Hideous Night: Autobiography, 1939–65* (London: Hamish Hamilton, 1966).

Russell, John, *From Sickert to 1948: The Achievement of the Contemporary Art Society* (London: Lund Humphries, 1948).

Sadler, Michael, *Michael Ernest Sadler: A Memoir by his Son*, with a foreword by John Piper (London: Constable, 1949).

Schafer, Murray, *British Composers in Interviews* (London: Faber and Faber, 1963).

Seymour, Claire, *The Operas of Benjamin Britten* (Woodbridge: Boydell Press, 2004).

The Shell Poster Book, foreword by Lord Montagu of Beaulieu (London: Profile Books, 1998).

Sheppard, Richard, 'Churchill College Chapel', *Churchbuilding*, 25 October 1968, 25: 21–23.

Sidnell, Michael, *Dances of Death: The Group Theatre of London in the 1930s* (London: Faber and Faber, 1984).

Sillars, Stuart, *British Romantic Art and the Second World War* (London: Macmillan, 1991).

Simon, Oliver, *Printer and Playground: An Autobiography of Oliver Simon* (London: Faber and Faber, 1966).

Sitwell, Osbert, *Left Hand, Right Hand! An Autobiography* (London: Macmillan, 1945).

Smithells, Roger and S. J. Woods, *The Modern Home: Its Decoration, Furnishing, and Equipment* (Benfleet, Essex: F. Lewis, 1936).

Spence, Basil, *Phoenix at Coventry* (London: Geoffrey Bles, 1962).

Spender, Stephen, Introduction, *War Pictures by British Artists. Second Series: Air Raids* (Oxford: Oxford University Press, 1943).

Symondson, Anthony and Stephen Bucknall, *Sir Ninian Comper: An Introduction to his Life and Work* (Reading: Spire Books and the Ecclesiological Society, 2006).

Todorov, Tzvetan, *Hope and Memory*, trans. David Bellos (Atlantic, 2004).

Uhlmann, Anne (ed.), *Ravilious at War: The complete work of Eric Ravilious, September 1939–September 1942* (Upper Denby: Fleece Press, 2002).

Wadsworth, Barbara, *Edward Wadsworth: A Painter's Life* (Salisbury: Michael Russell, 1989).

Walpole, Hugh, *Mr Perrin and Mr Trail* (London: J. M. Dent, 1935).

Ward, Frank, *The Lakes of Wales* (London: Herbert Jenkins, 1931).

West, Anthony, *John Piper* (London: Secker and Warburg, 1979).

Wheeler-Bennett, J. W., *King George VI: His Life and Reign* (London: Macmillan, 1958).

Whistler, Laurence, *Sir John Vanbrugh: Architect and Dramatist 1664–1726* (London, 1938).

Williams-Ellis, Clough, *Britain and the Beast* (London: J. M. Dent, 1937).

Wilson, A.N. *Betjeman*, London: Hutchinson, 2006.

Wilson, Edmund, *The Triple Thinkers: Twelve Essays on Literary Subjects* (London: John Lehmann, 1952).

Woods, S. J., 'John Piper as a Topographical Illustrator', *Image* 2 (Autumn 1949), 3–18.

—— *John Piper: Paintings, Drawings and Theatre Designs 1932–54* (London: Faber and Faber, 1955).

Woodward, Christopher, *In Ruins* (London: Chatto and Windus, 2001).

Index

At the end of the eighteenth century flint combined with stone or plaster was considered suitably decorative and "rustic" for use in garden pavilions and grottoes, the effect of the colour being an obvious attraction : as at West Wycombe† and Fawley Court, Buckinghamshire, Goodwood and elsewhere in Sussex. Vermiculations, patternings, chequerings and borderings are managed in flint follies with charming fantasy. In Buckinghamshire it is sometimes used as a rustic dressing for a yellow plaster in-filling.

Combined with yellow or white bricks it was fashionable and handy in Victorian times in Hampshire and Bedfordshire. The junction station at Micheldever, on the main line to Southampton, is a fine eyecatcher among the quiet Hampshire fields.

East Anglian flintwork is a speciality. The flints are so carefully shaped that the joints in a wall of flint need very little or no mortar, and the resulting black or dark grey wall is startling in its velvet-like richness of colour and texture. "Flushwork"—the intricate patterning of shaped flints set in stone—encouraged virtuosity. Chapels, porches and towers of many Norfolk and some Suffolk churches have it. The gateways so decorated make the Close at Norwich what it is.

† In the hilltop church and mausoleum here, neighboured by yews, it has a magnificent colour effect.

Flint-knapping has been carried on continuously at Brandon and elsewhere in the Thetford neighbourhood since prehistoric times. The knappers travelled, but not very far. The art is dying, but persists so far, or did so until the beginning of the present war. "Beside the major occupation of manufacturing gun-flints for the victims of unscrupulous gun-running the knappers still produce squared flint facings for churches and domestic structures. The cores resulting from flaking are squared or rounded up and used for building purposes. In 1876 these sold at 4s. per 100. (Rainbird Clarke, *ibid.*)

Right : Flintwork, decorative and structural. Top : Folly building in West Wycombe Park ; Centre : Farm buildings at Beddingham, Sussex ; characteristic of many such on the North and South Downs. Bottom : Unknapped flint in a Norfolk tower, at Burnham Market : a late mediæval example of the contrasting of flint with carved stone, that was to become so popular with Victorian church builders.